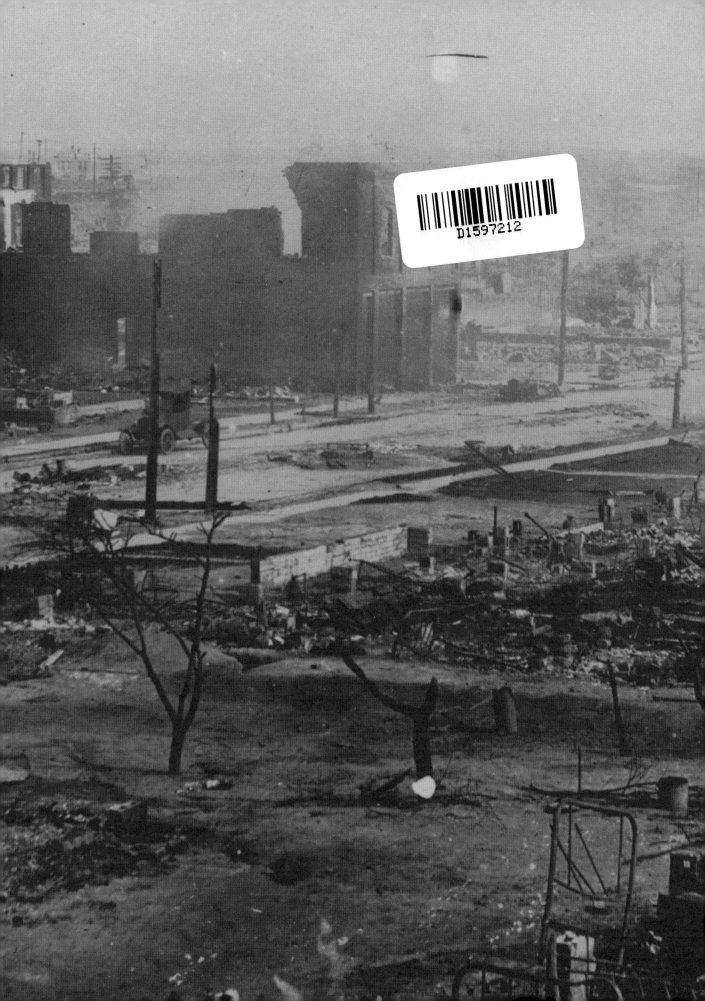

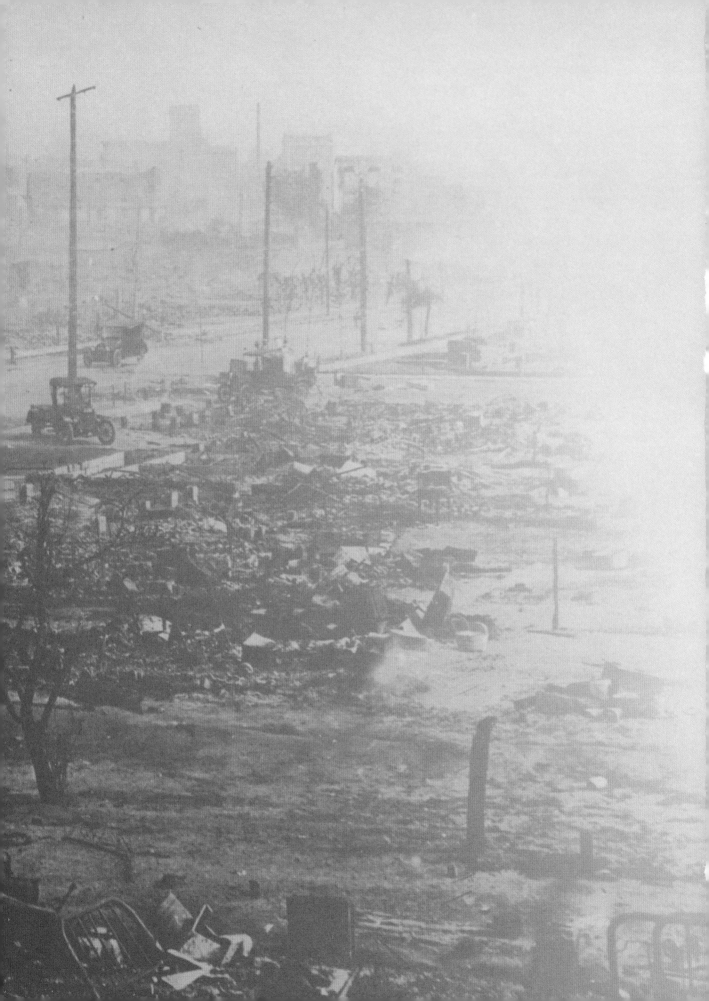

A Movement in Every Direction

A Movement in Every Direction

A Great Migration Critical Reader

Edited by

Jessica Bell Brown
Associate Curator of Contemporary Art at the
Baltimore Museum of Art

Ryan N. Dennis
Chief Curator and Artistic Director of the Center for Art &
Public Exchange at the Mississippi Museum of Art

Baltimore Museum of Art and Mississippi Museum of Art,
in association with Yale University Press, New Haven
and London

Contents

Directors' Foreword

Christopher Bedford
Dorothy Wagner Wallis Director of the Baltimore Museum of Art

Betsy Bradley
Director of the Mississippi Museum of Art

The more than six million Black US citizens who moved around and away
from the country's deepest southern region during the Great Migration
(1915–70) carried generations of trauma with them. But they also carried
seeds of imagination, creativity, and spectacular artistry that have been
borne out nationwide over the course of twentieth century. The children,
grandchildren, and great grandchildren of these migrants have trans-
formed the country, and perhaps nowhere has this transformation been
more profound than within the arts. Whether in the Mississippi-born blues
music that launched Detroit's soul music industry or in the descendants of
enslaved people who became Pulitzer and Nobel Prize laureates, the cre-
ation of new genres of music, literature, and visual art can be tied directly to
legacies of migration. What is less understood, however, is the link between
contemporary Black visual artists and their family migration stories. This
project, a partnership between the Baltimore Museum of Art (BMA) and
the Mississippi Museum of Art (MMA), institutions mapped at two impor-
tant nodes along the migration path, attempts to reveal unknown stories
of movement and making to foster new understandings of generational
connections between artists and our regional contexts. This partnership has
been driven by mutual institutional commitments to the power that artistic
insight lends to critical questions of equity and justice in our country today.

While the scope of this ambitious project is crystallized in the works of art
created and presented in the exhibition, its origin point is a thorough inves-
tigation of national, regional, and family histories. To that end, our brilliant
curators Ryan N. Dennis (Chief Curator and CAPE Artistic Director at the
MMA) and Jessica Bell Brown (Associate Curator of Contemporary Art at
the BMA) spent months absorbed in primary source documents, a distillation
of which fills these pages. They were ably assisted by Andrew W. Mellon
Post-Baccalaureate Curatorial Fellow Christina McField, Meyerhoff-Becker
Curatorial Fellow Cynthia Hodge-Thorne, Curatorial Research Associate
Amarie Gipson, and copy editor Amanda Glesmann. In the early stages of
the project's development Lydia Jasper offered tremendous research support.
We join the curators in thanking Eddie C. and C. Sylvia Brown Chief Cura-
tor Asma Naeem for her continued insights and enthusiasm for this project.
Jessica Novak, Meghan Gross, and Melanie Martin of the BMA publications
team deftly coordinated the organization of this book, which was brought
to life with a design by Polymode Studio and production management by
Lucia | Marquand.

This volume is the first of three publications that will transmit infor-
mation and engage exhibition visitors. Only because of early investments
by the Ford Foundation, under the visionary leadership of Darren Walker,
along with the generous stewardship of grants by Margaret Morton and
Rocio Aranda-Alvarado, were we able to take an idea of an exhibition that
invested in artists' processes to the next level of production. In Mississippi,
the Robert M. Hearin Support Foundation contributed the early financing
that allowed us to initiate this innovative and risk-taking project. The caring,

insightful, and generous Terry Carbone at the Henry Luce Foundation has been a constant companion during the exhibition development process, providing advice, support, and funding. We also owe thanks to The Andy Warhol Foundation for the Visual Arts, the National Endowment for the Humanities, the National Endowment for the Arts, and the W. K. Kellogg Foundation. Our museum partners, eager to mount the exhibition on its national tour, also gave confirmation that these stories of the American experience must be told, and that these artists are the ones to tell them.

The wealth of knowledge contained herein will be brought to life not only by the twelve eminent artists whose works will fill the exhibition, but also by our educators, led by Elizabeth Williams in collaboration with the MMA's education team, McKenzie Drake, Grayston Barron, and Merry Barnes, and by Gamynne Guillotte and Verónica Betancourt at the BMA. When the historical documents gathered here penetrate the personal narratives of those who dive into the pages of this publication, the continuum of meaning will be complete. We are grateful to all of those who, through their diligent and intelligent work, have enabled that intimate journey for so many by producing this volume.

The word Black
has geographic power,
pulls everybody in:
Blacks here—
Blacks there—
Blacks wherever they may be.

—**Gwendolyn Brooks,** *Primer for Blacks,* 1980

Introduction

Jessica Bell Brown and Ryan N. Dennis

Published in conjunction with the contemporary art exhibition *A Movement in Every Direction: Legacies of the Great Migration,* this reader is a compilation of perspectives on a story familiar to many: the mass exodus and dispersion of millions of African Americans out of the South into regions in the North, Midwest, and West over the course of the twentieth century. Upon further investigation of and reflection on the complexities of that narrative, and as organizers of the attendant exhibition of twelve contemporary artists—Mark Bradford, Akea Brionne, Zoë Charlton, Larry W. Cook, Torkwase Dyson, Theaster Gates, Allison Janae Hamilton, Leslie Hewitt, Steffani Jemison, Robert Pruitt, Jamea Richmond-Edwards, Carrie Mae Weems—with ties to the South and to migration writ large, we realized in the earliest stages of planning the show that the incredible history and legacy of this movement is far more complex than its typically neat and linear recountings suggest. *A Movement in Every Direction: A Great Migration Critical Reader* is meant to break open the story of the Great Migration and provide snapshots of moments leading up to and throughout its duration across the nation, both in real time and in the context of current scholarly retrospection on the history of Black life between 1870 and 1970.

We know that 90 percent of Black Americans lived in the South before 1915, and that by the 1970s nearly 50 percent were living in regions outside the South. As Isabel Wilkerson, Pulitzer Prize–winning journalist and author of *The Warmth of Other Suns: The Epic Story of America's Great Migration* (2010), reminds us, they traveled in routes of migration from Florida, Georgia, and the Carolinas to Virginia, Washington, DC, New York, and New Jersey. Streams of migrants traversed on trains, planes, and buses from towns and cities in Mississippi, Arkansas, and Alabama to Illinois and Michigan. They also dispersed from Louisiana to Southern California and to various West Coast cities. One fascinating aspect of this movement, aside from the steady stream toward American metropolises, is the quiet dynamism of those families who remained in the South and found agency or, at the very least, rootedness in their communities of origin. In many conversations, several of the artists commissioned for the exhibition posited the South as a wellspring for their creative pursuits. Wherever Black Americans went or wherever they chose to stay behind, where there are heartbreaking and seemingly relentless and systemic instances of hardship, racial terror, lynching, and Jim Crow apartheid there are also stories of abundance, land ownership, self-possession, and deep ancestral knowing.

A Movement in Every Direction: Legacies of the Great Migration is grounded in a key prompt: "What would happen if today's leading artists were given the space to think about the lasting impact of the Great Migration in a holistic, expansive, and dynamic way?" Our hope is that this project will attend to and complicate historical traumas, racial violence, and socioeconomic exigencies while at the same time examining the agency seized by both those who fled the South and those who remained behind. We have invited an incredible group of artists whose practices deal with personal and communal histories, familial ties, the Black experience, and the ramifications of land ownership and environmental shifts, among so much more, to expand our understanding of this pivotal moment in American

history. We look forward to considering the Great Migration further through the artists' points of view, which will be shared in the galleries and in the second companion publication through their vibrant stories of resilience, self-determination, and transformation.

All too often, the exploratory processes of researching and organizing an exhibition and producing a catalogue are hidden behind a veil. The countless hours spent in the archive, the news clippings and documents discovered, become tucked into files and cataloged in the recesses of the curatorial process, seldom shared with the wider public. Our aim with *A Movement in Every Direction: A Great Migration Critical Reader* is to reimagine the possibilities around access to original and secondary research. Organized in three sections—"Between Town and Metropolis: The Great Migration and the American City," "A Morsel, A Memory, A Feast: Lasting Legacies of Black Southern Foodways," and "Finding Sanctuary in Ourselves: Cultural Expressions of the Great Migration"—this volume brings together full texts and excerpts from more recent scholarly writings, news articles, and editorials, along with photographs, recipes, and related materials to create a more robust understanding of the Great Migration's impact on American culture. Many of these excerpts were culled from local or regional newspapers like the *Jackson Advocate,* or from African American publications like *The Crisis*, the *Chicago Defender*, and *The Afro-American*. Taken together, these outlets offer a unique and dynamic snapshot of the narration of the Great Migration and its impact on society in real time, while also capturing the implicit bias in much reportage on Black life. In sum, these selections are not intended to be comprehensive, but rather to act as a prompt for continued conversation around the themes of the exhibition: family, ancestry, land, self-determination, and liberation.

It is our hope that as you sift through the pages of this book a concept or a reading might grab your attention, sparking a desire to dive deeper into the lasting ramifications of migration and the myriad forces—personal, political, and social—that shape how families and communities move in the world in search of agency and human dignity. The histories we receive are often just part of the picture. Only when the pixels are brought together to form an expansive image can we truly grasp the fullness of our lives within and across the continuum of our deep historical legacies.

Editors' Note

With the exception of minor typographic and formatting corrections made for clarity and consistency, the previously published writings reprinted here are presented without alteration and retain their original spelling, capitalization, and punctuation.

The quotations on pages 19, 49, 65, 89, 125, 135, 143, 181, and 212 are unedited excerpts of letters written by African Americans seeking to resettle in the North during World War I that were published in Emmett J. Scott's "Letters of Negro Migrants of 1916–1918," *The Journal of Negro History* 4, no. 3 (July 1919).

1. Between Town and Metropolis: The Great Migration and the American City

The Great Migration was arguably one of the most impactful phenomena in twentieth-century American history. Inspired by the individuals who left the South in hopes of obtaining opportunities throughout the country, this section examines social, political, and demographic changes in the period just before 1915 through 1970. As historian Edward L. Ayers has discussed, "Across the South, towns of fewer than 2,500 people doubled in the 1870s and then doubled again by 1900, when more than 1.2 million people lived in two thousand such communities."[1] This section elucidates the subsequent movement patterns of that population, making connections between why people stayed in Southern cities and why they migrated north, east, and west and expanding the narrative beyond physical violence as the singular component that led to Black departure.

The conditions of Black life in late nineteenth- and early twentieth-century America were more expansive than many people have come to understand. A few conditions made it so: During Reconstruction, participation by African Americans in political, economic, and social life peaked as a result of civic activism to ensure better conditions. As Vann R. Newkirk II articulates in his essay "The Great Land Robbery" (2019, pages 50–60), in the period between Emancipation and the Great Depression, many individuals owned their land and successfully used it to generate wealth. These landowners (and migrants) formed both intentional and unintentional micro-communities for collective building and resource sharing, and this was perhaps what made possible their movement from Southern city to Southern city—what we have taken to calling "intra-South migration." As white people began to realize these truths, they countered with acts of deep oppression rooted in policy changes like the "Black Codes" and the adoption of statutes that went against African Americans, along with violence perpetrated by members of the general public as well as by individuals in positions of power.

Within this time, incredible strides were made by Black people to establish better futures for themselves and to move in self-determined ways that improved their lives and those of their families. Through signing up for the military, joining other government programs, and participating in the workforce in new ways, we became more adept at navigating professional life. Sociological studies like St. Clair Drake and Horace R. Cayton, Jr.'s *Black Metropolis: A Study of Negro Life in a Northern City* (1945, pages 90–98) and W. E. B. Du Bois's *The Philadelphia Negro: A Social Study* (1899, pages 74–81) allow readers to understand that these developments did not solely benefit the individual but in fact moved the collective forward with ripple effects we can see today. These texts show the *longue durée* of systemic challenges like social segregation, racism, and discrimination that Black communities have faced from the Reconstruction era right up to the present moment. "Between Town and Metropolis" reveals our dynamism during times when we were not set up to succeed. And it shows how the Great Migration story is our story, a commonality that is shared across generations who have deep ties to the American South. The following pages offer just a partial snapshot of a moment of American history, because as Bernadette Pruitt urges, "further studies of Black migrations from the farm to the city within the South are needed to complete the story."[2]

—JBB and RND

1. Edward L. Ayers, *Southern Journey: The Migrations of the American South, 1790–2020* (Baton Rouge: Louisiana State University Press, 2020), 51. Excerpted on pages 68–73 in this volume.
2. Bernadette Pruitt, "In Search of Freedom: Black Migration to Houston, 1914–1945," *Houston Review of History and Culture* 3, no. 1 (Fall 2005), reprinted on pages 102–15 in this volume.

Maryland's Best.
The Afro-American is e oldest, largest and wsiest weekly Newsper in Maryland.

THE AFRO AMERICAN

L. XXVII. No. 16.

THE AFRO-AMERICAN, BALTIMORE, MD. FRIDAY, DEC. 27, 1918.

918 A MOMENTOUS YEAR FOR THE NEGRO
YOUNG WIDOW GETS $7,500 DAMAGES
RED CROSS TREATS THOUSAND

REVIEW OF HE YEAR 1918

s Advance Made By Race Along Many Lines of Endeavor.

DiERS MAKE GOOD

Wages Bring Prosperity.
al Churches Ou tof Debt.
owden Gets New Trial.
gregation Measure Killed.

eview of the events, local and rywide during the past twelve as shows remarkable progress lines of material prosperity for d people. High wages and the ave given the colored brother a e and a push forward where he expected it before.

ping step with this material erity is the advance shown by rous events during the year to the bringing of interracial good and real Democracy for the oped peoples in the United States.

WAR COMES FIRST

and away ahead of everything a interest and importance during year looms the European War brought to a successful conclu ollowing the timely and nearly te entry of America and her r and half citizen army.

colored Americans glory in the hat 300,000 of these troopers black and distinguished them beyond all that anyone had oped. Worthy of special men and out above others the 15th ork Regiment, cited as a whole llantry in action. Sergeant Wm. who single handed put five to rout and Needham Roberts Harry Johnson disposed of 24 ine, not to speak of our own Separate Company boys. Ser Terry and Pinckney who won a War Crosses for bravery in

loss of the services of Colonel whom the War Department cked much as it did General have been more than made up the showing of the one thous olored officers trained at Fort oines and other camps, and by ection of Mr. Emmett Scott as Assistant to the Secretary of

r General Ballou, commander 92nd Division has made his nfamous for all generations by lletin number 35 enjoining col oldiers and officers not to stand r their legal rights. This to with the closed door policy of avy under Josephus Daniels tes part of the dark records year.

DENT WILSON WRITES ON BOTH SIDES ome black pages of the ecord, President Wilson wrote Continued on Page Four

B. & A. Still sulting Negroes

George Webster, a junior law of Howard University, was ac by William J. Poplar, white, Fairmount Ave., an employee

814th Infantry just landing from the White Star Liner Cedric, in New York.

Gets $7.500 For Husband's Death

Was Accidentally Swept Over board Judge Rose Awards Damages to Widow.

"What would you do if you sudden ly came into the possession of $7,500?" This is the question that Mrs. Wil liam Boddie will have to answer when she receives this amount of money as damages from the Mary land Dredging and Contracting Com pany which was the responsible party in causing the death of her husband on August 11th last.

The case of Mrs. Boddie versus the Baltimore and Ohio Railroad Com pany, Maryland Dredging and Con tracting Company, the Patapsco Ship Celling and Stevedore company, and the Empire Engineering Company, Incorporated was heard before Judge Rose in the United States Court on Tuesday.

The opinion was filed in her favor for $7500 against the Maryland Dredging Company. Judge Rose held that this company was chiefly re sponsible for the death of William Boddie, a stevedore, who was swept off a launch into the harbor and drowned. However the court re served the right to collect the damages from the other companies in case the Maryland Dredging Company did not pay them.

$10,000 ASKED FOR

When seen at her home, 806 Mc Donough street yesterday by a repre sentative of the Afro-American, Mrs. Boddie, who is a trim little brown skinned woman apparently in her twenties, was anxious to talk but was restrained by her mother, who does not like publicity.

Mrs. Boddie did say that her home was at Rocky Mount, North Carolina, and that she expected the Maryland Dredging Company to settle without taking the case to the next higher court. She said she had asked for $10,000.

POST OFFICE LIST OF COLORED TROOPS

Washington, December 22—For the convenience of the press as well as

WEARING HIS (WAR) CROSS WITH A SMILE

Right—Sergt. Rufus Pinckney. Left—Corporal Mack Watson.

Two Old First Separate Company Boys now in 372nd Infantry.

Note two stripes on Pinckney's right arm indicating two wounds, and stripe on left arm indicating six months service.— Most important Pinckney proudly wears the French War Cross and sports an automatic revolver captured from a German captain.

LABOR HEAD MAKES REPORT

Says Lynch Law Causes Color ed Exodus and Makes Adjustment Diffi cult.

Washington, D. C., December 24.— The report of the Secretary of La bor has just come from the press and will soon be ready for distribu tion. The Secretary, Mr. Wilson says "The appointment of a Negro as adviser to the Secretary on matters relating to the Negro race was urged by many white persons as well as Ne groes and was favorably recommend ed by the Advisory Council of the Department of Labor. After consul tation with many persons of both races, the Secretary appointed Dr. George E. Haynes as his adviser, with the title—Director of Negro Econom ics.

According to the Secretary's report, this step was taken not only because the advice of an expert was necessary but because it was generally felt that a race which makes up such a large share of our industrial army and has contributed so generously to our mil itary and naval forces is certainly en titled to a seat at the Secretary's Council table when matters affecting its interests are being considered.

DUTIES DEFINED

"The function of the Director of Negro Economics," says the Secre tary, "is to advise the Secretary on matters affecting the Negro wage earners and to ut line and direct plans toward greater productions in agriculture and other industries. The work of this Division since its estab lishment has amply justified its crea tion and my policy has been to refer to it for advice concerning administra tion of all problems peculiar to Ne groes as wage-earners."

NEGRO MIGRATION OF GREAT GREAT CONCERN

Congress is informed by the report that a very extensive document has been made by the Department of Labor under the supervision of Dr. James H. Dillard, President of the Jeanes and Slater Funds for Negro education in the South. The investigation was begun prior to the appointment of a Director of Negro Economics. How ever, the report was submitted to the Director of Negro Economics for final

814th INFAN HOME A

First Colored Regime barks In New Wednesday from L Cedric

New York, December White Star Liner Celtic com New York harbor yesterday 1157 officers of the 814th F Nearly the same number troops of several regiments board.

All the troops were glad home after the rough pass during which many suffered sickness.

The 814th was in training Winchester, England when th tice was signed and were home, without getting over to Five men from New York's regiment, the old 15th were board. All of the men were Camp Mills.

Songs of the men and the of their band could be heard the river and even up in They were some glad to

THROWS FRIEND FRO THIRD STORY WIN

Charged with having thre caller from the third story wi to the area way below, thereb ing almost instant death, Stevenson, who occupies apartment at 920 McCulloh st held at the Northwestern pol tion charged with murder.

George Trott, whose home his family at 556 W. Hoffman is the dead man.

About six-thirty a passing man heard the sound of a bo ing into the areaway among glass and other debris. roans he investigated and Trott bleeding and apparently ing from internal injuries.

Taken to the hospital, he died Monday morning. His sc his skull were broken, and his several injuries.

In a statement to the polic said, that Stevenson avows he fell thru the window, but the sash and other convicting evid the room caused the police to him.

BAKER ASKS SCOTT TO REMAIN

"A Review of the Year 1918"

The Afro-American (Baltimore), December 27, 1918

Shows Advance Made By Race Along Many Lines of Endeavor.

Soldiers Make Good

High Wages Bring Prosperity. Local Churches Out of Debt. Snowden Gets New Trial. Segregation Measure Killed.

A review of the events, local and countrywide during the past twelve months shows remarkable progress along lines of material prosperity for colored people. High wages and the war have given the colored brother a chance and a push forward where he never expected it before.

Keeping step with this material prosperity is the advance—shown by numerous events during the year toward the bringing of Interracial goodwill, and real Democracy for the oppressed peoples of the United States.

War Comes First

Far and away ahead of everything else in interest and importance during the year looms the European War lately brought to a successful conclusion following the timely and nearly too late entry of America and her million and a half citizen army.

All colored Americans glory in the fact that 300,000 of these troopers were black and distinguished themselves beyond all that anyone had ever hoped. Worthy of special mention stand out above others the 15th New York Regiment, cited as a whole for gallantry in action. Sergeant Wm. Butler, who single handed put five Hens [*sic*] to rout and Needham Roberts and Harry Johnson disposed of 24 Germans, not to speak of our own First Separate Company boys, Sergeants Terry and Pickney who won French War Crosses for bravery in action.

The loss of the services of Colonel Young, whom the War Department sidetracked much as it did General Wood, have been more than made up for by the showing of the one thousand and colored officers trained at Fort Des Moines and other camps, and by the selection of Mr. Emmett Scott as Special Assistant to the Secretary of War.

Major General Ballou, commander of the 92nd Division has made his name infamous for all generations by his Bulletin number 35 enjoining colored soldiers and officers not to stand up for their legal rights. This together with the closed door policy of the Navy under Josephus Daniels constitutes part of the dark records of the year.

President Wilson Writes on Both Sides

On the same black pages of the years record, President Wilson wrote the death sentence of five members of the 24th Infantry for the uprising at Houston. Over against it he uttered an official proclamation against lynching, through Mr. Emmett Scott called a conference of Editors to meet in Washington and sent a Negro correspondent to France.

Backing up the fine work of our soldiers, officers and other executives, the folks at home distinguished themselves in the Third and Fourth Liberty Loans, The Red Cross Drive, and the War Savings Stamps Campaign and wherever their contributions were kept separate from those of the whites, the records show that colored people did their share. A notable example is the local War Work Campaign where colored folk went seventeen thousand dollars over their quota.

In the Industrial Field

In the field of Industry, the war has given the colored man his chance, and the colored man has made good, in many striking cases. Charles Knight and his gang of riveters hung up a world's record for ship workers. Not long after this came along a gang of pile drivers working at Hog Island and hung up a pile driving record. Detroit gives an example of the kind of change that has taken place during the year, when the city officials point to 16,000 colored workers now employed in the shops and factories there at high wages, where before only a few hundred worked.

The continuation of the migration of colored folk from the Southland, had as its sequel the appointment of Dr. George C. Haynes, as director of the Bureau of Negro Economics, who has applied himself to bringing about a better understanding between blacks and whites in Southern states.

The Legal Side

In the Supreme Court of the land the villainous city segregation measures were given a black eye during the past year, and for good measure the Court of Appeals at Annapolis passed adversely on the same attempts of white folks to circumscribe colored residents. In the state the trial of John Snowden for murder of a white woman called forth large endeavors on the part of people over the whole state and District of Columbia in order to get his case before the Court of Appeals where it now rests.

The right of the W. B. and A. railroad to jim crow colored passengers between here and Washington was called into question several times during the year, and in the settlement of the cases now pending, it is expected to deal a mighty blow for freedom.

Educational Outlook in State Hopeful

In the state of Maryland, and throughout the country great strides have been measures by the schools. The establishment of the government classes in several larger schools like Tuskegee, Howard, Hampton and others, and the S.A.T.C. offering vocational and college studies to all al government expense have added an impetus to higher education, that will be felt for the next generation.

The speech of Governor Harrington at Salisbury and the energetic labors of State Superintendent Hoffington gave done the same thing for education in the state of Maryland. The opening of high schools (public) in other cities of the state outside of Baltimore is an evidence of large progress.

By contrast, the local school system suffers. The elementary education while splendid in kind is not attracting the number of pupils that it should, and the policy carried out with reference to the high school is perhaps largely responsible for this. The high school itself is a neglected institution.

Churches in Front

The unexampled material prosperity had manifested itself nowhere else so noticeably as in the churches. The M. E. Church announced the drive for a Centenary Fund. Three colored denomination s, A.M.E., A.M.E.Z., and C.M.E. held members looking toward organic union. The Southern Baptist still attempt to come to an agreement and heal the wounds caused by the split a year ago.

Asbury, Ames, Sharp St., St. John's and Ebenezer Churches freed themselves from all indebtedness, and look forward to larger social service. The Independent A. M. E. Church entered its new building. The church life among Catholics has been enriched by the appointment of Father J. H. Dorsey, one of the four colored priests in the country to the parish of St. Monica.

Beginning with he $12,000 rally of Bethel Church last Spring church rallies entered a new phase. The outcome of the $33,000 effort is being watched with more than local interest.

Elks Show Up Well

In the Fraternal world, the year has seen the split of the Odd Fellows, the second largest organization among colored people, the settlement of difference between white and colored Elks, and the adverse decision rendered against colored Shriners by Georgia Courts.

Worthy of special notice locally is the progress shown by the Pythians and Elks in their new homes. This latter organization in its annual convention in Baltimore last summer made an unusually favorable impression.

Personal Mention

The selection of two colored men as assistant to cabinet officers, the reelection of Judge Terrell to the Municipal bench in the District of Columbia, the election of Negroes to the legislature in several states and the offer to Dr. DuBois of the Captain's Commission indicate the larger value that is put on personal worth. "We are rising" there is not doubt about it. Surely and slowly headway is made, and the work goes on.

Under the heading "In Memoriam," the city is the poorer for the loss of sterling citizens like Wm. H. Daly, Rev. D. P. Seaton, W. H. Bishop, Dr. R. H. Johnson, Rev. P. W. Wortham and Alfred H. Pitts.

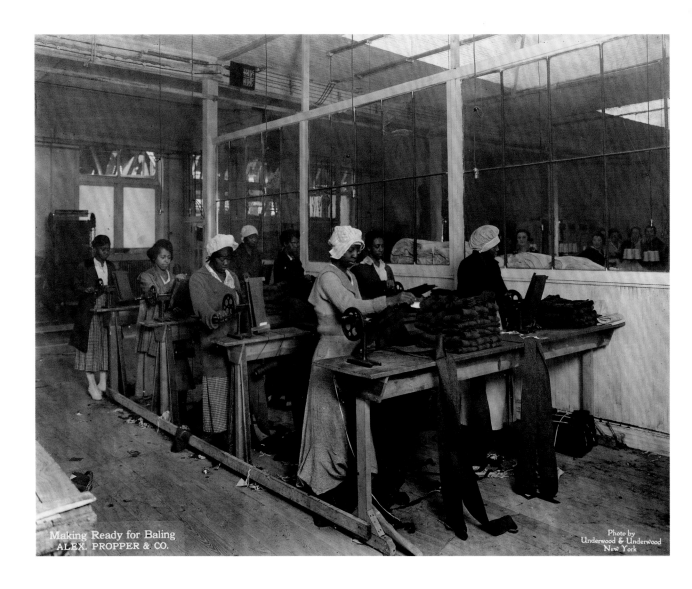

Making Ready for Baling
ALEX. PROPPER & CO.

Photo by
Underwood & Underwood
New York

Workers manufacturing spiral puttees
at the Alexander Propper & Company
plant, New York, 1918. Photograph by
Underwood & Underwood

"*Dear Sir:* . . . I am ready to come just as soon as you send the passes to us I want to bring a box of quilts and a trunk of clothes so you please send us the passes for me and daughter. Write me at once I am a negro woman. We will leave her Sat. if you send the passes . . ."

CORINTH, MS, APRIL 30, 1917

EXCERPT

Black Exodus: The Great Migration from the American South

"Introduction: A Stream of Dreams" by Blyden Jackson

Edited by Alferteen Harrison, xi–xx. Jackson, MS: University Press of Mississippi, 1991

It has been a long, long time, more than 500 years, since a young Portuguese mariner named Antam Gonçalvez captured some stray Africans around 1442 and took them back with him to his home port in Portugal as slaves. Inasmuch as Gonçalvez was negotiating waters off the west coast of Africa he may well be considered the unwitting beginner of the Atlantic slave trade. So, too, to him, conceivably, may be traced everything pertaining to black America, not excluding that hopeful trek, lasting approximately thirty years (about the extent of a human generation), of black Southerners from the South to the North that historians of black America sometimes call the Great Migration.

The Atlantic slave trade did bring some Negroes directly from Africa to our America, although far fewer than most people seem to think. The first black permanent residents of our America lived in Tidewater, Virginia—in other words, in the South. They actually did precede the Pilgrims, being left at Jamestown in 1619. There were, apparently, only twenty of them. Their consanguineous descendants here now number in excess of twenty-six million, about three million more than the number of residents our last census-takers were able to discover in California, America's most populous state. It may be tempting, therefore, to picture to one's self a great influx of blacks from Africa into the United States after the deposit of the Jamestown Negroes and consequently to postulate that in black America, there is the powerful presence of an African atavism. One could believe that this atavism is perpetuated, if by nothing else, by the aggregation of African-rooted recollections and practices in acquired behavior of millions of black Americans who were born and spent their formative years in Africa and who preserved and passed on African culture to black American children (who then passed them on to their children). But such has not been the case. Careful analysis of the slave trade demonstrates that, at the highest possible extreme, no more than 600,000 black Africans were ever delivered to the United States from 1619 until the middle 1860s (when the last slaves beached in North America) with no intervening "seasoning"—almost all of them, incidentally, before the end of the eighteenth century. "Seasoning," in the present context, refers to the training in Western enslavement received by a native African in the West Indies (or, in rare instances, elsewhere) before a transfer to the American mainland. It added only negligibly to the total of native Africans who ended their separation from their homelands within our America.

Even so, there have long been efforts by interested parties both within and without the select community of scholars to argue that there is a significant persistence of African traditions and artifacts (including language) in black America, particularly in that class and breed of black Americans often alluded to as "the black folk." To deny, with no proof, any possibility of African survivals in the present racial inheritance of black Americans, folk or otherwise, would certainly be to commit a grievous error. Moreover, in at least one isolated instance, that of the Gullah people, who have long been largely sequestered from other Americans in islands along the Atlantic coast from, roughly, Charleston, South Carolina, to Savannah, Georgia, the evidence of the existence of African survivals is too palpable to be ignored. Yet the phenomenon of provenience (where people came from) forces upon us a conclusion about the tremendous expansion in size of black America which can, in no wise, be refuted. That conclusion tells us, simply and clearly, that the main cause, by far, for black America's enormous growth is natural increase—that is, black births in America. Negroes situated on American soil have long been parenting children where they have lived much or all of their lives. These children have been doing as did their parents. This procreation of American blacks by American blacks has been going on for well over three hundred years. In that entire lengthy period of time no subtractions which would notably reduce the population of black America have occurred, whether, as examples, in the nineteenth century as a result of subsidies or forms of coercion or persuasion initiated by the pro-slavery colonizationists or in this century as a response to Marcus Garvey's clarion call to black Americans to return to Africa.

The psyches and ethos of black Americans, accordingly, with no exception that matters, have been formed and dominated by an American environment. This incontrovertible fact must be given its due weight in any attempt to properly appreciate the black American's Great Migration. One needs, in short, to apprehend how fully and unalterably American the American Negro truly is to detect with a sufficiently perspicacious eye the deeper currents of passion that metamorphosed into marching orders the fondest dream of the Southern black and energized his feet when he willed himself to forsake the South and travel north. He wanted, in that most candid expression of himself, one thing only, to enjoy America. He did not want to trade the values he had come to cherish in a country native to him for those

of any other nationality or culture. He merely wanted to make come true for himself what he believed he could see had already come true for virtually all other Americans, particularly in the respect paid to their dignity as persons and in the access allowed them to seek political and economic well-being among their fellow Americans. To speak in terms unequivocal, yet most accurate for him, he wanted to be more completely and more unrestrictedly American.

This desperate, gnawing yearning of his to fare in America at least as well as other Americans was, as it were, terribly intensified by the circumstance that he was not only so American. He was also very southern. As late as 1900, slightly more than nine of every ten inhabitants of black America still lived in the South. Theirs was, as is well-known, the South which had fought a bloody, savage war to keep blacks enslaved. In general this South was, as it had always been, about as great an antithesis to the ideal America for black people as could possibly be imagined. But even its racism was far from all about the South that Southern blacks could not abide. The South, even apart from the paranoia of its program of white supremacy, in comparison with the North, where a vigorous exploitation of the industrial revolution had produced a community vibrant with optimism and material progress, was a woefully antiquated social order too feudally agrarian for its own good. With or without slavery, this South was not the section of America where the future (or the present) seemed to show its brightest promise. The South had been appallingly static before it fired on Fort Sumter. Nothing about it after its surrender at Appomattox seemed essentially to have changed. It was narcotized by its worship of its golden myth of its antebellum self as a benign aristocracy. And its so-called Redemption following the era of Reconstruction could only be construed as what it unquestionably was, a resolute attempt to resurrect the past and return its race relations to the days of Calhoun and of masters and overseers. But, no less to its detriment, it lagged, in its whole way of life, behind the North. It was the North, as America entered a new century, into which capital, invention, entrepreneurial ingenuity, immigrants from overseas, and the might of corporate endeavor poured. It was the North which boomed, the North which, race aside, was bettering its preferential position to the South. It was the North where, apparently, everything was moving on.

News about this North, as was to be expected, constantly filtered down to southern Negroes. They could not but feel a strong inclination to test the veracity of the reports they received about it. As soon, then, as the late 1870s and early 1880s they launched their first attempt to make their way into this fabled Canaan. They chose as their initial point of entry the state of Kansas. A patriarchal black Tennessean, one "Pap" Singleton, took the lead in exhorting them into an exodus which gained for those who joined in it the sobriquet of "Exodusters." But all did not turn out for these "Exodusters" quite as had been hoped. That which they had pictured to themselves as mainly a potential crystal stair eventuated too extensively into a trail of tears. Nevertheless, their fate in Kansas, mixed as it was, diminished little, if at all, the general enthusiasm of southern Negroes for moving to the North.

So, as time continued on its way, Southern Negroes continued to steal away from the South. In 1914 came the assassination of an Austrian archduke, which precipitated World War I, thereby occasioning, as one side effect, a sudden and drastic decline in European emigration to America at precisely a moment when northern captains of industry and finance, recipients of huge contracts to supply their favored combatants with munitions and other emergency requirements for nations involved in modern war, experienced a need to quickly expand a labor force. Correlatively, the steady trickle of southern blacks into the North grew to a flood, thus creating, among other things, the classical black ghettos of urban America above the Mason-Dixon Line. As America (after recruiting two armies, one white and one black, to fight in World War I) entered the 1920s it found itself coexisting with women's suffrage, prohibition, bootlegging, the automobile age, radio, movie moguls and Hollywood stars, a burgeoning Babbittry, flappers, flush times for a while on Wall Street, a Lost Generation in literature and the arts, a new freedom for its youth, and the beginning of the end of any bucolic simplicites it had ever had. Concurrently, in black America, Harlem in Manhattan, the South Side in Chicago, and Paradise Valley in Detroit reached the peak of their prosperity, as did smaller replicas throughout the North of these cities within cities largely populated by the Great Migration and its offspring. But the northward surge of the southern Negro had crested by the end of the 1920s. It would never again be so high. Ahead of it, as of all America, in the womb of unknown time, were the worst depression yet in American history, a second and bigger World War, and our America of today, a miracle of modern science with powers for both good and evil beyond the wildest fantasies of any human creatures but those living now.

Inevitably, Negro literature bears within itself content, as well as themes and moods, reflecting the Great Migration. Indeed, it probably may be safely said that no other event, large or small, which competent students recognize as a valid part of black America's past has had an impact equal in mass or gravity upon the consciousness of black writers. Richard Wright's *Native Son*, for example, is steeped in the world of the Great Migration, as is the poetry of Gwendolyn Brooks and the drama of Lorraine Hansberry. Actually, as of now, two successive

generations of Negro writers and the beginning of a third have found the most abundant source of the material they have used in the Great Migration, if not literally in the migrants themselves and their deeds, then, in the special conditions left by the migrants to their descendants, the world which we may call, not too arbitrarily, the aftermath of the Great Migration. It may well be in truth that black writers have said even more about this aftermath than about the Great Migration itself. In so doing, it can be added, they have tended more toward commiseration than joy. They have perceived, in effect, a sequel to the Great Migration in its totality too exact a copy of the frustrations of the Exodusters in Kansas. They have been much aware of the slum housing, the school dropouts, the widespread chronic unemployment, the high incidence of vice, crime and violence and worse, perhaps, of all, the increase, statistically, of a dispossessed underclass in precisely those highways and byways of the North where once, while our century was young, uprooted southern Negroes settled to improve their lot. Black literature certainly is not satisfied with the northern aftermath of the Great Migration to which it has devoted so much of its time and its published work.

Still, all that southern blacks were hoping to attain through their Great Migration should not be deemed, apparently, to have been lost. The North is surely not as bad for Negroes as the South the Great Migration fled. Nor has change, either in race relations or otherwise, been so absent lately in the South as once it was. Jim Crow is gone. An amelioration of discrimination, as well as of segregation, has occurred. But also, not necessarily because of any changes connected with race, the sectionalism so long a barrier between the South and North apparently is vanishing as utterly as a whisper in the wind, too utterly, some people, especially some people of artistic bent, lament. There is a term, appreciably current now, which does convey a sense both of a radical elimination of variety in America (which may well be real) and of the aversion of Americans to whom diversity can be possessed of value to the implied meanings of this term. The term, itself, is "homogenization." It suggests an America wherein a vast sameness rules, a duplication by every integer of every other integer taxonomically its mate. And, it must be conceded, homogenization does appear to be rife in our America. All the cities with their shopping centers, supermarkets and subdivisions (which all look alike), all the airports, all the anchorpersons on the television new shows, all the cheerleaders, all the people on the street, all the entertainers, all the anything, look, and do, alike. In any case, former disparities no longer suggest a better life for blacks (or whites) in the North rather than the South. With the changes in race relations in the South and the effect upon America of homogenization, it is no wonder then that currently an episode in black history is repeating itself in reverse.

The Great Migration has turned around and is returning to the South.

From March 1985, until March 1988, of blacks in America, 586,385 went from the North back to the South. In these same three years, only 326,842 blacks followed the original pattern of the Great Migration and went from the South to the North. Moreover, quite interestingly, in reversing the Great Migration, the southgoing blacks are repeating, with a close exactitude, a pattern in the choice of routes reminiscent of their forebears. Southern blacks who years ago joined in the Great Migration tended to adhere to what I have persuaded myself to call lanes in their progress to their promised land. The lanes, not too astonishingly, were very logical. They catered to the taking of the shortest distance between two points. There were three of them. From the Southeast, Virginia through Florida, one lane followed the Atlantic coast up to Pennsylvania and the other mid-Atlantic states, or to New England. A second lane ran from Kentucky, Tennessee, Alabama, or Mississippi to the Midwest. It fed mightily the big black ghettos in Chicago and Detroit. The Far West, the West Coast, has always actually been for blacks a portion of the North. The third lane of the Great Migration, consequently, took blacks largely from Texas, Louisiana, and Arkansas to America along the Pacific slope and particularly to California. The present reverse migration, during the three years just cited above, has brought 219,809 blacks through its eastern lane back to the Southeast. Simultaneously, only 51,083 blacks have taken this lane north. Along the far western lane, comparable figures show 186,196 blacks returning to the South and only 92,085 journeying toward the states beyond the Rocky Mountains. The midwestern lane does tell a somewhat different story. From 1985 to 1988 black migration either to the South or to the North along this lane was close to identical. Migrants going in a southerly direction totaled 183,083. Those going to the North were, in aggregate, 183,674. Not every reversing migrant, of course, has adopted the appropriate lane, just as years ago, not every black traveling in the opposite direction went where an appropriate lane would have taken him. Still, the lanes are too significant a feature of black history not to receive more than cursory recognition. They also partly explain why, in some nuances deriving from distinctions between localized black subcultures in the South, a Harlem was never quite the same black urban ghetto as a South Side in Chicago or a Watts in Los Angeles.

Further extensions of the Great Migration are, of course, to us either prophecy or more or less scientific speculation. Its essence, however, has never changed and remains to this day as it has never otherwise been, a pilgrim's progress. The pilgrim, it should go without saying, is black America. The Celestial City is a status in America acceptable to blacks. Where this status is

does seem closer than it was when the Great Migration began. The great-grandchildren of the earliest migrants now are on their way in search of it. How tragic it would be should their pilgrimage last as long as that of their parents and parents' parents.

"Race Labor Leaving"

Chicago Defender, February 5, 1916

Much Concern Over Possible Shortage of Labor— Exodus Steady—Treatment Doesn't Warrant Staying

Selma, Ala., Feb. 4—The white people of the extreme south are becoming armed over the steady moving of race families out of the mineral belt. Hundreds of families have left during the past few months and the stream is continuing. Every effort is being made to have them stay, but the discrimination and the race prejudice continues as strong as ever. Not many years ago there was a dearth of labor in this part of the country and the steerage passengers from Europe were sought. They cannot do the work of the race men, as they do not understand. Local editorials in white papers are pleading with the business men to hold the race men if possible.

"Big Exodus of Negroes"

The Daily Banner (Cambridge, MD), October 9, 1916

Decrease in Immigration Because of the European War Is Causing Employers to Offer Fancy Wages For Common Laborers.

Leading industrial operators in the South are beginning to regard with alarm the large exodus of negroes from Alabama, Mississippi, and other Southern States to accept jobs in the industrial fields of New York, Pennsylvania, Illinois, Ohio, Missouri, and West Virginia. When the exodus started several months ago it was regarded lightly. Then it was found that labor agents were working among the negroes and were offering fancy prices for common labor. Now it is estimated that fully 50,000 negroes have left the "black belt" and the exodus is continuing at the rate of from 500 to 1000 men a week.

Various causes are assigned for the exodus. The restriction on European immigration which usually supplies the rough labor for the United States has caused employers to look to the South to supply this demand. Others place a political significance on the government. They believe the negroes are being taken to doubtful States in the North where they will be allowed to vote for the President and then be discharged and sent home.

In Anniston, Gadsden and Birmingham, industrial centers of Alabama, drastic laws and ordinances are being considered to check for foreign labor agents. Iron and mining interests are suffering because of the shortage of men. In other sections the exodus is regarded as an excellent thing for the South. It will mean the breaking up of immense plantations into smaller farms on which white labor will be employed. It will mean a greater diversification of crops and force farmers in the "black belt" of Alabama to depend less on the single crop. Since the war they have raised cotton to the exclusion of all other crops. Shifting of the black population in districts where they outnumber the whites six to one is regarded as a good omen among progressive Southerners.

In many cases negroes who have gone to the North are eager to return home. In letters to friends they declare that they were deceived in the promises of better conditions and that their treatment has been harsh at the hands of white competitive labor. They are asking aid to get back home. Again the cooler weather of the North is causing many Southern negroes to wish for their old homes on the plantations.

EXCERPTS

Capitol Men: The Epic Story of Reconstruction through the Lives of the First Black Congressmen

Philip Dray

Selections from Chapter 2: "A New Kind of Nation" and Chapter 9: "Divided Time," 26, 180. New York: Houghton Mifflin Harcourt, 2008

In early 1866 the committee recommended the passage of two bills—an extension of the Freedmen's Bureau (officially titled the Bureau of Refugees, Freedmen, and Abandoned Lands), which Lincoln had brought into existence in March 1865 to offer physical aid to war refugees and help establish equitable labor agreements between blacks and their former masters; and the Civil Rights Bill, which would undo the nefarious Black Codes and counter the much-lamented 1857 Supreme Court decision in *Scott v. Sandford,* better known as the *Dred Scott* case, which had denied that black people, slave or free, had standing as American citizens. The Civil Rights Bill, referring to the "fundamental rights belonging to every man as a free man," stated that all citizens and their property were entitled to equal protection under the law and that blacks were empowered to make their own labor contracts and initiate lawsuits. The president vetoed both bills, prompting the political cartoonist Thomas Nast, an ardent New York Republican of German descent who drew for *Harper's Weekly,* to depict an ornery Andrew Johnson kicking a chest of drawers containing terrified freed people—the Freedmen's "bureau"—down a flight of stairs.

While the debate over the new civil rights bill was testing Reconstruction's limits in Congress, a parallel struggle was taking shape in far-off Mississippi. This verdant agricultural land had, since war's end, experienced periods of relative political stability, enough so that blacks from more troubled states, such as Georgia, regarded it as something of a mainstay of Republican rule. Yet of the three states with black majority populations—Mississippi, Louisiana, and South Carolina—Mississippi would be the first in which whites achieved redemption, or home rule, and the methods by which this was accomplished, known as the Mississippi Plan, would become a regional model for that transformation.

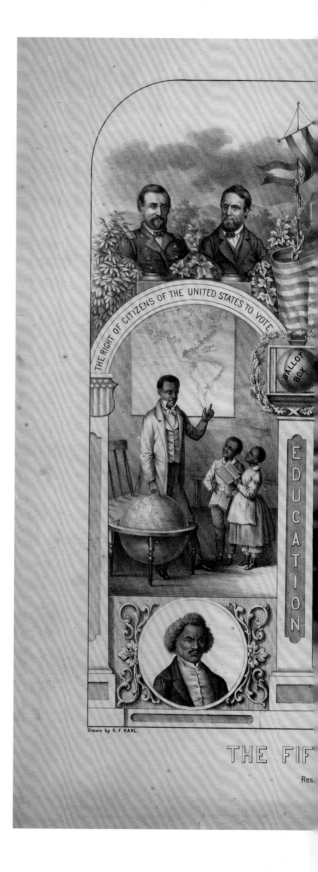

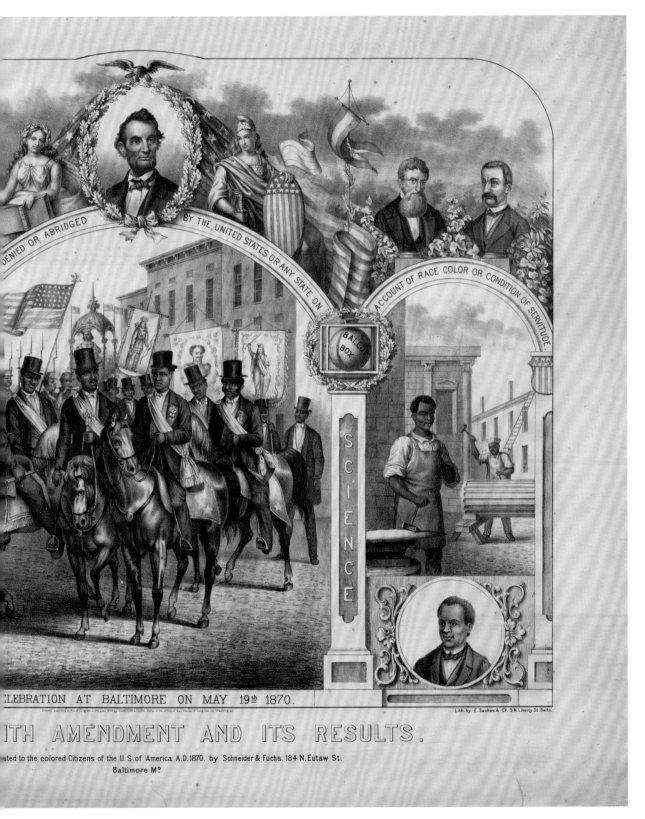

E. Sachse & Co., after an image by G. F. Kahl,
The Fifteenth Amendment and Its Results,
c. 1870

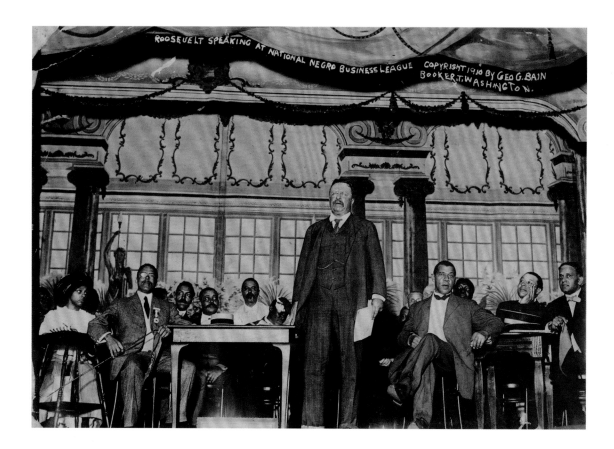

"The Negro in Local Politics"

The Aegis and Intelligencer (Bel Air, MD),
April 17, 1903

As a factor in municipal politics, the weight of the negro is already beginning to show in the Baltimore political campaign. In a recent interview ex-Governor Brown stated that he would like to see all of the city work in the hands of white people and that he deplored the employment of colored labor whenever it was unnecessary. The *Baltimore American* in a recent article accepts this as one of the issues and publishes a table of statistics tending to show that the negro vote is on the decrease. To the mind of any reasonable person, this would seem absurd when we consider that the negro population multiplies much more rapidly than the white. It is doubtless true that the registration books would show a different fact, but this is simply because the Democrats have lately been more alert in keeping the list of purged criminals and dead men on whose names it is easy to either repeat or substitute. With the average white person there is much truth in the refrain "All coons look alike to me," and it is frequently hard to recognize familiar faces among the colored brethren as their general appearance is very similar. This is much harder in the city where the daily contact with

the negro is not so frequent by those who are charged with the details of registration. Municipalities are overrun with a floating negro population which gravitates imperceptibly from one place to another and all that the average Republican has to do is keep the names upon the books for someone to vote upon.

The voters of Baltimore City certainly cannot forget City Hall in the days when Malster was the chief executive. Those of us who have had an occasion to visit the place on a matter of business distinctly recall the gang of worthless negroes hanging around the buildings and infesting its corridors. The same is true for the State House at Annapolis during the Lowndes regime. Many times it was a matter of physical impossibility, especially when Mudd was Speaker of the House, to get anywhere near the galleries of either the House or Senate on account of those unwelcome statesmen. That these things will have their weight no one can gainsay. We do not believe that the average Republican has any more use for the negro or does not love him any more, of course, we do not include Mr. Roosevelt in this list, than a Democrat, but it is an utter impossibility for them to be kept in control when their party is in power. The insolence to which the white people are unnecessarily subjected, is greatly augmented every time there is a Republican victory, and the race, always more or less lawless, becomes much more so when they feel that their own party is in the saddle. The files of the daily papers

covering Mr. Malster's official career will prove this statement. Hardly a day passed that the newspapers did not chronicle some indignity which had been heaped not only upon inoffensive white men, but also our women. While these indignities were not of grave criminal character, yet they were of an extremely outrageous nature.

Mr. Wachter, the Republican nominee, occupies a similar position to that of ex-Mayor Malster. He largely owes his present position to just such a vote as supported the former, and should he be elected, the old-time negro lawlessness may be expected. Many a self-respecting white man will cast his vote for the Democratic nominee for no other reason than that of attempting to hold the negro in his place.

"The Negro and Politics"

The Commonwealth (Greenwood, MS),
July 28, 1899

Honor should stand above office and the future should be guarded by the present. Now it makes no difference to us who voted the negroes unqualified in the Carroll County election, the McLaurin crowd or Allen crowd, it was a disgrace to the state and should be condemned by its fearless press. The lugging again of the negro into our state politics as was done at Carroll, Ferry and Yalobusha counties in their primary is a dishonor to the county and to the men engaged in such dirty work. The carrying of an election by that vote is but the entering wedge of the Republican party, whose election by office and boodle is only met by life and determination on the part of good citizens. This we do not want to see in Mississippi, but another election like the present will see it. The candidate for office who is not willing for the white man to decide his case is not fit for the place and should be defeated. Our county Leflore, which has three negroes to one white man, can feel proud of her election, as it was only the white men who voted and that vote gave it its new officers.

Opposite: U.S. President Theodore Roosevelt speaking at the Eleventh Annual National Negro Business League convention, New York, 1910. The group's founder, Booker T. Washington, is seated to his left. Photograph by George G. Bain

"Jackson an Oasis in the Desert of the South"

Ralph W. Tyler

Chicago Defender (weekend edition),
March 28, 1914

Remarkable Progress of Afro-Americans in Thriving City Cited by *Chicago Defender* Correspondent to Help Dim the Terrible Stain Lynching and Outlawry Has Placed Upon the State.

RACE SUCCESS BREEDS ENVY

Of the 22,600 Population 13,560 Are Afro-Americans Who Have $350,000 Invested in Business Enterprises and Who Pay Taxes on One Million Dollars' Worth of Real Estate.

Jackson, Miss., March 27—This state has more big, able Afro-Americans to the square yard than any other state in the union, and this city has a greater number of above the average Afro-Americans than any city of its size in the country. Because of the reports sent north regarding lynching in this state, the people of the north regard Mississippi as a hopeless area for the race. If you should come to the state, and especially to this city, see the wonderful progress being made by the race here, note the feeling existing between the two races, observe the fine residences and the splendid business establishments owned and controlled by Afro-Americans, you would at once conclude that the traditional bark of the race-hating white is not taken so seriously by the people down here. There are twelve lawyers in this city, each and all doing excellently well. Wherever a lawyer can succeed it is a fair advertisement for a locality as offering opportunities to the race.

Solving the Race Problem

These men down here are not professional race solvers. They are quiet, consistent, earnest solvers of the problem. Of the 22,600 population of this city 13,560–more than half—are Afro-Americans, who have $350,000 invested in business enterprises and who pay taxes on one million dollars' worth of real estate. Men like L. K. Atwood and W. A. Scott who have developed, respectively, a successful bank and a successful insurance company, and able attorneys, second to none, like Perry W. Howard, W. J. Latham and S. A. Beadle, who are constantly engaged in every line of thought and action to improve the race; and a successful physician, druggist and lawyer like S. D. Redmond, whose holdings exceed the half hundred thousand mark, and a virile editor like E. B. Topp are alone sufficient to develop an oasis in any desert. I have been to few places where I was so much impressed with the helpful activity, wealth-producing ability and intelligence on the part of our race as here in Jackson.

Envy Progress

I predict that, at the rate they are progressing, the Afro-Americans in the next quarter century will own more than 75 percent of the farm acreage in this state, and more than 40 percent of the city property, and will more than split even with the white man in control of business. Race prejudice in this state is now more largely because of the wonderful, rapid material and educational advancement of the race than because of inborn race hatred. The success of the Afro-Americans have achieved in the face of the most active and virulent race discrimination in itself argues for the ultimate dethronement of race discrimination. No legislation and no proscription or restriction can stop these Mississippian Afro-Americans.

College and Two Schools

There are two public schools here with a corps of twenty-five teachers, and Campbell College of which Dr. W. T. Vernon is president. Twelve churches give some indication that the moral and spiritual man is not at all neglected. It is estimated, and I investigated to make sure, that the Negroes in this city have $300,000 on deposit in banks here. This, with the value of their real estate and personal property, gives the Afro-Americans of Jackson a per capita wealth of $129. As a Frenchman would say, "that is magnificent," and especially so when you stop to reflect that Mississippi as a state, has perhaps done more to stop race progress than any other state.

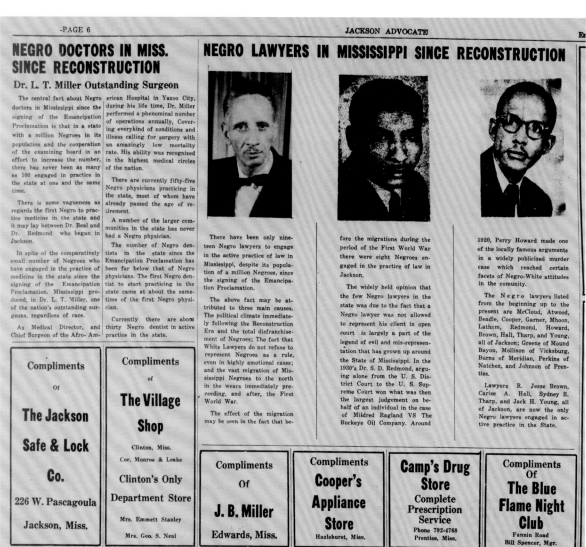

"Negro Doctors in Miss. Since Reconstruction," and "Negro Lawyers in Mississippi Since Reconstuction," *Jackson Advocate* Emancipation Proclamation Centennial Supplement, November 9, 1963

"Escaping Slaves"

The Crisis 13, no. 1 (November 1916): 22–24

The Macon, Ga., *Telegraph,* which next to the *Charleston News and Courier* is the funniest paper in the South when writing on the Negro problem, emits this wild, leading editorial on the Negro emigrant: "Police officers, county or city, all over the State, all over the South, should be bending every effort to apprehend and jail the labor agents now operating everywhere about us to take the best of our Negroes North to fill the rapidly widening labor breach there. This invasion of the South for Negroes isn't just a temporary raiding of our labor market, but is part of a well-thought-out and skillfully executed plan to rifle the entire South of its well-behaved, able-bodied Negro labor. Unskilled labor is at a high premium in the United States just now, a premium that will increase rather than be withdrawn. . . .

"There are those who say they'll come back quickly enough. But that isn't true. Ellis Island will not clear labor into this country again for at least one full generation, possibly two. . . .

"We must have the Negro in the South. The black man is fitted by nature, by centuries of living in it to work contentedly, effectively and healthily during the long summers of semi-tropical and tropical countries. He has been with us so long that our whole industrial, commercial and agricultural structure has been built on a black foundation. It is the only labor we have; it is the best we possibly could have—if we lose it we go bankrupt!

"Everybody seems to be asleep about what is going on right under our noses. That is, everybody but those farmers who have wakened up of mornings recently to find every male Negro over 21 on his place gone—to Cleveland, to Pittsburgh, to Chicago, to Indianapolis. Better jobs, better treatment, higher pay—the bait held out is being swallowed by thousands of them all about us. And while our very solvency is being sucked out from underneath we go about our affairs as usual: our police officers raid poolrooms for 'loafing Negroes,' bring in twelve, keep them in the barracks all night and next morning find that ten of them have steady, regular jobs, were there merely to spend an hour in the only indoor recreation they have; our county officers hear of a disturbance at a Negro resort and bring in fifty-odd men, women and boys and girls to spend the night in the jail, to make bond at ten per cent, to hire lawyers, to mortgage half of two months' wages to get back on their jobs Monday morning—although but a bare half dozen could have been guilty of the disorderly conduct. It was the week following that several Macon employers found good Negroes, men trained to their work, secure and respected in their jobs, valuable assets to their white employers, suddenly left and gone to Cleveland, 'where they don't arrest fifty niggers for what three of 'em done.' Many of these men who left haven't been replaced except with those it will take years to train to do their work as well as they did it—but at as high a cost from the start.

"It is the most pressing thing before this State today. Matters of governorships and judgeships are only bagatelle compared to the real importance of this Negro exodus going on from Georgia. There is a little lull now with winter coming on, but the spring will see it set in its full volume unless something is done at once to stop it."

The Montgomery, Ala., *Advertiser* takes up the same wail with a remarkable admission at the end:

"When the farmer who depends upon Negro labor goes to put in his crop next spring he will see that he is face to face with an ugly situation if he has been unable to keep Negroes on his place. The farmers of the Black Belt of Alabama cannot get on without Negro labor. Theoretically it is a fine thing to say that we will substitute white labor from abroad or from somewhere else. But where is that labor? It is not here. It is not to be found in the North and West for those sections are now suffering from labor shortages; that's why Negro laborers are leaving.

"And the Negro will not come back once he leaves the South."

Yet the masses of the South show little comprehension of the real meaning of this movement. The Birmingham, Ala., *Ledger,* for instance, waves a lordly hand:

"The sensible Negro will stay at home and take advantage here of the prosperity that is coming and the wise city authorities, who find Northern labor agents at work, will do a good thing to send them back North on the first train."

To be more specific: the Birmingham, Ala., *News* preaching of sanitation among Negroes says:

"These leaders of the Negroes can do a great personal service to themselves and to the community at large if they would emphasize upon the people of their race the supreme necessity of proper garbage and sewage disposal."

What in the name of common sense can poor, disfranchised laborers do in the matter of sewer and garbage disposal in a city like Birmingham? Only one thing, as we see it, and that is leave. Another matter has been mentioned several times by the Miami, Fla., *Daily Metropolis*:

"Many a hard working Negro, ignorant of business and afraid of the white man, has been dealt with most dishonorably by Miami dealers of a certain class. And it is time that honorable white men take a hand in protecting them against the extortionist seller of installment plan goods.

"In one instance, of which we have knowledge, a Negro woman paid $57 for a bedroom suite worth not more

than $25 and then she almost lost her money and the furniture because the dealer claimed she still owed $3!"

No wonder Northern papers like the *Duluth News Tribune* are smiling:

"If the South wants to keep all of its Negro labor and not share it liberally it will have to offer equal inducements in wages, living conditions and opportunity and a fuller measure of equality in treatment. If, on the other hand, it really wants to get rid of the Negro and substitute white labor, now is its chance."

Meantime colored papers are talking out. The *Southwestern Christian Advocate* says:

"Let us for a moment be frank with each other; the Negro at heart loves the South, its activities, its sunshine, its climate, but he is very much dissatisfied with the treatment that he otherwise receives. His families do not receive proper protection at the hands of constitutional authorities nor at the bar of public opinion. There are not proper facilities for the education of his children; there is not a congenial atmosphere for the development of self-respect and of racial contentment. We are disfranchised; we are hedged about and we are lynched without redress. Even a worm sometimes will recoil and a half dead hound will resent constant mistreatment. Is it any surprise, therefore, that in spite of all the Negro's natural inclination to Southern climate he so eagerly seizes an opportunity to go elsewhere?"

So, too, S. N. Jefferson, writing to a white Pensacola, Fla., paper says:

"It is probable that 'the well informed Negro' who told the Birmingham editor that it was good schools that was drawing the Negro could have given other and more potent reasons had he been so minded. He could have told how deep down in the Negro's heart he has no love for proscription, segregation, lynchings, the petty persecution and cruelties practiced against him, nor for the arresting of 'fifty niggers for what three of 'em done,' even if it does take all of this to uphold the 'scheme of civilization.'"

In San Francisco, where the unions have persistently refused to admit colored laborers, 250 Negroes are being used as strike breakers in a stevedore strike. A local colored paper says:

"There is no reason why the stevedores' union should not have had colored men in it as well as all the trades unions. They are men. They are here. They have the brain and brawn. Why not give them a chance? When will these unions turn from the error of their ways? There was a lively discussion in one of our local labor union's meetings this week with regards to the Negro strike-breakers at present in San Francisco. One indignant speaker remarked that the colored men did not hope to do that work; that they were only working for meanness, whereat a colored member arose to explain a few points, informing the council of this well-known

opposition to the black man as a laborer. Yes, possibly the union man had forgot."

There is some, though slight, evidence that the South is learning something from the migration of its laborers. The New Orleans, La., *Times Picayune* writes:

"The chances are that the Negro exodus, or drift, is likely to increase unless some better effort is made to check such of this emigration as would be prevented by legislating against those labor agents who deceive and hold out false pretences to seduce labor; or unless the conditions of the Negroes be improved in those sections where they are dissatisfied. It is well to remember there is now a formidable competition for Negro labor in the North without thought to the political or economic results that may follow."

A correspondent in the Birmingham, Ala., *News* adds:

"But taking it all in all, if the really strong men who, in fact, rule our Southern communities, would actively exert themselves in the interest of common fairness where the Negro is concerned no labor agents or other influence could ever succeed in any effort to take the Negro away from the South."

JOHN T. ADAMS
CHAIRMAN

FRED W. UPHAM
TREASURER

C. B. M.
SECRETARY

REPUBLICAN NATIONAL COMMITTEE

H. L. REMMEL
MEMBER OF ARKANSAS

LITTLE ROCK, ARKANSAS

October 3, 1923.

Hon. Henry C. Wallace,
Secretary of Agriculture,
Washington, D. C.

My dear Mr. Wallace:

On Saturday last I had a conference with President Coolidge and, among other things,
I took up with him the question of emigration of the colored man from the south to
the north.

This has become a very acute question in the south, as many thousands of colored men
and their families have gone north, in many instances leaving their cotton fields
with the crop half cultivated, selling what few goods they can and going north,
leaving the planters without labor to cultivate their fields. It has been stated
through the press that as many as 150,000 colored people have gone to the north
during 1923, some reports making it even more. This is of vital importance to our
planters and farmers, as the colored man and his family constitute practically the
agricultural labor in the alluvial bottom lands of all of our southern states.
The uplands or mountain regions are occupied by white people.

I suggested to the President that he appoint a commission of say five colored men
of recognized experience and ability and men of good intelligence to constitute a
commission and to make their headquarters at Tuskegee, Alabama, where the Booker
Washington school has been sending out young colored men, trained in scientific
agriculture and mechanics and women in domestic science; then these commissions
visit southern states at different times, calling conferences and conventions and
discussing with the colored people the importance of diversified farming and to
tell them that the south is the natural home of the colored man and his family.

 southern
These colored commissioners must be men of recognized worth and merit in the com-
munities from which they hailed and be practical agriculturalists. The President
seemed favorably impressed with my suggestions. I told him that I had previously
discussed this same matter with President Harding and he, also was favorably impressed
with the idea and thought he would appoint such a commission.

President Coolidge requested me to call on you and discuss the situation as I had with
him. I told him that I would have to leave that evening and would not have time to
discuss the merits of my recommendation, but would write you, and that is what I am
doing now. Since my return home I have had a number of white men, as well as colored
men, write me and also phone me, and some have called at my office, saying that they
thought my plan a good one. I would appreciate it very much, my dear Mr. Secretary,
if you would consider these suggestions and let me know your views in the matter.

 Yours very truly,

 H. L. Remmel

Letter from Republican National
Committee member H. L. Remmel to
U.S. Secretary of Agriculture Henry C.
Wallace regarding encouraging Black
sharecropping families to remain in the
South, October 3, 1923

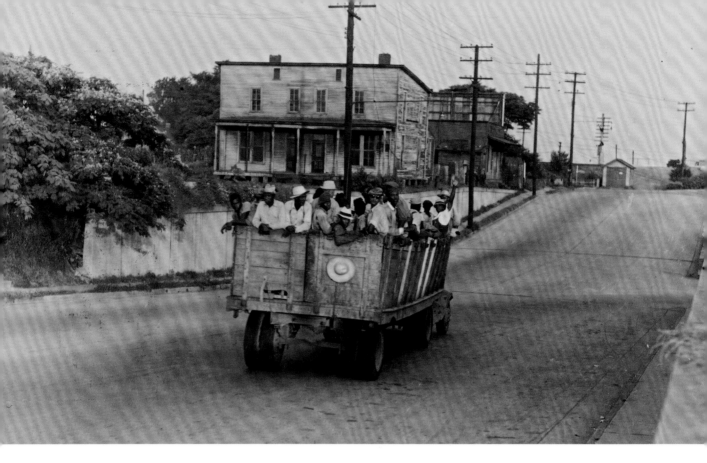

"Some Problems of Migration"

The Afro-American (Baltimore), June 1, 1923

The migration of Negroes from the South may prove to be a good thing not only in giving them wider and better opportunities, but also in stimulating a wider interest of the more fortunately situated members of this group.

There has been a noticeable effect on the racial relations in all centers where any appreciable number of migrants have gone. In Chicago or Detroit old residents tell you things are not what they used to be in the matter of race relations. In Baltimore some of the large department stores are beginning to show a disposition towards unfair discrimination.

All of this serves to emphasize how thoroughly linked are the interests and well-being of every colored man and woman in this country. We cannot rise as units. We must do so as a RACE.

Most of the centers are setting up machinery to handle the problems arising out of migration. Baltimore will pay and pay dearly if she neglects the welfare of these migrants allowing them to shift as best as they can in an already highly taxed community of bad housing and living conditions.

A truck driving a group of cotton hoers from Memphis to the Wilson Cotton Plantation in Mississippi County, Arkansas, 1937. Photograph by Dorothea Lange

"Interstate Migration of Negro Population"

William O. Scroggs

Journal of Political Economy 25, no. 10 (December 1917): 1034–43

For a clear understanding of the northern migration of Negroes in the years 1916 and 1917, a knowledge of the general movement of the Negro population since 1865 will prove very useful. Several recent writers have been prone to emphasize the development in the Negro within the past two years of "a sudden desire to move," but a little investigation soon reveals the fact that the black man, ever since the day of his emancipation, has shown a tendency to migrate.

At the close of the Civil War, when told that he was free, the Negro at once began to put his freedom to the test; and as the most palpable evidence of his liberty was his ability to come and go as he chose, it was only natural that he should begin to move about. At the end of every year thousands of tenants in the southern black belts may still be seen removing to other farms, in many cases without even taking the pains to examine beforehand the lands they are to cultivate or the houses they are to occupy. Such migrations do not appear in the census returns, but their social and economic importance is far-reaching. Dr. Booker T. Washington often found it necessary to urge his people to abandon their moving

propensities and to settle down and acquire property. At gatherings of Negro farmers he was fond of narrating a homely story of a chicken which belonged to one of these peripatetic tenants and which, from long-acquired habit, would walk up to its owner's cabin door on every first of January and squat down and offer its legs to be tied, preparatory to its journey to the next farm.

The possibility of the migration of a great number of freedmen from some sections of the South became evident almost as soon as the Civil War was over, and as early as November 27, 1866, Governor James L. Orr, of South Carolina, stated in a message to the legislature that the Negroes were

> *invaluable to the productive resources of the State, and if their labor be lost by removal to other sections, it will convert thousands of acres of productive land into a dreary wilderness. For this reason, I have felt it to be my duty to discourage their migration. The short crops of the present year should stimulate the planter and farmer to renewed energy and enterprise. He will, however, find his lands of little value if he cannot command labor to cultivate them. If the Negro remains here, his labor must be made sufficiently remunerative to subsist and clothe him comfortably. Schools must be established to educate his children, and churches built for his moral training.*[1]

This threatened migration, to which Governor Orr referred, was a westward movement, from South Carolina, Georgia, Alabama, and Mississippi to Louisiana, Arkansas, and Texas. It differed materially from the later migration to the North. In general, the westward movement in our country is actuated by causes similar to those that prompt European migration to America. It is a movement from a highly developed, densely populated region, where the economic stress is acute, to a region more sparsely populated, with undeveloped resources, where the struggle for existence is not so keen. This explains the lure of the Southwest for the Negro, as well as that of all the West for the white man. But there is another movement of population that operates in a manner quite the reverse of the principles just enunciated. This is the cityward movement, a migration to a region of denser population, keener competition, and more acute economic stress. Such a movement is the northern exodus of Negroes in 1916–17.

In the late sixties and early seventies the westward migration of Negroes attained considerable headway. It was at first a movement of individuals and soon became one of groups. Railway and land companies carefully fostered it and had their agents in various sections of the South, very much as trans-Atlantic steamship companies have maintained their runners in the remote rural districts of Southern and Eastern Europe to encourage emigration to America. A well-known Negro educator states that in 1874 he heard one of these agents boast that he had induced 35,000 persons in South Carolina and Georgia to leave for Arkansas and Texas.[2] This westward movement, however, was soon dwarfed into insignificance by a threatened migration on an unprecedented scale to Kansas from the lower Mississippi Valley early in the spring of 1879. The "Kansas Exodus," as it came to be called from its alleged resemblance to the flight of the Israelites from Egypt, presents several striking analogies to the movement of 1916-17. When the exodus to Kansas began, there was the same suspicion, as noted in 1916, that it was the result of efforts to colonize Negro voters in the North and make certain states safely Republican. In both cases this suspicion was finally allayed. There were also, in 1879 as in 1916, the assumption by a portion of the northern press that the Negro was fleeing north to escape ill-treatment, and the tendency on its part to lecture the South for its shortcomings in dealing with the black man. One may also note, in both instances, the same sort of uneasiness among the planters in those districts from which emigration had been excessive, the same assurance by some that all of the Negroes would eventually return, and the same introspective editorials in southern newspapers, with the candid admission that conditions might be better for the Negro, but with the added assertion that even as things were the South was a better place for him than the North. In both instances also may be observed the final recognition that the causes of the movement were basically economic. Of course, there are certain contrasts as well as parallels in these two movements, but the latter appear to be by far the more significant.

The Kansas movement of 1879 was due in large measure to the agricultural depression in the lower Mississippi Valley, but it was precipitated by the activities of a host of petty Negro leaders who sprang up in all parts of the South during the period of reconstruction. Foremost among these were Benjamin (better known as "Pap") Singleton, of Tennessee, and Henry Adams, of Louisiana. Singleton styled himself the "Moses of the Exodus" and personally supervised the planting of several colonies in Kansas.[3] Adams claimed to have organized a colonization council which attained a membership of 98,000.[4]

The exodus to the "Promised Land" of Kansas began early in March, 1879, and continued until May. The total number of emigrants, most of whom went to Kansas from Louisiana and Mississippi, has been estimated at all the way from 5,000 to 10,000, and many thousands more had planned to move, but were deterred by the misfortunes of those who constituted the vanguard. Leaving their homes when the weather was becoming warm, the early emigrants reached Kansas when spring chanced to be unusually backward and the country was still bleak and desolate. Thinly clad and often without

funds, they endured much suffering from want and sick-ness, and many of them became public charges. Societies were organized expressly to care for the "refugees," as they were called, and large numbers returned to their homes as soon as they were able, giving such dismal reports on their arrival as to dissuade others from fol-lowing their example. Perhaps a third of the emigrants remained, and many of these eventually attained a fair degree of prosperity.

The movement was ill-advised, and too much based on the Negro's sentimentalism. To him Kansas, pictured as the home of John Brown and the scene of many free-soil victories, seemed to be the ideal home for the black man. But he found on arriving a harsh climate, pioneer conditions, and small farmers who had no need of extra laborers and who were not especially friendly to the Negro. That individuals from among this group of emi-grants could surmount such difficulties and attain no small degree of wellbeing, is to the credit of the race. While the exodus caused much suffering, demoralization, and loss of property among the emigrants, it seems to have had at least one good result. In some instances it is said to have caused an improvement in the condition of the Negroes who remained at home. In communities where there had been considerable emigration there was said to have been a tendency to reduce rents and to offer the remaining tenants more favorable terms in general than had obtained prior to the exodus. Such a result would naturally be expected.

In 1888–89 there was a considerable migration of Negroes from southern Alabama to Arkansas and Texas, as a result of the activities of labor agents.[5] The rapid development of the mining industry of Alabama in the nineties caused a rapid influx of Negroes into the min-eral regions around Birmingham, and was the cause of much uneasiness among the cotton growers of the black belt. The advent of the boll weevil caused a great migra-tion of colored farmers in 1908–9 from the cotton fields to the cane fields of Louisiana. By 1914 the cotton belt of this state had recovered from the demoralization that followed the advent of the weevil; and the sugar planters, depressed by the prospects of free sugar, were reducing their acreage and employing fewer laborers. A tendency toward a counter-migration then showed itself, and labor agents again were active.[6]

These instances are cited in order to indicate that the northern migration of 1916–17 is no new and strange phenomenon. It differs from earlier movements chiefly in the matter of numbers involved. The European war has simply hastened and intensified a movement that has been under way for half a century. To the truth of this statement the reports of the census bear eloquent wit-ness. In 1860 there were 344,719 Negroes in the North; in 1910 there were 1,078,336, an increase of 212.8 per cent for the fifty-year period. In the South for the same period the rate of increase was 111.1 percent. In the last half-century, therefore, the relative increase of Negroes in the North has been nearly double that in the South. This shows a decided change from the conditions pre-vailing before the Civil War. At every census before 1860, except that of 1840, the Negro population of the South showed a greater relative increase than that of the North. Since 1860, however, the situation has been reversed, as is indicated by the following table:

PERCENTAGE OF INCREASE OF NEGRO POPULATION

Decade	North	South	Decade	North	South
1790–1800	24.1	34.0	1850–1860	20.3	22.1
1800–1810	18.7	39.2	1860–1870	[33.3]*	[8.8]*
1810–1820	18.0	29.5	1870–1880	[36.5]*	[34.7]*
1820–1830	29.2	31.6	1880–1890	16.2	13.5
1830–1840	38.9	22.2	1890–1900	25.1	17.2
1840–1850	23.7	26.8	1900–1910	18.3	10.4

*Owing to the great irregularities in the census of 1870, especially as it relates to the Southern states, comparisons of this year with those of 1860 and 1880 are wholly misleading, and in the foregoing table the percentages for these years are bracketed.

It thus appears that in every decade since the Civil War the Negro population of the North has been growing faster than that of the South. This increase can be accounted for in two ways only: by an excess of births over deaths, and by immigration from other states. The meager vital statistics available indicate that while the death-rate of the Negro in the North is lower than that of the Negro in the South, the birth-rate of the north-ern Negro is also lower and is just barely sufficient to balance the death-rate. The increase in the colored population of the Northern states appears therefore to be due almost wholly to immigration. The census fully substantiates this assumption. In 1910, 415,533 northern Negroes were southern-born. This is nearly two-fifths of the entire Negro population living in the North. Forty-seven percent of the Negroes living in New England in 1910 and more than 50 percent of those in the Middle Atlantic and East North Central divisions[7] were born outside these sections. In four of the former slave states (Maryland, Missouri, Kentucky, and Tennessee) there were actually fewer Negroes in 1910 than in 1900. These, it will be noted, are border states, where "the call of the North" is most likely to be first heard and heeded, and whence migration is easier and cheaper than it is farther south. It is also worthy of note that every one of the former slave states except Arkansas was "whiter" in 1910 than in 1900.[8] Indeed, if we exclude from our reckoning states having a Negro population of less than 2 per cent, the only states in the Union that became perceptibly "blacker" in the last census decade were West Virginia, whose percentage increased from 4.5 to 5.3, and Oklahoma, whose increase

was from 7 to 8.3 per cent. The increase in these states, however, is not large enough to give rise to problems like those in some sections of the old South.

It is interesting to note that the New England states, before 1910, were not appreciably affected by the northern migration. In three of these states (Connecticut, Rhode Island, and New Hampshire) the percentage of Negro population between 1880 and 1910 actually declined, in Maine it remained stationary, and in Vermont and Massachusetts it showed a very slight increase. New Hampshire actually contained fewer Negroes in 1910 than in 1790.

Another very interesting feature of the movement of Negroes in the United States is the fact that, in spite of the northward tendencies just described, the center of Negro population has been shifting steadily southward and westward. Since 1790 the center has changed from southern Virginia to northeastern Alabama. This is due to the fact that the drift of Negro population to the North before 1910 was most pronounced in the border states of Tennessee, Kentucky, Maryland, and Missouri, and that the increase in the states farther south more than offset the losses in these four states.

The Negro shows a tendency, not only to move northward, but also to move about very freely within the South. In fact, the region registering the largest net gain of Negroes in 1910 from this interstate movement was the West South Central division (Arkansas, Louisiana, Oklahoma, and Texas), which showed a gain from this source of 194,658. The Middle Atlantic division came second with a gain of 186,384, and the East North Central third with a gain of 119,649. On the other hand, the South Atlantic states showed a loss of 392,827, and the East South Central states a loss of 200,876 from interstate migration. While the Negroes have shown this marked inclination toward interstate movement, they nevertheless exhibit this tendency in less degree than do the whites. In 1910, 16.6 percent of the Negroes had moved to some other state than that in which they were born, while the percentage for the whites was 22.4. For the relative extent of intrastate migration by the two races, figures are of course unavailable.

As has already been indicated, the cause of the migration, like that of practically all great movements of peoples, is fundamentally economic. But this simple statement does not tell the whole story. The causes may be grouped as beckoning and driving, the first group arising from conditions in the North and the second from conditions in the South. Among the beckoning causes in 1916–17 were high wages, little or no unemployment, a shorter working day than on the farm, less political and social discrimination than in the South, better educational facilities, and the lure of the city. Among the driving causes were the relatively low wages paid farm labor, an unsatisfactory tenant or crop-sharing system, the boll

weevil, the crop failures of 1916, lynching, disfranchisement, segregation, poor schools, and the monotony, isolation, and drudgery of farm life. There is a noticeable tendency on the part of some Negro leaders to attribute the movement chiefly to the unrest due to mob violence and other ills, social and political, that fall to the lot of the black man. When we note, however, that lynching for the past twenty-five years has been slowly but surely decreasing and that disfranchisement is no new thing, but has been an accomplished fact for more than forty years, it becomes evident that, whatever grievances of this nature the Negro may have against the South, he has at least no new complaint and therefore no stronger reason for migrating on this account in 1917 than he has had for several decades. If adverse social and political conditions are the main cause of the northern migration, it is asked, why did the Negro not go in the eighties and nineties when lynchings were four times as frequent as they now are and when disfranchisement was effected by "bulldozing" and tissue ballots rather than by the more peaceful method of constitutional amendment? The answer to this question is that the Negro has no greater grievances now than formerly, but that he has a much better opportunity for escaping these grievances than he has had heretofore. The driving causes in the South are not of themselves sufficient to bring about such an exodus as was recently observed. There must be an avenue of escape to apparently better conditions, and this was presented when the European war created a vacuum in the northern labor market.

The effects of this interstate migration, like the effects of late foreign immigration, are largely matters of the future. But certain postulates with regard to the immediate effects may be readily formulated. So far as the migrations tend to bring about an equilibration of demand and supply in the labor markets of this country, the effect will be beneficial. The abundance of crude, cheap, and easily managed labor in the cotton belt has not been an unmixed blessing. It is a well-established fact, too, that the Negro does better in those districts where he is greatly outnumbered by the whites than he does in the black belts where he has little chance to study and emulate the white man's skill, thrift, and energy. The Negroes who go north may thus increase their own productive capacity, and at the same time, by relieving somewhat the congestion of black folk in their old homes, may improve the economic status of their neighbors who remain behind. A migration of Negroes in any number is likely also to affect the attitude of the southern employer of colored labor. It will tend to impress him with the idea of the black man's economic value as he had not been impressed before. The exodus of 1879 effected such a change of attitude on the part of the Mississippi River planters. A large number of them assembled in Vicksburg on May 5, 1879, and solemnly resolved "that the

colored race has been placed by the Constitution of the United States, and the states here represented, on a plane of absolute legal equality with the white race," and "that the colored race shall be accorded the practical enjoyment of all rights, civil and political, guaranteed by the said constitutions and laws."[9]

The migration has also its debit side. As already stated, it is a cityward movement of a rural population, and as such is attended with all the difficulties and dangers incident to such a movement on the part of any people. But there are additional difficulties when the newcomers to a city—even a northern city—chance to be colored. They must live in the least desirable part of the town, on filthy and neglected streets, and in poorly constructed, insanitary dwellings, for which they must frequently pay exorbitant rentals. There may be the additional handicap of industrial discrimination on account of race.

Dr. W. H. Crogman, of Clark University, Atlanta, Georgia, a well-known Negro educator, twenty years ago set forth the evils of this movement in the following words:

> Nothing was ever clearer to my mind than that this interstate migration has in it the seeds of moral death. It is a very Pandora's box. It strikes at the roots of those things by which only any people can hope to rise, destroys the home wherever it is established, and prevents its establishment where it is not. It retards the progress of education and acts like a withering blight upon the influence of the churches. . . . Over and over again have I known persons to leave their native state and after wandering through several others to return finally to the very spot whence they had started, having in that time gained nothing, acquired nothing, except that which is a property common to all bodies once set in motion—a tendency to keep moving.[10]

This statement, in the light of later developments, appears unduly pessimistic, and would probably be modified by its author today; but the fact cannot be gainsaid that the mere removal of the Negro to another environment is not the ultimate solution of what we call the "race problem"; at the most it can only modify the problem. As the European peasant does not escape all his economic ills when he stands for the first time under the Stars and Stripes, so the Negro will still have his troubles after crossing the Mason and Dixon line.

Notes

1. *South Carolina House Journal* (1866): 20–21.
2. W. H. Crogman, *Talks for the Times* (Atlanta, 1896), 54. The agent's statement is probably much exaggerated, but there must have been a considerable migration to have prompted him to make such a claim.
3. Walter Fleming, "'Pap' Singleton: The Moses of the Colored Exodus," *American Journal of Sociology* 15, no. 1 (July 1909): 61–82.
4. Senate Report, 693, Part II, Forty-Sixth Congress, Second Session.
5. *Southern Farmer*, Atlanta, Ga., June, 1889.
6. *New Orleans Times-Democrat*, March 26, 1914.
7. The Middle Atlantic and East North Central divisions comprise the states of New York, New Jersey, Pennsylvania, Ohio, Indiana, Illinois, Michigan, and Wisconsin.
8. While the percentage of Negro population in Arkansas increased, it was only to the extent of one-tenth of 1 percent.
9. *Vicksburg Daily Commercial,* May 6, 1879.
10. Crogman, *Talks for the Times,* 253–54.

"Bricks Hurled Through Church Window in Md."

New York Amsterdam News, April 1, 1925

Riot Squad Called Out When Whites Stone Negro Church in Baltimore

Disorder Follows Closely on Dedicatory Service— Pastor Says No Protest had Been Made When Purchase Was Announced

Baltimore, Md., March 30—The arrival of a riot squad from the Southwestern Police Station last night averted a panic in the Morningstar Baptist Church on West Fayette street, after the church had been bombarded with paving bricks.

The attack was the outcome of the colored congregation moving into a church in a neighborhood occupied by white persons, and follows similar trouble which occurred at a church at 1603 North Rutland avenue in recent months.

Services in the church yesterday were the first held there for almost five years. The congregation recently purchased the building which formerly was the Metropolitan Methodist Church South, and at one time housed one of the best-known congregations in the city.

Yesterday after morning services in their old structure on Saratoga Street, near Poppleton, the colored congregation, numbering almost 1,700 persons, marched in a body to their newly purchased church, where dedication exercises were held. Although the neighborhood is occupied by white persons, there were no demonstrations of hostility on the part of the residents.

Last night with the church packed to overflowing, the pastor was bringing the service to a close, when several bricks crashed through the stained glass windows in the balcony.

In a moment the congregation was in an uproar. Several men dashed from the church just in time to see several youths on the roofs of houses on the opposite side of the street drop the remainder of their missiles and flee.

Police were called, and Patrolmen Hayden, Woods, Block, and Spittle, Southwestern District, after assuring the worshippers that they would be protected, remained on duty until the close of the services and until the last of the large crowd was out of the vicinity.

The pastor last night said the purchase of the church had been made public and that no protest had been made to him about coming into the neighborhood.

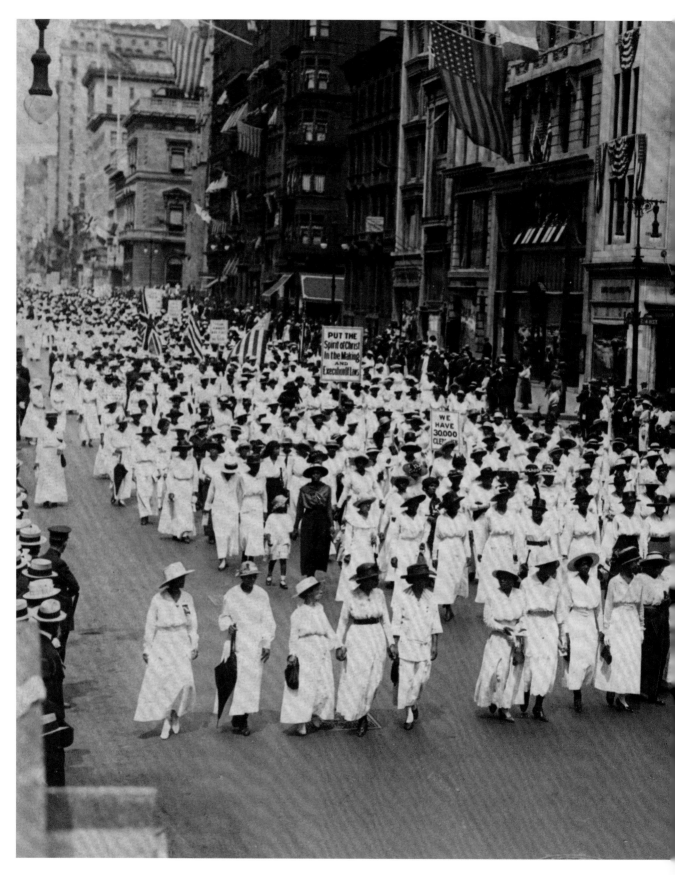

Silent protest parade against the East St. Louis riots, New York,
1917. Photograph by Underwood & Underwood

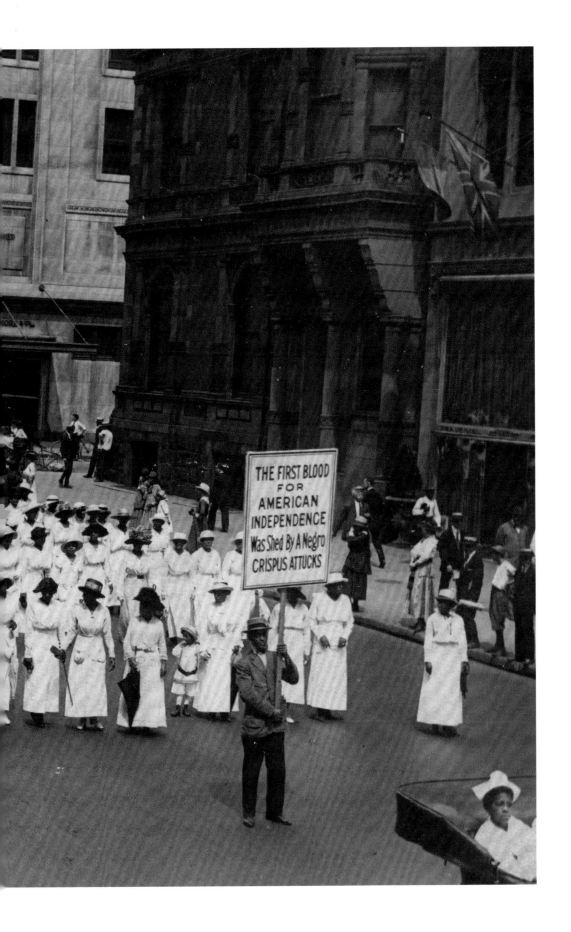

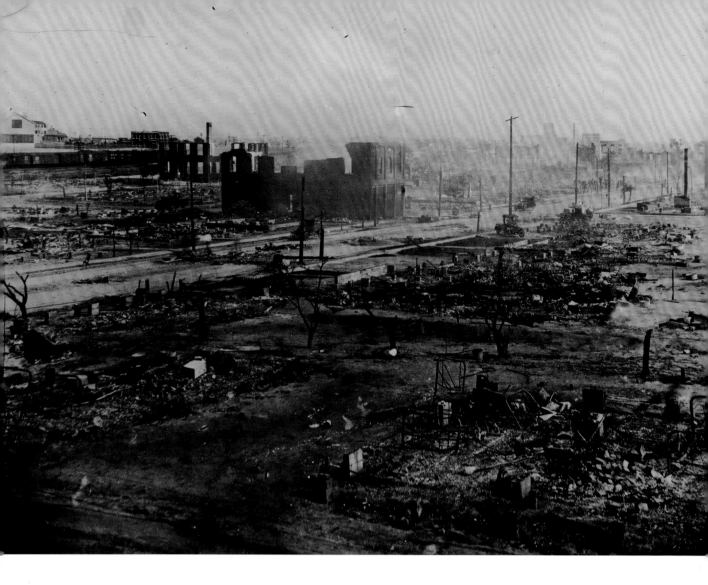

"The Tulsa Riots"

National Association for the Advancement of Colored People

The Crisis 22, no. 3 (July 1921): 114–16

Within six hours of the time, on June 1, when the New York *Evening Post* called up the National Office on the telephone to ask whether anything had been heard of race trouble in Tulsa, Okla., a representative was on the way to the battle-scarred city to investigate for the Association. Meanwhile reports continued to come in which showed that one of the most serious race riots in the country's history was in progress, lasting until June 2. The newspapers reported that practically the entire colored residence section of Tulsa was in flames, that shooting was going on and that motor cars and airplanes were being used by white people in the battle.

One of the first steps which the secretary took was to send a telegram to Governor Robertson of Oklahoma, urging him to use the full power of his office to put an end to the reign of violence and terror. Statements were also issued to the New York newspapers warning their readers that a race riot is never caused by one isolated case of assault, and that probably conditions of peonage in the country surrounding Tulsa had brought about a situation of dangerous ill feeling.

These statements received startling confirmation when, on June 2, four refugees from the riot zone appeared at the National Office. The names of the refugees were Lizzie Johnson, Stella Harris, Josie Gatlin and Claude Harris, all from Okmulgee. They had formed part of a group of eight which had left Oklahoma before the riots began. They told terrible stories of the oppression visited upon colored people, said that the practice of peonage was common, and that colored farmers were kept always in debt, the planters taking their crops and giving them only a bare subsistence in return. The refugees said warnings had been distributed weeks and months before the riot, telling colored people they would have to leave Oklahoma before June 1, or suffer the consequences. Cards had been posted outside the doors of colored people's homes warning them to get out of the state and a white newspaper of Okmulgee had published a similar warning.

The refugees had left Oklahoma and arrived in New York City possessing practically nothing except the clothes on their backs. Being members of that body they had gone, they said, to the offices of the Universal Negro Improvement Association, Marcus Garvey's organization, where they were told they could not be taken care of, and where, according to their accounts, efforts were made to communicate with Okmulgee to prevent other colored people from coming to New York.

Refused assistance by the Garvey organization, they were brought to the National Association for the Advancement of Colored People by Mr. Edward Givens, of 39 West 133rd Street, New York City. His role was indeed that of the good Samaritan, for he had taken these homeless people under his wing, had given them food, shelter and clothing and had tried to get them work.

A collection was at once taken up for them in the National Office, and in the offices of *The Crisis*, and the sum of $51.50 was presented to them to tide them over their immediate difficulties. At a meeting of the New York Branch on the same evening an additional contribution was raised for these people. Thereupon the secretary announced in the newspapers that a relief fund was to be established by the Association, and that every cent contributed to it would be applied to relief of the riot victims.

Meanwhile, the stories told by the refugees from the riot zone were sent out to the press and were prominently featured in the most important newspapers, appearing on the first page of the New York *World*, and being published in the New York *Times*, the *Tribune*, the *Herald*, the *Evening Post*, the *Globe*, and the *Evening World*.

The national secretary then took further action. He sent the following telegram to President Warren G. Harding in Washington:

The National Association for the Advancement of Colored People feels that an utterance from you at this time on the violence and reign of terror at Tulsa, Okla., would have an inestimable effect not only upon that situation but upon the whole country.

JAMES WELDON JOHNSON.

President Harding replied through his secretary on June 7 as follows:

Following the receipt of your telegram of June 2, the President, as you will have noticed, made a public expression of his regret and horror at the recent Tulsa tragedy, which reflected his sentiments.

Meanwhile telegrams had been sent to Oklahoma branches telling them that a representative of the National Office was on the way. The fearless temper of the men in the midst of the disturbance is well illustrated by the following telegram which the Boley, Okla., branch sent to the National Office in reply to its telegram. This telegram was received at the National Office on June 3:

Telegram received. Representative will have all moral and financial support demanded. Oklahoma branches and friends loyal and fearless.

C.F. SIMMONS.

At the time of writing, the refugees from Oklahoma are being cared for, and the Association is ready to publish the reports of its investigator as soon as they arrive.

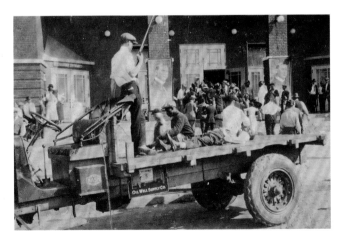

The aftermath of the Tulsa Race Riots, Tulsa, Oklahoma, 1921. Photographer unknown

Opposite: The Greenwood District, Tulsa, Oklahoma, following the Tulsa Race Riots, 1921. Published in *The Crisis* 22, no. 3, July 1921

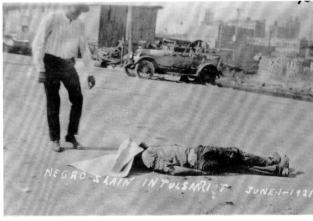

A felled victim of mob violence lying dead in the street, Tulsa, Oklahoma, documented on June 1, 1921. Photographer unknown

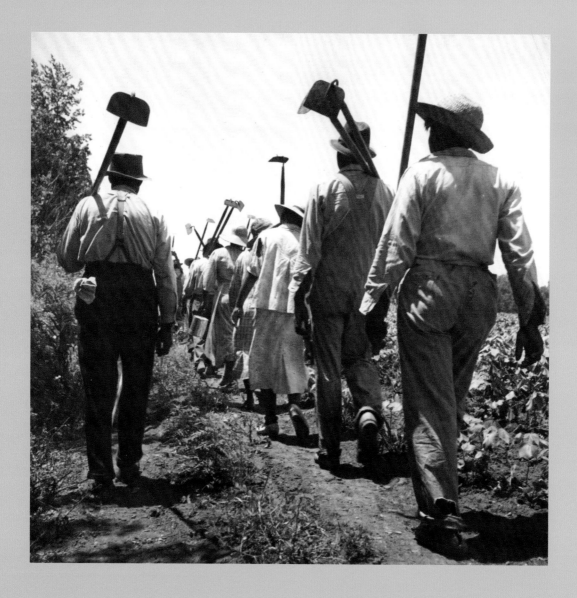

Cotton hoers working for $1.00 per
day near Clarksdale, Mississippi, 1937.
Photograph by Dorothea Lange

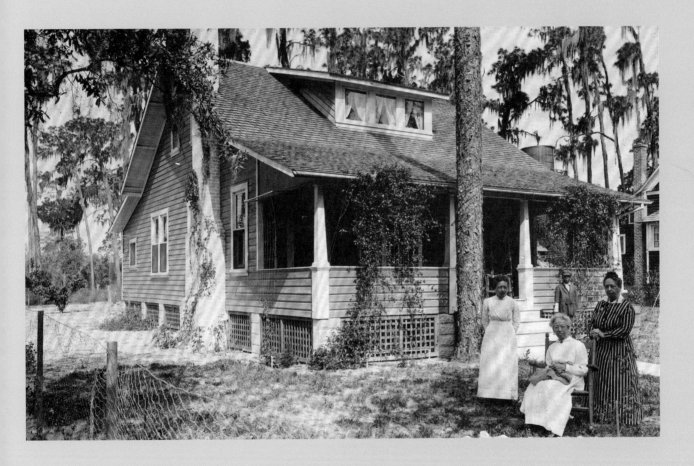

A Black family portrait in Florida, 1917.
Photographer unknown

"Negro Land-Owners"

The Republican (Oakland, MD), March 22, 1884

The Catholic World published the following interesting facts concerning the rate at which the negroes of the South are acquiring land:

Trained from their earliest years to the workings of the plantation or farm, inured to labor, and familiar with hardships, what wonder is it if the land is gradually slipping from the hands of the old masters or their children and passing into the hands of the quondam slaves or their offspring? In North Carolina, for instance, the colored people own a vast amount of land. There, at the State fair of 1882, a colored planter secured the prize of five tons of guano for the best cotton. In that State the colored people actually have their own fair, at which are seen the leading citizens, irrespective of color. In South Carolina the same changing of land is noticed. The leading newspaper of Charleston, so the writer was told by very responsible authority, sent a reporter to examine the land records in the offices of the various counties which make up South Carolina. His report on the amount of land owned by colored men caused a great consternation among the Palmetto chivalry. In Georgia, according to the writer of the "Negro Race in America," the colored people in 1879 owned 541,199 acres of land—an increase over 1878 of 39,309 acres. The value of this land was $1,548,758—an increase over the previous year's value of $57,523. Besides the land, they owned in horses, hogs, etc., $1,704,230, and in city and town property, $1,094,435. These sums, with others, such as household goods and the like, make an aggregate value of over $5,000,000 upon which the tax was over $100,000. And this is but one State. Considering the drawbacks under which the colored race have been laboring, the results are marvelous. In Florida some of the largest orange groves belong to colored men. The plantation of Jefferson and Davis, extending for miles along the Mississippi, belongs to a colored family named Montgomery.

Many believe the South will eventually be the property of its former slaves. The way in which they are acquiring land, the tenacity with which they hold on to it, their industry, and the steadily increasing knowledge of how to save, all point to the same conclusion: that the lands of the masters are becoming the property of the slaves. Such is, in human language, the bitter irony of fate; but, as a Christian would say it, such is the providence of God, who pulleth down the mighty and exalteth the humble.

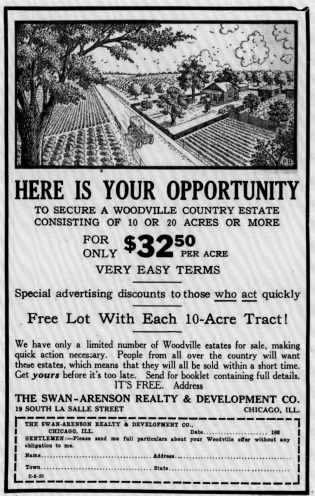

Land buying opportunity listed by the Swan and Arenson Realty and Development Co., Chicago, in *The Crisis* 20, no. 4, August 1920

"Churches Lead Hate Crusade"

The Afro-American (Baltimore), March 10, 1945

5 Join Drive to Keep Colored Residents Out

50 HOMES SOLD

Realtors and White Clerics Talk for *Afro*

Baltimore—The recent sales to colored families of homes on N. Fulton Avenue backfired this week with a public announcement by neighborhood white churches and organizations that they object and will resist by "persuasive means."

The advertisement of objection which appeared in daily papers on Wednesday followed a neighborhood meeting Friday night at St. Martin's Catholic Church and was signed by property owners, the Fulton Improvement Association and five churches, including St. Martin's.

A similar meeting is scheduled to be held tonight (Friday) at the same place.

Warnings to Realtors Quoted

The statement, listed as a "warning" and addressed "to real estate dealers, speculators, property owners, and their agents, building and loan associations, and all others concerned," said in part:

"We are strongly organized and determined to resist by all legal, moral, and persuasive means, the efforts of certain unscrupulous dealers, money-lenders, selfish property owners, and their agents to intimidate or force us to move from our homes."

The churches whose members signed the protesting advertisement are St. Martin's at 33 N. Fulton Avenue, Father Louis O'Donovan, pastor; Fulton Avenue Baptist, 1 N. Fulton Avenue, the Rev. Otis Mayhew, pastor; Fuller Baptist Church, 1142 N. Fulton Avenue, the Rev. J. B. Trotter, pastor; Garrett Park Methodist, 1901 W. Lexington Street, the Rev. H. E. R. Reck, and Franklin Street United Brethren, the Rev. Benjamin Blubaugh, pastor.

The Fulton Avenue and Franklin Street Churches are members of the Baltimore Federation of Churches.

"Not Against Colored People"

Asked what was the objection to respectable colored neighbors when the housing situation for colored residents is so acute, C. Maurice Sturm of 206 N. Fulton Avenue, an officer of the improvement association, said the advertisement was not directed against colored citizens.

Pointing out that colored occupancy had not yet created a problem in the 200 block, Mr. Sturm said: "My objection is against the tactics which these real estate dealers are using to give the impression that we are going to have colored neighbors, by advertising homes for sale without authority."

Hundreds Buy Own Homes Under Plan

JACKSON, Miss., (ANP) — A self-help program by Negroes in Jackson, Miss., is beginning to pay off these days with a new community of home owners in an area 17 blocks long and seven blocks wide.

Already settled on this development, the Crisler Boys' Opportunity City, are 250 families, all owning or buying their own lots and homes, a $20,000 school, and a large recreational club house.

Persons may build up their home in two ways—build themselves or have the homes financed. Those building their own homes have a more difficult time improving their homes because of expenses, but they improve slowly.

Low Rates

Under the financing plan lots may be bought on rates of $10 or $15 a month at a cost of $150 or more. Homes are purchased on $5 to $10.50 weekly or $20 to $42.50 monthly plans. Most families pay $26 a month including taxes, interest, insurance, repayment of principal and payup advantages.

The area already has been im-

proved with two miles of lighted streets and natural gas mains. The Mississippi Power and Light Company and the REA are servicing electricity to homes.

Other community services such as free delivery of ice, groceries, laundry, dairy products, and others also are provided.

Idea for the "city" was originated by Farish Crisler Sr., along along with Farish Jr., William, James and J. C. Crisler.

"Hundreds Buy Own Homes Under Plan,"
The New York Amsterdam News, May 13, 1950

Erroneous Ad Corrected

He then called attention to an *Afro* advertisement February 6 in which Marse S. Calloway advertised for sale six homes in the 200 block of N. Fulton Avenue. Admitting that this was a mistake Mr. Calloway ran a correction in the following week's paper.

"There is an apparent organized attempt to give the impression that Fulton Avenue is an open market," Mr. Sturm said, "and this is not true. I have talked to these people and they are perfectly satisfied to remain where they are. None of them of his own volition is freely offering his home for sale, from Mulberry Street on down. I know positively that no such sales have been made in this neighborhood as yet, and that the point at issue. The people are becoming incensed at the real estate dealers' methods of operation which I consider very unethical." (After Mr. Sturm made this statement, he stated in a letter to the *Afro* that he had given it no authority to quote him or use his name in print.)

What the Men of God Say

The pastors of the churches involved made the following statements:

The Rev. Mr. O'Donovan, 31 N. Fulton Avenue: "I don't know of any case where colored people have actually moved in this neighborhood, but we have heard rumors. We just don't want our people crowded out,

Ringgold's Store a Mecca for Many Maryland Notables

Late Thomas Ringgold Was a Pioneer Storekeeper. Kept a Grocery at Port Deposit for 49 Years.

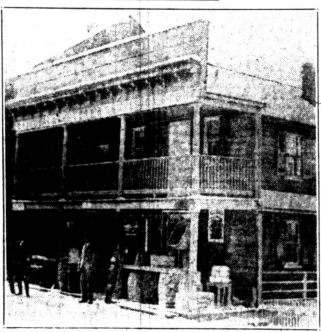

By THOMAS H. RINGGOLD

The subject of this sketch, the late Thomas Ringgold was a prosperous grocery merchant of Port Deposit, Maryland; for 49 years his store was a familiar establishment, known throughout the state as the Ringgold Store.

Mr. Ringgold was born in 1818 in Anne Arundel County, Md.; early in life he left home and resided several years in Baltimore, after which he settled in Port Dposit, Md., where he married Miss Mary H. Hopkins in 1849. She came from a family known as free colored people of Cecil County, Maryland. There were born to this union fourteen (14) children, seven (7) of which lived to maturity; there is living now one daughter, Mary H. Ringgold, of Baltimore, and a son, Thomas H. Ringgold, of Philadelphia, a real estate and insurance broker. His youngest daughter, the late Alice E. Brown, was married to Mr. William J. Brown, of Port Deposit, and Baltimore. Mr. Brown has been for years, butler and confidential man for the former Senator Joseph I. France of Maryland. We like to speak of Mr. France for the many good things he has done for Maryland and especially Port Deposit and many of its citizens.

Mr. Thomas Ringgold, the father, prospered in the grocery business and amassed quite a fortune; but the devastating floods of the Susquehanna River destroyed much of his property, business and fortune; other factors entered into this process of destruction; as an example all business up to about 1890, was conducted on monthly credit basis—hence the great loss on account of bad debts and failures. The introduction of chain groceries, eliminating individual effort; the shifting and consolidating of industries to large cities, followed by great migration of rural inhabitants, thus completing the disintegration of community and home life of the country. Mr. Ringgold's home was the mecca for church dignataries and other great leaders, such as Frederick Douglass, Mrs. Frances E. W. Harper, the celebrated poetess, and great temperance advocate and others. Himself a great church worker and highly respected citizen interested in every movement for the advancement of the race. His day however, was a day of strife, doubts, fears and great persecution, also, how he used to relate of his experience with the white hoodlums who would roll cannon balls against his store door; walk in his store and take whatever they chose and dare him to offer a word of protest; (but somehow) there was a little cloud of witnesses for justice, (and they were white people) who got together and put a stop to the depredations of this gang. From then, Thomas Ringgold went on successfully until adversity came into his life.

In order to intelligently grasp the full significance of this sketch of Thomas Ringgold, it will be necessary to get a clear perspective of Port Deposit, Maryland, situated on the east bank of the Susquehanna River, near Havre de Grace, was a depot for handling, transferring and shipping of lumber, coal, stone and farm products to various cities and centers, by convenient water-ways before the advent of railroads in the Susquehanna Valley. Here again can be seen the consequent destruction of rural and community life by the new form of transportation (The Railroads) as compared with methods in vogue before the Civil War and long after, many people were attracted to this busy town offering abundant opportunity for employment; two canals, one on each side of the river affording ample means for transporting commerce down to port; many huge rafts of timber from the great mountains and beautiful forest of Pennsylvania were floated down stream to be un-loaded and re-loaded on vessels— this with other activities made work and happiness for all.

Hence we move on to new ideals to new visions of life, of progress and enjoyment with a machine dancing to the doleful tune of a fast approaching dissolution of that sublime birthright—"That man shall earn his living by the sweat of his brow"—not by the whir of a machine.

Thomas H. Ringgold, "Ringgold's Store a Mecca for Many Maryland Notables," *The Afro-American* (Baltimore), March 5, 1932

that's all. We, of course, would regret any violence because that definitely is the wrong idea. But we're just interested in keeping our people permanently situated where they are."

Pen Chaplain Is Opposed

The Rev. Benjamin Blubaugh, 510 N. Monroe Street (Maryland penitentiary chaplain): "I did not attend the protest meeting. I am from Pennsylvania where colored and white live together and go to school together and I have nothing against colored persons. We have a high-class group of colored folks living on Lauretta Avenue and we have had no trouble with them. I maintain a friendly relationship with all those I know and those with whom I work with in the penitentiary. But I approve the action of the church in objecting against having them move into our community because the whites will move out. They have done this in other neighborhoods and they will do it here."

Asked whether the church shouldn't teach that both colored and white could live together in harmony, the Rev. Mr. Blubaugh said: "Maybe nobody had tried to convince them. Practices are different in Maryland from what they are in Pennsylvania. It would be pretty hard to show that to these Maryland people and they don't want to lose their homes."

"Look What Happened"

The Rev. Mr. Reck, 4203 Gelston Avenue: "We don't want colored to move into this neighborhood because it would depreciate the property. Look what happened on Montford Avenue. If we got only the respectable people like the ministers who attend our meetings, it would be different. I haven't anything against colored people because I was taught to give them a square deal, and I understand they are being used by these real estate dealers for sinister purposes. The day has not yet come for social equality. The overcrowded housing problem of the colored people affects this problem only in a general way. Several new housing projects are being built for them and it would be better for them to move into those rather than here on Fulton Avenue."

Say Colored Drink Whiskey

Asked whether it would be possible for colored families to keep Fulton Avenue homes in just as good condition as they do the housing projects, the Rev. Mr. Reck said: "No, they keep the housing projects in good condition because they are under restraint. I understand that the rules are so strict that they are not allowed to put empty whiskey bottles into the garbage cans. It's whiskey that brings out this low element, not the colored man himself. It's better that they not move in here because when you get a saloon in too, and an element of prejudice, you'll have trouble."

It's the People, Not Me

"Don't misunderstand my attitude towards the colored man, but the people here are afraid that should they move in, it will indirectly force them to move away." The Rev. Mr. Mayhew, who lives at 1835 W. Baltimore Street, was reported to be out of town until Saturday. The Rev. Mr. Totter, who neighbors said lives in Ellicott City, coming in only on Sunday for church meetings, could not be reached for a statement.

Christian Temple, a large church at 230 N. Fulton Avenue pastored by the Rev. Walter M. Haushalter, was not among the churches signing the advertisement of protest. This minister said he did not attend the last neighborhood meeting, but would attend the next and advance this theory:

What He'll Tell Them

"I am interested in interracial goodwill. The matter of real estate migration should not be approached in an atmosphere of hostility, but rather with co-operation between colored and white groups each representing the rights of the other. It's a situation which could well be considered and discussed in conferences between organizations such as the city council, the Baltimore Better Business Association, the real estate associations with the NAACP, and white civic church and social groups. The racial question in Baltimore, as in other American cities, must be settled by conferences and co-operative action of both colored and white people looking to the welfare of one another. I would be pleased to take part in any such conferences."

Colored Dealers Adamant

Colored real estate dealers who had advertised homes for sale on Fulton Avenue responded to the "warning" advertisement with the statement that colored people should live on Fulton Avenue or anywhere they can afford to purchase property, but should be accorded police protection if threatened with violence.

To this, Mr. Calloway added: "The white people are not doing all the fighting for democracy. If the Christian churches take this discriminatory stand, they are a set of hypocrites. We ourselves are going to fight discrimination in housing if we have to take the cases to the Supreme Court."

19 Homes Sold Already

He reported that he had made at least four sales of homes to colored owners in the 1400 block of Fulton Avenue and one in the 1600 block.

The Rev. J. Hiram Smith cited at least fifteen sales he made, including three houses already occupied by colored families. He listed four others wherein the white owners had approached him to make the sales, but he declined.

Land buying opportunity listed by the Swan and Arenson Realty and Development Co., Chicago, in *The Crisis* 19, no. 2, December 1919

Rev. Hiram Smith Talks

The minister had this to say in answer to the protest advertisement: "A few colored families took up residence on Fulton Avenue because a congested housing condition exists in every colored community in the city. The so-called Christian Church, the most democratic and the most sacred institution of our American life, has branded the owners of these properties, the salesmen and the associations that financed them, as being unscrupulous. The church also proclaims its strength and determination to fight this movement. I would like to point out that a group is never stronger than the principles it advocates. The church that has the pernicious ambition, the unethical courage and the unrighteous influence of the community shows a colossal weakness."

Says Church Must Reform

"If the church of Jesus Christ does not revise its attitude toward people of color, the war veterans who return will find an atmosphere of hate similar to that of the dictatorial Germans and Japanese. We trust, therefore, that the soldiers will learn enough about the destruction of hatred not to follow visionless church leaders."

Truly Hatchett reported that he had sold one house in the 500 block of Fulton Avenue and had two others under contract. Willard W. Allen, who said he regarded the sale of houses on Fulton Avenue as an "open field," added that those he had listed for sale were placed in his hands by the white owners themselves.

"Checking Migration"

Chicago Defender (weekend edition), August 9, 1919

The *Rochester Democrat and Chronicle* is responsible for the statement that they have seen no public contradiction of the story that has gained so much currency that the federal railroad administration has issued orders which are intended to have the result of hampering the buying of transportation by members of our group to the end of discouraging the emigration of our people to the North, and saving the South's labor supply. We are loathe to believe that any such order would emanate from Director General Hines, no matter where his personal sympathies lie.

The world knows the efforts put forth by the South to retain our labor. We were made the victims of unjust home-made laws, picked up by the police for no reason at all except that some contractor had sent in a call for more convict labor, and the grafting public officials proceeded to supply the demand. In this respect the South is an enigma. It wants us and it doesn't want us. The truth is it wants us as serfs and vassals, but not as men and citizens. The conditions upon which it wants us never will be complied with.

The fact is becoming apparent more and more every day that an enlightened and educated people of whatever race or nationality cannot be held as serfs and vassals. The South is destined to become a barren waste and a deserted wilderness if it persists in its indefensible methods to brutalize, humiliate and subjugate the members of our group residing there. As we advance in education and wealth we become more and more equipped to protect and defend ourself and family against injustice and wrong. The white South may as well realize now as later that the day is past when it can with impunity and with safety murder Colored men and brutalize our women. Migration will therefore continue to be one of the means employed to bring about the desired change.

"*Dear Sir:* I saw your advertisement in the *Chicago Defender*. I am planning to move North this summer. I am one of the R. F. D. Mail Carriers of Baton Rouge. . . . I want to buy property and locate in Chicago permently with my family."

BATON ROUGE, LA, APRIL 26, 1917

"The Great Land Robbery"

Vann R. Newkirk II
The Atlantic, September 2019

I. Wiped Out

"You ever chop before?" Willena Scott-White was testing me. I sat with her in the cab of a Chevy Silverado pickup truck, swatting at the squadrons of giant, fluttering mosquitoes that had invaded the interior the last time she opened a window. I was spending the day with her family as they worked their fields just outside Ruleville, in Mississippi's Leflore County. With her weathered brown hands, Scott-White gave me a pork sandwich wrapped in a grease-stained paper towel. I slapped my leg. Mosquitoes can bite through denim, it turns out.

Cotton sowed with planters must be chopped—thinned and weeded manually with hoes—to produce orderly rows of fluffy bolls. The work is backbreaking, and the people who do it maintain that no other job on Earth is quite as demanding. I had labored long hours over other crops, but had to admit to Scott-White, a 60-something grandmother who'd grown up chopping, that I'd never done it.

"Then you ain't never worked," she replied.

The fields alongside us as we drove were monotonous. With row crops, monotony is good. But as we toured 1,000 acres of land in Leflore and Bolivar Counties, straddling Route 61, Scott-White pointed out the demarcations between plots. A trio of steel silos here. A post there. A patch of scruffy wilderness in the distance. Each landmark was a reminder of the Scott legacy that she had fought to keep—or to regain—and she noted this with pride. Each one was also a reminder of an inheritance that had once been stolen.

Drive Route 61 through the Mississippi Delta and you'll find much of the scenery exactly as it was 50 or 75 years ago. Imposing plantations and ramshackle shotgun houses still populate the countryside from Memphis to Vicksburg. Fields stretch to the horizon. The hands that dig into black Delta dirt belong to people like Willena Scott-White, African Americans who bear faces and names passed down from men and women who were owned here, who were kept here, and who chose to stay here, tending the same fields their forebears tended.

But some things have changed. Back in the day, snow-white bolls of King Cotton reigned. Now much of the land is green with soybeans. The farms and plantations are much larger—industrial operations with bioengineered plants, laser-guided tractors, and crop-dusting drones. Fewer and fewer farms are still owned by actual farmers. Investors in boardrooms throughout the country have bought hundreds of thousands of acres of premium Delta land. If you're one of the millions of people who have a retirement account with the Teachers

Insurance and Annuity Association, for instance, you might even own a little bit yourself.

TIAA is one of the largest pension firms in the United States. Together with its subsidiaries and associated funds, it has a portfolio of more than 80,000 acres in Mississippi alone, most of them in the Delta. If the fertile crescent of Arkansas is included, TIAA holds more than 130,000 acres in a strip of counties along the Mississippi River. And TIAA is not the only big corporate landlord in the region. Hancock Agricultural Investment Group manages more than 65,000 acres in what it calls the "Delta states." The real-estate trust Farmland Partners has 30,000 acres in and around the Delta. AgriVest, a subsidiary of the Swiss bank UBS, owned 22,000 acres as of 2011. (AgriVest did not respond to a request for more recent information.)

Unlike their counterparts even two or three generations ago, black people living and working in the Delta today have been almost completely uprooted from the soil—as property owners, if not as laborers.

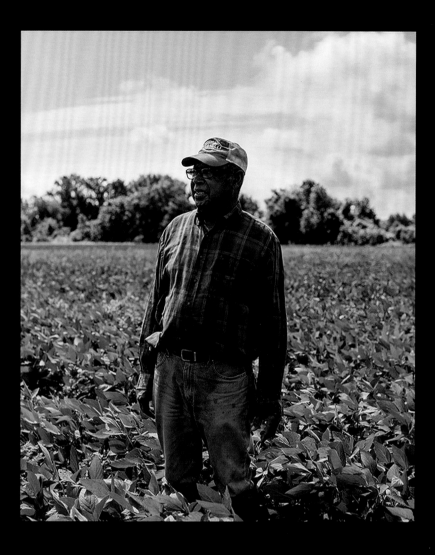

Left: A sign on a utility pole to deter hunters, near the old Scott family homestead, Drew, Mississippi; right: Willena's brother Isaac Daniel Scott Sr. amid soybeans in Mound Bayou

In Washington County, Mississippi, where last February TIAA reportedly bought 50,000 acres for more than $200 million, black people make up 72 percent of the population but own only 11 percent of the farmland, in part or in full. In Tunica County, where TIAA has acquired plantations from some of the oldest farmowning white families in the state, black people make up 77 percent of the population but own only 6 percent of the farmland. In Holmes County, the third-blackest county in the nation, black people make up about 80 percent of the population but own only 19 percent of the farmland. TIAA owns plantations there, too. In just a few years, a single company has accumulated a portfolio in the Delta almost equal to the remaining holdings of the African Americans who have lived on and shaped this land for centuries

This is not a story about TIAA—at least not primarily. The company's newfound dominance in the region is merely the topsoil covering a history of loss and legally sanctioned theft in which TIAA played no part. But TIAA's position is instrumental in understanding both how the crimes of Jim Crow have been laundered by time and how the legacy of ill-gotten gains has become a structural part of American life. The land was wrested first from Native Americans, by force. It was then cleared, watered, and made productive for intensive agriculture by the labor of enslaved Africans, who after Emancipation would come to own a portion of it. Later, through a variety of means—sometimes legal, often coercive, in many cases legal *and* coercive, occasionally violent—farmland owned by black people came into the hands of white people. It was aggregated into larger holdings, then aggregated again, eventually attracting the interest of Wall Street.

Owners of small farms everywhere, black and white alike, have long been buffeted by larger economic

Willena Scott-White's son Joseph White cutting grass on family land, Mound Bayou, Mississippi

forces. But what happened to black landowners in the South, and particularly in the Delta, is distinct, and was propelled not only by economic change but also by white racism and local white power. A war waged by deed of title has dispossessed 98 percent of black agricultural landowners in America. They have lost 12 million acres over the past century. But even that statement falsely consigns the losses to long-ago history. In fact, the losses mostly occurred within living memory, from the 1950s onward. Today, except for a handful of farmers like the Scotts who have been able to keep or get back some land, black people in this most productive corner of the Deep South own almost nothing of the bounty under their feet.

II. "Land Hunger"

Land has always been the main battleground of racial conflict in Mississippi. During Reconstruction, fierce resistance from the planters who had dominated antebellum society effectively killed any promise of land or protection from the Freedmen's Bureau, forcing masses of black laborers back into de facto bondage. But the sheer size of the black population—black people were a majority in Mississippi until the 1930s—meant that thousands were able to secure tenuous footholds as landowners between Emancipation and the Great Depression.

Driven by what W. E. B. Du Bois called "land hunger" among freedmen during Reconstruction, two generations of black workers squirreled away money and went after every available and affordable plot they could, no matter how marginal or hopeless. Some found sympathetic white landowners who would sell to them. Some squatted on unused land or acquired the few homesteads available to black people. Some followed visionary

leaders to all-black utopian agrarian experiments, such as Mound Bayou, in Bolivar County.

It was never much, and it was never close to just, but by the early 20th century, black people had something to hold on to. In 1900, according to the historian James C. Cobb, black landowners in Tunica County outnumbered white ones three to one. According to the U.S. Department of Agriculture, there were 25,000 black farm operators in 1910, an increase of almost 20 percent from 1900. Black farmland in Mississippi totaled 2.2 million acres in 1910—some 14 percent of all black-owned agricultural land in the country, and the most of any state.

The foothold was never secure. From the beginning, even the most enterprising black landowners found themselves fighting a war of attrition, often fraught with legal obstacles that made passing title to future generations difficult. Bohlen Lucas, one of the few black Democratic politicians in the Delta during Reconstruction (most black politicians at the time were Republicans), was born enslaved and managed to buy a 200-acre farm from his former overseer, as the historian John C. Willis has documented in his 2000 book, *Forgotten Time*. But, like many farmers, who often have to borrow against expected harvests to pay for equipment, supplies, and the rent or mortgage on their land, Lucas depended on credit extended by powerful lenders. In his case, credit depended specifically on white patronage, given in exchange for his help voting out the Reconstruction government—after which his patrons abandoned him. He was left with 20 acres.

In Humphreys County, Lewis Spearman avoided the pitfalls of white patronage by buying less valuable wooded tracts and grazing cattle there as he moved into cotton. (Spearman's biographical details, too, appear in *Forgotten Time*.) But when cotton crashed in the 1880s, Spearman, over his head in debt, crashed with it.[1]

Around the turn of the century, in Leflore County, a black farm organizer and proponent of self-sufficiency— referred to as a "notoriously bad Negro" in the local newspapers—led a black populist awakening, marching defiantly and by some accounts bringing boycotts against white merchants. White farmers responded with a posse that may have killed as many as 100 black farmers and sharecroppers along with women and children. The fate of the "bad Negro" in question, named Oliver Cromwell, is uncertain. Some sources say he escaped to Jackson, and into anonymity.

Like so many of his forebears, Ed Scott Sr., Willena Scott-White's grandfather, acquired his land through not much more than force of will. As recorded in the thick binders of family history that Willena had brought along in the truck, and that we flipped through between stretches of work in the fields, his life had attained the gloss of folklore. He was born in 1886 in western Alabama, a generation removed from bondage. Spurred

by that same land hunger, Scott took his young family to the Delta, seeking opportunities to farm his own property. He sharecropped and rented, and managed large farms for white planters, who valued his ability to run their sprawling estates. One of these men was Palmer H. Brooks, who owned a 7,000-acre plantation in Mississippi's Leflore and Sunflower Counties. Brooks was uncommonly progressive, encouraging entrepreneurship among the black laborers on his plantation, building schools and churches for them, and providing loans. Scott was ready when Brooks decided to sell plots to black laborers, and he bought his first 100 acres.

Unlike Bohlen Lucas, Scott largely avoided politics. Unlike Lewis Spearman, he paid his debts and kept some close white allies—a necessity, since he usually rejected government assistance. And unlike Oliver Cromwell, he led his community under the rules already in place, appearing content with what he'd earned for his family in an environment of total segregation. He leveraged technical skills and a talent for management to impress sympathetic white people and disarm hostile ones. "Granddaddy always had nice vehicles," Scott-White told me. They were a trapping of pride in a life of toil. As was true in most rural areas at the time, a new truck was not just a flashy sign of prosperity but also a sort of credit score. Wearing starched dress shirts served the same purpose, elevating Scott in certain respects—always within limits—even above some white farmers who drove into town in dirty overalls. The trucks got shinier as his holdings grew. By the time Scott died, in 1957, he had amassed more than 1,000 acres of farmland.

Scott-White guided me right up to the Quiver River, where the legend of her family began. It was a choked, green-brown gurgle of a thing, the kind of lazy waterway that one imagines to be brimming with fat, yawning catfish and snakes. "Mr. Brooks sold all of the land on the east side of this river to black folks," Scott-White told me. She swept her arm to encompass the endless acres. "All of these were once owned by black families."

III. The Great Dispossession

That era of Black ownership in the Delta and throughout the country, was already fading by the time Scott died. As the historian Pete Daniel recounts, half a million black-owned farms across the country failed in the 25 years after 1950. Joe Brooks, the former president of the Emergency Land Fund, a group founded in 1972 to fight the problem of dispossession, has estimated that something on the order of 6 million acres was lost by black farmers from 1950 to 1969. That's an average of 820 acres a day—an area the size of New York's Central Park erased with each sunset. Black-owned cotton farms in the South almost completely disappeared, diminishing from 87,000 to just over 3,000 in the 1960s alone. According to the Census of Agriculture, the racial

disparity in farm acreage increased in Mississippi from 1950 to 1964, when black farmers lost almost 800,000 acres of land. An analysis for *The Atlantic* by a research team that included Dania Francis, at the University of Massachusetts, and Darrick Hamilton, at Ohio State, translates this land loss into a financial loss—including both property and income—of $3.7 billion to $6.6 billion in today's dollars.

This was a silent and devastating catastrophe, one created and maintained by federal policy. President Franklin D. Roosevelt's New Deal life raft for agriculture helped start the trend in 1937 with the establishment of the Farm Security Administration, an agency within the Department of Agriculture. Although the FSA ostensibly existed to help the country's small farmers, as happened with much of the rest of the New Deal, white administrators often ignored or targeted poor black people—denying them loans and giving sharecropping work to white people. After Roosevelt's death, in 1945, conservatives in Congress replaced the FSA with the Farmers Home Administration, or FmHA. The FmHA

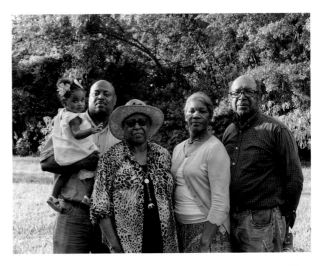

From right: Isaac Daniel Scott Sr. and his wife, Lucy Chatman-Scott; Willena Scott-White; and Willena's son Joseph White, with his daughter, Jade Marie White

quickly transformed the FSA's programs for small farmers, establishing the sinews of the loan-and-subsidy structure that undergirds American agriculture today. In 1961, President John F. Kennedy's administration created the Agricultural Stabilization and Conservation Service, or ASCS, a complementary program to the FmHA that also provided loans to farmers. The ASCS was a federal effort—also within the Department of Agriculture—but, crucially, the members of committees doling out money and credit were elected locally, during a time when black people were prohibited from voting.

Through these programs, and through massive crop and surplus purchasing, the USDA became the safety

net, price-setter, chief investor, and sole regulator for most of the farm economy in places like the Delta. The department could offer better loan terms to risky farmers than banks and other lenders, and mostly outcompeted private credit. In his book *Dispossession,* Daniel calls the setup "agrigovernment." Land-grant universities pumped out both farm operators and the USDA agents who connected those operators to federal money. Large plantations ballooned into even larger industrial crop factories as small farms collapsed. The mega-farms held sway over agricultural policy, resulting in more money, at better interest rates, for the plantations themselves. At every level of agrigovernment, the leaders were white.

Major audits and investigations of the USDA have found that illegal pressures levied through its loan programs created massive transfers of wealth from black to white farmers, especially in the period just after the 1950s. In 1965, the United States Commission on Civil Rights uncovered blatant and dramatic racial differences in the level of federal investment in farmers. The commission found that in a sample of counties across the South, the FmHA provided much larger loans for small and medium-size white-owned farms, relative to net worth, than it did for similarly sized black-owned farms—evidence that racial discrimination "has served to accelerate the displacement and impoverishment of the Negro farmer."

In Sunflower County, a man named Ted Keenan told investigators that in 1956, local banks had denied him loans after a bad crop because of his position with the NAACP, where he openly advocated for voting rights. The FmHA had denied him loans as well. Keenan described how Eugene Fisackerly, the leader of the White Citizens' Council in Sunflower County, together with representatives of Senator James Eastland, a notorious white supremacist who maintained a large plantation there, had intimidated him into renouncing his affiliation with the NAACP and agreeing not to vote. Only then did Eastland's man call the local FmHA agent, prompting him to reconsider Keenan's loan.

A landmark 2001 investigation by the Associated Press into extortion, exploitation, and theft directed against black farmers uncovered more than 100 cases like Keenan's. In the 1950s and '60s, Norman Weathersby, a Holmes County Chevrolet dealer who enjoyed a local monopoly on trucks and heavy farm equipment, required black farmers to put up land as collateral for loans on equipment. A close friend of his, William Strider, was the local FmHA agent. Black farmers in the area claimed that the two ran a racket: Strider would slow-walk them on FmHA loans, which meant they would then default on Weathersby's loans and lose their land to him. Strider and Weathersby were reportedly free to run this racket because black farmers were shut out by local banks.

Analyzing the history of federal programs, the Emergency Land Fund emphasizes a key distinction. While most of the black land loss appears on its face to have been through *legal* mechanisms—"the tax sale; the partition sale; and the foreclosure"—it mainly stemmed from *illegal* pressures, including discrimination in federal and state programs, swindles by lawyers and speculators, unlawful denials of private loans, and even outright acts of violence or intimidation. Discriminatory loan servicing and loan denial by white-controlled FmHA and ASCS committees forced black farmers into foreclosure, after which their property could be purchased by wealthy landowners, almost all of whom were white. Discrimination by private lenders had the same result. Many black farmers who escaped foreclosure were defrauded by white tax assessors who set assessments too high, leading to unaffordable tax obligations. The inevitable result: tax sales, where, again, the land was purchased by wealthy white people. Black people's lack of access to legal services complicated inheritances and put family claims to title in jeopardy. Lynchings, police brutality, and other forms of intimidation were sometimes used to dispossess black farmers, and even when land wasn't a motivation for such actions, much of the violence left land without an owner.

In interviews with researchers from the Smithsonian's National Museum of American History in 1985, Henry Woodard Sr., an African American who had bought land in the 1950s in Tunica County, said he had managed to keep up for years through a combination of his own industry, small loans from the FmHA and white banks, and the rental of additional land from other hard-pressed black landowners. Then, in 1966, the activist James Meredith—whose 1962 fight to integrate Ole Miss sparked deadly riots and a wave of white backlash—embarked on the famous March Against Fear. The next planting season, Woodard recalled, his white lenders ignored him. "I sensed that it was because of this march," he said. "And it was a lady told me—I was at the post office and she told me, she said, 'Henry, you Negroes, y'all want to live like white folks. Y'all don't know how white folks live. But y'all are gonna have to be on your own now.'"

Woodard's story would have been familiar to countless farmers in the Delta. In Holmes County, a crucible of the voting-rights movement, a black effort to integrate the local ASCS committees was so successful that it was subject to surveillance and sabotage by the Mississippi State Sovereignty Commission, an official agency created by Governor J. P. Coleman in 1956 to resist integration. Black landowners involved in running for the committees or organizing for votes faced fierce retaliation. In 1965, *The New Republic* reported that in Issaquena County, just north of Vicksburg, the "insurance of Negroes active in the ASCS elections had been

canceled, loans were denied to Negroes on all crops but cotton, and ballots were not mailed to Negro wives who were co-owners of land." Even in the decades after the passage of the 1965 Voting Rights Act, formal and informal complaints against the USDA poured out of the Delta.

These cases of dispossession can only be called theft. While the civil-rights era is remembered as a time of victories against disenfranchisement and segregation, many realities never changed. The engine of white wealth built on kleptocracy—which powered both Jim Crow and its slave-state precursor—continued to run. The black population in Mississippi declined by almost one-fifth from 1950 to 1970, as the white population increased by the exact same percentage. Farmers slipped away one by one into the night, appearing later as laborers in Chicago and Detroit. By the time black people truly gained the ballot in Mississippi, they were a clear minority, held in thrall to a white conservative supermajority.

Mass dispossession did not require a central organizing force or a grand conspiracy. Thousands of individual decisions by white people, enabled or motivated by greed, racism, existing laws, and market forces, all pushed in a single direction. But some white people undeniably would have organized it this way if they could have. The civil-rights leader Bayard Rustin reported in 1956 that documents taken from the office of Robert Patterson, one of the founding fathers of the White Citizens' Councils, proposed a "master plan" to force hundreds of thousands of black people from Mississippi in order to reduce their potential voting power. Patterson envisioned, in Rustin's words, "the decline of the small independent farmer" and ample doses of "economic pressure."

An upheaval of this scale and speed—the destruction of black farming, an occupation that had defined the African American experience—might in any other context be described as a revolution, or seen as a historical fulcrum. But it came and went with little remark.

IV. The Catfish Boom

World War II transformed America in many ways. It certainly transformed a generation of southern black men. That generation included Medgar Evers, a future civil-rights martyr, assassinated while leading the Mississippi NAACP; he served in a segregated transportation company in Europe during the war. It included Willena's father, Ed Scott Jr., who also served in a segregated transportation company. These men were less patient, more defiant, and in many ways more reckless than their fathers and grandfathers had been. They chafed under a system that forced them to relearn how to bow and scrape, as if the war had never happened. In the younger Scott's case, wartime service sharpened his inherited land hunger, pushing him to seek more

land and greater financial independence, both for himself and for his community. One of his siblings told his biographer, Julian Rankin, that the family's deepest conviction was that "a million years from now . . . this land will still be Scotts' land."

Upon his return to the Delta, Scott continued down his father's hard path, avoiding any interface with the FmHA and the public portions of the agrigovernment system, which by that time had spread its tendrils throughout Sunflower and Leflore Counties. He leaned on the friendships he and his father had made with local business owners and farmers, and secured credit for growing his holdings from friendly white bankers. Influenced by the civil-rights movement and its emphasis on community solidarity and activism, Scott borrowed from Oliver Cromwell's self-sufficiency playbook too. He used his status to provide opportunities for other black farmers and laborers. "Daddy said that everyone who worked for us would always be able to eat," Willena Scott-White told me. He made sure of more than that. Scott sent relatives' and tenants' children to school, paid for books, helped people open bank accounts and buy their own land. When civil-rights activists made their way down for Mississippi's Freedom Summer, in 1964, he packed up meals and brought them to rallies.

When Scott-White thinks of her father, who died in 2015, she seems to become a young girl again. With allowances for nostalgia, she recalls a certain kind of country poorness-but-not-poverty, whereby children ran barefoot and worked from the moment they could walk, but ate well, lived in houses with solid floors and tight roofs, and went to high school and college if they showed skill. "We lived in something like a utopia," Scott-White told me. But things changed at the tail end of the 1970s. Plummeting commodity prices forced highly leveraged farmers to seek loans wherever they could find them. Combined with the accelerating inflation of that decade, the beginnings of the farm-credit crisis made farming at scale without federal assistance impossible. Yet federal help—even then, two decades after the Civil Rights Act—was not available for most black farmers. According to a 2005 article in *The Nation,* "In 1984 and 1985, at the height of the farm crisis, the USDA lent a total of $1.3 billion to nearly 16,000 farmers to help them maintain their land. Only 209 of those farmers were black."

As Rankin tells it in his biography, *Catfish Dream,* Scott made his first visit to an FmHA office in 1978. With the assistance of Vance Nimrod, a white man who worked with the black-owned Delta Foundation, a nonprofit promoting economic advancement for black Mississippians, Scott secured an operating loan for a season of soybeans and rice from the FmHA agent Delbert Edwards. The first time was easy—although, crucially, Nimrod accompanied him to the Leflore County office,

in Greenwood. When Scott returned the next year without Nimrod, driving a shiny new truck the way his father used to, Edwards asked where Nimrod was. According to Rankin, Scott told the agent that Nimrod had only come to help secure that first loan; he wasn't a business partner. When Edwards saw Scott's vehicle, he seemed perplexed. "Who told you to buy a new truck?" he asked. Edwards ended up denying the requested loan amount.

At the same time, Edwards and the FmHA were moving to help local white farmers weather the storm, often by advising them to get into raising catfish. Commercial catfish farming was a relatively new industry, and it had found a home in the Delta as prices for row crops crashed and new legislation gave the USDA power and incentive to build up domestic fish farming. FmHA agents pushed white farmers to convert wide fields on the floodplain into giant catfish ponds, many of which would become contract-growing hubs for Delta Pride Catfish, a cooperative that quickly evolved into a local monopoly. The federal government poured millions of dollars into the catfish boom by way of FmHA loans, many of which were seized on by the largest white landowners, and kept those white landowners solvent. Mississippi became the catfish capital of the world in the 1970s. But the FmHA did not reach out to Scott, nor is there evidence that it supported the ambitions of any black farmers who might have wanted to get into catfish.

Scott decided to get into catfish anyway, digging eight ponds in fields where rice had grown the season before. He found his own catfish stocks and learned the ins and outs of the industry pretty much on his own. Scott finished digging his ponds in 1981, at which point, according to Rankin, Edwards of the FmHA visited the property and told him point-blank: "Don't think I'm giving you any damn money for that dirt you're moving." The Mississippi FmHA would eventually compel Edwards to provide loans for Scott's catfish operation for 1981 and 1982. But as court records show, the amount approved was far less than what white catfish farmers usually got—white farmers sometimes received double or triple the amount per acre that Scott did—and enough to stock only four of the eight ponds. (Edwards could not be reached for comment on any of the episodes recounted here.)

Scott's Fresh Catfish opened in 1983. As a marker outside the old processing shed now indicates, it was the first catfish plant in the country owned by an African American. But discrimination doomed the enterprise before it really began. Without enough capital, Scott was never able to raise fish at the volume he needed. He claimed in court and later to Rankin that he had also been denied a chance to purchase stock in Delta Pride—a requirement to become a contract grower— because he was black. Without access to a cooperative, he had to do the processing and packaging himself,

adding to the cost of his product. In 2006, Delta Pride and Country Select Catfish were combined into a new business entity, Consolidated Catfish Producers. When reached for comment, a spokesperson for Consolidated Catfish said that no employee at the new company could "definitively answer" questions about Scott or alleged discrimination against him.

Scott was in his 60s by the time his plant got off the ground. The effort took a toll. He slowly went blind. Arthritis claimed his joints. His heart began to fail. The plant limped quietly through the '80s and then shut down. Lenders began the process of foreclosing on some of Scott's cropland as early as 1983. In 1995, the FmHA approved a request from Scott to lease most of his remaining acres. The USDA itself had claimed most of his land by the late 1980s.

The downfall of the Scott catfish enterprise was proof of the strength and endurance of what the federal government would later state could be seen as a federally funded "conspiracy to force minority and disadvantaged farmers off their land through discriminatory loan practices." The Scotts were not small-timers. They had the kind of work ethic and country savvy that are usually respected around the Delta. When the powers that be finally prevailed over Ed Scott Jr., they had completed something decisive, something that even today feels as if it cannot be undone.

V. Farmers in Suits

But land is never really lost, not in America. Twelve million acres of farmland in a country that has become a global breadbasket carries immense value, and the dispossessed land in the Delta is some of the most productive in America. The soil on the alluvial plain is rich. The region is warm and wet. Much of the land is perfect for industrialized agriculture.

Some white landowners, like Norman Weathersby, themselves the beneficiaries of government-funded dispossession, left land to their children. Some sold off to their peers, and others saw their land gobbled up by even larger white-owned farms. Nowadays, as fewer and fewer of the children of aging white landowners want to continue farming, more land has wound up in the hands of trusts and investors. Over the past 20 years, the real power brokers in the Delta are less likely to be good ol' boys and more likely to be suited venture capitalists, hedge-fund managers, and agribusiness consultants who run farms with the cold precision of giant circuit boards.

One new addition to the mix is pension funds. Previously, farmland had never been a choice asset class for large-scale investing. In 1981, what was then called the General Accounting Office (now the Government Accountability Office) released a report exploring a proposal by a firm seeking pension-investment opportunities in farmland. The report essentially laughed off

the prospect. The authors found that only about one dollar of every $4,429 in retirement funds was invested in farmland.

But commodity prices increased, and land values rose. In 2008, a weakened dollar forced major funds to broaden their search for hedges against inflation. "The market in agricultural land in the U.S. is currently experiencing a boom," an industry analyst, Tom Vulcan, wrote that year. He took note of the recent entry of TIAA-CREF, which had "spent some $340 million on farmland across seven states." TIAA, as the company is now called, would soon become the biggest pension-fund player in the agricultural real-estate game across the globe. In 2010, TIAA bought a controlling interest in Westchester Group, a major agricultural-asset manager. In 2014, it bought Nuveen, another large asset-management firm. In 2015, with Nuveen directing its overall investment strategy and Westchester and other smaller subsidiaries operating as purchasers and managers, TIAA raised $3 billion for a new global farmland-investment partnership. By the close of 2016, Nuveen's management portfolio included nearly 2 million acres of farmland, worth close to $6 billion.

Investment in farmland has proved troublesome for TIAA in Mississippi and elsewhere. TIAA is a pension company originally set up for teachers and professors and people in the nonprofit world. It has cultivated a reputation for social responsibility: promoting environmental sustainability and respecting land rights, labor rights, and resource rights. TIAA has endorsed the United Nations–affiliated Principles for Responsible Investment, which include special provisions for investment in farmland, including specific guidelines with regard to sustainability, leasing practices, and establishing the provenance of tracts of land.

The company has faced pushback for its move into agriculture. In 2015, the international nonprofit Grain, which advocates for local control of farmland by small farmers, released the results of an investigation accusing TIAA's farmland-investment arm of skirting laws limiting foreign land acquisition in its purchase of more than half a million acres in Brazil. The report found that TIAA had violated multiple UN guidelines in creating a joint venture with a Brazilian firm to invest in farmland without transparency. The Grain report alleges that when Brazil tightened laws designed to restrict foreign investment, TIAA purchased 49 percent of a Brazilian company that then acted as its proxy. According to *The New York Times*, TIAA and its subsidiaries also appear to have acquired land titles from Euclides de Carli, a businessman often described in Brazil as a big-time *grileiro*—a member of a class of landlords and land grabbers who use a mix of legitimate means, fraud, and violence to force small farmers off their land. In response to criticism of TIAA's Brazil portfolio, Jose Minaya, then the

head of private-markets asset management at TIAA, told WNYC's *The Takeaway*: "We believe and know that we are in compliance with the law, and we are transparent about what we do in Brazil. From a title perspective, our standards are very focused around not displacing individuals or indigenous people, respecting land rights as well as human rights. . . . In every property that we have acquired, we don't just do due diligence on that

property. We do due diligence on the sellers, whether it's an individual or whether it's an entity."

Grain bins on Scott family land. The family's farms reflect a larger economic pattern in the Mississippi Delta: the shift away from cotton, once predominant, toward other crops.

TIAA's land dealings have faced scrutiny in the United States as well. In 2012, the National Family Farm Coalition found that the entry into agriculture of deep-pocketed institutional investors—TIAA being an example—had made it pretty much impossible for smaller farmers to compete. Institutional investment has removed millions of acres from farmers' hands, more or less permanently. "Pension funds not only have the power to outbid smaller, local farmers, they also have the long-term goal of retaining farmland for generations," the report noted.

Asked about TIAA's record, a spokesperson for Nuveen maintained that the company has built its Delta portfolio following ethical-investment guidelines: "We have a long history of investing responsibly in farmland, in keeping with our corporate values and the UN-backed Principles for Responsible Investment (PRI). As a long-term owner, we bring capital, professional expertise, and sustainable farming practices to each farm we own, and we are always looking to partner with expansion-minded tenants who will embrace that approach and act as good stewards of the land." The company did not comment on the history of any individual tract in its Delta portfolio.

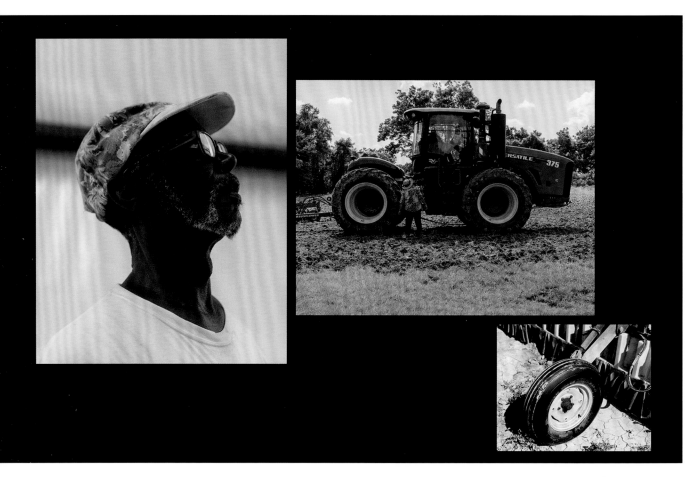

But even assuming that every acre under management by big corporate interests in the Delta has been acquired by way of ethical-investment principles, the nature of the mid-century dispossession and its multiple layers of legitimation raise the question of whether responsible investment in farmland there is even possible. As a people and a class, black farmers were plainly targets, but the deed histories of tax sales and foreclosures don't reveal whether individual debtors were moved off the land because of discrimination and its legal tools.

In addition, land records are spotty in rural areas, especially records from the 1950s and '60s, and in some cases it's unclear exactly which records the investors used to meet internal requirements. According to Tristan Quinn-Thibodeau, a campaigner and organizer at ActionAid, an anti-poverty and food-justice nonprofit, "It's been a struggle to get this information." The organization has tried to follow the trails of deeds and has asked TIAA—which manages ActionAid's own pension plan—for an analysis of the provenance of its Delta portfolio. Such an analysis has not been provided.

What we do know is that, whatever the specific lineage of each acre, Wall Street investors have found a lucrative new asset class whose origins lie in part in mass dispossession. We know that the vast majority of black farmland in the country is no longer in black hands, and that black farmers have suffered far more hardships than white farmers have. The historian Debra A. Reid points out that "between 1920 and 1997, the number of African Americans who farmed decreased by 98 percent, while white Americans who farmed declined by 66 percent." Referring to the cases studied in their 2001 investigation, Dolores Barclay and Todd Lewan of the Associated Press observed that virtually all of the property lost by black farmers "is owned by whites or corporations." The foundation of these portfolios was a system of plantations whose owners created the agrigovernment system and absorbed thousands of small black-owned farms into ever larger white-owned farms. America has its own *grileiros*, and they stand on land that was once someone else's.

VI. A Deeper Excavation

As we drove through the patchwork remnants of the Scotts' land, Willena Scott-White took me to the site of Scott's Fresh Catfish. Gleaming steel silos had turned into rusting hulks. The ponds were thick with weeds and debris. The exterior walls of the plant itself had

collapsed. Rusted beams lay atop ruined machinery. Fire ants and kudzu had begun nature's reclamation.

Late in Ed Scott Jr.'s life, as he slipped into Alzheimer's, Willena and his lawyer, Phil Fraas, fought to keep his original hopes alive. In the *Pigford v. Glickman* lawsuit of 1997, thousands of black farmers and their families won settlements against the USDA for discrimination that had occurred between 1981 and the end of 1996; the outlays ultimately reached a total of $2 billion. The Scotts were one of those families, and after a long battle to prove their case—with the assistance of Scott-White's meticulous notes and family history—in 2012 the family was awarded more than $6 million in economic damages, plus almost $400,000 in other damages and debt forgiveness. The court also helped the Scotts reclaim land possessed by the department. In a 1999 ruling, Judge Paul L. Friedman of the U.S. District Court for the District of Columbia acknowledged that forcing the federal government to compensate black farmers would "not undo all that has been done" in centuries of government-sponsored racism. But for the Scotts, it was a start.

"The telling factor, looking at it from the long view, is that at the time of World War I there were 1 million black farmers, and in 1992 there were 18,000," Fraas told me. The settlements stemming from *Pigford* cover only specific recent claims of discrimination, and none stretching back to the period of the civil-rights era, when the great bulk of black-owned farms disappeared. Most people have not pushed for any kind of deeper excavation.

Any such excavation would quickly make plain the consequences of what occurred. During my drive with Scott-White, we traveled through parts of Leflore, Sunflower, and Washington Counties, three of the counties singled out by Opportunity Insights, a Harvard University research group, as among the worst in the country in terms of a child's prospects for upward mobility. Ten

counties in the Delta are among the poorest 50 in America. According to new data from the Centers for Disease Control and Prevention on all 74,000 U.S. census tracts, four tracts in the Delta are among the lowest 100 when it comes to average life expectancy. More than 30 tracts in the Delta have an average life expectancy below 70. (The national average is 79.) In some Delta counties, the infant mortality rate is more than double the nationwide rate. As if to add gratuitous insult to injury, a new analysis from ProPublica finds that, as a result of the Internal Revenue Service's intense scrutiny of low-income taxpayers, the Delta is audited by the IRS more heavily than any other place in the country. In sum, the areas of deepest poverty and under the darkest shadow of death are the ones where dispossession was the most far-reaching.

The consequences of dispossession had long been predicted. Fannie Lou Hamer, a Sunflower County activist whose 1964 speech to a Democratic National Convention committee galvanized support for the Voting Rights Act, spoke often of the need for land reform as a precondition for true freedom. Hamer's utopian Freedom Farm experiment stressed cooperative land-ownership, and she said the concentration of land in the hands of a few landowners was "at the base of our struggle for survival." In her analysis, mass dispossession should be seen as mass extraction. Even as the U.S. government invested billions in white farmers, it continued to extract wealth from black farmers in the Delta. Each black farmer who left the region, from Reconstruction onward, represented a tiny withdrawal from one side of a cosmic balance sheet and a deposit on the other side. This dynamic would only continue, in other ways and other places, as the Great Migration brought black families to northern cities.

This cosmic balance sheet underpins the national conversation—ever more robust—about reparations for black Americans. In that conversation, given momentum in part by the publication of Ta-Nehisi Coates's "The Case for Reparations" in this magazine in 2014, I hear echoes of Mississippi. I hear echoes of Hamer, the Scotts, Henry Woodard Sr., and others who petitioned the federal government to hold itself accountable for a history of extraction that has extended well beyond enslavement. But that conversation too easily becomes technical. How do we quantify discrimination? How do we define who was discriminated against? How do we repay those people according to what has been defined and quantified? The idea of reparations sometimes seems like a problem of economic rightsizing—something for the quants and wonks to work out.

Economics is, of course, a major consideration. According to the researchers Francis and Hamilton,

The Scott family cemetery

"The dispossession of black agricultural land resulted in the loss of hundreds of billions of dollars of black wealth. We must emphasize this estimate is conservative. . . . Depending on multiplier effects, rates of returns, and other factors, it could reach into the trillions." The large wealth gap between white and black families today exists in part because of this historic loss.

But money does not define every dimension of land theft. Were it not for dispossession, Mississippi today might well be a majority-black state, with a radically different political destiny. Imagine the difference in our national politics if the center of gravity of black electoral strength had remained in the South after the Voting Rights Act was passed.

Politics aside, how can reparations truly address the lives ruined, the family histories lost, the connection to the land severed? In America, land has always had a significance that exceeds its economic value. For a people who were once chattel themselves, real property has carried an almost mystical import. There's a reason the fabled promise that spread among freedmen after the Civil War was not a check, a job, or a refundable tax credit, but 40 acres of farmland to call home. The history of the Delta suggests that any conversation about reparations might need to be *more* qualitative and intangible than it is. And it must consider the land.

Land hunger is ineffable, an indescribable yearning, and yet it is something that Americans, perhaps uniquely, feel and understand. That yearning tugged at me hardest as Willena Scott-White rounded out her tour of the fields, the afternoon slipping away. Out among the Scotts' fields is a clearing with a lone, tall tree. In the clearing is a small cemetery. A handful of crooked, weathered tombstones stand sentinel. This is where Ed Scott Jr. is buried, and where some of Willena's older siblings now rest. Willena posed for a picture beside her parents' grave. She told me that this is where her own bones will rest after her work on Earth is done.

"This is *our* land," she said.

Note
1. This article has been updated to reflect that the historian John C. Willis documented the biographies of Bohlen Lucas and Lewis Spearman in his book *Forgotten Time*.

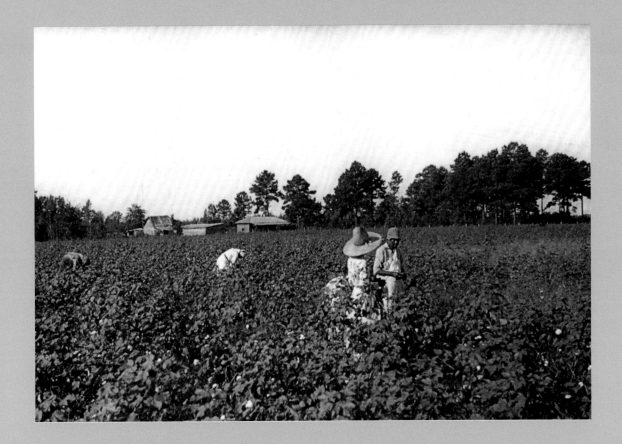

Men and women sharecroppers in a
Mississippi field picking cotton, 1932.
Photograph by Newbell Niles Puckett

Mississippi Power Company, "The More Abundant Life: Open Letter to Mississippians," *The Petal Paper* (Petal, MS), December 4, 1958

The More Abundant Life

Open Letter To Mississippians

The Superintendent of Documents in Washington, D. C., has published a booklet listing 1,800 communities within the United States that have available for sale or lease complete facilities for new industries, many offering financial aid as well as the support of organized groups. Factories vacate or abandon sites for many reasons.

Never before has there been keener competition among towns and cities for added payrolls to boost their local economies. State and local development agencies in the United States spent $40 million last year in an effort to attract new industries. The pressure is so pronounced that in some residential areas near congested centers there are organizations protesting this intensified industrial development which residents strove to escape by building suburban homes.

Restless Americans are definitely on the move - north, south, east and west. It is estimated that ten million of them move annually to some other state.

So the country undergoes many changes, as men and women migrate to more promising locations. The South can eventually attract the lion's share of these homeseekers and industrial establishments and perhaps regain the economic and financial leadership that it held a century ago but lost with the Civil War and Reconstruction.

We should be on the alert to profit from this great migration, to meet face to face the challenges and opportunities that these changing times present, fully realizing that industry and business seek among other things: nearness to markets and raw materials; transportation facilities; ample man and woman power; adequate utilities to provide energy; pleasant living conditions with good schools, churches and recreational advantages; fair taxation and law enforcement; civic consciousness and whole-hearted community support.

All these are essential, but industry also seeks a citizenship sympathetic with its problems in harmonious surroundings. Free enterprise thrives only where there is a good business climate, and men and women are dedicated to the American Way and have faith in its superiority over all other economical and political systems. We cannot endure to prosper half free.

The industrial revival in the South is now in full swing, so these are promising days for Mississippi. Electrified, enlightened and pulling together, its people are on their way to the more abundant life.

Mississippi Power Company

Lonnie Sweatt
Chairman of the Board

General Offices
Gulfport, Miss.

SERVING SOUTHEAST MISSISSIPPI

THE
WEEKLY ECHO
Published Weekly At 2508-5th Street

A Home Paper with a Home Editor, that tells the State news weekly

Mississippi, Standard Negro newspaper of character, circulation and opinion, with more than 10,000 reader

| VOLUME XVII | FRIDAY, MAY 23, 1941 | NUMBER 37 |

GEORGE CARVER WINS HUMANITARIAN AWARD

1,634,000 Negroes Leave South

Colored People Leave Dixie By Hundreds Of Thousands

According to reports by Dr. Samuel A. Stouffer, Professor of Sociology at the University of Chicago, it is estimated that 1,403,000 colored people left the south from 1930 to 1940. He also estimates that from 1920 to 1930, 682,000 Negroes left the south. From 1900 to 1910, 110,000 Negroes left the south. From 1910 to 1920, 439,000 left the south.

According to Professor Stouffer's report, we had one million, six hundred and thirty-four thousand Negroes to migrate from the southern states in forty years. This is practically as many people as we have in the entire state of Mississippi, both colored and white.

The Negroes leaving the south went largely to New York, California, Illinois Michigan, Pennsylvania, Ohio and New Jersey, with about seventy-six thousand of this number going to the border states of Delaware, Maryland, District of Columbia, West Virginia, Kentucky Tennessee and Missouri.

This information appeared in the Birmingham Age Herald of Friday, May 16 Professor Stouffer gives two possible reasons for the Negro's migration; namely, "The Negro has been losing out as compared with whites in southern agriculture and that more wide spread relief in the north was an attraction.

The Weekly Echo is not in position to interpret the meaning of these two reasons. We think that this statement "The Negro has been losing out as compared with whites in southern agriculture" is one that can be interpreted from different angles and the second reason, "that more wide spread relief in the north was an attraction" needs much study. Just what does Dr. Stouffer mean about the Negro Losing Out As compared with the Whites is hard to say. What does he mean when he says that that Wide Spread Relief In The North Was An Attraction?

This great migration has been going on since 1900. From 1900 to 1910, 110,000 Negroes migrated. From 1910 to 1920 439,000 Negroes migrated, which was practically four times as many. From 1920 to 1930 was the greatest decade of migration. If we will study the situation we may note that we hardly knew what Dr. Stouffer meant from 1900 to 1930. If Dr. Stouffer means Relief and Dole such as the government has been handing out for the past five or eight years If the learned Professor means relief from embarrassments, injustices, unequal opportunities, discrimination, poor school facilities, poor housing conditions maltreatment by land owners on farms etc., etc., then we can agree with him that it is RELIEF that the Negro is

SEARCHING for.

Yes, WIDE SPREAD RELIEF is an attraction. The Editor was born and reared in the south and it is heart rendering to think that millions of black people born and reared in the south, their home, are forced to leave their home in order that they might have WIDE SPREAD RELIEF.

The south is not only, as we see it,

selves can get WIDE SPREAD RELIEF Go to most any city in the north or in the east and you will find large numbers of southern white people who have made these sections their home. Young white men and women actually leaving the south and going elsewhere and the Editor of The Weekly Echo, while the Negro consciously migrates for WIDE SPREAD RELIEF we wonder if the southern whites are unconsciously seeking WIDE SPREAD RELIEF or a better country?

This south land of ours is God's great earth. The south land can be as important, as fair, as constructive, as humane as any place in the United States if the south will make it so While on the other hand it can be of such that not only black men and women, but whites as well, will seek WIDE SPREAD RELIEF or A BETTER COUNTRY.

ABOUT FOLK WE KNOW

Mrs. Ellean Matthew of 13th Avenue and 13th Street, is critically ill.

Mrs. Dollie Hardy is still very ill from her home on the Asylum Heights. Her sister, Mrs. Katherine Lee Williams is here from Saxton, Missouri at the bed side of her ill sister.

Mrs. Nancy Collins of West Enterprise an aunt of Mrs. Lula Larkin, passed Tuesday, May 20 from her home in Enterprise.

Mrs. Taylor, mother of Reverend W P. C. Taylor, pastor of the Rose Hill Circuit is in the city for the graduation exercises of the T. J. Harris High School, where her son, Priestly, is finishing

Mrs. M. J. Jones has spent some time at Hattiesburg this week, visiting a sick relative.

Mrs. Nancy Ivy of Muncie, Indiana is in the city visiting relatives and friends. She is grandmother to Mrs Emily Hosley McLamb.

STORK VISITS

The stork visited the home of Mr

STATE NEWS
HBA Lodges News

Waynesboro— Dear Editor: Please allow me space through the columns of the Weekly Echo to let the readers know that lodge No. 474 at Frost Bridge Miss., met on May 18 at which time our Field Agent, Brother W. M. Kinslow was present and installed officers for two years.

Reverend T. H. Johnson of Rose Hill preached a wonderful sermon. He preached from the 55 division of Psalm Subject: "If I had wings like a dove I would fly away and be at rest." Collection for the day was $8.00.

C. L. Howard, President,

Sarah Sims, Secretary.

Enondale, Miss— In the midst of life we are in death. We realized this fact more on the first of May at 5:00 o'clock when the death angel came so steadily in the home of John Gully and took him away. He had been in failing health for about seven months but he kept trying to go in spite of the fact he was steadily growing thinner and weaker but he wanted to support his family as long as he could. He was married to Mary Twilly to this happy union 2 children were born. Brother Gully was a member of Tamola Bethel M. E. Church from early manhood and lived true to his promise. He was a class leader, steward and trustee of his church for many years. He was popular and serviceable in civic life. He became a member of the H. B. A. in 1919, lodge number 64 of which he was elected president and remained president until his death.

The end came as a shock to the whole community, his many friends and relatives. Brother Gully knew and told his family that he was going home. He is sadly missed by all who knew him.

He leaves to mourn his passing, a devoted wife, two daughters, one son twelve grandchildren, five brothers and a host of relatives and friends. He is gone but not forgotten.

West Enterprise— Dear Secretary: This is to inform you of the death of Sister Nancy Collins, a member of the Old Folk Department, Lodge No. 247 Jas. Blanks, Jr., president. Mrs. Collins departed this life, May 20, 1941.

Philadelphia— Please publish the following program through the columns of the Weekly Echo: The ninth anniversary of H.B.A. No. 450 was observed Sunday, May 18. The following program was rendered: Welcome address, Miss Madie Smith; Solo, Velma Spivey; Paper, Mrs. Lillie Seals; Solo, Mrs. Emma Seals; Paper, Mrs. Gennie B. Haynes Solo, Mrs. Nora Wilson; Reading, Bro J. W. Clemon; Reading, A. Hardy; Talk by the Vice President, George Baxton; Solo, Little Miss A. Hardy Talk by President, Mrs. Annie Howze

The following visitors spoke: Rev. W H. Batts, Reverend Kimp, Reverend Davis Chatman, Brother Symon Adams and Brother Elir Seals. Collection for the day was $7.30.

Mrs. L. C. Hardy, Reporter

G. W. Carver Wins The Humanitarian Award
Marian Anderson And Others Share In The Outstanding Awards Of National Significance

—AWARD WINNER—

ATLANTIC CITY, N. J., May 23—For the second time in as many months a member of the race receives a major award of national significance for outstanding contributions to the American way of life. Sunday evening before a large gathering of prominent men and women at a dinner in the Traymore Hotel, Dr. George Washington Carver was presented with the 1940 Humanitarian Award of the Variety Clubs of America. Marian Anderson won the $10,000 Philadelphia Award.

Dr. Carver, world renowned scientist and director of research and experiment at Tuskegee Institute, is the third person to win the award and was chosen by a committee of prominent newspaper editors, magazine publishers, radio commentators and writers.

The winner received a silver plaque a citation and $1,000 in cash for opening new avenues of income to poor Southern farmers by developing new products of commercial value from common farm products, thus creating new business ventures that annually brings many millions of dollars to an impoverished section.

The two other winners of the award were Miss Martha Berry, founder and director of the Berry Schools and College at Mt. Berry, Ga., last year's winner, and Rev. Edward J. Flanagan founder of Boys' Town, Nebr. In 1939 Dr. Carver won the Roosevelt Medal for his contribution to Southern agriculture.

son's home in Columbus, Miss. She was visiting her son, Mr. William Linton when the grim reaper of death summoned her. She was a good, faithful member of Pilgrim Rest Baptist Church. She died in good standing with her church and lodge.

She leaves to mourn, one son, and four grand children. We feel that our loss is heaven's gain. Mrs. Clay will be missed by her many friends and lodge No. 317 also her pastor, Reverend Eddie Harris will miss her from her seat in the church.

Easter Perry, Reporter.

OPENING

The E. F. Young, Jr. Mfg. Company

—AWARD WINNER—

wishes to announce the opening of its new office, Monday May 26, 2418-5th street, annex, Young's Barber and Beauty Shop.

Mr. E. F. Young, Jr., President and Manager

Miss Mary F. Powe, (private) Sec'y to Mr. E. F. Young, Jr;

Mrs. L. M. McCarty, Secretary.

THANKS!..

We wish to express our appreciation and thanks to our many friends and to the members of The Willing Worker Club of Newell Chapel, and to the Cherrio-Home Makers Club for the many useful gifts and the kind favor shown in our distress since our home was recently destroyed by fire.

Mrs. Mary Chillis and Family

Boy Scouts Of America

The Boy Scouts of America, through Dr. James E. West, Chief Executive,

(Continued on page Three)

Federation Members Honored
By Tuskegee Institute

Ruby (Stutts) Lyells

Mrs. J. E. Johnson, Prentiss Institute, Chairman of the Advisory Board, and past President of the Mississippi State Federation of Colored Women's Clubs, Inc., and President of the Southeastern District of the National Association of Colored Women was honored by Tuskegee Institute last week. The Institution of which she is a graduate, in re-

Mrs. L. T. Miller, Yazoo City, Chairman of the Executive Board of the State Federation of Colored Women's Clubs and past President of the State National Federation was named president-elect in the recent annual session of the Women's Auxiliary to the Medical, Dental, and Pharmaceutical Association of Mississippi. This organization is affiliated with the National

tation. Club women all over the State appreciate their connections with women like Mesdames Johnson and Miller.

The honors which have come to them indicate, in a way, the scope of the activities engaged in by Federation Members. Still fresh on the minds of club members as the news of a the

"Any Northern State."

DECATUR, AL, APRIL 25, 1917

Front page of *The Weekly Echo*
(Meridian, MS), May 23, 1941

WHY JIM CROW IS FLYING NORTH

BY W. O. SAUNDERS

(As Published in Collier's, The National Weekly)

(Continued from last week)

The Negro is flocking North to high wages, entering industries that pay him $5 to $10 a day for his work—and pay him in cash. To get North and get these wages and educate his children, he is forsaking a land that too often gives him only a pitiful dole of corn meal and sorghum, declares him a debtor still to the landlord after his work of a year is done, and as a rule provides only a three months' school term for his children.

We southerners have tried to fool ourselves into a belief that the Negro was forsaking the South to flee into a field of industry in which he could not compete. This is not true. The Negro is proving himself a more satisfactory day laborer than the lower class immigrants who have manned many of the more important industries. He is hard, enduring and docile—and he can understand orders given in English. If the Negro had not proved his work as a day laborer the North would not be sending for him and paying his transportation.

Again, we have been fooling ourselves with a lot of talk about the hard conditions confronting the Negro in the North. Our newspapers are full of it. It is mostly twaddle. I have seen Negroes swarming in the most wretched tenements in congested districts in northern cities. But they are not worse than the cabins in which so many of these Negroes lived in the South.

THE WHITE MAN'S WORD

Have you ever seen a typical Negro cabin on a plantation in the Mississippi valley? It is usually only a diminutive board structure of two rooms, in which a family of five, six, eight or more eat and sleep. The common type of these cabins is called a "shotgun house," because of its single-barrel construction. During the hot summer months sleep in one of these cabins is next to impossible. When it rains the water often pours through the roof. I have never seen one of these cabins screened, and only on small farms have I seen windows other than a near-tight wooden shutter. Compared to these, the squalid brick tenements of the North are very mansions in the skies. The roofs of the city tenements do not leak; snakes and lizards and insects do not crawl up through the crevices in the floors.

It is not unusual for an illiterate black man and his family to work for a landowner for a year, growing nothing but cotton. The landlord will permit him to grow no corn because he could steal the corn or appropriate a bit of it for his food. He can have no pig and no poultry because pigs and poultry must have grain or the scraps from a kitchen. There are no scraps from the poor Negro's kitchen.

In a year the Negro tenant may produce 10, 20, 30 or more bales of cotton. He and his wife and children pick this cotton in the fall and carry it to the gin, where it is pressed into bales. The Negro turns the baled product of his labor over to the landlord and awaits a settlement. Sometimes the landlord says at the end of the year: "Well, John, you did pretty good this year; you raised a good crop and you owe me only $40." For a year that Negro and his whole family have toiled and sweated. During this time they have lived on limited rations bought at the commissary owned by the plantation owner. The rations consist almost wholly of sorghum and corn meal. And at the end of the year the Negro is told he is in debt. He cannot challenge the white man's word. He has kept no accounts of his own because he does not know how. He dares not appeal to the law, because the law is the white man's law. He suffers in silence, and when opportunity comes he steals away in the night.

In the North he finds a city that provides a year-round school term for his children, a community center for himself and his wife, a city dispensary to give him drugs when he is sick and penniless, a public-health nurse and hospital care when he needs them and a dozen helpful agencies to which he can turn in emergency.

I have before me a bill of complaint drawn up by Negroes in a mass meeting in Jackson, Miss., on May 1, 1923, giving the reasons why they are leaving the South. It starts with the statement that "the Negro feels that life is not safe in Mississippi, and his life may be taken with impunity at any time by a white man. * * * The Negro has generally despaired of obtaining his rights as a citizen in this section."

The document goes on to particularize, laying emphasis upon the fact of his lack of education and uplift opportunities. He complains of the fact that for every $20 spent for the education of white children in the state only $1 is spent for the education of the Negroes; of the 800 consolidated schools in Mississippi, all are for whites; of 50 and odd agricultural schools for whites, there is not one for Negroes; and there is not a dollar for the tubercular, for the feeble-minded, for the blind or for the derelict Negro youth, though millions are spent on whites.

The complaints made by the Negroes of Mississippi are typical of the complaints made by Negroes in other southern states. They are all too true. And yet one seldom hears mention of the Ku Klux Klan by the Negro. The Kluckers are the least of his troubles. The fact of organized mobs arrayed in night gowns and pillow cases makes little difference to him. He was lynched before the night shirt and the pillow case were thought of. Only the better class of Negroes are particularly alarmed over the Ku Klux. The better class of Negroes see in the organization a sinister agency further to estrange the whites and the blacks in the South and prevent racial adjustments. I may come to that later.

I have indicated the immediate effect of this wholesale exodus of southern Negroes upon the agriculture of the South. What, then, of its effect upon the North? What of its effect upon the moral, social and economic progress of the Negro in America? These are questions which America must face squarely and at once if the peace of the nation and the personality of the Afro-American is to be preserved. The North is temporarily profiting by the shift of Negro labor. But the North is finding itself with a race problem in its hands that is as alarming as the race problem of the Potomac.

WITH RULES REVERSED

The Negroes attracted to the North in this and recent years are largely from the lowest classes. They are illiterate, happy-go-lucky, highly emotional, highly gregarious and grossly ignorant. They have been fed upon wild tales of equality, and they enter the cities of the North wild to experience hitherto unknown freedom and social privileges. The unschooled Negro fresh from the South in his new surroundings is exploited by machine politicians, who make him extravagant promises which they never intend to fulfill. In the South a white man may hate the Negro as a class, but he will put himself out to befriend an individual Negro. In the North white men profess a great interest in the uplift of the Negro as a class, but ignore the individual. In the North his children may sit side by side with white children in public schools, but he and his wife are shoved aside as rudely in white hotels, theaters and restaurants as in the South. He finds his life in the North more confusing than in the South. He has been led to believe that the attitude of the North is more broad and tolerant toward the Negro than is the attitude of the South. He finds that this is far from being true—and the North hasn't had enough experience with the Negro to know exactly how to receive him and place him. Left to himself, he will work out a place for himself; fanatical leaders often misdirect his energies and inflame his imagination.

The race problem is no longer a local problem left to the South to solve in its own way; it is a problem for the metropolitan centers of the North, and if I mistake not the signs and temper of the time the North will shed blood over the problem if it does not interest itself immediately.

EXCERPT

"The Outer Pocket"

Lue Ella Pennington

The Crisis 29, no. 5 (March 1924): 222

Louisville, Alabama—I am a little Southern Negro girl. I am thirteen years of age. I want to write you the story of Southern life. My mother was reared in the South. And also my grandmother too. I have often heard my grandmother tell of her mother's home in South Carolina, where she was stolen and brought here as a slave; how my grandmother was sold from her mother. Her and her twin brother was taken away from each other when they was nine years of age. It was twenty years before they ever met again. When they met again, she said they went down on bended knees and prayed together to never be separated again in life; that their children might grow up to be a successful race. My grandmother is dead and also my great uncle. My grandmother has seventy-five grandchildren and great grandchildren. My uncle's family is here in the South. When my mother first started to schools he had to go to a white teacher. When she begin to learn so fast the teacher begin to find fault of her. And so her brother that was raised in the house with the white people he had a very good learning. He would teach my mother. Sometime the white people would not want them to have no books but through the help of God there was a way provided for them and so I believe it was the Lord who has brought us safe this far. So I will close this. Will write more next time of Southern life. My name is Lue Ella Pennington.

W. O. Saunders, "Why Jim Crow is Flying North," *Chicago Defender*, December 29, 1923

"The Observation Post: White Southerners Now Moving North"

David Ward Howe

Chicago Defender (national edition), June 17, 1939

A report outlining economic conditions in the rural areas of the South has just been issued by the Division of Social Research of the Works Progress Administration. The report presents detailed information indicating the comparative status of the races and is well worth reading.

Among the many interesting and significant problems analyzed in this report is the problem of migration: The report discloses that contrary to the general opinion "rural families of the Race were found to be more stable than their white neighbors." According to the report, the depression migrants are for the most part white persons, and there are three to five times as many whites as Race persons among "depression migrants."

"White House, Biddle Deny Plan To Restrict Migration"

Jackson Advocate (Jackson, MS), August 21, 1943

Roosevelt Spokesman Says F.D.R. Has Not Received Suggestion

Washington, D.C.–(ANP)—A denial by a White House spokesman that such had been received and by Attorney Francis Biddle himself that he opposed preventing the free movement of individuals from place to another, whether Negro or white, complicated charges last week that Biddle had recommended to President Roosevelt that Negro migration to many northern communities [be] halted because of the Detroit race riot and increasing racial tension in other large urban areas.

The Attorney General's denial was disclosed in an exchange of letters with Lester Granger, National Urban League secretary, and released Friday.

"I do not think that any effort should be made to prevent the free movement of individuals from one place to another, whether Negro or white, except as war requirements for manpower must be met," said Biddle in the statement. "The whole problem seems to be one which requires careful study and research before any program can be worked out, and particularly a study by those private organizations which are devoted to Negro warfare."

Following publication by the *New York Post* early last week that in a special report to President Roosevelt on the Detroit riot the attorney general had recommended, among other things, that Negro migration into certain industrial areas be limited or halted, "due to the inability of colored migrants to be absorbed by the community because of their physical limitations or cultural background," the White House issued a categorical denial that such a memorandum had ever been received.

However, before the *Post* exposed the matter, it was common talk among inner Washington circles that such a communication had been sent to the President under the date of July 15 or over the signature of Francis Biddle, the attorney general.

EXCERPTS

Southern Journey: The Migrations of the American South 1790–2020

Edward L. Ayers

Selections from Section 2: "The Restless South, 1860–1940," 51–53, 57–59, 64. Baton Rouge: Louisiana State University Press, 2020

A New South

Pushed and pulled by deep and rapid changes, the rural people of the South moved repeatedly after 1880. More than half of all tenants moved every year, and farm laborers moved from one season to the next. White tenants and laborers moved even more often than their Black counterparts. High birthrates filled tenant shacks and farmhouses.

The migrations of the New South were purposeful but not as coordinated as they had been in the slave South. State-sponsored lotteries of indigenous lands no longer existed, nor did slave traders working to distribute African American people exactly where the market demanded, though labor agents recruited men and women to work in some of the more isolated places. Railroads reached into some remote areas, creating towns and markets where they had not existed before. Logging companies bought land, stripped it of its trees, and abandoned the used-up acreage. Black and white families followed, trying to benefit from the dislocations and newly cleared land. Manufacturing pulled in ever more people to textile factories and mill villages.[1]

Towns and cities replaced rural settlement as the engines of growth. Those places drew people out of the country, either as refugees from dismal rural areas or as ambitious seekers of new opportunities. Once people of either race moved to a town, they were unlikely to return; young people left the countryside more frequently than their elders.

Across the South, towns of fewer than 2,500 people doubled in the 1870s and then doubled again by 1900, when more than 1.2 million people lived in two thousand such communities. More than 90 percent of southerners by 1890 lived in a county crossed by a railroad, altering the rhythms of daily life and transforming agriculture, industry, and politics. The cities of the South grew as fast as those of the North and West, two of the most rapidly urbanizing places in the world.

Railroads extended the reach of a new cotton empire far beyond the cotton kingdom of slavery. By 1891, the South grew twice as much cotton as it had in 1861. The rail lines brought in guano, fertilizer that allowed the plants to flourish where before they would not grow profitably. Landlords demanded that sharecroppers, Black and white, grow only cotton; their food would be purchased, on credit, at a plantation store. Landowners and merchants wrung all they could from white and Black farmers alike, deploying expensive credit, liens, mortgages, and high prices at stores.[2]

The harder southern farmers, Black and white, worked—the more cotton they planted, picked, ginned, baled, and shipped—the further they fell behind. The price of cotton relentlessly declined, from twenty-four cents in 1870 to seven cents in 1894. The South's near monopoly of cotton had been sacrificed during the Civil War; now, India and Egypt offered laborers paid even less than those in the American South. Consumers around the world drove prices lower as millions of them purchased inexpensive cotton clothing from burgeoning suppliers. Global demand doubled between 1860 and 1890 and then doubled again by 1920.[3]

Driven by the same machinery of transportation, communication, and commerce that powered other settler societies, including the North, the South became a failed settler society whose essential ingredient—a commodity to sell on the world market—suffered falling prices and overproduction. Black southerners barely had a chance. Without the advantages enjoyed by white southerners before emancipation—inexpensive land, easy credit, and high prices for cotton—former slaves and their descendants struggled. They could not establish farms even though they shared the ideal of household autonomy that had driven the South's original settler society. The federal government did not support Black farmers as it had white farmers in the South nor as it was then doing with white farmers in the West.

Farms shrank as rural districts became crowded through natural increase and as parents divided acreage among children. The open range on which farmers had relied disappeared; laws declared that hogs and cattle now had to be fenced in and kept out of other people's fields. Fertilizer, seed, work animals, and implements became expensive necessities. Pushed ever more intensively, farms suffered from eroded soil, cut-over woods, and abandoned fields. White tenancy spread like a cancer.[4]

Black migration responded quickly to both constraint and possibility. In the 1870s, when a massive depression wracked the region and the nation, Black people moved in great numbers to the upper Piedmont of South Carolina and Georgia, where cotton grew in new fields. Others migrated to a strip of Alabama's Black Belt connected to markets by new railroads. The largest numbers of African American migrants traveled to the Mississippi Delta and the plantation districts of Arkansas

and Louisiana as the dislocations of war faded and the richest soil in the nation beckoned.[5]

Some Black southerners banded together to establish their own communities through migration. Most famously, the "Exodusters," fired by religious belief as well as a determination to escape the violence and intimidation of the post-Reconstruction South, organized a mass migration to Kansas from Mississippi River districts. Tens of thousands of men, women, and children made the move in the decade after 1879, many of them going to the cities and others to the uplands of Kansas, the only land they could afford. At the same time, Black people formed independent communities in Texas, Florida, and the Indian Territory. Thousands of Black southerners dreamed of moving to Africa to build new lives for themselves, contributing money and organizing support for a large effort soon smothered by opposition and lack of resources.[6]

The future state of Oklahoma witnessed the history of the New South in especially concentrated form. After the Civil War, the federal government punished the Native peoples who had aligned with the Confederacy. The members of the Five Tribes—Cherokees, Choctaws, Chickasaws, Creeks, and Seminoles—were forced to relinquish their land rights to various railroad companies. Their territory also took on a new name, Oklahoma, " red people" in the language of the Choctaws. The federal government forced them to give up the practice of shared land and settle on individual allotments. Year after year, land originally reserved for Native peoples was taken until only a small portion of the territory remained in their hands.

White officials and reformers worked to dissolve tribal bonds and make American Indians into independent citizens. Over several decades and after a series of legal decisions, tribal identity and sovereignty shifted from a focus on the land the people occupied to their membership in a particular Native nation. This transition alienated American Indians from their land even as it made their bodies the vehicles of their identity—a particularly dangerous development in the time when legal racial segregation gripped the South and overt racial prejudice filled the nation. White southerners viewed anyone claiming Native identity with misgivings, suspecting that they were actually "colored" by association with African Americans. Claiming membership in a tribe, nevertheless, granted some security as a citizen as well as claims to any tribal property. American Indians found strong incentives to maintain this identity. Tribes began keeping rolls of those recognized as tribal citizens, though

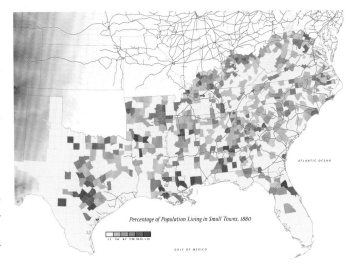

Percentage of Population Living in Small Towns, 1880

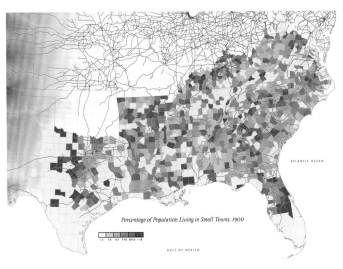

Percentage of Population Living in Small Towns, 1900

Top: Percentage of population living in small towns, 1880. Across the entire South, in areas long settled and recently settled, people move to hamlets and towns along the new railroads.

Bottom: Percentage of population living in small towns, 1900

practices varied and generated conflict among American Indians and with white officials and claimants.

As decades passed, confusion and uncertainty persisted. Though many Native peoples had roots in the South and lived and moved within the region, they could not be counted or mapped in consistent ways. The displacement and erasure of Native communities in the settler-slave society of the early nineteenth century continued under a different guise at the beginning of the twentieth. As in the earlier displacement, though, legal removal did not remove actual people. Native southerners did not disappear, even if they remained invisible to white people. American Indians used their extended families, flexible gender roles, separate

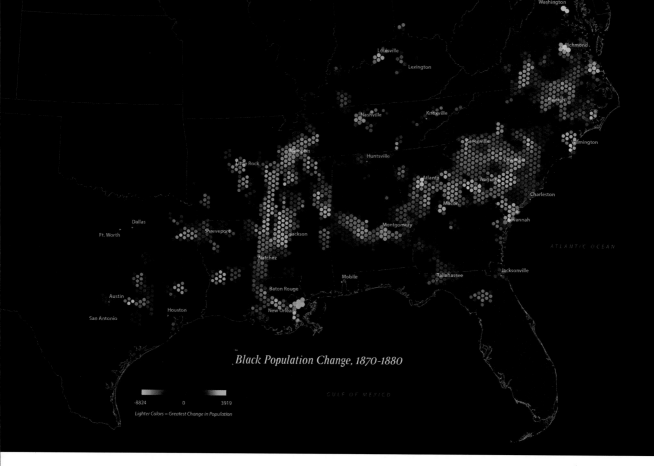

Black Population Change, 1870-1880

-8824 0 3919

Lighter Colors = Greatest Change in Population

Christian churches, and movement itself to sustain their tribal identities.[7]

In 1889, land in the Oklahoma Territory was thrown open to white settlement, and by 1890, white people numbered more than 128,000 residents, far greater than the 50,000 Natives living there. Eastern Oklahoma attracted white migrants from Arkansas, Missouri, and Texas. The rest of Oklahoma filled with a mix of migrants from the Midwest and Upper South.[8]

Black settlers accounted for about 10 percent of the non-Native population in Oklahoma, many of them settling in "all-Black" communities established earlier by railroad companies in the Indian Territory. Some formerly enslaved people of the region took advantage of the racial complexity of Oklahoma to move among Black, Native, and white communities. More than 100,000 Black people moved to Oklahoma between 1890 and 1910 but found their ambitions frustrated when the legislators of the new state instituted racial segregation as one of their first acts. Thousands of African American settlers in Oklahoma explored moving to Africa.[9]

Elsewhere in the South, the movement to cotton districts slowed and narrowed in the 1880s, as African Americans sought new opportunities for logging and turpentining in other regions and work in towns and cities, but accelerated again in the 1890s. Black people pushed into lands that had been cut over for lumber and now were offered at cheap prices that poorer people of both races might afford: the wiregrass regions of Georgia and Florida, the lowlands of Mississippi and Louisiana, and the piney woods across the lower parts of the Gulf states. Black farmers were also able to take advantage of low land prices in the Upper South as white people left. About half the Black farmers in those states managed to acquire at least some land, their numbers growing until 1910.[10]

Notes

1. I have detailed the events and transformations of the New South in *The Promise of the New South: Life after Reconstruction* (New York: Oxford University Press, 1993). For more on railroads, see R. Scott Huffard Jr., *Engines of Redemption: Railroads and the Reconstruction of Capitalism in the New South* (Chapel Hill, NC: University of North Carolina Press, 2019).

2. Louis A. Ferleger and John D. Metz, *Cultivating Success in the South: Farm Households in the Postbellum Era* (Cambridge, UK: Cambridge University Press, 2014); Michael Wayne, *The Reshaping of Plantation Society: The Natchez District, 1860–1880* (Baton Rouge, LA: Louisiana State University Press, 1983), 45; Steven Hahn, *The Roots of Southern Populism: Yeoman Farmers and the*

Above: Black population change, 1870–1880. Even as political turmoil tears at the South during Reconstruction and its aftermath, Black southerners seek out places where they might find safety in numbers in the most productive farming areas of the cotton South and in cities and towns.

Transformation of the Georgia Upcountry, 1850–1890 (New York: Oxford University Press, 1983).

3. Sven Beckert, *Empire of Cotton: A Global History* (New York: Alfred A. Knopf, 2015), 278, 311.

4. Erin Steward Mauldin, *Unredeemed Land: An Environmental History of Civil War and Emancipation in the Cotton South* (New York: Oxford University Press, 2011), 6–12.

5. See John C. Willis, *Forgotten Time: The Yazoo-Mississippi Delta after the Civil War* (Charlottesville: University Press of Virginia, 2000), 7–11; James C. Cobb, *The Most Southern Place on Earth: The Mississippi Delta and the Roots of Regional Identity* (New York: Oxford University Press, 1992); Brian D. Page, "'In the Hands in the Lord': Migrants and Community Politics in the Late Nineteeth Century," in *An Unseen Light: Black Struggles for Freedom in Memphis, Tennessee,* ed. Aram Goudsouzian and Charles W. McKinney Jr. (Lexington, KY: University Press of Kentucky, 2018), 13–38.

6. Nell Irvin Painter, *Exodusters* (New York: W. W. Norton, 1976); James H. Conrad, *Freedom Colonies: Independent Black Texans in the Time of Jim Crow* (Urbana, IL: University of Illinois Press, 2005); Steven Hahn, *A Nation under Our Feet: Black Political Struggles in the Rural South from Slavery to the Great Migration* (Cambridge, MA: Harvard University Press, 2003). Ikuko Asaka points out, "As commonwealth settler societies steadily built themselves up into 'white men's countries,' the United States went through the final phase of western continental expansion without according African Americans equal access to its attendant material benefits or the symbolic status of the upwardly mobile frontier settler." *Tropical Freedom: Climate, Settler Colonialism, and Black Exclusion in the Age of Emancipation* (Durham, NC: Duke University Press, 2017), 24.

7. For powerful accounts of these struggles, see Mikaela M. Adams, *Who Belongs? Race, Resources, and Tribal Citizenship in the Native South* (New York: Oxford University Press, 2016); Gina Caison, *Red States: Indigeneity, Settler Colonialism, and Southern Studies*

(Athens, GA: University of Georgia Press, 2018); Rose Stremlau, *Sustaining the Cherokee Family: Kinship and the Allotment of an Indigenous Nation* (Chapel Hill, NC: University of North Carolina Press, 2011); Katherine M. B. Osburn, *Choctaw Resurgence in Mississippi: Race, Class, and Nation Building in the Jim Crow South, 1830–1977* (Lincoln, NE: University of Nebraska Press, 2014); and Christopher Arris Oakley, *New South Indians: Tribal Economics and the Eastern Band of Cherokee in the Twentieth Century* (Knoxville, TN: University of Tennessee Press, 2018).

8. Michael J. Hightower, *1889: The Boomer Movement, the Land Run, and Early Oklahoma City* (Norman, OK: University of Oklahoma Press, 2018); Michael F. Doran, "Population Statistics of Nineteenth-Century Indian Territory," *Chronicles of Oklahoma* 53 (1975–76): 494–515.

9. Kendra T. Field, "'No Such Thing as Stand Still': Migration and Geopolitics in African American History," *Journal of American History* 102 (December 2015): 693–718; Field, *Growing Up with the Country: Family, Race, and Nation after the Civil War* (New Haven, CT: Yale University Press, 2018).

10. See Debra A. Reid and Evan P. Bennett, eds., *Beyond Forty Acres and a Mule: African American Landowning Families since Reconstruction* (Gainesville: University Press of Florida, 2012); and Robert C. Kenzer, *Enterprising Southerners: Black Economic Success in North Carolina, 1865–1915* (Charlottesville, VA: University Press of Virginia, 1997).

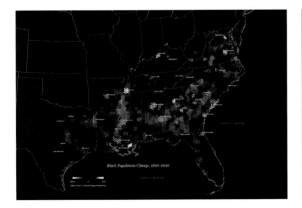

Black population change, 1890–1900. Black southerners push farther west and south even as others move to cities, especially Birmingham, New Orleans, and Memphis. Many Black people leave the Upper South, sometimes for cities in the Midwest and Northeast.

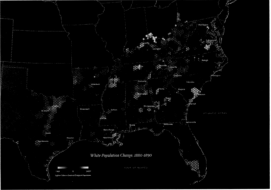

White population change, 1880–1890. In a virtual reverse of Black movemen, white southerners flee old plantation districts for the new lands of Texas and Arkansas and the old lands of the upland South.

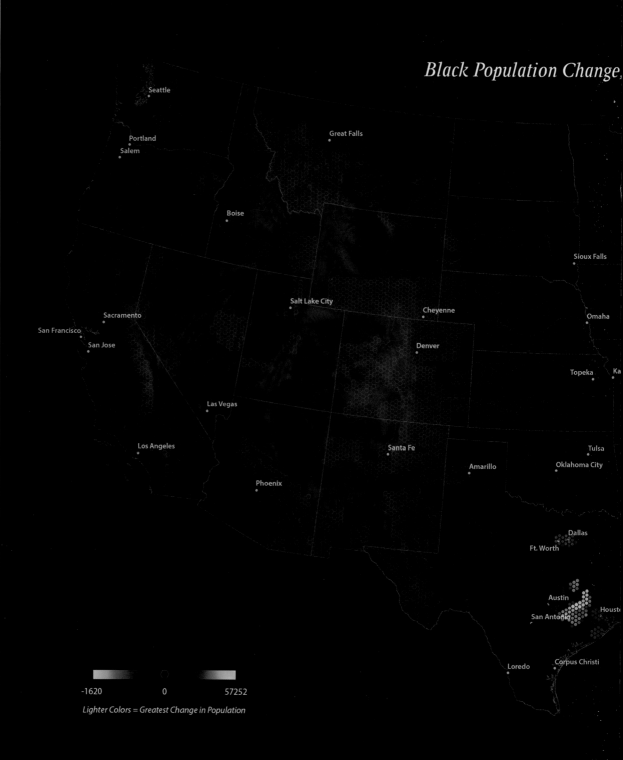

Black Population Change,

Seattle

Portland
Salem

Great Falls

Boise

Sioux Falls

Salt Lake City

Cheyenne

Omaha

Sacramento

San Francisco
San Jose

Denver

Topeka Ka

Las Vegas

Los Angeles

Santa Fe

Tulsa

Amarillo

Oklahoma City

Phoenix

Dallas
Ft. Worth

Austin

Houst
San Antonio

Loredo

Corpus Christi

-1620 0 57252

Lighter Colors = Greatest Change in Population

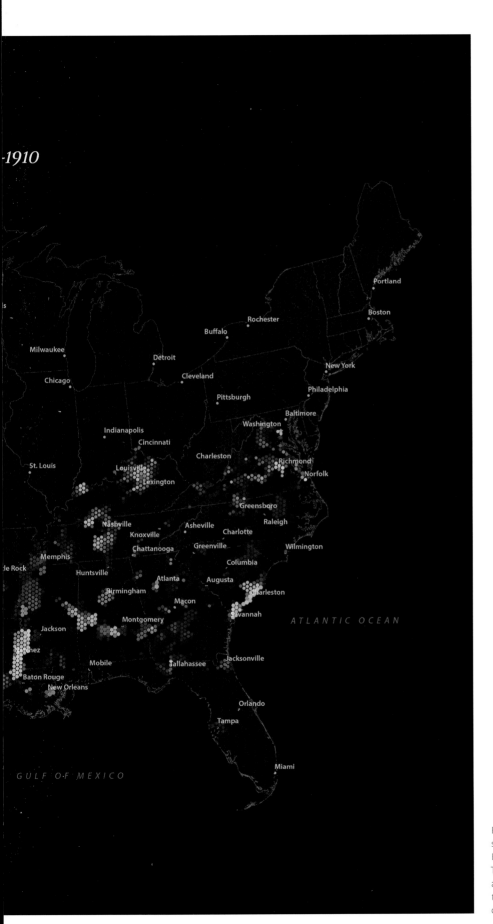

-1910

Black population change, 1900–1910. Black southerners abandon large parts of the Black Belt, the Mississippi Valley, western Tennessee, and the plantation districts along the Atlantic in the decade before the Great Migration, moving to southern cities as well as the Mississippi-Yazoo Delta.

EXCERPTS

The Philadelphia Negro:
A Social Study

W. E. B. Du Bois

Philadelphia: University of Pennsylvania Press, 1899

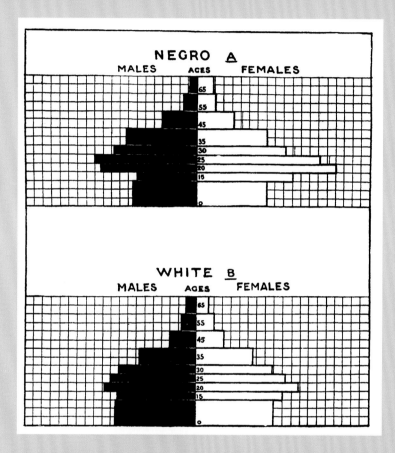

We find then in Philadelphia a steadily and, in recent years, rapidly growing Negro population, in itself as large as a good-sized city, and characterized by an excessive number of females and of young persons.

*

The Seventh Ward, 1896.—We shall now make a more intensive study of the Negro population, confining ourselves to one typical ward for the year 1896. Of the nearly forty thousand Negroes in Philadelphia in 1890, a little less than a fourth lived in the Seventh Ward, and over half in this and the adjoining Fourth, Fifth and Eighth Wards:

Ward.	Negroes.	Whites.
Seventh	8,861	21,177
Eighth	3,011	13,940
Fourth	2,573	17,792
Fifth	2,335	14,619

The distribution of Negroes in the other wards may be seen by the accompanying map:

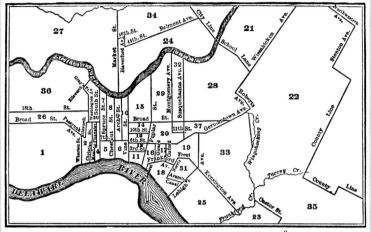

WARDS OF PHILADELPHIA, WITH NEGRO POPULATION, 1890.

1st Ward	794	7th Ward	8861	13th Ward	539	18th Ward	1	23d Ward	1026	28th Ward	641	33d Ward	190
2d "	522	8th "	3011	14th "	1379	19th "	275	21th "	930	29th "	1476	31th "	1073
3d "	861	9th "	497	15th "	1751	20th "	1333	25th "	260	30th "	1789	35th "	Added
4th "	2573	10th "	798	16th "	104	21st "	93	26th "	1375	31st "	16	36th "	since
5th "	2335	11th "	11	17th "	124	22d "	1798	27th "	2077	32d "	382	37th "	1890.
6th "	125	12th "	338										

*

The question of illiteracy is a difficult one to have answered without actual tests, especially when the people questioned have some motives for appearing less ignorant than they actually are. The figures for the Seventh Ward, therefore, undoubtedly understate the illiteracy somewhat; nevertheless the error is not probably large enough to deprive the figures of considerable value, and compared with statistics taken in a similar manner they are probably of average reliability.[†] Of 8,464 Negroes in the Seventh Ward the returns show that 12.17 per cent are totally illiterate. Comparing this with previous years we have:

1850 44 per cent.	1890 18 per cent.	[††]
1856 45½ "	1896 (7th Ward) 12.17 "	7
1870 22 "		

[†] As has before been noted, the Negroes are less apt to deceive deliberately than some other peoples. The ability to read, however, is a point of pride with them, and especial pains was taken in the canvass to avoid error; often two or more questions on the point were asked. Nevertheless all depended in the main on voluntary answers.

[††] This looks small and yet it probably approximates the truth. My general impression from talking with several thousand Negroes in the Seventh Ward is that the percentage of total illiteracy is small among them.

*

The large number of young people in the Seventh Ward probably brings the average of illiteracy below the level of the whole city. Why this is so may be seen if we take the illiteracy of four age-classes:

Age.	Read and Write.	Read.	Illiterate.
Youth, 10 to 20 years of age	94%	2%	4%
Men and women, 21 to 30 years of age . .	90	6	4
Men and women, 31 to 40 years of age .	77	6	17
Men and women, over 40 years of age . .	61	10	29

The same difference is plain if we take the returns of the census of 1890 for the colored population of the whole city:

Age.	Illiterate Males.	Illiterate Females.	Total Illiterates.
10 to 19	138	216	354
20 to 34	836	1,096	1,932
35 to 44	1,098	1,571	2,669
45 and over	334	775	1,109
Total (including those of unknown age)	2,450	3,719	6,169
	Males.	Females.	Colored Persons.
Population over 10	15,981	18,266	34,247
Per cent of total illiteracy	15%	21%	18%

*

Separating those in the Seventh Ward by sex, we have this table, showing a total illiteracy of 10 per cent among the males and 17 per cent among the females:

ILLITERACY BY SEX AND BY AGE PERIODS.—SEVENTH WARD.										
	Males.					Females.				
Sex—Ages.	Total.	Read and Write.	Read.	Wholly Illiterate.	Unknown.	Total.	Read and Write.	Read.	Wholly Illiterate.	Unknown.
Youth, 10 to 20 years .	550	514	10	13	13	792	730	16	38	8
Post-bellum men, (born since 1865), 21 to 30 years . . .	1,396	1,229	45	61	61	1,492	1,283	55	116	38
Men of war time (born between 1855 and 1866), 31 to 40 years	978	784	40	111	43	1,032	697	84	211	40
Freedmen (born before 1856), over 40 years	887	625	63	181	18	1,101	558	136	381	26
Of unknown age . .	120	12	1	3	104	116	24	2	4	86
Total	3,931	3,164	159	369	230	4,533	3,292	293	750	198

Granting that those reporting themselves as able to read should in most cases be included under the illiterate, and that therefore the rate of illiteracy in the Seventh Ward is about 18 per cent, and perhaps 20 per cent for the city, nevertheless the rate is, all things considered, low and places the Philadelphia Negroes in a position not much worse than that of the total population of Belgium (15.9 per cent), so far as actual illiterates are concerned.[†]

† The Seventh Special Report of the United States Commissioner of Labor enables us to make some comparison of the illiteracy of the foreign and Negro Populations of the City:

Nationalities.	Persons able to Read and Write.		Illiterates.		Comparison of Illiteracy.
Italians, 1894	1396	36.37 p. c.	2442	63.63 p. c.	
Russians, 1894 . . .	1128	58.08 "	814	41.92 "	
Poles, 1894	838	59.73 "	565	40.27 "	
Hungarians, 1894 . .	314	69.16 "	140	30.84 "	
Irish, 1894	541	74.21 "	188	25.79 "	
Negroes, 7th W., 1896	6893	81.44 "	1571	18.56 "	
Germans, 1894 . . .	451	85.26 "	78	14.74 "	

The foreigners here reported include all those living in certain parts of the Third and Fourth Wards of Philadelphia. They are largely recent immigrants. The Russians and Poles are mostly Jews. — ISABEL EATON.

*

What do the mass of the Negroes of the city at present do for a living, and how successful are they in those lines? And in so far as they are successful, what have they accomplished and where they are inefficient in their present

sphere of work, what is the cause and remedy? These are the questions before us, and we proceed to answer the first in this chapter, taking the occupations of the Negroes of the Seventh Ward first, then of the city in a general way, and finally saying a word as to the past.

Occupations in the Seventh Ward.—Of the 257 boys between the ages of ten and twenty, who were regularly at work in 1896, 39 per cent were porters and errand boys; 25.5 per cent were servants; 16 per cent were common laborers, and 19 per cent had miscellaneous employment. The occupations in detail are as follows:†

```
Total population, males 10 to 20  . . . . 651
Engaged in gainful occupations  . . . . 257
                                         ====

Porters and errand boys . . . . . . . 100      39.0 per cent.
Servants . . . . . . . . . . . . . . 66        25.5    "
Common laborers . . . . . . . . . . 40         16.0    "
Teamsters . . . . . . . . . . . . . 7
Apprentices . . . . . . . . . . . . 6
Bootblacks . . . . . . . . . . . . 6
Drivers . . . . . . . . . . . . . . 5
Newsboys . . . . . . . . . . . . . 5
Peddlers . . . . . . . . . . . . . 4
Typesetters . . . . . . . . . . . . 3
Actors . . . . . . . . . . . . . . 2
Bricklayers . . . . . . . . . . . . 2
Hostlers . . . . . . . . . . . . . 2
Typewriters . . . . . . . . . . . . 2
Barber, bartender, bookbinder, factory
   hand, rubber-worker, sailor, shoe-
   maker—one each . . . . . . . 7
                                    — 51       19.5    "
                                    257        100  per cent.
```

† The returns as to occupations are on the whole reliable. There was in the first place little room for deception, since the occupations of Negroes are so limited that a false or indefinite answer was easily revealed by a little judicious probing; moreover there was little disposition to deceive, for the Negroes are very anxious to have their limited opportunities for employment known; thus the motives of pride and complaint balanced each other fairly well. Some error of course remains: the number of servants and day-workers is slightly understated; the number of caterers and men with trades is somewhat exaggerated by the answers of men with two occupations: e.g., a waiter with a small side business of catering returns himself a caterer; a carpenter who gets little work and makes his living largely as a laborer is sometimes returned as a carpenter, etc. In the main the errors are small and of little consequence.

*

Of the men twenty-one years of age and over, there were in gainful occupations, the following:

```
In the learned professions . . . . . . 61        2.0 per cent. ††
Conducting business on their own ac-
   count . . . . . . . . . . . . . 207           6.5    "
In the skilled trades . . . . . . . . 236        7.0    "
Clerks, etc. . . . . . . . . . . . 159           5.0    "
Laborers, better class . . . . . . 602
Laborers, common class . . . . . 852
                                  — 1454          45.0   "
Servants . . . . . . . . . . . . . 1079          34.0   "
Miscellaneous . . . . . . . . . . 11             .5     "
                                   3207           100 per cent.
   Total male population, 21 and over . . . . . 3850.²
```

†† A more detailed list of the occupations of male Negroes, twenty-one years and over, living in the Seventh Ward in 1896 as follows:

Entrepreneurs.

Caterers	65	Employment Agents	3
Hucksters	37	Lodging House Keepers	3
Proprietors Hotels and Restaurants	22	Proprietors of Pool Rooms	3
		Real Estate Agencies	3
Merchants: Fuel and Notions	22	Job Printers	3
Proprietors of Barber Shops	15	Builder and Contractor	1
Expressmen owning outfit	14	Sub-landlord	1
Merchants, Cigar Stores	7	Milk Dealer	1
Merchants, Grocery Stores	4	Publisher	1
Proprietors of Undertaking Establishments	2		——
			207

In Learned Professions.

Clergymen	22	Dentists	3
Students	17	Editors	1
Teachers	7		——
Physicians	6		61
Lawyers	5		

In the Skilled Trades.

Barbers	64	Apprentice	1
Cigar Makers	39	Boilermaker	1
Shoemakers	18	Blacksmith	1
Stationary Engineers	13	China Repairer	1
Bricklayers	11	Cooper	1
Printers	10	Cabinetmaker	1
Painters	10	Dyer	1
Upholsterers	7	Furniture Polisher	1
Carpenters	6	Gold Beater	1
Bakers	4	Kalsominer	1
Tailors	4	Locksmith	1
Undertakers	4	Laundryman (steam)	1
Brickmakers	3	Paper Hanger	1
Framemakers	3	Roofer	1
Plasterers	3	Tinsmith	1
Rubber Workers	3	Wicker Worker	1
Stone Cutters	3	Horse Trainer	1
Bookbinders	2	Chemist	1
Candy Makers	2	Florist	1
Chiropodists	2	Pilot	1
Ice Carvers	2		——
Photographers	2		236

Clerks, Semi-Professional and Responsible Workers.

Messengers	33	Policemen	5
Stewards	31	Sextons	4
Musicians	20	Shipping Clerks	3
Clerks	18	Dancing Masters	3
Agents	15	Inspector in Factory	1
Clerks in Public Service	8	Cashier	1
Managers and Foremen	6		——
Actors	6		159
Bartenders	5		

Servants.

Domestics	582	Nurses	2
Hotel Help	457		——
Public Waiters	38		1079

Laborers (Select Class).

Stevedores	164	China Packers	14
Teamsters	134	Watchmen	14
Janitors	94	Drivers	12
Hod Carriers	79	Oyster Openers	4
Hostlers	44		——
Elevator Men	22		602
Sailors	21		

This shows that three-fourths of the male Negroes ten years of age and over in gainful occupations are laborers and servants, while the remaining fourth is equally divided into three parts: one to the trades, one to small business enterprises, and one to professional men, clerks, and miscellaneous employments.

Turning now to the females, ten to twenty years of age, we have:

Housewives	38	4.5	per cent.
At work [3]	289	36.5	"
At school	333	42.0	"
At home, unoccupied, etc.	133	17.0	"
Total female population 10–20	793	100	per cent.

[3] This includes 12 housewives who also work.

Of the 289 at work there were:

In domestic service 211	73.0	per cent.
Doing day's work 32	11.0	"
Dressmakers and seamstresses. 16	5.5	"
Servants in public places 12	4.3	"
Apprentices 6		
Musicians 4		
Teachers 3		
Clerks 2		
Actresses 2		
Hairdressers 1		
— 18	6.2	"
289	100	per cent.

Taking the occupations of women twenty-one years of age and over, we have:

Domestic servants 1262	37.0	per cent.
Housewives and day laborers 937	27.0	"
Housewives 568	17.0	"
Day laborers, maids, etc. 297	9.0	"

Laborers (Ordinary).

Common Laborers 493	Casual Laborers 12	
Porters 274	Miscellaneous Laborers 4	
Laborers for City 47		—
Bootblacks 22		852

Miscellaneous.

Rag Pickers 6	Prize Fighter 1	
"Politicians" 2		
Root Doctors 2		11

In skilled trades 221	6.0	per cent.
Conducting businesses 63	2.0	"
Clerks, etc. 40	1.0	"
Learned professions 37	1.0	"
3425	100	per cent.
Total female population 21 and over 3740. [4]		

[4] A more detailed list of the occupations of female Negroes, twenty-one years of age and over, living in the Seventh Ward in 1896, is as follows :

Entrepreneurs.

Caterers 18	Undertakers 3
Restaurant Keepers 17	Child-Nursery Keepers 3
Merchants 17	—
Employment Agents 5	63

Learned Professions.

Teachers 22	Students 7
Trained Nurses 8	—
	37

Skilled Trades.

Dressmakers 204	Manicure 1
Hairdressers 6	Barber 1
Milliners 3	Typesetter 1
Shrouders of Dead 4	—
Apprentice 1	221

Clerks, Semi-Professional and Responsible Workers.

Musicians 12	Matrons 2
Clerks 10	Actress 1
Stewardesses 4	Missionary 1
Housekeepers 4	
Agents 3	40
Stenographers 3	

Laborers, etc.

Housewives and Day Workers . 937	Janitresses 22
Day Workers 128	Factory Employe 1
Public Cooks 72	Office Maids 12
Seamstresses 48	—
Waitresses in Restaurants, etc. 14	1234

Servants.

Domestic Servants 1262	

Leaving out housewives who do no outside work and scheduling all women over twenty-one who have gainful occupations, we have:

Professions	37
Working on own account	63
In trades	221
Clerks and agents, etc.	40
Day workers, janitresses, seamstresses, cooks, etc.	1234
Servants	1262
	2857

*

Disease/Death Rate per 100,000, 1891–1896

Disease.	Death Rate per 100,000, 1891–1896.
Consumption	426.50
Diseases of the nervous system	307.63
Pneumonia	290.76
Heart disease and dropsy	172.69
Still and premature births	210.12
Typhoid fever	44.98

Death Rate of Philadelphia by Age Periods, For 1890.

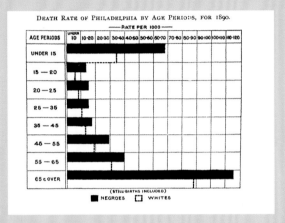

The Contact of the Races

It goes without saying that most private schools, music schools, etc., will not admit Negroes and in some cases have insulted applicants.

Such is the tangible form of Negro prejudice in Philadelphia. Possibly some of the particular cases cited can be proven to have had extenuating circumstances unknown to the investigator; at the same time many not cited would be just as much in point. At any rate no one who has with any diligence studied the situation of the Negro in the city can long doubt but that his opportunities are limited and his ambition circumscribed about as has been shown. There are of course numerous exceptions, but the mass of the Negroes have been so often refused openings and discouraged in efforts to better their condition that many of them say, as one said, "I never apply—I know it is useless." Beside these tangible and measurable forms there are deeper and less easily described results of the attitude of the white population toward the Negroes: a certain manifestation of a real or assumed aversion, a spirit of ridicule or patronage, a vindictive hatred in some, absolute indifference in others; all this of course does not make much difference to the mass of the race, but it deeply wounds the better classes, the very classes who are attaining to that to which we wish the mass to attain. Notwithstanding all this, most Negroes would patiently await the effect of time and commonsense on such prejudice did it not today touch them in matters of life and death; threaten their homes, their food, their children, their hopes. And the result of this is bound to be increased crime, inefficiency and bitterness.

It would, of course, be idle to assert that most of the Negro crime was caused by prejudice; the violent economic and social changes which the last fifty years have brought to the American Negro, the sad social history that preceded these changes, have all contributed to unsettle morals and pervert talents. Nevertheless it is certain that Negro prejudice in cities like

Philadelphia has been a vast factor in aiding and abetting all other causes which impel a half-developed race to recklessness and excess. Certainly a great amount of crime can be without doubt traced to the discrimination against Negro boys and girls in the matter of employment. Or to put it differently, Negro prejudice costs the city something.

The connection of crime and prejudice is, on the other hand, neither simple nor direct. The boy who is refused promotion in his job as porter does not go out and snatch somebody's pocketbook. Conversely the loafers at Twelfth and Kater streets, and the thugs in the county prison are not usually graduates of high schools who have been refused work. The connections are much more subtle and dangerous; it is the atmosphere of rebellion and discontent that unrewarded merit and reasonable but unsatisfied ambition make. The social environment of excuse, listless despair, careless indulgence and lack of inspiration to work is the growing force that turns black boys and girls into gamblers, prostitutes and rascals. And this social environment has been built up slowly out of the dis appointments of deserving men and the sloth of the un-awakened. How long can a city say to a part of its citizens, "It is useless to work; it is fruitless to deserve well of men; education will gain you nothing but disappointment and humiliation?" How long can a city teach its black children that the road to success is to have a white face? How long can a city do this and escape the inevitable penalty?

RELATIVE NEGRO POPULATION OF THE STATES OF THE UNITED STATES.

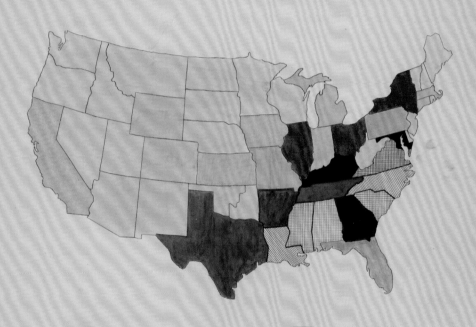

■ 750,000 NEGROES AND OVER	▦ 100,000 — 200,000
▦ 600,000—750,000	■ 50,000 — 100,000
▨ 500,000—600,000	▧ 25,000 —50,000
▨ 300,000—500,000	▧ 10,000 — 25,000
■ 200,000—300,000	▧ UNDER—— 10,000

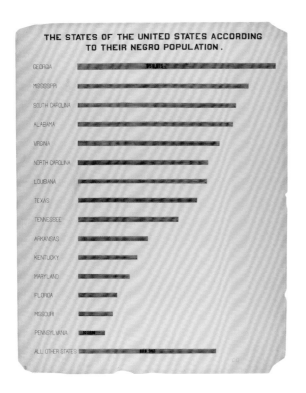

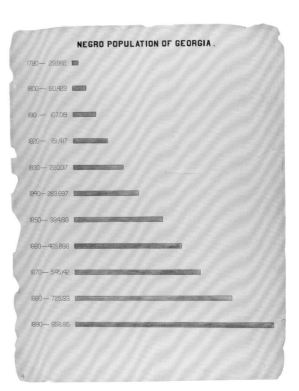

Opposite: W. E. B. Du Bois, *Relative Negro population of the states of the United States*, c. 1900. One of several charts prepared by Du Bois for the Negro Exhibit of the American Section at the Paris Exposition Universelle in 1900 to show the economic and social progress of African Americans since emancipation.

W. E. B. Du Bois, *The states of the United States according to their Negro population*, c. 1900

W. E. B. Du Bois, *Negro population of Georgia, by decade from 1790 to 1890*, c. 1900

"40,000 to Baltimore"

The Afro-American (Baltimore), February 23, 1963

The Baltimore Health Department estimates the natural increase in the colored population (births over deaths) was 60,000 in the past ten years. The in-migration during the same period was 40,000.

"Migration Costs State Over 400,000"

Holmes County Herald (Lexington, MS), December 21, 1961

State College, Miss.—Migration cost Mississippi over 400,000 persons during the past decade, according to computations of Experiment Station sociologists. This loss, large enough to populate three cities about the size of Jackson, has turned a normally growing state population into a declining one.

Ellen S. Bryant and Dr. G. L. Wilber have recently released results of their population study at Mississippi State University. Their figures take into account the natural increase of births over deaths in the state. The net migration figure represents people who left Mississippi and their loss was not offset by other people moving in.

Their report states in part: "When the home community cannot provide new incomes, migration becomes a necessity and can be considered a desirable method of balancing available workers to available jobs in a progressive economy. On the other hand the lost of investment and manpower ensuing from out-migration is a heavy financial incumbrance to residents of the state. If the cost of rearing and educating a child in Mississippi to age 18 is assumed to be $12,000 per white child and $5,000 per non-white child, the lost investment in migrating youth to Mississippi people can be estimated at somewhat over $1 billion during the decade. If we assume conservatively [text missing] a year had they remained in Mississippi, migration is costing the state an additional $600 million a year in earned wealth. When this figured is multiplied by the number of remaining working years in each migrant's lifetime, the figure becomes astronomical. If investment and production losses are added together Mississippi's migration loss during the 1950s cost the state an average of $700 million a year.

"Plants Must Hire Negroes, Manpower Chief Says"

New York Amsterdam Star-News, September 12, 1942

All Labor to Be Used, He Asserts

Baltimore Will Be Testing Ground in Big Mass Effort

Baltimore—"Employers who are not now employing Negroes must make their plans to use them." A. A. Liveright, War Manpower Commission director for the Baltimore area, announced this week.

Mr. Liveright also pointed out that plants which are using Negroes in small numbers and on unskilled jobs, must plan the use of them in larger numbers and on jobs commensurate with their skills and training.

He stated that his use of the word "must" did not imply the existence of compulsory legislation but rather that "it is just an obvious fact that all sources of local labor must be used if our war program is not to be bog down. And you may rest assured that the Government will not sit idly by and let that happen."

Baltimore Selected

Baltimore was selected as a testing ground by the Commission because it is in an area in which tons of thousands of new war workers are needed and because labor shortages can be eased by the increased use of Negroes and women.

Mr. Liveright was selected to execute plan for an effective manpower program in Baltimore. He is working out the Operations Division of the War Manpower Commission under the direction of Brig. General Frank J. McSherry. The successful working out of the Baltimore problem will serve as a blueprint for other critical labor shortage areas of the country.

Has Participated

The Negro Manpower Service, of which Dr. Robert C. Weaver is Chief, is a part of the operations division and has participated in the development of policies and procedures. Julius M. Gardner, field assistant to Dr. Weaver, is working with Mr. Liveright in the Baltimore area.

A new training center is being established for Negroes now taking war courses. The center which is now in operation will converted into a school exclusively for shipbuilding. For the first time in Baltimore's history, Negroes will be taught pipefitting, marine electricity, shipfitting, and many other courses. Training is already being given in wielding aircraft riveting, small parts assembly and machine operation.

SOUTH HURT BY LABOR SHORTAGE

"Negro migration" to the north, northwest and northeast increases rather than slackens in pace. It has caused much worry to the Southern farmer and has caused laws to be passed in an effort to halt the exodus and yet, despite these proposed laws, the exodus goes merrily on; the plowman leaves his mule hitched to the plow and catches the evening train for parts unknown. The Southern propaganda used by newspapers north and south, denying that the Ku Klux Klan and the Jim Crow laws are responsible for the movement fails to hold the laborer south. Reports coming from authentic sources say that the better class have joined the "movement north."

The Urban league in Chicago made a check-up on members of the Race coming to this city on four Sundays, June 17, June 24, July 1 and July 8. The result was that the league found that 3,603 persons migrated here from the south, coming into two stations, the Illinois Central and the Chicago & Eastern Illinois.

Why He Left

A small portion of these newcomers will leave Chicago for other cities, using this city as a transferring place. A small number are expected to return south in the fall—school teachers and visitors to their relatives, but the greater majority have bid the south good-by—forever. "The only thing that will carry me back there," said one man, "is to bury my mother and no sooner than I can catch a train after we have laid her to rest. I'm headed this way again. Why, man, you don't know the conditions, and you folks up here don't know one-tenth what is going on down there. I stood it as long as I could, then I left. When I get a few dollars saved up I'm buying a ticket here for mother and sending it to her. Why, in my town, a Colored*man can't buy a ticket to St. Louis nor Chicago. I had to come to Memphis, and had to lie to the ticket agent. A few nights before I left there was a train loaded with laborers for a northern point and the white people put a man with the smallpox aboard and at the next junction all were unloaded. Some were arrested. Man, it's just terrible how they do us," and he gave a sigh of freedom as he looked up at the tall buildings along Michigan Ave. He is one of the many thousands who have come north.

There is much blame placed on the shoulders of the paid labor agents by states in the south. In the state of Georgia 228,938 members of the Race have left in the last three years, and 77,500 of these have left Georgia in the last six months. This report is from the figures compiled by the Georgia Bankers' association (white), and which is expected to have overlooked hundreds of those who have left that the association didn't get a check on—many of the migrants going to other states and then coming north.

The following bill is pending in the state legislature of Georgia, and provides.

"That it shall be unlawful for any person or persons, acting for themselves, or as the agent of any persons, firm or corporation, to enter this state for the purpose of enticing, soliciting, hiring or in any manner offering any enticement or inducement to any person or persons within the limit of this state, or in any way or manner assist a citizen of this state to remove, leave or migrate to any other state or territory.

"That any person carrying on the business of soliciting or inducing, assisting, aiding or abetting any citizen of this state to leave the said state, shall be declared and defined an immigration or labor agent.

"Violations of the law will be deemed not a misdemeanor but a felony with punishment fixed by imprisonment and labor in the penitentiary for a term of not less than three nor more than seven years."

Conditions Must Change

The South realizes, rather the big business man down there knows, that the way to relieve this exodus is not by laws, but by dealing with the Race in an entirely different attitude than in the past. Jim Crow laws must go and the "brother" demands a fair trial in the courts. High wages is NOT the motive for leaving, as pictured by southern journalists. Injustice drives these folks away. The arguments put up by the southerners are the same as put up by them ten and twenty years ago. The Race is not to be buncoed into staying in the South by the old-time arguments that the "South is the best place" for them. The southern white man has not even tried to make the worker satisfied. Now comes the Ku Klux, an organization that defies both state and national governments. The Tuskegee hospital affair, the recent lynchings in Missouri, Texas and Louisiana, the treatment of the Race all over the Southland, the animosity of the white storekeeper against Tuskegee right in Tuskegee because of the fact that graduates of that school are entering business in that town, all have played their part. The Jim Crow law, added to all these, coupled with the fact that your money is counterfeit for something to eat or a place to sleep or first-class railroad accommodations if your face is black or if you have a trace of "Negro blood" that is visible, is more than a real man or woman can stand and they pack their belongings, sell out at a big sacrifice to find a home "somewhere in the North."

Those who have come North and find they can make a living write back home and encourage the rest of their relatives to leave. All the laws cannot stop this brotherly love for freedom.

At a recent conference between white and Colored speakers in Mississippi to consider the "economic problem," the Colored speakers are quoted as having said, "The mass of the Negro race went to stay here, but THEY ARE NOT GOING TO DO IT UNDER THE PRESENT CONDITIONS."

And Georgia is not the only state to suffer the hardships because of the ill treatment accorded the Race. Alabama has lost three and one-half per cent of the laborers of Color who worked the farm crops last year. They have gone North. Arkansas has lost 15,000 farmers and 22,750 have left the state of South Carolina since last fall.

An Associated Press dispatch from North Carolina states that "the migration of Negroes from North Carolina has stopped 50 highway construction programs."

Pastors, whose churches have been deleted by the movement, have packed their frock coats and gone in search of their flocks. Physicians and dentists have joined the movement. In some sections of the South the entire Race populations of some hamlets have become extinct.

A letter from a friend in this section of the country to his friend down South is defeating the anti-immigration laws passed by the southern states. Wages have started to advance in the South, but the lock is still on the door of the voting booth, the Jim Crow cars and the segregation laws remain and as long as they remain on the statute books—continue the exodus.

"South Hurt by Labor Shortage," *Chicago Defender*, August 4, 1923

MOST NEGROES PER SQ. MILE IN D. C.

WASHINGTON.—In 1920 the population of the United States averaged 35.5 inhabitants per square mile of territory.

The Negro population averaged 3.5 persons for each of the 2,973,774 square miles that constitutes the total land area of the United States.

Leading all other areas was the District of Columbia with a colored population of 1,832.7 persons per square mile, followed in the order named by states in which there are ten or more colored inhabitants per square mile: South Carolina, 28.3; Maryland, 24.6; Georgia, 20.5; Mississippi, 20.1; Alabama, 17.5; Virginia, 17.1; North Carolina, 15.7; Delaware and Louisiana, 15.4, and Tennessee, 10.8.

In the northern states, New Jersey ranked in first place in the density of the colored population with an average of 15.6 persons per square mile, followed by Pennsylvania with 6.3; Ohio with 4.5; New York, 4.2; Illinois, 3.3, and Missouri, with 2.6 colored inhabitant per square mile.

Since 1920, however, decreases in the South and increases in the North have followed as a result of the continued migration; and it is probable that Pennsylvania has now joined New Jersey and that these are the only northern states in which there are ten or more colored inhabitants per square mile of land area.

"Most Negroes Per Sq. Mile in D.C.," *The Afro-American* (Baltimore), July 3, 1926

Basically Colored Counties Drop to 180 with Migration

WASHINGTON

Because of migration, there were in 1940 only 180 counties in the United States in which colored persons constituted 50 per cent of the population, whereas in 1900 there were 286 counties of the type.

In an analysis of census data issued by J. C. Capt, director of the Bureau of the Census, it is pointed out that migration alone can account for the difference because the birth rate has remained

majority colored counties represented 42.7 and 47.8 per cent, respectively.

Of the total colored population of the United States, the 286 counties in 1900 included 4,057,619 persons or 45.9 per cent, while the 180 in 1940 included 2,642,808 or 20.5 per cent.

In the decades between 1900 and 1940, the population decreased noticeably, the 264 predominantly colored counties in 1910 having 3,932,484; the 221 in 1920 having

COLORED POPULATION OF COUNTIES IN WHICH COLORED PERSONS CONSTITUTED 50 PER CENT OR MORE OF THE TOTAL POPULATION BOTH IN 1940 AND IN 1930, BY STATES. (A minus sign (—) denotes decrease)				
STATE	No. of Counties	1940	1930	% of Inc.
Total	177	2,692,000	2,541,543	2.4
Alabama	18	389,068	380,863	2.2
Arkansas	9	193,308	188,282	2.7
Florida	3	41,616	39,875	4.4
Georgia	46	350,991	365,234	—3.9
Louisiana	14	176,737	165,815	6.6
Mississippi	34	729,713	690,476	5.7
North Carolina	8	137,984	134,345	2.7
South Carolina	22	360,981	353,555	2.1
Tennessee	2	39,543	38,322	3.2
Texas	3	41,050	40,982	0.2
Virginia	18	141,009	143,794	—1.9

high and the boundary changes been minor.

Decline in Maryland

Moreover, it was found that despite the decline in the number of counties, the number of States in which majority colored counties were located in 1940 include all which had such counties in 1900 except Maryland.

The 180 counties listed for 1940, moreover, represented nearly one-sixth (16.2 per cent) of the total 1,109 counties in eleven States. In Mississippi and South Carolina,

3,251,440 and the 191 in 1930 having 2,738,432 or 23 per cent of the total colored population.

In five counties, it was found, the percentage of the colored population was between 80.9 and 85.5; between 70.2 and 79.4 in 36; between 60 and 69.8 in 54 and under 60 in 80.

Rural farm areas accounted for 73.9 per cent of the population of those counties in 1940, rural non-farm areas for 13.6 per cent and urban sections, which were found in only 85 counties, for 12.5.

"Basically Colored Counties Drop to 180 with Migration," *The Afro-American* (Baltimore), April 14, 1945

"As I for one that am not satisfied to content myself with little and to remain in the same old rut for the sake of lengthy assiation and fair treatment I am making My appeal to you in your wide aquaintence with conditions to help me to take advangage of an oppertunity that I might other wise miss . . ."

TOPEKA, KS, MAY 1, 1917

EXCERPTS

Black Metropolis: A Study of Negro Life in a Northern City

St. Clair Drake and Horace R. Clayton

Selections from Chapter 3: "The Great Migration: Black Diaspora (1914–1918)," Chapter 4: "Race Riot and Aftermath: Riot (1919)," and Chapter 5: "Between Two Wars: Getting a Foothold (1919–1924)," 58–76, 83. New York: Harcourt, Brace and Company, 1945

Chapter 3
"The Great Migration: Black Diaspora (1914–1918)"

In 1914 the tide of European migration was suddenly reversed.[1] As country after country was drawn into the First World War, foreign born men streamed home from Pittsburgh and Cleveland, Detroit and Toledo, from mills and mines, to shoulder arms. Immigration virtually ceased. Chicago, too, lost thousands of workmen.

As the war dragged on, the United States gradually transformed itself into an arsenal and granary for Europe. Farmers laid more land to the plow while industrial plants expanded production. A city whose economic life depended upon the foreign-born to handle its meat, wheat, and steel now experienced a manpower crisis at the very moment when profits were highest and production demands greatest.

Then the great mass of caste-bound Negroes in the South stirred. For several years the cotton kingdom had been ravaged by the boll weevil sweeping up from Mexico. Flood and famine, too, had continually harassed the cotton farmers of the Mississippi Valley. Prior to 1915, however, there had been little to encourage plantation laborers to risk life in the city streets. Now there were jobs to attract them. Recruiting agents traveled south, begging Negroes to come north. They sometimes carried free tickets in their pockets, and always glowing promises on their tongues. For the first time, southern Negroes were actually being invited, even urged, to come to Chicago. They came in droves 50,000 of them between 1910 and 1920. And as each wave arrived, the migrants wrote the folks back home about the wonderful North. A flood of relatives and friends followed in their wake.

A bewildered South had visions of a land left desolate for lack of labor. From every southern state the Negroes came, despite desperate attempts to halt the exodus:[2]

Up from Florida—where the city fathers in Jacksonville passed ordinance requiring labor recruiters from the North to buy a $1,000 license or take the alternative of sixty days in jail and a $600 fine.

Up from Georgia—where the Macon city council exacted a recruiting license fee of $15,000 and demanded that the labor agent be recommended by ten local ministers, ten manufacturers, and twenty-five businessmen.

Up from Alabama—where fines and jail sentences were imposed upon any person, firm, or corporation guilty of "enticing, persuading, or influencing" labor to leave Montgomery.

Up from Mississippi—where agents were arrested, trains stopped, and ticket agents intimidated. And at Brookhaven, a chartered car carrying fifty men and women was deliberately sidetracked for three days.

Still they came!

As coercion failed, worried businessmen and planters resorted to conciliation and persuasion in an effort to stem the tide. Leading southern white newspapers began to condemn lynching and the inequitable treatment of Negroes in the courts. Conferences were held in large cities and out-of-the-way southern towns at which Negro leaders were implored to use their good offices with the field hands. The more astute Negro negotiators began to wring promises of more schools, better treatment, higher wages, and other reforms from men who a year before would have scorned to confer with "niggers." Idealistic southern friends of the Negro found their tasks suddenly eased by these economic imperatives. The southern caste system was in the process of profound modification.[3]

The *Chicago Defender*, a Negro weekly edited by Robert S. Abbott, a native of Georgia who had come north in the Nineties and made good, played a leading role in stimulating the migration. It coaxed and challenged, denounced and applauded. It organized a "Great Northern Drive" and succeeded in getting itself banned from many a southern community. It scoffed at the Southerners' reforms under duress:[4]

> *Turn a deaf ear to everybody. . . . You see they are not lifting their laws to help you. Are they? Have they stopped their Jim Crow cars? Can you buy a Pullman sleeper where you wish? Will they give you a square deal in court yet? Once upon a time we permitted other people to think for us today we are thinking and acting for ourselves with the result that our "friends" are getting alarmed at our progress. We'd like to oblige these unselfish (?) souls and remain slaves in the South, but to their section of the country we have said, as the song goes, "I hear you calling me," and have boarded the train singing, "Good-bye, Dixie Land."*

Eventually America entered the war. More southern Negroes came to replace the men who were drafted. For four years the tug of war between northern industry and southern planters, northern Negro leaders and southern leaders, continued. The migrants kept streaming

up the Mississippi Valley, riding the real trains of the Illinois Central over the same route their forefathers had traveled on the Underground Railroad. When the tide slackened in 1920, Chicago had over a hundred thousand Negroes among her population—an increase of 148 per cent in ten years.

Most Negroes visualized the migration as a step toward the economic emancipation of a people who had been tied to the southern soil and confined to common labor and personal service in the North. The Chicago Defender expressed this philosophy in an shortly before the United States entered the war. Declaring that "it is an ill wind that blows no one good," Editor Abbott saw the European war not only as "bloody, tragic and deplorable" but also as opportunity. Coldly realistic, he developed his apologia for encouraging the migration. The European war, he said,[5]

> . . . has caused the people of this and other neutral countries to prosper greatly in a financial way. It has meant that the thousands who a year ago were dependent upon charity are today employed and making a comfortable living for themselves and their families. The colored man and woman are, and must be for some years to come, laborers. There is no line of endeavor that we cannot fit ourselves for. These same factories, mills and workshops that have been closed to us, through necessity are being opened to us. We are to be given a chance, not through choice but because it is expedient. Prejudice vanishes when the almighty dollar is on the wrong side of the balance sheet. . . .
>
> Give the best that is in us when we answer the call. It is significant that the great west is calling to the southern black man to leave his old home and come out here where the prospects are bright for the future. Slowly but surely all over this country we are gradually edging in first this and then that place, getting a foothold before making a place for our brother. By this only can the so-called race problem be solved. It is merely a question of a better and a closer understanding between the races. We are Americans and must live together, so why not live in peace?

Negroes were getting the foothold, but the peace and understanding did not follow. White Chicagoans viewed the migrants with mixed feelings. As laborers they were indispensable. As neighbors they would have to be tolerated. Union men were apprehensive. Only "Big Bill" Thompson, the Republican Mayor, and his coterie of politicians truly welcomed them, as the traditional political of the Negro people and watched the First and Second Ward Black Belt amazingly.

The attitudes of the general public were undoubtedly shaped to some event by Chicago's newspaper headlines

and stories which, day after de, commented in a none too friendly vein:[6]

HALF A MILLION DARKIES FROM DIXIE SWARM TO THE NORTH TO BETTER THEMSLEVES

NEGROES INCITED BY GERMAN SPIES
Federal Agents Confirm Reports of New Conspiracy in South; Accuse Germans for Exodus from South

2000 SOUTHERN NEGROES ARRIVE IN LAST TWO DAYS
Stockyards Demand for Labor Cause of Influx

COMMITTEE TO DEAL WITH NEGRO INFLUX
Body Formed to Solve Problem Due to Migration to Chicago from South

WORK OUT PLANS FOR MIGRATING NEGROES
Influx from the South Cared For by the Urban League and Other Societies

Negroes were rapidly replacing foreigners as Chicago's "problem."

Black Lebensraum

The sudden influx of Negroes into Chicago immediately resolved itself into a struggle for living space. Between 1900 and 1914, the Black Belt and its satellite areas had absorbed over ten thousand Negroes without any serious difficulty. Now the saturation point was reached, and although the migrants had jobs, there were literally no houses to accommodate them. Building construction had virtually ceased with the outbreak of the war. Doubling-up and overcrowding became inevitable. The Black Belt had to expand, and this situation aroused exaggerated fears throughout the city. Where would the black masses, all bearing the mark of the plantation upon them, find a place to live?

As in the case of immigrants, the bulk of the southern migrants during the First World War gravitated first to those areas of the "colony" where rents were cheapest and housing poorest. They took over the old, dilapidated shacks near the railroad tracks and close to the vice area. These neighborhoods had been abandoned in the previous decade by Negroes who became more prosperous and were able to move away. Now their less affluent brothers replaced them.

This tremendous demand for houses resulted in an immediate rocketing of rents for all available accommodations and in the opening of new residential areas to Negroes. There were tremendous profits to be made

by both colored and white realtors who could provide houses. And so the spread of the Negro areas of residence began, with the whites fleeing before them. Artificial panics were sometimes created in white areas by enterprising realtors who raised the cry, "The Negroes are coming," and then proceeded to double the rents after the whites had fled.[7]

By 1920 a pincers movement of the Negro population had begun along the two boundaries of the Black Belt, a mile apart, and the pocket in between had begun to close up. As Negroes moved in, they bought the synagogues and churches, often at highly inflated prices, took over the parks and playgrounds, and transformed white and mixed communities into solidly Negro areas.

To the west of the Black Belt were the Irish, traditional enemies of the Negroes in Chicago; to the east were native-Americans and the more prosperous Jews, guarding jealously the approaches to the desirable lake front where they had made investments in residential property. The Negroes pressed against both communities, and as they swept southward, the whites in their path moved east and to the outlying areas of the city—but homes were scarce.

The impact of the expanding Black Belt on institutions in white middle class communities has been vividly described by the pastor of Chicago's oldest white Baptist church, which was eventually sold to Negros:[8]

> *In 1915 the cry was heard, "The Negroes are coming." The church reported in 1918, "Our church has been greatly handicapped during the past year by the great influx of colored people and the removal of many Whites." The Negroes coming from the South by tens of thousands, lured by the promise of high wages in the packing houses, mills, and railroad yards of Chicago, warmed to the blocks surrounding the church building. Beautiful homes occupied by families belonging to the church for generations were sold for whatever price they could obtain. The membership declined to 403 and only 10 persons united with the church in that year. The church was face to face with catastrophe. No eloquent preaching, no social service, could save a church in a community that was nearly 100 per cent Negro. . . . Meanwhile the Negroes steadily pushing down the alleys southward with their carts of furniture, are breakwater but Forty-seventh Street running east and west still stands as a breakwater against the oncoming tide. If it crumbles there will be some new history for the First Church.*

But the "breakwater" finally burst. Forty-seventh Street is now in the center of the Black Belt.

The expansion of the Black Belt developed so much friction that in the invaded neighborhoods bombs were occasionally thrown at Negro homes and those of real-estate men, white and colored, who sold or rented property to the newcomers. From July 1, 1917, to March 1, 1921, fifty-eight such bombs were hurled.[9]

This conflict over space often came to a head where Negroes and whites met in public places at the beaches and playgrounds and in the public schools. Particular resentment was manifested against Negroes who frequented beaches that white people had come to think of as their own. Playground fights between Negro and white children were epidemic. Policemen, social workers, and teachers, even when they were not themselves antagonistic to Negroes, often resorted to segregation as a convenient method of keeping the peace.[10] Yet throughout this period, despite tension in the areas peripheral to the Black Belt, there were also adjusted neighborhoods in other sections of the city where Negroes and whites maintained their neighborly relations and where no hostility was evident.[11]

During the war period, civic leaders viewed the situation with some foreboding. The Chicago Urban League was founded in 1917 to deal specifically with the problem of adjusting the migrants to city life. The churches, the newspapers, the YMCA, and the YWCA had deliberately set themselves the task of training the peasant folk in the city ways and of trying to interpret them to the Negro Old Settlers and to those sections of the white community which resented their presence. Incident after incident, however, augured an eventual crisis. In 1919 it came.

Chapter 4
"Race Riot and Aftermath: Riot (1919)"

Here and there throughout America, the tensions of postwar readjustment flared into open violence. On the labor front and along the color-line, deep-laid frustrations, uneasy fears, and latent suspicions bobbed to the surface. Group antagonisms suppressed and sublimated were the "Palmer raids"; for the Negro, lynchings and riots. The South, particularly, was nervous. Returning Negro soldiers, their horizons widened through travel, constituted a threat to the caste system. They must be kept in their place. A wave of interracial conflicts swept the country involving communities in the North as well as in the South.

Chicago was not spared its measure of violence. The sporadic bombing of Negro homes in 1918 was but the prelude to a five-day riot in 1919 which took at least thirty-eight lives, resulted in over five hundred injuries, destroyed $250,000 worth of property, and left over a thousand persons homeless. For the first time since 1861 the Negro was the center of a bloody drama. Then he was the hero; now he was the villain.[12]

The generally disturbed background out of which the Chicago riot exploded is revealed by a news item in the Chicago *Tribune* for July 4, 1917, reporting a protest

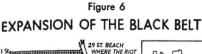

Figure 6
EXPANSION OF THE BLACK BELT

Adapted from map in *The Negro in Chicago*, Chicago Commission on Race Relations, University of Chicago Press, 1922.

two years before, this was a pogrom. But the Negroes fought back.

Attacks and reprisals were particularly bitter up and down the western and southern boundary between the Irish neighborhoods and the Black Belt. Here youthful white gangs—the so-called athletic clubs—functioning with the tacit approval of the ward politicians who sponsored them, raided the Negro community, attacking the people whom for years they had derided as "jigs," "shines," "dinges," "smokes," and "niggers," and who were now fair game. The rising smoke from burning homes in the white neighborhoods around the stockyards and the railroad tracks, during the next two days, was silent evidence of the embittered Negroes' reprisals.

The reaction of most colored civic leaders was ambivalent. Publicly they were constrained to be conciliatory and to curb the masses who did the actual fighting. Privately, despite a recognition of the horrors of the riot, like Negroes of all classes they justified the fighting as self-defense and as proof that Negroes would not supinely suffer mistreatment. They did not view a riot as unmitigated evil if it focused attention upon injustices. To them it held the same paradoxical elements of good emerging from evil that Wilson saw in the First World War or Lenin in the Russian Revolution.

There were some, however, particularly among Old Settlers,[14] who viewed the riot as the tragic end of a golden age of race relations. They were very bitter against the southern Negroes, who, they felt, had brought this catastrophe upon them. A group of representative business and professional men met to devise means for ending the disorder. Among the speakers was a lawyer who had come to Chicago from Georgia by way of Canada in 1893, studied law, and amassed some wealth. He insisted that "a lot of the trouble is due to Negroes from the South" and called upon "some representative Negroes from the same part of the country [to] do what they can to help quiet things down."

Many Negroes expressed their resentment against one Old Settler who began his address by placing the blame for the riot on the colored population, stating that "One of the chief causes of the trouble is that the colored men have been taught they must act on the policy of an eye for an eye and a tooth for a tooth." They condemned him as an "Uncle Tom"[15] when he continued: "This starts a series of reprisals that is likely to go on until the white man will get mad, and if he does we know what will happen to the man of color. Some of us forget that the white man has given us freedom, the right to vote, to live on terms of equality with him, to be paid well for our work, and to receive many other benefits."

They ridiculed him as a "white man's nigger" for his warning: "If the white man should decide that the black man has proved he is not fit to have the right to vote, that right may be taken away. We might also find it difficult to

meeting against a bloody riot which had occurred in East St. Louis, Illinois. The article, headlined, "LAWYER WARNS NEGROES HERE TO ARM SELVES," quoted one of Chicago's most respected and conservative Negro leaders as saying, "Arm yourselves now with guns and pistols." Another equally prominent leader was quoted as declaring that he "hoped God would demand 100,000 white lives in the War for each Negro slaughtered in East St. Louis."[13]

The Chicago riot began on a hot July day in 1919 as the result of an altercation at a bathing beach. A colored boy swam across the imaginary line which was supposed to separate Negroes from whites at the Twenty-ninth Street beach. He was stoned by a group of white boys. During the ensuing argument between groups of Negro and white bathers, the boy was drowned. Colored bathers were enraged. Rumor swept the beach, "White people have killed a Negro." The resulting fight, which involved the beach police and the white and colored crowd, set off six days of rioting. (Figure 6)

Pitched battles were fought in the Black Belt streets. Negroes were snatched from streetcars and beaten; gangs of hoodlums roamed the Negro neighborhood, shooting at random. Instead of the occasional bombings of

receive other favors to which we have been accustomed, and then what would happen to us? We must remember that this is a white man's country. Without his help we can do nothing. When we fight the white man we fight ourselves. We can start a riot but it takes the white man to stop it. We are not interested now in what started the riot, but how to stop it. The Germans thought these same people were so easy-going that they wouldn't fight, and they kept stirring things up until the Americans got mad. That ought to be warning enough! If this thing goes on for three days more there will be no jobs for our men to go back to."

They agreed, however, with his solution, provided it were impartially applied: "If the city cannot restore order then let us with the aid of the militia, have martial law, and take the arms away from the hoodlums."[16]

The bitterness felt by even the more conservative Negro leaders is plainly revealed in the tone of the annual report of Provident Hospital for 1919. Proud of the efficiency with which it handled riot casualties, the hospital board detailed its activities as follows:[17]

. . . A crowd of young white toughs from in and near Wentworth Avenue, mainly mere boys, began raids into the colored district, destroying, wounding and killing as they went. On one of these trips the raiders shot into the hospital. That evening fifteen victims were treated at the hospital, one white, the rest colored . . . the majority stabbed or clubbed, and a few shot.

As early as three o'clock in the afternoon on Monday, a mob gathered about the hospital. Feeling was running high. Many of the nurses, worn and tired by long hours of excitement and hard work, found human nature too weak to stand the hideous sights and bloodshed and begged to be taken away . . . but except for short spells of hysteria they were at their posts every minute of the time without sleep and without proper nourishment, for it was difficult from the start to get food into the hospital.

During the twenty-four hours from midnight Sunday to midnight Monday, seventy-five victims were taken care of. A number were taken by friends after having received treatment and a number died. Of these patients nine were white. Cots were placed in the wards and in the emergency room until every available space was occupied; then the victims had to lie upon the floor.

The demand on the hospital surgical supplies and food supplies was heavy; furnishings and equipment suffered; surgical instruments were lost and broken; mattresses were ruined, and furniture was wrecked.

The references to the treatment of white patients were a deliberate build-up for two devastating paragraphs:

It should be borne in mind that the conditions in the colored district were exactly reversed in certain white localities where any offending colored person who appeared was ruthlessly slaughtered, whether man, woman, or baby. From these localities came the raiding parties that caused substantially all the trouble.

The white doctors, of course, were not in attendance during this time and many of the colored staff doctors and the three colored house internes worked day and night; sometimes six operations were in progress at one time.

The daily newspapers headlined the Riot as big news, at the same time editorializing against it. The *New Majority*, organ of the Chicago Federation of Labor, prominently displayed an article, "FOR WHITE UNION MEN TO READ," reminding the workers of their "hatred of violence on the picket line" and insisting that a heavy responsibility rested on them "not because they had anything to do with starting the present trouble, but because of their advantageous position to help end it."[18] The general public watched and read, but did not participate. Probably its sympathies were divided and its loyalties confused.

The Riot was ended on its sixth day by the state militia, belatedly called after the police had shown their inability, and in some instances their unwillingness, to curb attacks on Negroes.

Reconciliation (1920–1922)

One result of the Riot was an increased tendency on the part of white Chicagoans to view Negroes as a "problem." The rapid influx from the South had stimulated awareness of their presence. The elections of 1915 and 1917 had indicated their growing political power in the Republican machine—a circumstance viewed with apprehension by both the Democratic politicians and the "good government" forces. Now the Riot, the screaming headlines in the papers, the militia patrolling the streets with fixed bayonets, and the accompanying hysteria embedded the "Negro problem" deeply in the city's consciousness.

Civic leaders, particularly, were concerned. They decided that the disaster demanded study, so Governor Lowden appointed the non partisan, interracial Chicago Commission on Race Relations to investigate the causes of the Riot and to make recommendations. For the next twenty years its suggestions set the pattern of activity for such civic groups as the Urban League, the YMCA, and various public agencies. The Commission's report was the first formal codification of Negro white relations in Chicago since the days of the Black Code.

After a year of study the Commission reported that it could suggest no "ready remedy," no "quick means of assuring harmony between the races," but it did offer

certain suggestions in the hope that "mutual understanding and sympathy between the races will be followed by harmony and co-operation." It based its faith on "the civic conscience of the community" and opined that "progress should begin in a direction steadily away from the disgrace of 1919."

Immediately after the Riot there had been some sentiment favoring a segregation ordinance. The alderman of one white ward introduced a resolution in the City Council asking for an interracial commission to investigate the causes of the Riot and "to equitably fix a zone or zones . . . for the purpose of limiting within its borders the residence of only colored or white persons." Alderman Louis B. Anderson, Mayor Thompson's colored floor leader, "spoke with acerbity and resentment"[19] against the resolution, and it was referred to the judiciary committee and subsequently dropped. The Governor's Commission, too, was emphatic in its repudiation of such a solution, declaring that: "We are convinced by our inquiry . . . that measures involving or approaching deportation or segregation are illegal, impracticable and would not solve, but would accentuate, the race problem and postpone its just and orderly solution by the process of adjustment."

The Negro had come to Chicago to stay!

The Commission was very specific in its charges and did not hesitate to allocate responsibility for the conditions which produced the Riot. Even governmental agencies were asked to assume their share of the blame. To the police, militia, state's attorney, and courts, the Commission recommended the correction of "gross inequalities of protection" at beaches and playgrounds and during riots; rebuked the courts for facetiousness in dealing with Negro cases, and the police for unfair discrimination in arrests. It suggested the closing of the white adolescent "athletic clubs." It asked the authorities to "promptly rid the Negro residence areas of vice resorts, whose present exceptional prevalence in such areas is due to official laxity." The City Council and administrative boards were asked to be more vigilant in the condemnation and razing of "all houses unfit for human habitation, many of which the Commission has found to exist in the Negro residence areas." In such matters as rubbish and garbage disposal, as well as street repair, Negro communities were said to be shamefully neglected. Suggestions were made that more adequate recreational facilities be extended to Negro neighborhoods, but also that Negroes should be protected in their right to use public facilities anywhere in the city.

The Board of Education was asked to exercise special care in selecting principals and teachers in Negro communities; to alleviate over-crowding and double-shift schools; to enforce more carefully the regulations regarding truancy and work-permits for minors, and to establish adequate night schools. Restaurants, theaters, stores, and other places of public accommodation were informed that "Negroes are entitled by law to the same treatment as other persons" and were urged to govern their policies and actions accordingly.

Employers and labor organizations were admonished in some detail against the use of Negroes as strike-breakers and against excluding them from unions and industries. "Deal with Negroes as workmen on plane as white workers," was the suggestion. Negroes were urged to join labor unions. "Self-seeking agitators, Negro or white, the same who use race sentiment to establish separate unions in trades where existing unions admit Negroes to equal membership" were roundly condemned.

As to the struggle for living space, a section of the report directed toward the white members of the public reiterated the statement that Negroes were entitled to live anywhere in the city. It pointed out several neighborhoods where they had lived harmoniously with white neighbors for years, insisted that property depreciation in Negro areas was often due to factors other than Negro occupancy, condemned arbitrary advance of rents, and designated the amount and quality of housing as "an all-important factor in Chicago's race problem." The final verdict was that "this situation will be made worse by methods tending toward forcible segregation or exclusion of Negroes."

Not all of the Commission's advice and criticism was directed at public agencies and white persons, however. The Negro workers who had so recently become industrialized were admonished to "abandon the practice of seeking petty advance payments on wages and the practice of laying off work without good cause." There was an implied criticism of the colored community, too, in a statement urging Negroes "to contribute more freely of their money and personal effort to the social agencies developed by public-spirited members of their group; also to contribute to the general social agencies of the community." Negroes were asked to protest "vigorously and continuously . . . against the presence in their residence areas of any vicious resort" and to assist in the prevention of vice and crime.

The Commission expressed particular concern over growing race consciousness, a phenomenon of which the riot itself was evidence. The Negro community was warned that "while we recognize the propriety and social values of race pride among Negroes . . . thinking and talking too much in terms of race alone are calculated to promote separation of race interests and thereby to interfere with racial adjustment." Negro newspapers were advised to exercise greater care and accuracy in reporting incidents involving whites and Negroes and to abandon sensational headlines and articles on racial questions. The investigation had revealed the existence of several small Negro groups such as the Garveyites and Abyssinians, who were bitterly opposed to any

interracial collaboration. The Commission rebuked them indirectly: "We recommend to Negroes the promulgation of sound racial doctrines among the uneducated members of their group, and the discouragement of propaganda and agitators seeking to inflame racial animosity and to incite Negroes to violence." There was finally, a word of commendation for the work of "the Chicago Urban League, the Negro churches, and other organizations in facilitating the adjustment of migrant Negroes from the South to the conditions of living in Chicago."

In addition to specific recommendations of the type referred to above, the report proposed a long-range educational program grounded in the belief that "no one, white or Negro, is wholly free from an inheritance of prejudice in feeling and in thinking. . . . Mutual understanding and sympathy . . . can come completely only after the disappearance of prejudice. Thus the remedy is necessarily slow."

Social and civic organizations, labor unions and churches, were asked "to dispel false notions of each race about the other," such as "the common disposition, arising from erroneous tradition and literature, to regard all Negroes as belonging to one homogeneous group and as being inferior in mentality and morality, given to emotionalism, and having an innate tendency toward crime, especially sex crime." Prominent among the myths which the Commission sought to explode was one which drew the following comment: "We commend to the attention of employers who fear clashes or loss of white workers by taking on Negro workers the fact that in 89 per cent of the industries investigated by this Commission, Negroes were found working in close association with white employees, and that friction between these elements had rarely been manifested."

In implementing such a program, a frequent interchange of speakers between Negro and white groups was urged. Public-school principals and teachers were asked to "encourage participation by children of both races in student activities as a means of promoting mutual understanding and good race relations in such schools and in the community. The daily press, which had been excoriated by the report, was asked to tone down its sensational treatment of Negro crime and to print more news about Negro achievement. And as a concession to that aspect of Negro-white relations referred to in the Eighties by the *Conservator*, the Commission recommended the capitalization of the word "Negro" in racial designations, and avoidance of the word *nigger* "as contemptuous and needlessly provocative."[20]

Old Settlers and New
When the Great Migration began there were about forty-four thousand Negroes in Chicago. When it ceased there were over a hundred thousand. As has been seen, the impact of this influx upon the white community resulted in a race riot. Its effect on the colored Old Settlers, as while less dramatic, was nevertheless disturbing.

The southern migrants reacted enthusiastically to the economic opportunities and the freer atmosphere of the North. But the Old Settlers were far from enthusiastic over the migrants, despite the fact that many of them were eventually to profit by the organization of the expanding Negro market and the black electorate. The Riot, to them, marked a turning point in the history of Chicago. Even today, as they reconstruct the past, they look back on an era before that shattering event when all Negroes who wanted to work had jobs, when a premium was placed on refinement and gentility, and when there was no prejudice to mar the relations between Negroes and whites. As they see it, the newcomers disturbed the balance of relationships within the Negro community and with the white community. From their point of view, the migrants were people who knew nothing of the city's traditions, were unaware of the role which Negroes had played in the political and economic life of Chicago, and did not appreciate "the sacrifices of the pioneers."

Old Settlers still complain that the migrants "made it hard for all of us." Typical of such statements is that of a woman who came to Chicago as a child in the Nineties: "There was no discrimination in Chicago during my early childhood days, but as the Negroes began coming to Chicago in numbers it seems they brought discrimination with them."

Another woman, whose family arrived in 1906, insists that "There's just as much difference in Chicago now as to what it was then as night and day. Why, you could work anywhere. You could even *demand* what you wanted, but you can't do that now. The people wasn't so prejudiced then as they are now."

The theme of these denunciations is usually the idea that the migrants "didn't know how to act" or that they "spoiled things," rather than the mere fact of an increase in the number of Negroes. Occasionally, the remarks are tinged with scorn and bitterness, as in the case of a colored civil engineer who came to Chicago before the Spanish American War: "As far as Negroes are concerned, there were very few here then, and the ones that were here had been here for years. They were just about civilized and didn't make apes out of themselves like the ones who came here during 1917–18. We all suffer for what one fool will do."

Old Settlers sometimes cite specific areas of activity in which they insist little prejudice was shown. One of them paints a glowing picture of the "good old days":

During that time [1912] there wasn't any difference shown in color at all. In the Loop itself they had Negro clerks in the leading stores. So far as professional and businessmen were concerned, the colored doctors had as many white customers as

colored. During that time, people would get the first doctor they could, regardless of color. White people didn't pay any attention to your color. In fact, I went every where I wanted to go and there was no difference shown me, and you can look at my color and see that nobody'd mistake me for any other nationality. You take the restaurants—you could go into any of them downtown that you wanted to and you would be served courteously.

Another Old Settler, a son of slave parents, came to the city in 1887 from Missouri at the age of nineteen. He mentions the prevalence of miscegenation as an index to the freedom existing at the time:

"In those days Chicago was in its youth. I was a young man and soon got a job waiting table in various restaurants and working in hotels. I made eighteen dollars a month.

"Well, all the Negroes lived down round the Loop. Those were the good old days. There was some colored men that had white wives and they lived good and was respectable. My aunt lived on Twenty-second and Cottage—I lived with her. There was a white family lived there and we all got along fine."

Much of this testimony must be discounted as retrospective myth but the fact remains that the Great Migration and the Riot profoundly altered relationships between Negroes and the white residents of Chicago and changed the basic economic and social structure of the Negro community. In 1910 Negroes formed a small, almost insignificant part of the city's life. By 1920 there were enough to attract attention, and the rapidity of the influx had excited apprehension.

The bulk of the migrants came to the city from the semi-folk culture of the rural South where the daily round was timed by what one eminent anthropologist has called "the great clocks of the sky,"[21] and where the yearly rhythm of life was set by the cultivation of the cotton and the cane. Their first task was to adjust themselves to a modern industrial city. Life in the city involved the substitution of the clock for the sun and the discipline of the factory for that of the agricultural cycle. It meant, too, an adjustment to a complex world with a wide variety of associations and churches, a multitude of recreational outlets, and new opportunities in industry and politics.

When the migrants first poured into the city, social agencies and community institutions made a conscious effort to adjust them to city life. But the Negro community as it exists today is not so much the product of any conscious manipulation by social agencies and Old Settlers as it is a natural growth. The migrants were gradually absorbed into the economic, social, and political life of the city. They have influenced and modified it. The city has, in turn, changed them.

The introduction of over fifty thousand new individuals into the Black Belt within a period of ten years swelled the membership of all existing organizations to the bursting point. As groups of migrants found their congenial intellectual and social levels, old organizations accepted new members; additional units of older associations and churches were formed; new types of organizations came into being. Old social patterns, too, were often modified by the migrants who brought their southern customs. Leaders sometimes had to shift their appeals and techniques to deal with the newcomers. New leaders poured up from the South to challenge and supplement or supplant the indigenous leadership. Old Settlers could not isolate the newcomers. They were eventually swamped by them.

The migrants found a functioning political machine in the Black Belt which welcomed their participation. From the South where they were disfranchised they came into a community where the Negro vote was not only permitted but was actually cultivated. The migrants learned quickly, and they were soon incorporated into the First Ward machine in the bailiwick of the news-making bosses, "Bath-house John" Coughlin and "Hinky Dink" Kenna. In the Negro Second Ward they learned that the political life of the community was allied with the world of the saloon and the gaming house. They learned to deal with such influential figures as "Mushmouth" Johnson, the gambler, and "Teenan" Jones, the saloon-keeper, those powerful and almost legendary figures of the Negro demimonde and underworld. It was all new and exciting. The migrants accepted it with gusto and found their place in the pattern, often learning to play the game of politics with skill and daring.

In 1910 Chicago's Negroes were a relatively small group of servants. By 1920 they formed a large segment of the industrial proletariat. Between war's end in 1918 and war's beginning in 1939, over 100,000 more Negroes were absorbed by Chicago's rapidly expanding economy, and the measure of their fate was keyed to the crescendos and diminuendos of the American life during the Twenties and Thirties.

Chapter 5
"Between Two Wars: Getting a Foothold (1919–1924)"
The Lean Years

During the Fat Years, the Negro newspapers "plugged" the dream of Black Metropolis while blasting away at the pattern of white attitudes which created and perpetuated it. Their major thrusts were reserved for those who denied Negroes equal economic opportunity. "Perhaps Negroes could turn their Black Belt into a community of which the city would be proud," they argued, "but only if they were allowed to get better jobs and thus raise their purchasing power and political

power." Between 1924 and 1929 the prospects seemed bright.

Then, in 1929, the *Defender* sounded an alarm:

"Something is happening in Chicago and it should no longer go unnoticed. During the past three weeks hardly a day has ended that there has not been a report of another firm discharging its employees, many of whom have been faithful workers at these places for years."[22]

Negroes were advised to "toe the line," work hard and behave decently, in order to impress their employers. By March the paper was thoroughly aroused, and in the mood to find a scapegoat. Its headlines verted to an old object of attack with a plea for the federal government to "ARREST FOREIGN WORKERS WITHOUT CITIZENSHIP." The paper considered it unfair for "foreigners" to hold jobs while Negroes were jobless, and further charged the foreign-born being "apt students of segregation" who would not work side by side with Negroes.[23] The Urban League, more sober in its appraisal of the situation, called a conference of leaders in Black Metropolis, after stating that "every week we receive information regarding the discharge of additional Race workers who are being replaced by workers of other races."[24] For the first time in its history, the *Defender* began to advise Negroes to stay in the South.

Notes

1. Chicago Commission on Race Relations, *The Negro in Chicago* (Chicago: University of Chicago, 1922), chap. 3 (hereafter referred to as *The Negro in Chicago*).
2. E. J. Scott, *Negro Migration During the War* (Oxford, UK: Oxford University Press, 1920), 72–85.
3. Allison Davis, B. R. Gardner, and Mary R. Gardner, *Deep South* (Chicago: University of Chicago, 1941), 422–82.
4. *Chicago Defender,* editorial, October 7, 1916.
5. *Chicago Defender*, January 9, 1915.
6. *The Negro in Chicago*, 529–30.
7. Ibid., chap. 4.
8. P. J. Stackhouse, *Chicago and the Baptists* (Chicago: University of Chicago, 1933), 200–207.
9. *The Negro in Chicago*, 122–33.
10. Ibid., chap. 6, "Racial Contacts."
11. Ibid., 108–13.
12. *The Negro in Chicago*, 12–20.
13. *Chicago Tribune,* July 4, 1917.
14. A term used by both Negroes and whites in Chicago to designate persons who lived in Chicago prior to the First World War.
15. "Uncle Tom," the hero of Harriet Beecher Stowe's famous novel of the abolitionist era, has become for colored people a symbol of the subservient Negro. The term thus serves as a satirical condemnation of any Negro who is thought to be currying favor with white people.
16. Quoted from a manuscript document, Cayton-Warner Research.
17. Annual Report of Provident Hospital and Training School, 1919, Provident Hospital in the Race Riot of July, 1919, Issued by Authority of the Board of Trustees.
18. Quoted in *The Negro in Chicago,* 45.
19. *Chicago Daily News,* August 5, 1919.
20. *The Negro in Chicago,* 595–651.
21. This term is used by Robert Redfield in his vivid account of Yucatan, *Tepoztlán, a Mexican Village: A Study of Folk Life* (1930).
22. *Chicago Defender*, January 29, 1929.
23. Ibid, March 10, 1929.
24. Ibid.

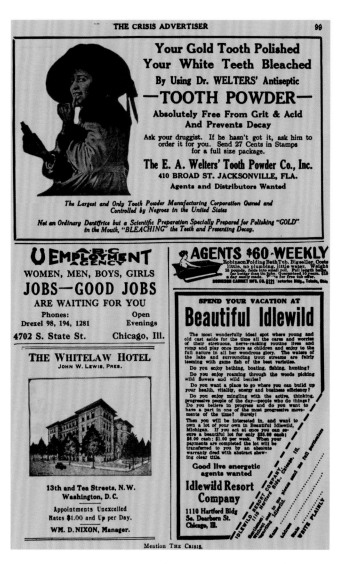

Advertisements published in *The Crisis* 19, no. 2, December 1919

"3rd of Negroes Going to Chicago Are from State"

The Chronicle (Pascagoula, MS), December 19, 1962

Chicago (UPI)—Gov. Otto Kerner was in Chicago Tuesday a few blocks from where Mississippi Gov. Ross Barnett was trying to recruit industry out of Illinois.

Kerner's office said he had no plans to meet Barnett. "As far as I know, Gov. Kerner was not informed of Gov. Barnett's visit," an aide said.

The aide said Kerner had carried on the traditions of extending visiting governors such courtesies as assigning state troopers to them, "but we can't do that if we don't know they're here, can we?"

The aide said Barnett probably realizes Kerner has not been friendly to Barnett's action to keep a Negro from registering at the University of Mississippi.

"Gov. Kerner was the first governor to wire President Kennedy that he supported his stand in the matter," the aide said.

The aide said dissatisfaction with life in Mississippi has led to the migration of many Negroes into Illinois.

A spokesman for the Chicago Urban League said Negro migrants into Chicago averaged 15,000 a year between 1950 and 1960, and now averaged about 10,000 yearly.

A third of these come from Mississippi, he said.

"Green Pastures of WPA Entice Negroes to City"

Charles Leavelle

Chicago Daily Tribune, September 15, 1938

Thousands Come North to Get Easy Money

This is the thirteenth in a series on the Works Progress administration—what it is doing for and to the WPA workers and what it is doing to the nation.

In one of their greatest migrations since world war days, southern Negroes are coming into Chicago and Cook county by the thousands. They are pouring in from the cotton country, the rich sugar coast, and from the eroded red lands of Tennessee and Arkansas.

The green pastures that beckon them are the friendly preserves of the federal Works Progress administration. The easy work and (to them) high wages mean emancipation indeed. It is even better than the forty acres and a mule the carpet baggers promised their grandfathers.

It's Different Up North

The least they can make is $55 a month. Many make $65. And this is more money than most of them ever have had before. A survey of WPA Negroes in Cook County has disclosed that a surprising percentage of them never had a salaried job before coming north.

The south has the WPA, just as the other states have, but the wages it pays are much lower. Chicago's $55 WPA laborer would make $30 a month down south. If he were colored he might have a hard time getting on at all. It is certain none of the choice WPA would come his way.

In the north it is different—and for an excellent reason. Down in the cotton country the Negro would vote Republican, if he were allowed to vote—which he isn't in most states.

Here he is not only allowed to vote; he has to, if he stays on the WPA. And as a member of that great political army he is expected to vote the Democratic ticket.

Makes Many New Democrats

Thus the Roosevelt government lures the Negro out of the south, leaving WPA jobs open to white voters. It changes the Negro from a potential though impotent Republican into an active northern Democrat. Both the southern Negro and the Roosevelt government think it is a wonderful idea.

Meanwhile, the migration has attracted the attention of census experts. They regard it as a definite population shift. And they trace it directly and almost entirely to the WPA.

Social workers in northern cities have estimated the influx as high as 250,000 in the last five years. Howard D. Gould, director of research and statistician for the Chicago Urban League, believes that this figure is too large, but it is certain, he says, that between July 1936 and July 1938—two years—20,000 southern Negroes have settled in the Chicago area. They are chiefly from Mississippi, Alabama, Louisiana, Arkansas, Tennessee, Oklahoma, and Kentucky, he adds.

Survey of these states failed to establish even an approximate figure for the number of Negroes who have come north. There have been thousands of them, however, according to the railroads, employment, and relief agencies, welfare bureau, and Negro organizations.

Formula of Getting on WPA

The migration began soon after President Roosevelt took office in 1933 and increased sharply after the creation of the WPA, Gould declared. This was a direct reversal of the trend during the last two years of the Hoover administration. Negroes then were leaving the north by the thousands and returning to their old homes.

Their method of settling here preparatory to getting on the WPA has been reduced almost to formula, social workers assert. They stop for a time with relatives to accustom themselves to changed conditions and customs. Then they make affidavit that they have lived here the necessary year. They go on relief, then to the WPA.

The number of Negroes on Cook county WPA projects has increased noticeably in the last year. More and

more of them are appearing in the labor gangs. In the vast sewing project at 510 West 51st Street, 90 percent of 3,300 women employed are colored, according to Vincent Owles, a skilled labor foreman there.

Rise in Illiteracy Rate

They are causing a rise in illiteracy both on the WPA and in Cook County. WPA officials report that the number of workers who endorse checks with a mark—because they can't write their names—is higher now than ever before.

Amazingly, many of the southern colored people who are newly arrive think Theodore Roosevelt is the President of the United States. This belief is encouraged by political executives of the WPA because "Col. Teddy" became a hero to the colored race when he dined in the White House with Booker T. Washington.

In the north WPA workers complain that Negroes are given preference over white married men because votes and campaign funds can be gouged more easily from the colored man. There is a fear, too, that the increasing number of colored people will cause a downward trend in wages.

And in the south it is cotton picking time. Already there are reports that pickers are scarce in Tennessee, Arkansas, and Mississippi. As the bulk of the crop begins to open, this shortage is expected to increase; there are fears that it will become acute. Planters blame both the migration to the north and local relief.

Shortage of Domestic Help

In many sections there is a shortage of domestic colored help. Southern whites are reluctant to take jobs as servants. And other lines of work are affected.

Capt. Dick Dicharry, master of the Mississippi river steamer *Tennessee Belle,* reports that roustabouts and freight handlers are hard to find. "At many landings we can't get men to unload the boat," he said. "A few years ago Negroes used to fight for these jobs. But they don't rush down the riverbank to beg for them now. In fact, they don't come down to the river at all, and it's hard to find them in the towns. Where we used to offer them a quarter we now make it a dollar. And the ones that are left usually give us the same answer: 'No thank you, Cap'n. We got a dollar.'"

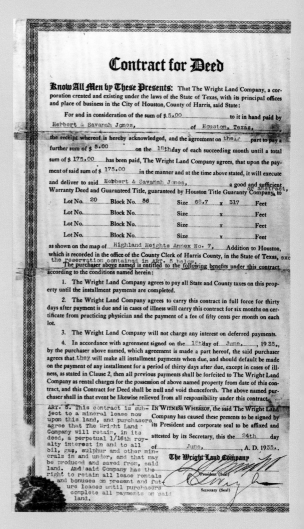

Contract for deed signed by Herbert and Savanah Jones and the Wright Land Company, Houston, 1935

Land purchase receipt issued to Herbert and Savanah Jones, 1935

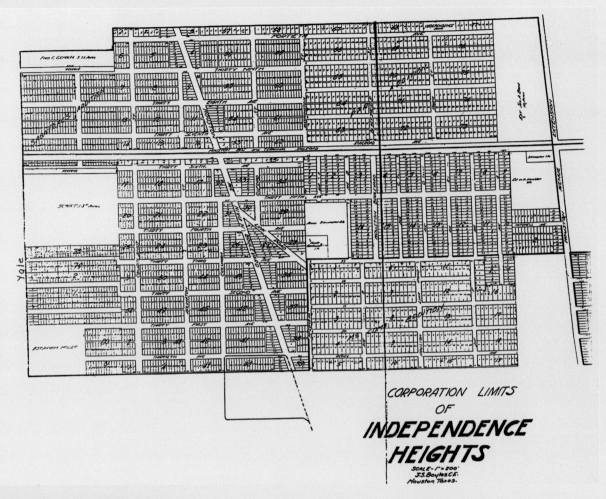

Map of the corporation limits of
Independence Heights (Houston), one
of the first Black communities in Texas,
1915–28

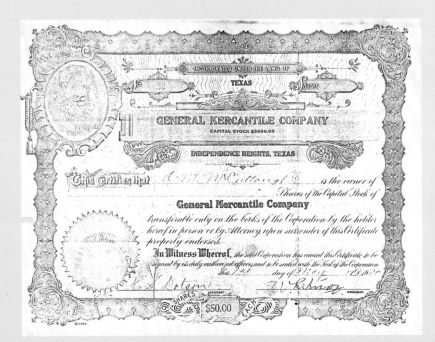

Certificate signifying Arthur McCullough's
ownership of stock in General Mercantile
Company, Independence Heights
(Houston), 1938

"In Search of Freedom: Black Migration to Houston, 1914–1945"

Bernadette Pruitt

The Houston Review of History and Culture (now *Houston History*) 3, no. 1 (Fall 2005): 48–57, 85–86

Martha Williams certainly knew hard times. Martha, a homemaker, occasionally worked as a washerwoman or domestic to earn extra money and make ends meet in a rural area in southern Louisiana. Her husband Charlie, like many African American men from southern Louisiana, earned his living as a tenant farmer and artisan. Frustrated with their marginal existence in the Bayou State, the pair left for the Houston area not long after the outbreak of World War I. More than anything else, the heightened call for cotton and petroleum goods during and after the war stimulated unprecedented migration streams from the surrounding countryside into the more urban, industrial centers along the Gulf Coast.[1]

Charles and Martha, like many newcomers to the greater Houston industrial region, hoped the area would

Houston Colored High School—later Booker T. Washington High School—provided a source of hope, strength, and vigor for those African American students from the surrounding countryside who longed to complete their schooling.

offer them and their unborn children economic and educational opportunities, as well as greater civil rights and racial autonomy. In this sense, their decision to relocate to Alief, then a small town west of Houston, reflected an amplified social consciousness and self-awareness with regards to their future aspirations. The Williams family moved on to the Fifth Ward in Houston in the early 1920s after the births of their first two children. The Fifth Ward, originally developed for middle-class Whites after the Civil War, had become a working-class community, and it appealed to the Williams because of its close proximity to manufacturing firms near the newly-built Houston Ship Channel.[2] One such firm, the Southern Pacific Railroad Shop on Liberty Road in the Fifth Ward, routinely hired African American men as both unskilled and skilled laborers.[3] In the decade following World War I, the family's conditions improved, and they eventually rented a home in the increasingly Black-occupied ward.[4]

Like so many others, the family faced hard times in the Great Depression. The nation's worst economic calamity devastated the working poor, especially Black families like the Williams. The Depression took a heavy toll on the family, which included four more children by the early 1930s. Martha and Charlie soon separated. Charlie, like many unemployed and frustrated Black men of the period, left his family, went from odd job to odd job, and traveled to and from the countryside in search of temporary work.

His young wife, accustomed to working as co-wage earner and housewife, now had to support a family of seven on the meager earnings of a laundress. She and her children left their home on Cage Street and moved in with neighbors. The single mother worked on and off at a bag factory and as a cook for an affluent White family. Unfortunately, like many Black domestics during the Great Depression, Martha routinely found herself out of work. Martha Williams and other Black domestics across the country increasingly had to compete for personal service work with Whites, Latinas, and other out-of-work Blacks—clerical staffers, schoolteachers, social workers, librarians, medical professionals, secretaries, sales consultants, and housewives.[5]

During her periods of unemployment, single mother Martha Williams applied for and received public assistance from the Harris County Department of Public Welfare and the newly-formed Federal Emergency Relief Administration (FERA). In spite of her trying circumstances, wife, mother, and migrant Martha Williams remained proactive, steadfast, and determined to care for her family. Like other Black newcomers to the city from nearby eastern Texas and southern Louisiana in the first half of the twentieth century, of its close proximity to manufacturing firms near the newly-built Houston Ship Channel.[2] One migrant, Martha Williams, relied on

kith and kin, Houston's expanding labor market, a sense of purpose as a wife and mother, public assistance and charity when necessary, a fervent spiritual purpose in the face of travails, and an activist resolve to overcome racial discrimination and overarching poverty. Through force of will and hard work, she made a home for her family in Houston.

The Great Migration to Houston

Thousands of migrants like Martha Williams came to Houston in the first half of the twentieth century. Some 44,000 Black women, children, and men moved to Houston between the years 1914 and 1945, principally from eastern Texas and southern Louisiana.[6] Migration boomed from 1914 through 1930 before slowing in the 1930s because of the Great Depression and then expanding rapidly after the United States entered World War II in late 1941. Like their contemporaries who left the rural, small-town, and urban South for industrialized centers in the Midwest, Northeast, and West, migrants to Houston helped define the Great Migration and Second Great Migration of the twentieth century.[7]

Between 1915 and 1970, an estimated seven million African Americans moved to industrial cities across the country from rural, small-town, and urban centers throughout the South. While many abandoned the South completely, others moved away from the farm to the city within the South, often moving first to nearby towns from farms, then on to larger industrial centers in their regions. Occasionally children and grandchildren of recent migrants to Southern cities sought better options outside the region and endorsed the idea of permanent relocation to Los Angeles, the San Francisco Bay Area, Chicago, or Detroit. A good number, nevertheless, remained in the South. According to historian Earl Lewis, in the first few decades of the twentieth century alone, most Black migrants in the South moved to Southern metropolitan centers and not cities outside the region.[8]

For the tens of thousands of emigrants from eastern Texas and Louisiana, migration to Houston seemed a viable solution to a host of deteriorating conditions. Displaying the spiritual resolve and survival instincts of kidnapped West African immigrants turned chattel slaves, defiant runaways, and free/freed people of color, tens of thousands fled harsh economic conditions and deteriorating race relations in the rural and small-town South to seek a better future. For many Blacks who came to Houston in the first half of the twentieth century, migration was a form of protest and activism, since they moved in search of socioeconomic autonomy, sociopolitical self-determination, racial advancement, and peace of mind. Although they could not be certain what fate awaited them in Houston, they knew all too well that the rural South presented very limited opportunities for advancement, extremely poor schools for

their children, and an increasingly harsh caste system based on strict racial segregation.[9]

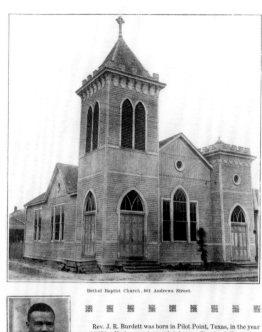

Bethel Baptist Church, 801 Andrews Street.

Rev. J. R. Burdett was born in Pilot Point, Texas, in the year of 1878. He is a graduate of Arkansas Baptist College, class of 1911. His property consists of a home in Little Rock, Ark. He was married to Miss Estella Waddy in 1905. Came to Houston in 1915 to pastor the Bethel Baptist Church at 801 Andrews Street. He is a member of R. F. C. and G. U. O. O. F. Pastor at Forest City, Ark., for six years. Missionary work four years. Joined the Baptist Association of Texas.

Without question, the soul of Black Houston rested in its church homes. Like their counterparts across the United States, African American Christians in early twentieth-century Houston relied on their faith in an enormous way; they equally depended on their spiritual guide, the congregation's pastor.

Only a few studies in recent years have examined how Black in-migrations within the South changed the character of places to which migrants moved.[10] Fewer scholarly works have studied the Great Migrations to urban centers west of the Mississippi River, to cities like Dallas, San Antonio, Shreveport, El Paso, Tulsa, Oklahoma City, and Houston that at times reluctantly absorbed the migrations of Black and Brown bottom-rung workers from Texas, Louisiana, and Mexico. The existing studies of Black migration out of the South tell one part of a complex story; further studies of Black migrations from the farm to the city within the South are needed to complete the story.[11]

Houston's Rise as an Urban Mecca

Migrants to Houston, like others who traveled north to Detroit, Chicago, New York, Cleveland, Milwaukee, Pittsburgh, and Philadelphia; or west to the San

Francisco Bay region, Seattle, Portland, Los Angeles, San Diego, and Phoenix, relocated to a destination point that witnessed unprecedented population and industrial growth in the first half of the twentieth century. Houston's population of 44,633 in 1900 matched Yonkers, New York; Holyoke, Massachusetts; Ft. Wayne, Indiana; Akron, Ohio; Saginaw, Michigan; Lancaster, Pennsylvania; Lincoln, Nebraska; and Waterbury, Connecticut. Houston's 1900 population, however, paled in comparison to the Southern centers of New Orleans, Atlanta, Charleston, Charlotte, Louisville, Memphis, Jackson, Jacksonville, Montgomery, Birmingham, and Richmond.

Over the next five decades, population increase, capital investment, along with industrialization would precipitate Houston's phenomenal rise to the top as one of the world's leading manufacturing producers. Houston by 1930 would become the largest city in the state and the second largest in the South; by 1940, the city had become twenty-first in the entire United States. By 1950, it replaced New Orleans as the South's largest Mecca; and the Bayou City also became the fourteenth largest in the nation. Without question, the city's population surge of 600,000 during the first half of the century was unprecedented for both a Southern city and to an extent, the nation as a whole. While Midwestern and Northeastern metropolitan centers continued to grow in population and size, unlike Houston and Los Angeles, most of the increases were the effects of outlying suburban growth, not annexation or population increase within the city limits. So incredible was Houston's population explosion that it ranked second in the nation in population growth, behind Los Angeles for much of the twentieth century.[12]

The rise of a permanent workforce, profitable manufacturing industry, and commercial enterprises along the Houston Ship Channel and entire Upper Texas Gulf Coast (UTGC) refining region, along with the emergence of Dallas as one of the nation's centers of finance and business, and San Antonio as an expansive industrial center, all precipitated the phenomenal rise of urban Texas and the permanent decline of its rural counterpart. In 1900, 17 percent of the state's residents lived in cities; by 1940, the figure had increased to 45 percent, and over 60 percent by 1950. Although other Texas urban centers increased in population and size—San Antonio, Dallas, Beaumont, Port Arthur, El Paso, Corpus Christi, Austin, Galveston, Waco, Lubbock, and San Angelo—Houston's population explosion outdistanced these cities by almost eight times between 1900 and 1940. Equally important, in 1900, 82 percent of the state's Black population resided in rural communities; a half century later, 65 percent lived in communities defined by the Bureau of Census as cities. The dominance of Houston as one of the country's leading manufacturing and trading centers became

evident by World War II as the Bayou City's population surpassed that of other cities in the Lone Star State, South, and entire United States. Migration to Houston, without question, seemed plausible for internal migrants from surrounding places.[13]

Map of Houston, 2005. African American concentrated Super Neighborhoods for 1914–1945: 1. Acres Homes 2. Independence Heights 3. Fifth Ward 4. Fourth Ward 5. Third Ward 6. Sunnyside

Migration as a Form of Activism

While scholars rarely associate mobility with radicalism, the act does mirror the actions and attitudes of some contemporary Blacks who elected to thwart or challenge traditional codes of conduct. During the harshest years of Jim Crow, many realized their futile options in rural and small-town Texas and Louisiana, turned away from what employers and landlords expected of them, and gambled on migration to nearby Houston. The act of migration was one of the few practical options available to Blacks in the rural South who grew weary of the numbing reality of agricultural labor and brutal racism. Migration did not directly challenge segregation, but it did tap into the resolve of thousands of Blacks and encouraged them to resist the worst abuses of the Jim Crow system and find some way to make at least marginal improvements in their lives. As illustrated in the works of Luther Adams, whose writings on the Great Migrations to Louisville point out that in-coming migrants who remained in Kentucky felt compelled to support civil rights, Black migrants to Houston through their decision to remain in the South in many ways indirectly and directly sparked later acts of protests in their children and grandchildren in the 1950s and 1960s.[14]

Putting family ties first, these migrants felt compelled to remain in close proximity to those places they left behind. Again, they did not follow other migrants to the North and West, but rather, searched within their soul,

Between Town and Metropolis: The Great Migration and the American City

and reached out to a community that would allow them easy accessibility to ailing parents, churches, siblings, extended family, and spouses. In rural and small-town Texas and Louisiana, these migrants saved their pennies, packed their families' belongings, walked on their bare feet, jumped on the back of wagons or pickup trucks, boarded trains and buses, or rode in cars, and moved to nearby Houston and other cities for renewed prospects and opportunities. As newly transplanted Houstonians, they built on the self-help activism learned in their former rural and small-town communities, activism that on a daily basis, countered the painful burden of race in American society, activism that paved the way for new strategies to fight White racism later in the century.[15]

Chain Migration

Those dissatisfied with life in rural areas heard of opportunities in Houston from a variety of sources. They received letters from family and friends who had already moved to the city. They traveled to and from the city themselves. Migrants to Houston used a complex web of communication networks in their search for homes, employment options, schools, churches, social affiliations, and business associations. Informal employer/employee recommendations provided newcomers with jobs. Businesses advertised positions in local Black weeklies and occasionally sent agents to recruit workers. Migrants relied heavily on the *Houston Informer*, a major newspaper written for the Black community that featured job notices, feature stories, and editorials that discussed current affairs and sociopolitical issues facing people of color. Railroaders, especially service personnel—Pullman porters, waiters, maids, cooks,

and redcaps—provided commentary on Black life and culture in Houston. Churches also offered prospective newcomers perspectives on city life, jobs, schools, and political affairs. Church services, concerts, church-wide annual events, and statewide and regional conventions allowed for visits from the country to the city. Worship services, pastoral anniversaries, choral concerts, Sunday School District Meetings, and National Baptist Conventions allowed for both reprieves from the harsh realities on the cotton and sugarcane farms, and discussions on rural-to-urban migrations to Houston.[16]

Individual family histories illustrate the inner workings of a process that historians have called "chain migration." Landowner, schoolteacher, husband, father, and church member Calvin L. Rhone of Fayette County served many years as the LaGrange delegate of the Texas Baptist State Sunday School Convention (TBSSSC). An organization that fostered religious doctrine, cultural pride, self-determination and identity, leadership skills, spiritual growth, and intellectual fervor among Sunday-School superintendents and teachers within the Black Baptist faith, the TBSSSC regularly convened in Houston. Here, Rhone cultivated long-lasting friendships, including a close relationship with TBSSSC regional secretary W. L. Davis, also of LaGrange, a longtime personal friend and recent migrant to Houston.

Although Calvin Rhone and his wife of over 30 years, Lucia, loved the country life on their 300-acre farm in Fayette County, several of their children—Benjamin, Beulah, and Calvin Jr.—relied on their parents' friendships with Davis and others when they moved away from home, entered college, and relocated to nearby Houston. The Rhone offspring later used their own friendships and personal connections at Prairie View and Wiley Colleges, within the International Longshoremen's Association (ILA), school districts where they taught, and in their many affiliations, and continued the cultivation of these relationships through their lifetime. As they bought homes, joined churches, entered their perspective careers in education and longshoring, and had families, they too extended the chain and offered invaluable assistance to later newcomers—nieces, nephews,

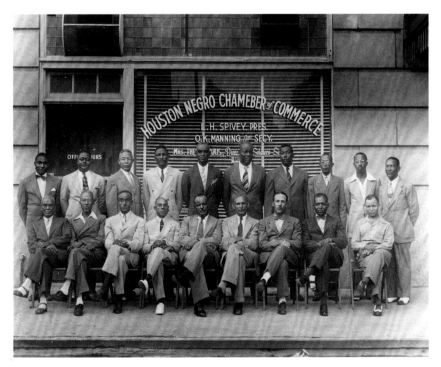

In the middle 1930s, business owners and prosperous, middle-class non-business owners formed the Negro Chamber of Commerce to formulate continued business prospects for African American economic leaders and foster racial independence. Migrants and non-migrants alike formed this important community agency.

godchildren, family friends, and the offspring of former students and classmates—as they relocated to Houston. Many left the country to finish school, find jobs, and escape the degradation of humiliation and despair in Fayette County or other small cotton-based communities throughout eastern Texas.[17]

Migrants generally emigrated from surrounding communities in eastern Texas and southern Louisiana. Most migrants to Houston, not surprisingly, left places east of the Brazos River, particularly southeastern and East Texas rural and small-town communities that surrounded the oil refining region that stretched from the Houston Ship Channel to the Beaumont-Orange-Port Arthur Golden Triangle area and on to Lake Charles, Louisiana. Although some families relocated to the city in one trip, many did not. Some made stepwise migrations to various communities before finally arriving in Houston. Usually, men moved to Houston and only after a few months or a few years, saved their money and sent for their wives, children, and parents. Interestingly during the 1930s, migrants often took return trips to rural areas to try to earn extra money for their families. These return or re-step migrations also built on earlier seasonal movements between the farm and city. Migration streams from the country, which began pouring into the city immediately after Emancipation, built on and

formed established neighborhoods inside the city's older wards and both incorporated and unincorporated communities on the fringes of the city's boundaries, places that would in time form the heart of Houston's Black community.[18]

These communities included Freedmantown in the Fourth Ward, which had been created by former slaves after the Civil War; the Third Ward and the nearby unincorporated community of Sunnyside; Independence Heights, known to many as Texas' first all-Black city; Acres Homes, an unincorporated settlement of Blacks northwest of Houston annexed by the city in the early 1970s; and the Fifth Ward, including Frenchtown, a neighborhood formed in 1922 by southern Louisiana Catholic migrants of French ancestry. In these areas of growing Black populations, cultural constructs of Blackness fostered pride, business enterprises, congregations, schools, a college, homeownership, networking, social clubs and organizations, union organizing, families, political astuteness, ethnic identities, class consciousness, entrenched racial segregation, racial awareness, disagreements, and occasional altercations.

Although the majority of newcomers came from small towns and farm communities in eastern Texas, nearly one-quarter fled Louisiana, especially southern Louisiana, the location of the nation's greatest concentration

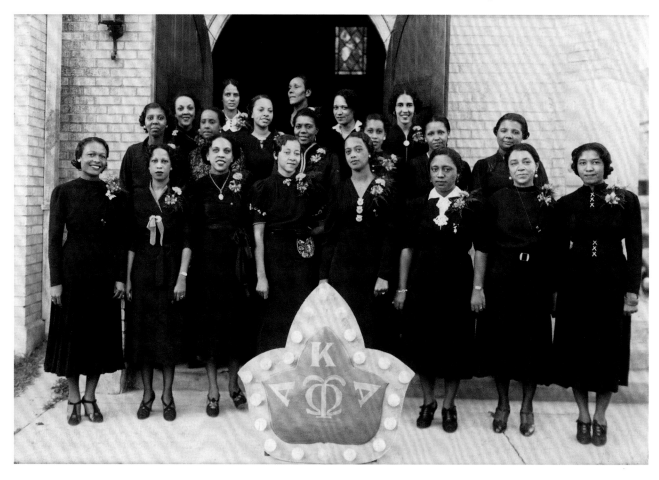

of Black Catholics. Economic need and natural disasters encouraged large-scale in-migrations to Houston among Louisiana-born Protestants and Catholics, including Creoles, in the late 1920s. Charles E. Lewis, a sharecropper in St. Martinsville, married Bertha Marie Thomas, a college graduate from Strait University—now Dillard University. Bertha taught Black farm children in the rural community of St. Martinsville—in St. Martin Parish—while her husband struggled as a sharecropper and on-and-off railroad employee with Southern Pacific. Frustrated by limited futile options in rural Louisiana—especially as cotton prices steadily declined throughout the 1920s—the couple decided to migrate to Houston in 1927, after the Great Flood of 1927 precipitated large-scale migration streams westward from southeastern Louisiana. After two years of living with relatives and in boardinghouses, the couple bought a home in Fifth Ward on Bleaker Street. Louisiana migrants like Charles and Bertha Lewis, who moved to Houston for economic empowerment, relied heavily on their families, friends, cultural traditions, and community institutions.[19]

Amazingly, the sparsely-populated neighborhoods in these African American communities near sprawling farmlands, wooded forests, and endless prairies, prior to World War II often reminded newcomers of their previous hometowns and rural areas. According to high school and college classmates, fellow sorority sisters, and former educators Thelma Scott Bryant and Hazel Hainesworth Young, their Fourth and Fifth Ward neighborhoods were home to varying segments of the African American community—physicians, schoolteachers, businessmen, longshoremen, unskilled workers, and domestics. This diversity, according to the two, empowered schoolchildren, encouraged adults, and brought people closer together. Schoolteachers and music instructors, for example, tutored students away from the classroom; elders kept their eyes on children and grandchildren courting the opposite sex; the community observed the Juneteenth holiday with festivals, parades, baseball games, competitions, and church musicals; and congregations occasionally honored special guests and recent newcomers with receptions and dinner parties. Young, for example, as a pre-teen, remembers the galas given by groups, including her church, Antioch Baptist Church, to honor the 24th United States all-Black Army Infantry that guarded the newly-formed Camp Logan (Memorial Park) before the tragic and regrettable August 24, 1917, Houston Riot.[20]

In an era of widespread segregation and discrimination, Blacks who left the countryside for Houston could not escape Jim Crow, but migration to the Bayou City did give them a semblance of hope and security in their self-contained, Black neighborhoods, benevolent societies, churches, schools, business establishments, nightclubs, and civic organizations free of White control. Most importantly, migration to Houston provided many African Americans with one essential pathway toward greater independence: steady blue-collar jobs.[21]

Migrants in the Houston Workforce

For experience in and exposure into the wage-earning world, farmers who migrated to the city usually relied on the temporary or seasonal migrations that seemingly resonated into training grounds for later, more permanent migrations. Black men, whose work performance largely built on seasonal employment options off the farm, primarily worked as unskilled laborers in manufacturing, transportation, commerce and trade, and personal service. They always earned the least in wages in all areas of the employment sector; worked in the dirtiest, most dangerous, and arduous of manufacturing and transportation-sector work. For a number of reasons, 80 percent of Houston Blacks worked in the city's unskilled labor force.

Although most newcomers trekked to the city for jobs and socioeconomic autonomy, compared to their White counterparts, they saw little in the way of upward mobility. They realized the sobering fact that the city's labor-force composition made them more vulnerable to economic contractions, underemployment, competition from both the small but growing Mexican labor force and occasional White labor pool, outsourcing, and other changes in the economy. Houston's workforce composition also revealed the material gulf between Blacks and Whites. For example, as the city's engineers, carpenters, bricklayers, boilermakers, and foremen, White Americans sustained the highest paying jobs in Houston industries. On the other hand, Houston industries primarily employed African Americans— and Latinos—as unskilled laborers. Blacks particularly fared poorly in professions outside industry and trade. In 1920 and 1940, White men held 97 percent of the city's male clerical positions; and for the same years, they occupied 93 percent of the male professional positions. This material disparity between the two groups of workers, coupled with White antagonism and opposition to interracial union solidarity, brought to the surface the existence of the city's dual labor system that relegated Blacks to less pay and fewer socioeconomic freedoms for their families. One of the most telling indications of this dual workforce was a family's reliance on female and child labor in the African American community. While most White adolescents finished high school, the vast majority

Opposite: Members of Alpha Kappa Omega Chapter of Alpha Kappa Alpha Sorority, Inc., c. 1942. Hazel Hainesworth Young, who taught Latin and was a counselor at Yates High School and active in Antioch Baptist Church, is among those shown (second row, far left).

of Blacks did not. Most dropped out of school before their freshman year of high school. African American youths left school prematurely to give financial support to their families.

Census data, according to historian Earl Lewis, provide the most effective form of analysis on the African American workforce and the many challenges African American workers faced daily. The general rate of job participation in the Houston workforce among Black men describes both their easy accessibility to certain jobs and their overall vulnerability to underemployment. The job-input rate of Black men increased largely because of rural-to-urban migration. The Black-male labor force rose from 12,538 in 1920 to 21,543 in 1930, an increase of almost 60 percent. Over 23,000 men comprised the African American male workforce in 1940. Of the 21,543

African American male laborers living in Houston at the time of the 1930 census, almost one-third (7,050 males) moved to the city in the 1920s. Twenty-five percent of the 1940 African American male workforce (3,673 men) moved to the city in the 1930s. While represented in each general labor-force division, Black men more often than not found themselves occupying bottom-rung jobs. They made up almost 70 percent of the non-skilled manufacturing male labor force for the years 1920 and 1930. African American unskilled workers labored in four workforce arenas: industrial, transportation, trade, and personal service. In each, Black men found themselves limited to low-paying positions, jobs historically held by Blacks, while Whites labored in higher-paying occupations reserved for Whites.[22]

African American males found themselves unable to break this tumultuous cycle for two reasons. While White antagonism and racism in the workforce prevented African American occupational advancement, this problem also partly reflected the varied composition of the city's economy, especially its reliance on ports and waterways, which depended heavily on African American longshoremen. Black longshoremen, for example, outnumbered their White counterparts by three to one. Longshoreman work, grueling and arduous, did not attract large numbers of White men after 1900. White men earned more money at oil refineries, steel foundries, construction companies, and in other segments of the transportation area. Like their Black contemporaries in Baltimore, Beaumont, Charleston, Galveston, New Orleans, Memphis, Charleston, Norfolk, Mobile, and Savannah, along with Mexican dockworkers in Galveston, Corpus Christi, Houston, and Beaumont, Black stevedores in the Bayou City remained disproportionately at the bottom rung of the manufacturing and transportation arenas, in part because of their close association with commerce and trade along Southern docks as stevedores. This numerical advantage did in fact give Black stevedores in the Bayou City socioeconomic and sociopolitical leverage over their White colleagues.

Because of their numerical plurality in the industry and local ILA, Black longshoremen garnered the vast majority of the dock work along the ship channel (at least until the emergence of the Fifty-Fifty Plan, which guaranteed White dockworkers equal work along the channel), growing respect among a small pool of fellow White stevedores, and an excellent reputation in the shipping industry as efficient and exemplary workers.[23]

With the exception of self-employed business owners or professionals with all-Black clienteles, the vast

This photograph of Houston schoolteacher Pinkie Yates, the daughter of freedman and community agent Rev. Jack Yates, exemplifies a lifelong pledge to Black educational empowerment.

number of African American workers witnessed daily, relentless racism. The city's segregated workforce benefited Whites at the expense of Blacks by excluding Black workers from most skilled manufacturing jobs. But this also meant that Blacks faced relatively little competition for labor gang jobs, especially in the giant refineries and oil-tool manufacturing factories that grew along the ship channel. Although these jobs were the lowest paying positions in the large manufacturing plants, they paid well compared to many other jobs traditionally available to Blacks. In a few instances, Houston's segmented labor force worked to the advantage of African Americans.

Black women also labored in the worst-paid areas of the Houston economy, primarily in the personal-service job sector. They equally took a commanding lead in maintaining the economic survival of their families and the overall African American community. Again, Black males could not alone sustain their families and communities on their meager incomes. These workers needed the aid of their wives and sometimes, unfortunately, their children. The city especially allowed Black women greater accessibility to jobs, better schools for their children, and educational opportunities that sometimes allowed their entrance into the middle-class job arena. Slowly they challenged White hegemony on the job and engaged in race consciousness activities in general. Interestingly, Black women asserted a greater degree of autonomy within the African American family as breadwinners. Often they found themselves as the only working persons in the household. Because of the negative stigma attached to personal-service work, they held these positions without large-scale competition (at least until after World War II).

Women in the Black community also lost their husbands prematurely to death more so than White females; and sometimes husbands abandoned their families or frequently traveled to the country as re-step or return migrants for work during the planting and picking seasons. Black women as wage earners maintained their responsibilities in the home as wives, mothers, and homemakers, cooking, cleaning, ironing, washing, tending to sick loved ones, caring for husbands and small children, and enrolling older youths in school. These migrants, as co-wage earners or sole providers, greatly shaped the lives of their families and communities by ensuring the economic and social survival of their households. Latinas would not dominate this workforce until well after World War II. A few African American women, however, labored as unskilled or semiskilled laundresses and cotton-compress workers; and White females largely shrugged off unskilled work for skilled and professional jobs in manufacturing, clerical and sales, business management, public service, medicine, law, accounting, and science and technology.[24]

Named for Anna Dupree's beloved mother, the Eliza Johnson House opened its doors in 1949 for African American seniors. Here, a proud Anna Dupree remembers the importance of valuing the African American elderly, a source of strength in the community. Her loving grandmother, a freed slave, encouraged her continuously.

While the percentage of Blacks living in Houston declined as the twentieth century progressed due to increased rural-to-urban migration streams among Whites and Browns, Blacks represented a higher proportion of the Houston labor force due largely to the high volume of women in the workforce. They entered the Houston job market in disproportionate numbers compared to White females. For example, in 1940, they made up 15 percent of the female population in the state and 36 percent of the overall Houston workforce for women. They were also a significant part of the Black workforce in the city. In 1920, they were 38 percent of the entire Black workforce for the year; and in 1930, they comprised 40 percent of the overall Black job force. For 1940, they equaled 43 percent of the total Black workforce. The number of Black women in the overall African American workforce rose to almost half of the total Black labor force by 1940. Black females, without question, in Houston insured the durability of their families and communities in tough times. Actually as expressed by historians Jacqueline Jones, Darlene Clark Hine, Kathleen Thompson, and others, twentieth-century African American women simply continued the arduous, painstaking, and often proud work traditions that their foremothers established in Africa and America centuries ago, while White and Mexican women in Houston for the most part only entered the workforce at the onset of World War I. Black females in the city and entire nation led the way among working women in the twentieth century.[25]

Only 15 to 20 percent of Houston Blacks, including migrants, during the interwar period entered the civil service, entertainment, education, ministry, medicine,

dentistry, nursing, law, undertaking, publishing, barber-
ing, hairdressing, and lucrative business ventures. The
Black middle class gradually expanded after World War
I, especially in the field of education. Black women made
up around 15 percent of the city's female profession-
als during the interwar period; female schoolteachers,
however, made up 70 percent of all African American
female professionals. For migrants and established resi-
dents alike, these rapid changes spelled some economic
growth for Blacks, at least until the dawn of the Depres-
sion. These socioeconomic influences would also pave
the way for greater political representation, educational
opportunities, and activism in later years.[26]

Self-Help and the Roots of the Modern-Day Civil Rights Movement

Even during the uncertainty of the Great Depression,
activism, self-help, and community agency flourished.
Increasingly, Black activism during the Depression
focused on charity and community agency. In spite of
growing unemployment (which at times almost dou-
bled that of Whites), limited local and federal welfare for
indigent families, and continued in-migration streams,
people in Houston's expanding African American com-
munity remained hopeful. Both longtime residents and
recent newcomers gave to the indigent and needy in
numerous ways. Often, African American groups gave
to Blacks, Whites, and Browns. One Fifth Ward congre-
gation distributed food to the needy of all races all day,
while ministers on the west side of town only catered
to Whites.[27]

Mostly however, Blacks helped Blacks: Alpha Kappa
Alpha and Zeta Phi Beta sororities held annual fund-
raisers for the elderly, physically and mentally disabled,
indigent, and homeless, especially in the winter; Black
organizations like the ILA annually raised money for the
city's private charity agency, the Community Chest; and
churches all across the city provided needed resources
for its members and communities. Pastor L. H. Simp-
son and the Pleasant Hill Baptist Church in Fifth Ward,
for example, raised hundreds of dollars every year for
the Community Chest; in later years, Simpson headed
the local NAACP branch, unsuccessfully ran for the
Houston City Council, and chaired the Colored Bap-
tist Minister's Association for 30 years. A caring soul,
he also opened a nursing home in Walker County near
Huntsville.[28]

Women's auxiliary ministries of local congregations
also formed soup lines in the Fifth Ward, the Third
Ward, and Independence Heights. Christian women's
groups throughout the city also collected perishable
foodstuff from grocers and meatpacking houses. The
indigent regularly received food, clothing, and mone-
tary donations from neighborhood churches. Church
caregivers themselves often faced harsh circumstances

Successful business woman and caring soul Anna
Dupree—along with her business partner and
husband Clarence—opened the Anna Dupree
Cottage of the Negro Child Center after World
War II. Clarence, himself an orphan, made it a
life's mission to facilitate improved services
and resources for the city's African American
orphan community. The center merged with the
Depelchin Center in the 1980s.

when their husbands lost decent jobs. Yet, these com-
munity agents assisted others in need during this period
of extreme economic hardship. The efforts of ministers,
civic leaders, women's groups could not, of course, end
the Great Depression, but they could help people in
times of great need.

The United States' entry into World War II ended
the Great Depression, precipitating the return of large-
scale in-migration streams from Texas, Louisiana, and
Mexico. It also galvanized grassroots activism, activism
that helped prepare the way for the modern-day Civil
Rights Movement. As United States defense contrac-
tors in the Houston area accelerated mass production,
businesses and the federal government stepped up their
efforts to hire out-of-work White farmers, men of color,
women, adolescents, and immigrants for employment
opportunities. Triggered equally by the massive decline
of individually-owned farms, increased farm mechani-
zation throughout Texas, and the newly-formed Bra-
cero Program, which offered Mexican nationals (and
Mexican Americans) migratory work on Texas farms,
nearly 20,000 Blacks moved into the Houston area
between 1940 and 1945 for jobs. Although migrants
worked primarily as unskilled laborers, for the first time
in large numbers, they predominated in the industrial
workforce.[29]

Black workers, not surprisingly, experienced mount-
ing racial bigotry in the workplace. Wartime vigilance,

increased union organizing among Blacks, promises made by the Roosevelt Administration to curtail racial bigotry in defense plants, and a growing call among African American leaders to advance racial equality, all created a mood of resistance to entrenched racism. On February 14, 1942, the largest Black weekly in the nation, the *Pittsburgh Courier* newspaper, initiated the "Double V" sociopolitical philosophy among African American journalists, civil rights activists, grassroots organizers, ministers, middle-class professionals, rank and file workers, along with others within the Afro-American community. During World War II, Americans of African descent demanded victory abroad over the Axis enemies of the United States, and victory over the enemies of Black civil rights and social justice in the United States (and abroad as well).[30]

Houston's African American community answered the "Double V" call in a number of ways. Black union membership reached 30,000 by the mid-1940s. Black laborers in defense plants more readily worked with Mexican American allies and filed lawsuits with the newly created Fair Employment Practice Committee (FEPC), which attempted to halt racial bigotry in the form of union sanctions, wage differentials, intimidation, and firings. Many workers joined forces with the larger Black community in their fight against racial discrimination. Black steelworkers, for example, worked with publisher and community activist Carter Wesley to combat racial segregation and discrimination in their industry. Industrial workers, in the end, however, largely fell short of their expected goal to eradicate workforce discrimination during World War II. While newspaper publisher and attorney Wesley worked alongside African American unionists to eradicate racial discrimination in what Earl Lewis calls the work sphere, civil rights activist and former schoolteacher Lulu B. White, who had migrated to Houston from Elmo, Texas, raised heightened public awareness in the African American community as her demonstrations, mass protests, and boycotts denounced racism in all segments of society, especially in the defense industry. The outspoken activist also lambasted politicians for their refusal to enforce FEPC compliance in the Houston area. It would largely take another generation before African American industrial workers could decisively dismantle stratified and codified racial discrimination at Houston-area industrial plants.[31]

Other strategists and strategies followed suit. Black teachers, unlike industrial workers, won an immediate victory during World War II. Black teachers, primarily women, earned low salaries compared to both White colleagues and Black male administrators; they earned 30 to 50 percent less in salaries than their White peers with equal credentials. Equally troubling, Black teachers faced a hostile White-controlled school district that refused to distribute funds fairly. Fortunately, a vigorous

letter-writing and editorial campaign led by the *Houston Informer*'s Carter Wesley convinced the board to concede. Historian William Kellar refers to the triumph as the first real victory for Black civil rights in the city.[32]

One year later in 1944, the NAACP and Black Texans won a decisive victory over discrimination when the United States Supreme Court ruled that the Texas all-White Democratic primary violated the Fourteenth Amendment of the Constitution. For a generation, African Americans in the Lone Star State had fought hard to secure their Constitutional right to vote. Varying segments of the community—migrants and established residents, middle-class professionals and rank-and-file workers, Protestants and Christians, nightclub owners and ministers, and business owners and wage earners—utilized their self-help and community agency resources to channel an effective protest strategy that led to the re-establishment of Black voting rights. The 1940s, according to historians Darlene Clark Hine and Merline Pitre, stirred vigor, passion, and anti-racist rancor among rank-and-file and middle-class African Americans, so much that the collective and independent acts of protest-activism threatened the foundation of the status quo like never before.[33]

Although most Black wartime activists utilized the courts, media, mobility, boycotts, higher earnings, workplace politics, and organizing strategies to fight racial injustice in the 1940s, others used their checkbooks and business savvy to promote racial autonomy. The growing Black business class in Houston produced people who had reached levels of economic success that allowed them to provide funds for Black activism. The lives of Clarence and Anna Dupree illustrate how some Black migrants to Houston worked hard to succeed and then used their wealth to help others.[34]

Born in 1891 in Carthage, Texas, a small community in Panola County just south of Marshall, Anna Johnson, the eldest of six children, lived a typical East Texas life as the daughter of sharecroppers. The family moved to Galveston in 1904, where Anna met her future husband, Clarence A. Dupree of Plaquemine, Louisiana. Orphaned at age seven, Clarence worked odd jobs at Galveston hotels and barber shops. White customers cared for Dupree by providing him with shelter, food, and clothing. Anna and Clarence soon met, fell in love, then married in 1918. The newlyweds moved to Houston shortly thereafter. Clarence worked as a porter at the Bender Hotel; his bride worked as a beautician in a White beauty salon. Anna soon joined a more exclusive establishment in the city's River Oaks subdivision, securing a prosperous clientele among River Oaks and Montrose housewives. Even as the two struggled during the Depression years, residing in the Fourth Ward and living off Clarence Dupree's meager earnings, they managed to save $20,000. By the late 1930s, they invested their

savings in real estate ventures that provided important services to the Black community. They reopened the Pastime Theater on McKinley in the Third Ward, built the El Dorado business center at Elgin and Dowling in 1939, and opened a pharmacy, men's apparel shop, and paint store. They also invested in the El Dorado Ballroom, a nightclub that for decades hosted parties, dances, and social events.

The following year, the Duprees opened the Negro Child Center on Solo Street in the Fifth Ward. Having been an orphan, Clarence realized the importance of a first-class orphanage in the community for African American children. Anna also opened the Eliza Johnson Home for the Negro Aged at 10010 Cullen Boulevard. The facility, named for her late mother, was home to ninety seniors. The community builders also donated $11,000 to Houston College for Negroes and the construction of the Thornton M. Fairchild Building. They contributed annually to the United Negro College Fund; formed the first little league baseball team for Black children; raised money for Camp Robinhood, the first Girl Scout Camp in the state for Black girls; and encouraged others to donate money and land for other causes, including the South Central YMCA and St. Luke's Episcopal Church, both on Wheeler Avenue near Texas Southern University.

The Duprees and other wealthy Blacks in Houston formed a bridge between the poor and the well-to-do. They never forgot where they came from and bettered the lives of thousands of African American college students, seniors, club members, youths, church members, and the indigent. Their activism came in the form of both migration and community agency. Their protests rarely provoked criticism among Whites. Nor did they threaten their traditional White clientele by publicly denouncing Jim Crow segregation. To the contrary, they found opportunities to secure land and businesses within a segregated society and then to use their wealth to provide needed services for African Americans. Their work illustrates the process through which the Black community in Houston achieved greater racial autonomy by generating both the leadership and the funding needed for self-help programs.

Such community activism and self-help initiatives accelerated important changes for Houston's Black community and paved the way for later forms of political activism. Activists as migrants, community builders, wage earners, and prayer warriors found themselves even more compelled to rebuild their homes, churches, neighborhoods, schools, and expanding institutions. Even during periods of massive underemployment and unemployment, activists put the needs of others first. The vigilance of World War II protesters essentially built upon earlier forms of activism; at the same time,

these methods provided a secure footing for later acts of human rights resistance.

After World War II, Houston's bustling economy encouraged continued in-migrants from Texas and Louisiana for the next two generations. Although the economic recession of the mid-1980s precipitated massive layoffs and business closings in the oil refining and technology arenas, rejuvenated financial growth in medical science, computer technology, engineering, and natural gas later stimulated renewed migrations to the Houston area.

Indeed, by the last two decades of the twentieth century, Houston, for some, the nation's Sunbelt capital, witnessed two new demographic trends: College-age youths, unemployed adults, and retired seniors from regions outside Texas and Louisiana, principally from the Midwest and California, more readily relocated to Houston, reversing the original Great Migrations of their grandparents and parents to obtain quality college educations and jobs in the city's expanding service-sector economy. Black Caribbeans, Central Americans, Ethiopians, along with West African nationals, especially Nigerians, attracted also to Houston's inexpensive public and private colleges, low cost of living, warm climate, and career possibilities in medical science, technology, engineering, and space exploration, found the Southwestern metropolis attractive as well. These recent internal migrants and immigrants from abroad have formed separate ethnic enclaves; forged enthralling cultural, familial, political, and economic alliances with and within Houston's larger Black community; and certainly benefited from and added to the Great Migrations of the past century.[35]

In the early twentieth century, Blacks in rural areas faced difficult choices in confronting the harsh realities of an oppressive Jim Crow system. Direct challenges to White hegemony brought swift reprisals, including death. But while White Southerners succeeded in erecting effective barriers to Black socioeconomic, educational, and political freedoms, they could not block Black migration. Through information networks within their families, communities, and churches, African Americans learned of better opportunities available to them. Many of them then acted, effectively using movement as a means to challenge White authority, undermine their socioeconomic powerlessness, and thwart their diminished status as impoverished, uneducated, disfranchised, and landless victims.

Black resistance to White supremacy through migration steadily increased in the first half of the twentieth century, costing individual landowners sometimes tens of thousands of dollars when sharecroppers and other tenants abandoned farms and contractual agreements. Many migrants left the South, drawn by the lure of industrial jobs in the Midwest and Northeast. But the

growth of Southern cities presented another option, one that allowed migrants to stay in closer contact with their families and their hometowns. For several generations of Blacks in rural East Texas and western Louisiana, Houston, with its fast-growing economy, was one obvious destination.

This is not, of course, to say that Houston was an ideal place for Blacks to live; indeed, by 1950 it was the nation's largest Jim Crow city. Nonetheless, it was a place to escape the most severe conditions of tenant farming and to start a new life. Within the confines of segregation, the growing Black communities in Houston offered a degree of freedom and a measure of autonomy for Blacks who could find some refuge from Jim Crow in what amounted to small cities of African Americans in and around Houston. This was particularly true for the emerging Black middle class of professionals and businesspersons who served largely Black clienteles. In Houston, Blacks built their own self-help organizations and read newspapers that reported on events in their communities. They sent their children to segregated schools that were poorly funded compared to the city's other schools, but were nonetheless among the best in the entire South for the children of the Black working class. The city also offered the fundamental building block for autonomy and independence, access to jobs. Even in the all-Black labor gangs of Houston-area manufacturing plants, Black migrants found employment that offered better pay, working conditions, and job security than the life of the sharecropper many had left behind in the countryside.

Blacks who left the countryside in search of self-improvement in the city often found what they sought: a better life for themselves and their children. Even those who found urban poverty to be a poor substitute for rural poverty at least had made a personal choice to try to change their situation. This was a fundamental form of activism, the resolve to do whatever was necessary to improve the conditions of life. Many of those who found relative prosperity in Houston sought to help others in their communities and to begin to challenge the constraints placed on them by segregation. In this sense, the steady, quiet, and gentle activism and self-help of Black Southerners in the early twentieth century smoothed the road for later, more direct and confrontational forms of civil rights activism. While contributing to Houston's growth, often with back-breaking labor, these migrants laid the foundation for a city that would remove at least the legal barriers to fuller participation by their children and grandchildren.

Ironically, while the Great Migrations, like the Harlem Renaissance, New Deal, World War II, and modern-day Civil Rights Movement, encouraged unprecedented societal transformations and major breeches in White supremacy, it failed to eradicate widespread poverty and structural racism for people of color. Some scholars today even suggest that the Great Migrations and other forms of passive resistance, known here as accommodation-activism, has perhaps hindered African American progress.[36] Nevertheless, the Great Migrations of the twentieth century did, without question, open doors of progress to millions of internal migrants, migrant families, their descendants, African American communities, and contemporary migrants/immigrants of these communities.

Notes

1. A more academic version of this article has been published in the *Journal of Urban History*. For more detailed citations, please see Bernadette Pruitt, "'For the Advancement of the Race': The Great Migrations to Houston, Texas, 1914–1941," *Journal of Urban History* 31 (May 2005): 435–78. Social Service Department Client Case Files, Box 11851–12651, Harris County Archives, Harris County Criminal Justice Center, Houston, Texas (hereafter cited as Social Service Case Files).

2. Cary D. Wintz, "Blacks in Houston Today," Historic Houston Online, http://www.houstonhistory.com/sitemap/history4b.htm, accessed May 12, 2005.

3. While Southern Pacific Railroad hired Blacks as skilled workers, the company used racial differentials and relegated the group to lower pay compared to Whites, classifying Black skilled employees as "helpers." Manuscript Census, Harris County, 1920, reel 1812–1814, Bureau of Census, Record Group T625, Clayton Genealogy Library, Houston, Texas.

4. Historian W. D. Wright makes a compelling case for the use of "Black," instead of "black," when defining people of African descent in the United States. According to Wright, middle-class, activist-oriented, and professional African Americans have in recent years urged society to capitalize the first letter in the word "black," when describing African Americans of the United States. This designates ethnicity, while "black," defines race and color. Wright also argues that this designation must and should be determined by African Americans, and not others. I have, therefore, decided to adopt "Black," when defining the race and ethnicity of people of African descent, instead of "black." To avoid controversy, I have also decided to use "White," when defining people of European descent, "Brown," when referring to people of Latin American descent, and so forth. See W. D. Wright, *Black History and Black Identity: A Call for a New Historiography* (Westport, Connecticut: Praeger, 2001), 1–21.

5. Social Service Case Files, Box 11851–12651; Bernadette Pruitt, "Domestic Workers," in *Encyclopedia of the Great Depression,* ed. Robert McElvaine (New York: Macmillan Reference USA, 2003), 241–44; Mary Romero, *Maid in the U.S.A, Tenth Anniversary Edition* (New York: Routledge, 2002), 65–142; Julia Kirk Blackwelder, *Now Hiring: The Feminization of Work in the United States, 1900–1995* (College Station: Texas A&M University Press, 1997), 65–166.

6. The estimated migration figure of 44,000 for the 1914–1945 period is predicated on census findings in net intercensal age cohort tables and National Housing Agency Reports for the Second World War.

For a detailed explanation of these census figures and all census information provided throughout this article, see Pruitt, "'For the Advancement of the Race,'" 435–78.

7. Gilbert Osofsky, *Harlem: The Making of a Ghetto, 1890–1930,* 2nd ed. (New York: Harper Torchbooks, 1971), ix, 17–19, 128–35; Allan Spear, *Black Chicago: The Making of a Negro Ghetto, 1890–1920* (Chicago: University of Chicago Press, 1967), vii–x, 11–12, 129–31.

8. Joe William Trotter, Jr., ed., "Introduction. Black Migration in Historical Perspective: A Review of the Literature," in *The Great Migration in Historical Perspective* (Bloomington: Indiana University, 1991); Earl Lewis, *In Their Own Interests: Race, Class, and Power in Twentieth Century Norfolk* (Berkeley: University of California Press, 1991), 1–30; Howard Dodson and Sylviane A. Diouf, ed., *In Motion: The African-American Migration Experience* (Washington, D.C.: National Geographic, 2004).

9. Howard O. Beeth and Cary D. Wintz, eds., "Economic and Social Development in Black Houston during the Era of Segregation" in *Black Dixie: Afro-Texan History and Culture in Houston* (College Station: Texas A&M Press, 1992), 88–89; Darlene Clark Hine, *Black Victory: The Rise and Fall of the White Primary in Texas,* rev. ed. (1979; repr., Columbia: University of Missouri Press, 2003), 43–45; Merline Pitre, *In Struggle against Jim Crow: Lulu B. White and the NAACP, 1900–1957* (College Station: Texas A&M University Press, 1999), 24–26.

10. For a thorough discussion of works that discuss the Great Migrations within the South, see Pruitt, "'For the Advancement of the Race,'" 435–78.

11. For a general description of rural-to-urban and small-town-to-city migration to Houston in the early decades of the twentieth century, see Bernadette Pruitt, "For the Advancement of the Race: African–American Migration and Community Building in Houston, 1914–1945," (PhD diss., University of Houston, 2001); For more on Latinos moving in the Texas industrial labor force during and immediately after World War I, see Rodolfo Acuña, *Occupied America: A History of Chicanos,* 5th ed. (New York: Longman, 2004), 148–202; Arnoldo De León, *Ethnicity in the Sunbelt: Mexican Americans in Houston,* 2nd ed. (College Station: Texas A&M University Press, 2003), 3–56. Emilio Zamora, *The World of the Mexican Worker in Texas* (College Station: Texas A&M University Press, 1993).

12. Marvin Hurley, *Decisive Years for Houston* (Houston: Houston Chamber of Congress, 1966), 43–47, 53–59, 415–17; Texas Almanac, 2002–2003: 2000 Census Data (Dallas: Dallas Morning News, 2001), 125–27, 287, 383–99; Joseph A. Pratt, *Growth of a Refining Region* (Greenwich, Connecticut: JAI Press, 1980), 19–23; 46–50, 83–85, 109–17.

13. Ibid.

14. Luther J. Adams, "African American Migration to Louisville in the Mid-Twentieth Century," *Register of the Kentucky Historical Society* 99, no. 4 (2001): 363–84; Robin Kelley, "We Are Not What We Seem: Rethinking Black Working-Class Opposition in the Jim Crow South," in *The New African American Urban History*, ed. Kenneth W. Goings and Raymond A. Mohl (Thousand Oaks, California: Sage Publications, 1995), 363–84.

15. Christopher Linsin, "Point of Conflict: Twentieth Century Black Migration and Urbanization," *Journal of Urban History* 21 (May 1995): 527–35.

16. John S. MacDonald and Leatrice D. MacDonald, "Chain Migration, Ethnic Neighborhood Formation and Social Networks," in *Millbank Memorial Fund Quarterly* 42 (1964): 82–97; Lewis, *In Their Own Interests,* 22–30.

17. Calvin L. Rhone to Lucia J. Rhone, December 20, 1920, Rhone Family Papers, 1860–1971, 3U171:2, Afro-American Collection, Center for American History, University of Texas-Austin; obituary of Calvin L. Rhone, Sr., Western Star, January 29, 1921, Rhone Family Papers, 3U180:1, Afro-American Collection, Center for American History, University of Texas-Austin.

18. Andrew Webster Jackson, *A Sure Foundation* (Houston: Webster-Richardson Publishing, 1940), 29–30.

19. Raymond Lewis, interview by author, February 14, 1998, Houston, Texas, in the possession of author; Carol Rust, "Frenchtown," *Houston Chronicle*, February 23, 1992; Houston Subdivisions—Frenchtown—Vertical File, Texas Room, Houston Public Library; Glenn R. Conrad and Carl A. Brasseaux, *Crevasse!: The 1927 Flood of Acadiana* (Lafayette: Center for Louisiana Studies, 1994), 1–30; Carl A. Brasseaux, Keith P. Fontenot, and Claude F. Oubre, *Creoles of Color in the Bayou Country* (Jackson: University Press of Mississippi, 1994), xi–xii, 40–67, 113–20.

20. Thelma Scott Bryant, interview by author, July 25, 1996, Houston, Texas; Joseph Williams, interview, February 13, 1998, Houston, Texas; Henry Coleman, interview by author, February 13, 1998, Houston, Texas; Hazel Young, interview by author, Houston, Texas, August 7, 1996; Vivian Hubbard Seals, interview by author, Houston, Texas, May 17, 1999 (all copies of interviews in possession of author); Jesse O. Thomas, *A Study of the Social Welfare Status of the Negro in Houston, Texas* (Houston: Webster-Richardson Publishing Co., 1929), 7–27; C. Calvin Smith, "The Houston Riot of 1917, Revisited," *The Houston Review: History and Culture on the Gulf Coast* 13 (Fall 1991): 85–102; Garna L. Christian, *Black Soldiers in Jim Crow Texas, 1899–1917* (College Station: Texas A&M University Press, 1985), 145–72.

21. Ernest Obadele-Starks, *Black Unionism in the Industrial South* (College Station: Texas A&M University Press), xv–38, 129–33.

22. Although this study relies on sample welfare applicants who received public assistance in the first half of the twentieth century, it primarily concentrates on the vast majority of Houston-area residents who did not receive assistance. Census materials and supporting sources such as oral histories, manuscript collections, church records, biographies, and memoirs point to the vast majority of Blacks in Houston who did not receive public aid from federal and local governments.

23. Although the census classified stevedores as unskilled workers, Jesse O. Thomas, a social worker for the National Urban League, referred to the members of the International Longshoremen's Association (ILA) as skilled laborers. See Thomas, *A Study of the Social Welfare Status of the Negro,* 9–18.

24. Jacqueline Jones, *Labor of Love, Labor of Sorrow: Black Women, Work, and the Family from Slavery to the Present* (New York: Basic Books, 1986), 110–34, 147; James M. SoRelle, "The Darker Side

of 'Heaven': The Black Community in Houston, Texas, 1917–1945" (PhD diss., Kent State University Press, 1980), 110–27; Ruthe Winegarten, *Black Texas Women: 150 Years of Trial and Triumph* (Austin: University of Texas Press, 1996), 156–57.

25. Darlene Clark Hine and Kathleen Thompson, *A Shining Thread of Hope: The History of Black Women in America* (New York: Broadway Books, 1998), 192–258.

26. William Henry Kellar, *Make Haste Slowly: Moderates, Conservatives, and School Desegregation in Houston* (College Station: Texas A&M University Press, 1999), 26–40; Jacqueline Jones, *Labor of Love, Labor of Sorrow*, 110–34, 147.

27. Randy J. Sparks, "'Heavenly Houston' or 'Hellish Houston'?: Black Unemployment and Relief Efforts, 1929–1936," *Southern Studies* 25 (Winter 1986), 355, 360; Lullelia Harrison, interview by author, September 23, 1999; Social Service Case Files, Boxes 24–1674, 1882–6600, 11851–12651, 12984–15153, 15170–16536, 17041–17821, 17286–17455, and WPA.

28. "God, Politics & Love: The Example of Rev. L. H. Simpson and Pleasant Hill Baptist Church," Box 1, Rev. L. H. Simpson & Pleasant Hill Baptist Church Collection, Houston Metropolitan Research Center, Houston Public Library (hereafter cited as Simpson Collection, HMRC, HPL); "Annual Statement, Financial Department, Pleasant Hill Baptist Church, 1934," Box 1, Folder 3, Simpson Collection, HMRC, HPL; "The Houston Community Chest: A Description of Nine Months Working with a Statement of Accounts and List of Subscribers with Amounts Pledged, 1930," Box 4, Folder 5, Simpson Collection, HMRC, HPL.

29. "Negro Workers and the National Defense," 2–3, Bureau of Training Industry Service, General Records, 1940–1945, War Manpower Commission, Record Group 211, National Archives College Park, Maryland; Housing and Urban Development, War Housing Program, WHP No. 5–Q3–C4, RG 207; Henry Allen Bullock, "Some Readjustments of the Texas Negro Family to the Emergency of War," *Southwestern Social Science Quarterly* 25 (June 1944–March 1945): 102–03; Neil Foley, *The White Scourge: Mexicans, Blacks, and Poor Whites in Texas Cotton Culture* (Berkeley: University of California Press, 1997), 163–82. The Houston–Harris County migration figures are based on the Ration Book No. 2 for Harris County.

30. Richard M. Dalfiume, "The 'Forgotten Years' of the Negro Revolution," *Journal of American History* 55 (June 1968), 95–96; Luther Stullivan, *Roots of the Stullivan Family* (Houston: n. p., 1981), 18–20.

31. Michael Botson, "Jim Crow Wearing Steel-Toed Shoes and Safety Glasses: Duel Unionism at the Hughes Tool Company," *Houston Review: History and Culture of the Gulf Coast* 16 (Winter 1994): 110–16.

32. Amilcar Shabazz, "Carter Wesley and the Making of Houston's Civic Culture before the Second Reconstruction," *Houston Review of History and Culture* 1 (Summer 2004): 2–12; Nancy Ruth Eckols Bessent, "The Publisher: The Autobiography of Carter Wesley" (master's thesis, University of Texas, 1981), 3–7; Ira Bryant, *The Development of Houston Negro Schools* (Houston: Informer Publishing Co., 1935), 93–97.

33. *Smith v. Allwright*, 321 U.S. 657–66 (1944); Robert V. Haynes, "Black Houstonians and the White Democratic Primary, 1920–45,"

in *Black Dixie: Afro-Texan History and Culture in Houston* (College Station: Texas A&M University Press, 1992), 197.

34. George McElroy, "Anna Dupree Looks with Pride on Her Life," *The Informer and Texas Freeman*, December 9, 1972, Box 1, Folder 5, Anna Dupree Collection, HMRC, HPL; Larry J. Jackson, "The Development of Black Business in Texas" (master's thesis, Texas Technical University, 1979), 58.

35. Barbara Vobejda, "Census Report Sees Big Shift of Blacks to Southern States," *Houston Chronicle,* January 9, 1998.

36. Maulana Karenga, *Introduction to Black Studies,* 3rd ed. (Los Angeles: University of Sankore Press, 2002), 134–35; Na'im Akbar, *Breaking the Chains of Psychological Slavery* (Tallahassee, Florida: Mind Productions & Associates, 1997), 1.

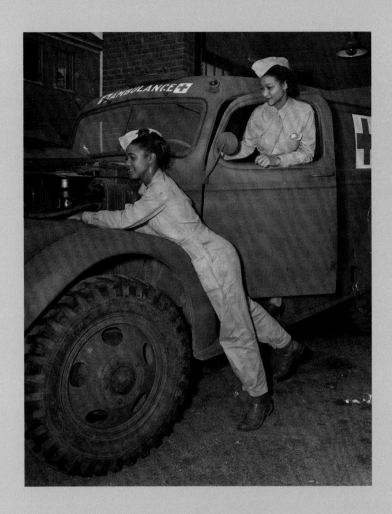

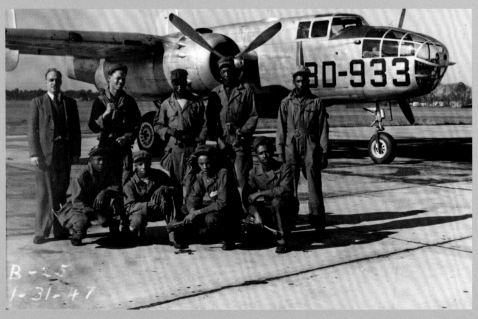

Top: Two United States Army Signal
Corps mechanics repairing an ambulance,
date and photographer unknown

U.S. Army Air Corps Fighter Group
No. 332, Columbus, Ohio, 1947.
Photographer unknown

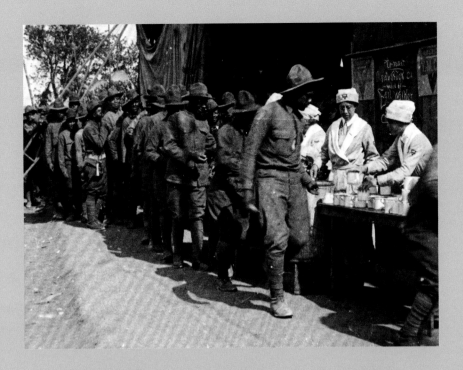

Top: Soldiers on a soup line at the YMCA,
1917. Photographer unknown

United States Army Sergeant Franklin
Williams poses for a portrait with his
family prior to his deployment, Baltimore,
1942. Photograph by Jack Delano

"The Year 1943"

The Afro-American (Baltimore, MD), January 1, 1944

Set 1943 down as a year of important gains.

No figures yet available, but estimates are that as many as 800,000 colored people have come north seeking war jobs. War Manpower Commission regulations still tie many agricultural workers to sharecropping but no bars yet prevent the movement of domestics, and it is from the ranks of these that the migration still continues.

The Army has enrolled 700,000 men. Some 5,000 of them are officers, including 300 chaplains. New regulations lift the ban on promotions above the rank of first lieutenant and open the door to the naming of staff officers. Three nursing units are overseas and the Women's Army Corps is accepting recruits.

In World War I there were over 400,000 colored soldiers and 1,300 officers, including 60 chaplains.

Today, four squadrons of pursuit flyers are at, or are en route to, the front, and new groups are being trained as bombers. Two combat divisions are in training and one of these is believed ready for overseas service.

As in World War I, most colored troops are in quartermasters and engineering services, and the proportion of colored officers is woefully small, but there is no doubt of the progress.

Color bars are still up in the Navy, which is to take a half million men this year and refuses to commission any colored men or enlist any colored women in the WAVES. There are no colored Navy doctors, nurses, or chaplains yet. The pressure increases daily. The question is, how long will the Navy be able to hold out?

Progress has been more rapid in the Coast Guard and Marine Corps, where colored units have found the going not so tough. Before this year, no colored men had been accepted as Marines.

Thanks to the National Maritime Union, the Merchant Marine leads all war-time units in recruiting and upgrading colored men. This is the one democratic arm of the service, where the color line has been abolished, and the races work together in perfect harmony.

The President's Fair Employment Practice Committee has compelled war industries to open half a million jobs for the first time to colored workers. It has lacked power to enforce its decisions and has been heckled by Congress and by Southern die-hards, but despite these handicaps it has made real gains in war-time employment.

In race relations we must debit 1943 with the New York and Detroit riots. They represent the failure of city and law-enforcement agencies rather than any curb to progress. In Detroit white people were the aggressors; in New York it was the colored people. Similar riots could have occurred anywhere. They evidence a pressure for, and a resistance to, new employment opportunities for colored workers.

The year has seen a renewed willingness on the part of religious and welfare organizations to plan for a better world. An increasing number of leaders, men and women, Wendell Willkie, Pearl Buck, Lillian Smith, Mrs. Franklin D. Roosevelt, Thomas E. Dewey, Herbert Agar, and Carey McWilliams, have come out for equal rights for all races. And behind them is a strong middle-class consciousness that our hypocritical public policy and religious practice are indefensible—that segregation must go.

The year 1944 will not be any easier than 1943. But not for 65 years has any new year offered us more genuine hope for a brighter day in which the colored American can see real freedom within his grasp.

EXODUS—1960 STYLE

Over a million and a half non-whites moved away from the south during the 1950-1960 period. Few returned. In 1900, 90 per cent of all colored people lived in the south. Today, the figure is 61 per cent.

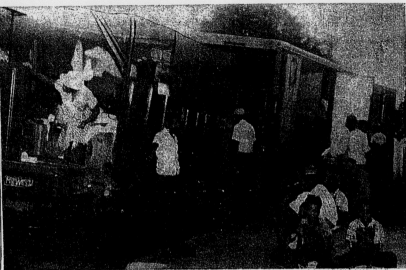

ON THE WAY—These migrants from the Carolin pause for a rest as they trek north to what they believe will be a promised land.

WASHINGTON (NNPA)—Nearly 1,500,000 persons of color left the South between 1950 and 1960 and settled in the North and West, the Census Bureau reported last week.

Estimates released by the bureau indicate that although most of them went North, the considerable migration west to California (which began in the 1940's) has been maintained.

More colored people, 323,000, left Mississippi during the decade than left any other state, and California added 254,000, the largest number of non-whites, to its population.

Although the term "non-white" is used in estimates, the Census Bureau noted, with particular reference to migration from the South, that the number of non-whites other than colored persons was negligible.

Explanation

The bureau did not explain the reasons for the continued migration, but many experts have had this subject under study for years.

Undoubtedly, mechanization on the farms in the South and the lack of opportunity are largely responsible for the trend.

Those who quit Dixie during the past decade also enhanced their political strength when they moved to the big Northern cities where their votes are sought after.

There is a feeling in some quarters that the migration of non-whites will assist the white Southerner in accommodating himself to desegregation in the long run.

90 per cent

The extraordinary movement of colored persons from the South during this century is demonstrated by the fact that 90 percent of the colored population of the United States lived in the South in 1900.

By 1920 this figure had declined to 85 percent; in 1950 it was 68 percent, and in 1960 about 61 percent.

About two-thirds of those leaving the South went to the north - eastern or north-central states in roughly equal numbers.

The remainder went farther west, most to California.

At the time of the 1960 census, the total population of the United States was said to be 88.6 percent white, in 159,000,000 people, with about 19,000,000, or 10.5 per cent being colored.

Although 36,000 colored citizens migrated to Maryland in 1950-60, the race population of the state remained at 16 percent.

Staging post

The Nation's Capital, which long has been a sort of staging post for colored people on their way north, had a net non-white immigration of 54,000, compared with about 61,000 in the 1940's.

Figures released by the Census Bureau indicate that the migration of colored people from the South has increased during every decade since the beginning of the Twentieth Century.

An exception is noted in the 1930's, when the "Great Depression" deprived the large industrial north-eastern and north-central states of their attraction.

1950

Figures published in 1950 showed there was very little colored migration from the North back to the South. Estimates at the time indicated that there were 2,600,000 colored people living in the North who had been born elsewhere; some 100,000 living in the South were not native-born.

While figures indicate that the migration of the past decade was a record, compared to 1,254,000 in the 1940's, there is some evidence that it is slowing down.

"Exodus—1960 Style," *The Afro-American*
(Baltimore), January 13, 1962

THE 1970 census will show that the United States has a population somewhat in excess of 205 million, an increase of about 25 million since the last census was taken in 1960. This will hardly come as a revelation, for sample surveys taken by the Bureau of the Census since the last complete count provide an accurate annual record of broad changes in the American population. The question has even been raised as to whether the nation might not dispense with a laborious head count every 10 years and substitute the cheaper and actually more reliable sample surveys to keep track of population growth and change. However, only a complete count can provide the detailed knowledge of individual states, counties, cities and smaller areas desired by many users of the census for political, commercial and scientific purposes. Indeed the primary reason for taking a census as prescribed by the Constitution is to discover shifts in the population of Congressional districts before reapportioning seats in the House of Representatives.

When the results of the 1970 census are finally tabulated and submitted to Congress in roughly eight months, they will doubtless contain a few surprises—perhaps the kind of unexpected finding produced by special censuses of Los Angeles and Cleveland in 1965. Those studies disclosed that the districts of Watts and Hough had experienced net losses of population since 1960 and that an insignificant number of new arrivals had come to Watts and Hough from outside the Los Angeles and Cleve-

DENNIS H. WRONG is a professor of sociology at New York University and the author of "Population and Society."

land metropolitan areas. Since both sections were the scenes of black rioting in the middle sixties, the conventional association of urban racial tensions with heavy black in-migration and resultant overcrowding obviously must be qualified.

Even though the census is likely to disclose little that is not already known about the broad outlines of recent population changes, coming as it does at the end of one decade and the beginning of another, it provides the full demographic context in which to locate the major events of the recent past and suggests the limits framing future social, economic and political trends. Our tendency to "periodize" American history into decades, each with its distinctive flavor, has no doubt been accentuated by the fact that censuses have been taken in all years ending in zero since 1790, though perhaps the founding fathers instituted the practice because they were also prone to the periodizing habit.

THE nineteen-sixties are generally regarded as a particularly troubled and turbulent decade. And for perhaps the very first time in American history, the turbulence is widely believed to have resulted, at least in part, from the sheer growth of the population. Thus, rather more significance than usual is likely to be attributed to the 1970 census figures on the size, growth and growth rate of the population. In the past the continuing growth of the American population has been viewed with indifference or complacency when "bigger" has not actually been equated with "better." Today, however, fears are widely expressed that population increase is the fundamental

cause of our major social problems and that America is at last approaching, if it has not already arrived at, a condition of overpopulation.

Concern over pollution and the ecological crisis is invariably linked to the pressures of continuing population growth. "Zero Population Growth" clubs have been created at some colleges. Several major political figures who have passed the Vietnam test (otherwise they would hardly be on campus) have been booed by student audiences for "copping out" when they have refused to commit themselves to laws restricting all couples to no more than two children. The proponents of a number of popular causes, initially espoused on a variety of moral and ideological grounds, frequently appeal to the specter of overpopulation as an addi-

tional argument on their behalf. Equal salaries and wages for women, liberalized abortion laws, tighter marriage laws and easier divorce laws, the distribution of contraceptives to coeds, greater tolerance of homosexuality, communal living arrangements to replace the traditional family, even the fears of genocide expressed by black militants have been justified with references to the "runaway" growth of the American population.

When I recently suggested at a campus symposium that alarm over population growth was excessive and that there were perhaps more immediately effective ways of combating environmental deterioration than prohibiting births, another panelist —a former editor of Ramparts, no less—accused me of gross irresponsibility, to the applause of the audience. The gist of my speech was that the population problems of the United States stemmed largely from population redistribution—in effect, from the "urban explosion"—rather than from sheer growth, in contrast to the nations of the Third World, where the need for eliminating rapid growth was a primary one if they were to achieve substantial economic progress.

My critic, who announced that he had difficulty restraining his temper while listening to me, maintained that my distinction between the situation of the United States and that of the overcrowded countries of the Third World reflected an "obsolete nationalism" if not "imperialism." He went on to cite scarifying figures on the worldwide per capita consumption of resources and the increased strain on them from every addition of a new child to the population. As I pointed out in my rejoinder, his vague and apocalyptic prophecies of worldwide famine and collapse before

What the census will show about us in the turbulent sixties
Portrait Of a Decade

By DENNIS H. WRONG

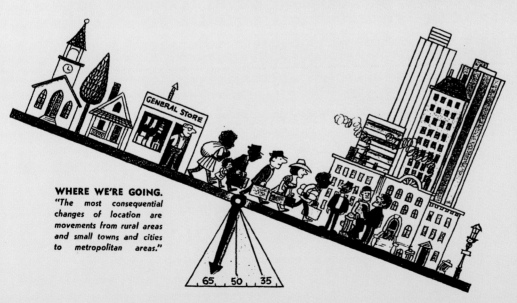

WHERE WE'RE GOING. "The most consequential changes of location are movements from rural areas and small towns and cities to metropolitan areas."

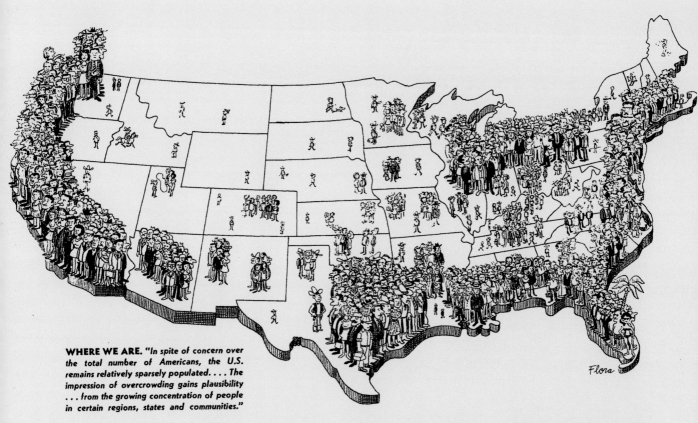

WHERE WE ARE. *"In spite of concern over the total number of Americans, the U.S. remains relatively sparsely populated. . . . The impression of overcrowding gains plausibility . . . from the growing concentration of people in certain regions, states and communities."*

the end of the century omitted any reference to the decline of the birth rate in America (and elsewhere) or to the reduction in desired family size reported by contemporary American women in recent surveys. He obviously felt that it was complacent of me at best and immoral at worst even to differentiate descriptively between the demographic condition of the United States and that of the Third World.

Later, an earnest young woman announced that she intended to contribute to a better world by refusing to bear more than one child, by selling her car and taking up hitchhiking and by giving up the use of detergents. She was congratulated by one of the speakers for truly "living her politics."

To what extent will the results of the census provide support for these fears? The answer, unfortunately, is unlikely to be clear-cut. The population increase of 25 million since 1960 is the second largest between censuses in the history of the nation, surpassed only by a jump of nearly 29 million in the nineteen-fifties. But viewed in relation to the population base from the preceding census, the increase in the sixties comes to just under 14 per cent, which—although it is nearly double the 7.2 per cent increase in the Depression-ridden thirties—is the second lowest intercensal increase on record. By 1969 the average increase of the American population was about 1 per cent a year, or less than half the world rate. These figures unmistakably confirm that the "baby boom" of the nineteen-forties and fifties, to which many of the alarmists are belatedly reacting, has come to an end. Yet the lower rates of increase are still well above zero, and the ever-growing size of the base population makes the apparently moderate growth rates somewhat deceptive if we translate the percentages into numbers of people added to the population each year or each decade. (It's like the compound-interest formula on savings accounts.)

CENSUSES, which give us snapshot pictures of the size and composition of the population once every 10 years, cannot by themselves provide information on the continuous changes the population undergoes as a result of births, deaths, immigration and emigration. The key to changes in the growth rate in the United States, as in other relatively advanced industrial countries, is the trend of the birth rate, which is determined by relating the number of births recorded by the National Office of Vital Statistics in a given period to a base population derived from the most recent census.

The slower rate of increase of the American population in the sixties reflects a decline of the birth rate that began in 1957. Yet the present age distribution of the population indicates that proportionately larger numbers of people, and specifically of women, will enter the age groups from which parents are recruited in the seventies than in the early sixties. These potential parents are, of course, the products of the "baby boom" after World War II. For example, infants born in 1957, the all-time banner year for American births, reached the age of 13 by 1970 and can be expected to have commenced reproducing themselves by 1980. The sheer numbers now entering the parental ages, a consequence of the high fertility of the fifties, will raise the birth rate in the decade to come even if these young people elect to have fewer children per capita than their parents had.

Thus, the concern over a continued population increase is justified for the immediate future. However, the very depth and extent of this concern, particularly on college campuses, suggests a disposition on the part of those voicing it to avoid the "moderate-sized"—that is, three- or four-child—families of the fifties. The enormous power of the mass media combined with the exposure of larger numbers of young people to the culture of the campus make it altogether possible that decisions on family size and the spacing of children will be directly influenced by fears of overpopulation *before* the more painful consequences of expanding numbers are actually experienced. A zero rate of population growth, therefore, appears within the range of possibility before the end of the century, if not by the end of the nineteen-eighties. Moreover,

(Continued on Page 25)

Above and following pages: Dennis Wrong, "Portrait of a Decade: What the census will show about us in the turbulent sixties," *New York Times*, August 2, 1970

Portrait of
a decade

(Continued from Page 23)
just as forecasts of "incipient population decline" continued to be advanced by demographers and other observers in the nineteen-forties *after* the rise in fertility was well under way, so the present concern about overpopulation comes *after* a trend toward smaller families has become manifest. The American crude birth rate (the number of births per thousand population) in 1968 was the lowest ever recorded, even lower than in the Depression.

No doubt the very rapid dissemination of "the pill" in the early sixties greatly increased general awareness of the degree to which family size is subject to personal choice. And with the widespread belief in a direct connection between population growth and environmental damage, the choice is readily converted into a moral issue, a matter of social conscience. Americans have used contraception to restrict the number of children they produce for nearly a century, but the invention of new and immensely effective contraceptive methods together with alarm over the effects of burgeoning population on the environment and the "quality of life" may for the first time have made total population growth a consideration influencing the child-bearing decisions of millions of people. Nor are current anxieties about the medical effects of the pill likely to counteract this new awareness, for alternative contraceptive methods remain available. The American birth rate, in fact, began its decline several years before the mass marketing of the pill and even more years before intra-uterine devices (I.U.D.'s) became available.

IN spite of the concern over the increase in the total number of Americans, the United States remains relatively sparsely populated, ranking behind Britain, Switzerland, Mexico and the Philippines—none of them considered strikingly overcrowded—in population density, or the average number of persons per square mile. The impression of overcrowding in the United States gains plausibility less from the over-all increase in numbers than from the growing concentration of people in certain regions, states and communities. In the nineteen-sixties, as in the past, internal migration made an important, though reduced, contribution to

changes in the distribution of the American population. Migration, moreover, has a "multiplier effect": because most migrants are young adults, they raise the birth rate of the areas to which they move and lower it in the areas they vacate.

California gained about 3.7 million people in the sixties, more than twice the roughly 1.5 million gained by Texas and New York, while Nevada, Arizona and Alaska showed the largest percentage increases among the states. Five states — North and South Dakota, Mississippi, West Virginia and Wyoming — experienced sufficiently large net out - migrations to result in small population declines. In general, the West and the Southwest continued to attract migrants from the rest of the country, while the North Central region suffered net out - migration. Between 1960 and 1968 fully one out of every three counties in the United States actually *lost* population.

Most of these counties were in a belt reaching from the agricultural Middle West southward to Texas and Louisiana and eastward across the South to Georgia and South Carolina, and most of them have been losing population ever since the thirties. Nearly *half* of all counties lost population in the fifties. The drop to one-third in the sixties reflects a general slowing up of migration. These facts sharply contradict prevalent visions of the inexorable filling up of the open spaces as a result of a population explosion. Actually, there is *more* open space in the United States today than there was a generation ago, and—even allowing for uninhabitable desert and mountain areas that were once rangeland or sites of mining towns—much of it is actual or potential farmland in the middle of the country.

The most consequential changes of location made by Americans are movements from rural areas and small towns and cities to metropolitan areas. The "urban explosion," rather than a general "population explosion," produces or contributes to the traffic jams, the clogging of transportation facilities, the strain on public services, air and water pollution and the defilement and disappearance of open countryside which create the sense of crisis and claustrophobia felt these days by so many Americans.

The term "urban" is no longer meaningful insofar as it suggests those clearly demarcated built-up areas we call "cities," for the bulk of

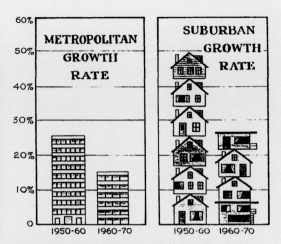

SLOW-UP. *"The sixties witnessed a continuation of the trends of the fifties at a slower rate. Metropolitan areas grew more rapidly than the national population, but their growth was greatest in the suburbs."*

the growth of the urban population since the twenties, and especially since World War II, has been in the suburban rings outside the central cities. The Bureau of the Census now distinguishes in its tabulations between *metropolitan* and *non-metropolitan* areas, the latter including both farm and non-farm residents of what were formerly called "rural areas" as well as all residents of cities and towns of less than 50,000. The shifts of population from nonmetropolitan to metropolitan areas, between metropolitan areas and from central cities to suburbs within metropolitan areas constitute the major changes in American population distribution.

THE sixties witnessed a continuation of the trends of the fifties, but at a slower rate. Metropolitan areas grew more rapidly than the national population, but their growth was greatest in the suburbs. The over-all metropolitan rate of growth was roughly 14.5 per cent, as compared with 26.5 per cent in the fifties, a growth rate about 2 per cent higher than that of the population as a whole. Just under two-thirds of our population now lives in metropolitan areas. The metropolitan growth was concentrated in the suburbs, which increased by 26.5 per cent, as compared with a growth rate of 49 per cent for the fifties. By the end of the sixties, central cities had replaced nonmetropolitan areas as the slowest-growing areas. Their increase was only 1.3 per cent, and such cities as Buffalo, Cleveland, Des Moines, Louisville, New Haven and Rochester were shown to have lost population by spe-

cial censuses taken since 1960. The 1970 census will undoubtedly disclose similar declines in many more cities.

The suburbs and the real or alleged characteristics of suburbanites received a lot of attention, mostly unfavorable, from sociologists and social critics in the fifties. Although the movement to the suburbs continued throughout the sixties, attention shifted to the problems of the central cities and the economic plight of their residents. The reason, of course, is primarily race: the growing concentration of Negroes in the central cities, replacing white migrants to the suburbs and becoming a larger proportion of the city population when whites move out. Which trend—black in-migration or white out-migration—predominated in specific cities will not be ascertainable until the detailed tabulations of the new census become available.

By 1969, however, more than half of the total Negro population, 55.2 per cent, lived in central cities. Washington, D. C., was still the only large city with more Negroes (69 per cent) than whites, but in Newark the population was almost evenly divided, and the proportion of blacks in the populations of Baltimore, New Orleans, Memphis and Atlanta was estimated at 40 per cent or slightly more in the late sixties. Except for Newark, the only Northern city close to 40 per cent was Detroit, which had 39 per cent. Perhaps the racial battleground will shift back to the South in the decade ahead, but this time it is likely to be centered in the urban South.

The gross changes since 1960 in the distribution of the

Many have seen the 60's as a crucial transition period

races by residence were not, however, as great as they are often believed to have been. The proportion of the total white population living in central cities declined between 1960 and 1969 by about 4 per cent (from 30 to 25.8), while the suburban proportion went up by 5 per cent (from 33.1 to 38); the proportion of the total black population in central cities increased by nearly 4 per cent (from 51.5 to 55.2) and in the suburbs by just over 1 per cent (from 13.2 to 14.7). Since 1966 the central cities have been losing an average of half a million persons a year, the result of a net white out-migration exceeding the growth of the black population. One-third of the black increase is a result of net in-migration, the remainder of natural increase (the excess of births over deaths). As these figures indicate, the trend toward racial polarization between the cities and the suburbs, which became clearly established nearly 30 years ago, continues relentlessly in spite of widespread alarm and policies aimed at arresting it.

Yet since 1968 there have appeared for the first time signs of a sharply accelerated movement of Negroes to the suburbs, especially the inner suburbs, along with a decline in the rate of growth of black populations in central cities. The numbers involved are still small, but the new trend may be significant. What its continuation might imply for future race relations is uncertain. It could reduce the polarization of white suburbs and black cities, but it could also extend the pattern of polarization outward from the central city to embrace the inner suburban rings as well.

THE findings of the new census on the situation of Negroes, especially on social and economic differentials between whites and Negroes, are likely to receive closer and more critical scrutiny than any of its other conclusions. Even the taking of the census and the procedures followed have become a sensitive issue. A few black militant groups urged their followers to refuse to answer the census takers' questions, but a far larger number of black leaders counseled cooperation, promoted the slogan "it pays to be counted" and

promised vigilance in overseeing the performance of the Bureau of the Census to insure a full and honest count.

Sensitive to charges of underenumeration of Negroes, the bureau was determined this year to avoid any repetition of the 1960 census, in which, according to its own estimate, as many as 14 per cent of all Negro males (as against only 2 per cent of white males) were not counted. But since the new census was taken at the end of March, there have been complaints from black community groups that many blacks in the big-city slums were missed again or were unable to complete the mail questionnaire sent to residents of large metropolitan areas. The tabulation of the census has, in fact, been delayed while the bureau investigates these and other complaints.

The issue is crucial because the poorest and most deprived blacks are the most likely to be missed. The statistics would therefore falsely upgrade the socio-economic status of Negroes and understate their relative disadvantages vis-à-vis whites. Such errors would, of course, be magnified in districts with large black populations.

However, even if substantial underenumeration of poor urban Negroes is avoided—or if it is generally believed to have been avoided—the census reports on the condition of Negroes are certain to be subject to varying and conflicting interpretations. During the sixties the Bureau of the Census, in collaboration with the Bureau of Labor Statistics, issued periodic reports on the characteristics of the Negro population. The most recent of these, "The Social and Economic Status of Negroes in the United States, 1969," has attracted some attention from public officials, journalists and social scientists. Its findings will be checked against the more exhaustive and detailed breakdowns of the complete census.

This 1969 report showed that Negroes were, as they had been in 1960, about 11 per cent of the population. Their fertility rates were somewhat higher than those of whites, but had followed the same upward and downward movements since 1950. Fifty-five per cent of all Negroes still lived in the South, an 8 per cent decline since 1960. Net migration of Ne-

groes out of the South was still considerable, but continued to decline from the peak volume of the nineteen-forties.

Negro median family income was, by 1968, 60 per cent of the white level, a 6 per cent increase in the ratio since 1960. In the South, however, Negro income was slightly more than half of white income; in the other regions it ranged from 69 per cent in the Northeast to 80 per cent in the West. In 1968, one-third of all nonwhite families had incomes of $8,000 or more, as compared with only 15 per cent in 1960; the proportions for whites were 58 per cent in 1968 and 39 per cent in 1960, indicating a slightly higher relative gain for whites. On the other hand, 29 per cent of Negro families had incomes below the poverty line ($3,553 for a nonfarm family of four in 1968) as opposed to only 8 per cent of white families; in 1959 the proportions were 48 per cent for Negroes and 15 per cent for whites. The decline in poverty was somewhat greater for whites.

The unemployment rate in 1969 for nonwhites was the lowest since the Korean war, but was still double the white rate. Between 1960 and 1969 the percentage of workers in highly skilled occupations increased more rapidly for Negroes and other races than for whites, and nonwhites also experienced a greater decrease in persons employed as laborers, domestic servants and in farm occupations. In spite of large relative gains, nonwhites were still represented in the two most skilled and best paying occupational groups (professionals and managers) by less than half their proportion of the total population. In education, the percentage of Negroes enrolled at every level from nursery school to college increased sharply during the sixties. The percentage of Negro males aged 25 to 29 who had completed four or more years of high school rose from 36 in 1960 to 60 in 1969; the comparable figures for whites were 63 and 78.

I MIGHT go on and summarize data on housing, living conditions and health, the family, military status and voting participation. But they tell a similar story of absolute black gains in all areas, some relatively greater than for whites, others relatively lesser, and the persistence of wide differentials favoring whites in most areas. The fact that the circumstances of blacks have improved, however modestly and starting from what-

ever low levels, needs stressing because I have found that the presentation of the statistical evidence is greeted by students — and not only by students — with amazement and incredulity. Lacking any historical perspective and having so recently "discovered" the unfavorable position of blacks in American society, students find it very hard to believe that *any* progress can have taken place, especially during the years of the iniquitous Vietnam war. Suspicious of statistical abstraction by contrast with "lived experience" and raised in comfortable suburbs where there was little visible evidence of pov-

66There have appeared signs of an accelerated movement of Negroes to the suburbs . . . What this implies for race relations is uncertain.99

erty or the squalor of black ghettos, they often seem to feel that the sheer existence of the latter refutes any quantitative indications of improvement. There is also the tendency, common to liberals as well as those students who define themselves as radicals, to evaluate the present by the ideal standard of full equality, whereas statistical trends inevitably compare the present with the past. As a result, one finds a strong disposition to dismiss the evidence in toto as an apologia for evil, or even as a pack of self-serving lies put out by the "Establishment."

Few of the advances made are remarkable, and the "glass of water" parable clearly applies to them: optimists may declare the glass "half full" while pessimists are at liberty to describe it as "half empty." Both, of course, are right. One may also select from the statistics to stress for polemical purposes either absolute differences between blacks and whites, relative differences or unequal rates of change in a wide variety of areas. All demographic data lend themselves to such manipulation. From the standpoint of proclaimed aspirations, rhetorical commitments and time and

energy — if not money — invested at all levels of government as well as by private organizations in efforts to right the historical injustice of the Negro's position in American society, one may readily conclude that a mountain labored throughout the sixties to bring forth a mouse. Moreover, some gains registered by blacks may owe less to policies adopted than to unplanned consequences of other, possibly transitory, circumstances such as a temporarily favorable age distribution among Negroes or the effects on the economy and on employment of the Vietnam war.

Yet there *have* been real gains, and the rate of improvement *has* quickened. The record hardly indicates total neglect, whether "benign" or otherwise. It is unlikely that the fuller data to be provided by the new census will reverse or even greatly modify this general conclusion.

IN general, except for the beginning of a trend toward relative improvement in the position of Negroes in several areas, the demographic profile of the nineteen-sixties shows no dramatic reversals of direction either in the overall growth pattern of the American population, in its distribution or in its major social and economic characteristics. Trends that began at the end of the Depression or even earlier in the century continued, though at slower rates. Even the significant decline in fertility commenced, as we have seen, in the late fifties.

Many people have seen the sixties as a crucial transition decade in American life, whether as the beginning of the decline of the republic or as a breakthrough to a new and hopeful social transformation. The demographic indices, however, reveal no startling changes—in contrast, for instance, to the Depression decade, when most major social and economic trends, even rural-to-urban migration, were temporarily reversed. But this is to be expected; population movements have a momentum of their own and change more slowly than our political and cultural responses to the world around us. Often we become aware of and react against the consequences of population trends only when they have already begun, almost imperceptibly, to change. Perhaps the demographic trends of the sixties will be seen in retrospect to have been more of a turning point than is apparent now. ∎

"I will gladly take position in northern city or county where a mans a man here are a few positions which I am capable of holding down. Laborer, expirance porter, butler or driver of Ford car. Thaking you in advance for your kindness, beg to remain."

NEW ORLEANS, LA, APRIL 23, 1917

"The Long-Lasting Legacy of the Great Migration"

Isabel Wilkerson

Smithsonian Magazine, September 2016

In 1963, the American mathematician Edward Lorenz, taking a measure of the earth's atmosphere in a laboratory that would seem far removed from the social upheavals of the time, set forth the theory that a single "flap of a sea gull's wings" could redirect the path of a tornado on another continent, that it could, in fact, be "enough to alter the course of the weather forever," and that, though the theory was then new and untested, "the most recent evidence would seem to favor the sea gulls."

At that moment in American history, the country had reached a turning point in a fight for racial justice that had been building for decades. This was the year of the killing of Medgar Evers in Mississippi, of the bombing of the 16th Street Baptist Church in Birmingham, of Gov. George Wallace blocking black students at the schoolhouse door of the University of Alabama, the year of the March on Washington, of Martin Luther King Jr.'s "I Have a Dream" speech and his "Letter From a Birmingham Jail." By then, millions of African Americans had already testified with their bodies to the repression they had endured in the Jim Crow South by defecting to the North and West in what came to be known as the Great Migration. They were fleeing a world where they were restricted to the most menial of jobs, underpaid if paid at all, and frequently barred from voting. Between 1880 and 1950, an African American was lynched more than once a week for some perceived breach of the racial hierarchy.

"They left as though they were fleeing some curse," wrote the scholar Emmett J. Scott, an observer of the early years of the migration. "They were willing to make almost any sacrifice to obtain a railroad ticket and they left with the intention of staying."

The migration began, like the flap of a sea gull's wings, as a rivulet of black families escaping Selma, Alabama, in the winter of 1916. Their quiet departure was scarcely noticed except for a single paragraph in the *Chicago Defender*, to whom they confided that "the treatment doesn't warrant staying." The rivulet would become rapids, which grew into a flood of six million people journeying out of the South over the course of six decades. They were seeking political asylum within the borders of their own country, not unlike refugees in other parts of the world fleeing famine, war and pestilence. Until that moment and from the time of their arrival on these shores, the vast majority of African Americans had been confined to the South, at the bottom of a feudal social order, at the mercy of slaveholders and their descendants and often-violent vigilantes. The Great Migration was the first big step that the nation's servant class ever took without asking.

"Oftentimes, just to go away is one of the most aggressive things that another person can do," wrote John Dollard, an anthropologist studying the racial caste system of the South in the 1930s, "and if the means of expressing discontent are limited, as in this case, it is one of the few ways in which pressure can be put on."

The refugees could not know what was in store for them and for their descendants at their destinations or what effect their exodus would have on the country. But by their actions, they would reshape the social and political geography of every city they fled to. When the migration began, 90 percent of all African Americans were living in the South. By the time it was over, in the 1970s, 47 percent of all African Americans were living in the North and West. A rural people had become urban, and a Southern people had spread themselves all over the nation.

Merely by leaving, African Americans would get to participate in democracy and, by their presence, force the North to pay attention to the injustices in the South and the increasingly organized fight against those injustices. By leaving, they would change the course of their lives and those of their children. They would become Richard Wright the novelist instead of Richard Wright the sharecropper. They would become John Coltrane, jazz musician instead of tailor; Bill Russell, NBA pioneer instead of paper mill worker; Zora Neale Hurston, beloved folklorist instead of maidservant. The children of the Great Migration would reshape professions that, had their families not left, may never have been open to them, from sports and music to literature and art: Miles Davis, Ralph Ellison, Toni Morrison, August Wilson, Jacob Lawrence, Diana Ross, Tupac Shakur, Prince, Michael Jackson, Shonda Rhimes, Venus and Serena Williams and countless others. The people who migrated would become the forebears of most African Americans born in the North and West.

The Great Migration would expose the racial divisions and disparities that in many ways continue to plague the nation and dominate headlines today, from police killings of unarmed African Americans to mass incarceration to widely documented biases in employment, housing, health care and education. Indeed, two of the most tragically recognizable descendants of the Great Migration are Emmett Till, a 14-year-old Chicago boy killed in Mississippi in 1955, and Tamir Rice, a 12-year-old Cleveland boy shot to death by police in 2014 in the city where his ancestors had fled. Their fates are a reminder that the perils the people sought to escape were not confined to the South, nor to the past.

The history of African Americans is often distilled into two epochs: the 246 years of enslavement ending after the close of the Civil War, and the dramatic era

of protest during the civil rights movement. Yet the Civil War-to-civil rights axis tempts us to leap past a century of resistance against subjugation, and to miss the human story of ordinary people, their hopes lifted by Emancipation, dashed at the end of Reconstruction, crushed further by Jim Crow, only to be finally, at long last, revived when they found the courage within themselves to break free.

<center>***</center>

A little boy boarded a northbound train with his grandmother and extended family, along with their upright piano and the rest of their worldly possessions, stuffed inside wooden crates, to begin their journey out of Mississippi. It was 1935. They were packed into the Jim Crow car, which, by custom, was at the front of the train, the first to absorb the impact in the event of a collision. They would not be permitted into the dining car, so they carried fried chicken and boiled eggs to tide them over for the journey.

The little boy was 4 years old and anxious. He'd overheard the grown-ups talking about leaving their farm in Arkabutla, to start over up north. He heard them say

they might leave him with his father's people, whom he didn't know. In the end they took him along. The near abandonment haunted him. He missed his mother, who would not be joining them on this journey; she was away trying to make a stable life for herself after the breakup with his father. He did not know when he would see her again. His grandfather had preceded them north. He was a hardworking, serious man who kept the indignities he suffered under Jim Crow to himself. In Mississippi, he had not dared stand up to some white children who broke the family's wagon. He told the little boy that as black people, they had no say in that world. "There were things they could do that we couldn't," the boy would say of the white children when he was a grown man with gray hair and a son of his own.

The grandfather was so determined to get his family out of the South that he bought a plot of land sight unseen in a place called Michigan. On the trip north, the little boy and his cousins and uncles and aunts (who were children themselves) did not quite know what Michigan was, so they made a ditty out of it and sang it as they waited for the train. "Meatskin! Meatskin! We're going to Meatskin!" They landed on freer soil, but

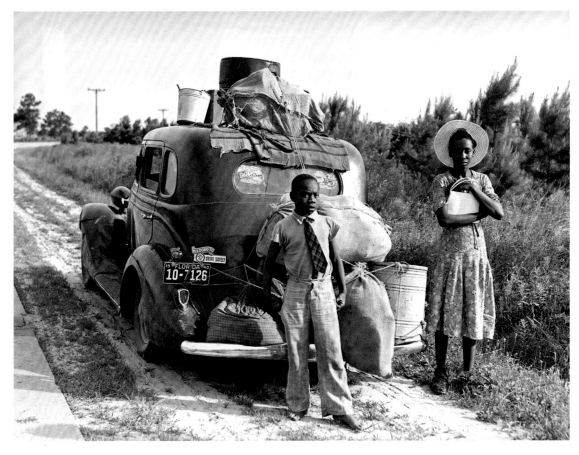

An African-American family leaves Florida for the North during the Great Depression

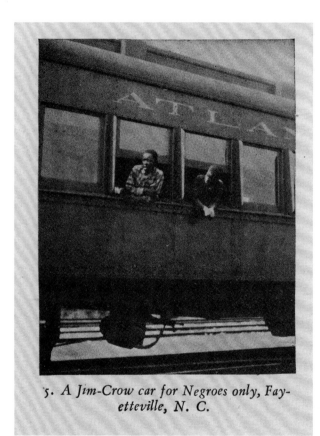

If You are a Stranger in the City

If you want a job If you want a place to live
If you are having trouble with your employer
If you want information or advice of any kind
CALL UPON

The CHICAGO LEAGUE ON URBAN
CONDITIONS AMONG NEGROES

3719 South State Street

Telephone Douglas 9098 T. ARNOLD HILL, Executive Secretary

No charges—no fees. We want to help YOU

Chicago League on Urban Conditions job
advertisement card, c. 1920

5. A Jim-Crow car for Negroes only, Fay-
etteville, N. C.

African-Americans fled on foot and by
car, bus, and ferry, but most commonly by
train, where they were seated up front in
the Jim Crow car, closer to the engine's
smoke and cinders.

between the fears of abandonment and the trauma of
being uprooted from his mother, the little boy arrived
with a stutter. He began to speak less and less. At Sunday
school, the children bellowed with laughter whenever
he tried. So instead, he talked to the hogs and cows and
chickens on the farm, who, he said years later, "don't
care how you sound."

The little boy went mute for eight years. He wrote
down the answers to questions he was asked, fearing
even to introduce himself to strangers, until a high school
English teacher coaxed him out of his silence by having
him read poetry aloud to the class. That boy was James
Earl Jones. He would go on to the University of Mich-
igan, where he abandoned pre-med for theater. Later
he would play King Lear in Central Park and Othello
on Broadway, win Tony Awards for his performances
in *Fences* and in *The Great White Hope* and star in films
like *Dr. Strangelove*, *Roots*, *Field of Dreams* and *Coming
to America*. The voice that fell silent for so long would
become among the most iconic of our time—the voice of
Darth Vader in *Star Wars*, of Mufasa in *The Lion King*,
the voice of CNN. Jones lost his voice, and found it,
because of the Great Migration. "It was responsible for
all that I am grateful for in my life," he told me in a recent
interview in New York. "We were reaching for our gold
mines, our freedom."

The desire to be free is, of course, human and univer-
sal. In America, enslaved people had tried to escape
through the Underground Railroad. Later, once freed
on paper, thousands more, known as Exodusters, fled
the violent white backlash following Reconstruction
in a short-lived migration to Kansas in 1879. But con-
centrated in the South as they were, held captive by the
virtual slavery of sharecropping and debt peonage and
isolated from the rest of the country in the era before
airlines and interstates, many African Americans had
no ready means of making a go of it in what were then
faraway alien lands.

By the opening of the 20th century, the optimism of
the Reconstruction era had long turned into the terror of
Jim Crow. In 1902, one black woman in Alabama seemed
to speak for the agitated hearts that would ultimately
propel the coming migration: "In our homes, in our
churches, wherever two or three are gathered together,"
she said, "there is a discussion of what is best to do. Must
we remain in the South or go elsewhere? Where can we
go to feel that security which other people feel? Is it best
to go in great numbers or only in several families? These
and many other things are discussed over and over."

The door of escape opened during World War I,
when slowing immigration from Europe created a labor
shortage in the North. To fill the assembly lines, compa-
nies began recruiting black Southerners to work the steel
mills, railroads and factories. Resistance in the South to
the loss of its cheap black labor meant that recruiters
often had to act in secret or face fines and imprison-
ment. In Macon, Georgia, for example, a recruiter's
license required a $25,000 fee plus the unlikely recom-
mendations of 25 local businessmen, ten ministers and
ten manufacturers. But word soon spread among black

Southerners that the North had opened up, and people began devising ways to get out on their own.

Southern authorities then tried to keep African Americans from leaving by arresting them at the railroad platforms on grounds of "vagrancy" or tearing up their tickets in scenes that presaged tragically thwarted escapes from behind the Iron Curtain during the Cold War. And still they left. On one of the early trains out of the South was a sharecropper named Mallie Robinson, whose husband had left her to care for their young family under the rule of a harsh plantation owner in Cairo, Georgia. In 1920, she gathered up her five children, including a baby still in diapers, and, with her sister and brother-in-law and their children and three friends, boarded a Jim Crow train, and another, and another, and didn't get off until they reached California.

They settled in Pasadena. When the family moved into an all-white neighborhood, a cross was burned on their front lawn. But here Mallie's children would go to integrated schools for the full year instead of segregated classrooms in between laborious hours chopping and picking cotton. The youngest, the one she had carried in her arms on the train out of Georgia, was named Jackie, who would go on to earn four letters in athletics in a single year at UCLA. Later, in 1947, he became the first African American to play Major League Baseball.

Had Mallie not persevered in the face of hostility, raising a family of six alone in the new world she had traveled to, we might not have ever known his name. "My mother never lost her composure," Jackie Robinson once recalled. "As I grew older, I often thought about the courage it took for my mother to break away from the South."

Mallie was extraordinary in another way. Most people, when they left the South, followed three main tributaries: the first was up the East Coast from Florida, Georgia, the Carolinas and Virginia to Washington, D.C., Baltimore, Philadelphia, New York and Boston; the second, up the country's central spine, from Alabama, Mississippi, Tennessee and Arkansas to St. Louis, Chicago, Cleveland, Detroit and the entire Midwest; the third, from Louisiana and Texas to California and the Western states. But Mallie took one of the farthest routes in the continental U.S. to get to freedom, a westward journey of more than 2,200 miles.

The trains that spirited the people away, and set the course for those who would come by bus or car or foot, acquired names and legends of their own. Perhaps the most celebrated were those that rumbled along the Illinois Central Railroad, for which Abraham Lincoln had worked as a lawyer before his election to the White House, and from which Pullman porters distributed copies of the *Chicago Defender* in secret to black Southerners hungry for information about the North. The Illinois Central was the main route for those fleeing Mississippi

Jackie Robinson

for Chicago, people like Muddy Waters, the blues legend who made the journey in 1943 and whose music helped define the genre and pave the way for rock 'n' roll, and Richard Wright, a sharecropper's son from Natchez, Mississippi, who got on a train in 1927 at the age of 19 to feel what he called "the warmth of other suns."

In Chicago, Wright worked washing dishes and sweeping streets before landing a job at the post office and pursuing his dream as a writer. He began to visit the library: a right and pleasure that would have been unthinkable in his home state of Mississippi. In 1940, having made it to New York, he published *Native Son* to national acclaim, and, through this and other works, became a kind of poet laureate of the Great Migration. He seemed never to have forgotten the heartbreak of leaving his homeland and the courage he mustered to step into the unknown. "We look up at the high Southern sky," Wright wrote in *12 Million Black Voices*. "We scan the kind, black faces we have looked upon since we first saw the light of day, and, though pain is in our hearts, we are leaving."

Zora Neale Hurston arrived in the North along the East Coast stream from Florida, although, as was her way, she broke convention in how she got there. She had grown up as the willful younger daughter of an exacting preacher and his long-suffering wife in the all-black town of Eatonville. After her mother died, when she was 13, Hurston bounced between siblings and neighbors until she was hired as a maid with a traveling theater

troupe that got her north, dropping her off in Baltimore in 1917. From there, she made her way to Howard University in Washington, where she got her first story published in the literary magazine *Stylus* while working odd jobs as a waitress, maid and manicurist.

She continued on to New York in 1925 with $1.50 to her name. She would become the first black student known to graduate from Barnard College. There, she majored in English and studied anthropology, but was barred from living in the dormitories. She never complained. In her landmark 1928 essay "How It Feels to Be Colored Me," she mocked the absurdity: "Sometimes, I feel discriminated against, but it does not make me angry," she wrote. "It merely astonishes me. How can any deny themselves the pleasure of my company? It's beyond me."

She arrived in New York when the Harlem Renaissance, an artistic and cultural flowering in the early years of the Great Migration, was in full bloom. The influx to the New York region would extend well beyond the Harlem Renaissance and draw the parents or grandparents of, among so many others, Denzel Washington (Virginia and Georgia), Ella Fitzgerald (Newport News, Virginia), the artist Romare Bearden (Charlotte, North Carolina), Whitney Houston (Blakeley, Georgia), the rapper Tupac Shakur (Lumberton, North Carolina), Sarah Vaughan (Virginia) and Althea Gibson (Clarendon County, South Carolina), the tennis champion who, in 1957, became the first black player to win at Wimbledon.

From Aiken, South Carolina, and Bladenboro, North Carolina, the migration drew the parents of Diahann Carroll, who would become the first black woman to win a Tony Award for best actress and, in 1968, to star in her own television show in a role other than a domestic. It was in New York that the mother of Jacob Lawrence settled after a winding journey from Virginia to Atlantic City to Philadelphia and then on to Harlem. Once there, to keep teenage Jacob safe from the streets, she enrolled her eldest son in an after-school arts program that would set the course of his life.

Lawrence would go on to create *The Migration Series*—60 painted panels, brightly colored like the throw rugs his mother kept in their tenement apartment. The paintings would become not only the best-known images of the Great Migration but among the most recognizable images of African Americans in the 20th century.

Yet throughout the migration, wherever black Southerners went, the hostility and hierarchies that fed the Southern caste system seemed to carry over into the receiving stations in the New World, as the cities of the North and West erected barriers to black mobility. There were "sundown towns" throughout the country that banned African Americans after dark.

The constitution of Oregon explicitly prohibited black people from entering the state until 1926; whites-only signs could still be seen in store windows into the 1950s.

Even in the places where they were permitted, blacks were relegated to the lowest-paying, most dangerous jobs, barred from many unions and, at some companies, hired only as strike breakers, which served to further divide black workers from white. They were confined to the most dilapidated housing in the least desirable sections of the cities to which they fled. In densely populated destinations like Pittsburgh and Harlem, housing was so scarce that some black workers had to share the same single bed in shifts.

When African Americans sought to move their families to more favorable conditions, they faced a hardening structure of policies and customs designed to maintain racial exclusion. Restrictive covenants, introduced as a response to the influx of black people during the Great Migration, were clauses written into deeds that outlawed African Americans from buying, leasing or living in properties in white neighborhoods, with the exception, often explicitly spelled out, of servants. By the 1920s, the widespread use of restrictive covenants kept as much as 85 percent of Chicago off-limits to African Americans.

At the same time, redlining—the federal housing policy of refusing to approve or guarantee mortgages in areas where black people lived—served to deny them access to mortgages in their own neighborhoods. These policies became the pillars of a residential caste system in the North that calcified segregation and wealth inequality over generations, denying African Americans the chance accorded other Americans to improve their lot.

In the 1930s, a black couple in Chicago named Carl and Nannie Hansberry decided to fight these restrictions to make a better life for themselves and their four young children. They had migrated north during World War I, Carl from Mississippi and Nannie from Tennessee. He was a real estate broker, she was a schoolteacher, and they had managed to save up enough to buy a home.

They found a brick three-flat with bay windows in the all-white neighborhood of Woodlawn. Although other black families moving into white neighborhoods had endured firebombings and mob violence, Carl wanted more space for his family and bought the house in secret with the help of progressive white real estate agents he knew. He moved the family late in the spring of 1937. The couple's youngest daughter, Lorraine, was 7 years old when they first moved, and she later described the vitriol and violence her family met in what she called a "hellishly hostile 'white neighborhood'" in which literally howling mobs surrounded our house." At one point a mob descended on the home to throw bricks and broken concrete, narrowly missing her head.

But not content simply to terrorize the Hansberrys, neighbors then filed a lawsuit, forcing the family to move

out, backed by state courts and restrictive covenants. The Hansberrys took the case to the Supreme Court to challenge the restrictive covenants and to return to the house they bought. The case culminated in a 1940 Supreme Court decision that was one of a series of cases that together helped strike a blow against segregation. But the hostility continued.

Lorraine Hansberry later recalled being "spat at, cursed and pummeled in the daily trek to and from school. And I also remember my desperate and courageous mother, patrolling our household all night with a loaded German Luger, doggedly guarding her four children, while my father fought the respectable part of the battle in the Washington court."

In 1959, Hansberry's play *A Raisin in the Sun*, about a black family on Chicago's South Side living in dilapidated housing with few better options and at odds over what to do after the death of the patriarch, became the first play written by an African American woman to be performed on Broadway. The fight by those who migrated and those who marched eventually led to the Fair Housing Act of 1968, which made such discriminatory practices illegal. Carl Hansberry did not live to see it. He died in 1946 at age 50 while in Mexico City, where, disillusioned with the slow speed of progress in America, he was working on plans to move his family to Mexico.

The Buckeye Steel Castings Company in Columbus, Ohio

The Great Migration laid bare tensions in the North and West that were not as far removed from the South as the people who migrated might have hoped. Martin Luther King Jr., who went north to study in Boston, where he met his wife, Coretta Scott, experienced the depth of Northern resistance to black progress when he was campaigning for fair housing in Chicago decades after the Hansberrys' fight. He was leading a march in Marquette Park, in 1966, amid fuming crowds. One placard said: "King would look good with a knife in his back." A protester hurled a stone that hit him in the head. Shaken, he fell to one knee. "I have seen many demonstrations in the South," he told reporters. "But I have never seen anything so hostile and so hateful as I've seen here today."

Out of such turmoil arose a political consciousness in a people who had been excluded from civic life for most of their history. The disaffected children of the Great Migration grew more outspoken about the worsening conditions in their places of refuge. Among them was Malcolm X, born Malcolm Little in 1925 in Omaha, Nebraska, to a lay minister who had journeyed north from Georgia, and a mother born in Grenada. Malcolm was 6 years old when his father, who was under continuous attack by white supremacists for his role fighting for civil rights in the North, died a violent, mysterious death that plunged the family into poverty and dislocation.

Despite the upheaval, Malcolm was accomplished in his predominantly white school, but when he shared his dream of becoming a lawyer, a teacher told him that the law was "no realistic goal for a n-----." He dropped out soon afterward.

He would go on to become known as Detroit Red, Malcolm X and el-Hajj Malik el-Shabazz, a journey from militancy to humanitarianism, a voice of the dispossessed and a counterweight to Martin Luther King Jr. during the civil rights movement.

At around the same time, a radical movement was brewing on the West Coast. Huey Newton was the impatient son of a preacher and itinerant laborer who left Louisiana with his family for Oakland, after his father was almost lynched for talking back to a white overseer. Huey was a toddler when they arrived in California. There, he struggled in schools ill-equipped to handle the influx of newcomers from the South. He was pulled to the streets and into juvenile crime. It was only after high school that he truly learned to read, but he would go on to earn a PhD.

In college he read Malcolm X and met classmate Bobby Seale, with whom, in 1966, he founded the Black Panther Party, built on the ideas of political action first laid out by Stokely Carmichael. The Panthers espoused self-determination, quality housing, health care and full

employment for African Americans. They ran schools and fed the poor. But they would become known for their steadfast and militant belief in the right of African Americans to defend themselves when under attack, as had been their lot for generations in the Jim Crow South and was increasingly in the North and West.

Perhaps few participants of the Great Migration had as deep an impact on activism and social justice without earning the commensurate recognition for her role as Ella Baker. She was born in 1903 in Norfolk, Virginia, to devout and ambitious parents and grew up in North Carolina. After graduating from Shaw University, in Raleigh, she left for New York in 1927. There she worked as a waitress, factory worker and editorial assistant before becoming active in the NAACP, where she eventually rose to national director.

Baker became the quiet shepherd of the civil rights movement, working alongside Martin Luther King Jr., Thurgood Marshall and W. E. B. Du Bois. She mentored the likes of Stokely Carmichael and Rosa Parks and helped to create the Student Nonviolent Coordinating Committee—the network of college students who risked their lives to integrate buses and register blacks to vote in the most dangerous parts of the South. She helped guide almost every major event in the civil rights era, from the Montgomery bus boycott to the march in Selma to the Freedom Rides and the student sit-ins of the 1960s.

Baker was among those who suggested to King, then still in his 20s, that he take the movement beyond Alabama after the success of the bus boycott and press for racial equality throughout the South. She had a keen understanding that a movement would need Southern origins in order for participants not to be dismissed as "Northern agitators." King was at first reluctant to push his followers in the aftermath of the taxing 381-day boycott, but she believed that momentum was crucial. The modern civil rights movement had begun.

Baker devoted her life to working at the ground level in the South to organize the nonviolent demonstrations that helped change the region she had left but not forsaken. She directed students and sharecroppers, ministers and intellectuals, but never lost a fervent belief in the power of ordinary people to change their destiny. "Give light," she once said, "and people will find the way."

Over time, as the people of the Great Migration embedded themselves in their cities, they aspired to leading roles in civic life. It could not have been imagined in the migration's early decades that the first black mayors of most major cities in the North and West would not be longtime Northerners, as might have been expected, but rather children of the Great Migration, some having worked the Southern fields themselves.

Ella Baker

The man who would become the first black mayor of Los Angeles, Tom Bradley, was born on a cotton plantation in Calvert, Texas, to sharecroppers Crenner and Lee Thomas Bradley. The family migrated to Los Angeles when he was 7 years old. Once there his father abandoned the family, and his mother supported him and his four siblings working as a maid. Bradley grew up on Central Avenue among the growing colony of black arrivals from the South. He became a track star at UCLA and later joined the Los Angeles police force, rising to lieutenant, the highest rank allowed African Americans in the 1950s.

Seeing limits on his advancement, he went to law school at night, won a seat on the city council, and was elected mayor in 1973, serving five consecutive terms.

His name would become a part of the political lexicon after he ran for governor of California in 1982. Polls had overestimated support for him due to what was believed to be the reluctance of white voters to be truthful with pollsters about their intention to vote for his white opponent, George Deukmejian. To this day, in an election involving a non-white candidate, the discrepancy between polling numbers and final outcomes due to the misleading poll responses of white voters is known as

the "Bradley Effect." In the 1982 election that Bradley had been favored to win, he lost by a single percentage point. Still, he would describe Los Angeles, the place that drew his family out of Texas, as "the city of hope and opportunity." He said, "I am a living example of that."

The story of African Americans on this soil cannot be told without the Great Migration. For many of them, the 20th century was largely an era of migrating and marching until freedom, by law and in their hearts, was won. Its mission over, the migration ended in the 1970s, when the South had sufficiently changed so that African Americans were no longer under pressure to leave and were free to live anywhere they chose. From that time, to the current day, a new narrative took hold in popular thought that has seized primarily on geographical census data, gathered every ten years, showing that since 1975 the South has witnessed a net increase of African Americans, many drawn (like other Americans) to job opportunities and a lower cost of living, but also to the call of their ancestral homeland, enacting what has come to be called a "reverse migration."

The phrase and phenomenon have captured the attention of demographers and journalists alike who revisit the trend after each new census. One report went so far as to describe it as "an evacuation" from the Northern cities by African Americans back to the place their forebears had fled. But the demographics are more complex than the narrative often portrayed. While hundreds of thousands of African Americans have left Northern cities, they have not made a trail to the farms and hamlets where their ancestors may have picked cotton but to the biggest cities of the South—Atlanta, Houston, Dallas—which are now more cosmopolitan and thus more like their Northern counterparts. Many others have not headed South at all but have fanned out to suburbs or smaller cities in the North and West, places like Las Vegas, Columbus, Ohio, or even Ferguson, Missouri. Indeed, in the 40 years since the migration ended, the proportion of the South that is African American has remained unchanged at about 20 percent—far from the seismic impact of the Great Migration. And so "reverse migration" seems not only an overstatement but misleading, as if relocating to an employer's Houston office were equivalent to running for one's life on the Illinois Central.

Richard Wright relocated several times in his quest for other suns, fleeing Mississippi for Memphis and Memphis for Chicago and Chicago for New York, where, living in Greenwich Village, barbers refused to serve him and some restaurants refused to seat him. In 1946, near the height of the Great Migration, he came to the disheartening recognition that, wherever he went, he faced hostility. So he went to France. Similarly, African

Americans today must navigate the social fault lines exposed by the Great Migration and the country's reactions to it: white flight, police brutality, systemic ills flowing from government policy restricting fair access to safe housing and good schools. In recent years, the North, which never had to confront its own injustices, has moved toward a crisis that seems to have reached a boiling point in our current day: a catalog of video-taped assaults and killings of unarmed black people, from Rodney King in Los Angeles in 1991, Eric Garner in New York in 2014, Philando Castile outside St. Paul, Minnesota, this summer, and beyond.

Thus the eternal question is: Where can African Americans go? It is the same question their ancestors asked and answered, only to discover upon arriving that the racial caste system was not Southern but American.

And so it was in these places of refuge that Black Lives Matter arose, a largely Northern- and Western-born protest movement against persistent racial discrimination in many forms. It is organic and leaderless like the Great Migration itself, bearing witness to attacks on African Americans in the unfinished quest for equality. The natural next step in this journey has turned out to be not simply moving to another state or geographic region

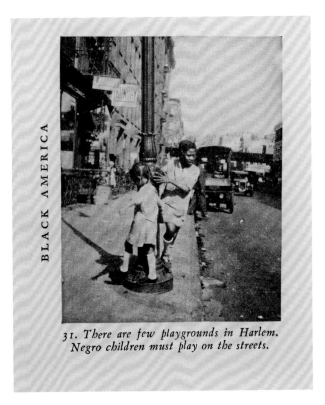

BLACK AMERICA

31. *There are few playgrounds in Harlem. Negro children must play on the streets.*

The North's urban centers, like Harlem, saw dramatic increases in black population between 1910 and 1920: 65% in New York, 150% in Chicago and over 600% in Detroit. In the same time frame, black-owned businesses in the U.S. jumped from 5,000 to 70,000, as new opportunities arose.

but moving fully into the mainstream of American life, to be seen in one's full humanity, to be able to breathe free wherever one lives in America.

From this perspective, the Great Migration has no contemporary geographic equivalent because it was not solely about geography. It was about agency for a people who had been denied it, who had geography as the only tool at their disposal. It was an expression of faith, despite the terrors they had survived, that the country whose wealth had been created by their ancestors' unpaid labor might do right by them.

We can no more reverse the Great Migration than unsee a painting by Jacob Lawrence, unhear Prince or Coltrane, erase *The Piano Lesson*, remove Mae Jemison from her spacesuit in science textbooks, delete *Beloved*. In a short span of time—in some cases, over the course of a single generation—the people of the Great Migration proved the worldview of the enslavers a lie, that the people who were forced into the field and whipped for learning to read could do far more than pick cotton,

scrub floors. Perhaps, deep down, the enslavers always knew that. Perhaps that is one reason they worked so hard at such a brutal system of subjugation. The Great Migration was thus a Declaration of Independence. It moved those who had long been invisible not just out of the South but into the light. And a tornado triggered by the wings of a sea gull can never be unwound.

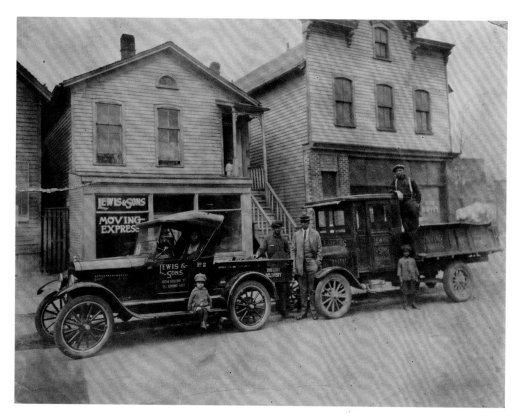

A moving company in Cleveland

"Wages here are so low can scarcely live We can buy enough to eat we only buy enough to Keep up alive I mean the greater part of the Race . . ."

ELLISVILLE, MS, MAY 1, 1917

Following pages: Madam C. J. Walker
School of Beauty Culture, spring 1939
graduating class pictured outside the
entrance, St. Louis, Missouri, 1939.
Photographer unknown

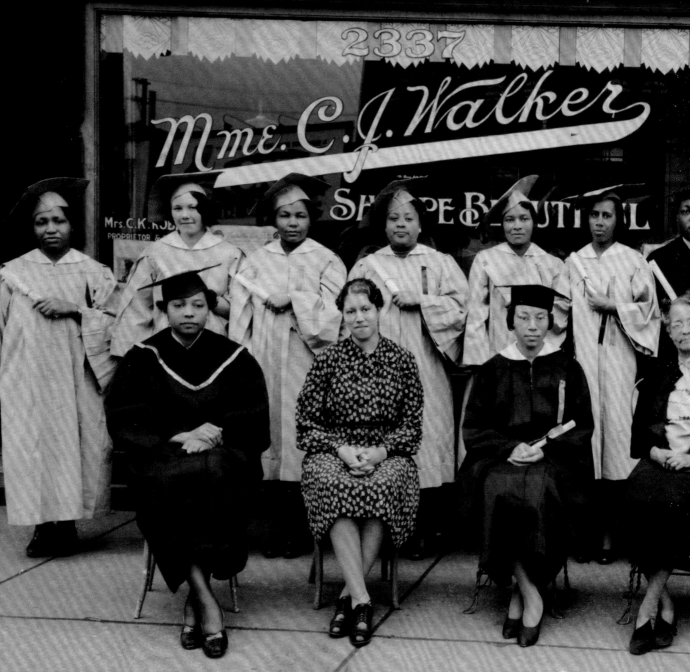

MME. C. J. WALKER
AGENTS' SUPPLIES

2337

Mme. C. J. Walker

SHOPPE BEAUTIFUL

Mrs. C. K. ROB...
PROPRIETOR & ...

SPRING SEMI-ANNUAL GRADUATION CLASS

THE SCHOOL OF BEAUTY CULTURE.

MRS. C. K. ROBINSON
OWNER and INSTRUCTOR

ENTRANCE
TO
SCHOOL

MARCH 26TH 1939

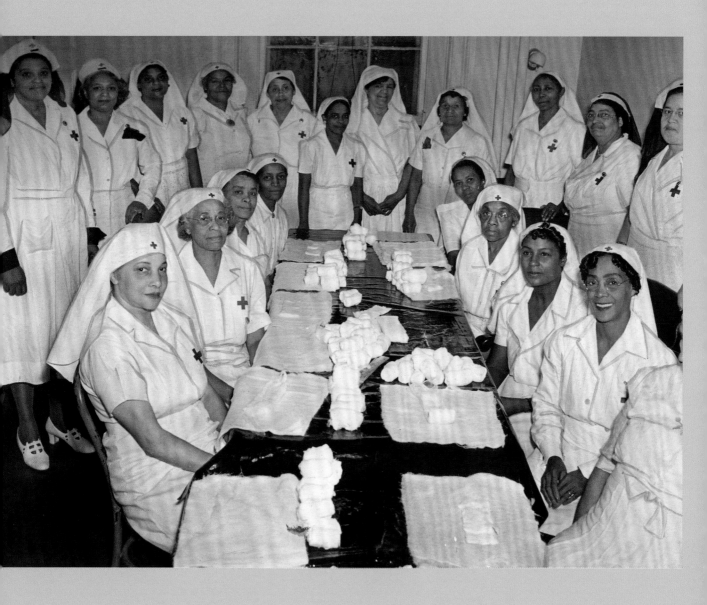

Nurses at Provident Hospital (1894–1999),
an essential training ground for Black
doctors and nurses, Baltimore, 1942.
Photographer unknown

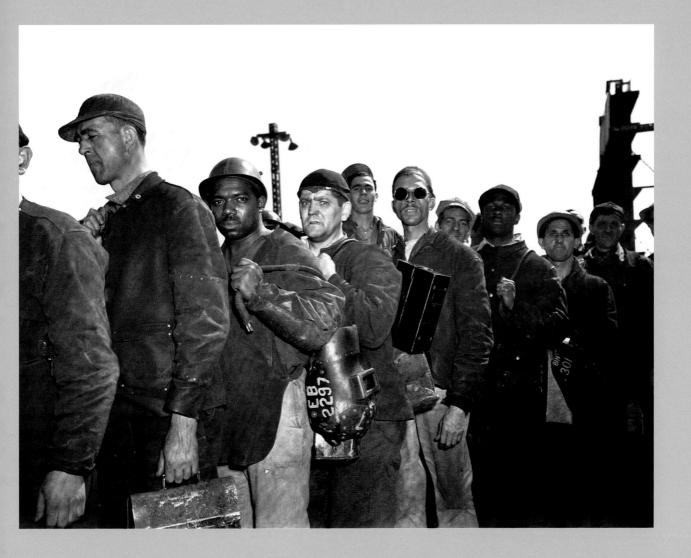

A portrait of the workmen of the Liberty
ship *Frederick Douglass* at the Bethlehem-
Fairfield shipyards. Baltimore, May 1943.
Photograph by Roger Smith

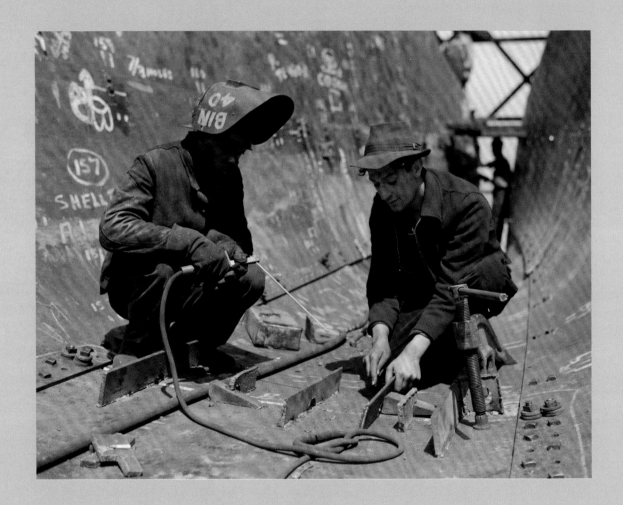

Workers at the Bethlehem-Fairfield
shipyards during constuction of
the Liberty ship *Frederick Douglass*,
Baltimore, 1943. Photograph by
Roger Smith

Members of the Ancient Egyptian Arabic
Order Nobles Mystic Shrine (AEAONMS),
Emith Court and Emith Temple of Kansas,
c. 1955. Photograph by Leon K. Hughes

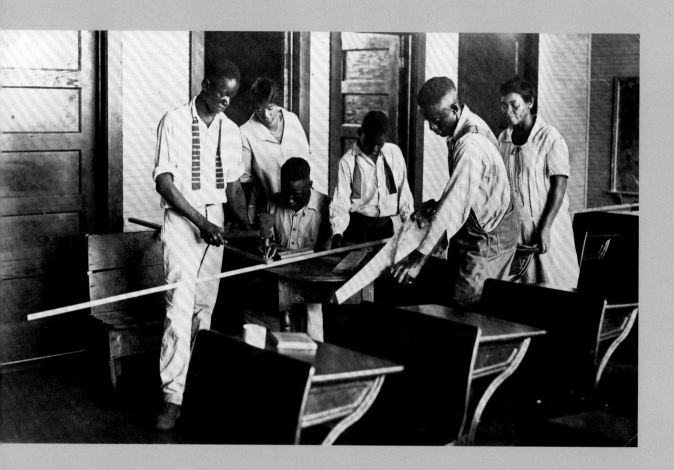

Students making window screens,
Tennessee, c. 1924. Photograph by Harry
Stoll Mustard

"I can recruit 15 good honest men whom I believe wolild make good and can leave as soon as transportation for same is pro-vided. Hopeing to hear from you soon I remain *Yours truly.*"

MOBILE, AL, APRIL 30, 1917

A young worker testing the repairs
made to a radio at a National Youth
Administration workshop, New England,
c. 1940. Photographer unknown

A doctor and a Works Progress Administration
nurse examine a young boy for tuberculosis in
Birmingham, Alabama, c. 1938. Photographer
unknown

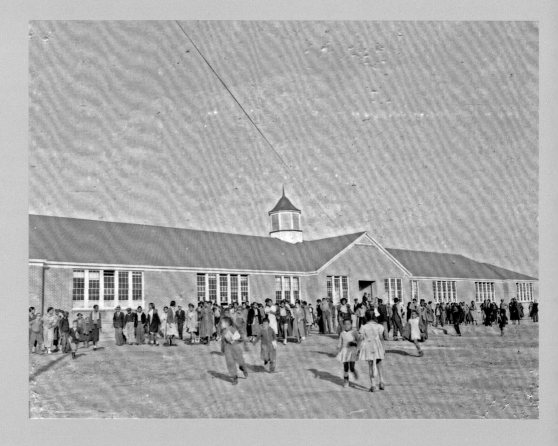

Top: Young Black workers in training
through the Works Progress
Administration's National Youth
Administration, c. 1941. Photograph by
Barbara Wright

A Black grammar and high school building
constructed by the Works Progress
Administration, Brookhaven, Mississippi,
c. 1938. Photographer unknown

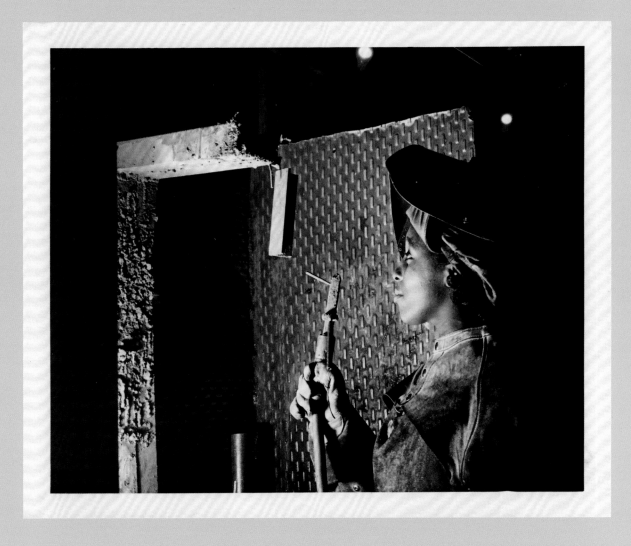

A National Youth Administration welder
at work, c. 1935–43. Photographer
unknown

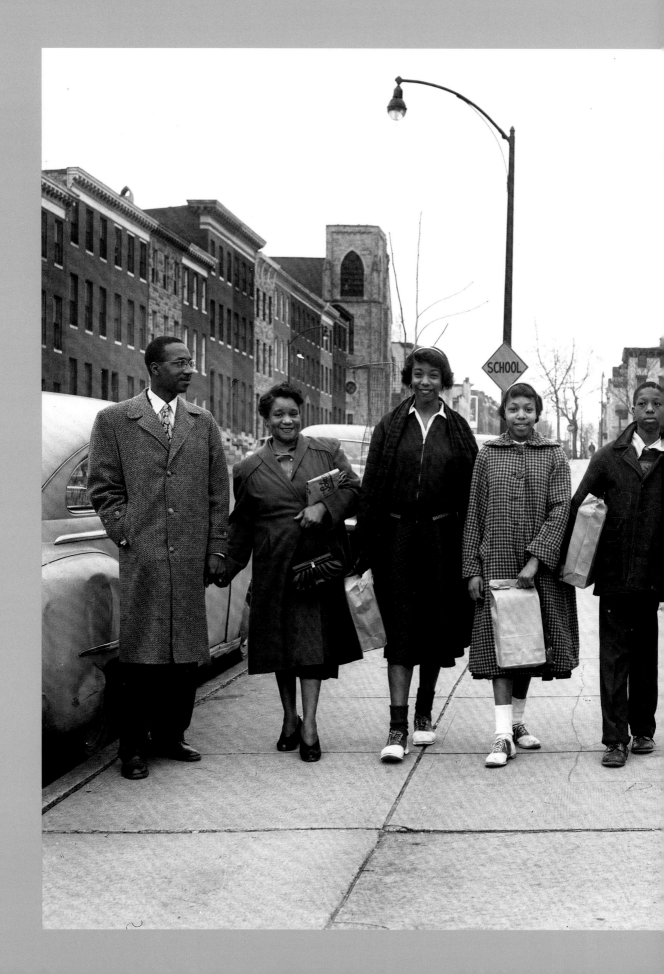

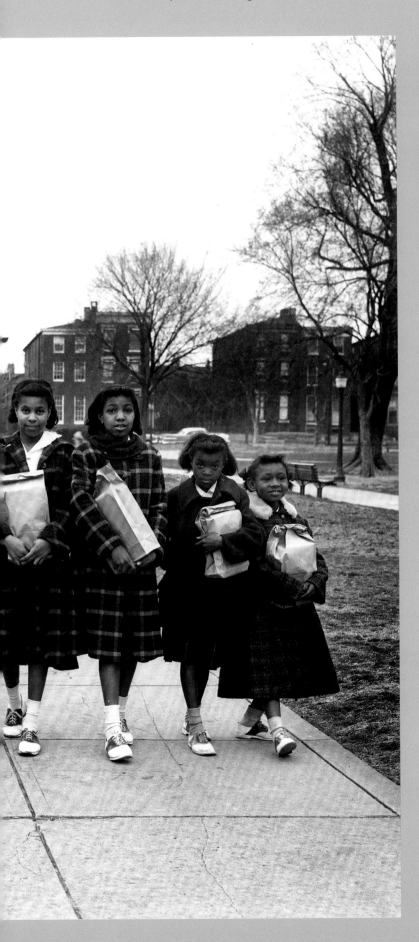

The Dean family shopping for Easter shoes, Baltimore, 1956. Photograph by I. Henry Phillips Sr.

Image and Text Credits: Section 1

The permission of rights holders has been obtained whenever necessary and possible. Applicable copyright holders, photographers, and sources beyond those named in the text headers and image captions are as follows.

pp. 15, 16–17, 32, 45–48, 82, 86, 88, 118–119: Courtesy of the *AFRO American Newspapers* Archives. p. 18: American Unofficial Collection of World War I Photographs, Records of the War Department General and Special Staffs, 1860–1952, National Archives and Records Administration. p. 20–22: Reprinted with permission of University Press of Mississippi. pp. 23, 27–28, 48, 66, 67, 82, 83, 87: Reprinted by permission from *The Chicago Defender*. pp. 23, 26, 27, 44, 63, 64, 86, 99: *Chronicling America: Historic American Newspapers*, Library of Congress. p. 24: Excerpt from *CAPITOL MEN: The Epic Story of Reconstruction through the Lives of the First Black Congressmen* by Philip Dray. Copyright © 2008 by Philip Dray. Reprinted by permission of Mariner Books, an imprint of HarperCollins Publishers. All rights reserved. pp. 24–25: Prints and Photographs Division, Library of Congress Washington, D.C., LC-DIG-pga-02587. pp. 26, 41 (left and right), 43, 116 (top and bottom), 136–37: Robert Langmuir African American Photograph Collection, Stuart A. Rose Manuscript, Archive, and Rare Book Library, Emory University. p. 28, 67: Reprinted by permission of *Jackson Advocate*. pp. 29–30, 37, 40–41, 44, 48, 66, 98: *The Crisis*, The Crisis Publishing Company. https://archive.org/details/pub_crisis. p. 31: Records of the Office of the Secretary of Agriculture, 1794–ca. 2003, National Archives and Records Administration. pp. 32, 42: Farm Security Administration Collection, Photographs and Prints Division, Schomburg Center for Research in Black Culture, The New York Public Library. pp. 32–36: *Journal of Political Economy* 25, no. 10 (1917): 1034–43. http://www.jstor.org/stable/1823158. pp. 38–39: Prints and Photographs Division, Library of Congress, LC-DIG-ds-00894. p. 40: Tulsa Race Massacre Collection, Tulsa Historical Society & Museum. pp. 50–60: From *The Atlantic*. © 2019 The Atlantic Monthly Group, LLC. All rights reserved. Used under license. Photographs by Zora J. Murff. p. 61: Newbell Niles Puckett Memorial Gift, Cleveland Public Library, Special Collections. p. 68–73: Reprinted with permission from Louisiana State University Press; maps by permission from Justin Madron and Nathaniel Ayers. pp. 74–81: W. E. B. Du Bois. *The Philadelphia Negro: A Social Study*. 1899. https://archive.org/details/philadelphianegroodubo/. pp. 84–85: Daniel Murray Collection, Prints and Photographs Division, Library of Congress, Washington, D.C., LC-DIG-ppmsca-33864; LC-DIG-ppmsca-33865; LC-DIG-ppmsca-33866. pp. 90–98: Excerpts from *BLACK METROPOLIS: A Study of Negro Life in a Northern City* by St. Claire Drake and Horace R. Cayton. Copyright © 1945 by St. Clair Drake and Horace R. Cayton, renewed 1973 by St. Clair Drake and Susan Woodson. Reprinted by permission of Mariner Books, an imprint of HarperCollins Publishers. All rights reserved. pp. 99–100: From *Chicago Tribune*. © 1938 *Chicago Tribune*. All rights reserved. Used under license. p. 100: RG0063-004 (top) and RG0063-003 (bottom), Town of Independence Heights Collection 1915–1989, The African American Library at the Gregory School, Houston Public Library. p. 101: RG0063-PH021 (top) and RG0063-013 (bottom), Town of Independence Heights Collection 1915–1989, The African American Library at the Gregory School, Houston Public Library. pp. 102–15: Courtesy the author and *Houston History*, Center for Public History, University of Houston. p. 102: MSS0281-001a, Reverend Jack Yates Family and Antioch Baptist Church Collection, The African American Library at the Gregory School, Houston Public Library. p. 103: The African American Library at the Gregory School, Houston Public Library. p. 104: istockphoto/Rainer Lesniewski. p. 105: MSS0133-PH124, Hicks Family Collection, 1890s–1960s, The African American Library at the Gregory School, Houston Public Library. p. 106:

11. A Morsel, A Memory, A Feast: Lasting Legacies of Black Southern Foodways

The impact of the Great Migration permeated every aspect of life and culture in this country. Consideration of African American Southern foodways and sensibilities is paramount in chronicling the creative and social shifts that occurred as Black chefs and home cooks, the keepers of family culinary traditions, circulated steadily throughout the country. As food historian Jessica B. Harris (see pages 179–80) has adeptly argued: "The movements of African Americans created a preserved-in-amber version of the South in Harlem, New York; Southside, Chicago; and Oakland, California. People settled in—in areas by the railroad depots on the wrong sides of the tracks and in hastily subdivided apartments and later in housing projects—to create new homes and neighborhoods."[1] From farm to table, narratives of the forced migration of the transatlantic slave trade are shot through with consistent connections to the land and its bounty.

The story of Black America is equally yoked to Southern food and the shifting of Black foodways as a consequence of migration. In her landmark history of Black culinary traditions *The Jemima Code: Two Centuries of African American Cookbooks* (see pages 177–78), Toni Tipton-Martin traces the evolution and proliferation of "soul food" cookbooks amid the rise of the Black Power movement in the tumultuous 1960s, the last decade of the Great Migration. Frederick Douglass Opie's 2008 opus *Hog and Hominy: Soul Food from Africa to America* (see pages 154–68) offers a sociological read of Black foodways, focusing on the movement of working-class food traditions of the coastal regions of South Carolina and the Caribbean as they find their way back and forth between the North and the South.

Food is not only history. Food is nostalgia. Food is memory. Food is expression. Food is love. Every recipe is an heirloom and a prism through which to see anew. Taking a nod from the contemporary focus of the visual artists in the exhibition, this section spotlights leading chefs and transformative food writers like Baltimore-based writer and interdisciplinary artist Krystal C. Mack (pages 194–97) and Mississippi-born chef Enrika Williams (pages 190–93), who each ruminate here on themes of ancestry, land, and Southernness by taking a simple dish and weaving through it precious stories of migration, family, and continuity.

—JBB and RND

1. See Jessica B. Harris, "Migration Meals: How African American Food Transformed the Taste of America," *Eating Well*, February 8, 2021, https://www.eating well.com/longform/7888077/migration-meals, reprinted on pages 179–80 in this volume.

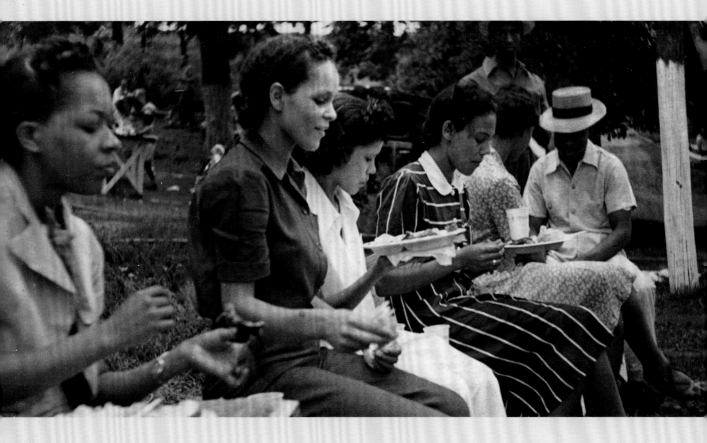

Women in a park, date and photographer
unknown

EXCERPT

Hog and Hominy: Soul Food from Africa to America

Frederick Douglass Opie

Selection from Chapter 4: "The Great Migration: From the Black Belt to the Freedom Belt," 55–82. New York: Columbia University Press, 2008.

When World War I started in Europe in 1914, food prices in the southern United States increased, and a business depression occurred that lasted until the summer of 1915. In addition, the boll weevil's destruction of black belt cotton crops and the flooding of some sections of the South and beyond led to a shortage of crops in 1916 and low demand for agricultural workers. There was also a "demand for labor in the North and higher wages offered there," according to a 1919 black migration study commissioned by the U.S. Department of Labor.[1]

For the first time in their lives, owners of large plantations in states such as Alabama had to tell their tenants they could not advance food to them and advised them to relocate. Food shortages, low wages, and unemployment resulted in the exodus of large numbers of African American wage-earning farmhands, sharecroppers, and tenant farmers, who supplied the lion's share of unskilled labor in the rural southern United States. In addition to economic factors, political forces also shaped their decision to leave the South.

In small towns and villages in states such as South Carolina, whites roughly handled and corporally punished African American residents. The 1919 Department of Labor migration study reported: "The beating of farm hands on the large plantations in the lower south is so common that many colored people look upon every great plantation as a peon camp: and in sawmills and other public works it is not at all unusual for bosses to knock Negroes around with pieces of lumber or anything else that happens to come handy." African Americans also regularly faced lynch mobs throughout the rural South. Seldom encountered before or during Reconstruction, incidents of lynching became quite common by 1910. The situation for blacks in urban centers was not much better. In southern cities, white public officials shamefully neglected public services and badly needed infrastructure improvements in African American neighborhoods. Harassing and humiliating to African American southerners, Jim Crow laws were a constant threat to civil rights, even within educational and recreational facilities.[2]

Many southern blacks traveled north by rail after receiving letters from friends and family testifying to better conditions and wages in the North. Others learned about the "real advantages of the North"—such as better educational opportunities, higher wages, and better options—through African American–owned-and-operated newspapers published in Chicago, Cleveland, Philadelphia, and New York. These papers kept black southerners aware of Jim Crow oppression, including lynchings and mob violence. By 1917 almost half a million southerners migrated to the North and Midwest to work in fast-growing basic industries. They created new lives for themselves in Kansas City, Chicago, Philadelphia, New York, and other major cities.[3]

Writer Langston Hughes, originally from Kansas, migrated to New York City to attend Columbia University, arriving there at the start of the Harlem Renaissance. In the 1920s African American artists such as Hughes, Zora Neale Hurston, Countee Cullen, Claude McKay, Alain Locke, Ethel Waters, Duke Ellington, and others received unprecedented and widespread support and enthusiasm for their work.[4] Artists of the Harlem Renaissance reflected a new radical consciousness associated with a "New Negro" movement that championed black culture and the ideology of self-determination.[5]

Many migrants traveled by rail from the black belt to the "freedom belt,"[6] as northern employers desperate for laborers provided free passage. African Americans accustomed to confronting Jim Crow policies while traveling acquired the habit of packing food for train rides. This allowed them to avoid humiliating treatment at segregated eating establishments that refused black customers or required them to go to a rear window of an eatery with a sign marked "Colored" over it (I discuss this in greater detail in a later chapter). Family and friends packed empty shoe boxes with cold sandwiches and other goodies. James Weldon Johnson remembered taking the train from Jacksonville to Atlanta. He wrote, "In those days no one would think of boarding a train without a lunch, not even for a trip of two or three hours; and no lunch was a real lunch that did not consist of fried chicken, slices of buttered bread, hard-boiled eggs, a little paper of salt and pepper, an orange or two, and a piece of cake."[7] In the 1930s Maya Angelou and her brother traveled on a train without adult supervision from California to Arkansas. "A porter had been charged with our welfare—he got off the train the next day in Arizona—and our tickets were pinned to my brother's inside coat pocket." Angelou recalled African American "passengers, who always traveled with loaded lunch boxes, felt sorry for 'poor little motherless darlings' and plied us with cold fried chicken and potato salad."[8]

Mothers, unaware of how long a trip would take, supplied relocating family members with enough provisions for the trip and more. South Carolinian Liza Bowman,

as the story goes, must have spent days preparing for her son's move from one region to another. She prepared "tons of hoecake biscuits, pan after pan of corn bread, fried rice cakes, pickled vegetables, tomatoes, okra, beets, string beans, squash, and jar after jar of cooked beans!" In addition, she sent along "cured and smoked bacon, slabs of salt pork, hams and jerk beef; she packed sacks of cornmeal, flour, grits, dried beans, and rice," dried fruit, and herbs.[9]

Lack of space for gardens in the North altered African American eating habits. In the South, people ate peas and beans of one kind or another two to three times a week. In the North, people ate them only occasionally and then often ate the canned variety because of the limited access to land and because the colder climatic conditions restricted their ability to grow inexpensive garden vegetables. In the North, cooks continued to make corn bread regularly, but for some unknown reason it became distinctly sweeter. Southerners dismissed the sweeter northern interpretation of corn bread as unfit for consumption. Over time, however, the corn bread of newcomers from the South became more northern in style, just like the migrants themselves.

Moving North provided African Americans with the opportunity to cook on more modern stoves than were found in the South. In addition, moving to the North required that the cooks who prepared southern food improvise and make do, which is the historical hallmark of African American cuisine. Except for the handful of wealthy migrants who prospered, most southern migrants continued inventing dishes that stretched and transformed what they could afford to purchase on meager working-class wages. Generally, this meant the continuation of the very unhealthy practice of eating the cheapest cuts of meat, particularly pork; seasoning legumes and vegetables with salt pork; and deep-frying chicken and other food.

Adam Clayton Powell, Jr., son of the pastor of Harlem's Abyssinian Baptist Church and former member of the U.S. House of Representatives, recalled his childhood days and the food he grew up eating in Harlem in his autobiography. Representative Powell was also a minister and became the pastor of his father's church. Both of Powell's parents were southerners. His father was born in 1865 in Franklin County, Virginia, at Martin's Mill, and his mother was born in 1872 on the campus of Christiansburg Academy, in Christiansburg, Virginia. The mother of the senior Powell was a "Negro-Indian woman named Sally," and his stepfather was a former slave named Dunn. In Franklin County, Virginia, the family rose to a breakfast of "fried fatback, corn pone cooked in the ashes of the fireplace, and coffee made of rye grains." In 1875 the family relocated to Coldsburg, West Virginia. After accepting a call to the ministry in 1884, the senior Powell attended seminary in

Washington, D.C., and then served as the pastor of several Baptist churches in the Northeast between 1888 and 1908. In 1908 he accepted the job of senior pastor of Abyssinian Baptist Church in Harlem.[10]

The younger Powell remembers that, during his childhood years in Harlem, his mother stretched the meat or fish from the Sunday meal into dishes that lasted through the next Saturday: "A whole boiled cod, which I loathed, with its head and eye balefully looking at me, always offered its bones, tail, fins, and again that head as the basis of a New England fish chowder." When his father started fishing in the spring, his mother cooked fried "fish four times a week until the cold weather rolled in." Similarly, when rabbit was in season, "hucksters drove through the blocks with barrels of rabbits" for sale. His mother purchased enough rabbit to serve it in one form or another for a week. Culinary repetition also occurred when quarts of oysters and large smoked country hams arrived from relatives still living in the South. "Fresh greens were always cooked with this ham, from wild watercress in the spring to winter kale."[11]

Powell describes a time in Harlem "when it was a disgrace to bring in bread from a store and, for that matter, anything that was already baked." In his middle-class Harlem home, the family's black coal-burning stove "was a place of magic," where his mother made corn bread, biscuits, and muffins. For breakfast she fixed pancakes, salted mackerel, codfish cakes, and baked beans. The beans cooked "all night long on the back of the stove with plenty of black molasses on top and hunks of salt pork inside."[12]

Stories of eating from Powell's youth provide evidence that migration to the North did not alter African American cookery significantly. Migrants in the North continued to feel that breakfast should be a banquet, complete with ham, fried fish, eggs, sausage, bacon, grits, red-eye gravy, corn bread, and molasses. Lunch and dinner also remained the same, featuring large amounts of corn bread, greens, and various parts of the pig. For some migrants, cooking traditional dishes like pork chops with red-eye gravy, chitlins, trotters, snout and jowls, and hog maws reminded them of their past and their southern roots.[13] Some migrants, like the Powells, received pork by mail from relatives in the South who slaughtered hogs in the winter. Collards and cabbage seasoned with salt pork, fried chicken, and sweet potato pie carried with them similar memories of childhoods in the South.[14]

As members of Harlem's upper class, migrant families like the Powells could afford to eat like northern white elites or maintain their southern traditions. Studies on the city of Chicago by Tracy N. Poe, St. Clair Drake, and Horace R. Cayton show that black elites in that city could afford to eat very differently when they wanted to from working-class African American migrants who

regularly consumed traditional southern food.[15] Two characters interviewed by Drake and Cayton, named Baby Chile and Mr. Ben, were a case in point. Mr. Ben recalls a dinner party at Baby Chile's apartment: "Baby Chile called us to the kitchen for supper—a platter of neckbones and cabbage, a saucer with five sausage cakes, a plate of six slices of bread, and a punchbowl of stewed prunes (very cold and delicious). Baby Chile placed some corn fritters on the table, remarking, 'This bread ain't got no milk in it. I did put some [egg] in it, but l had to make it widout any milk.'"[16] In contrast, the social gatherings of the Chicago's black upper class featured food and beverage that was far more expensive than the traditional southern meal items that Baby Chile and Mr. Ben enjoyed. Speaking of northern elite African Americans in Chicago, Drake and Cayton write: "All through the year there is a continuous round of private informal parties and formal dinners. . . . On their tables one will find wild duck and pheasants in season, chicken and turkey in season and out, and plenty of their finest spirits and champagne."[17]

Perhaps members of the black upper class enjoyed fried chicken, yams, grits, and greens at home with their families and served more expensive foods at important social gatherings. The lower classes, however, made do with cheap ingredients almost all the time. An African American woman living on the West Side told Drake and Cayton, "One thing, over here you can always get something to eat at the market like a basket of beans or tomatoes and potatoes for a dime, before they are graded." She added, "If you get more than you can use yourself, you can always sell or trade what you don't want."[18]

Family Diets from South Carolina

South Carolina agricultural experiment station reports about family diets in the Piedmont and lower coastal plains areas of South Carolina provide excellent insights into the eating traditions migrants brought with them when they left the South.[19] Researchers studied black and white farm families in Marion, Florence, Darlington, Lee, Dorchester, Sumter, and Charleston counties. Some owned, rented, or share-cropped land; others worked as wage-earning farmhands. The records showed that the

"dietary habits" of African American families "resembled those of white families in corresponding sections of the state."[20]

The focus here will be on the lower coastal region of South Carolina because records of food menus in black and white homes for summer, spring, fall, and winter are available. Not surprisingly, the spring and summer menus in the lower coastal region contain greater food diversity than the fall or winter menus. As for meat consumption, both black and white coastal farmers ate a lot of fried meats. A typical spring and summer menu primarily consisted of pork dishes such as "fried fat meat," "fried ham," "fried [pork] shoulder," and "fried side meat [salt pork and bacon]." African Americans cooked fried pork dishes in addition to boiled pork dishes such as boiled pork shoulder and boiled ham.[21] A similar study done in 1928 in the Mississippi Delta by Dorothy Dickins of Mississippi A & M, an HBCU, showed that blacks in that region also typically fried and boiled their food, with most vegetables "overcooked in fat" and meat "fried done and hard." Both meats and vegetables were "overdone as well as greasy," which at least in part explained "the high death rate, the frequent illnesses, and lack of energy" among African Americans in the Delta.[22] Coastal South Carolinians prepared vegetables, meats, and fish in a similar fashion to farmers in the Mississippi Delta.

Both white and black cooks regularly ate fried fish. During the summer months, however, white families ate shrimp dishes such as "fried shrimp" for breakfast and shrimp and stew for dinner. Similarly, gumbo only appeared on a white menu. For African Americans, shrimp appeared at only one time, and it was on a fall

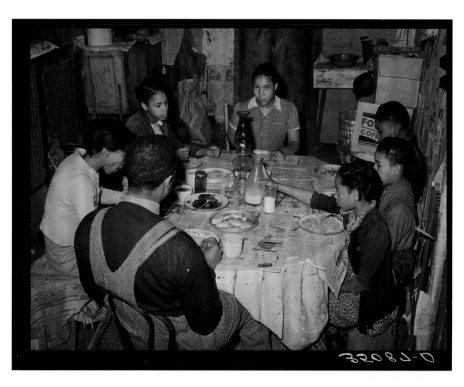

Negro tenant farmer eating breakfast in Creek County, Oklahoma

menu as the breakfast dish "shrimp and gravy." Side dishes also reveal ethnic similarities and differences in coastal South Carolina. Both black and white cooks regularly served com bread, rice, and "okra and tomatoes" in the spring and summer months. Side dishes distinctive to white coastal cookery were "ham bone with green beans," "stewed pears," potato salad, "squash with butter and cream," and "fried corn." In contrast, "hominy with fat meat gravy," "cabbage with fat meat," and "green beans boiled with fat pork" were all distinctly African American.[23]

In the fall and winter, common meats prepared among black and white cooks included fried pork, fried fat pork, fried pork shoulder, and more fried side meat. "Beefsteak" sausage, "liver hash," beef stew, salmon, and "salmon and gravy" appeared only on white menus. In contrast, "shrimp and gravy," oysters, fried rabbit, and pork stew cooked with pig ears, feet, and backbone appeared only on African American menus. These distinctive African American dishes were made in addition to southern staples such as fried pork and fried fat pork. White coastal cookery in the fall and winter included side dishes such as "dried peas cooked with fat pork," "field peas with fat pork," "turnips cooked with pork," coleslaw, baked sweet potato, "peach pickle," and "macaroni pie." The side dishes that were common to both black and white cooks were biscuits, corn bread, baked sweet potatoes, turnips, and what Africans Americans called "dried peas boiled with fat meat," which appeared as "dried peas cooked with fat pork" on white menus. The only distinctively African American side dishes on the menu were "collards boiled with meat" and "collards boiled with fat pork."[24]

A survey of the seasonal menus reveals that white coastal farmers economically fared much better than African Americans in 1939. This is evidenced by the appearance of luxury drinks and foods such as iced tea, jam, jelly, preserves, pies, cakes, and "jello with custard" on white menus. All these required store-bought sugar, baking powder, and spices. Coconut, bananas, "loaf bread," "bakers bread," cocoa, salmon (most likely canned salmon), and macaroni are other examples of luxury store-bought items that only appeared on white menus. The store-bought items that African Americans in coastal South Carolina apparently liked and ate were bologna, cheese, and crackers. When hog-killing meat was used up, both black and white families probably purchased their side meat, salt pork, and bacon from a store.[25]

The macaroni pie that appeared on white menus may possibly refer to macaroni and cheese.[26] There is another reference to the southern preparation of macaroni and cheese in the 1928 report about farm families in the Mississippi Delta by Dorothy Dickins. Dickins found that most African American women had never tasted macaroni and cheese and only a few cooked it for their families because they complained that it was too "starchy and gummy." Dickins goes on to say, "The majority feels that they have too little cash to spend on something which they perhaps cannot properly prepare or which, if they can, the family probably will not like."[27] What is interesting about this quote is that since the 1960s no African American feast I have attended prepared by southern-born women was considered complete without at least one large pan of labor-intensive homemade baked macaroni and cheese with bread crumbs on top. During research for this book, neither oral nor written sources provided an explanation of how and when the dish became a part of the culinary lexicon of African Americans.

Dickins's 1928 study found that, as African Americans improved their environment and education, the variety in their diets increased. As a result, the high school and college educated had more nutritious eating habits, with larger amounts of fruits and vegetables composing their overall caloric intake, than did their less-educated neighbors. For an uneducated African American in the Delta, an increase in income "generally means an increase in quantity but not necessarily an increase in variety of food. As environment and intelligence improve, variety of food used increases," writes Dickins.[28] For many black belt residents, migrating northward provided access to education and exposure to people from around the world. In their new environments, southerners worked and lived in close quarters with Jews, West Indians, Latin Americans, and Europeans. These "foreigners" taught southern African American migrants how to cook and enjoy foods—like macaroni—that back home they called white folks' food. Over time they adopted foods such as macaroni and cheese and pancakes as their own.

African-Influenced Cuisines of the Caribbean

Immigrants from the Caribbean who migrated to New York after World War I started a number of restaurants in East Harlem. (An extensive discussion of Caribbean migration to New York will come in a later chapter.)[29] Cubans in New York had a reputation for being epicureans. As one report noted, Cubans "love food, drink and delicacies of every kind, but it must be good." The Ideal, at Lenox Avenue and 115th, and Toreador, at 110th, introduced African Americans to traditional Cuban food like *agie el dulce*, a sweet chili con carne typically served with a side order of fried plantains.[30] One of the oldest Puerto Rican restaurants was Pascual Quintana's El Caribe, which opened in 1920 at 235 West 116th Street. It started off as a place where working-class folks would go to order a thirty-cent *mixta* dinner—meat or fish and rice and beans from a steam table—and a coffee. In 1927, a year before the start of the Depression, the restaurant relocated to Fifth Avenue, where new management changed the menu to attract wealthier customers.

Famous Latin American professional boxers as well as locals came to enjoy traditional dishes such as *mafongo con chicharrones*, mashed green plantains mixed with mashed fried pig skin and covered with garlic, onion, and hot pepper sauce, and *pollo frito*, fried chicken served with fried plantains or fried potatoes and a salad. *Arroz con gallina*, chicken and rice seasoned with ham, salt pork, tomatoes, green peppers, annatto seeds, salt, garlic, and onions, was another popular dish.[31]

The Saturday special was *sancocho*, a stew made with sweet and plain potatoes, chicken, beef, and pork; green and ripe plantains; yucca; Spanish yams; and a typical Spanish sauce seasoned with annatto seeds, salt, garlic, and onions. Sunday's menu included *sancocho* plus *lechon azado*, oven-roasted pork basted with a mixture of annatto seeds, black pepper, salt, vinegar, and oil. "An individual ration of this dish, with an addition of fried plantains and salad (tomatoes and lettuce), usually costs 45 cts." Chefs at the restaurant followed the rural Puerto Rican custom of cooking with tubers and seasoning with pork and lard. Cooks at Fuentes, for instance, prepared rice with lard and saffron. They also made refried white, red, and black beans with salt pork, garlic, and annatto seeds. Other migrant cultures evidently influenced foodways in New York City's Puerto Rican diaspora: Fuentes's menu also included Virginia ham, Mexican tamales, and other foods outside traditional Puerto Rican cuisine.[32]

El Favorito was another well-known Puerto Rican eatery in Spanish Harlem. It was located at 2055 Eighth Avenue between 111th and 112th streets. Puerto Rican, African American, and British and French West Indian low-wage factory workers lived in the neighborhood; the great majority of the residents spoke Spanish. The spotless restaurant remained open twenty-four hours a day serving meals as cheap as thirty-five cents. El Favorito also sold traditional Latin American desserts such as flan, rice pudding, and sweet breads.[33]

Like many Harlem eateries, El Favorito did its best business on the weekend between 1 and 4 a.m., when "the merrymakers once more crowd the restaurant as soon as the theatre and the dance halls are closed." Following a night out on the town, customers ordered tons of "Puerto Rican style tamales" made from mashed green plantains stuffed with chopped chicken and veal, pepper, olives, and capers, wrapped in a special paper, and then boiled. A Sunday afternoon favorite was *paella a la Valenciana*. This saffron rice, meat, and seafood-based dish from Spain was very popular in both Cuba and Puerto Rico. It contained "trout, clams (in shells), shrimps, eel, and devil fish in addition to chicken, olives and partially covered with pimentos." Non-Latin American offerings on the menu included traditional New England clam chowder, southern pig's feet, North

American bacon and eggs, "and all kind of American sandwiches and desserts."[34]

In urban areas in and around New York, Europeans, Caribbeans, and southerners interacted in tenement houses, on the job, and on the streets, where they purchased new types of inexpensive good-tasting foods. Italian vendors sold pepper-onion-sausage sandwiches and Italian ices. Yiddish-speaking Jews sold *arbis*, knishes, and sweet potatoes. *Arbis* were large cooked chickpeas served with salt and pepper in paper bags for between three and five cents. Knishes were "crisp, brown-crusted cakes made of potatoes mashed with oil, onions, salt, and pepper and selling at two for 5 cents." Puerto Rican vendors sold meat patties filled with ground meat and garlic and finished with decorative crusts; the patties came in a variety of styles including "cuchifritos, moricillas, alcapurrias, and empanadillos de yucca." African American vendors sold soft-shell crabs, fried fish, and oysters.[35] Migration and immigration in short meant more than re-creating one's culinary traditions in northern urban centers such as New York and Chicago. It meant maintaining old inexpensive rural eating traditions and incorporating new ones from Europe and African-influenced ones from the Caribbean.

Case Studies
What follows are case studies of various individuals who migrated North during their teens and twenties. Their stories illustrate the point that most often families and networks of extended families migrated North with time spent in more than one northern city before they settled. Most of the case studies are about people who became food professionals in the North, working as live-in domestics for white families. The majority of migrants worked as domestics. They were also quite entrepreneurial; it was not uncommon for domestic servants to have side jobs taking cake and pie orders and catering parties and weddings for the friends and associates of the white families who employed them full time. Other migrants went to work in the kitchens of hospitals and restaurants. Each migrant brought along his or her own food traditions, and their stories map episodes of southern migration to Harlem and Westchester County. The case studies are important because they provide essential biographical details about southerners whose written and oral histories I discuss in later chapters. Some of them are my older, southern-born relatives who adapted and mixed their culinary traditions as they moved North and passed them on to our family's northern-born younger generations.

Tillie Eripp

At age eighteen, a poor African American woman named Tillie Eripp migrated alone from Tampa, Florida, to Philadelphia. Writer Sarah Chavez interviewed her for the WPA Federal Writers' Project "America Eats," which was never published. New York City's WPA unit called their study "Feeding the City." In it, Chavez and other writers gathered insightful records about Depression-era food history. Chavez learned that teenager Eripp suffered desperately from loneliness after she arrived in Philadelphia. "Soon, through the help of a friend, she secured a job as a cook in a boarding house, where she remained for several years," wrote Chavez. She migrated from Philadelphia to New York in 1928, just before the Great Depression started. Her first job was operating a concession stand selling fried chicken at Harry Hansbury's speakeasy. Increasing demand for her chicken led her to move to a storefront space next to the speakeasy, where she ran Tillie's Chicken Shack.

Eripp struggled in getting the business off the ground, depending entirely on inexperienced help. "Once the success of the venture was assured she added to her menu, occasionally serving collard greens, pigtails, black-eyed peas, yams and hogshead," wrote Chavez. The restaurant served hot biscuits and coffee with every meal, "and each customer was permitted as many biscuits as he or she desired." Later she added spoon corn bread, a variety of vegetables, and salads to the menu. In 1932 she moved her place of business to 237 Lenox Avenue, just above 121st Street.[36]

Migrants from Windsor, North Carolina

Matilda Taylor worked as a schoolteacher in Windsor, North Carolina (Benjamin Outlaw's hometown as well). There, she raised four children—Luesta, Maggie, Bertha, and Dick—apparently alone. Bertha was the first to leave Windsor, migrating to Ossining, New York, in Westchester County, where she found a job working as a domestic doing cooking and cleaning for a wealthy white family. In 1930 Westchester County, the nation's "premier suburban region," had an African American population of 23,000.[37]

Luesta was the next to go, originally leaving Windsor to earn a teacher's certificate at North Carolina Normal School for teachers. She dropped out of school, eloped, and migrated with her husband to Philadelphia. Apparently Bertha sent word that she had jobs lined up for her sisters in Ossining. "My mother [Luesta Duers]," recalled Margaret Opie, "was the upstairs maid, and my aunt Bertha was downstairs, they all did domestic work. And one of the things you will find is that a lot of the women, especially black women, those were the jobs available to them." Luesta "did laundry, there was always a way in which they took the skill they had and marketed it."

The oldest child, Maggie, born in 1903, was by all accounts the best cook in the family (after her mother), renowned for making an abundance of great food out of scraps, handouts, and leftovers, all assembled in a black cast-iron skillet. Maggie married Charlie White of Windsor. The couple had a daughter named Katie and three boys named Booker, Charlie, and Horace before they split and Charlie began a second family with another woman in Windsor. Maggie, following the lead of her sisters Bertha and Luesta, migrated with her children to Ossining.

Eventually she found a good job working as a cook for a white family in Ossining named the Brants.[38] She rented a flat in the Italian immigrant section of the village. Katie, Maggie's only daughter and one of our family's best cooks, remembered her neighbors well. "You know I learned how to cook using Italian" seasonings like sage because the neighbors "used to give us food." Merchants "would give mama different things you know, meat leftover that they didn't sell."[39]

Migrants from Cloverdale, Virginia

Ella (Christopher) Barnett was born in the rural farming community of Cloverdale, Virginia, in 1915. When she was thirteen, she worked for a white woman and her husband as domestic in Cloverdale, and "they were as nasty as they could be to colored people . . . colored people had a hard time."[40]

Her largely absentee father, Claven Christopher, was one of the earliest members of her family to head north from Cloverdale in search of opportunity. "He worked in New Jersey but lived in Cloverdale, and he came home maybe once every two or three years," said Barnett.

Claven Christopher worked as a cook in the railroad camps of the black workers who laid track in New Jersey and New York, including through the Tarrytowns. Apparently, railroad contractors laying track up north hired southern-born African Americans, paying for their passage north and providing wages in addition to room and board in work camps as far north as New York.[41]

Barnett's father was the best cook she knew of as a child growing up in Cloverdale. "He was one of the best cooks in the world. He was such a good cook that people named him Cook." Up north, people did not know him as Claven Christopher but instead by the name Cook. No one where he worked in New Jersey knew him as Christopher, says Barnett, "but all you had to say was Cook, and everybody knew him."[42]

Washington "Wash" Opia (a name later changed to Opie by a local official during a property transaction) came to Cloverdale, Virginia, as a railroad camp cook. He was a West Indian migrant that decided to purchase land and start a farm in Cloverdale after marrying Mollie Cox in 1898. She died, and he remarried, taking up with Fannie Christopher in 1913. She was an unwed mother with two boys to raise: Fred, born in 1908, and Neal, born in 1910. The couple had several additional children together. Lucy Demmie married Fred Opie. Barnett's sister, Martha, married Lucy's brother, Horace Demmie.[43]

Lucy Opie migrated from Cloverdale to North Tarrytown in the late 1920s or the early 1930s. In North Tarrytown, the majority of the southern-born migrants came from Virginia, the remainder from North Carolina, South Carolina, Florida, Georgia, and Maryland, in descending numbers. Most of them rented homes, creating a black enclave in the Valley Street section of town. They worked predominantly at private homes for white residents as cooks, live-in domestic servants, chauffeurs, and laundresses. Others worked as laborers, truck drivers, and factory workers.[44]

All indications are that the first job Fred Opie, Sr., had in New York was as a heavy equipment operator with the construction crew that built the Rockefeller estate at Pocantico Hills. "I think that when John D. was developing Pocantico Hills . . . in the 1890s and early 1900s a lot of migrant workers from the South, black migrant workers from the South, came up to work primarily for the Rockefellers. Because there was a lot of manual labor that had be done," said Fred Opie, Jr. He added, "because until the war [World War II], General Motors did not hire black people." [45] As a result, most of the male migrants from the South in the Tarrytowns found employment at Pocantico Hills during the almost seventy-five years it took to build the miles of stone walls and dozen or more stone barns and houses and the mansion. Once the construction was completed, black southern women staffed the kitchens and cooked food for the Rockefellers and their guests.[46]

Lucy Opie did domestic work, particularly cooking. A superb cook, she prepared traditional southern dishes. What was unique about her cooking, according to her daughter, Dorothy, was that "the first ingredient she put in was a piece of love, stirred it up. Then she put in the ingredients, salt and pepper and whatever." In addition, as a southerner, she had the habit of cooking with a lot of lard and seasoning her vegetables with pork. She also continued the southern tradition of canning produce. "My mother canned everything, she did a lot of canning, she worked very hard."[47]

Lucy Opie was also an excellent baker, often preparing biscuits; hot cross buns; cakes; mincemeat, rhubarb, sweet potato, and cherry pies; and peach cobbler. Many of these baked goods were made from the fruits and vegetables grown in the family garden her husband kept. She and her husband also operated a storefront bakery in North Tarrytown until the Depression put them out of business. According to her son Fred Opie, Jr., "in Tarrytown there were not too many black businesses" like the one his parents operated. "Most of the black businesses were moving businesses, moving companies."[48]

In time, Lucy Opie sent for her brother Horace, who came to New York with his wife, Martha. After Martha arrived, she sent for her cousin, Ella Barnett, and her other sisters down in Virginia. Barnett explains, "My sister [Martha] got married and her husband's sisters were up

here. And when she married their brother they brought her and her husband up here. Then when she got up here she brought her family up here, one by one." Barnett was thirteen when she migrated to New York.[49]

Nora Burns White

Nora Burns White migrated from Blaney, South Carolina, to New York City with two other girls in 1942. She was fourteen. White recalls, "My mother was a very smart person. But how she let me come to New York with two other girls" the same age continues to perplex her daughter. One of the girls lived in the Bronx, and she was down in South Carolina visiting her cousin. "Luis was going back with Mary and I said to my mam 'Could I go?' and for some reason or another she said 'yes.'" White's older sister, Luella, had already migrated to Harlem the summer before. But, "Luella did not know that I was coming to New York."[50]

Her mother packed a box full of "fried chicken, bread, and cake" to eat during the train ride, "enough to last us all the way to New York. I think it took us something like twenty-four hours to get there." She adds, "On the train then, there wasn't any place to eat on the train because it was segregated." Jim Crow laws restricted black passengers to the coach car, and most of the other African Americans sitting there with the three young girls had similar boxes filled with food. "And we were in the coach, right there next to the [coal-burning] engine. And by the time we got to New York, everybody was so dirty and greasy."

They arrived at Penn Station without a clue as to how to exit the station, never mind how to get to Luella's apartment building. A boy just a little older than they asked them if they were lost and showed them how to get the A train up to 125th Street in Harlem where her sister rented a room. At this point in the interview, White yet again wondered, "What went through my mother's mind to let me go to New York?" Yet her mother likely realized that White would have better opportunities in New York than as the daughter of a single parent who tenant farmed in South Carolina.

Georgia, another roomer in the same building, originally from Roanoke, Virginia, worked as a cook for a private home on Amsterdam Avenue in Manhattan near Columbia University. She asked her employer if she was interested in hiring someone to help out in the kitchen. "She said yes and hired me, so of course I put my age up to twenty-one. . . . I think she paid me fifteen or twenty dollars a week," recalled White. She learned most of her cooking skills working with Georgia on that first job.

Trained and inspired by her mentor, Georgia, at eighteen Nora White left her sister and the Harlem rooming house on 121st Street for upstate New York, where she worked as a cook for the family of a Dr. Kensdale, a scientist who worked on the Manhattan Project. When she questioned whether she was qualified for the job, she reports, "Georgia said to me, 'Oh no you can do it. Get yourself a cookbook, and add a little something, or take away a little something so that it taste right.'" She remembers learning on the job, like the time the Kensdale family requested eggplant Parmesan for dinner. White recalled thinking, "Oh my Lord! What am I going to do?!" So she went to the cookbook, found the recipe for eggplant Parmesan, and went ahead and fixed the meal; it turned out very well. She learned how to make a host of dishes using a similar tactic: the help of a cookbook and taste buds well versed in the southern African American culinary tradition of how to make something taste just right.[51]

Understanding what African Americans in the South used to make their food taste right is the key to explaining the uniqueness of down-home cuisine. In African American culture, seasoning was an art form passed down through oral tradition. It could only be learned through a lengthy apprenticeship like the one Nora White had with her mentor Georgia, an experienced cook, followed by years of practice. Ultimately, it becomes instinctive.[52]

African American children, mostly female, began their cooking apprenticeships at a young age, closely observing older cooks within their family and extended family. Over time, adults would assign chores of ever-increasing difficulty to acclimate the child to the art of cooking. "Because our recipes were seldom written down, we had to rely on mamma's and grandma's experience and what we could learn by watching as they went about their chores in the kitchen," writes one author of a soul food cookbook. "The advantage of learning at grandmother's elbow is discovering things which are not found in any book." You learn how to season and cook food by being there when momma does it. Then one day somebody finally turns to you and tells you to make something and you do it. "For this reason the soul food cook usually knows instinctively how much salt to add, when the grease in the pan is hot enough, and how long before it's time to open the oven."[53]

South Carolinian Alexander Smalls learned how to cook while serving as his mother's "chief helper" in the kitchen on Saturday nights and Sunday mornings. "My mother and I would begin cooking about eight in the evening if there were pies or cakes or yeast rolls to be made. . . . By Sunday morning, breakfast and dinner were both happening at once—roast roasting, bacon frying, grits bubbling, potatoes boiling—so the kitchen was already a profusion of smells" by the time the macaroni and cheese and fried chicken were started. In addition to apprenticing in his mother's kitchen, Smalls also learned the art of seasoning and cooking from his grandfather, who was a great cook: from him, he learned how to season and cook catfish, "red-eye vinegar gravy with sage sausage," and "skillet rice with fresh parsley."[54]

Seasoning was learned by tasting other people's food and inquiring what ingredients and cooking techniques they used. It was during informal "kitchen conversations" that people exchanged family secrets for cooking fried chicken and other dishes. Some of the secrets were as simple as the use of a seemingly unlikely seasoning or marinade. For instance, one cook's mother marinated her chicken in peanut butter thinned with milk the night before frying it. In the morning, she would pat the chicken dry and fry it in seasoned cooking oil. Another secret was in the cooking fat. "Momma [saved] not only all bacon drippings, but sausage [drippings], too." If there wasn't enough to fry all the chicken, then she flavored her frying oil with it, which gave "an extra-special tastiness to the meat."[55]

Various amounts of spices and herbs, particularly salt and pepper, crushed red pepper, bay leaf, sage, and sugar, are partly responsible for the "down-home" flavor associated with southern African American cuisine. African American seasoning also depends on several fresh vegetables, including chopped scallions and/or onions and garlic. Apple cider vinegar and Worcestershire and

Tabasco sauces are also staples in seasoning southern dishes. As mentioned earlier, the final component that makes African American food unique is the addition of pork flavor into dishes. Collards, kale, and turnip greens are seasoned with pieces of pork; fish and chicken are deep-fried in cooking oil made of or flavored with pork-based drippings (oil and sediment left in a pan after cooking bacon or sausage). Perhaps what's most southern about southern food is the inclusion of pork in some shape or fashion in just about every dish.[56]

Nettie C. Banks

Nora White eventually became a good friend and catering partner with southern migrant Nettie C. Banks. Banks was born in 1921 in the farming community of Samos, Virginia, in Middlesex County. Traveling to Baltimore to visit her sister and mother, who were working there that summer, she ended up staying. All three women earned money working as domestics. "In the South you kind of migrated to wherever you had relatives. My mother had a brother in Baltimore who had a big house."

While in Baltimore Banks attended public school. Later, the family returned to Virginia. "I was good at school and loved school. But the community did not have a high school; finally the ministers got together and built a high school. But they built it like in mid-county and you had to pay to get to the high school." During the Depression, there were a lot of Monday mornings when her mother could not afford the $1.50 per week bus fare. "I was embarrassed I guess . . . but that's when I decided I didn't want to do that anymore." So, at age seventeen she told her mother she would go to Philadelphia to find work. It was 1938. People used to go to Samos for vacation, and migrants like Banks would then catch a ride with them to Philadelphia.

In Philadelphia Banks met her husband, George, also a migrant from Virginia. They worked as domestics in Philadelphia until the end of World War II (her husband left to serve in the military), when a wealthy white family offered them "a job with more money and, we thought, better opportunity in [Ossining] New York." Most of the African Americans in Ossining in the 1930s and 1940s were southern-born, just like Nettie and George Banks. In my interview with her, she explained that she had relatives who had moved to New York to work as domestics for a white family. The family was looking for someone else to do the same kind of work. "And that's how we came, we had an interview," and they took the job as sleep-in domestics. "At the time that we came up, it was normal that we were sort of relegated, doomed to do house work."[57]

Firsthand accounts of migrants who settled north of New York City are evidence that Harlem was not always the final destination for southern migrants. Some stopped in Harlem and stayed with relatives until they located better opportunities. Many of them marketed their cooking skills to wealthy white families further north. Westchester County was attractive to southern migrants because jobs as cooks were much higher paying than were those in the South. By the time of the Depression, there were pockets of southern African American migrant communities in river towns along the Hudson River in places like Ossining, the Tarrytowns, and Peekskill. There were similar communities east of the Hudson in Mount Vernon, Elmsford, and White Plains. All these communities were accessible on the Harlem and Hudson train lines that carried passengers north of New York City several times a day.

In the host communities to which they migrated, southern migrants were introduced to new eating traditions, particularly influences from Italian immigrants. In Ossining, Katie Green learned from Italian neighbors how to season food with "Italian spices."[58] As a domestic, Nora White had to learn how to prepare new dishes like eggplant Parmesan that her white employers requested. The creolized eggplant that she cooked surely tasted different from the one an Italian American would have prepared. Nora's cooking up north was influenced by her mother's South Carolina cuisine, the kitchen traditions of her Virginia-born friend and mentor Georgia (who also taught her how to cook and modify recipes from books), and the recipes she found for foods like eggplant Parmesan, which were largely unfamiliar to southerners.[59]

Migrants from the South introduced southern traditions to African Americans born up north. Lucy Opie, for example, taught her northern-born grandchildren to carry box lunches when they traveled and to enjoy peach cobbler and mincemeat and rhubarb pies. Mincemeat and rhubarb pies were exotic alternatives to those made with apples that her grandchildren were accustomed to eating as New Yorkers raised in the apple-rich Hudson Valley region. After a couple of slices accompanied by a tall glass of cold milk, they grew to love them. In fact, they recall getting excited about going to Grandma Opie's house as children during the holiday season because her southern hospitality meant she would always offer something sweet like a slice of pie or cake served with a scoop of homemade vanilla ice cream.

Special Occasions: Christmas, Watch Night, and Homecoming

Christmas for African Americans has traditionally been a very special holiday centered on sweets and offerings like chicken, ham, and a tableful of complementary side dishes. For those without much, Christmas might have meant little more than killing a chicken for dinner. Those in better financial condition celebrated with an assortment of meats and sweets such as "cakes, succulent pies, and luscious puddings."[60]

Ruth and Roy Miller, whose parents migrated north in the 1920s, shared with me their memories of holiday cuisine. Ruth was born in Harlem in 1932. Her mother migrated there from Savannah, Georgia; she worked as a professional cook. Ruth has vivid memories of her mother's holiday cooking. "We would have chicken and dumplings. We would have macaroni and cheese. We would have . . . sometimes cabbage with some smoked meat; collard greens, actually many times all of the greens would be combined: collards, kale, turnips; candied sweet potatoes; and many times red rice, okra, and tomatoes. . . . We would have spareribs with cabbage and sweet potatoes." Roy Miller, born in Harlem in 1924, said, "That's interesting because that's a crossover. Because my [West Indian] aunts used to do red rice and all of that. I can't say that is a purely West Indian dish, it may be part of an assimilation. . . . It emanated from the South, but my aunts used to do that beautifully also."[61]

Dessert was a celebrated part of the holiday menu. For dessert, "my mother made banana pudding, sweet potato pie, you know, apple pie, lemon meringue pie, and cakes," said Ruth Miller. West Indians made fruitcake, which was also traditional among southerners. Clara Bullard Pittman was born in 1948 in the very rural farming community of Pinehurst, Georgia. She recalls that on Christmas her mother made homemade fruitcake from what she grew in her yard. She also made "cakes and pies from scratch."[62] Making Christmas fruitcake was a long process, according to Benjamin Outlaw. When asked what Christmas was like growing up in Windsor, North Carolina, Outlaw responded, "Oh boy, it was like heaven." Mother "would start cooking her fruitcake, sometime about a month before Christmas. And she always made [either apple or grape] wine" and poured the "wine on the cake until Christmas . . . building it up . . . it was the best fruitcake I have ever eaten." Hattie Outlaw also made "all kinds of cakes: chocolate, vanilla, coconut, lemon." He went on to say, "Now Christmas was wonderful, she had everything you could mention, all kinds of meats." In addition, the family ate all kinds of vegetables at Christmas because the family raised their own vegetables, and "during the summertime she put that stuff up in a jar . . . butter beans, snap beans, corn."[63]

On Christmas in Blaney, South Carolina, Nora Burns White recalled, "we always had a ham, you know, because we raised pigs." They also had "all kinds of cakes, that's when my mother would do some cooking because she would do some baking about a week before Christmas."[64] In Charlotte County, Virginia, Yemaja Jubilee's mother always made lemon icebox pies for Christmas. "She made it out of condensed Carnation milk, vanilla wafers: she'd squeeze fresh lemon juice in it, egg whites, sugar, and butter and she would cream that up and put it inside a vanilla wafer crust. She did all this from scratch," says Jubilee, except for the vanilla wafers. It was called icebox pie "because you have to put it in the refrigerator for it to chill." The pie was only made on special occasions like Christmas. In addition to dessert, her mother also cooked capons for Christmas. A lady who lived down the street raised them. Jubilee's mother would stuff and bake them "the same way you did a turkey . . . the regular roosters were tough . . . but capons were tender and flavorful." Jubilee adds, "We always had ham on Christmas and Thanksgiving."[65]

In Virginia, Nettie Banks grew up with the tradition of eating pork and poultry on Christmas. If there was a ham left over from a hog-killing day earlier in the winter, her mother would boil that, and it would become a part of the Christmas feast. "Then they would have roast chicken. We didn't do a lot with turkey people didn't have turkeys. My grandmother raised turkeys but we did not ordinarily have turkeys. We would have what they called fowl. And they would boil that then put it in the oven and baste it and bake it some. It was nice and brown." Before she migrated north in 1938, she recalled eating chitlins on Christmas if there were any leftover from hog killing. "You know they would make whatever was available ."[66]

For Reginald T. Ward, Christmas in the city of Robinsonville, North Carolina, was similar to Christmas at Nettie Banks's home. Christmas meant ham, turkey or chicken, and barbecue, "chopped barbecue." Ward left North Carolina right after high school to attend the University of California at Los Angeles and later settled in the city of Mount Vernon, in Westchester County, New York. He explained that barbecue in New York meant barbecued ribs or chicken, "but in North Carolina barbecue, a whole pig is barbecued, cooked, and they chop it up with the different spices in it like vinegar and red pepper." At Christmas, Ward's mother would also make "oyster dressing" from leftover corn bread and bread, oysters, celery, onions, salt and pepper. "And some made sausage dressing."[67]

Joyce White recalled that for Christmas dinner in Choctaw County, Alabama, her mother "roasted fresh pork and made corn bread dressing, potato salad, and greens."[68] (Duke University's Stephen Erwin argued that collard greens were best when one ate them southern style. "It helps a great deal if one has pepper vinegar to sprink[le] over the collards before eating them and corn

pone and fresh pork make collards a delight to eat."[69] Joyce White's Christmas in Alabama would be filled with the "warming aroma of Chicken 'n' Dumplings, which was made with a big hen, since we seldom had turkey." Often her mother would "simmer the hen whole and then bake it in the oven with the corn bread, and that was our 'turkey,'" reflected White.[70]

Watch Night

Another African American southern religious tradition that should be mentioned is the Watch Night, or New Year's Eve service. Watch Night dates back to the end of the Civil War. In 1862 President Abraham Lincoln declared his famous Emancipation Proclamation, which set slaves in Confederate territories free as of January 1, 1863. As a result, African Americans across much of the South held religious services, many of them secretly, in which they praised and otherwise worshipped God as they watched the New Year and freedom arrive. Thus after 1863 African Americans regularly celebrated Watch Night and New Year's Eve in honor of Emancipation Day. Southerners carried their religious traditions with them when they migrated north.[71]

St. Clair Drake and Horace R. Cayton hold that the religious traditions of the rural South were "modified by contact with the complexities of a large northern city."[72] Yet southern migrants did not abandon their tradition of church membership. By 1945 the South Side of Chicago had about five hundred African American churches: "To the uninitiated, this plethora of churches is no less baffling than the bewildering variety and the colorful extravagance of the names. Nowhere else in Midwest Metropolis could one find, within a stone's throw of one another, a Hebrew Baptist Church, a Baptized Believer's Holiness Church, a Universal Union Independent, a Church of Love and Faith, a Holy Mt. Zion Methodist Episcopal Independent, and a United Pentecostal Holiness Church. Or a cluster such as St. John's Christian Spiritual, Park Mission African Methodist Episcopal, Philadelphia Baptist, Little Rock Baptist, and the Aryan Full Gospel Mission, Spiritualist."[73]

In addition to church membership, southern migrants brought with them a tradition of important yearly church programs and free food. Most likely to include free food were services on special occasions such as Easter, Thanksgiving, Christmas, and Watch Night. "In addition to these Christian red-letter days," report Drake and Cayton, " Baptisms, anniversaries, installations [of new ministers], youth nights, and choir nights" were wellattended yearly programs where down-home southern cooking was available in abundance for free.[74] In Chicago it was "not unusual to find a total of over 10,000 people attending" an important event at the four largest churches, and "an equal number distributed among the smaller churches." African American churches in Chicago continually offered "concerts, pageants, plays, suppers, and other similar activities."[75]

As in the South, one of the most important events of the year was Watch Night service on New Year's Eve. This southern tradition had people filling church pews as early as 6:45 p.m. to secure a seat for a 7:00 p.m. Watch Night service at any of the five largest African American churches in Chicago. During the service the congregation sang hymns, listened to choirs, prayed, and worshipped until midnight. Then came an important part of the Watch Night service: the feast that followed the arrival of the New Year. Just after midnight, the members of the hospitality committee—the wives of the church—slipped into the kitchen to heat up food and then arrange it on the table of the fellowship hall, generally located in the basement or on the second floor of a church.

Frances Warren noted that, during her childhood, most families in the South ate black-eyed peas (cowpeas common to Igboland) and rice, especially at midnight on New Year's. For an unknown reason, some southerners believed "it was good luck." Warren was born in Atlanta in 1928 but spent most of her childhood in Miami, Florida. Her husband, Jim, grew up on a farm not far from Birmingham, Alabama, where blacks and whites followed the same New Year's eating traditions. Born in 1925, Jim believed that the black-eyed peas and rice on New Year's tradition had something to do with the influence of "black culture," but he was not exactly sure where the practice originated.[76] North Carolinian Reginald Ward said, "I don't care where you are, in New York" black folk on New Year's Day are going to eat "strictly pork." Tradition calls for cooking "black-eyed peas, hog head, a whole hog head now, pig tails, pigs feet." Ward went on to say, "You can go just about anywhere, and people who were born in the South, Georgia, Alabama, Mississippi, North Carolina, Tennessee," cook pork on New Year's Day.[77]

Having lived in California in the 1960s, Ward noticed that, "everybody born in the South was looking for pork" on New Year's. As a result, the price of smoked and pickled pork parts like pigs' feet and hog maws in California supermarkets became expensive around New Year's. Ward reported that pork, collard greens, and black-eyed peas seasoned with smoked or salt pork, along with "potato salad, candied yams, macaroni and cheese, and corn bread" were traditional dishes that southern black folk around the country ate on New Year's.[78]

A child of white southerners, Jim Warren was raised on the same type of southern cooking. He recalled that during the Depression he would share meals with black farmhands at his family's farm in Alabama. In the process, he learned that his mother shared the same cooking traditions as black women. These traditions included those like New Year's dinners complete with black-eyed peas

and rice, beans and greens cooked with ham hocks, and sweet potato pie.[79]

On New Year's, Yemaja Jubilee's mother oven-roasted a whole, hickory wood-smoked hog's head and prepared black-eyed peas. She explains, "We raised hogs, and when they harvested the pig they would put the head down in salt [for about six weeks] and then they'd smoke it." In Charlotte County, Virginia, "where I was raised, most of the people ate that or some kind of pork" on New Year's.[80]

Southern superstition established the tradition of serving hopping John in addition to other traditional dishes that depended on where the southern migrant community was from. Hopping John is a combination of black-eyed peas and rice, beans, red peppers, and salt pork cooked to a stew-like consistency. It is probable that the dish evolved out of the rice and bean mixtures such as dab-a-dab, the rice, beans, vegetables, meat, palm oil, and pepper dish that West African slaves survived on during the Middle Passage.[81] "On New Year's Day," in Virginia, recalled Lamenta Crouch, "we always had black-eyed peas and some kind of greens" along with "ham hocks or country ham." "Country ham" refers to the type of ham typically cooked on Christmas, "smoked ham, what they called the good old Virginia hams."[82] In Bertie County in northeastern North Carolina, Hattie Outlaw prepared her New Year's Day meal on the sixth of January, which she called "old Christmas." What is noteworthy here is that Hattie Outlaw's menu did not include pork. "Mama would make roast chicken, collard greens, desserts, and stuff like that," recalls her son, Benjamin Outlaw.[83]

Homecoming

After the start of the Great Migration in 1914, most southern-born African Americans who left for the North referred to revivals down South as "homecoming week." For instance, after moving up north, Joyce White, raised in Choctaw County, Alabama, recalled how "many of the people who had left our county years before would mark their return home by the revival at such and such church."[84] Churches typically held revivals in July and August after farmers had harvested their crops, when people had an abundance of food, money, and time for leisure. "I remember homecomings quite clearly" said Marcellas C.D. Barksdale, born in 1943 in Annandale, South Carolina. "My mother was a churchgoer and she would drag me [along], especially to the big events. We had the homecoming, pastor's anniversary, Easter program, and all of them were social as well as cultural and religious programs." He adds, "More often than not, when they had those big occasions, they would have these big eatings, as I called it. All the members would bring food, sometimes they would have commonly cooked food. The men would

make a barbecue pit, put coals in and put a grill over it." There would be "potato salad and macaroni and cheese, and none of it was refrigerated, it's no [sic] wonder we didn't die from the mayonnaise." The food would be put outside on long tables with white tablecloths.[85]

Some churches held fish fries the day before revival Sunday. Southerners would rig large galvanized iron drums with charcoal burners. Deep cast-iron pans or skillets were placed on top to fry the fish a "rich golden brown," and it was served "piping hot." At one Mobile, Alabama, fish rodeo, "one thousand pounds of fish was fried and served to anywhere from six hundred to a thousand guest[s]."[86] Despite the popularity of a Saturday fish fry, revival Sunday and the start of a week of preaching and dinner on the grounds was the event of the year in most southern communities. Joyce White remembers Sunday was the big day and "all the families in the Negro community who were active in the church would prepare an array of dishes for the afternoon dinner."[87]

In African American religious tradition, men and women had different labor assignments. Men preached and were responsible for making a crudely built long table, while women were responsible for singing and cooking food to spread out on the table. There were often turf battles over who was the best cook in a congregation. These were a part of the culture and dynamics of a church family.

Joyce White remembers the competition well in her hometown in Choctaw County, Alabama. She observed that the womenfolk "would vie to outdo one another" with their "peach cobbler, blackberry pie, banana pudding, chocolate cake, pound cake, and sometimes even homemade ice cream." Although the culinary competition was intense, it did not disturb another important role African American church functions played in the South. Events like revivals were "soul-satisfying" affairs where African American southerners could pass time in "comfort and security" free from "the harsh reality of our Jim Crow world...."[88]

Southern African American churches established a tradition of continuous interchurch visiting that cut across denominational lines. Generally, when a pastor went to preach at a revival service that another church held, his congregation, choir, and soloist accompanied him. After moving up North, soloist Alexander Smalls, originally from Spartanburg, South Carolina, recalled performing at a southern revival.

The best was to sing on a revival Sunday at a rural church. . . . There was never any pay for the soloist, but with a spread of food running from one side of the church to the other, money simply didn't matter. These sisters and brothers had harvested a table fit for Baptist Pilgrims full of the Holy Spirit and very hungry. Platters of beans and rice, turnip greens and poke salad, butter beans with chopped

tomatoes and fresh onions, yellow squash casserole with brown bread crumbs, fresh beets in orange sauce, stewed greens beans and ham hocks, wild turkey in brown gravy, hams glazed in raisin sauce, all the fried young chicken a body could want, trays of deviled eggs, macaroni salad, baskets of biscuits, cornbread and hoecakes. Stacked-up pies, cakes (pineapple upside-down being my favorite), peach cobblers, and all kinds of Jell-O molds in every shade.[89]

Nettie Banks remembered scenes of her mother cooking for a church revival meal in Middlesex County, Virginia. "I can see my mother in the kitchen, with water just running down, she would be soaking wet." The women of the congregation spent long hot hours boiling and peeling potatoes, cleaning, cutting, seasoning, and cooking collard greens, chickens, and fish. In addition, there were the buttermilk biscuits, yeast rolls, and layer cakes, all made from scratch. Women would bring baskets of food with them to church, where they would spread it out on a long outdoor table on the church grounds, "and people came and ate." There were plenty of vegetables and "some people who were good at making corn pudding, . . . brought corn pudding, macaroni and cheese, and chicken; chicken, of course, always chicken."[90] In addition to serving as a spiritual fueling station for the soul and a refuge from racism, revivals kindled a passion for African American foods like fried chicken, pound cake, cobblers, and sweet potato pie. "Sweet potato pie," wrote one WPA staffer, "is very tasty when made right. It should not be too stiff, so as not to choke you, having enough milk and plenty of butter, sugar, nutmeg, and vanilla or lemon flavoring."[91]

Notes

1. R. H. Leavell, T. R. Snavely, T. J. Woofter, Jr., W. T. B. Williams, and Francis D. Tyson, *Negro Migration in 1916–17* (Washington, D.C.: Government Printing Office, 1919), 27, 58–61, 78–79, n5.

2. Leavell et al., *Negro Migration*, 87, 104–5; Michael Perman, *Struggle for Mastery: Disfranchisement in the South, 1888–1908* (Chapel Hill: University of North Carolina Press, 2001), 269.

3. Leavell et al., *Negro Migration*, 101, 105, 107, 28–31. On the Great Migration in general, see Carole Marks, *Farewell—We're Good and Gone: The Great Black Migration* (Bloomington: Indiana University Press, 1989). On the migration to Chicago, see James Grossman, *Land of Hope: Chicago, Black Southerners, and the Great Migration* (Chicago: University of Chicago Press, 1989). On Westchester County, see Andrew Wiese, *Places of Their Own: African American Suburbanization in the Twentieth Century* (Chicago: University of Chicago Press, 2004), chap. 2. On Harlem, see Gilbert Osofsky, *Harlem: The Making of a Ghetto. Negro New York, 1890–1930* (New York: Harper Torchbooks, 1964). On Cleveland, see Kenneth L. Kusmer, *A Ghetto Takes Shape: Black Cleveland, 1870–1930* (Urbana: University of Illinois Press, 1976).

4. For more on the Harlem Renaissance, see Anne Elizabeth Carroll, *Word, Image, and the New Negro: Representation and Identity in the Harlem Renaissance* (Bloomington: Indiana University Press, 2005).

5. Sheila Ferguson, *Soul Food: Classic Cuisine From the Deep South* (New York: Grove Press, 1989), xiii–xiv; Langston Hughes, *The Langston Hughes Reader* (New York: Braziller, W31958), 368–71.

6. The term "freedom belt" comes from Gene Baro, "Soul Food," *Vogue* 155 (March 1970), 80.

7. James Weldon Johnson, *Along This Way: The Autobiography of James Weldon Johnson* (New York: Viking, 1933), 64–65. See Leavell et al., *Negro Migration*, 28; Louis Armstrong, *Satchmo: My Life in New Orleans* (New York: Da Capo, 1986), 189; Maya Angelou, *I Know Why the Caged Bird Sings* (1969; reprint, New York: Bantam, 1970), 4.

8. Angelou, *I Know Why the Caged Bird Sings*, 4.

9. Alexander Smalls, *Grace the Table: Stories and Recipes from My Southern Revival, with Hattie Jones* (New York: HarperCollins, 1997), 16–17.

10. Adam Clayton Powell, Jr., *Adam by Adam: The Autobiography of Adam Clayton Powell, Jr.* (New York: Dial, 1971), 1–8.

11. Ibid., 17–18.

12. Ibid., 16.

13. Ferguson, *Soul Food*, xxi–xxvi.

14. Smalls, *Grace the Table*, 18–20, 65–66; Joyce White, *Soul Food: Recipes and Reflections from African-American Churches* (New York: HarperCollins, 1998), 149.

15. St. Clair Drake and Horace R. Cayton, *Black Metropolis: A Study of Negro Life in a Northern City* (1945; repr. Chicago: University of Chicago Press, 1993); Tracy N. Poe, "The Origins of Soul Food in Black Urban Identity: Chicago, 1915–1947," *American Studies International* 37, no. 1 (February 1999): 5–7.

16. Drake and Cayton, *Black Metropolis*, 608.

17. Ibid., 547.

18. Ibid., 578–79.

19. A. D .A. Moser, "Farm Family Diets in the Lower Coastal Plains of South Carolina," South Carolina Agricultural Experiment Station, Clemson Agricultural College, bulletin no. 319, June 1939, and "Food Habits of South Carolina Farm Families," South Carolina Agricultural Experiment Station, Clemson Agricultural College, bulletin no. 343, November 1942.

20. Moser, "Food Habits of South Carolina Farm Families," 25.

21. Moser, "Farm Family Diets in the Lower Coastal Plains of South Carolina," 42–44.

22. Dorothy Dickins, "A Nutrition Investigation of Negro Tenants in the Yazoo Mississippi Delta," Mississippi Agricultural Experiment Station, A & M College, bulletin no. 254, August 1928, 33.

23. Moser, "Farm Family Diets in the Lower Coastal Plains of South Carolina," 42–44.

24. Moser, "Lower Coastal Plains of South Carolina Farm Families," 44–45.

25. Ibid., 45.

26. Ibid., 42–45.

27. Dickins, "A Nutrition Investigation of Negro Tenants," 35.

28. Ibid., 4–47.

29. For more on Caribbean migration to New York, see Frederick Douglass Opie, "Eating, Dancing, and Courting in New York: Black and Latino Relations, 1930–1970 ," *Journal of Social History* (2008).

30. Harvey Brett, "Report on Cuban Population in N.Y.C.," November 25, 1935, p. 3 (see also pp. 1, 4), "Feeding the City Project Collection," WPA Papers, New York City Municipal Archives, New York, N.Y. (hereafter FCWPA), roll 269; Strong, "Puerto Rican Colony in N.Y.," 1935(?), p. 2, FCWPA, roll 269.

31. Jose Pastrana, "Fuentes Restaurant 1326 Fifth Avenue," December 10, 1940, pp. 1–2, "Eating Out in Foreign Restaurants," FCWPA, roll 144.

32. Ibid., 3; "Central American, Spanish American," p. 11, "Eating Out in Foreign Restaurants," FCWPA, roll 153.

33. Jose Pastrana, "El Favorito Restaurant," pp. 1–2, FCWPA, roll 269 .

34. Ibid., 2–4; Strong, "Puerto Rican Colony in N.Y.," pp. 3–4.

35. "Street Vendors," pp. 7–9, FCWPA, roll 153.

36 . Sarah Chavez, "Harlem Restaurants," September 26, 1940, p. 2, FCWPA, roll 144.

37. Wiese, *Places of Their Own*, 26.

38. Margaret B. (Cooper) Opie, interview, summer 2005; Katie (White) Green, interview, summer 2005.

39. Green, interview.

40. Ella (Christopher) Barnett, interview, summer 2005.

41. Ibid.

42. Ibid.

43. Ibid.; Opie family Bible, consulted in Cloverdale, Virginia.

44. 1930 federal census of the village of North Tarrytown.

45. Fred Opie, Jr., interview, summer 2005.

46. Ibid.

47. Dorothy Opie, interview, summer 2005.

48. Fred Opie, Jr., interview.

49. Barnett, interview.

50. For more on African-American migration to Harlem, see Osofsky, *Harlem*.

51. Nora White, interview, summer 2005.

52. Verta Mae Smart-Grosvenor, "Soul Food," *McCall's* 97 (September 1970): 72.

53. Pearl Bowser and Joan Eckstein, *A Pinch of Soul in Book Form* (New York: Avon, 1969), 13.

54. Smalls, *Grace the Table*, 6, 18–20.

55. Bowser and Eckstein, *A Pinch of Soul in Book Form*, 190.

56. Ibid., 13, 154.

57. Nettie C. Banks, interview, summer 2005.

58. Green, interview.

59. White, interview.

60. A. L. Tommie Bass, *Plain Southern Eating from the Reminiscences of A.L. Tommie Bass, Herbalist*, ed. John K. Crellin (Durham, N.C.: Duke University Press, 1988), 79–80; White, *Soul Food*, 297–98.

61. Ruth and Roy Miller, interview, 2005.

62. Clara Bullard Pittman, interview, summer 2005.

63. Outlaw, interview.

64. White, interview.

65. Yemaja Jubilee, interview, summer 2005.

66. Banks, interview.

67. Reginald T. Ward, interview, summer 2005.

68. White, *Soul Food*, 293.

69. Stephen Erwin, "Collards," November 14, 1984, box 1, Autobiographical Writings, Rare Book, Manuscript, and Special Collections Library, Duke University.

70. White, *Soul Food*, 293.

71. Ibid., 273.

72. Drake and Cayton, *Black Metropolis*, 613.

73. Ibid., 381.

74. Ibid., 418.

75. Ibid., 423.

76. Frances Warren and Jim Warren, interview, summer 2005.

77. Ward, interview.

78. Ibid.

79. Warren and Warren, interview.

80. Jubilee, interview.

81. This interpretation was first suggested by Jessica B. Harris in *Iron Pots and Wooden Spoons: Africa's Gifts to New World Cooking* (New York: Atheneum, 1989), xvi; the dab-a-dab dish is mentioned on p. 47 of [Africanus, pseudo.], "Remarks on the Slave Trader, and the Slavery of the Negroes," in *A Series of Letters* (London: J. Phillips, 1788).

82. Lamenta Diane (Watkins) Crouch, interview, summer 2005.

83. Outlaw, interview.

84. White, *Soul Food*, 1–3.

85. Marcellas C. D. Barksdale, interview, summer 2005.

86. Mary A. Poole, "Alabama Deep Sea Fishing Rodeo," November 5, 1937, p.1, box A 13, file Alabama Cities and Towns, Mobile Cuisine, Work Project Administration (State Records), Manuscript Division, Library of Congress, Washington, D.C. (hereafter WPA SR).

87. White, *Soul Food*, 1–3.

88. Ibid.

89. Smalls, *Grace the Table*, 73.

90. Banks, interview.

91. Gracilla, "Barboursville, Virginia," August 18, 1941, p. 1, box A 829 file, WPA SR.

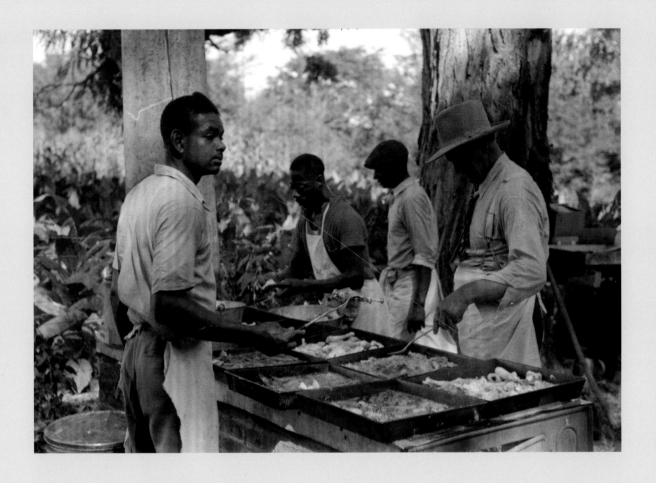

Cooking fried supper for a benefit picnic
on the grounds of St. Thomas's Church,
near Bardstown, Kentucky, 1940

"Edna Lewis and the Black Roots of American Cooking"

Francis Lam

New York Times Magazine, October 28, 2015

The air around Bethel Baptist Church in Unionville, Va., is sweet with pine and moss. From the road, Bethel seems like any other small-town white clapboard church, though a closer look shows some wear: a few holes in the windows, spidery cracks in the vinyl siding, a plastic Christmas tree tossed into the woods behind its gravel lot, sun-bleached to a shade of blue God never intended. But the church was built to last, and it's still solid at nearly 125 years old. It sits at the corner of Marquis and Independence Roads: nobility and freedom, a fitting location for a place founded by black people who decided they weren't going to worship at the back of white churches anymore.

One of those founders was Chester Lewis, an angular man with wide, piercing eyes who spent much of his life enslaved a couple of miles down Marquis Road. After emancipation, he built a house and planted orchards with a few other families on a plot of land his former master ceded to him. He and his wife, Lucinda, were illiterate, but they welcomed Isabella Lightfoot, a black graduate of Oberlin College, to use a part of their home as a school for the fledgling community's children. They farmed, fished and foraged all their food, threshing their own wheat, raising their own animals and walking over to Jackson's General Store for salt, spices, vanilla and Valentine's Day presents. They struggled but were self-reliant, relishing their freedom, and they named their settlement Freetown.

In Freetown, the people lived close to the land, cooking their harvest in wood stoves, using wells and streams to keep food cool. And they lived close to one another. Chester and Lucinda's granddaughter Edna Lewis remembered food as the center of its culture of work and community. In 1984, she told Phil Audibert, a documentarian: "If someone borrowed one cup of sugar, they would return two. If someone fell ill, the neighbors would go in and milk the cows, feed the chickens, clean the house, cook the food and come and sit with whoever was sick. I guess rural life conditioned people to cooperate with their neighbors." Their conversation was recorded a half-century after Lewis moved away, but the impression her community made on her was still profound.

Her father died in 1928, and the rest of the family, which included six children who survived into adulthood, struggled during the Depression. Lewis left Freetown by herself as a teenager, joining the Great Migration north. Eventually, the rest of the community left, too. Today, Freetown is just a stand of fruit trees, and Jackson's store has become someone's rickety machine shop, its porch greening with vines of Virginia creeper crawling through the floorboards. But nearby, there are a few gravestones behind a white fence. I read the epitaphs when I visited, arriving at the grave I had come to pay my respects to: "Dr. Edna Lewis, April 13, 1916–February 13, 2006, Grande Dame of Southern Cooking." I reached out to touch it, but then pulled back my hand; I remembered that I had the scent of cheap fried chicken on my fingers, fried chicken that I am sure Miss Lewis, as she was always known, would not have approved of.

It was tasty, that chicken, in the way that pre-fried chicken plucked out from a pile under heat lamps can be tasty: salty and greasy, slicking the lips with bird fat. But Lewis, who placed Southern cooking in the pantheon of great cuisines, respected fried chicken as a special-occasion food. She made hers not by punishing it in a pot of hot grease, but by patiently turning it in a shallow pan, crisping it over time in a blend of lard, butter and country ham, a technique that reflects something greater than the flavor of conjoined fats. When Lewis was growing up in Freetown, she learned that there was a season truly perfect for frying chickens—late spring to early summer, when the birds were the right size and had the right feed—just as there was a season for peaches and a season for blackberries. Foods, Lewis argued, are always temporal, so all good tastes are special. And when you have only a few chances every year to make something, you make it well. You use home-rendered lard to cook the bird. You brown the breasts first, then lay them on top of the sizzling legs so that they finish cooking gently in the heat above the pan. You slip in a slice of country ham to season the fat. That's how you give thanks for it.

Along the way, fried chicken has become a fraught food, somehow both universally beloved and also used in ugly stereotypes of black people. But Lewis treated all the food she prepared, perhaps all things she did, with dignity and sensitivity. You get this sense in photos of her: She always stood tall, often dressed in clothes made of African fabrics, her white hair crowning her head. Almost everyone who met her describes her as "regal." It's almost as if her parents knew, when they gave her the middle name Regina.

Lewis went on from Freetown to become a revered chef and cookbook author, a friend to literati and movie stars and the winner of nearly every award our culinary institutions had to give. Today, her name is revered among food-world cognoscenti but less well known than your average Food Network star, and yet her championing of Southern food, and cooking it close to the land, is more relevant than ever. "We weren't ready for her then," one of her acolytes, Alice Waters, says. "Now we are."

"Our mother was an excellent cook," Lewis's younger sister, Ruth Lewis Smith, told me recently. "Our Aunt Jennie was an excellent cook. A lot of our family went to Washington, D.C., to work as cooks. When they came home, they all learned from each other." The elite homes of Virginia, going back to the days when the Colonial elite socialized with French politicians and generals during the Revolutionary War, dined on a cuisine inspired by France. It was built on local ingredients— many originally shared by Native Americans or brought by slaves from Africa—and developed by enslaved black chefs like James Hemings, who cooked for Thomas Jefferson at Monticello. Because this aristocratic strain of Southern cuisine was provisioned and cooked largely by black people, it came into their communities as well, including Freetown. Smith is 91 and still raises chickens; a cage of quail coo in her kitchen. When I called her, she asked me to call back later because her apple butter had been on the stove for two days, and it was ready for canning.

As a girl, Lewis busied herself with gathering berries, sewing and other home-taught skills. She watched the older women intently, learning to cook alongside them. After leaving Freetown, she made her way to New York City, where she took a job at a laundry and was fired three hours later: She'd never ironed before. She became a Communist and bristled at having to enter employers' buildings through the back door but nonetheless worked for a time as a domestic, helping to put her baby sister Naomi through art school. At one point, she became a sought-after seamstress, making dresses for Doe Avedon and Marilyn Monroe, and dressing windows for the high-end department store Bonwit Teller. Surrounded by bohemians and fashion figures, she gave dinner parties for her friends, channeling her memories of her mother and aunt at the stove.

In 1948, Johnny Nicholson, a regular at Lewis's table, was getting ready to open a cafe on the Upper East Side. As Nicholson used to tell it, Lewis walked by, about to take another job as a domestic, when she looked into her friend's place and said it would make a terrific restaurant. A week later, Lewis was cooking lunch at Cafe Nicholson. She offered a tidy menu: herbed roast chicken, filet mignon, a piece of fish, some cake, a chocolate soufflé. The restaurant was a smash. It had a dining room like a fabulist's dream: floral displays and soaring palm fronds dipping down to kiss the heads of guests like Paul Robeson, Tennessee Williams and Gore Vidal. Truman Capote would come into the kitchen, purring at his new friend Edna for a fix of biscuits. William Faulkner once flattered Lewis by asking if she had studied cooking in Paris. But no, her sister Ruth Lewis Smith told me: She learned to make soufflés from their mother, back in Virginia. Smith, in fact, often made them herself, after the restaurant took off and she came to help out.

The restaurant critic Clementine Paddleford reviewed the restaurant in 1951 in *The New York Herald Tribune,* calling that soufflé "light as a dandelion seed in a wind" and noting a sense of pride in the chef: "We saw Edna peering in from the kitchen, just to see the effect on the guests and hear the echoes of praise." But Lewis wasn't just the chef. With Jim Crow in full effect and de facto segregation the reality in most of the North, this granddaughter of slaves had become a partner in a business that counted Eleanor Roosevelt among its favorite customers.

In 1961, Judith Jones, an editor at Knopf, ushered in an era of fascination with French cuisine by publishing an intensely detailed cookbook called *Mastering the Art of French Cooking*, written in part by a tall, warbling woman named Julia Child. A decade later, Jones was looking for someone to help America turn its sights to the glories of its own tables. One day, the chief executive of Random House, Knopf's parent company, asked Jones if she would meet his friend, a socialite named Evangeline Peterson. Peterson had taken a liking to a wonderful caterer and wanted to write down her recipes. Unsure of what the meeting would yield, Jones agreed to it. "But when Edna swept into my office, in this beautiful garb, her hair piled up, she was just such a presence that you were a little awed by her," she says.

After leaving Cafe Nicholson in the mid-1950s, Lewis had continued her cinematically eclectic life. She and her husband, a Communist activist named Steve Kingston, spent time as pheasant farmers in New Jersey, until all the birds died overnight from a mysterious disease. She opened and closed her own restaurant. She began catering and teaching cooking classes and took a job as a docent in the Hall of African Peoples in the American Museum of Natural History. A slip on a snowy night broke her ankle and, bored during her recovery, she accepted Peterson's invitation to write together.

They had essentially finished writing a book, *The Edna Lewis Cookbook*, that Jones thought was fashionable but characterless. But when Lewis started talking, recalling scenes of growing up in Freetown and the foods they had gathered, grown, harvested, shot, hooked and cooked, Jones lit up. "I knew this was a voice that could teach us," she said. This was the story of American food that she had wanted to hear. Peterson graciously went home, Jones asked questions, Lewis wrote answers on yellow legal pads and the seeds of her classic, *The Taste of Country Cooking*, were sown. Lewis would go on to write more books and to hold chef posts at esteemed landmarks like Middleton Place in South Carolina and Gage & Tollner in New York. But she will be forever remembered for writing the book that started with that meeting.

The Taste of Country Cooking, published in 1976, is revered for the way it shows the simple beauty of food

honestly made in the rhythm of the seasons—the now common but at the time nearly forgotten ethos of eating farm-to-table—and for the way it gave a view of Southern food that was refined and nuanced, going beyond grease, greens and grits. "Until recently, we Southerners were very apologetic about our food," Lewis's friend, collaborator and eventual caretaker Scott Peacock told me. "But she wrote about it with such reverence." She inspired generations of Southern cooks to honor their own roots. Alice Waters, who is usually credited for sparking the American organic-and-local movement at Chez Panisse in California, says: "It was certainly revolutionary at that point. I was such a Francophile, but when I discovered her cookbook, it felt like a terribly good friend. By then, we were already in a fast-food world, and she showed the deep roots of gastronomy in the United States and that they were really in the South, where we grew for flavor and cooked with sophistication. I had never really considered Southern food before, but I learned from her that it's completely connected to nature, totally in time and place."

The book is, in one sense, a country manual, with instructions on picking wild mushrooms and the best way to turn dandelions into wine. (It tastes like Drambuie, Lewis offers helpfully.) It's also a cookbook, because there are teaspoons and tablespoons and "cook uncovered for 10 minutes." But perhaps the truest way to describe the book is as a memoir told in recipes, where every menu, dish and ingredient speaks to her childhood in rural Virginia and how her community made a life from the land, taking pleasure in the doing of many things.

It stands as an exemplar of American food writing, a complex, multilayered, artistic and even subtly subversive document. And it stands on the other side of a cruel tradition in cookbooks from the first half of the 20th century, one in which black domestic cooks often had their recipes recorded and written by their white employers, who tended not to flatter the help in the process. Toni Tipton-Martin's 2015 book *The Jemima Code,* a bibliography of African-American cookbooks, collects some examples of this, including one from 1937 called *Emma Jane's Souvenir Cookbook,* by Blanche Elbert Moncure. In the equivalent of blackface dialect, a servant cook, Emma Jane, ostensibly says, "I ain't no fancy cake maker but here is a re-ceet dat 'Ole Miss' taught me," then goes on to give the cake a name involving both a racial slur and an insult to her own intelligence.

Lewis is a sensitive, even-toned renderer of beauty. Her small stories in *The Taste of Country Cooking* gently urge the reader toward a life of mindfulness, a life of learning to see the details. Early in the book, she describes a spring morning: "A stream, filled from the melted snows of winter, would flow quietly by us, gurgling softly and gently pulling the leaf of a fern that hung lazily from the side of its bank. After moments of complete exhilaration we would return joyfully to the house for breakfast." As Jones once said on a panel, "You felt all through her writing that she was giving thanks for something precious."

In a passage called "Hog Killing," Lewis recalls the day each fall when her family would turn pigs into pork. It's not gruesome, but it is earthy. Today, at a time when the phrase "rock-star butchers" has occasion to exist, making us reckon with the mortal reality of meat isn't so shocking. But it's still grounding to read these lines: "My father would remove the liver and the bladder, which he would present to us. We would blow the bladders up with straws cut from reeds and hang them in the house to dry. By Christmas they would have turned transparent like beautiful balloons." Can you imagine being so intimately connected to the guts of life that you could look at a bladder, just separated from its pig, and see a balloon for your Christmas tree? Can you imagine seeing so much to love around you?

But those same hogs also point toward deeper meaning in the text. The next paragraph reads: "The following morning my brothers and sisters and I would rush out before breakfast to see the hogs hanging from the scaffolds like giant statues. The hogs looked beautiful. They were glistening white inside with their lining of fat, and their skin was almost translucent."

In November 1918, two years after Lewis was born, a black man, Charles Allie Thompson, was lynched in Culpeper, a nearby town. A mob hung him from a tree after claims that he raped a white woman. He had been seen asking her to help with butchering, at hog-killing time. It's not clear whether Lewis knew this story. But she was not naïve. "She could see the ugly in the world," Peacock says. "This is someone who had street smarts." She wrote *The Taste of Country Cooking* while in her 50s, in the 1970s, after years as a political radical, after the civil rights movement, after marching for the Scottsboro Boys, nine black teenagers accused of raping two white women, who escaped being lynched in Alabama in 1931 only to be railroaded into shoddy convictions. (They were all eventually pardoned or had their convictions overturned, some posthumously.) Whether Lewis intended to imbue her hog-killing scene with such references, it became impossible for me to read *The Taste of Country Cooking* without a sense of the wider setting of her story and how she chose to tell it without terror, how she refused to let the past, her past, be defined by anyone else but her.

If someone handed you a book about a settlement of freed slaves trying to live off the land, what would you expect? A story of struggle, at least. Privation and desperation, probably. But in Lewis's telling, it is a story of peace and celebration, of receiving the gifts of the earth and hard work. The children sing at concerts in this story.

The recipes are arranged by menus with formal titles as literally quotidian as "A Late Spring Dinner" or "A Cool-Evening Supper," because the very acts of cooking and serving and eating food are worthy of occasion. It is a story of refinement, not in the fine-china sense but in the sense of being meticulous and careful about the way the people of Freetown raised and grew and trapped and foraged and prepared their food, because their lives were worth that. The pleasure of that was due them.

Lewis took the story of rural black people, formerly enslaved black people, and owned it as a story of confidence and beauty. She didn't have an easy life, even in her Freetown years. Her family suffered through two stillborn children and two more who died young of pneumonia. But she chose to see, and to show us, beauty; and under the shadow of oppression and slavery, that is a political act. I spoke with Lewis's niece, her youngest sister Naomi's daughter, Nina Williams-Mbengue, who, at age 12, took her aunt's handwritten sheets of yellow legal-pad paper and typed the manuscript for *The Taste of Country Cooking*. Her aunt never said her book was meant to be political. But she often spoke of being inspired by the people and the humane, communal spirit of Freetown. Williams-Mbengue said: "She just didn't have any notion that these people were less-than because they were poor farming people. She wanted to make their lives count." And then she added: "Imagine being enslaved, then rising above that to build your own town. Aunt Edna was always amazed that one of the first things they did was to plant orchards, so that their children would see the fruit of their efforts. How could those communities have such a gift? Was it that the future had to be so bright because they knew the past that they were coming out of?"

One of the most quietly devastating passages in American literature is the opening of *Narrative of the Life of Frederick Douglass, an American Slave*: "I was born in Tuckahoe, near Hillsborough, and about twelve miles from Easton, in Talbot county, Maryland. I have no accurate knowledge of my age, never having seen any authentic record containing it." Here we find so many of slavery's psychological horrors in Douglass's two simple, measured, masterful sentences: I can tell you, in great detail, about the location of my body. But I can't tell you how long I have been here, because the system that made my body someone else's property keeps the most basic, most intimate fact of my own life away from me.

It's possible to hear the echoes of Douglass's sentences in the first lines of *The Taste of Country Cooking*: "I grew up in Freetown, Virginia, a community of farming people. It wasn't really a town. The name was adopted because the first residents had all been freed from chattel slavery and they wanted to be known as a town of Free People." You can hear the echoes in the even tone, in facts, plainly stated, that have to say no more to say so

much. The message here is empowered, almost fierce: Our town may not have been a town, according to the people who draw the maps and place the post offices. But it was a town, a whole world, because we, and I, say so.

"The book was this coming out," Jones says. "But she felt able and entitled to it. She was very strong in her beliefs." When they were working on the book together, Jones noticed that there wasn't a menu for Thanksgiving. She asked Lewis about it, who said, quietly: "We didn't celebrate Thanksgiving. We celebrated Emancipation Day." And so she wrote a menu for that, leaving it to the reader to figure out why.

Nearly every year, Lewis went back to Virginia, often visiting the site where Freetown had stood, even when all that remained was a stone chimney and a few houses, sagging as if molten. But she would delight in feeling the soil under her feet with her older sister Jenny, who still lived nearby. "I remember trailing along behind them, picking blackberries, the brambles getting caught in my pants and my hair," Williams-Mbengue says. "And they would be giggling, picking berries and wild greens for salads." While she was writing *The Taste of Country Cooking*, Lewis cooked with Jenny to refresh her memory of the techniques and the flavor and often called her from New York while testing the recipes. She read historic cookbooks to learn more about the cooking done by blacks in the past, how Native Americans ate, what French influences Thomas Jefferson brought to her home region. She spoke of the creativity of black women in the kitchen; how that represented some measure of freedom when they otherwise had none. "She always talked about how, in spite of these people being slaves, they created a cuisine that would become world-renowned," Williams-Mbengue says.

Lewis stood as the ambassador of that cuisine, who announced the universality of its appeal and importance and who wrote, in part, to preserve it. She feared that the departure of people from the land, and the rise of fast food and convenience foods, would change the culture of cooking. "Southern cooking is about to become extinct," she said to *The New York Times Magazine* in 1992. And she feared, too, that people would lose sight of who should be credited for that cooking. "It's mostly black," she said, more forceful in her later years, because blacks "did most of the cooking in private homes, hotels and on the railroads." She began work on, but never finished, a book about the significance of black cooks in Southern food.

Southern food has had its ups and downs in the national consciousness. In 1962, Eugene Walter of Mobile, Ala., wrote of his culinary homesickness while traveling for *Gourmet* magazine: "It's interesting that in New York one can find authentic food of every country on earth, save of the South. What is advertised as Southern fried chicken is usually an ancient fowl encased in

a cement mixture and tormented in hot grease for an eternity. Southern biscuits à la New York are pure cannon wadding. Gumbo they've not even heard of." But for the last nine years, by my calculations, two-thirds of the nominees for the James Beard Foundation's annual award for the best book on American cooking have been on the subject of Southern food. Southern books have won the award all of those years but one. Yet none of those Beard award winners, or nominees, were black.

Leni Sorensen is a Virginia historian of African-American cooks. "Many black people have not heard of Edna Lewis because they're urban and raised in schools to learn that farming is dirty and slavery was awful, so let's not talk about it," she told me. "There is a feeling: 'Oh, hell no, we just got *off* the farm.' And for many black people, to see any activities done under slavery now as professional is just too painful." Joe Randall, a chef of five decades and a friend of Lewis's, says: "Cooking was relegated to black folk, and when Johnson signed the Civil Rights Act, a lot of civil rights leaders said, 'We don't have to work in your restaurants anymore.'" Randall taught hospitality management at universities and says, "A lot of my students' grandparents said, 'I didn't send my baby to college to be no cook.'"

Once cooking became a profession with cultural cachet—Randall attributes this rise to the moment in 1977 when the Department of Labor began classifying chefs not as "domestics" but as "professionals"—many black chefs then became pigeonholed as "soul-food cooks." In her 2011 book *High on the Hog*, the culinary scholar Jessica B. Harris writes that in the 1960s "soul food was as much an affirmation as a diet. Eating neckbones and chitterlings, turnip greens and fried chicken became a political statement for many." But Lewis publicly distanced herself from soul food, once saying to *Southern Living* magazine, "That's hardtimes food in Harlem, not true Southern food." Adrian Miller, who wrote a book called *Soul Food*, says he understands where Lewis was coming from: "This is the food of black migrants, who were transplanting a cuisine to where they couldn't always find what they had before. So they had to find substitutes, like canned and processed ingredients. I think Lewis thought it just was something different than the scratch cooking that she made." Lewis came directly from slaves and from the land and the food that they grew and prepared for themselves. Her food wasn't a remix of food that they got from the elite; it was the same food as the elites ate, only they owned it themselves. She had no truck with the belittling mainstream idea of soul food—cheap and greasy—as the totality of black cooking, but it's easy to see how her words would fall hard on ears that still hear pride in the term.

It has been almost 10 years since Lewis died, 40 since she published *The Taste of Country Cooking*. Who carries her torch? There are many calling for seasonal, organic

eating, but who else has been afforded the iconic position Lewis held, to keep showing us the rich history and influences that black cooks have had on American food? Jones found Lewis by chance. Is America looking hard enough for the next Edna Lewis?

It's a question that has weighed on Tipton-Martin for years, as she pored over hundreds of African-American cookbooks to write *The Jemima Code*. She got to speak to Lewis at a food writer's event and, while still in awe of her, steeled herself to tell her that she was not the only one. "I told her that I wanted to tell the world that there were more women like her than just her," she said. A while later, Lewis sent her a letter, written on the same kind of yellow legal pad that she used to write *The Taste of Country Cooking*. "Leave no stone unturned to prove this point," she wrote. "Make sure that you do."

EXCERPT

Every Nation Has Its Dish: Black Bodies and Black Food in Twentieth-Century America

Jennifer Jensen Wallach

Selection from Chapter 4: "Regionalism, Social Class, and Elite Perceptions of Working-Class Foodways during the Era of the Great Migration," 109–12. Chapel Hill: The University of North Carolina Press, 2019

Regional Conflicts During the Great Migration

Both the culture shock that Bessie Delany described after her first exposure to southern working-class food and the tensions between the fictional Tempy and the rest of her family over what to eat are representative of other interactions among respectable eaters and those whose food habits they thought were in need of reform. These conflicts became the most pronounced in the context of the Great Migration, which took place between 1910 and 1970, when 6 million African Americans left the South for urban centers in other regions.[1] This massive migration dramatically changed the demographics of many of the final destination cities, creating cultural skirmishes throughout the route of the Great Migration as migrants brought regional tastes with them. As the numbers of migrants increased, their food practices were met with increasingly fierce opposition.

Not only did this outmigration lead to cultural clashes between southern migrants and respectable eaters already living in terminus cities, but it also led to a profound and lasting shift in how the cuisine of southern rural African Americans was characterized. Many

northern respectable eaters had been born outside of the South and thus did not have the same culinary birthright as the southern migrants. Others had already learned to discard, or perhaps to hide, many of the vestiges of a diet they associated with slavery or with southern poverty in the name of upward mobility and assimilation, and they resented the infusion of unrepentant southern-style eaters. Nonetheless, southern cooking survived transplantation, much to the consternation of those who linked dietary change to racial progress. Furthermore, in spite of the protestations of respectable eaters, who were determined to resist the essentialist implications embedded in the idea of a racial rather than a regional style of eating, southern food slowly became identified as "black" cuisine in these northern urban contexts.[2]

Cultural battles over the fate of southern foodways were particularly pronounced in Chicago, one of the most sought-after destinations for southern migrants during the first half of the twentieth century. In 1890, only 2 percent of the city's population was African American. During World War I, the black population quickly more than doubled, reaching 100,000 people. By 1970, the black presence in the city constituted a third of the total population.[3] This rapid demographic shift inspired class and cultural conflicts between the newcomers and members of the already-established black community who worried not only that new arrivals would provide competition for scarce resources like jobs and housing but also that their allegedly less refined behavior might earn the enmity of the local whites who controlled these resources. Unsurprisingly, given the centrality of food to the project of uplift, these anxieties were frequently manifested in the form of disagreements about what constituted proper food behavior.

A column in the *Chicago Defender* in 1910 encapsulated the heightened state of class tensions in the black community during this era. The unnamed writer complained about "loud talking" at a local theater. Appropriately enough, given the symbolic significance of pork as an iconic southern food, the columnist accused these noisy theatergoers, whom he suspected were "newcomers to our city," of treating the community space as if it were a "hog-pen."[4] Overt prejudices against both southern migrants who behaved "like pigs" and southern-derived eating practices heavy in pork products, especially low-status scraps and offal, were apparent in the pages of the *Chicago Defender*, where columnists paternalistically advised members of the community who allegedly did not know any better against eating the meat-and-carbohydrate-heavy diet associated with southern cooking.[5]

The ongoing southern taste for pork, one of the most reviled symbols of culinary difference in the minds of some assimilationist eaters, was evidenced in the presence of numerous barbecue restaurants and casual "pig

ankle joints," which dotted the city's South Side, the area where the black population was concentrated. For the entrepreneurially inclined, setting up a small restaurant generally required less capital and fewer specialized skills than many other kinds of small businesses. Thus food-related businesses—restaurants and small groceries—became the most common variety of black-owned enterprises in Chicago.[6]

The centrality of pork consumption in the life of the community was dramatized when Rogers' Pig Ankle College caught fire in 1911. Workers desperate to salvage the small business's valuable inventory frantically threw pigs' feet, intestines, and mouths onto the city streets, blocking traffic on State Street for an hour.[7] The sight of porcine body parts piled up on a major thoroughfare acted as a visual reminder of the importance of vernacular food culture to an increasingly large proportion of the inhabitants of that section of the city. From the perspective of respectable eaters, the grisly display of animal flesh also served as a metaphor for the unruly lower classes who, in the minds of respectable eaters, opened up their own racialized bodies for public display through their rowdy behavior and by proudly consuming food with negative historical and cultural connotations.

Many members of the black middle class were fearful that their efforts to appear respectable would be overshadowed by what they regarded as the bad behavior of some of the less fortunate members of their race. In a 1939 short story by William H. A. Moore, which was set in Chicago, the author describes some of the characters as "bad eggs." He presents the fact that one man ran a "pig ankle joint and moonshine cellar" as sufficient evidence to substantiate the fact that he had lax morals.[8] Indeed, the consumers and purveyors of less choice scraps of pig flesh were often stigmatized by the elite as being a social embarrassment to the black community. A 1915 article in the *Chicago Defender* described "pig ankle joints" in general as being "unsightly and unsanitary."[9] Furthermore, food reformers were fearful that the poor dietary habits of those of the present generation would have a detrimental impact on their children. The interracial Chicago Commission on Race Relations, which was charged with contextualizing the events of the 1919 race riot in that city, bemoaned poor living conditions in the black community and decried the "ignorance of parents" who allegedly did not know how to feed their children properly, giving them, for example, too many pork products and not enough green vegetables.[10]

Although these anxieties were heightened by the demographic transformations that occurred during the Great Migration, class anxieties about food consumption drew upon preexisting class-based stereotypes. For example, in his 1899 classic sociological study, *The Philadelphia Negro,* Du Bois somberly judged that "in habits of personal cleanliness and taking proper food

and exercise, the colored people are woefully defi-
cient."[11] He blamed their current plight on the legacy
of slavery and despaired that the poor black people of
Philadelphia "waste much money in poor food and in
unhealthful methods of cooking."[12] Chief among the
food items eaten in black Philadelphia, which Du Bois
disapproved of, was "pork fried, grease."[13] Middle-class
distaste for working-class food habits was evident in the
South as well. In a social anthropological study of 1930s
Natchez, Mississippi, a team of researchers led by Alli-
son Davis found that members of the black middle class
described the lower classes as "'dirty,' 'filthy,' or 'nasty'"
and described "an actual physical revulsion toward prox-
imity with lower-class persons."[14] This sense of disgust
was easily transferred either from the individual to the
foods he or she consumed or from the foods back to the
individual. In a circular fashion, unrespectable eating
habits were used to stigmatize members of the working
class, and those of the working class were stigmatized
because they ate unrespectable foods.

Middle-class ideas about culinary respectability
were often used to create and maintain class divisions.
Although members of the black middle class feared that
improper working-class behavior might damage the
prospects of those who failed to embrace the lessons of
uplift—for example, by refusing to stop publicly con-
suming scraps of pork—their lessons in reform were also
self-serving. As Evelyn Brooks Higginbotham observes,
although uplift enabled black Americans to challenge
racism by demonstrating their ability to conform "to
the dominant society's norms and manners," it also
empowered its adherents to criticize what they regarded
as "negative attitudes and practices among their own
people."[15] On the one hand, reformers hoped that the
working class would heed their advice and behave in
a way that would reflect well upon the race. However,
on the other hand, they had incentive to hope that their
lessons in racial elevation would be ignored because
they directly benefited from ongoing class stratification.
Without the existence of an allegedly culturally back-
ward working class to serve as their foil, members of the
middle class were unable to illustrate the extent of their
own accomplishments.

Notes
CD: *Chicago Defender*

1. U.S. Census Bureau, "Great Migration."
2. Bégin, *Taste of the Nation,* 76.
3. Layson and Warren, "Chicago and the Great Migration."
4. "Loud Talking in the Pekin." CD, April 25, 1910, 1.
5. Poe, "Origins of Soul Food," 9. A. Wilberforce Williams, a phy-
 sician who served as the health editor for the *Chicago Defender*
 from 1911 to 1929, published numerous articles advising readers on
 proper nutrition and on topics such as how to avoid obesity. See, for

example, A. Wilberforce Williams, "What to Eat in Cold Weather,"
CD, March 11, 1922, 12, and "Obesity," CD, October 11, 1924, 12.
6. Poe, "Origins of Soul Food," 17.
7. "Rogers' Pig Ankle College Burns," CD, June 17, 1911, 1.
8. William H. A. Moore, "And Christ Came," CD, December 30, 1939,
131.
9. "Pig Ankle Joints," CD, May 29, 1915, 41.
10. Chicago Commission on Race Relations, Negro in Chicago, 264.
11. Du Bois, *Philadelphia Negro,* 161.
12. Du Bois, 178.
13. Du Bois, 161.
14. Davis, Gardner, and Gardner, *Deep South,* 234.
15. Higginbotham, *Righteous Discontent,* 187.

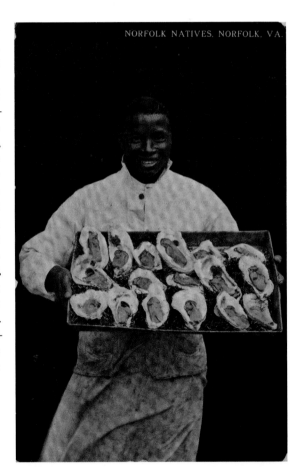

Postcard, "Norfolk natives, Norfolk, VA,"
1915

EXCERPT

The Jemima Code: Two Centuries of African American Cookbooks

Toni Tipton-Martin

Selection from "1961–1970: Soul Food: Mama's Cooking Leaves Home for the City," 78–81. Austin: University of Texas Press, 2015

It seemed to me while certain foods have been labeled "soul food" and associated with Afro-Americans, Afro-Americans could be associated with all foods.

—VERTAMAE GROSVENOR, 1970

With the same hidden passion that enabled their ancestors to enliven monotonous plantation diets, southern cooks who migrated North and West improvised and made do with whatever was in the cupboard and on the shelves of the corner store. They did what European immigrants had done: establish their ethnic identity around the symbols of their rural culture, cooking country food as a way to satisfy a longing for home. Their menus appealed to city folks, too, showing up in juke joints, chicken shacks, and barbecue stands. "The very things that made them [migrants] most visibly ethnic, allowed them, paradoxically to integrate into the urban consumer economy," Tracy Poe explained in her pioneering study "The Origins of Soul Food in Black Urban Identity: Chicago, 1915–1947." In 1961, for instance, Sylvia Woods opened a restaurant in Harlem, featuring a home-style menu of fried chicken, barbecue ribs, grits, black-eyed peas, collard greens, sweet potatoes, cornbread, and sweet potato pie. In urban areas from New York to Chicago, restaurateurs like her achieved prosperity and a modicum of fame by serving inexpensive food that once was considered backward and country.

They called it soul food.

By 1968, the word "soul" had become the cultural identifier symbolizing this type of black expression: soul music, soul dance, soul food. "Soul" became shorthand for black dignity and pride. In his autobiography, the Nation of Islam leader Malcolm X remembered the soul food fixed by his landlady. The poet and writer Amiri Baraka went so far as to list soul foods in his 1966 book *Home: Social Essays*. "He [Baraka] insisted that hog maws, chitlins, sweet potato pie, barbecued ribs, hopping John, hush puppies, fried fish, hoe cakes, biscuits, salt pork, dumplings, and gumbo all came directly out of the black belt region of the South and represented the best of African American cookery," wrote Frederick

Douglass Opie in his exhaustive exploration of African American cookery, *Hog and Hominy: Soul Food from Africa to America*.

The first soul food cookbooks began to appear in the late 1960s. They struggled to define the improvisational aspects that characterized dishes prepared with soul against the rigid requirements of scientific cooking. At the time, white culinary and nutrition "experts" were gushing over haute cuisine made by innovative chefs, promoting the exotic flavors of immigrant cuisines, and building up health foods. African American cooking could be just as innovative, exotic, and healthful, but black authors secured their place at the publishing table by glorifying and translating their mysterious foodways into codified formulas that sought to distinguish their dishes from those cooked by southern white people.

Jim Harwood wrote in *Soul Food Cook Book* (1969): "Soul food takes its name from a feeling of kinship among Blacks. In that sense, it's like 'Soul Brother' and 'Soul Music'—impossible to define but recognizable among those who have it. But there's nothing secret or exclusive about Soul Food." In the same year and in a book with the same title, Bob Jeffries expanded the idea, contending that the catalogue of soul food dishes is long and varied, distinguished from other southern food primarily by race:

Like jazz, [soul food] was created in the South by American Negroes, and although it can safely be said that almost all typically southern food is soul (up until World War II nearly all the better cooks in the South were Negro), the word soul, when applied to food, means only those foods that Negroes grew up eating in their own homes; food that was cooked with care and love—with soul—by and for themselves, their families, and friends. This, of course, included much of what is now termed traditional southern fare, dishes such as Deep-Fried Chicken, Spareribs, and Country Ham, but it was also much more.

The problem entangling Harwood, Jeffries, and other early "ideologues of soul food," Opie says, is that their books "failed to embrace and incorporate cuisines of other peoples of African descent migrating to the United States from the Caribbean after the turn of the century." They forgot other stuff too.

Soul food had its roots in southern cuisine, and southern cuisine was a rich culinary tradition. But the soul food roster omitted the aspects of country cooking on farms, where dishes were based on fresh fruits and vegetables from the garden or fresh buttermilk courtesy of the family cow.

As a result, soul food became a signifier for "slumming," reenergizing a long-standing debate that had quietly raged about black foodways as a demarcation line

and Saturday night might be spent at a downtown (or uptown) joint that served barbecue that would be at home in Memphis or Montgomery. The commercial streets of these neighborhoods boasted small mom and pop African American restaurants that served the tastes of the Black South the homesick transplants craved: smothered pork chops with thick gravy spooned over buttery rice, slow-cooked pots of greens to be eaten with chopped onions, vinegar and the hot sauce that graced each table with its fiery presence. Breakfasts offered creamy grits and sausage patties with biscuits to drown in syrup. Neighborhood bars slaked thirsts with liquor (maybe some corn liquor could even be found under the bar if a patron had recently returned from the South). Before it became the tag line for a popular television show, everyone knew your name and probably your family in these spots, and there was always news from the Southern home places.

I grew up in such a neighborhood in Jamaica, Queens, in the 1950s, daughter of a nuclear family blessed with two grandmothers who unwittingly bathed me in Southern mores. My paternal grandmother, who had arrived in New York City from central Tennessee in the early 1920s, kept her Southern ways despite living in the South Jamaica housing project. She laboriously made beaten biscuits which she served complete with Alaga syrup (the name I would later learn was a composite of Alabama, Louisiana and Georgia). Buttermilk was always in her refrigerator, and from late spring through the fall she would work in the small plot of land that she and other tenants had behind their building, no doubt remnants of victory gardens past. The collard greens that she grew were left until the first frost and then seasoned with smoked pork. Her food was that of the hardscrabble rural South. My maternal grandmother, although from Virginia, had followed her minister husband to Plainfield, New Jersey, where the Baptist church had placed my grandfather. There, she re-created the Virginia cookery of her youth complete with home-canned watermelon rind and Seckel pear pickles, fluffy yeast rolls, garden-fresh vegetables, macaroni and cheese, and crystal pitchers filled with minted lemonades and other cool drinks all year round. She was my Edna Lewis before I knew of Edna Lewis. Each grandmother provided me with a clear Southern culinary roadmap.

At home, there was Southern food aplenty on special days: freshly made biscuits each Sunday with a larger one for my father that we called the hoecake, cornbread at dinner most every night and cornmeal stuffing in the turkey at Thanksgiving along with candied sweet potatoes and an obligatory sweet potato pie. New Year's Day meant a trip to the store for black-eyed peas and collard greens. Now that those days are more than half a century behind me, I find that without thinking I maintain many of the Southern culinary traditions of my youth,

especially those connected with New Year's festivities. My menu for that day is a celebration of the Great Migration, as most of the dishes on the table came straight from those Southern grandmothers. Grandma Jones' roast pork complete with crackling is the centerpiece of the meal. Grandma Harris took over in the smoked pork-flavored, slow-cooked, stewed-to-a-low-gravy collard greens that are traditionally eaten to guarantee folding money, and in the black-eyed peas that were cooked with the rice as Hoppin' John for luck. I've added a Southern succotash of okra, corn and tomatoes as a personal tribute to the pod that for me signals African heritage food.

My New Year's offerings are simply one demonstration of the tenacity of African American culinary traditions. Others are evidenced throughout the year at birthday parties and summer barbecues, family reunions and Thanksgiving dinners, Sunday suppers, church outings and weeknight meals. Ways of being that began many decades prior and thousands of miles away in the kitchens of the urban and rural South turn up in the kitchens of the Northeast, Midwest and West in a gustatory testimonial to the Great Migration and the enduring ties that bind.

"I am a Southern cook, butler or Janitor I have two boys age 15 yrs & 13 yrs, and wife that does maid work now I would like for you to help me locate myself & family some where up there for work I can furnish reference to thirteen years of service at one place I am anxious to come right away."

JACKSONVILLE, FL, DATE UNKNOWN

Shakti Baum, 2018

Shakti Baum

Miss Mary, Sweet Honey, and the Cornbread

My Aunt Winne had a big Doberman that scared me to death. My only safe space was in the kitchen, because she didn't allow dogs in the kitchen where cooking was going on. In that kitchen I became an unwilling student, forced by circumstance and fear to make cornbread.

My Aunt Winnie taught me the ancestral intricacies of my Grandmother Mary's recipe, from which all things of goodness came. With her big voice, she commanded, "2 cups of this, 1 cup of that, some oil, and then some sugar, some baking powder and salt," which she showed me how to measure with the palm of my hand. She had a big cast iron skillet, which was heavier than me, that had also belonged to my grandmother. While I stubbornly scraped the batter into the hot skillet, she would tell me how beautiful my grandmother was, "black as night and beautiful as all get out," she would say. I heard this story every time we made cornbread in the kitchen together. I'm sure we made other things, but I can't remember.

It didn't occur to me, as a child, that I was carrying on a legacy. I couldn't have fathomed at that age the beauty and privilege of knowing this recipe, how far it had traveled, or how many hands had perfected it. My Grandma Mary's recipe had made its journey from "yonder way" by way of "so and so" and finally made its way to "these parts." I've since added my own touches to Grandma Mary's recipe: a bit of basil, tarragon, French butter, chive, honey and such. My updates to the recipe are good, but never as good. Every time I make this recipe I think of my Aunt Winnie, with her big voice, and the accuracy of measuring with the palm of my hand. I imagine my Grandma Mary, whom I never met, "black as night and beautiful as all get out."

Shakti Baum is the owner of Babette Market, a boutique cooking and event space. She is also the chef for Project Row Houses as well as the founder/director of the Oxtail MashUp Culinary Competition. She is driven to create great events with good vibes and delicious food.

Griddled Sweet Corn Cake with Tarragon and Honey Butter

YIELD: 6 SERVINGS

TOTAL TIME: 1 HOUR 45 MINUTES

INGREDIENTS

Grilled Sweet Corn Cake

1½ cups cornmeal

2½ cups all-purpose flour

½ cup white sugar

2 tablespoons baking powder

1 teaspoon salt

⅔ cup grapeseed oil

⅓ cup melted butter

2 tablespoons honey

4 eggs, beaten

2½ cups whole milk

Tarragon and Honey Butter

1 stick of unsalted butter at room
 temperature

2 tablespoons fresh tarragon,
 chopped

1 tablespoon raw honey

¼ teaspoon black pepper

¼ teaspoon sea salt

Optional:
add ¼ cup mashed blueberries or
 strawberries
add 1 teaspoon orange zest
substitute fresh basil for tarragon

DIRECTIONS

Preheat oven to 350 degrees and grease a one-pound loaf pan.

Mix all dry ingredients—cornmeal, flour, sugar, baking powder, and salt—in a mixing bowl.

Pour in the grapeseed oil, melted butter, honey, beaten eggs, and milk, and stir just to moisten. Do not over mix.

Pour the batter into the greased loaf pan and bake in the preheated oven for about 45 minutes, until the top of the cornbread starts to brown and cracks. Cool in the pan for an hour.

In the meantime, make the tarragon butter.

In a medium bowl, gently mix all ingredients until just combined. Chill in refrigerator or serve room temperature.

Once the cake is cooled, turn it out and slice it into 6 thick slices.

Heat an oiled skillet. Griddle slices 'til nicely brown and crispy on the edges.

Remove and top with a generous amount of tarragon and honey butter.

Nick Wallace, 2021

Nick Wallace

It started about thirty-three years ago when I was eight years old and served pig cheeks from my granny, Ms. Lennel Donald, in Edwards, Mississippi, on our family farm.

It's a dish that takes most pains away when you sit at the dinner table and begin to share everything family style. This is when the stories start about the daily struggles or the daily wins. It's a place of peace and all that was being thought about while my granny was cooking over the stove, cleaning meat, cleaning vegetables, washing dishes—doing all that with a smile.

This safe place that my family owns is located in the backside of Edwards. That was intentional to keep the next generation safe from all the happenings in downtown Edwards, on the roads, and throughout the highways. It was our happy place, and that was done with purpose. One of the many things my family is good at is cooking. Growing food, taking care of animals, planning family engagements on the farm, fixing the lawnmowers and chainsaws, building fences, picking pecans, chasing down chickens, and digging up sweet potatoes. So this is my magical moment of a dish that I remember that brought so many smiles to my family, and I hope it does the same for you.

Nick Wallace is the founder of Nick Wallace Culinary, Nissan Cafe by Nick Wallace, and his non-profit Creativity Kitchen.

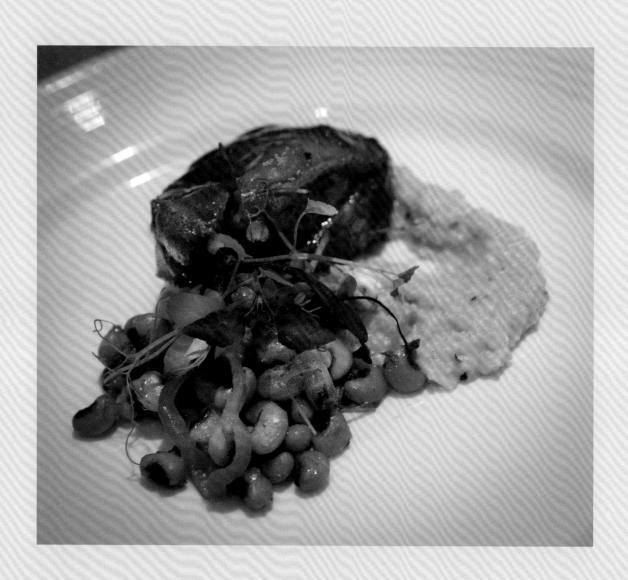

Braised Pig Cheek with Fresh Micro Carrots, Morel Mushrooms, and Peewee Potatoes

YIELD: 6 SERVINGS

TOTAL TIME: 2½ HOURS

INGREDIENTS

Braised Pig Cheek

3 tablespoons olive oil

1 large onion, diced

1½ lbs pork cheeks, with any excess fat cut off

1 tablespoon flour, seasoned with kosher salt and coarse black pepper

3 garlic cloves, finely chopped

½ teaspoon ground cumin

1 teaspoon paprika

1 cinnamon stick

½ cup dry red wine, your choice

2 cups beef stock

Vegetables

1 lb whole micro carrots

8 oz morel mushrooms

1 lb peewee potatoes

2 tablespoons kosher salt

1 teaspoon white pepper

2 tablespoons olive oil

DIRECTIONS

Heat a large pan on medium heat and add 2 tablespoons of the olive oil, then add the onion. Cook gently for 15 minutes until onions are translucent and lightly browned. Remove them from the pan and set aside.

Toss the pork cheeks in the seasoned flour. Add the remaining oil to the pan and turn up the heat to medium-high. Brown the pork cheeks all over, setting them aside when browned. Turn the heat down to medium.

Return all the pork and the onions to the pan. Add the garlic, cumin, paprika, and cinnamon stick, and cook for two minutes.

Pour in the wine. Use your spoon to scrape the bottom of the pan.

Pour in the beef stock, then bring the pan to a simmer. Simmer with a lid or, if you don't have a lid, wrap tightly with some aluminum foil, for 2 hours or until the pork is tender.

Separately wash and scrub the carrots, mushrooms, and potatoes, and soak them in water to draw out any dirt or sand.

Start a medium-size pot of water on the stove and bring to a boil at medium-high. Add 2 tablespoons of kosher salt and 1 teaspoon of white pepper to the water.

When water is boiling, drop in the potatoes and cook for 15–20 minutes, until fork tender. When the potatoes are done, take a spider utensil to fish them out of the water and place them on a baking sheet to dry and cool slightly.

Then with the same water, drop the carrots in for 8 minutes. When they are cooked, place them with the potatoes.

Next, grab a large sauté pan, add 2 tablespoons of olive oil on medium heat, and transfer the dry potatoes and carrots to the pan and sauté for 6 minutes.

Once the potatoes and carrots finish sautéing, transfer them back to the baking sheet. Place the morels in sauté pan and, using the same oil, sauté for 5 minutes. Then let them hang out until it's time to plate up the entire dish.

Enrika Williams

I am from West Point, Mississippi, born and raised in this warm hamlet (pun intended) nestled in the northeastern hills, full of lyrical sounds of the blues, the oral traditions of some of the finest storytellers (Daddy called them liars . . . lol) and the most eloquent party throwers and event planners ever. I grew up here during the early 1980s, and I remember the jobs available to the majority of my childhood friends' parents, including my own. . . . They taught, they fed us in schools, took care of us at the health department, and they worked in the factories.

One of the major ones was Bryan Brothers Meat Packing company. Working in a meat-packing plant in a small industrial town that prides itself on the bountiful and endless availability of beef and mainly pork products set the tone for a diet steeped in having one or several of these products available at any function, gathering, or cookout. I grew up loving pork, and pork stirs a special nostalgia for me in my deepest of childhood memories. The images of joy, celebration, and connectivity that always resonate when I cook or encounter a wonderful piece of pork are never far removed.

Pork was always the epicurean backdrop of a summer tale of cousins visiting from "up North"—by way of Chicago, Detroit, Cleveland—who always claimed we were "country" (read as unsophisticated and crass) because we ate with gusto and gleam . . . all parts of the pig—usually with a heap of hot sauce and mustard . . . or some doctored-up barbecue sauce that we would lick from our fingers with meticulous greed. We loved our pork, and even as society casts shame and disdain for the love of "poke," I still love it. In moderation, of course.

There was always a connectivity in visiting relatives who still had their slight Mississippi drawl, which became thicker on the tongue the longer they stayed in their visits home, down here . . . those same ones that moved away years before in search of new jobs and the promise of fancy city life and new opportunities . . . who smile with the corners of their eyes at the mention of a pig ear sandwich or some rib tips that are so tender you could gum them with ease. They offer to take a bite, because they haven't had any that tasted THIS close to good since they visited last time. They too are transported and recall their own memories around pork. It took me getting older and more reflective in my memories and cultivating that into my own honorings as a chef and one who plays with food for a living. Pork fed us in many ways. If you raised them, sold them in the store, cooked them for a living or worked on the kill floor at Bryan to process it . . . that thread of connectivity runs quite the way, through generations, across state lines and rediscovered traditions.

I recently went home to attend the funeral of a family member. There is something both deeply moving and immensely intimate in the ritual of the repast. Repast for us means a meal and a space for comforting, to provide support, and it usually turns into an impromptu family reunion. My small-town community, my family, has always been one of tremendous shows of love and hospitality and rest . . . no matter the lack of frequency or how recent your visit. The womenfolk (I lovingly refer to them as such) are most

Opposite: Enrika Williams, 2021

certain to come in and take care of the family. The greatest demonstration of this love is the bounty of food that is offered.

There is typically a hierarchy of who prepares what . . . greens and dressing and beans are for the seasoned professionals in this arena. They know how much to make, and nothing less than feeding thirty football players will do for portions. In case you didn't know, nothing is measured. It's enough when you declare it's enough. Then there are the sweets and desserts and Kool-Aid and iced tea ladies, and they are the ones who mean well, but their forte is working with sugar, so they are usually delegated to that duty. That leaves the chicken and the ham. Chicken preparation can be excused and you can get some buckets or boxes from the local place if you choose, but that HAM?! That ham tends to be the scene-stealer every time. Sometimes cooked in Coca-Cola and adorned with maraschino cherries, pineapple slices, and studded with cloves? It is THE show. It is never sliced perfectly thin like they would do at Picadilly's . . . the attempt is there, but you're liable to end up with a jagged piece that sat in the Coke/sugar syrup a bit too long, and there is a piece of that fat dangling . . . and you don't mind that it ain't cute but tastes divine. You know that the reason for this season is one of mourning and paying respect, but tasting the food and having the women heap scoops of comfort and joy transcends the location.

It was in these moments of watching these women smile and serve and offer food in a ritual of love, of remembrance, of service and just being hospitable and welcoming, that brought me full circle to childhood memories of pork, which over time has gotten a bad name and been eaten WAY out of moderation. It makes me remember the times and the thing that connected us through the years, through recipes and stories and cookouts and card games. All in its ability to feed and sustain us either directly or indirectly. I come from a place with people who are proud, nourishing, and sometimes recommended to be ingested in small doses. Kinda like ham. Kinda like home. Kind of like me. The connectivity is alive and well and thriving and appreciative. Kinda like home, kinda like memory. Certainly like me.

Recently, my Aunt Tina made the most succulent of hams, and I had to ask for her recipe. Here it is, in abridged form, but sure to be as succulent and divine as any you have ever tasted.

Enrika Williams is a chef and owner of Fauna Foodworks, a culinary food lab in Jackson, Mississippi, that produces thoughtful, ingredient-driven, bohemian-chic cuisine.

Ham, the Way Aunt Tina Told Me

YIELD: 12–14 SERVINGS

TOTAL TIME: 3–4 HOURS

INGREDIENTS

1 whole country ham, bone in, roughly 8–10 lbs (fresh and not frozen works best for this method)

1 large brown paper bag (called a "sack" if you are from West Point, Mississippi)

Enough water to pour into the bottom of your large pan

A rack to anchor the bagged ham over your large pan

Bacon grease, or drippings or vegetable oil to coat the inside of the bag

DIRECTIONS

Preheat the oven to 400 degrees. Grease the inside of the bag with the bacon grease or vegetable oil. Place the ham in the bag and close tightly. Pour in enough water to come up ¼ of the side of the large pan. Place the bagged ham on the rack that is sitting over the roaster pan.

Place this in the oven and cook slowly for roughly 2½ to 3 hours. This helps the skin crisp on the outside and keeps the ham moist on the inside. Once the ham is cooled, you can pull it apart and eat it immediately or slice and chill it for another day.

Krystal C. Mack, 2020

Krystal C. Mack

Even though i am city-living in Baltimore, Maryland, i feel most connected to the roots of my family's history in Virginia and the Carolinas when i am cooking or in the garden. It is that connection that has allowed me to discover and reimagine traditions that were forgotten by my family over time. As an interdisciplinary artist, food is most often the chosen medium for my work. It allows me to dive deeply into layers of the personal and political, using comestibles to create a new or different type of social discourse. i love to experiment with classic recipes and heirloom ingredients in my work, like peppers, greens, tomatoes, and sweet potatoes, but i know better than to experiment with my family's favorite dishes at our holiday get-togethers. This was a lesson i learned the hard way.

While my family likes to try new things here and there, they definitely like what they like, and for the most part i can respect that. They are often hesitant to try my food if it's "too different" or "extra" (i.e., different types of grains, edible flowers, etc.), so this recipe is jokingly for them. i call this "Not My Mama's Potato Salad" because it is a salad and it is made with potatoes, but it is definitely not a potato salad and it is absolutely not Andrenette's potato salad. Andrenette is my mom and she makes the best potato salad, hands down. Every Black family has a relative that hooks up a dish the best, and in my family my mother makes the best potato salad. It is a straightforward, vibrational recipe, and whenever there is a cookout everyone always asks, "Did Netty make the potato salad?" i've seen folks hit a U-turn halfway to the buffet table if the answer is no. Some things you just can't compete with.

One day i will master her recipe, but until then i can make my own classics and create new traditions. While my family can be picky about what they eat, i've never let that discourage me. If anything, it's empowered me to further explore Black Southern cuisine and honor our everyday ingredients in new and inventive ways. i believe that this "potato salad" recipe does just that. It also introduces newer techniques for staples of Black cuisine, like broiling mustard greens in the oven and roasting sweet potatoes in coffee beans. So please enjoy this salad recipe, which i repeat IS NOT AT ALL my mama's potato salad recipe. Love you, Ma.

The lowercase "i" is an intentional element of Mack's writing voice in her recipes and essays as an artist. It has been retained here at her request.

Krystal C. Mack is a Baltimore-based interdisciplinary artist using her social practice to highlight food's role in healing, community building, and empowerment.

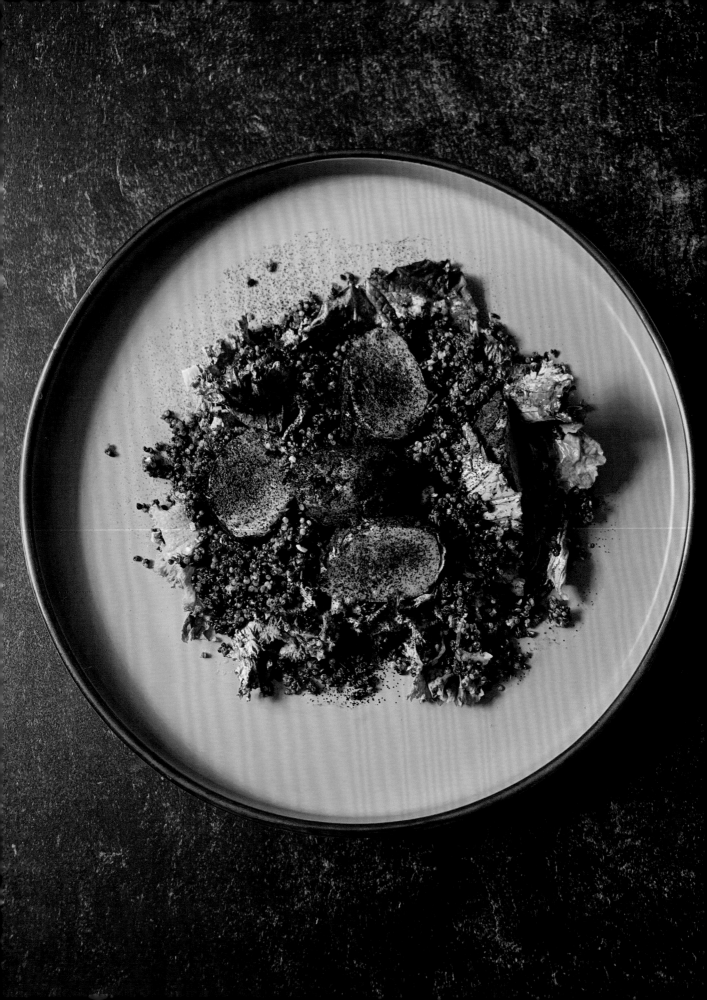

Not My Mama's Potato Salad

(COFFEE-ROASTED SWEET POTATOES WITH BROILED MUSTARD GREENS AND ZESTY BEET QUINOA)

YIELD: 2—4 SERVINGS

TOTAL TIME: 1 HOUR 20 MINUTES

INGREDIENTS

Dressing

1 tablespoon shallot, minced

1 small cayenne pepper, seeded and minced, or ¼ teaspoon crushed red pepper

1 tablespoon plus 1 teaspoon red wine vinegar

2½ teaspoons maple syrup

Juice of ½ a lemon

Coffee-Roasted Sweet Potato

1 medium sweet potato

2 teaspoons sea salt

1½ cups decaffeinated whole bean coffee

Zesty Crispy Beet Quinoa

1 cup quinoa, rinsed

¼ teaspoon cardamom

2-inch piece of ginger, peeled

2 star anise

1 teaspoon crushed red pepper flakes

½ teaspoon sea salt

1½ cups beet juice

½ cup of grapeseed oil

2 teaspoons garlic, minced

Broiled Mustard Greens

A little more than a ½ lb of mustard greens, washed and patted dry

1 tablespoon olive oil

DIRECTIONS

Combine shallot, cayenne, red wine vinegar, and maple syrup. Set aside to marinate.

Preheat your oven to 425 degrees. Wash your potato thoroughly, leaving the skin slightly damp. Pierce it a few times with a fork. Sprinkle salt over the entire surface of the potato. Pour the coffee beans into a Dutch oven, fully covering the bottom. Add the potato and cover it with the lid. Place the pot into the oven and cook for 45 minutes to an hour (roast time will vary depending on the size of your potato). Remove potato from the oven and allow it to cool. Use long tongs to char the potato by holding it over the flame of your stovetop. You want the flame to entirely blacken the skin, so rotate until it is fully charred. Be sure to use an oven mitt to avoid burning your hands. Once the potato is completely charred, turn off the flame and allow it to cool. Once cool, slice the potato into ½-inch-thick medallions.

Put the quinoa, cardamom, ginger, star anise, red pepper flakes, and sea salt into a saucepan. Add the beet juice and bring it to a boil over high heat. Once boiling, reduce the heat to low, cover the saucepan, and cook for 20 minutes or until the juice is fully absorbed. Spread the quinoa on a sheet pan to air dry. Line a large plate with paper towels. Pour the canola oil in a large skillet over medium-high heat. When the oil begins to smoke, add the quinoa and fry it, constantly stirring with a spatula until it becomes crisp and a deeper burgundy color, about 7 minutes. Add the garlic and cook for about a minute. Turn off the heat and quickly transfer the quinoa-garlic mixture to the paper-towel-lined plate to drain.

Trim away the tough ends of the greens. Toss the leaves with olive oil and sprinkle with salt and pepper. Place the greens in a single layer on a lightly oiled sheet pan. Broil for 30 seconds to a minute, making sure not to burn the leaves. You want the leaves to have a bit of browning with a crispiness to the curly edges of the mustard greens. Transfer greens to a serving dish.

Squeeze lemon juice over the greens. Nestle the medallions of sweet potatoes among the mustard greens. Spoon the dressing all over the salad and season with salt and pepper to your taste. Spoon the fried quinoa into the folds of the salad and serve.

Image and Text Credits: Section II

III. Finding Sanctuary in Ourselves: Cultural Expressions of the Great Migration

Featuring critical analysis of the artistic and spiritual expressions of the Great Migration and ephemera of the world-building of generations of new migrants, this section looks at the religious movements, cultural expressions, and creative urgencies that offered individuals a greater sense of self, collectivity, and purpose—and even the chance to expand their identities beyond the race, class, and social structures linking them to conditions of subjugation. In *New World A-Coming: Black Religion and Racial Identity During the Great Migration* (2016, pages 204–17), Judith Weisenfeld offers insight into the Nation of Islam, the Congregation Beth B'nai Abraham, the Commandment Keepers Ethiopian Hebrew Congregation, the Moorish Science Temple of America, and Father Divine's interracial Peace Mission, all of which exploded in membership in parallel with the Black population boom in American cities. Jean Toomer's *Cane*—a Harlem Renaissance masterpiece and one of the most important modernist novels of the twentieth century—ruminates on working-class Southern life and Northern life simultaneously, breaking free of perceived linearity around the directional flows of people and ideas typically associated with the Great Migration (see pages 220–22). *Cane* provides a model for theorizing Black Southern subjectivity as foundational to the modernist literary avant-garde and giving Black Americans the space to "push back the fringe of pines upon new horizons."[1]

Memories of the South as the crucible of Black culture provided the foundation for many developments in modern literature, visual art, and music. As the Mississippi blues evolved into jazz and Jacob Lawrence created his epic paintings of human promise *The Migration Series* (1940–41), millions of Black Americans traveled with their hopes, dreams, ambitions, and expressions, giving shape to a period of creativity and unique cultural sensibilities in the early decades of the twentieth century. The idea of cultural expression as self-determination, marked in ways that moved beyond oppression, underlies every aspect of this exhibition and publication project. Migrants came together to form and sustain collectives, finding strength, stability, and refuge, and even flourishing amid the harsh realities of redlining, Jim Crow apartheid, and ever-increasing social stratification.

Harlem is an undeniable Mecca of the Great Migration, and its presence in this section looms large, from the iconic Apollo Theater to the cabarets of the Cotton Club. Leslie King-Hammond's seminal essay on the environment that shaped Lawrence's Harlem paintings (pages 228–41) considers the late artist's commitment to picturing uptown working-class life, particularly the newcomers to the fabled New York community, who "self-consciously restructured their entire way of living and thinking," willing into fruition a "dynamic environment" that made an indelible mark on Black culture.[2] Beyond Harlem, regional haunts across the country were equally important. The Royal Theater in Baltimore saw Cab Calloway, Eubie Blake, and Billie Holiday grace the stage, and in August Wilson's Pittsburgh, the Crawford Grille hosted performances by jazz legends. The stories of these historic nodal points outside of major metropoles underscore the wide-reaching sonic, social, and aesthetic possibilities that accompanied those Southern newcomers and hopefuls and the ways they transformed this country and American culture nationwide.

—JBB and RND

1. Jean Toomer, *Cane* (1923; repr. New York: Liveright, 2011), 24.

2. Leslie King-Hammond, "Inside-Outside, Uptown-Downtown: Jacob Lawrence and the Aesthetic Ethos of the Harlem Working-Class Community," in *Over the Line, the Art and Life of Jacob Lawrence*, Peter T. Nesbett and Michelle DuBois, eds. (Seattle: University of Washington Press, 2001), 69, reprinted on pages 228–41 in this volume.

Zora Neale Hurston, 1938.
Photograph by Carl Van Vechten

Rings and earrings for rheumatism,
Mississippi, c. 1920–40, from sociologist
Newbell Niles Puckett's research
documentation of the folk beliefs of
African Americans in the Southern
United States

EXCERPTS

New World A-Coming: Black Religion and Racial Identity during the Great Migration

Judith Weisenfeld

Selections from Introduction: "Religio-Racial Identities," and Part I: "Narratives," 1–21, 23–28. New York: NYU Press, 2018

Introduction
Religio-Racial Identities

When forty-seven-year-old Alec Brown Bey appeared at his local Philadelphia draft board on April 26, 1942, he submitted to the same brief process as that undergone by an estimated thirteen million other men between the ages of forty-five and sixty-four who had been called in the fourth round of draft registration during the Second World War.[1] On the first part of the form Brown Bey provided information about his date and place of birth, his current residence, his employment status, and a contact person, all of which were straightforward. The second part of the form that required the draft registrar to provide a physical description of the registrant, including height, weight, hair color, eye color, complexion, and race proved more complicated, and Brown Bey struggled to feel accurately represented. Registrars no doubt asked the men sitting before them their exact height and weight, and in this case registrar George Richman reported that Brown Bey was six feet two inches tall and weighed 175 pounds. The form also called for the registrar to indicate the registrant's race by checking the appropriate box from a list of options: White, Negro, Oriental, Indian, or Filipino. The complications arose from Brown Bey's rejection of the government's classification of him as "Negro."

A native of Manning, South Carolina, Brown Bey had joined the millions of southern blacks moving north in the Great Migration of the 1920s and 1930s who, upon arrival, met black immigrants from the Caribbean also looking for expanded economic, political, and social opportunities in the urban North of the United States.[2] While migrants did not generally set out for the North or immigrants travel to the United States with the express purpose of seeking new religious options, they nevertheless encountered, and many contributed to, a diverse urban religious culture. The era saw significant religious transformations within African American Christianity, with the rise in participation in black Protestant churches in northern cities, the increasing importance among these of Holiness and Pentecostal churches, and

the development of the storefront church.[3] The religious changes that immigration and migration spurred were not limited to varieties of African American Christianity, however. In this period and in these urban contexts noticeable numbers of people of African descent began to establish and participate in movements outside of Protestantism, and many turned for spiritual sustenance to theologies that provided new ways of thinking about history, racial identity, ritual and community life, and collective future.

It is almost certain that when Alec Brown Bey arrived in Philadelphia, probably in the late 1930s, his name was simply Alec Brown and that, at that time, he probably would not have minded being included in the category of "Negro," either in daily life or on an official government document such as the draft registration card. But sometime between settling in Philadelphia and appearing before the draft board in 1942, Brown had become a member of the Moorish Science Temple of America (MST). The group had been chartered in Chicago in 1925 by southern migrant Noble Drew Ali, whose followers viewed him as a prophet bringing the message that so-called Negroes were, in actuality, literal descendants of Moroccan Muslims, although born in America. Through his encounter with members of this religious movement, Brown became convinced that he was not a Negro and that to think of and refer to himself as such violated divine command. To signal his acceptance of the truth of the MST's theology and account of black history, Brown took what Drew Ali taught was his "true tribal name" of Bey and followed his prophet's call to return to his original religion of Islam. In accord with his beliefs about his religious and racial identity, he asked draft registrar George Richman to amend the preprinted government form so that he could be represented properly. He was not a Negro, he insisted. Richman acquiesced, crossing out one of the categories printed on the form and writing in "Moorish American."

The sterile two-page registration form offers little sense of the substance of the exchange between Brown Bey and Richman that led to Richman's amendment of government-supplied racial designators. We can never recover the details of this bureaucratic and interpersonal transaction, but the surviving draft registration document reveals the depth of Brown Bey's commitment to this racial identity and hints at what was certainly a fraught exchange as he tried to persuade Richman to write "Moorish American" on the card. In the end, Brown Bey was successful in having himself represented according to his understanding of divine will. At the same time, Richman inserted his own perspective that ran counter to Brown Bey's and conformed to conventional American racial categories. On the section of the form requiring registrars to affirm the truth of

the information presented, Richman indicated that he believed Brown Bey "to be a Negro."

Members of other religious movements that emerged in northern cities in the early twentieth century asserted racial identities at odds with American racial categories, and we see evidence of these commitments in the draft registration process. Barbadian immigrant Joseph Nathaniel Beckles became persuaded through his interactions with members of the Commandment Keepers Ethiopian Hebrew Congregation (CK), led by Wentworth Arthur Matthew, an immigrant from Saint Kitts, that he was not a Negro, but a descendant of one of the lost tribes of Israel that had migrated to Ethiopia. In the course of registering for the draft, Beckles rejected the categories presented to him and convinced the registrar to cross out the check mark she had placed next to Negro and substitute "Ethiopian Hebrew." Georgia migrant Perfect Endurance, a member of the Peace Mission (PM), which was organized around belief in the divinity of the movement's leader, Father Divine, sat before a draft registrar in New York that same April weekend as did Brown Bey and Beckles, and also questioned the government-supplied racial designations. In this case, Perfect Endurance, who had changed his name to reflect his new spiritual state, acted on Divine's preaching that race is the creation of the devil. Because he had set aside his old self and now understood himself in nonracial terms, he asked that the draft registrar indicate his true race, which he considered to be "human."[4] As was the case with Brown Bey and Beckles, Perfect Endurance's declaration not only was aimed at securing racial reclassification, but also explicitly linked religious and racial identity in ways that challenged conventional American racial categories.

This book is a study of the theologies, practices, community formations, and politics of early twentieth-century black religious movements that fostered novel understandings of the history and racial identity of people conventionally categorized as Negro in American society. Each of the groups I examine offered followers a distinctive interconnected religious and racial identity that rejected the descriptor of Negro and stood outside the Christian churches with which the majority of African Americans had long been affiliated. African Americans had long been affiliated. Members of MST affirmed Moorish American Muslim identity, members of the Nation of Islam (NOI) understood themselves to be Asiatic Muslims, those in Ethiopian brew congregations embraced the history of the biblical Israelites as their own, and Father Divine's followers in the PM rejected racial designations in favor of common humanity. Even as they promoted different configurations of an intertwined religious and racial sense of individual self and people history, the groups held in common a conviction that only through embrace of a true and divinely ordained identity could people of African descent achieve their collective salvation.

I use the term "religio-racial identity" to capture the commitment of members of these groups to understanding individual and collective identity as constituted in the conjunction of religion and race, and I refer to groups organized around this form of understanding of self and people as religio-racial movements. In some sense, all religious groups in the United States could be characterized as religio-racial ones, given the deeply powerful, if sometimes veiled, ways the American system of racial hierarchy has structured religious beliefs, practices, and institutions for all people in its frame. I employ religio-racial in a more specific sense here, however, to

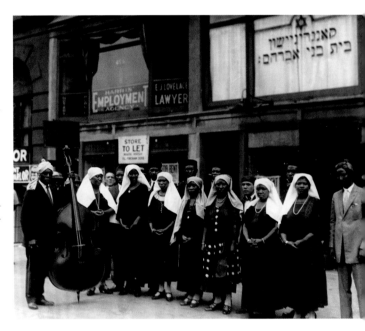

Rabbi A. Josiah Ford (left) of the Congregation Beth B'nai Abraham, with members of his choir, 1925

designate a set of early twentieth-century black religious movements whose members believed that understanding black people's true racial history and identity revealed their correct and divinely ordained religious orientation. Islam was created for black people, the NOI's leaders argued, for example, and PM members believed that only those who abandoned the racial categories of the devil and reconceived of themselves as raceless humans were worthy of Father Divine's grace. Thus, these movements not only called on blacks to reject the classification of themselves as Negro, which leaders taught was a false category created for the purposes of enslavement and subjugation, but offered alternative identities for individual members and black people as a whole. This book illuminates the content and contours of those new religio-racial ways of understanding the black self

and black history, and focuses on how members of the religio-racial movements enacted the identities they understood to be their reclaimed true ones in daily life.

In rejecting Negro racial identity, leaders and members of these groups did not repudiate blackness or dark skin but, rather, endowed it with meaning derived from histories other than those of enslavement and oppression. That is, they detached the fact of differences in skin color among people from the American racial structure that invested such difference with hierarchical significance and moral meaning. Members of the religio-racial movements undertook the work of resignifying blackness in the context of a hierarchical racial frame that also proved flexible in adjusting to demographic changes that challenged its working categories. Science, religion, law, and custom collaborated to support a racial order in which whites placed people of African descent at the bottom and cast them as incapable of development

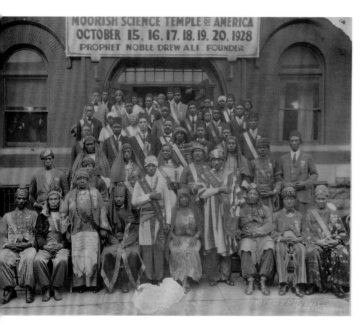

Portrait of MST leaders in Moorish garb outside Unity Hall, Chicago, during the 1928 convention

or progress. This status was permanent and unchangeable, proponents of racial hierarchy insisted, derived from the fact of biological capacity, itself the product of God's design, according to many. Yet race is not fixed. The variety of categories operative in America's racial system at different historical moments as well as the assortment recognized in context outside the United States lay bare the constructedness and malleability of race. At the same time, the persistence of racial systems and the oppressive structures through which governments maintain them have guaranteed the social, political, economic, and religious power of race in America. That is, race is at once a culturally constituted

interpretation of human difference and a social and individual reality in everyday life with profound material consequences.

Because the primary effect of racial construction has been the production and maintenance of social hierarchy, scholars have tended to emphasize white people's agency in race making, with people of African descent and others classified as not white as solely the objects of construction. In this view, whites maintain the power to create and impose race and restrict access to the most privileged racial category in America, while those not considered white have few means to defy the system unless possessing the physical characteristics that enable passing into whiteness.[5] There is no doubt that the structures through which whites have enforced race, especially state-sanctioned classificatory rubrics regulating people from birth to burial, have helped to confer a sense of fixity and permanence on the American racial system. Indeed, the religio-racial movements emerged and grew alongside an expanding government at all levels that encoded race into its regulation of immigrant, education, housing, and marriage, among other aspects of life.[6] Nevertheless, people of African descent in the United States have often contested racial categories, worked to reshape racial meaning by challenging racial hierarchy, or sought to dismantle race altogether, seeking other bases for collective identity still rooted in shared African descent.

This study highlights the agency of black people as religious subjects in constructing, revising, or rejecting racial categories and thereby producing frameworks for religio-racial identity. Much of the scholarship on groups like the MST, Ethiopian Hebrew congregations, and Father Divine's PM explored their religious authenticity, asking questions about the degree to which they might be considered "really" Muslim, Jewish, or Christian, for example. Recent valuable work examining some of these groups has sought to take seriously the religious strivings of the leaders and members and to do so in a way that makes them legible according to such recognizable theological rubrics.[7] Such scholars argue for a more capacious understanding of Islam, Judaism, and Christianity such that nonnormative versions can be taken as authentic iterations of these traditions. These works usefully reject the impulse in some earlier scholarship to interpret the groups as either "cults" outside the bounds of appropriate religion or primarily political because their religious beliefs and practices did not conform to traditional approaches.

The racial assertions by members of these groups that they are Moorish, Asiatic, Ethiopian Hebrew, or even raceless have not fared as well, with scholars often interpreting such reformulations through religious means as the denial of a true and fixed racial location in favor of an imagined identity.[8] But bracketing their

racial claims obscures the fact that, for them, religion and race were inextricably linked. We cannot begin to understand the racial identities of these women and men without exploring their religious sensibilities, and we cannot take full account of how they understood themselves religiously without engaging their racial self-understandings. In contrast to approaches that characterize such claims as fanciful or misguided attempts to escape from a "real" racial identity, this book explores religious means by which people of African descent in the early twentieth-century United States entered into the processes of racial construction and produced their own religio-racial meaning.[9] This book does not evaluate the authenticity of religious claims or racial narratives of members of these groups, but focuses instead on understanding how they sought to redefine black peoplehood by restoring what they believed was a true collective identity. It is a study of the cultures of religion and race in early twentieth-century black America, using the religio-racial movements as a window into varieties of black identity and exploring the power for members of these movements, their families, and their communities of embracing alternative religio-racial identities.

New World A-Coming

The religio-racial movements were the unique products of the early twentieth-century urban North and flourished in cities like Chicago, Hartford, Newark, New York, Philadelphia, Pittsburgh, Toledo, and Trenton, among others.[10] Northern cities were transformed during the Great Migration through the dramatic increases in the number of black residents and by the religious, cultural, and political creativity black migrants generated. No longer bound by the traditions of small community life and often feeling that Protestant churches had failed to address their material needs and spiritual longings, many migrants set aside long-standing ways of thinking about black identity, claiming different histories and imagining new futures. Some of the movements that emerged in this period rejected religion altogether in favor of radical secular political organizing, while others sought to mobilize religion in new ways to effect a reimagined black future.[11] The religio-racial movements were prominent among the new options, and this study focuses on their development from the early 1920s through the late 1940s. All are still in existence today, but with the exception of the NOI's increased prominence in the 1950s and 1960s, the groups were at the height of their popularity during the interwar period, gaining influence in the context of the migration era's cultural and religious transformations. In terms of numbers, which are difficult to determine definitively, membership in the groups ranged from a few thousand in Ethiopian Hebrew congregations to ten thousand or more in the

NOI and MST, respectively, and tens of thousands in the PM.

The early twentieth-century migration of southern African Americans to northern cities coincided with a period of immigration of more than a hundred thousand people of African descent from the Caribbean to the United States. Seeking greater economic opportunity in the context of the collapse of the sugar economy, citizens of the British, French, Dutch, Danish, and Spanish Caribbean immigrated to the United States.[12] In 1930, nearly one-quarter of Harlem's residents were black immigrants from the Caribbean, and other such immigrants lived in Brooklyn, the Bronx, and Queens, transforming the culture of black New York.[13] While the impact of Caribbean immigration in this period was most apparent in New York City, immigrants settled in other cities in the North, including East Coast destinations like Newark and Philadelphia, and mid-western ones like Detroit and Chicago. Jamaican immigrant and socialist journalist W. A. Domingo referred to his fellow Caribbean immigrant residents of Harlem as "a dusky tribe of destiny seekers" and chronicled the challenges they faced upon arrival, particularly in light of a general ignorance on the part of their new neighbors about the Caribbean.[14] Notwithstanding the challenges black cultural diversity presented, Caribbean immigrants interacted with American-born people of African descent in social, political, and religious arenas in the black neighborhoods of the urban North. In contrast to migrants from the South who were most likely to be affiliated with Baptist, African Methodist, Holiness, or Pentecostal churches, immigrants from the British West Indies, the largest group among the Caribbean-born in the United States in this period, were more often Anglican or Roman Catholic on arrival, although there were also Methodists, Baptists, and Pentecostals among their numbers. Despite the fact that theological differences and divergent worship styles at times separated Caribbean immigrants from African Americans, they too, like their American-born neighbors in the cities, contributed to the religious innovations of the period, sometimes in distinctive ways and sometimes in cooperation with African Americans.

Many in black urban communities with personal commitments to Christianity and investment in black churches as the nexus for political organizing found the increasing religious diversity of the period alarming. Black religious and political leaders as well as black academics examining these developments worried that the theologies, practices, political attitudes, and social organization of the religio-racial movements undermined the case for African American fitness for full citizenship. Especially concerning was the possibility that the rise of such groups would provide ammunition for whites to portray "black religion" as necessarily irregular religion and essentially emotional and excessive in

character. In the influential 1944 ethnographic study *Black Gods of the Metropolis: Negro Religious Cults of the Urban North*, Arthur Huff Fauset framed his investigation around questions about the "predisposition of the Negro toward religion and certain forms of religious attitudes," responding, in part, to a perspective that rendered black people compulsively religious and in forms that white scholarly interpreters viewed as primitive. Fauset's study of the MST, the PM, a congregation of black Jews, and a number of Holiness churches led him to reject the notion that there exists any unique Negro "religious temperament."[15] Nevertheless, the specter of the sorts of racialized evaluations of African and African diaspora religious life that had supported enslavement and segregation hung over the response of many blacks to the emergence of the religio-racial movements.

Fauset and many other black commentators at the time offered contextual rather than racialized explanations, emphasizing the role of economic and social marginalization in supporting a varied religious landscape in northern cities in general and fostering the emergence of the religio-racial movements. Journalist Roi Ottley, for example, attributed the striking presence of healers and vendors of spiritual medicines to the terrible health conditions faced by destitute urbanites during the Depression. "These were the conditions," Ottley wrote. "Under the economic stress, hundreds of cultists-fakirs and charlatans of every brand-swept into the Negro communities, set up shop, and began to flourish in a big way."[16] So present were they in the street, storefront, and residential buildings in Harlem, Ottley noted, that "the cultists—those jackals of the city jungles—appeared to have the right of way."[17] Economic arguments like those Ottley and others made to account for the rise of the religio-racial movements in the early twentieth-century urban North are appealing, particularly since the emergence of many coincided with economic crisis. Indeed, many of the groups provided material support in times of hardship and addressed race and economics in their religio-racial systems. But neither financial greed on the part of the founders and leaders nor economic need on the part of members can account primarily for their profound personal and social investments in these movements through which they hoped to transform black communities, racially, religiously, and socially.[18]

The degree to which the rise of the religio-racial movements was the result of and contributed to the declining influence of black churches and their leaders was also of concern to many contemporary scholars, journalists, and religious leaders. Sociologist Ira De Augustine Reid offered sharp criticism of these alternative to mainstream black Protestantism in a 1926 article in *Opportunity*, the journal of the National Urban League, writing, "The whole group is characterized by the machinations of impostors who do their work in

great style. Bishops without a diocese, those who heal with divine inspiration, praying circles that charge for their services, American Negroes turned Jews 'over night,' theological seminaries conducted in the rear of 'railroad' apartments, Black Rev. Wm. Sundays, Ph.D., who have escaped the wrath of many communities, new denominations built upon the fundamental doctrine of race—all these and even more contribute to the prostitution of the church. And there seems to be no end to their growth."[19] Reid worried about the disproportionate appeal of these newer options relative to mainstream black churches, concluding, "While the aggressive minority is pushing forward with intelligent and modern interpretation of a gospel that was once wholly emotionalized, the satellites have glittered with their emotional paroxysms and illusive and illiterate mysticisms . . . While the one steadily prods at social problems with instruments both spiritual and physical, and methods religious and humanitarian, the others are saying 'Let us prey.' And they do."[20]

Where Reid blamed predatory promoters of new religious groups for what he felt was religious chaos and weakened churches, Fauset looked to black churches and their leaders themselves to understand declining influence in the period, as in a speech he wrote on "Leadership and the Negro," Fauset concluded, "Church leadership among Negroes as among other groups is definitely on the wane. A great many Negroes feel that the preachers themselves have contributed to the repudiation of such leadership by their bigotry, and even more perhaps, by the crass selfishness and the lack of morality of some of them . . . As for young educated Negroes, they have practically abandoned the church completely."[21] In *Black Gods* he recognized the work the urban religious movements did to help migrants and immigrants adapt to the conditions of the northern cities. In this new environment, black churches could no longer assume the allegiance of African Americans, he argued, nor take for granted that they would be the institutions to which urban blacks would turn for political outlet.

At the same time that he took seriously the increasing visibility and importance of the newer movements in urban environments, Fauset was cautious about their long-term significance in black religious life. He figured that the groups had attracted "substantial" numbers and were increasing in size, but reminded his readers that their membership accounted for a small percentage of the religious population of African Americans. "Therefore, it would be as grave an error to discount the significance of the presence of the cults as it would be overestimate their importance," he wrote, preferring to focus on what they revealed more broadly about black culture. For his part, Reid emphasized "the inordinate rise of religious cults and sects" in his analysis of the African American religious landscape, although he

Summer Bible Institute, c. 1920–40,
from sociologist Newbell Niles Puckett's
research documentation of the church
life of African Americans in the Southern
United States

eventually came to see their emergence as a response to the particular conditions of urban life in the interwar years as well as to the failures of black Protestant churches to remain relevant. He concluded that "their influence and reach are enormous and significant—perhaps more socially adapted to the sensationalism and other unique characteristics of city life, and the arduousness and bitter realities of race, than the prayerful procrastinations of the church institutions they now supplant."[22]

The fact that many of the movements that emerged in this period rejected Christianity and that some were organized around a charismatic figure with a prophetic message or messianic claim led to the conclusion among contemporary observers and later scholars that "cult" is the most appropriate term to describe them. Some scholars, like Fauset, deployed the term without pejorative intent to indicate a new religious group in the early stages of development. Others, like Reid, labeled movements "cults" in an evaluative move to mark them as illegitimate, privileging mainstream Christianity as the norm against which other theological and institutional formations should be judged.

The label "cult," then, tells us less about a group's theology or members' self-understandings than about the commitments of those who use the label. Rather than evaluating the religious orthodoxy of any given group, this book explored the cultural and organizational contexts in which people embraced and lived in religio-racial identities other than the mainstream of Negro and Christian. I use the term "religio-racial movements" to highlight the common characteristics that unite them for the purposes of this study and focus on Ethiopian Hebrew congregations, the MST, the NOI, and the PM as the central groups promoting alternative religio-racial identities. This approach brings diverse movements into conversation with one another with respect to their approaches to religion and black racial identity, but also recognizes that other analytical rubrics, such as that of the study of new religious movements, might bring different characteristics to the fore or call for a different set of case studies. In short, rather than position the groups under consideration in this volume in relation to a presumed normative center by labeling them "cults" or "sects" or isolate them from broader cultural and religious influences as new religions, I examine them as windows into religious challenges to conventional racial categories and explore what participation in the movements meant for members.

Every Race Should Have a Name

The religio-racial identities these movements supported represented a departure from the more common commitment in black America to Negro and Christian identity, but part of their appeal lay in the fact that they also

contributed to long-standing discussions about black history, identity, and the relationship of religion to black collectivity. Members of these groups were not cultural outsiders in insisting that race labels were of great consequence and had broader social and spiritual significance. The terms people of African descent have used to describe themselves collectively have changed over time, from the frequent use of African and Ethiopian in nineteenth-century America to Negro, Colored, and Afro-American in the early twentieth century. Moreover, these "race names" have occasioned vigorous debates within black communities and in relation to the structures of political power about the nature of collective identity.[23] While shifts in naming have not always been part of larger projects to rethink racial categories, the question of what people of African descent in the United States have called themselves and of how they might compel others to use the same terms has often been connected to broad visions of black history. In this regard, the proposals by members of the MST that people of African descent should refer to themselves as Moorish Americans or those in Father Divine's PM that they should abandon racial language altogether, for example, were part of more general cultural conversations among blacks in America in the early twentieth century.

Discussions of the power of race naming took place in a variety of arenas, and people of African descent expressed diverse views. In the winter of 1932 the Baltimore *Afro-American* launched a contest for its readers to "settle this business once and for all as to the best race designation."[24] Over the course of five weeks, readers sent telegrams to cast votes for their preferred racial descriptor in the hopes that they would win a prize in a random draw. In the end, the paper received more than six thousand votes, and from early on "Negro" and "Colored"—ironically, the two suggestions the newspaper titled *Afro-American* provided on the printed voting coupon—led the competition. Readers expressed passionate opinions on the subject, with "Negro" garnering the majority of votes, although the three prize winners in the random draw advocated "Colored."[25] Some who voted for "Negro" did so in opposition to the term "Colored" and expressed discomfort with the latter's suggestion of racial mixture and applicability to other peoples not of African descent. Affirmative arguments for "Negro," which had only recently begun to be capitalized in the white press as a mark of respect, emphasized the benefits of its definitive racial character as opposed to simply being descriptive of skin color. Most advocates of the label wrote about their sense of the term as fostering racial unity and pride, and many drew connections between that pride and the future fortunes of American Negroes.[26]

Some of those who favored the term "Colored" saw in its implication of racial mixture recognition of the fact of variety among people of African descent and felt the term an appropriate cognate to the umbrella label of "white" for people of European descent. Other supporters rejected "Negro" because they felt it kept them tied to the humiliations of slavery and provided an opportunity for whites to pronounce it in a way that suggested a derogatory slur. Even as the terms "Negro" and "Colored" emerged as readers' clear preferences, some contest participants proposed alternatives, with many turning to the Bible, drawing on Psalm 68:31, to promote "Ethiopian" as the correct and divinely ordained racial designation, others suggesting terms like "American," "Afro-American," "Ethio-African," "Polynational," "Omnational," and "Black." Members of the MST participated in the contest, casting their votes for "Moorish American," insisting, as did one Philadelphia member, "Take off the slavery name 'Negro' and give us our God-given name, Moorish-American, and let us be men among men."[27]

A random-draw contest might seem a surprising venue for rich discussions of the relationship among racial designators, black collective identity, and civil rights, but readers' entries in the *Afro-American*'s game reveal the degree to which many blacks in the United States felt deeply invested in the power of group naming to produce collective shame or foster pride. Many such discussions in the nineteenth and early twentieth centuries took place among intellectuals and political leaders, but the *Afro*'s contest shows how vibrant and lively such discussions could be among members of the general public.[28] Many people of African descent in early twentieth-century America cared deeply about the political and social consequences of group naming and understood their corporate future to be tied to the perception of their group. Mrs. Ora E. Brooks of Baltimore captured this sentiment vividly in her endorsement of "Negro" in the *Afro-American*'s contest, explaining that it "distinguishes our race from others. Every race should have a name."[29]

Occasions when members of the public engaged intellectuals on the question of race designations highlight the depths of investment in the political consequences of naming. In 1928, when high school student Roland A. Barton wrote to the NAACP's magazine the *Crisis* to question its use of "Negro" as a global term for people of African descent (a term he characterized as "a white man's word to make us feel inferior"), editor W. E. B. Du Bois counseled the young man, "Do not . . . make the all too common error of mistaking names for things. Names are only conventional signs for identifying things. Things are the reality that counts. If a thing is despised, either because of ignorance or because it is despicable, you will not alter matters by changing its name. If men despise Negroes, they will not despise

them less if Negroes are called 'colored' or 'Afro-Americans.'"[30] He further informed Barton that it is not easy to "change the name of a thing at will" because of the deep associations names acquire. "Negro" has useful meanings attached to it, he argued, and "neither anger nor wailing nor tears can or will change the name until the name-habit changes." For Du Bois and others, the search for a new label was simply a distraction from the more important tasks of political, economic, and social development. Scott Andrews of Warren, Ohio, wrote to the *Negro World*, the periodical of Marcus Garvey's Universal Negro Improvement Association (UNIA), asserting this view. He wrote that the debates about "whether we should be called Negroes or colored people" were a waste of time and caused people to lose "sight of the substance in the foolish pursuit of the shadow." Andrews contended that the substance of the work involved "carving out a glorious destiny for the race" and, once accomplished, the resolution of the name question would follow easily.[31]

For members of the MST who entered the *Afro-American*'s contest and those in other groups promoting alternative religio-racial identities to those of Negro and Christian, names were not simply signs for identifying things as Du Bois had insisted nor a distraction from the most pressing issues facing people of African descent. Members of the religio-racial movements who advocated unconventional ways of thinking about black racial identity countered that there are correct names for peoples and that these names have divine origins. They maintained that misnaming black people collectively as well as individually had the dire religious consequences of cutting off access to divine knowledge and thwarting possibilities for a productive collective future. The political and social concerns evident in the exchange between Barton and Du Bois motivated people like Alec Brown Bey to assert alternative identities, but members of religio-racial movements also acted in submission to what they believed was a divinely constituted racial and religious self. They understood the work of restoring their true, God-given identity to involve acceptance of a different narrative of race history.

Leaders and members of religio-racial movements were not alone in presenting religious narratives of black peoplehood, and as with debates about race names, they contributed to broader discussions about religion and black solidarity. Many African American race history narratives linked black collective identity and destiny to biblical narratives like the Exodus story, and the Bible was important in some of the religio-racial movements.[32] The political philosophy of Jamaican immigrant Marcus Garvey's UNIA also contributed to the intellectual, cultural, and theological currents that fostered the emergence of alternative religio-racial narratives among blacks in early twentieth-century America. Garvey

"Sir: I am writing you on matters pertaining to work and desirable locations for industrous and trust worthy laborers. Me for myself and a good number of Friends especially thousand of our people are moving out from this section of whom all can be largely depended upon for good service. . . . Any information as to employment and desirable locations especially for good School Conditions Church Etc., will be appreciated."

HATTIESBURG, MS, DECEMBER 4, 1916

proclaimed that blacks were a transnational, global, and connected people and promoted a black nationalism focused, in part, on reclaiming Africa as a spiritual and political homeland. He labored both rhetorically and materially to achieve this end, calling on people of African descent to learn of their race's glorious history in order to dispel what he called "the inferiority illusion" and work together through the UNIA to create a strong and united Negro world.[33] Garvey's invigorating vision of transnational black pride "opened windows in the minds of Negroes," to use journalist Roi Ottley's phrase.[34] Moreover, the UNIA served as a crossroads where African Americans and black Caribbean immigrants, some of whom founded and joined religio-racial movements, interacted and exchanged ideas about race pride, history, and future possibilities. Although they imagined black collective identity in varied ways, the founders and leaders of the religio-racial movements shared with Garveyites the sense of an urgent need to unify people of African descent, emphasizing connections across space and time.

Popular historians of the period also helped to open up the intellectual space for blacks in the United States to think in unconventional ways about narratives of peoplehood, religious history, and racial identity. Jamaican-born Joel Augustus Rogers, who immigrated to the United States in 1906, was an influential figure in this regard, with books like *From "Superman" to Man*, in which he attacked racial hierarchy and notions of white superiority, and the many editions of the pamphlet *100 Amazing Facts about the Negro, with Complete Proof A Short Cut to the World History of the Negro*. Rogers also wrote for the black press, most notably a regular column on "Your History" in the *Pittsburgh Courier* in the 1930s.[35] He offered his readers an ambitious global history, highlighting the cultural and political contributions of people of African descent across time while also arguing that the ubiquity of racial inter-mixing throughout history made it impossible to speak of pure races. Religion was not Rogers's main focus, but he often addressed religious developments in his global histories of race, encouraging readers to situate biblical narratives in a longer historical scope and insisting that, "our moral heritage . . . derives from a wider human past enormously older than the Hebrews."[36] Rogers's emphatic message that black history predates enslavement in the New World resonated powerfully with the kinds of narratives members of the religio-racial movements embraced.

The religio-racial movements undoubtedly represented something new in early twentieth-century black America: new political and social configurations that resulted from migration and urbanization, new theologies and histories, and new forms of religious organization. At the same time, founders, leaders, and members of these groups participated in broader, long-standing discussions in black communities about religion and racial identity. General interest among blacks in the United States in this period in the relationship between "race names" and civil rights, the prominence of Garvey's race pride movement, and the influence of popular race histories addressing religious themes were all part of the cultural context in which the religio-racial movements emerged. In addition to participating in broader cultural trends of the period, the founders and leaders of these movements emphasized other sorts of continuities, presenting their religio-racial identities as divine truth, often as knowledge available in ancient times and recovered through the person of the leader. They taught their followers that acceptance of their God-given identities renewed connections to their ancestors and true histories and set them apart from those who were ignorant of or rejected the truth.

Apostles of Race

This book explored the individual and social experiences of black people in early twentieth-century America who accepted as divine truth the religio-racial identities put forward by Ethiopian Hebrew congregations, the MST, the NOI, and Father Divine's PM. The study is organized thematically and offers a comparative discussion of the narrative shape and material outcomes of varied visions of black religio-racial systems to configure individual senses of self and orient members in broader social worlds. Part I offers an overview of the narratives of identity the founders and leaders of the movements conveyed to potential adherents, in which they provided new ways of understanding their origins as a people, the events that led them to their current social, religious, and political locations, and their corporate futures. While each group presented potential members with a unique formulation of religio-racial identity, their success in the crowded religious and cultural arena of urban black America depended on a similar set of components that authorized and supported that identity. I argue that for the thousands of black people who joined them, the appeal of these movements derived from a combination of confidence in the authority of the founder or leader and the power of the leader's narrative of religio-racial identity. In analyzing the narratives I highlight how some groups reoriented believers' sense of peoplehood in relation to particular geographic regions and others by offering a new understanding of the chronology of sacred events for others.

Accepting the religio-racial identity offered by one of these groups as divinely ordained and true involved both a faith commitment and daily enactment of that identity. Part II turns to the varied practices the groups developed to produce and maintain members' religio-racial identities. Contemporary observers often noted, for example, that participants in some of the movements

adopted new and exotic dress or changed their names. While commentary at the time was often derisive and characterized these changes as signs of religious and racial fakery, for members of these groups such practices of self-fashioning were powerful means by which they experienced and expressed their new religio-racial identities. Similarly, approaches to diet, health, and healing maintained the restored religio-racial individual and helped connect the individual to his or her new sense of self in an ongoing way. The transformations set in motion by embrace of a new religio-racial identity extended beyond the individual and enjoined believers to build community in ways that derived from that identity. In addition to defining the nature of family relationships, the groups' religio-racial theologies generated community structures and fostered dispositions toward the nation and urban environments that provided important contexts for members' experiences and expressions of their identities. Part III explored these community formations and also examines the impact that interactions among the various groups and with mainstream Protestants had on broader debates in black America about religion and racial identity.

Most studies to date have focused on the life histories of the founders and leaders, with particular attention to the theologies they promoted. Recovering the stories of the rank-and-file members of these groups has proved challenging given the limited textual record, but archival collections of letters, material artifacts, photographs, and newspaper coverage, for example, have contributed to my analysis. The degree to which vital records such as marriage and death certificates and government documents like census sheets, draft registration cards, immigration forms, and the complex corpus of FBI surveillance of some of the groups and their leaders can offer insight into the experiences of members of religio-racial movements surprised me, and working with them has opened up new ways to think about sources for the study of race and religion in the United States. In the course of my research I came to see such bureaucratic paperwork as rich and complex records of religio-racial life. Reading with, through, and against such documents to find evidence of mundane and extraordinary experiences of religio-racial identity illuminates members' work of race making and maintenance and the social contexts in which this work took place. Situating the archives of the bureaucracy as offering central sources for this study also highlights the power of the state to shape and constrain both religious experience and racial identity. In individual transactions and in collective encounters with government agencies, members of religio-racial movements challenged the state's power to categorize them and define black identity. Careful reading of newspapers, vital records, and bureaucratic documents also reveals the strong presence of women as members of the

religio-racial movements and, in some cases, in positions of leadership and authority, despite the fact that all of the religio-racial groups I examine were founded by men. Turning from the promulgation of official theology to the lived experiences of members allows us to recognize women's religio-racial commitments and attend to their contributions to religious race making through participation in these groups.

Attention to these unconventional sources for understanding African American religious history makes Alec Brown Bey and many others like him visible as religio-racial actors. Sitting before the draft registrar on that Sunday in April 1942, Brown Bey insisted that he be represented accurately as a Moorish American on the form that committed him to possible military service on behalf of the United States. When asked to give the name and address of a person who would be able to assist in contacting him, Brown bey listed Albert Smith Bey, a migrant from North Carolina who lived with his own family just three blocks from Brown Bey and was a leader in the Philadelphia MST.[37] The draft registration card captures the personal and public significance for Brown Bey of the restoration of his Moorish American religio-racial identity and signals his location in a larger institutional and social community of MST members in Philadelphia. Stories like Alec Brown Bey's are at the core of this book's exploration of the desires and experiences of those who joined religio-racial movements in early twentieth-century America.

Part I
Narratives

Carrie Peoples probably found it strange that the peddler going door-to-door in her Detroit "Paradise Valley" neighborhood in the summer of 1930 offered history lessons along with the clothes he sold. Indeed, the clothing itself provided a lesson, serving as the starting point for a broader discussion of history, identity, and the sacred. The man told Peoples that her "home country [was] in the East" and that the people there, "her own people," had made the silks he offered to her and her neighbors.[38] She found the peddler's wares appealing enough to invite him into her home and, over time, he continued to talk with her and other African Americans, mostly migrants from the South, about the history of their people. Gradually the gatherings grew larger and larger until the group moved to a rented hall on Hastings Street. Peoples remembered that the peddler-turned-teacher eventually told his auditors, "My name is W. D. Fard and I came from the Holy City of Mecca. More about myself I will not tell you yet, for the time has not yet come. I am your brother. You have not seen me in my royal robes."[39] Fard said that his divine mission was "to find and bring back to life his long lost brethren, from whom the Caucasians had taken away their language,

their nation and their religion," Islam.[40] Whatever her first impressions of these encounters, Peoples became persuaded of the truth of his account of history and understanding of her racial and religious identity. The man she came to view as a prophet convinced her that her true home was the city of Mecca and that her ancestors had been stolen away from there only to end up in "the wilderness of North America." To signal her full acceptance of Fard's teaching, Carrie Peoples became Carrie Mohammed and joined an estimated eight thousand members of the Lost-Found Nation of lslam in Detroit in the early 1930s.[41]

The black "cities within cities" of the early twentieth century offer many compelling stories similar to Carrie Peoples's of migrants from the South and immigrants from the Caribbean encountering preachers and teachers who insisted that black people had been laboring under the false belief that they were Negroes. These preachers proclaimed that this misconception had caused social, economic, psychological, physical, and spiritual damage, and they taught that the only way to restore complete health for individuals and black people as a whole was to embrace one's true identity. They found many eager listeners, hungry for meaning in an urban world of simultaneous promise and hardship and in an era of continued struggle for civil rights. As these newer groups grew and left their marks on the cultural and religious landscape, their presence also produced significant anxiety among some observers.

Many critics of the shifting religious landscape of early twentieth-century black urban life focused on the spellbinding personal magnetism of the groups' leaders.[42] Critics most often spoke of the dangers of charisma in relation to leaders who claimed divinity, but also condemned those who presented themselves as uniquely empowered to deliver the truth of black religio-racial identity. Commentators often linked narratives about the natural susceptibility of the black masses to such "fakers" to these tales of the irresistible power of the dangerously charismatic "cult" leader. One white ethnologist captured the sentiment of some about the striking religious diversity of the black communities of the urban North when he observed, "Generally speaking my impression is that while negroes are a race inclined to be religious, they are not particular, however, as to the nature of the religion of their worship. You will find among them in Harlem also Mahometans and Buddhists. They go where they are led."[43] Even as this analysis emerged from trenchant stereotypes among many whites about blacks' natural religiosity, the emphasis on the fluidity of affiliation in urban areas in this period resonates with many black commentators' expressions of concern about the religious diversification set in motion by the Great Migration.

Following the lead of contemporary critics of these groups in focusing solely on charismatic personalities whose followers were eager to be guided anywhere obscures the complexity and variety of presentations of alternative religio-racial identities in these movements and the seriousness with which prospective members engaged them. The power of personality undoubtedly contributed to the founders' success in gaining a following, particularly because each presented himself as having privileged access to divine knowledge. It was a combination of charisma and the persuasiveness of the narrative of sacred history and divinely ordained identity that ultimately moved Carrie Peoples and others to reject much of their former lives in favor of a new framework of religio-racial identity. Peoples believed that Fard was a trustworthy vehicle of religio-racial truth, but her ongoing commitment to the identity he promoted stemmed from more than susceptibility to the lure of charisma. Those who embraced a new religio-racial identity were motivated as much by the information they learned about their individual and collective history, their relationship to God, and their place in the world as by the person of the leader.

The narratives of identity the founders and leaders of congregations of Ethiopian Hebrews, the MST, Father Divine's PM, and the NOI put forward all reject the category of Negro as a fabricated product of slavery and subjugation in the Americas. Each argued, albeit through different routes, that their followers' true history, whether as Ethiopian Hebrews, Asiatic Muslims, or raceless humans, began long before the establishment of European colonies in the Americas and the enslavement of Africans. These approaches to reorienting the identities of so-called Negroes drew on and contributed to broader political and social currents in the period, and the groups' leaders and members cared deeply about equipping themselves to be agents in the global political

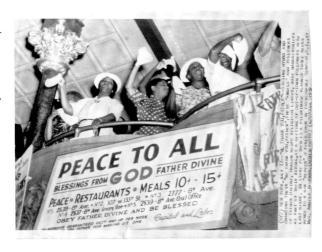

Sign advertising Peace Mission Restaurants, Harlem, 1939

context of the interwar years. But narratives of alternative religio-racial identity were more than political charters for action in the present moment; they were spiritual maps that oriented followers toward the past and the future in new ways that, in turn, shaped members' daily lives and interactions with others. Government, religious, and scholarly observers may have routinely characterized these as primarily political movements and excluded them from the realm of the religious, but for those who embraced this new knowledge about self, community, and history, religion was central to their transformations.

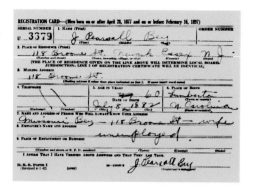
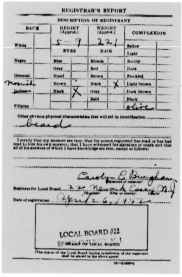

Pearsall Bey's World War II Draft Registration card. U.S. World War II Draft Registration Cards, Serial Number U 3379, Local Board 22, Newark, N.J., April 26, 1942

While each person's path to accepting a new identity reflected an individual history and private spiritual longings, the particular details of which are often difficult to recover from the surviving records, we can come to understand the transformative power of these religio-racial identities by considering how they frame questions of ultimate meaning, conceptions of the divine, understandings of divine will, and produce ideas about the nature of and relationship between the spiritual and the material. For members of these groups, such questions were refracted through a desire for knowledge about history and a sense of place in the world and, as such, were shaped by the specific racial context of early twentieth-century America. Many migrants and immigrants to northern cities were seekers, looking not only for economic opportunity but also new personal and spiritual options. As many commentators at the time noted, these seekers encountered an abundance of theologies and identity options through which to satisfy their spiritual needs. Indeed, in many cases, people moved from one group to another. NOI members in Chicago in the late 1940s reported belonging to a number of religious groups and organizations in sequence, including the Seventh-day Adventists, Jehovah's Witnesses, an "Israelite Movement," and Garvey's UNIA, among others, before finding answers and fulfillment in the NOI.[44] In other cases members of religio-racial movements combined political, social, and religious options as suited their individual needs. In 1944 a Newark, New Jersey, man who was affiliated with an African repatriation organization reported that he had belonged to the MST from 1929 to 1932, but was also a follower of Father Divine from 1930 on and lived in a PM residence while still a member of the MST.[45] Immigrants, southern migrants, and native-born northerners crossed paths in these groups, adopting identities and affirming histories that linked them in new ways that were fostered by the city's diversity.

At the same time, immigrants and migrants frequently took divergent paths, manifesting attraction to different religio-racial options. Members of the MST and the NOI, for example, were more likely to have been southern migrants than immigrants. Members of the most prominent Ethiopian Hebrew congregations were more likely to have been immigrants from the Caribbean. Father Divine's PM attracted a combination of migrants and immigrants, but more of the former than the latter. Part of the explanation for this tendency of migrants to congregate in certain groups and immigrants in others lies in patterns of migration in the period. The MST and the NOI, led by men who themselves had migrated from the South, were headquartered in midwestern cities where there were fewer immigrants from the Caribbean than in East Coast cities. Congregations of Ethiopian Hebrews, founded and led by immigrants, tended to be concentrated in New York City, home to a large population of Caribbean immigrants. The PM was headquartered on the East Coast, where it drew both black southern migrants and Caribbean immigrants, and the membership of the West Coast branches in California and Washington State was predominantly white.

Leaders of religio-racial movements provided answers to questions about black identity that, in some cases, engaged specific religious traditions: Judaism in the case of the Ethiopian Hebrews, Islam for the MST and the NOI, and Christianity in the PM's case. They did not simply call on followers to exchange one religion for another, however, but provided frameworks for understanding black history and identity that reoriented members in space and time. Rather than concentrating solely on the charismatic leader or the religious traditions they engaged, the two chapters that follow examine the movements' authorizing frameworks to explore how they functioned as comprehensive religio-racial identity in relation to sacred geography in the MST and

Ethiopian Hebrew congregation and the other examines how concern with divine time and chronology structured the narratives of identity in the NOI and PM. Members of the MST and Ethiopian Hebrew congregations embraced a narration of black sacred history elaborating a racial link of regions of Africa and arguing that right understanding of this connection restored their religio-racial identity. Although space and place were significant for the NOI and the PM—Mecca in the case of the former and the utopic space of Father Divine's kingdom on earth in the latter—time or sacred chronology organized the narrative of identity in these groups, with members of the NOI emphasizing their status as the earth's original people and PM members striving to inhabit Father Divine's eternal earthly kingdom. Attending to these thematic commonalities opens up new ways of understanding the movements' appeal to potential members and highlights how their religio-racial systems oriented believers toward the past, present, and future.

Notes

The citations below reflect the information available in the original publication.

1. DR, Alec Brown Bey, Serial Number U1981, Local Board 51, Philadelphia, Pa., April 26, 1942.
2. 1940 USFC, Philadelphia County, Pa., Philadelphia City, ED 51–1348, Household 57.
3. Best, *Passionately Human, No Less Divine*; Sernett, *Bound for the Promised Land*.
4. DR, Joseph Nathaniel Beckles, Serial Number U1274. Local Board No. 79, Bronx, N.Y., April 25, 1942; Walter Walcott, Serial Number U1225. Local Board No. 63, New York, N.Y., April 27, 1942; Perfect Endurance, Serial Number U548, Local Board No. 48, New York, N.Y., April 27, 1942.
5. Recent studies like Gross, *What Blood Won't Tell*, and Pascoe, *What Comes Naturally*, are noteworthy in their expansive view of race and their attention to the work of people in a range of racial classifications to challenge the logic of race in American life and law.
6. See also Sylvester A. Johnson's discussion of the United States as a racial state in which religion plays a formative role. Johnson, *African American Religions, 1500–2000*.
7. For example, Dorman, *Chosen People*; Dallam, *Daddy Grace*; Curtis and Sigler, *New Black Gods*; Curtis, *Black Muslim Religion in the Nation of Islam*.
8. For example, Fathie Ali Abdat speaks of MST founder Noble Drew Ali "play[ing] an Eastern personae as Allah's Asiatic Prophet" in "Before the Fez," 5.
9. My approach has been influenced by a variety of works, including Jackson, *Thin Description*; Johnson, "Rise of Black Ethnics"; Sigler, "Beyond the Binary."
10. There is a large and rich literature on the Great Migration. For a recent overview, see Wilkerson, *Warmth of Other Suns*.
11. See, for example, Kelley, *Freedom Dreams*.
12. Ottley, *New World A-Coming* 1; Watkins-Owens, *Blood Relations*, 4.
13. Osofsky, Harlem, 131.
14. Domingo, "Tropics in New York," 648.
15. Fauset, *Black Gods of the Metropolis*, 10, 97. Fauset's work inspired this study, and I examine some of the groups he profiled. My focus on groups that promoted alternative religio-racial identities has led me to include some groups not addressed in *Black Gods* and to exclude the Holiness churches.
16. Ottley, *New World A-Coming*, 86
17. Ibid., 87.
18. Fauset, *Black Gods of the Metropolis*, 76; Hardy, "No Mystery God"
19. Reid, "Let Us Prey," 277.
20. Ibid., 278.
21. Arthur Huff Fauset, "Leadership and the Negro," n.d, Box 2, Folder 58, AHF.
22. Reid, *In a Minor Key*, 85–86.
23. Stuckey, *Slave Culture*, chap. 4.
24. AA, February 13, 1932.
25. AA, April 2, 1932.
26. On the capitalization of Negro, see NYT, March 7, 1930, March 9, 1930; NYAN, March 12, 1930; CD, March 15, 1930.
27. AA, March 26, 1932.
28. See, for example, Guterl, *Color of Race in America*.
29. AA, March 26, 1932.
30. *Crisis*, March 1928, 96–97.
31. *Negro World*, July 1, 1926.
32. Mafly-Kipp, *Setting Down the Sacred Past*; Glaude, *Exodus*.
33. *Negro World*, July 17, 1926.
34. Ottley, *New World A-Coming* 81.
35. Rogers, *From "Superman" to Man*; Asukile, "Joel Augustus Rogers"; Simba, "Joel Augustus Rogers."
36. Rogers, *100 Amazing Facts about the Negro*.
37. PT, May 29, 1971.
38. Beynon, "Voodoo Cult"; Sahib, "Nation of Islam," 66. There are few sources available for studying the NOI prior to the 1950s. Rather than read later sources into the movement's early years, I rely on Beynon's and Sahib's sociological accounts, both of which include interviews with members and the latter extensive participant observation of life in the NOI.
39. Beynon, "Voodoo Cult," 896.
40. Ibid., 901.
41. Ibid., 897; CD, December 3, 1932.
42. For example, AA, June 10, 1933; NYAN, March 30, 1927.
43. Maurice Fishburg, author of *The Jews: A Study of Race and Environment* (New York: Charles Scribner's Sons, 1911), quoted in Godbey, *Lost Tribes a Myth*, 254.
44. Sahib, "Nation of Islam," 105–6.
45. MST FBI, Part 17, 10.

Following pages: Reincarnated prophet Noble Drew Ali and the Moorish Temple of America, Chicago, 1934. Photograph by Barnard Studio

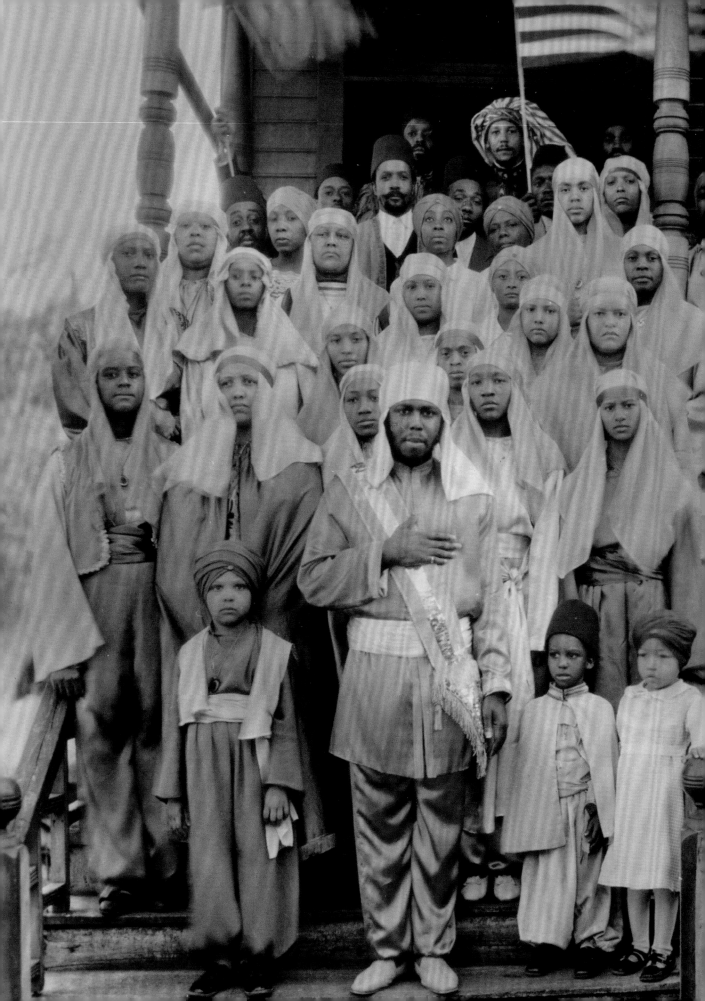

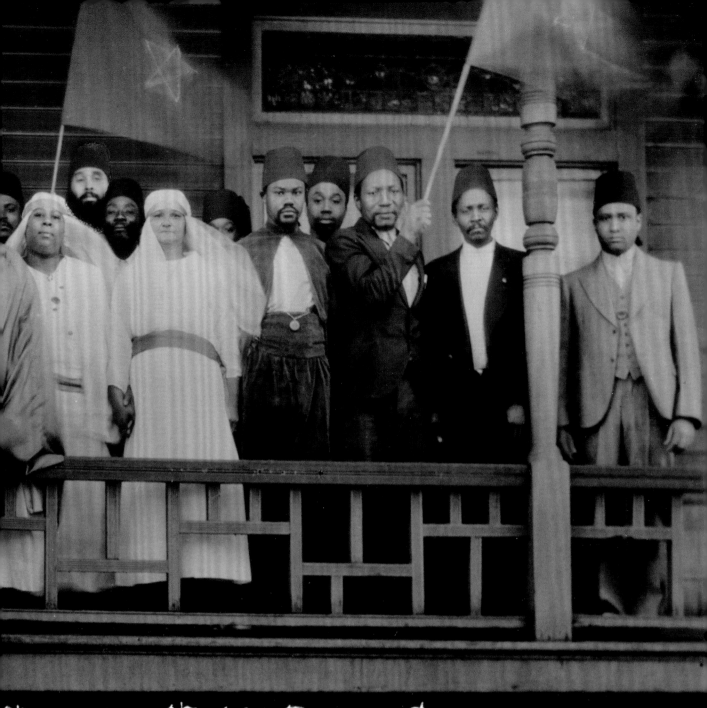

Prophet Noble Drew Ali
"Reincarnated"
founder of the Moorish Science
Temple of America Aug. 1934

Selected poems

from *Cane*

**Jean Toomer
1923; repr. New York:
Liveright, 2011**

"Prayer"

My body is opaque to the soul.
Driven of the spirit, long have I sought to temper it unto the
 spirit's longing,
But my mind, too, is opaque to the soul.
A closed lid is my soul's flesh-eye:
O Spirits of whom my soul is but a little finger,
Direct it to the lid of its flesh-eye.
I am weak with much giving.
I am weak with the desire to give more.
(How strong a thing is the little finger!)
So weak that I have confused the body with the soul,
And the body with its little finger.
(How frail is the little finger.)
My voice could not carry to you did you dwell in stars,
O Spirits of whom my soul is but a little finger . . .

"Harvest Song"

I am a reaper whose muscles set at sun-down. All my oats are
 cradled.
But I am too chilled, and too fatigued to bind them. And I
 hunger.

I crack a grain between my teeth. I do not taste it.
I have been in the fields all day. My throat is dry. I hunger.

My eyes are caked with dust of oatfields at harvest-time.
I am a blind man who stares across the hills, seeking stack'd
 fields of other harvesters.

It would be good to see them . . . crook'd, split, and iron-ring'd
 handles of the scythes. It would be good to see them, dust-
 caked and blind. I hunger.

(Dusk is a strange fear'd sheath their blades are dull'd in.)
My throat is dry. And should I call, a cracked grain like the oats
 . . . eoho—

I fear to call. What should they hear me, and offer me their
 grain, oats, or wheat or corn? I have been in the fields
 all day. I fear I could not taste it. I fear knowledge of my
 hunger.

My ears are caked with dust of oat-fields at harvest-time.
I am a deaf man who strains to hear the calls of other harvesters
 whose throats are also dry.

It would be good to hear their songs . . . reapers of the sweet-
 stalked cane, cutters of the corn . . . even though their
 throats cracked, and the strangeness of their voices deafened
 me.

I hunger. My throat is dry. Now that the sun has set and I am
 chilled, I fear to call. (Eoho, my brothers!)

I am a reaper. (Eoho!) All my oats are cradled. But I am too
 fatigued to bind them. And I hunger. I crack a grain. It has
 no taste to it. My throat is dry . . .

O my brothers, I beat my palms, still soft, against the stubble
 of my harvesting. (You beat your soft palms, too.) My pain is
 sweet. Sweeter than the oats or wheat or corn. It will not
 bring me knowledge of my hunger.

EXCERPT

Cane
by Jean Toomer

**"Afterword" by Rudolph P. Byrd
and Henry Louis Gates, Jr.**

**1923, repr. New York: Liveright,
2011**

The man who would startle his small but enthusiastic readership with the originality of *Cane* entered the cultural world of the Lost Generation downtown in Greenwich Village primarily through his close friend, the writer and critic Waldo Frank. Uptown, simultaneously, Toomer was emerging as one of the New Negro writers of the Harlem Renaissance, chiefly through the stewardship of its erstwhile "dean," Alain Locke, who edited the movement's signature manifesto, *The New Negro,* in 1925. In the two or three years preceding the publication of *Cane* in 1923, Toomer—perhaps more than any other black writer—moved seemingly effortlessly between these two cultural worlds. Both movements were shaped by their own vibrant and defiant theories of language, art, culture, and history, some of which they shared, some of which they did not. But both, in their ways, challenged, to an unprecedented degree, conventional American definitions of race and social strictures defined by the so-called color line. In so very many ways, these two movements were mutually constitutive, Janus faces of a larger, unfolding concept of American modernism, although they have been frequently and mistakenly cast as discrete, isolated formations in American literature and culture.[1]

1. Perhaps the earliest scholar to query Toomer's relationship to the writers of the "Lost Generation" and the New Negro movement or Harlem Renaissance was Robert A. Bone in *The Negro Novel in America* (1958). Since then Toomer's relationship to the communities of writers who collectively constitute the various forms of American modernism has been examined by Rudolph P. Byrd, Charles T. Davis, Ann Douglas, Richard Eldridge, Genevieve Fabre, Maria Farland, Michel Feith, Alice P. Fisher, Karen S. Ford, S. P. Fullwinder, Henry Louis Gates, Jr., Jane Goldman, Nathan Grant, Leonard Harris, Mark Helbling, George Hutchinson, Robert B. Jones, Cynthia R. Kerman, Catherine G. Kodat, Victor Kramer, Vera Kutzinski, Charles R. Larson, Nellie Y. McKay, Charles Molesworth, Arnold Rampersad, Frederick L. Rusch, Mark A. Sanders, Charles Scruggs, Robert B. Septo, Alan Trachtenberg, Darwin T. Turner, Mark Whalan, and Jon Woodson, among other scholars.

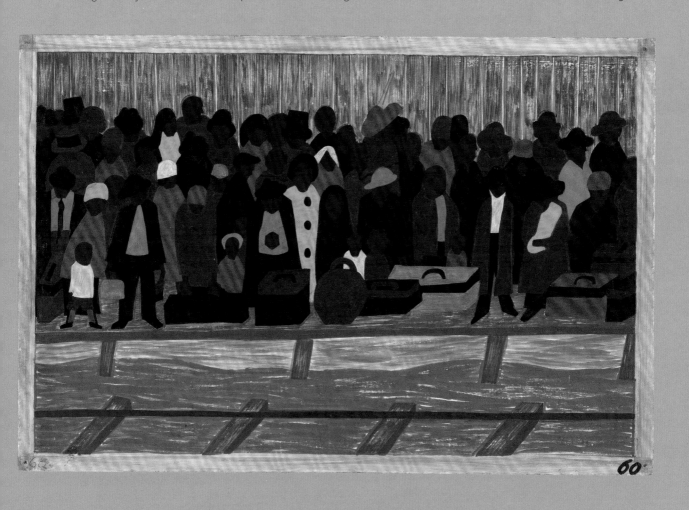

Jacob Lawrence, *The Migration Series*, Panel 60: *And the Migrants Kept Coming*, 1940–41. Tempera on gesso on composite board, 12 × 18 in. (30.5 × 45.7 cm). The Museum of Modern Art, New York, Gift of Mrs. David M. Levy

"Afraid"

Langston Hughes
The Crisis 29, no. 1 (November 1924): 21

We cry aloud among the skyscrapers,
As our ancestors
Cried among the palms in Africa;
Because we are alone,
It is night,
And we're afraid.

"Black Satin"

S. W. Henry
Poetry 28, no. 5 (February 1926): 298

Black-Satin, I love you, I want you!
I love the shimmering splendor of your skin!
Come home with me now to my house—
I will light a thousand candles for you,
I will put you in a great carved bed,
With white, white sheets and a scarlet coverlid—
Ebony against snow.
Little black panther I love to feel your warm
Breath against my neck—
You are the dark flower of my heart.

"My Son"

Georgia Douglas Johnson

The Crisis 29, no. 1 (November 1924): 28

STRONGER than man-made bars, the
 chain,
That rounds your life's arena,
Deeper than hell the anchor sweeps
That stills your young desires;
Darker than night the inward look
That meditation offers,
Redder than blood the future years
Roll down the hills of torture!
But ah! you were not made for this,
And life is but preluding—
The major theme shall hold its sway
When full awake, not dreaming,
Your ebon foot shall press the sod
Where immortelles are blooming;
Beyond the glaze of fevered years
I see—THE DAY IS COMING!

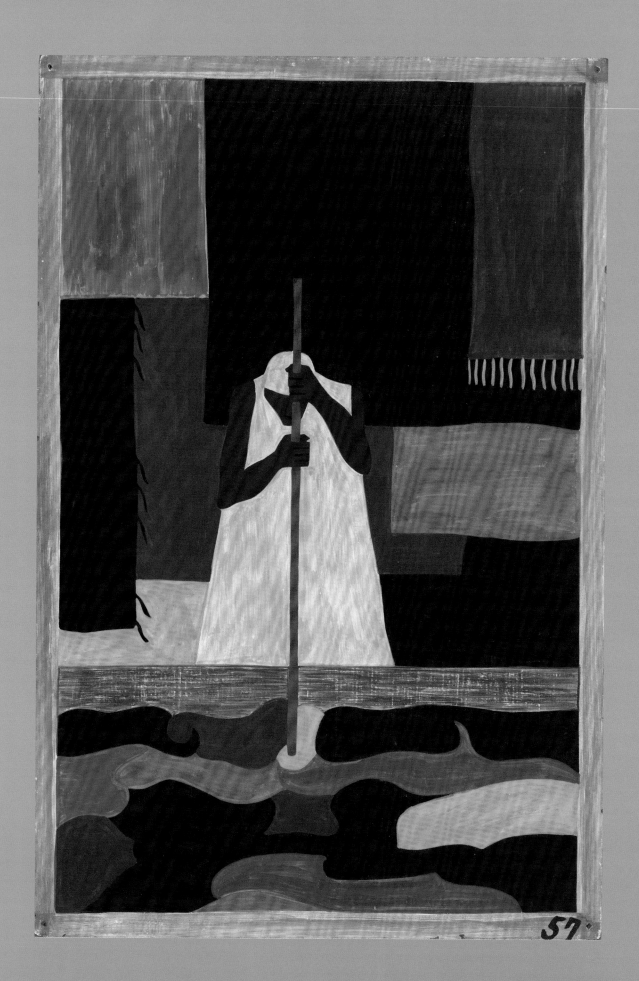

57.

"A Song to a Negro Wash-Woman"

Langston Hughes
The Crisis 29, no. 3 (January 1925): 115

Oh, wash-woman,
 Arms elbow-deep in white suds,
 Soul washed clean,
 Clothes washed clean,—
 I have many songs to sing you
 Could I but find the words.

Was it four o'clock or six o'clock on a winter afternoon,
 I saw you wringing out the last shirt in Miss White
 Lady's kitchen? Was it four o'clock or six o'clock?
 I don't remember.

But I know, at seven one spring morning you were on
 Vermont Street with a bundle in your arms going to
 wash clothes.

And I know I've seen you in a New York subway train in
 the late afternoon coming home from washing clothes.

Yes, I know you, wash-woman.
I know how you send your children to school, and high-
 school, and even college.
I know how you work and help your man when times are
 hard.
I know how you build your house up from the wash-tub
 and call it home.
And how you raise your churches from white suds for the
 service of the Holy God.

And I've seen you singing, wash-woman. Out in the back-
 yard garden under the apple trees, singing, hanging
 white clothes on long lines in the sun-shine.

And I've seen you in church a Sunday morning singing,
 praising your Jesus, because some day you're going to
 sit on the right hand of the Son of God and forget
 you ever were a wash-woman. And the aching back
 and the bundles of clothes will be unremembered
 then.

Yes, I've seen you singing.

And for you,
 O singing wash-woman,
 For you, singing little brown woman,
 Singing strong black woman,
 Singing tall yellow woman,
 Arms deep in white suds,
 Soul clean,
 Clothes clean,—
 For you I have many songs to make
 Could I but find the words.

Opposite: Jacob Lawrence, *The Migration Series*, Panel 57: *The female workers were the last to arrive north*, 1940–41. Casein tempera on hardboard, 18 × 12 in. (45.7 × 30.5 cm). The Phillips Collection, Washington, D.C., Acquired 1942

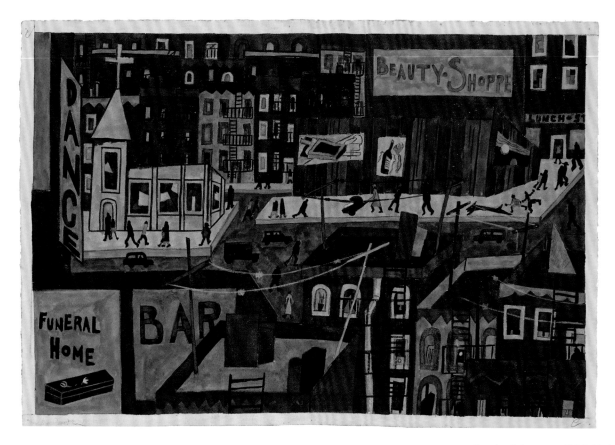

fig. 1 Jacob Lawrence, *This Is Harlem*, 1943. Gouache on paper, 15⅜ × 22¹¹⁄₁₆ in. Hirshhorn Museum and Sculpture Garden, Smithsonian Institution. Gift of Joseph H. Hirshhorn

Opposite: fig. 2 Harlem street scene, date unknown

EXCERPT

Over the Line, the Art and Life of Jacob Lawrence

"Inside-Outside, Uptown-Downtown: Jacob Lawrence and the Aesthetic Ethos of the Harlem Working-Class Community" by Leslie King-Hammond

Edited by Peter T. Nesbett and Michelle DuBois, 67–84. Seattle: University of Washington Press, 2001

The gestures that make us conscious of security or freedom are rooted in a profound depth of being.

—Gaston Bachelard, *The Poetics of Space*

The emergence of Jacob Lawrence and his sustained presence within the landscape of American art pose complex questions regarding the accepted conventions of an evolving modernist aesthetic. How could African American artists of the 1930s envision themselves in a modernist canon in a society that did not recognize them as part of the political, social, or human fabric of this country? Fortuitously, Lawrence found himself

in Harlem, New York, that is, inside one of the most paradoxical cities of the 1920s and 1930s and outside the center of mainstream America. This new city within a city, with its New Negroes,[1] created its own sense and sensibility of modernism, very different from that of the downtown, primarily white, community. The experiences Lawrence had in Harlem became the bedrock of his character and identity. Harlem provided a place of security and offered him the freedom to express, in Bachelard's words, his "profound depth of being" and self-worth. Harlem was his universe and his university, and Lawrence would spend his entire life transforming his impressions of black working-class life into paintings, prints, and drawings (fig. 1). He developed an aesthetic style that both challenged and contributed to the tides of modernist categorization and philosophical thought.

Inside Harlem

Jacob Lawrence, Jr., was born in 1917 in Atlantic City, New Jersey. By 1919, the year of the "Red Summer" of racial violence,[2] his family had moved to Easton, Pennsylvania, and become part of the Great Migration of African Americans, West Indians, and Africans who

relocated to the North from southern or rural, isolated communities and countries.³ Originally from South Carolina and Virginia, the Lawrence family, like the tens of thousands of black migrants, hoped to find more promising economic opportunities, better jobs, housing, education, and freedom from tyranny, violence, and sexual abuse. African diaspora people were looking for a means to participate with full advantage and privilege in the democracy of the United States: In 1924, after his parents separated, Jacob's mother moved the family to Philadelphia. Rosa Lee Armstead Lawrence then left her children in foster care and migrated to Harlem, where she worked for several years until she had earned enough money to send for her family. Jacob Lawrence was thirteen years old when he arrived in Harlem in 1930.

The move north may not have been as wrenching for the Lawrence family as it was for many others. Life was very different in the North for black people accustomed to small-town lifestyles (fig. 2). The slower pace of rural life was replaced with the speed and accelerated movements common to developing urban centers dense with cars, taxis, buses, trolleys, trains, and crowds of people constantly moving through the streets. Instead of living in one or two-story houses on a farm, the black migrants now lived in small apartments of densely compacted

vertically designed housing in tenements, which confined them to a life that was carried on more inside than outside. The pastoral sounds of nature were replaced with the urban din of people, traffic, radios, and modern machines moving across concrete sidewalks and cobblestone streets and above the ground on elevated tracks. The South, the Caribbean, and Africa are characterized by temperate to hot climates; by contrast, the northern United States are cold, windy, and harsh in winter. Harlem was teeming with people trying to adjust to all of this. Young Jacob Lawrence, with his fertile, inquisitive, creative mind, arrived in the midst of a city that was unlike anything any African American migrant, much less this thirteen-year-old impressionable youth, could imagine. The hardships experienced by these new urban African Americans were further exacerbated by the inescapable fact of their social alienation and disenfranchisement from American society at large.

Historically, 1930 marks a shift in the flourishing New Negro movement, popularly recognized as the Harlem Renaissance, when the literary arts slowed and the visual arts began to evolve. This prolific flowering of creative black talent attracted and produced an unprecedented number of black politicians, businessmen, lawyers, intellectuals, writers, musicians, and artists. In spite of the economic difficulties, this new cultural and sociological

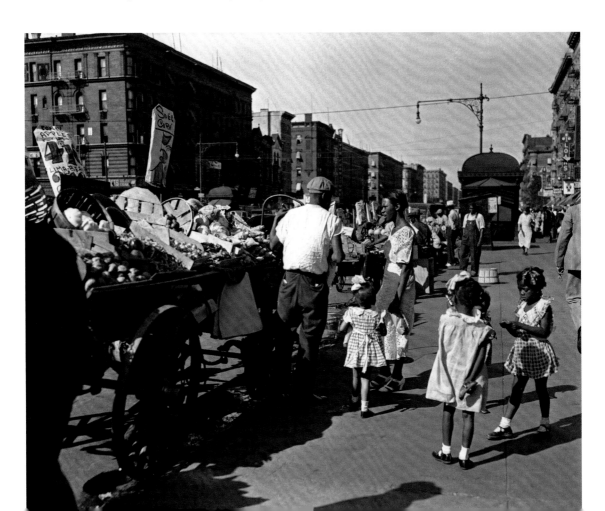

enclave enjoyed a sense of optimism that was shared by many who entered the rarefied atmosphere of Harlem. James Weldon Johnson—lawyer, educator, songwriter, diplomat, as well as a fierce advocate for civil rights and black artistic expression—wrote in *Black Manhattan* (1930) that Harlem, "the greatest single community anywhere of people descended from age-old Africa appears at a thoughtless glance to be the climax of the incongruous.... It strikes the uninformed observer as a phenomenon, a miracle straight out of the skies."[4]

Harlem was such fertile ground for the imagination that writers, both black and white, had individualized, impassioned critical responses to it. Richard Wright was hired by the Works Progress Administration (WPA) to write about Harlem in the late 1930s. Wright's description of the community crystallizes the essence of Harlem's magnetism:

> *Negro Harlem, into which are crowded more than a quarter of a million Negroes from southern states, the West Indies and Africa has many different aspects. To whites seeking amusement, it is an exuberant, original and unconventional entertainment center, to Negro college graduates it is an opportunity to practice a profession among their own people; to those aspiring to racial leadership it is a domain where they may advocate their theories unmolested; to artists, writers and sociologists it is a mine of rich material; to the mass of Negro people it is the spiritual capital of Black America.*[5]

Claude McKay, one of the more highly lauded West Indian New Negro migrants, was a noted writer of the Harlem Renaissance. Not as optimistic or awed as Johnson, McKay's view of Harlem is circumscribed by the political, social, and economic urgencies of segregated life in the urban North combined with the devastating impact of the depression and its aftermath:

> *Harlem is the queen of black belts, drawing Afroamericans together into a vast humming hive. They have swarmed from the different states, from the islands of the Caribbean and from Africa. And they still are coming in spite of the grim misery that lurks behind the inviting facades. Over-crowded tenements, the harsh Northern climate and unemployment do not daunt them. Harlem remains the magnet.*
>
> *Harlem is more than the Negro capital of the nation. It is the Negro capital of the world. And as New York is the most glorious experiment on earth of different races and diverse groups of humanity struggling and scrambling to live together, so Harlem is the most interesting sample of black humanity marching along with white humanity. Sometimes it lags behind, but nevertheless it*

> *is impelled and carried along by the irresistible strength of the movement of the white world.*[6]

Johnson, McKay, and Wright, like numerous other "Harlem Literati"[7] of the period such as Langston Hughes, Countee Cullen, Zora Neale Hurston, and Jean Toomer as well as activists and intellectuals such as W. E. B. Du Bois, Marcus Garvey, Arthur A. Schomburg, and Alain Locke, sought to articulate a self-conscious African American identity. At the same time they debated what made Harlem Harlem. On the one hand, Harlem was grounded in African ancestral traditions, philosophies, folklore, music, dance, and religion as practiced and carried north by the new black migrants. On the other hand, Harlem was a new city caught in the flux of modernism, technology, and urbanity. Jacob Lawrence was a witness to the acculturated, innovative, and improvised lifestyles created by these confluences of the Great Migration, the depression, the jazz age, and the emergence of the New Negroes of the Harlem Renaissance. Looking back at this time, Lawrence remembers vividly that the 1930s "was actually a wonderful period in Harlem although we didn't know this at the time. Of course it wasn't wonderful for our parents. For them, it was a struggle, but for the younger people coming along like myself, there was a real vitality in the community."[8] There were no antecedents for this situation. Whether you were an insider, privileged as a descendant member of African ancestry, or a white Euro-American outsider, visiting as a tourist, voyeur, or patron, Harlem remained a place of wonder and mystery.

A vital aspect and particular fascination of the human landscape of Harlem was observed by Nancy Cunard from a downtown, white patronage perspective. In 1934 she edited a weighty anthology, *Negro*, whose essays echoed in part, Alain Locke's 1925 anthology *The New Negro*, in which he formally announced "that a new spirit is awake in the masses."[9] Locke wrote from inside Harlem as the voice of reason and as the intellectual aesthetic architect of the New Negro art movement. Cunard however, in her contribution to her anthology provides a telling outsider's observation of white America's fascination and preoccupation with race and racial mixes:

> *For in Harlem one can make an appreciation of a race. Walk down 7th Avenue—the different types are uncountable. Every diversity of bone-structure, of head shape, of skin colour; mixes between Orientals and pure Negroes, Jews and Negroes, Red Indians and Negroes, mulattoes of all shades, yellow, "high yaller" girls, and Havana-coloured girls, and, exquisitely fine, the Spanish and Negro blends; the Negro bone, and the Negro fat too, are a joy to the eye.*[10]

Cunard's description provides vivid, painterly detail of a community of black people who represented every aspect of the African diaspora. These observations were not lost to the black community but contributed to an internal infracultural antagonism arising from the issues of color, class, and caste consciousness rooted in the residual history of slave plantation societies and culture.

It was in this milieu that Jacob Lawrence found himself. The migration of people of African descent from other locations in the United States and the Caribbean, moving to this small geographical location in great numbers and then self-consciously restructuring their entire way of living and thinking, created a dynamic environment. Lawrence was immersed in this, and at his impressionable age, he was very much formed by these circumstances. He was obviously well aware that the time and place were unique, for he very much wanted to capture them in his art.

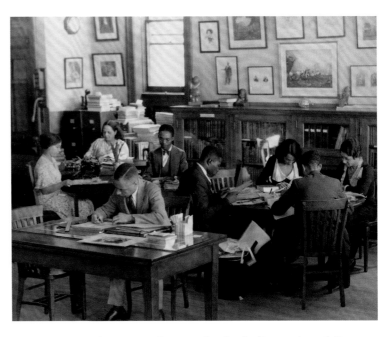

Art and Opportunity

Jacob Lawrence is the first major artist of the twentieth century who was technically trained and artistically educated within the art community of Harlem. Given the restrictions of segregation and the dire economic conditions for black Americans, training in professionally accredited and recognized art academies was difficult, if not impossible, for the majority of black artists in America. Harlem provided the crucial aesthetic foundation and establishments to encourage the training and artistic education of its community as part of its philosophical movement of racial uplift. This was done by founding institutions to promote the history and culture of Africa and African Americans and by setting up art schools and workshops to teach the rudiments of artistic production. While many individuals participated in this process, several had a specific and direct impact on Lawrence as a young man.

Arthur Schomburg, a black Puerto Rican, noted historian, and bibliophile, was passionate in his support of the arts. In 1911 he founded the Negro Society for Historic Research, appointing William E. Braxton art director. Schomburg went on to sponsor numerous exhibitions of contemporary art by African Americans and of traditional African art, many at the Brooklyn YMCA. By 1921 Schomburg's efforts were rewarded with a new base at the 135th Street branch of the New York Public Library in Harlem (later to become the Schomburg Center for Research in Black Culture), housing one of the most distinguished collections of literature and artifacts on African and African American culture. Thwarted by lack of access to educational or cultural institutions downtown, Lawrence and numerous black artists found this library to be a natural haven in their quest to reclaim their historical legacy. With the additional resources from the YMCA located across the street, the 135th Street library made an ideal forum for exhibitions and social, cultural, and political events. Many photographs of African Americans reading were published in the black press of the period (fig. 3), stressing the importance of literacy as one of the newly found opportunities of the Great Migration.

fig. 3 Reading Room at the 135th Street library, c. 1930

Arts education was beginning to take form in Harlem at this time, and it was introduced to children at a young age. Arts and crafts classes were offered in community day-care programs such as Utopia Children's House, where Lawrence's mother sent him while she worked. It was here, in 1930, that Lawrence received his earliest art instruction from Charles "Spinky" Alston, a young painter and graduate student at Columbia University Teachers College. Lawrence continued his art studies in 1934 under Charles Alston at the Harlem Art Workshop and at his studio at 306 West 141st Street, which became a mecca for the artists in Harlem. During this time, Alston was also director of the WPA Harlem Mural Project, and artists working on projects assigned to that area would sign up at Studio 306. Unaware at the time of the magnitude of this historic experience, Lawrence later recalled meeting such notables as Alain Locke, Addison Bates, Langston Hughes, Ralph Ellison, William Aaron Douglas, Orson Wells, and, later, Ronald Joseph, Robert Blackburn, Georgette Seabrooke Powell, and Romare Bearden. Lawrence recalls that the

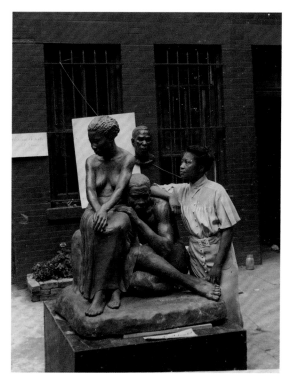

fig. 4 Augusta Savage with *Realization*, 1934

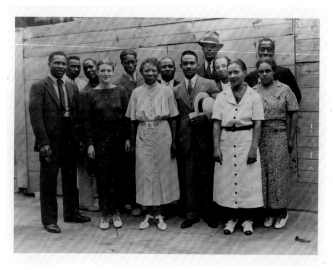

fig. 5 WPA Harlem Community Art Center instructors, 1930s. Front row left to right: Zell Ingram, Pemberton West, Augusta Savage, Robert Pious, Sarah West, and Gwendolyn Bennett. Back row left to right: Elton Fax, Rex Gorleigh, Fred Perry, William Artis, Francisco Lord, Louise Jefferson, and Norman Lewis

conversations centered on "what they thought about their art. . . . It was like a school. . . . Socially, that was my whole life at that time, the '306' studio."[11]

The sculptor and political activist Augusta Savage (fig. 4) was another dynamic member of the Harlem community who had a profound affect on Lawrence's development as an artist. One of the most important teachers of the period, she had a strong influence on Lawrence. In 1932 she opened the Savage Studio of Arts and Crafts on 143rd Street. Everyone was welcome, and many young artists, including Norman Lewis, William Artis, Elton Fax, Ernest Crichlow, Elba Lightfoot, Marvin and Morgan Smith, and Gwendolyn Knight, came to study with her. In 1933 she organized a group of young black intellectuals into the Vanguard, an activist group that met weekly to discuss issues of race and politics.[13] In 1936 Savage renovated a garage, which she called the Uptown Art Laboratory, for teaching art classes to children and young black artists seeking her guidance. Lawrence regularly attended Savage's classes and formed an especially close friendship with Robert Blackburn, Ronald Joseph, and Gwendolyn Knight. They would regularly visit the 135th Street library, museums, galleries, and lectures both uptown and downtown, constantly discussing the art they saw, critical issues regarding modernism, and the aesthetic aspirations of African American artists. As the largest and most important school in Harlem, the Laboratory evolved in 1937 into the Harlem

Community Art Center (fig. 5) and as such is still active today. The project was so successful that by 1938, with more than three thousand students enrolled, a second site had to be found to accommodate the demand for classes. That the laboratory became a model for later WPA art centers affirms the importance of community-based arts education.

The emergence of art centers and schools of art was the spiritual and aesthetic life force of the Harlem community, and because of them Lawrence benefited immensely. But equally important was the presence in the community of practicing professional artists. Aaron Douglas was an influential example. Douglas arrived in New York at the onset of the Harlem Renaissance in 1924. A professionally trained artist, he soon became the principal visual artist of the Harlem Renaissance and provided a sense of stability and guidance to the younger black artists. In 1934 he completed six murals for the lecture hall of the New York Public Library at 135th Street. The series, *Aspects of Negro Life*, depicts the history of the Negro from Africa to America. The artist's formal devices—stylized, flat, cubist elements rendered in muted tones—reflect Douglas's assimilation of Egyptian-inspired aesthetics combined with his response to modernism. Douglas put into visual terms the ethos of the uptown Harlem working-class African American that was also to be found in all the black communities across America. Douglas recalled that "the field

of plastic art was in a unique position in that there was almost no background; we had no tradition. Everything was done . . . almost for the first time . . . we were so hungry . . . as I look back at the things that I produced, it was so readily received and cheerfully received. . . . The Harlem Community never refused anything that I did. They accepted it; they put it forward."[14] Lawrence also was the beneficiary of this magnanimous spirit.

In addition to the impact of significant efforts from within the community, there were individuals and foundations outside of Harlem, some run by white people, that were also encouraging the cultural efforts of African Americans. In 1914 Joel E. Spingarn, then chairman of the National Association for the Advancement of Colored People (NAACP), established the Spingarn Medal for "the highest and noblest achievement of an American Negro."[15] The creative and performing arts were among those disciplines recognized for meritorious achievement and often received critical attention in *Crisis*, the magazine published by the NAACH. The magazine's editor, W. E. B. Du Bois, one of the most important activist historians of the twentieth century, argued vociferously and eloquently for the intrinsic value of the African American artist as a vital contributor to his culture. Du Bois championed all the arts—drama, literature, music, and dance—and urged the black communities of America, which were also in a period of cultural florescence, a beit on a smaller scale than in Harlem, to "let us train ourselves to see beauty in black."[16]

The Harmon Foundation, established by the real estate developer William E. Harmon in 1922, granted the Distinguished Achievement among Negroes award from 1926 to 1933. From 1928 to 1933 over forty-five prizes and honorable mentions were granted and hundreds of works of art were exhibited in Harlem and across the United States. The Rosenwald Fund, established by Julius Rosenwald of Chicago, also played a significant role in the patronage of African American artists. Lawrence received loans from the Harmon Foundation and three fellowships from the Rosenwald Fund.

Lawrence was a product of the particular migration-depression culture of Harlem, within the larger context of America. Although these were difficult times economically, they were nonetheless optimistic and motivating for those in the artistic realm in Harlem. It was fortuitous for Lawrence that institutional and financial support systems were taking shape. Lawrence always looks back to the support he received from numerous individuals and institutions as being crucial to his artistic development and pursuit of art as a career.

"Finding His Own Way"

Charles Alston, as the director of the art program at Utopia Children's House, soon recognized that Lawrence had exceptional abilities; he would later reflect that "there was always something very simple and direct about his approach."[17] He felt strongly that "it would [have been] a mistake to try to teach Jake. He was teaching himself, finding his own way. All he needed was encouragement and technical information."[18] The first images that excited the young Lawrence were nonfigurative geometric shapes arranged in patterns of black and white and in bright primary colors. Lawrence describes "how I was playing with color: I always liked it."[19] Using crayons and then poster paints at Utopia House, he began to make compositions, no longer extant, inspired by his own home. Rosa Lee Armstead Lawrence had made a significant effort to create a beautiful home for her family in spite of the financial stress of the depression. The artist recalled:

> Our homes were very decorative, full of pattern, like inexpensive throw rugs, all around the house. It must have had some influence, all this color and everything. Because we were so poor the people used this as a means of brightening their life. I used to do bright patterns after these throw rugs; I got ideas from them, the arabesques, the movement and so on.[20]

At this early stage in his life Lawrence unwittingly was beginning to see, as Du Bois had urged, the "beauty in black," meaning black people and their lives. Lawrence began his own investigation inside his home as it was configured by his mother, doing the best she could to create a cheerful environment in her tenement apartment. Zora Neale Hurston identified this phenomenon in her seminal essay "Characteristics of Negro Expression," published in Nancy Cunard's *Negro*, as "the urge to adorn." Hurston, a woman far ahead of her time—an anthropologist, folklorist, writer, poet, actress—described the typical interior of the homes of many poor working-class black families who, migrating from the South, transplanted that aesthetic into their northern domiciles:

> On the walls of the homes of the average Negro one always finds a glut of gaudy calendars, wall pockets and advertising lithographs. The sophisticated white man or Negro would tolerate none of these, even if they bore a likeness to the Mona Lisa. No commercial art for decoration. Neither the calendar nor the advertisement spoils the picture for this lowly man. He sees the beauty in spite of the declaration of the Portland Cement Works or the butcher's announcement. I saw in Mobile a room in which there was an over-stuffed mohair living room suite, an imitation mahogany bed and chifferobe, a console victrola. The walls were gaily papered with Sunday supplements of the Mobile Register. There were seven calendars and three wall pockets. One of them was decorated with a

*lace doily. The mantel shelf was covered with
a scarf of deep home-made lace, looped up with a
huge bow of pink crepe paper. Over the door was
a huge lithograph showing the Treaty of Versailles
being signed with a Waterman fountain pen.*[21]

This penchant for decoration, springing from the
poorer segments of the black population, was one facet
of the quest for an aesthetic ideal in the black community
in the 1930s. Du Bois's emphasis on the individual African American and personal concepts of self-worth, by
contrast, was an elitist stance addressed to the "Talented
Tenth."[22] Lawrence was not, by Du Bois's definition, a
member of this group. He was, as Alston described him,
a "poor kid," and consequently his sources of inspiration
came from his working-class mother and the migration-
depression culture that she embodied. Likewise, Hurston's assessments did not cater to the "Talented Tenth"
but rather to the working class and the masses of African
Americans who were too caught up in the struggle to
survive to be able to participate in the formalist expressions of the New Negro movement. Yet the Renaissance
never could have reached the visionary level of creativity it did had not the working-class people of Harlem
provided, in Wright's words, a constant "mine of rich
material" that inspired the artistic intellect of the New
Negro literati. Douglas, when queried later in life about
his aesthetic ideal and the contributions of the common
man to the era of the New Negro, stated:

> *As a matter of fact, if you had asked him about
> culture, he would have been hard-put to explain it
> at all, certainly to explain the black man's part in
> it. But, he was part of it, although he didn't under
> stand this thing he did not actually consciously
> make a contribution: he made his contribution in
> an unconscious way. He was the thing on which
> and around which this whole idea was developed.
> And from that standpoint it seems to me his con
> tribution is greater than if he had attempted con
> sciously to make a contribution.*[23]

The working-class environment as decorated by
Lawrence's mother and that inspired him to create his
first abstract images of rug designs was no less important
than the more fanciful interiors created by the "sophisticated" individuals who also sought to live in beauty.
Hurston's analysis of African American interior domestic space was conflicted. She admitted, "It was grotesque,
yes. But it indicated a desire for beauty ... decorating a
decoration. . . . The feeling back of such an act is there
can never be enough beauty, let alone too much." What
was important, Hurston declared, was the value such
decoration assumed in people's lives. "Perhaps his idea
of ornament does not meet conventional standards, but
it satisfies the soul of its creator."[24] The most ordinary
daily tasks, events, and routines, such as decorating

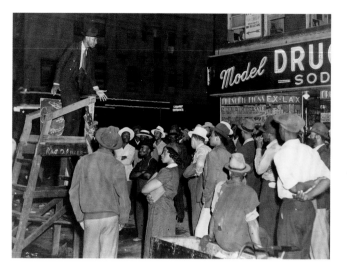

fig. 6 Marvin and Morgan Smith, *Street-
Corner Meeting, 125th Street*, c. 1938

one's home, would consume Lawrence's entire
imagination. He would
use what he saw around him every day to document
the visual culture, beauty, and artistic spirit of Harlem.

As Lawrence became more skilled in the execution
of his small compositional studies he became increasingly prolific in his production of images that captured
the essence of Harlem's character, identity, and cultural
ethos. His *Street Orator's Audience* (fig. 7), which
echoes a photograph by Marvin and Morgan Smith
entitled *Street-Corner Meeting, 125th Street* (fig. 6), is
one example of his work from this period. Jacob and his
colleagues from Savage's art schools capture an essential feature of the Harlem community at that time. In
Lawrence's composition the audience, nearly transfixed
by the orator's message, is viewed from the perspective
of the speaker. These "soap box" sessions became an
important testing ground for political and social leaders to hone their verbal skills and transmit information
quickly throughout the community.

The streets of Harlem—their movement, the people,
the local color, and the sounds—became a bottomless
source of visual and spiritual inspiration for Lawrence.
His ability to tell the story of a community visually
revealed his capacity for observation and acute attention
to detail. The flatness of the forms allows the subject to
move in a storyboard, cinematic style almost in anticipation of the next frame of action. Lawrence would not
become just the storyteller, or visual griot, of Harlem,
but in fact he would become the biographer of an extraordinary community and the autobiographer of the artist
who evolved from it.

Lawrence's emphasis on Harlem as the primary subject matter in his nonserial paintings of the late 1930s
and early 1940s is distinct from the art of many of his
colleagues and mentors at the time. Whereas Lawrence
drew thematic inspiration from his immediate environment, many other artists created images that strongly

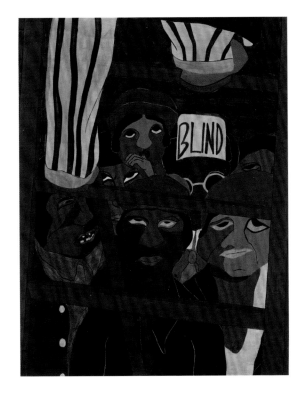

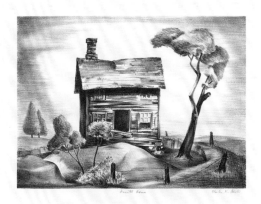

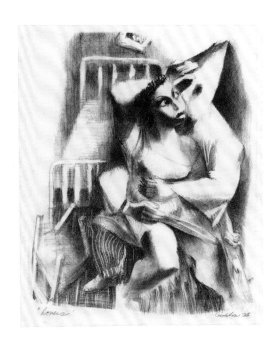

recalled their lives and experiences in the South. Alston's *Deserted House* (fig. 8) epitomizes what Hale Woodruff comed the "Out-House School."[25] The exhausted land on which the deteriorating house sits is a reminder of a lost era. Ernest Crichlow's *Lovers* (fig. 9) is an indictment of an insidious rape scene that records the abuses of the Ku Klux Klan that contributed to the black exodus north to freedom. Figurative imagery was important to African American artists and their communities who longed for a representation that would honor their likeness. However, the lure of abstraction and the question of modernism charged the intellect of artists like Norman Lewis, whose *Umbrella* (fig. 10) tests abstraction's potential to convey modernist interpretations of African American life. Alston, Crichlow, Lewis, and Lawrence worked closely during the years of the 1930s and acted as mutual catalytic forces on each other's lives and art. From this small sample of images—all produced in Harlem in the 1930s—it is clear that no two artists in Harlem worked in the same style. The diversity of styles and approaches available gave the artists freedom to express themselves individually while having the support and admiration of their peers.

Recognition of Lawrence's early paintings of Harlem came In February 1938 when, at the age of twenty, he had a solo exhibition at the 135th Street YMCA. Sponsored by the James Weldon Johnson Literary Guild, this was a remarkable moment of affirmation and celebration of an artist's youthful yet mature vision. Alston, in his introductory statement in the brochure that accompanied the exhibition, gives a perceptive critique of an

Clockwise from left:

fig. 7 Jacob Lawrence, *Street Orator's Audience*, 1936. Tempera on paper, 24⅛ × 19⅛ in. Collection of Tacoma Art Museum. Gift of Mr. and Mrs. Roger W. Peck by exchange

fig. 8 Charles Alston, *Deserted House*, 1935–43. Lithograph, sheet: 14½ × 18¼ in.; image: 11 × 15¼ in. The Metropolitan Museum of Art, Gift of New York City WPA, 1943

fig. 9 Ernest Crichlow, *Lovers*, 1938. Lithograph, sheet, 15 × 12⅝ in.; image: 14 × 11¾ in. The Metropolitan Museum of Art, Gift of Reba and Dave Williams, 1999

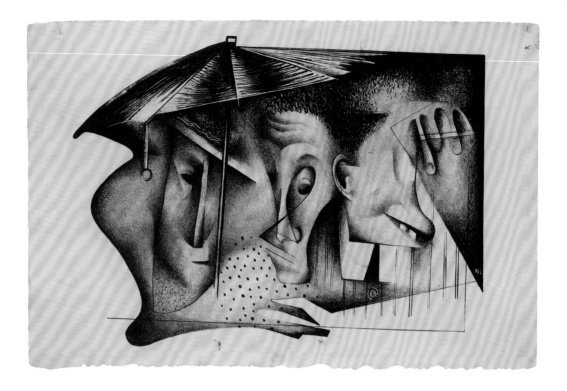

fig. 10 Norman Lewis, *Umbrella*, 1938. Lithograph, sheet: 12⅜ × 17 in. The Metropolitan Museum of Art. Gift of Reba and Dave Williams, 1999

achievement of this magnitude so early in the life of an artist:

> The place of Jacob Lawrence among younger painters is unique. Having thus far miraculously escaped the imprint of academic ideas and current vogues in art to which young artists are most susceptible, he has followed a course of development dictated entirely by his own inner motivations.
>
> Any evaluation of his work to date is most difficult, a comparison impossible. Working in the very limited medium of flat tempera he achieved a richness and brilliance of color harmonies both remarkable and exciting.
>
> He is particularly sensitive to the life about him; the joy, the suffering, the weakness, the strength of the people he sees every day. This for the most part forms the subject matter of his interesting compositions.
>
> Still a very young painter, Lawrence symbolizes more than any one I know, the vitality, the seriousness and promise of a new and socially conscious generation of Negro artists.[26]

Attuned to modernism as it was evolving, Alston realized that it would be difficult if not impossible to find counterparts for Lawrence's work. Lawrence had already begun to define a new brand of modernism in part by using black subject matter as the prime vehicle of his expression. The exhibition at the 135th Street

YMCA was a watershed moment for Jacob Lawrence and an endorsement of his work from within his community.

A "Peerless Delineator" Emerges

Lawrence painted not just what he saw, but also what he heard from the oral historians of Harlem. Lectures on aspects of African and African American history and culture given at the 135th Street library (history previously unknown to Lawrence since the topic was not part of the New York City public education curriculum) sparked his interest in these subjects. He, along with many other artists, heard lectures by Joel C. Rogers, Richard B. Moore, and the carpenter-cum-scholar "Professor" Charles C. Seifert.[27] These lectures were part of a community-wide effort in Harlem to learn and value the history of African Americans and their contribution to American history. Lawrence was so impressed after having heard one of Seifert's lectures that he was inspired to research the history and political struggles of his people. Motivated by the courageous events he studied, he was compelled to create, in rapid succession, series of paintings on the important African American heroic narratives, *The Life of Toussaint L'Ouverture* (1938), *The Life of Frederick Douglass* (1939), and *The Life of Harriet Tubman* (1940). The stories and the struggles of these monumental freedom fighters became icons of survival and hope. In 1941 he painted *The Migration of the Negro*, based on his family's experience, the recollections of

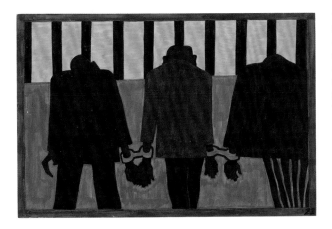

fig. 11 Jacob Lawrence, *The Migration Series*, Panel 22: *Another of the social causes of the migrants' leaving was that at times they did not feel safe, or it was not the best thing to be found on the streets late at night. They were arrested on the slightest provocation*, 1941. Casein tempera on hardboard, 12 × 18 in. The Museum of Modern Art, New York, Gift of Mrs. David M. Levy

people in his community, and research completed at the New York Public Library.

Lawrence's intent for the series was nothing less than educational in the most profound sense. Pivotal to the success of the series were the complementary texts that accompanied each panel. Because looking at art was new to the New Negroes, Lawrence tried, through the text panels, to underscore the message of his art and to validate his viewers' newly found sense of literacy. Panel *No. 22* (fig. 11) of the series depicts the stark, bitter reality of unprovoked social injustice as it is dramatically played out in the backs of three black victims, handcuffed together facing the harsh vertical restraints of a prison cell. The composition is wrought with the pain of injustice, hopelessness, and the anonymity of the subjects, who represent anyone of African descent. The caption for the panel provides an explanation for the image: "Another of the social causes of the migrants' leaving was that at times they did not feel safe, or it was not the best thing to be found on the streets late at night. They were arrested on the slightest provocation." In this case, the panel and the text offer no hope of escape or redemption.

After Lawrence finished *The Migration of the Negro* series, the insularity of his artistic world was broken when Edith Halpert exhibited the series at her gallery, the Downtown Gallery—the very name of which is significant. By her invitation, Lawrence became the first artist of African descent to be represented by a downtown gallery. As important as this event was to Lawrence, it did not sway him from his primary objective: to document the legacy of African American people in Harlem.

The experience of creating historical works in series format led Lawrence to think of images that functioned as thematic groupings. Between 1942 and 1943 Lawrence embarked on a group of thirty paintings that focused directly on life in Harlem. In *This Is Harlem* (fig. 1), the early lessons of creating patterns from the geometric and arabesque patterns of his mother's scatter rugs and the block prints he created at the Harlem Art Workshop reached new levels of virtuosity. Here

the Harlem community is animated through the bold colors, repeating patterns, and the asymmetrical design of the composition. The sounds and music of the jazz age were not lost on Lawrence as he incorporated the aural elements of rhythms, breaks, and changes into the visual polyphony of Harlem's environment, people, and culture. Technically, his work in the medium of gouache became more sophisticated through the assistance of Romare Bearden, who had a studio in the same building and who also shared a love of Harlem and jazz.[28]

Throughout the 1930s and well into the 1940s, Lawrence depicted some of the most fundamentally important issues for African Americans in post-depression Harlem. These include the desperate plight of black working women, the illness and disease that were the consequence of living in tight quarters and with inadequate health care, and the prominent role that religion and spirituality played in people's daily lives.

Though Lawrence's work at the time includes countless depictions of working-class labor, it exhibits a special sensitivity to the working women of Harlem, both socially and politically. The dire employment conditions in America made the lives of African Americans particularly difficult, and Lawrence witnessed this firsthand, as his mother struggled to work as domestic help and then return home, tired, to raise three children singlehandedly. Black women suffered the indignity and physical stress of having to work in domestic service regardless of their educational achievements (fig. 12). For example, despite Zora Neale Hurston's accomplishments, she was not spared the onus of working as a domestic simply to survive. In *Ironers* (fig. 13) Lawrence shows the female worker from several perspectives—that of the primary caretaker of her home, of an employed worker in service to a white family, and of a factory worker in the New York garment industry. The angular arms of the women ironing show strength. The bent heads indicate resignation to the repetitive, dulling, boring work. The anonymity of the subjects, shown in many of Lawrence's works, indicates the commonplaceness of this condition to all black women of

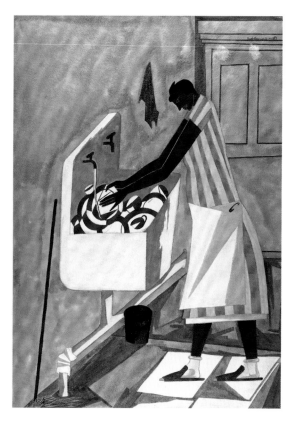

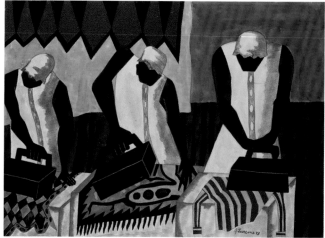

Left: fig. 12 Jacob Lawrence, *Home Chores*, 1945. Gouache on paper, 29½ × 21¹⁄₁₆ in. The Nelson-Atkins Museum of Art, Kansas City, Missouri. Anonymous gift

Right: fig. 13 Jacob Lawrence, *Ironers*, 1943. Gouache on paper, 21½ × 29½ in. Collection of Ann and Andrew Ditenfass

that era. Lawrence's observations of life in Harlem were echoed in a 1937 study of the working conditions of black domestic workers. The study, sponsored by the federal government's New Deal programs, was condemnatory. "The problem of Negro domestic workers in the United States, affecting eighty-five percent of all Negro women workers, demands immediate action by the federal government. Their wages, hours, and standards of living, even lower than those for white workers in both rural and urban communities, offer a challenge to American ideals of social legislation."[29]

In addition to Lawrence's sympathy to the conditions of working-class black women, there was also great respect for their strength and perseverance, and this respect was fostered in part by his deep friendship and marriage, in 1941, to the artist Gwendolyn Clarine Knight. Born on the island of Barbados, she immigrated with her family to the United States, living in Saint Louis for a while and then settling in Brooklyn.[30] Her education at Howard University in the art department allowed her to study with the painter Lois Mailou Jones and the historian-painter James Porter. However, when the depression forced Knight to leave Howard, she returned to New York to continue her studies in the art schools of Harlem. Knight, a quietly focused woman of confidence, discipline, and elegance, deeply respected, supported, and protected Lawrence's talent and vision. Her strength of character owed much to her Barbadian heritage. From the time of slavery Barbadian women

historically developed strong patterns of survival and resistance in response to extreme exploitation and abuse. The historian Hilary McD. Beckles maintains that, as a result, Barbadian women "did become, by the instinctive process of self-protection, nothing less than natural rebels."[31] Gwendolyn Knight Lawrence channeled her rebellious nature, and in her partnered relationship with Lawrence, she formed a unique alliance with an artist equally matched to her own independence and intellect. Lawrence has always respected her opinions, philosophically and aesthetically.

Health concerns were predominant in postdepression era Harlem, not surprisingly, due to the density of the population following the Great Migration. Death, dying, illness, and physical and spiritual well-being were matters of constant urgency for black Americans. Limited access to health care and hospital facilities was one of segregation's greatest affronts to the tenets of democracy (fig. 14). In the face of such poor systemic conditions, the black church became a place of spiritual and psychological centering. As the migrants moved to the North from the South, the Caribbean, and Africa, they brought with them a myriad of religions grounded in African religions and philosophical belief systems. Charismatic figures like Father Divine and Daddy Grace drew huge followings. Black Jews and Muslims proliferated within the religious landscape of

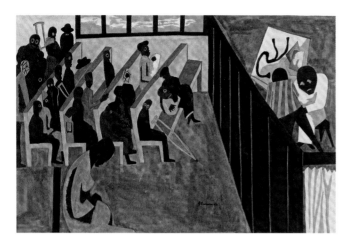

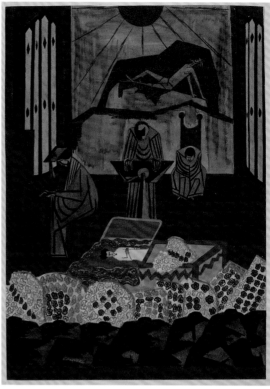

Left: fig. 14 Jacob Lawrence, *Harlem Hospital's Free Clinic Is Crowded with Patients Every Morning and Evening*, 1943. Gouache on paper, 21³⁄₁₆ × 29⅛ in. Portland Art Museum, Portland Oregon. Helen Thurston Ayer Fund

Right: fig. 15 Jacob Lawrence, *Funeral Sermon*, 1946. Gouache and watercolor on paper, 29⅜ × 21⅛ in. Brooklyn Museum of Art. Anonymous gift, 48.24

Harlem and added to the already innate sense of spirituality, great pageantry, elaborate rituals, lavish regalia, and stylized fashions.[32]

Lawrence's *Funeral Sermon* is one of many images that depicts spiritual life in Harlem (fig. 15). The black preacher stands off-center in the picture plane as he prepares the congregation for the deceased's passage to transmigrate from this mortal world to the final, otherworldly state of being. This is a beguiling representation of a funeral. For black people this is a passage of particular meaning and intensity. The act and actions of preaching take on special significance as articulated by the scholar Henry H. Mitchell:

> In its involvement of the entire person, Black preaching not only communicates gut level, sustaining core belief and motivation, it affirms the person and her/his culture, providing communion with God in the souls' "mother tongue." In other words, the preaching and worship traditions have survived amidst an alien majority culture precisely because they serve functions such as emotional support and affirmation of otherwise dehumanized personhood.[33]

Lawrence has not only captured the ritual of the funeral but references the entire cosmology of the African diasporic spiritual and religious activities of Harlem.

Everywhere Lawrence went, his eyes were a camera, and scene after scene fed his artistic appetite. He found material in the leisure time that was precious to the new working-class migrants—both young and old.

Because downtown New York establishments such as clubs were off-limits for African Americans to patronize, people in Harlem made their own recreation. It took many forms, such as rent parties, shooting pool, dancing, singing, playing "numbers," cards, checkers, dominos, and telling "tall" stories (fig. 16). The children played stickball, jump rope, hide-and-seek, and hand-clapping and sidewalk chalk games.

Lawrence is not given to making long explanations about his work; when he does discuss it, he, like his creations, is always clear, focused, and concise. He has said: "Most of my work depicts events from the many Harlems which exist throughout the United States. This is my genre. My surroundings. The people know . . . the happiness, tragedies, and the sorrows of mankind as realized in the teeming black ghetto."[34] Lawrence's commitment to his artistic vision was so strong that it inspired Claude McKay to inscribe a copy of his autobiography, *A Long Way from Home*, to the artist with these words: "For Jacob Lawrence, a peerless delineator of the Harlem scenes and types."[35]

Throughout his early work, Lawrence was relentless in his quest to preserve the Harlem ethos—its humanity and the heroic achievements of its common working-class people—by transforming it into art. He was himself one of the masses who worked and lived in Harlem, and he passionately believed in the community and its people. He later made the strong claim: "I am part of the Black community, so I am the Black community

speaking."[36] Through his innovative figurative abstractions that mirrored the vast reservoir of culture and history of the jazz depression-migration-era culture as it was expressed in Harlem, Lawrence gave visual affirmation and reality to a thoroughly authentic modernist style. That it can be directly attributed to the dynamics of an African American aesthetic moves Lawrence and all of black America from outside the edge to inside the center of modernist ideals.

Notes

Epigraph: Gaston Bachelard, *The Poetics of Space* (Boston: Beacon Press, 1969), 224.

1. The New Negro was a manifestation of the Harlem Renaissance, that emergence and flourishing of black writers, artists, and poets who, with an assertive spirit, artistic determination, and self-conscious racial pride, crystallized their new sense of cultural identity. See Alain Locke's seminal anthology *The New Negro* (1925; reprint, New York: Atheneum, 1968).

2. In 1919 twenty-five race riots and other incidents occurred across the United States. Racial tension between blacks and whites just after World War I was high. Although the riots had common issues grounded in the negative treatment of African Americans, each riot had its own specific causes. James Weldon Johnson, who was an investigator for the National Association for the Advancement of Colored People, coined the term "Red Summer" for this period in history. See Alana J. Erikson, "Red Summer," *Encyclopedia of African American Culture and History,* ed. Jack Salzman, David Lionel Smith, and Cornel West (New York: Macmillan Library Reference USA, Simon & Schuster Macmillan), vol. 4, 293–4; also William M. Tuttle, Jr., *Race Riot: Chicago in the Red Summer of 1919* (New York: Simon & Schuster; 1972).

3. The Great Migration was a very layered, complex, and self-determined African American phenomenon. The scholar Joe W. Trotter, Jr., asserts, "The Great Migration was by no means a simple move from southern agriculture to northern cities. It had specific regional and subregional components. It also had

international ramifications for people in the Diaspora of the West Indies and Africa." Joe W. Trotter, Jr., "Migration/Population," in *Encyclopedia of African American Culture and History,* 1782.

4. James Weldon Johnson, *Black Manhattan* (New York: Arno Press, 1968), 3–4.

5. Quoted in *The WPA Guide to New York City* (New York: Random House, 1982), 57.

6. Claude McKay, *Harlem: Negro Metropolis* (New York: Harcourt Brace Jovanovich, 1968), 16.

7. "Harlem Literati" was a term coined by Langston Hughes to describe the black literary intellectuals of the Harlem Renaissance. In his autobiography *The Big Sea,* Hughes devotes a special section to his compatriots. See Langston Hughes, "Harlem Literati," in David Levering Lewis, ed., *The Portable Harlem Renaissance Reader* (New York: Penguin Books, 1994), 81–85.

8. Quoted in Jane Van Cleve, "The Human Views of Jacob Lawrence," *Stepping Out Northwest* 12 (Winter 1982): 33–37.

9. Alain Locke, "Enter the New Negro," *Survey Graphic* 6, no. 6 (March 1925): 631.

10. Nancy Cunard, ed., *Negro—An Anthology* (New York: Frederick Unger Publishing Company, 1934), 53–54.

11. Quoted in Jacquelin Rocker Brown, "The Works Progress Administration and the Development of an Afro-American Artist, Jacob Lawrence, Jr.," unpublished paper (Howard University, Washington, D.C., 1974), 109.

12. Although it is now impossible to know what specific techniques and curricular pedagogy Savage used in her workshops, she was known to be a fierce activist, motivator, mentor, nurturer, friend, ally, and teacher to hundreds of African American artists and children in Harlem. Jacob Lawrence attributes Savage with remembering his birthday and taking him down to the WPA to sign up as an easel artist. See L. King-Hammond, "Quest for Freedom, Identity, and Beauty: New Negro Artists Prophet, Savage and Burke," in *Three Generations of African American Women Sculptors: A Study in Paradox* (Philadelphia: Afro-American Historical and Cultural Museum, 1996), 26–37.

13. Juanita Marie Holland, "Augusta Christine Savage: A Chronology of Her Life, 1892–1962," in *Augusta Savage and the Art Schools of Harlem* (New York: Schomburg Center for Research in Black Culture, New York Public Library, 1988), 12–19.

14. Leslie M. Collins, "Aaron Douglas Chats about the Harlem Renaissance," an oral history interview, Fisk University Library, Special Collections, quoted in Lewis, ed., *Portable Harlem Renaissance Reader,* 120–21.

15. "Spingarn Medal," *The Crisis* 8, no. 2 (June 1914): 88.

16. W. E. B. Du Bois, "Opinion of W. E. B. Du Bois: In Black," *The Crisis* 20, no. 6 (October 1920): 263–64.

17. See "Biographical Chronology," *Charles Alston: Artist and Teacher,* exh. cat. (New York: Kenkeleba Gallery, 1990), 20.

18. Quoted in Romare Bearden and Harry Henderson, *Six Black Masters of American Art* (Garden City, N.Y.: Doubleday, 1972), 102.

19. Jacob Lawrence, lecture, School of Art, University of Washington, Seattle, November 15, 1982.

20. Jacob Lawrence, interview by Ellen Harkins Wheat, February 15, 1983, in *Jacob Lawrence: American Painter,* exh. cat. (Seattle

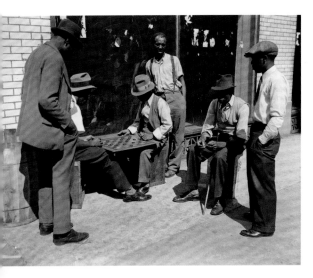

fig. 16 Checkers on Lenox Avenue, 1935

and London: University of Washington Press in association with the Seattle Art Museum, 1986), 29.

21. Zora Neale Hurston, "Characteristics of Negro Expression," in Cunard, ed., *Negro,* 25.

22. This was a concept espoused by black educator, philosopher, and author W. E. B. Du Bois, emphasizing the necessity for higher education to develop the leadership capacity among the most able 10 percent of African Americans. Du Bois was one of a number of black intellectuals who feared what he perceived was an over-emphasis on industrial training. He believed this could result in the confinement of blacks to the ranks of second-class citizenship. To achieve political and civil equality, Du Bois stressed the impor-tance of educating blacks so they could enter the professional ranks and then dedicate themselves to helping the masses.

23. "Aaron Douglas Chats about the Harlem Renaissance," quoted in Lewis, ed., *Portable Harlem Renaissance Reader,* 119.

24. Hurston, "Characteristics of Negro Expression," 26.

25. Quoted in Albert Murray, "An Interview with Hale Woodruff," in *Hale Woodruff: Fifty Years of His Art* (New York: Studio Museum in Harlem, 1979), 72.

26. Charles Alston, introduction to Lawrence's exhibition at the 135th Street YMCA, as quoted in Milton W. Brown, *Jacob Lawrence,* exh. cat. (New York: Whitney Museum of American Art, 1974), 9.

27. See Charles C. Seifert, *The Negro's or Ethiopian's Contribution to Art* (1938; repr., Baltimore: Black Classic Press, 1986). The intro-duction contains an insightful description of the grand opening of the Harlem Art Workshop. This small publication contains nine topics in two chapters that were most probably presented at the 135th Street library lecture series. The publication also attests to the strong interest and involvement scholars had with the artistic community of Harlem. See also Elton Fax, *Seventeen Black Artists* (New York: Dodd, Mead and Company, 1971), 152.

28. Fax, "Jacob Lawrence," in *Seventeen Black Artists,* 158–59.

29. See Joe W. Trotter and Earl Lewis, eds., *African Americans in the Industrial Age: A Documentary History, 1915–1945* (Boston: Northeastern University Press, 1996), 181.

30. See Irma Watkins-Owens, *Blood Relations: Caribbean Immi-grants and the Harlem Community, 1900–1930* (Bloomington and Indianapolis: Indiana University Press, 1966), 20–21. Carib-bean immigrants were under economic stresses similar to those of African Americans in the southern regions of the United States. Barbados's conditions were especially bleak and warranted relo-cation to survive.

31. Hilary McD. Beckles, *Natural Rebels: A Social History of Enslaved Black Women in Barbados* (New Brunswick, NJ: Rutgers Univer-sity Press, 1989), 177.

32. See Arthur Huff Pauset, *Black Gods of the Metropolis: Negro Reli-gious Cults in the Urban North* (Philadelphia: University of Penn-sylvania Press, 1944); C. Eric Lincoln, ed., *The Black Experience in Religion* (Garden City, N.Y.:Anchor Books, 1974); and Larry G. Murphy, J. Gordon Melton, and Gary L. Ward, eds., *Encyclo-pedia of African American Religions* (New York and London: Garland Publishing, 1993), 607. It must be noted that this is a field of scholarship that has grown considerably since the 1930s. These particular studies give a wealth of evidence to support the wide range of religious groups active in the North.

33. Henry H. Mitchell, "Preaching and the Preacher in African Amer-ican Religion," in Murphy, Melton, and Ward, eds., *Encyclopedia of African American Religions,* 607.

34. Quoted in David Shapiro, ed., *Social Realism: Art As a Weapon* (New York: Frederick Unger Publishing Company, 1973), 217.

35. Jacob Lawrence and Gwendolyn Knight Lawrence, transcript of tape-recorded interview by Paul J. Karlstrom, November 18, 1998, Archives of American Art, Smithsonian Institution, Wash-ington, D.C., 13.

36. Jessica B. Harris, "The Prolific Palette of Jacob Lawrence," *Encore* (November 1974): 52.

NEW YORK, N. Y.

Hotels — Motels — Tourist Homes — Restaurants
(Harlem)

```
★ ROYAL HOTEL ★

TELEPHONE AND RADIO IN ALL ROOMS

● BATHS AVAILABLE            ● ROOM SERVICE

● AIR-CONDITIONING           ● RESTAURANT

306 West 116th Street             New York 26, N. Y.
            Tel.: UNiversity 5-3210
```

Braddock Hotel	126th St. & 8th Ave.
Woodside Hotel	2424 7th Ave.
Grampion Hotel	182 St. Nicholas Ave.
Y.M.C.A.	180 W. 135th St.
Y.W.C.A.	175 W. 137th St.
Revella Hotel	307 W. 116th St.
Elton Hotel	227 W. 135th St.
Cadillac Hotel	235 W. 135th St.
Rich's Plaza Hotel	35 Bradhurst Ave.
Mel's Plaza Hotel	115 W. 118th St.
America Hotel	145 West 47th St.
Richard Hotel	6 Bradhurst Ave.
Wilthom Hotel	2027 7th Ave.
Dewey Square Hotel	201-203 West 117th St.
The Tenrub Hotel	328 St. Nicholas Ave.
Hotel Theresa	2090 7th Ave.
★HOTEL FANE	205 West 135th St.
★CROSSTOWN HOTEL	515 West 145th St.
Currie Hotel	101 W. 145th St.
Olga Hotel	695 Lenox Ave.
Cecil Hotel	208 W. 118th St.
Barbera Hotel	501 W. 142nd St.
Douglas Hotel	809 St. Nicholas Ave.
Manhattan Hotel	504 Manhattan Ave.
Delta Hotel	409 W. 145th St.
Edgecombe Hotel	345 Edgecombe Ave.
Surprise Restaurant	2319 7th Ave.
Lulu Belle's Restaurant	317 W. 126th St.
Four Star Restaurant	2433 7th Ave.
Esquire Luncheonette	2201 7th Ave.
Brown's Restaurant	210 W. 135th Ave.
E & M Restaurant	2016 7th Ave.

41

MARYLAND

Hotels — Motels — Tourist Homes — Restaurants

Annapolis

Brown Hotel	50 Clay Street
Dixie Hotel	52 Washington Street
Alsop's Restaurant	Northwest & Calvert Sts.

Baltimore

York Hotel	1200 Madison Avenue
Smith's Hotel	Druid Hill Ave. & Paca Street
Majestic Hotel	1602 McCulloh Street
Y.W.C.A.	1916 Madison Avenue
Honor Reed Hotel	667 No. Franklin
Y.M.C.A.	1617 Druid Hill Avenue
Sphinx Restaurant	2107 Pennsylvania Avenue
Upton Restaurant	Cor. Monroe & Edmondson
Sess Restaurant	1639 Division Street
G & L Restaurant	Fayette & Gilmore Sts.
Spot Bar-B-Q Restaurant	1530 Penna. Avenue

Bowie

Stephen Bowie Hotel	Bowie-Laurel Road

Cumberland

Glenwood Manor Tourist Home	927 Glenwood Street

Glenburne

Brook's Drive Inn	113 Crainway N.E., Rt. 301

Frederick

Mrs. J. Makel Tourist Home	119 East 5th Street
Mrs. W. W. Roberts Tourist Home	316 W. South Street
Crescent Restaurant	16 W. All Saint Street
Harmon Hotel	226 N. Jonathan Street

Hagerstown

Harmon Tourist Homes	226 N. Jonathan Street
Ship Tea Room	329 N. Jonathan Street

Havre De Grace

Johnson's Hotel	415 So. Stokes Street

Princess Anne

Victory Restaurant	137 Broad Street

```
★ FRANKLIN HOTEL ★
PRIVATE BATH  —  100% AIR-CONDITIONED  —  COMPLETELY NEW
    N.H.A. MEMBER  —  WALL TO WALL CARPETING
   U. S. Route 50 — 6 Blocks West of U. S. Route 13
     Phone 9394            SALISBURY, MD.
            Melvin Hutt, Manager
```

Waldorf

Blue Jay Motel	U. S. 301

27

Above and opposite: Cover and pages
from *The Negro Travelers' Green Book:
Fall 1956: The Guide for Travel & Vacations*
(New York: Victor H. Green & Co.), 1956

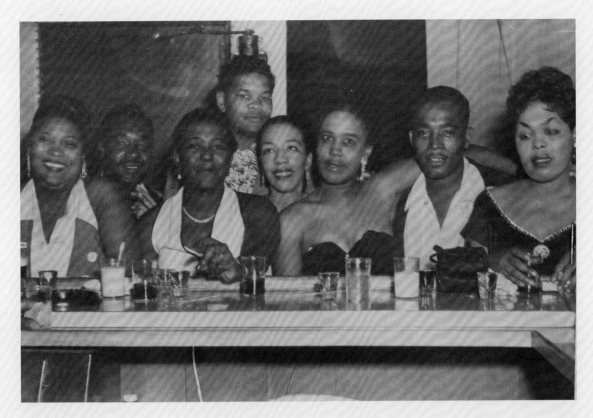

Patrons at The Blue Note,
Philadelphia, date and
photographer unknown

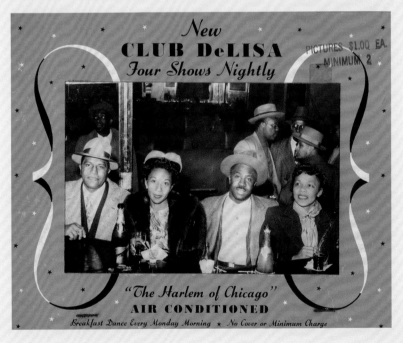

Advertisement for Club DeLisa, Chicago,
c. 1950

Opposite: The Apollo Theater, Harlem,
date and photographer unknown

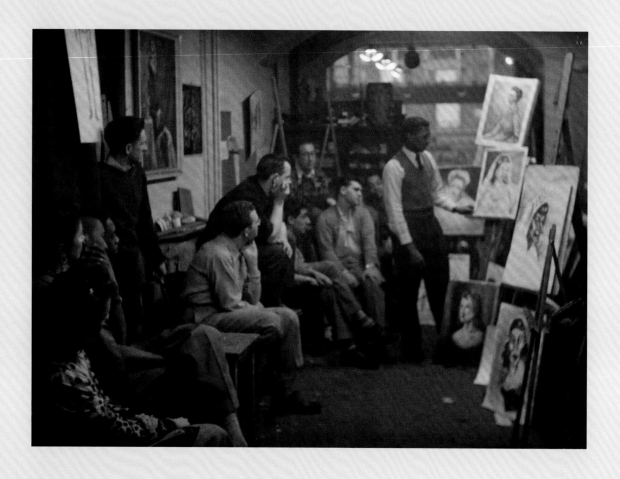

An arts salon, location unknown,
c. 1940–50. Photographer
unknown

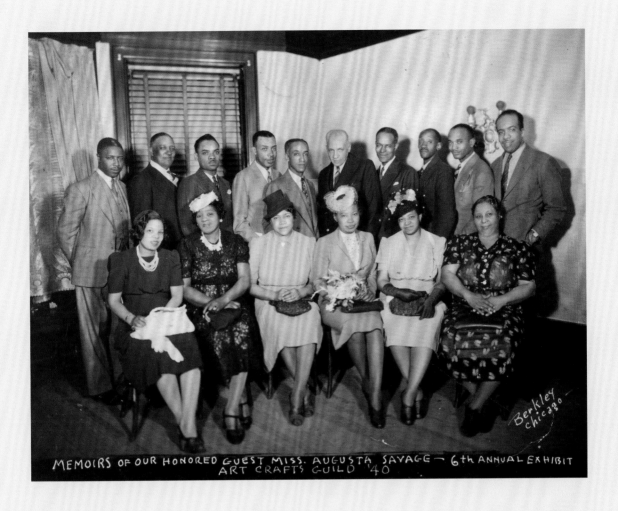

Augusta Savage with members of the Art Crafts Guild at their Sixth Annual Exhibit, Chicago, 1940. Photographer unknown

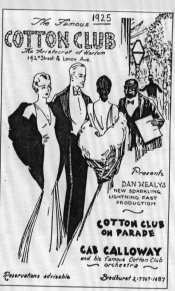

Advertising flyer for *The Cotton Club Presents: Cab Calloway*, 1925

Opposite: Small's Paradise, Harlem, 1955. Photograph by Austin Hansen

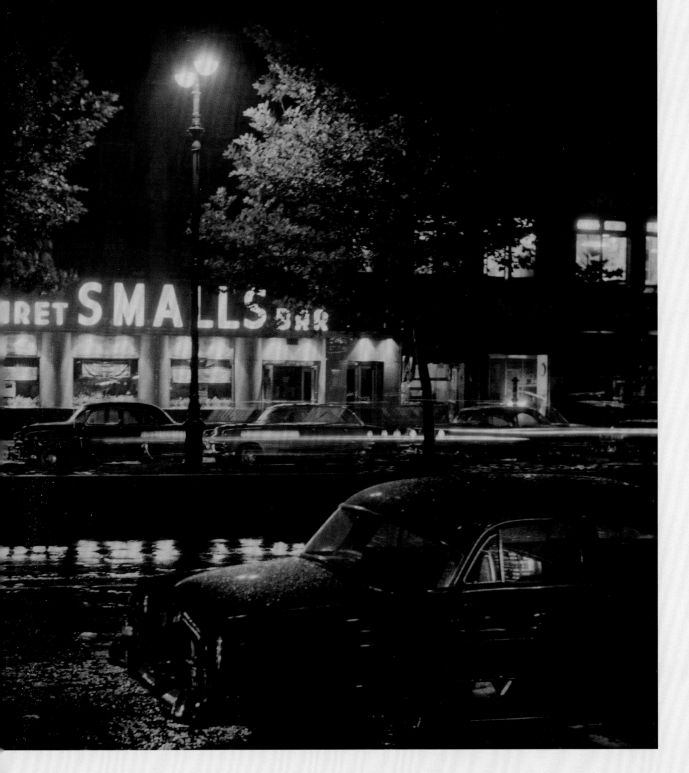

LAFAYETTE THEATRE

2225 SEVENTH AVENUE

Phone: TIllinghast 5-1424

New York City

FEDERAL THEATRE

THE PRESENTS

HALLIE FLANAGAN
Director

PHILIP W. BARBER
Director for N. Y. C.

"MACBETH"

BY
WILLIAM SHAKESPEARE

Arranged and Staged by ORSON WELLES - Costumes and Settings by NAT KARSON
Lighting by Feder

The Federal Theatre Project is part of the W.P.A. program. However, the viewpoint expressed in the play is not necessarily that of the W.P.A. or any other agency of the Government.

SYNOPSIS OF SCENES

ACT I.	ACT II.	ACT III.
Scene 1—The Jungle	Scene 1—The Palace	Scene 1—The Palace
Scene 2—The Palace	Scene 2—The Jungle	Scene 2—The Coast
INTERMISSION	INTERMISSION	Scene 3—The Jungle
(Ten Minutes)	(Eight Minutes)	Scene 4—The Palace

MUSIC

The Lafayette Theatre Orchestra under the direction of Joe Jordan

OVERTURE....................Yamekraw...................James P. Johnson
("YAMEKRAW" is a genuine Negro treatise on spiritual, syncopated, and blues melodies expressing the religious fervor and happy moods of the natives of Yamekraw, a Negro settlement situated on the outskirts of Savannah, Georgia. It is believed to be the first Negro rhapsody.)
INTERMEZZOAdagio Aframerique...................Porter Grainger
INTERMEZZO.......................River.............Arranged by Joe Jordan

STAFF OF THE LAFAYETTE THEATRE

Managing Producer ...John Houseman
Casting Director..Edward G. Perry
House Manager ..Paul Floyd
Stage Manager ...Leroy Willis
 Edward Dudley, Jr.
Assistant Stage Managers...Earl Shepherd
 Jack Murray
 Gordon Roberts

Master ElectricianByron Webb	Scenic ConstructionCharles White
Master CarpenterJames Kinard	Wardrobe DepartmentLena Tyers
Master of Properties...Fred H. Marshall	Anne Gray
Dept. of Information....701 Eighth Ave.	Display DepartmentTipp Beavers

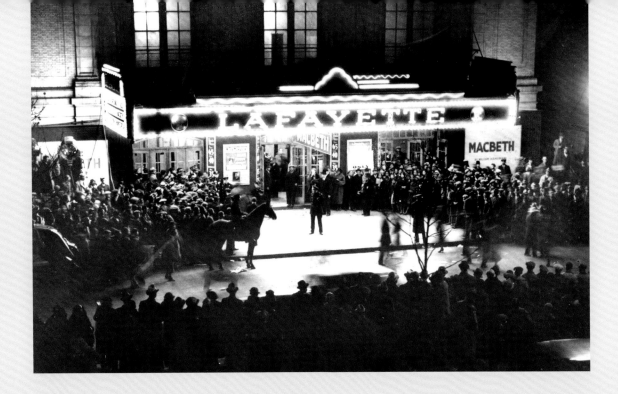

FEDERAL THEATRE

New Lafayette Theatre

Works Progress Administration

CAST OF CHARACTERS

Duncan	(The King)	Service Bell
Malcolm	(Son to the King)	Wardell Saunders
Macduff		Maurice Ellis
Banquo		Canada Lee
Macbeth	NOBLES	Jack Carter
Ross		Frank David
Lennox		Thomas Anderson
Siward		Archie Savage
First Murderer		George Nixon
Second Murderer		Kenneth Renwick
The Doctor		Lawrence Chenault
The Priest		Al Watts
First Messenger		Philandre Thomas
Second Messenger		J. B. Johnson
The Porter		J. Lewis Johnson
Seyton		Larrie Lauria
A Lord		Charles Collins
First Captain		Lisle Grenidge
Second Captain		Gabriel Brown
First Chamberlain		Halle Howard
Second Chamberlain		Benny Tattnall
First Court Attendant		Chauncey Worrell
Second Court Attendant		George Thomas
First Page Boy		Viola Dean
Second Page Boy		Hilda French
Lady Macduff		Marie Young
Lady Macbeth	NOBLE LADIES	Edna Thomas
The Duchess		Alma Dickson
The Nurse		Virginia Girvin
Young Macduff		Bertram Holmes
Daughter to Macduff		Wanda Macy
Fleance		Carl Crawford
Hecate		Eric Burroughs
First Witch		Wilhelmina Williams
Second Witch		Josephine Williams
Third Witch		Zola King
Witch Doctor		Abdul

COURT LADIES—Helen Carter, Carolyn Crosby, Evelyn Davis, Ethel Drayton, Helen Browne, Bruce Howard, Aurelia Lawson, Margaret Howard, Lulu King, Evelyn Skipworth.
COURT GENTLEMEN—Herbert Glynn, Jose Miralda, Jimmy Wright, Otis Morse, Merritt Smith, Walter Brogsdale, Harry George Grant.
SOLDIERS—Benny Tattnall, Herman Patton, Emanuel Middleton, Ivan Lewis, Thomas Dixon, George Spelvin, Albert Patrick, Chauncey Worrell, Albert McCoy, William Clayton Jr., Allen Williams, Halle Howard, William Cumberbatch, Henry J. Williams, Amos Laing, Louis Gilbert, Theodore Howard, Leonardo Barros, Ollie Simmons, Ernest Brown, Merritt Smith, Harry George Grant, Herbert Glynn, Jimmy Wright, George Thomas, Richard Ming, Clifford Davis.
WITCH WOMEN—Juanita Baker, Beryle Banfield, Mildred Taylor, Sybil Moore, Nancy Hunt, Jacqueline Ghant Martin, Fannie Suber, Hilda French, Ethel Millner, Dorothy Jones.
WITCH MEN—Archie Savage, Charles Hill, Leonardo Barros, Howard Taylor, Amos Laing, Allen Williams, Ollie Simmons, Theodore Howard.
CRIPPLES—Clyde Gooden, Clarence Potter, Milton Lacey, Hudson Prince, Cecil McNair.
VOODOO WOMEN—Lena Halsey, Jean Cutler, Effie McDowell, Irene Ellington, Marguerite Perry, Essie Frierson, Ella Emanuel, Ethel Drayton, Evelyn Davis.
VOODOO MEN—Ernest Brown, Howard Taylor, Henry J. Williams, Louis Gilbert, William Clayton Jr., Halle Howard, Albert McCoy, Merritt Smith, Richard Ming.
DRUMMERS—McLean Hughes, James Cabon, James Martha, Moses Myers, Jay Daniel.

CREDITS

Assistant Director Thomas Anderson
Musical Arrangements under the direction of Virgil Thomson.
Voodoo Chants and Dances under the direction of Asadata Dafora Horton.
Dances under the direction of Clarence Yates.
Chorus under the direction of Leonard de Paur.
Costumes, Painting and Properties executed by the Federal Theatre Workshop.
Building by the Construction Staff of The Lafayette Theatre.
Masks executed by James Cochran.

Opposite and above: Cover and pages from playbill for the WPA production of *Macbeth*, produced by Orson Welles, at the Harlem Lafayette Theatre, 1936

Top: Opening night of *Voodoo Macbeth*, produced by the Works Progress Administration Federal Theatre Project, Harlem Lafayette Theatre, 1936. Photographer unknown

EXCERPT

Challenge of the Modern: African-American Artists, 1925–1945

"Location, Space and Self-Image: 'Remapping' the Terrain of Black Creativity" by Lowery Stokes Sims

Part II, 41–45. New York: The Studio Museum in Harlem, 2003

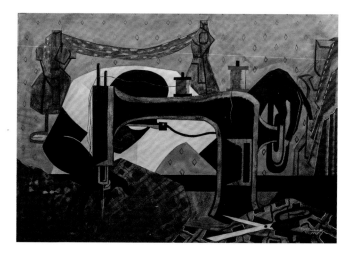

> *The 1920s was a transitional period in American history for African-Americans socially, economically and politically, one in which the locus of black presence is shifting northward and urbanward, thereby remapping the African-American landscape and the American perception of what blackness means in American culture.*[1]

The so-called Great Migration of African Americans from the South to the North between 1913 and 1946 may be considered the pivotal event in the history of African Americans in modernism. With that change of locale, not only were blacks able to a degree to ameliorate their economic, political and social condition, but also to create new lifestyles, from the clothes they wore to how they spoke to the spaces they created or adapted to live in to the way they worshiped. Although Jeffrey Stewart reminds us that "the South [remained] in the subconscious of the recent black migrant,"[2] Sharon Patton has noted that these changes in black life were accompanied by a "sense of optimism" that encouraged "a revolt against traditional values and an exploration of new ideals . . . "

> *The term "New Negro," used at the end of the nineteenth century to denote social and economic improvements since slavery, became attached between 1900 and the 1930s to a renewed racial pride, expressed in economic independence, cultural and political militancy.*[3]

While the literature of this period usually focuses on the activities and lifestyles of the elite and their preoccupations with class, color and connections, the African-American working class is also an important societal force and subject matter for its artists. Jacob Lawrence, who moved to Harlem in 1930 at the age of 13, retold the story of the Great Migration in his signature series completed in 1941, capturing not only the hopes and aspirations of the working class but also the tensions between newcomers and long-time residents in black urban areas. Lawrence would also document their aspirations towards literacy (as patrons of libraries); the

new employment opportunities available to them in his depictions of construction workers, skilled craftsmen, office workers and seamstresses in the 1940s; the working class fighting for its rights staging a rent strike (1942); and the appearance of a new technology that would transform American society after World War II—*Television* (1945).

With the onset of the Depression, the economic challenges faced by all Americans were intensified in the black community. In a composition created early in his career, Romare Bearden depicts musicians attempting to eke out a living on the streets using heroically simplified forms from Cubism to imbue them with a sense of presence comparable to Hayward Oubre's portrait of a *Stevedore*. Elizabeth Catlett uses her version of this modernist vocabulary in her *Red Cross Nurse*, typical of many African Americans who—along with white women—began the eventual transformation of the American workforce after the Second World War. Bringing her interest in African art to these depictions, she transcends issues of stereotyping and caricature and engages the characteristics of "tribal" art to achieve dignified, uncompromising portraits. Charles Sebree's presentation of a War Worker reveals a probable encounter with the French modernist artist Fernand Léger, who exiled himself in the United States during World War II.[4] The strong outlines, essentialized features and emphatic physique of this figure recall those that populated Léger's workers' paradises of the 1940s.

While the story of blacks in the military during the two world wars is beyond the scope of this project, Selma Burke's maquette for a *Monument to Airmen*, despite its florid "beaux arts" pretensions, underlines how black participation in the war inspired a body of new subject matter among African-American artists. Indeed, Malvin Gray Johnson's 1934 portrait of a World War I veteran, along with what seems to be a pendant portrait of a postal worker, encapsulates the struggles

Jacob Lawrence, *The Seamstress*, 1946. Gouache on paper, 21⅝ × 29⅞ in. (54.9 × 75.9 cm). University Museum, Southern Illinois University, Carbondale

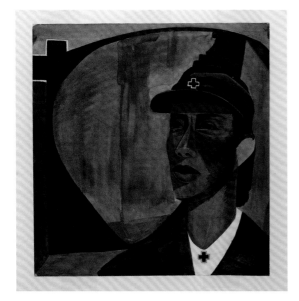

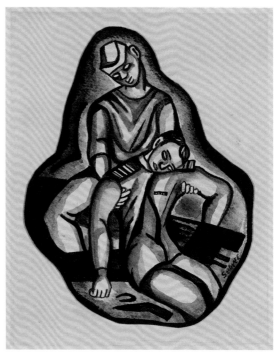

and triumphs of African Americans. Their direct gazes and self-conscious presentation in full uniform speak volumes about the aspirations of African Americans toward full citizenship in American society. Black army life was also a source of inspiration to both William Johnson and Palmer Hayden, the latter drawing on his own experiences as a cavalryman in the Philippines during World War I.

Among the visual arts, photography—which Robin D. G. Kelley describes as a "mighty weapon" against the "deliberate distortion of black images in popular cultures"[5]—in particular, allowed African Americans to define and depict themselves regardless of artistic style or figural convention. Deborah Willis has highlighted the role of photography as a means by which individuals could announce their newfound prosperity but also visualize their success at their chosen professions.[6] Photography, writes Willis, "played a crucial role in examining and re-examining the dreams and ideals of the black working classes by making socially and class-conscious images of the African-American community."[7] These images included VanDerZee photographs of the UNIA parades (Marcus Garvey's Universal Negro Improvement Association), which impressed the young Jacob Lawrence who noted the visual impression made on him by the weekend and holiday parades in Harlem of members of "all sorts of religious and fraternal organizations . . . wearing resplendent uniforms of all colors and lavishly trimmed with gold."[8] Meanwhile, the working class found economic advancement in the "trickle-down" entrepreneurship of Madame C. J. Walker, whose corps of sales personnel VanDerZee captured in her tea salons where they gathered for periodic proselytizing. In another photograph, a young woman, seated at a desk, looks up from her book to gaze out the window—her

seriousness of purpose only underlined by her glasses and sensible oxford shoes.

African Americans also began to confront the spaces in which they lived and how they lived in them. Jacob Lawrence remarked on the visual impact of the Harlem environment: the "endlessly fascinating patterns" of "cast-iron fire escapes and their shadows created across the brick walls." He noted the "variegated colors and shapes of pieces of laundry on lines stretched across the backyards . . . the patterns of letters on the huge bill boards and the electric signs."[9] He would reminisce to Paul Karlstrom that, "Even in my mother's home, people of my mother's generation would decorate their homes in all sorts of color . . . so you'd think in terms of Matisse"[10] . . . in the . . . brightly colored 'Oriental' rugs covering the floors at home . . . their configurations and their repetitions, in their geometry, and the diversity of their colors."[11] It is interesting to see interior spaces captured by Lawrence and Horace Pippin, respectively, in 1937 and 1943. Both show a comparable appointment of quilts and objects that define the familial home, however humble, one in the city the other in rural Pennsylvania. This interest in textiles and textures is not incidental. Leslie King-Hammond reminds us that Lawrence also learned block printing on fabric from Sarah West at the Workshop.[12] All of

Above left: Elizabeth Catlett, *Red Cross Woman (Nurse)*, c. 1944. Tempera on paper, 20½ × 20 in. (52.1 × 50.8 cm). Hampton University Museum, Hampton, VA

Above right: Charles Sebree, *The Rescue of Dorrie Miller*, 1942. Gouache with brush and black ink on wove paper, sheet (irregular): 6⅝ × 5¼ in. (16.83 × 13.34 cm). National Gallery of Art, Washington, DC, Corcoran Collection (The Evans-Tibbs Collection, Gift of Thurlow Evans Tibbs, Jr.)

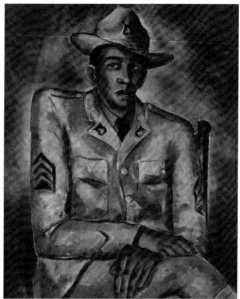

as a "change agent and catalytic instrument of black community economic development on a land base."[17]

The faculty at Tuskegee not only included graduates of their program but also individuals such as Robert Taylor, the first African American to graduate from the architecture school at MIT (and as valedictorian) in the 1890s. Melvin Mitchell writes that during Taylor's tenure at Tuskegee (1891–1915) there was a "vital connection . . . between black culture and architecture" and the lifestyles projected in their designs were seen as a means to transform African Americans into a *modern* people' [emphasis this writer's].[18] The Tuskegee architecture legacy was disseminated to Howard University in Washington, D.C., in the early 1900s by John Lankford and William Sidney Pittman—both students of Taylor.[19] By 1919, according to Mitchell, the architectural program at Howard University had not only superceded that of Tuskegee but also framed a new view of an architectural career for African Americans: the architect/builder of the late nineteenth century was gradually replaced by gentleman architect.

As it had in Tuskegee, the architecture department at Howard University dominated the on-campus building program particularly with the arrival at Howard in 1924 of Albert Cassell, a Cornell-trained architect. Given there was scant patronage among African Americans for a culturally specific architectural idiom or at least a modernist one, this situation provided an important

these experiences would have instructed Lawrence in the method of simplifying form and becoming conscious of the visual potential for rhythmic repetition, and he would gradually become "aware of similar patterns in the cityscape around him."[13] He would even ascribe his use of gouache to his environment, noting that its physical qualities complement the "hard, bright, brittle" aspects of Harlem during the Depression.[14]

One of the glaring omissions in most surveys of black creativity during the Harlem Renaissance, the WPA era or the early 1940s, is the practice of architecture. There are instances of artists who record the city—in this exhibition we've included Palmer Hayden's view of Wall Street and Alston's abstract painting from the late 1940s that captures the essence of the New York skyline at night. However, the key role that African Americans played in literally building for this country during slavery did not easily translate into their being accepted as architects. While Benjamin Banniker is credited with participating in preparing the design of Washington, D.C., in the late eighteenth century, and Louis Metoyer studied architecture in Paris in the 1870s,[15] training for black architects in this country was first carried out at Tuskegee Institute where it was part of Booker T. Washington's program to provide skill sets for newly freed slaves.[16] The black architect was therefore viewed

Above left: Selma Burke, *Untitled (Monument to Tuskegee Airmen)*, 1942. Painted plaster, 9½ × 6 × 6 in. (24.1 × 15.2 × 15.2 cm). Courtesy of Michael Rosenfeld Gallery LLC, New York

Above right: Malvin Gray Johnson, *Negro Soldier*, 1900–1934. Oil on board, 38 × 30 in. (96.5 × 76.2 cm). Schomburg Center for Research in Black Culture, Art and Artifacts Division

Right: James VanDerZee, *The Black Cross Nurses of the Universal Negro Improvement Association*, 1924. Modern silver print, 10 × 13 in. (25.4 × 33 cm). James Van Der Zee photographs, David M. Rubenstein Rare Book & Manuscript Library, Duke University

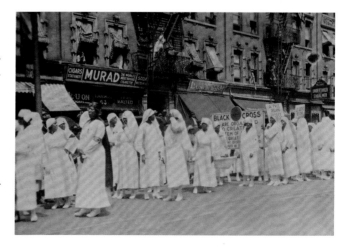

laboratory for students to explore and experience ideas and concepts that lay outside the more conservative preferences of their probable client base. As Mitchell notes, for the most part architects—even individuals such as John Louis Wilson and Vertner Tandy, who were close to Harlem Renaissance circles in New York—had been "socialized to see architecture only in White Anglo-Saxon Protestant cultural terms."[20]

As in the visual arts, the exposure to European and Euro-American modernism provided a more round-about way for African Americans to connect with their African heritage. When Hilyard Robinson assumed the chairmanship of the architecture department at Howard in 1938, students were exposed to modernist sensibilities in the field.[21] Along with Paul Williams, who practiced in Los Angeles, Robinson forthrightly engaged the notion of modernism in architecture. As Melvin Mitchell notes:

> Williams did some of his best design work in the new modernist idiom . . . [but] . . . it was Robinson who made an exclusive commitment to avant-garde International style modernism. While Williams was devoted to the idea of the modern house (he published a book on the subject), Robinson was devoted to the idea of "modern housing as social reform." He patterned himself after the Congress Internationale Architects Moderne . . . [and] . . . through his European travels in the 1930s actually spent time personally touring the modernist [Walter] Gropius-Mies [van der Rohe] organized housing exhibitions in Germany. Robinson also toured modernist social projects in Amsterdam and Rotterdam.[22]

Robinson presumably was able to put some of these progressive ideas about housing as "social reform" in his design for the Langston Terrace public housing project in 1934–75.[23] The next generation of architects at Howard was trained under individuals such as Louis Fry, who was the first black graduate from the architecture program directed by Walter Gropius at Harvard. Fry returned to Howard 1947 "to help prepare the first crop of second generation Washington, D.C. architects who were returning from World War II."[24] These included John Jacob Sims, who has left several student drawings that show a distinct primitivizing tendency with its adaptation of Aztec design in an entrance to a museum, and Wrightian ethos in designs for a mountain chapel and ranch house. Sims's museum entrance project is noteworthy given Melvin Mitchell's observation that no "cultural point of view" could be found in the work of black architects during this period despite the influential presence of Alain Locke, who, as we have seen, promoted the exploration of connections between African Americans and African art.[25]

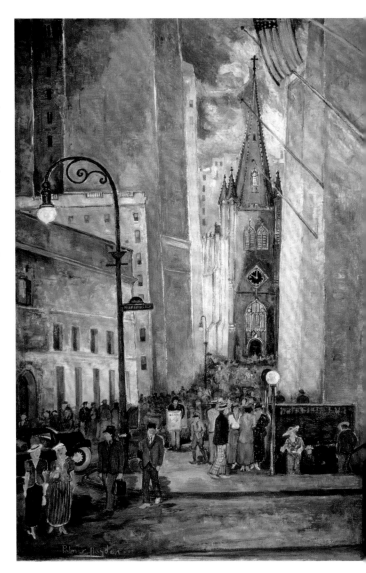

Palmer Hayden, *Wall Street*, 1936. Oil on canvas, 34 × 25½ in. (86.4 × 64.8 cm). Collection of the Harmon and Harriet Kelley Foundation for the Arts, San Antonio

A vital connection between generations of architects at Howard University was the course in watercolor rendering that Lois Mailou Jones had taught for the architecture department, thus providing an important bridge between the fine arts and architecture departments. In the context of this current discussion it is noteworthy that although she is known primarily as a painter, Jones had early on pursued a career as a designer. In the late 1920s she did freelance textile and fabric designs for department store and textile manufacturers such as the F.A. Foster Company in Boston and the Schumacher Company in New York.[26] Designs included in this exhibition from the 1930s show a variety of abstract designs and Decoesque motifs that seem more advanced in feeling than her painting at the time. She joined a number of American artists, notably Stuart Davis, whose design work was not only a way to supplement their income at

a time when the art market was not as well developed, but also a way to demonstrate how "modern art could be applied to commercial design."[27] Likewise, Anna Russell Jones in Philadelphia studied textile design at the Philadelphia School of Design for Women and worked at the James G. Speck Studio before establishing her own studio in 1928 from which she sold designs for carpets and wallpapers. During World War II she worked as a graphic designer as a member of the Women's Army Auxiliary Corps creating maps, plans and propagandistic posters.

For the most part, however, any African American who may have had an opportunity to work in design did so as anonymous workers for hire in large firms—as did many white designers and artists—receiving no credit for their creative concepts. Nonetheless, the notion of an artist's life, outside the strictures and expectations of middle-class life, allowed artists to depict that life. Hale Woodruff's *San Miguel Allende* speaks to the opportunities for black artists to travel abroad, as his *Studio Interior* captures the essence of artistic life.

Notes

1. Jeffrey C. Stewart, "Paul Robeson and the Problem of Modernism," in *Rhapsodies in Black: Art of the Harlem Renaissance,* ed. Richard Powell and David Bailey (London: Hayward Gallery, 1997), 95.

2. Ibid.

3. Sharon F. Patton, *African American Art* (Oxford and New York: Oxford University Press, 1998), 110.

4. See Melvin Marshall and Black Kimbrough, "Above and Beyond Category: The Life and Art of Charles Sebree," *The International Review of African American Art* 18, no. 3 (1985): 3–17.

5. Robin D. G. Kelley, "Foreword," in Deborah Willis, *Reflections in Black: A History of Black Photographers 1840 to the Present* (New York and London: W. W. Norton & Company, 2000), ix.

6. Deborah Willis and Carla Williams, *The Black Female Body: A Photographic History* (Philadelphia: Temple University Press, 2002), 153.

7. Ibid., 144.

8. Charles Alan, unpublished manuscript on Jacob Lawrence, ca. 1973, 12.

9. Ibid.

10. Paul J. Karlstrom, "Oral history interview with Jacob Lawrence and Gwendolyn Knight," 1998 November 18. Archives of American Art, Smithsonian Institution, Washington, D.C., 77.

11. Alan, 13.

12. Leslie King-Hammond, "Inside-Outside, Uptown-Downtown: Jacob Lawrence and the Aesthetic Ethos of the Harlem Working Class Community," in *Over the Line: The Art and Life of Jacob Lawrence,* ed. Peter T. Nesbett and Michelle DuBois (Seattle: University of Washington Press, 2001), 67–85.

13. Alan, 13.

14. A. Jacobowitz, interview with Jacob Lawrence, March 21, 1968. Archives of American Art, Smithsonian Institution, Washington, D.C., Part I: 11.

15. Patton, *African American Art,* 34. This is also noted in Melvin L. Mitchell, *The Crisis of the African-American Architect: Conflicting Cultures of Architecture and (Black) Power* (San Jose, New York, Lincoln, Shanghai: Writers Club Press, 2001), 24.

16. Mitchell, *The Crisis of the African-American Architect,* 25–26.

17. Ibid., 26–27. Mitchell also postulates that this placed the new black architects in the middle of the Washington–Du Bois debates on whether job skills and land or the vote, civil rights and social equality were the key to black emancipation.

18. Ibid., 28.

19. Ibid., 35–38.

20. Ibid., 56.

21. Ibid., 41.

22. Ibid., 44.

23. As a result of this commission he became the foremost black design authority on modernist public housing. He would later collaborate with the McKissack family firm of Nashville, Tennessee, to design an air base at Tuskegee to train the nation's first black combat pilots—the famous Tuskegee airmen. Ibid.

24. Mitchell, *The Crisis of the African-American Architect,* 46.

25. Ibid., 54.

26. Tritobia Hayes Benjamin, *The Life and Art of Lois Mailou Jones* (San Francisco: Pomegrante Artbooks, 1994), 6–7.

27. See Lowery Stokes Sims, "Stuart Davis in the 1930s: A Search for Social Relevance in Abstract Art," in Sims, *Stuart Davis: American Painter* (New York: The Metropolitan Museum of Art, 1991), 67. Davis's dealer, Edith Halpert (who also handled the work of Jacob Lawrence), organized an exhibition on this subject in 1934 entitled *Practical Manifestations in American Art.* Along the same lines the following year the exhibition *Modern American Art in Modern Room Settings* was organized at the Modernage Furniture Company in New York.

EXCERPT

"Who Set You Flowin'?": The Great Migration Narrative

Farah Jasmine Griffin
Chapter 5: "New Directions for the Migration Narrative: Thoughts on *Jazz*," 184–97. New York: Oxford University Press, 1996

Instead of pretending to sum up everything in a neat and tidy manner, I want to initiate a more sustained reading of one migration narrative—Toni Morrison's *Jazz.* Because Morrison's novel challenges the framework presented within these pages, it serves to open rather than close any further discussion of the migration narrative.

Toni Morrison's oeuvre attests to the dispossession, displacement, and mobility that characterize black life in the Americas. *The Bluest Eye* (1970) and *Sula* (1974)

are both situated around the migration of significant characters. *Tar Baby* (1981) explores the lives of "cultural exiles"[1] who live on a Caribbean island. *Beloved* (1987) documents the life of a runaway slave, Sethe, as well as the forced and volunteer wanderings of African-Americans following the Civil War and during the Nadir. As I have demonstrated, *Song of Solomon* (1977) is an especially important migration narrative, but *Jazz* (1992) is Morrison's most explicit migration narrative to date. It revisits the theme of black mobility and modernity. In so doing, it explicitly revises some of the most important tropes of the migration narrative—tropes that Morrison helped to define through her creative and critical writings.

In *Jazz*, Morrison still considers the major moments of the migration narrative: the catalyst to migration, the initial confrontation with the urban landscape, the navigation of that landscape, and the construction of the urban subject. Nevertheless, she challenges her own notions of the possibility of the city for the migrant and she introduces a new notion of the ancestor.

Jazz was published in 1992. It spent eleven weeks on the *New York Times* bestsellers list and even longer on the Blackboard African-American bestsellers list.

Jazz is the story of Joe and Violet Trace and Joe's dead teenage lover, Dorcas. All three are migrants to the city. At the novel's opening, Joe has murdered Dorcas and Violet attends Dorcas's funeral in order to stab the corpse. The novel's primary narrator is a quirky, often unreliable, omniscient presence. As with a jazz performance, the characters are given their solos, moments to flourish—but they always return to the arrangement of the omniscient narrator. She tries to control the tale, but sometimes individual soloists break free of the arrangement that she tries to impose on them. Dorcas, the murdered black woman, is given but one solo at the end of the novel. Throughout the text the dead teenager is a presence (but not a ghost) who helps the other characters come to terms with themselves.

Joe and Violet Trace, the central migrants of the text, migrate from Virginia to New York in 1906. Their Virginia is a place of towns with Old Testament names,[2] dispossession, violence, and orphaned children. After arriving in the North, their experiences in the South still shape their decisions. For instance, because both Violet and Joe were abandoned by their mothers, they associate freedom with a childless urban life.

Whereas in the earlier migration narratives the South is often the site of family, here it is filled with motherless children. Violet describes the events that directly precede the suicide of her own mother, Rose:

[White men] came, talking low as though nobody was there but themselves, and picked around in our things, lifting out what they wanted—what was theirs, they said, although we cooked in it, washed sheets in it, sat on it, ate off of it. That was after they had hauled away the plow, the scythe, the mule, the sow, the churn and the butter press. Then they came inside the house. . . . When they got to the chair where our mother sat nursing an empty cup, they took the table out from under her and then while she sat there alone, and all by herself like, cup in hand, they came back and tipped the chair she sat in. She didn't jump up right away, so they shook it a bit and since she still stayed seated—looking ahead at nobody—they just tipped her out of it like the way you get the cat off the seat if you don't want to touch it or pick it up in your arms. You tip it forward and it lands on the floor. No harm done if it's a cat because it has four legs. But a person, a woman, might fall forward and just stay there a minute looking at the cup, stronger than she is, unbroken at least and lying a bit beyond her hand. Just out of reach.[3]

Instead of nursing her children, Violet's mother nurses an empty cup, a cup that is stronger than she. Rose's descent into madness begins even before this final act of dispossession. In fact, she has endured so much, her daughter wonders:

What was the thing, I wonder, the one and final thing she had not been able to endure or repeat? Had the last washing split the shirtwaist so bad it could not take another mend and changed its name to rag? Perhaps word had reached her about the four-day hangings in Rocky Mount: the men on Tuesday, the women two days later. Or had it been the news of the young tenor in the choir mutilated and tied to a log, his grandmother refusing to give up his waste-filled trousers, washing them over and over although the stain had disappeared at the third rinse. They buried him in his brother's pants and the old woman pumped another bucket of clear water. Might it have been the morning after the night when craving (which used to be hope) got out of hand? When longing squeezed, then tossed her before running off promising to return and bounce her again like an India-rubber ball? Or was it that chair they tipped her out of? Did she fall on the floor and lie there deciding right then that she would do it. Someday. . . . What could it have been, I wonder? [p. 101]

The litany of reasons that may have led to her suicide seems endless. They range from the small domestic tearing of an old dress, one she mends and irons for lack of a new one, to the large political terrorization of black people (the lynchings here are similar to the one described by Baldwin in *Go Tell It on the Mountain*); from her longing for a husband forced to leave because of his political activity, to her own dispossession as a

result of these activities. Morrison outlines both the political and interior pains of being a black woman during the Nadir of black history.

Rose appears to suffer from depression. Her depression is a long time coming. It is a madness not brought on by her genetic makeup but created by her social circumstances. She is the rounded mourning figure of Jacob Lawrence's panel 15. Black women experience white terror as victims of violence and as mothers and wives. The consequences of their torture lead to motherless children—in this case, Violet and her four siblings.

Joe is also a motherless child: He is abandoned by a mother who appears mad. Rose's madness is quiet and unobtrusive, brought on by years of racial oppression. We never know if Joe's mother is really insane or simply "Wild." We never know the cause of her insanity. If Rose is the mourning figure of Lawrence's painting, then Wild is one of Toomer's Southern women taken to the extreme. She is a madwoman who lives in the cane field, the one who has become an indelible part of the Virginia landscape. As with the reapers of Toomer's *Cane*,[4] here, the men who cut the cane fear cutting her: "Cutting cane could get frenzied sometimes when young men got the feeling she was just yonder, hiding, and probably looking at them. One swing of the cutting blade could lop off her head" (p. 166). Though she gives birth to Joe, Wild is incapable of mothering him.[5] As was the case with Rose, who nursed the teacup instead of her children, Wild refuses to nurse Joe when he is born.

Joe and Violet, two motherless children, find each other under a tree in Virginia. Together, they decide to leave the South and to migrate to the city. Like the "motherless child" of the African-American spiritual, they, too, "spread their wings and fly." The South they leave behind is one where the possible ancestors are driven mad. The only source of ancestral wisdom comes from an elder who mentors Joe, the Hunter's Hunter—Henry Lestory. The wisdom he shares with Joe would help him to navigate the urban landscape, but Joe forgets the advice given to him: "Never kill the tender and nothing female if you can help it." Joe notes that Lestory "taught me two lessons I lived by all my life. One was the secret kindness of white people—they had to pity a thing before they could like it. The other—well I forgot it" (p. 125).

In general, the South that Joe and Violet leave is a place characterized by what Morrison names the Dispossession:

One week of rumors, two days of packing, and nine hundred Negroes, encouraged by guns and hemp, left Vienna, rode out of town on wagons or walked on their feet to who knew (or cared) where. With two days' notice? How can you plan where to go, and if you do know of a place you think

will welcome you, where is the money to arrive? [pp. 173–74]

The movement of this paragraph is filled with an overwhelming sense of uncertainty and absurdity. In naming it "The Dispossession," Morrison gives it grand historical proportions; it becomes an era, a signpost of the black experience like the Middle Passage, Slavery, the Civil War, Reconstruction, the Nadir, *the Dispossession*, the Great Migration.

Joe and Violet's migration to the city is situated in the context of this grand historical narrative. First the author gives us the historical and then, within the context of the historical, she situates the individual. Joe and Violet are two individuals in the thousands contained in the word "They":

They came on a whim because there it was and why not? They came after much planning, many letters written to and from, to make sure and know how much and where. . . .

However they came, when or why, the minute the leather of their soles hit the pavement—there was no turning around. Even if the room they rented was smaller than the heifer's stall and darker than a morning privy, they stayed to look at their number. . . . Part of why they loved it was the specter they left behind. The slumped spines of the veterans of the 27th Battalion betrayed by the commander for whom they had fought like lunatics. The eyes of thousands, stupefied with disgust at having been imported by Mr. Armour, Mr. Swift, Mr. Montgomery Ward to break strikes then dismissed for having done so. The broken shoes of two thousand Galveston longshoremen that Mr. Mallory would never pay fifty cents an hour like the white ones. The praying palms, the raspy breathing, the quiet children of the ones who had escaped from Springfield Ohio, Springfield Indiana, Greensburg Indiana, Wilmington Delaware, New Orleans Louisiana, after raving whites had foamed all over the lanes and yards of home.

The wave of black people running from want and violence crested in the 1870s; the 80s; and the '90s but was a steady stream in 1906 when Joe and Violet joined it. [pp. 32–33]

Note the sites of persecution are not strictly Southern. "Southern" is a metaphor for all sites where black people are dispossessed, disenfranchised, and brutalized. This includes Midwestern and Northern cities like East St. Louis. The race riots of East St. Louis are the catalyst of the migration of the text's third significant migrant, Joe's teenage lover, Dorcas. Dorcas is yet another orphan, having lost both her parents to the racial violence of those riots. She loses her life, however, to the jealous rage of her lover.

Without familial ties, Joe, Violet, and Dorcas are migrants who seek to create themselves anew in the city. Without the maps provided by Southern ancestors, they are ill-equipped to navigate the urban landscape. They, along with all the migrants of *Jazz*, are like the music for which the book is named. These migrants explode onto the cityscape, capturing its character, its rhythm, forever changing it, and it forever changing them. They go to Harlem in search of safe space only to find that the safety of that space is very tenuous.

At first glance, Morrison's descriptions of the migrant's initial confrontation with the urban landscape seem optimistic, filled with vibrancy and color, not unlike Toomer's "Seventh Street." Joe and Violet enter "the lip of the City dancing all the way." Like millions of others they enjoyed "look[ing] at their number, hear[ing] themselves in an audience, feel[ing] themselves moving down the street among hundreds of others who moved the way they did, and who when they spoke, regardless of the accent, treated language like the same intricate, malleable toy designed for their own play." They are part of a thriving, throbbing black crowd. In the city, there are no lone black figures—there is a black throng, who, unlike Wright's migrants, possess and reshape language. Although there is racial violence in the city, "up here if you bust out a hundred'll bust right along with you" (p. 128).

For Violet and Joe, and even for Alice Manfred, aunt of Dorcas and resident prude, Harlem appears to be a "safe space." Alice Manfred notes "she had begun to feel safe nowhere south of 110th Street" (p. 54). White New Yorkers may greet migrants with violence, but Harlem seemed to offer them a safe homespace. Nevertheless, very early in the text, even before the story unfolds, the narrator begins to undercut the sense of Harlem as a free and safe space:

> Breathing hurts in weather that cold, but whatever
> the problems of being winterbound in the City they
> put up with them because it is worth anything to
> be on Lenox Avenue safe from fays and the things
> they think up; where the sidewalks, snow-covered
> or not, are wider than the main roads of the towns
> where they are born and perfectly ordinary people
> can stand at the stop, get on the streetcar, give the
> man the nickel, and ride anywhere you please,
> although you don't please to go many places because
> everything you want is right where you are: the
> church, the store, the party, the women, the men,
> the postbox (but no high schools), the furniture
> store, street newspaper vendors, the bootleg houses
> (but no banks), the beauty parlors, the barbershops,
> the juke joints, the ice wagons, the rag collectors,
> the pool halls, the open food markets, the number
> runner, and every club, organization, group, order,
> union, society, brotherhood, sisterhood or associa-

> tion imaginable. The service trails, of course, are
> worn, and there are paths slick from the forays
> of members of one group into the territory of
> another where it is believed something curious or
> thrilling lies. Some gleaming, cracking, scary stuff.
> [pp. 10–11]

The cityscape painted by this paragraph portrays a place of seemingly endless possibility. It is a place that appears to be free of white people, yet they are that nameless presence, those "members of one group" who "foray" into Harlem, in search of the "curious or thrilling." Even when not visible, a white presence controls and restrains the possibility of Harlem. The limitations are parenthetical, contained by parenthesis much in the way that they contain the aspirations of black Harlemites. At first, whites control black people without violence. They place limits on education and true economic opportunity. This "free, safe" space is neither free nor safe. The white presence will come in search of entertainment and it will also come wielding pipes like the one "those whitemen" took to Joe's head in the summer of 1917.

Harlem is not as safe a space as the migrants anticipated. Even those spaces considered most safe, those sites of the "South in the city," are possible sites of victimization. This is especially true for women. Like Lacy's tenement, Brooks's kitchenette, and Naylor's neighborhood, the apartment buildings of *Jazz* seem to constitute community, hospitality, and home:

> Up those five story apartment buildings and the
> narrow wooden houses in between people knock on
> each others doors to see if anything is needed or can
> be had. A piece of soap? A little kerosene? Some fat,
> chicken or pork, to brace the soup one more time?
> Whose husband is getting ready to see if he can find
> a shop open? Is there time to add turpentine to the
> list drawn up and handed to him by the wives?
> [p. 10]

However, for a writer who has stressed the significance of neighborhood and community, it is significant that this attempt to describe community lacks the specificity of a name. Neither the neighborhood nor the city is named, and those five-story apartment buildings do not even have an address.[6] This is our first clue that the building does not really constitute community. Joe Trace is one of those neighborly husbands who help to make the building a community. He is the man the women welcome in their midst, the one with whom they feel safe. His very voice is a site of the "South in the city":

> Besides, [the women] liked his voice. It had a pitch,
> a note they heard only when they visited stubborn
> old folks who would not budge from their front

yards and overworked fields to come to the city. It
reminded them of men who wore hats to plow and
to eat supper in; who blew into saucers of coffee,
and held knives in their fists when they ate. [p. 71]

His voice is "home." In light of this, it would appear that
his voice is the repository of the ancestor. However, it
might sound like the ancestor but not embody the sub-
stance of the ancestor. After all, Joe Trace has forgotten
the most significant advice given to him by a Southern
elder. In "City Limits, Village Values: Concepts of the
Neighborhood in Black Fiction," Morrison notes that
it is the presence of the ancestor in the city that consti-
tutes the neighborhood, or home. In the city, the ances-
tor as we have come to know her is absent.

Joe Trace's voice may remind the black women of
"home," yet he proves to be fatal to at least one black
woman. Alice Manfred thinks,

The brutalizing men and their women were not just
out there, they were in her block, her house.
A man had come in her living room and destroyed
her niece. His wife had come right in the funeral
to nasty and dishonor her. She would have called
the police after both of them if everything she knew
about Negro life had made it possible to consider.
[p. 74]

Neither the church nor the home is a safe space, espe-
cially for black women. Morrison challenges the notion
that any of the preceding spaces are safe. Sites like the
home, the house party, the church, sites where there
is no white intrusion, do not constitute safe space. In
Harlem, "citylife is streetlife" (p. 119). The street comes
into the church and the home. What is worse is that
these spaces are violent spaces, not only because of the
intrusion of whites, but also because of the violence
of other blacks. Dorcas is murdered in an apartment
at a house party. In other migration narratives, house
parties and rent parties were safe spaces for migrants.
Worse still is the lack of anger, indignation, and horror
following her murder. Her aunt doesn't call the police
because she knows they do not value black lives. Her
best friend is angry at her for leaving. Her lover is never
punished; he simply wallows in self-pity. And his crazy
wife tries to deface her corpse.

The lack of public outcry following Dorcas's death is
evidence the lack of value placed on black people. The
urban blacks of *Jazz* love desire but not other human
beings. The city makes them this way. All of the efforts
to combat the dehumanizing effects of the city appear
inappropriate.

Alice Manfred tries to contain Dorcas in juvenile
clothing, thick hose, and restrained hair. "However tight
and tucked in her braids, however clunky her high-
topped shoes that covered ankles . . . however black and
thick her stockings, nothing hid the boldness swaying

under her cast iron skirt." Encouraged by the music
that embodies her migrant energy, sensuality, and anger,
Dorcas resists her aunt's attempts to contain her. Alice's
map for navigating the urban landscape, a map that calls
for "deafness and blindness" and restraint, is useless.

Alice Manfred's map calls for deafness and blind-
ness; Violet Trace's attempts to navigate that landscape
result in her bouts with insanity. As with her mother,
Violet also appears to suffer from mental illness. How-
ever, her illness is not depression, but split personality.
Depression has depth and substance. It has its own
narrative. Violet's split personality is a fragmented self,
an especially fitting disorder for the city. The narrator
describes Violet's bouts with insanity as cracks. "I call
them cracks because that's what they are. Not openings
or breaks, but dark fissures in the globe light of the day."
These dark fissures make the narrative of her days less
coherent. Violet describes her illness in terms of "that
other Violet," who "walked about the City in her skin;
peeped through her eyes and saw things" (p. 89). That
other Violet is Violent:

Where [Violet] saw a lonesome chair left like an
orphan in a park strip facing the river, that other
Violet saw how the ice skim gave the railing's black
poles a weapony glint. Where she, last in line at
the car stop, noticed a child's cold wrist jutting
out of a too-short, hand-me-down coat, that Violet
slammed past a white woman into the seat of a
trolley four minutes late. [p. 90]

Although Violet's musings about "that other Violet"
seem to confirm her insanity, it soon becomes appar-
ent that the development of "that other Violet" helps
Violet to navigate the city. Where Violet sees images of
passive victims, lone orphans, or children who have not
been cared for, "that other Violet" seizes the opportu-
nity for action, for self-defense. Perhaps Violet's illness
is a mechanism that sustains her. She realizes that what
appears to be a literal fragmentation of her psyche is
in fact a means of survival. "That Violet" is the deci-
sive, tough, strong Violet who used to live in the South:
"*That* Violet is not somebody walking around town, up
and down the streets wearing my skin and using my
eyes shit no *that* Violet is me! The me that hauled hay
in Virginia and handled a four-mule team in the brace"
(pp. 95–96).[7]

Violet navigates the city by splitting her personality;
Alice Manfred tries to navigate it by becoming deaf and
blind to it. Joe Trace tries to buy "safe space" by buying
Dorcas's affections and renting a neighbor's apartment
for their weekly trysts. In bed, he and Dorcas share the
emptiness they feel over the loss of their mothers. He
tells her about the South. This rented bed becomes the
site of illicit sex, a site of "safe time" and intimacy. It is
a tentative safety, though, dependent not on love but on
desire, which is fleeting.

In *Jazz*, migrants fall in love with the city and not with each other. They desire the image of themselves against its skyline:

> *[They] forget what loving other people was like— if they ever knew, that is. I don't mean they hate them, no, it's just that what they start to love is the way a person is in the City; the way a schoolgirl never pauses at a stoplight but looks up and down the street before stepping off the curb; how men accommodate themselves to tall buildings and wee porches, what a woman looks like moving in a crowd, or how shocking her profile against the backdrop of the East River. [p. 34]*

They love an image, a painting, a photograph—where individuals are but backdrops or adornment to the true object of their affection—the city and how it makes them feel: "Their stronger, riskier selves."

The music of the city, the black jazz that comes to define the city and the era, serves as a source for constructing a black urban subject. It helps to create a subject in opposition to the one that the city attempts to create: in opposition and yet somehow still defined by it. Power constructs the resisting subject. Jazz music embodies *and* gives voice to their experience.

Alice Manfred's response to jazz music is one side of the tremendous debate that surrounded the music in the 1920s. At first her view reflects the exhortations of the reactionaries and the fundamentalists: "She knew from sermons and editorials that it wasn't real music—just colored folks' stuff: harmful, certainly; embarrassing, of course; but not real, not serious" (p. 59).[8] Nevertheless, Manfred is very, very perceptive in that she hears anger of antilynching protests in the music. In Alice Manfred, Morrison begins to launch her project of redefining, reclaiming the jazz in the term Jazz Age. The happy-go-lucky, welcome fun sought by white interlopers to Harlem is a mask for the complex of emotions and experiences voiced in the music.

While Alice Manfred hears its anger, her young charge Dorcas hears its sensual seductiveness:

> *Dorcas lay on a chenille bedspread, tickled and happy knowing that there was no place to be where somewhere, close by, somebody was not licking his licorice stick, tickling the ivories, beating his skins, blowing his horn while a knowing woman sang ain't nobody going to keep me down you got the right key baby but the wrong keyhole you got to get it bring it and put it right here or else. [p. 61]*

The music calls Dorcas; it is "a City seeping music that begged and challenged each and every day. 'Come' it said. 'Come and do wrong.'" Throughout the text, jazz is like an addictive drug. It entices, it seduces, it makes the takers think they can do the impossible, and it makes addicts of them. Like the first-generation urban-born, or those who migrated as children, like "citymen . . . closed off to themselves, wise young roosters," like the "schoolgirl [who] never pauses at the stoplight," the jazz of this novel is urban, urbane, and capable not only of defining a black urban reality but also of shaping American modernity. Jazz is both a character of this book as well as the form it takes.

In content, jazz becomes a metaphor for the migrants. The final vision of this narrative is a vision where migrants and their music are influenced by but also profoundly influence and redefine the city to which they migrate.

In a very important paragraph Morrison details her understanding of the impact the migrants have on American cities and American culture:

> *When I see them now they are not sepia, still, losing their edges to the light of a future afternoon. . . . For me they are real. Sharply in focus and clicking. I wonder, do they know they are the sound of snapping fingers under the sycamores lining the streets? When the loud trains pull into their stops and engines pause, attentive listeners can hear it. Even when they are not there, when whole city blocks downtown and acres of lawned neighborhoods in Sag Harbor cannot see them, the clicking is there. In the T-strap shoes of Long Island debutantes, the sparkling fringes of daring short skirts that swish and glide to music that intoxicates them more than the champagne. It is in the eyes of the old men who watch these girls, and the young ones who hold them up. It is in the graceful slouch of the men slopping their hands into the pockets of their tuxedo trousers. Their teeth are bright; their hair is smooth and parted in the middle. And when they take the arms of the T-strap girls and guide them away from the crowd and the too-bright lights, it is the clicking that makes them sway on unlit porches while the Victrola plays in the parlor. The click of dark and snapping fingers drives them to Roseland, to Bunny's; boardwalks by the sea. Into places their fathers have warned them about and their mothers shudder to think of. Both the warning and shudder come from the snapping fingers, the clicking. And the shade. Pushed away into certain streets, restricted from others, making it possible for the inhabitants to sigh and sleep in relief, the shade stretches—just there—at the edge of the dream, or slips into the crevices of a chuckle. It is out there in the privet hedge that lines the avenue. Gliding through rooms as though it is tidying this, straightening that. It bunches on the curbstone, wrists crossed, and hides its smile under a wide-brim hat. Shade. Protective, available. Or sometimes not; sometimes it seems to lurk rather than hover kindly,*

*and its stretch is not a yawn but an increase to be
beaten back with a stick. Before it clicks, or taps or
snaps its fingers. [pp. 226–27]*

In this paragraph, Morrison begins to redefine the Jazz
Age. There are many predominant literary allusions in
this passage. The most obvious are the allusions to the
writing of F. Scott Fitzgerald, the writer who coined
the term "Jazz Age" and who attempts to chronicle it.
However, in his documentation, black people and their
music provide the colorful backdrop for the center-
stage activities of his Long Island debutantes, flappers,
and graceful tuxedoed young men. Black migrants and
their music are the servants who tidy up Sag Harbor
mansions and the musicians who play the music to
which daring short skirts swish and glide. In his reflec-
tions on the era he helped to document, "Echoes of
the Jazz Age" (1931), Fitzgerald barely mentions the
music or its creators. For him, the period between May
1919 and October 1929 was a time when "a whole race
[went] hedonistic, deciding on pleasure."[9] According
to Kathy Ogren,

> *F. Scott Fitzgerald's fiction about the exploits of
> young and perhaps "lost" white American youth
> usually garnered [the] honor [of being most asso-
> ciated with the Jazz Age.] . . . In fact, there is very
> little accurate depiction of jazz performance in
> Fitzgerald's fiction. . . . Fitzgerald's strength as a
> jazz age scribe rested more in his ability to capture
> the affection of young white college students for jazz
> than in his accuracy about musical performance.*[10]

However, the presence of jazz music sparks something
in Fitzgerald and his characters. It is more than back-
ground music at the lavish parties; it initiates a mood
and sense of desire and longing. In *The Great Gatsby*,
"When the 'Jazz History of the World' was over girls
were putting their heads on men's shoulder in a pup-
pyish, convivial way, girls were swooning backward
playfully into men's arms, even into groups knowing
that someone would arrest their falls" (pp. 54–55).
 Fitzgerald's "Echoes of the Jazz Age" is filled with
nostalgia:

> *Sometimes, though, there is a ghostly rumble among
> the drums, an asthmatic whisper in the trombones
> that swings me back into the early twenties when
> we drank wood alcohol and everyday in every way
> grew better and better, and there was a shorten-
> ing of skirts, and girls all looked alike in sweater
> dresses . . . and it seemed only a question of a few
> years before the older people would step aside and
> let the world be run by those who saw things as
> they were—and it all seems rosy and romantic to
> us who were young then, because we will never*

*feel quite so intensely about our surroundings any
more. [p. 22]*

This is one of those moments that Morrison has defined
as a narrative space where "black people ignite crit-
ical moments of discovery or change or emphasis in
literature not written by them."[11] Here as elsewhere in
Fitzgerald's work, black people are hidden beneath ref-
erences to their music or in almost surreal momentary
images as they glide by in limousines or appear out of
nowhere in the ash heap of *The Great Gatsby*. In con-
trast, Morrison captures the Jazz Age as a moment of
African-American modernity.
 Jazz, like Morrison's important critical essay, "Play-
ing in the Dark: Whiteness and the Literary Imagina-
tion," attempts to reveal the black presence lurking
in the shadows of the American literary imagination.
According to Morrison, "American writers were able
to employ an imagined Africanist persona to articulate
and imaginatively act out the forbidden in American
culture." Morrison defines Africanism as "a term for
the denotative and connotative blackness that African
peoples have come to signify, as well as the entire range
of views, assumptions, readings and misreadings that
accompany Eurocentric learning about these people."[12]
 During the Jazz Age black migrants and jazz music
became that "imagined Africanist persona" that allowed
white writers, musicians, and consumers of black culture
to "articulate and imaginatively act out the forbidden
in American culture." Morrison's novel is an attempt to
reclaim the Jazz Age, to place the creators of jazz at its
very center and to shed light on the shadows.
 In addition to revising the Jazz Age to expose the
black presence, Morrison also challenges those portray-
als of the Harlem Renaissance that have focused primar-
ily on the literary and visual arts as well as the efforts of
Harlem Renaissance "architects" W. E. B. Du Bois and
Alain Locke. Again, she does this by constructing her
narrative around working class black migrants and the
music that defines and sustains their lives.
 The second set of allusions to the paragraph cited ear-
lier once again refer to *Cane*, another text that portrays
the black migrant experience. Muriel and Mrs. Pribby
of "Box Seat" click into their chairs. Dan Moore is the
South in the city of that story, the migrant doomed to
failure on the urban landscape. Muriel is a migrant who
loses much of her Southern past, acquiring in exchange
for it a mechanical "click." The click of that story rep-
resented a negative of modernization. It is the harsh
metallic and mechanic sound that stands in contrast to
the soft, sensual lyricism of Toomer's Southern women.
In the preceding excerpt, it is transformed to a sound
that embodies the migrant. First, she tells us the migrants
are no longer "sepia colored . . . losing their edge to light."
They are not photographs, but the clicking of the camera.

They have become that instrument of modernity. As the paragraph unfolds, the clicking becomes the sharp, quick rhythmic snap of a finger, tap of a foot, click of a high heel. The migrants of her passage share much with the migrants of Toomer's "Seventh Street." Like those migrants of Seventh Street, these migrants are also "pushed into certain streets, restricted from others." Nonetheless, their music infiltrates suburban homes and communities, influencing daughters to defy their fathers. The migrants and their music sometimes appear to be "protective" servant types, who hum a tune as they clean. At other times they are migrants of Seventh Street, aggressive, strong, and threatening. At times like these, the migrants are beaten back with sticks, their music beaten back in the antijazz discourse that fueled public debate. Still, "Everywhere they go they are like a magician-made clock with hands the same size so you can't figure out what time it is, but you can hear the ticking, tap, snap." While Richard Wright's migrants were oppressed by the clock, Morrison's become a new clock, with a new measure of time.

The final vision of the narrative is one where the migrants have been transformed and have transformed American culture and society. There is no looking back, no return to a mythical South. Instead they continue to exist on the urban landscape and they even manage to survive it in order to live and love. In this novel, the text embodies a new figure, not the Southern ancestor or the Stranger, but an odd combination of both—the migrant. The voice of the omniscient narrator is the voice of the book itself. The narrator, like the ancestor, is "indeterminate: it is neither male nor female; neither young nor old; neither rich nor poor. It is both and neither."[13] It is a voice that is playful, unreliable, appearing to be all-knowing yet constantly undermining itself. It is a voice that embodies oral culture, instrumental jazz arrangements, paintings, photographs, and history.

From its very beginning, the "Sth" with which it opens, the narrative suggests the indignant teeth sucking of a black woman. Later the book-narrator becomes a blueswoman. Listen:

He became a Thursday man and Thursday men are satisfied.

I can tell from their look some outlaw love is about to be, or already has been, satisfied.

Weekends and other days of the week are possibilities, but Thursday is a day to be counted on . . .

So why is it on Thursday that the men look satisfied? . . .

For satisfaction pure and deep,
For balance in pleasure and comfort, Thursday can't be beat—

As is clear from the capable expression on the faces of the men and their conquering stride in the street.

They seem to achieve some sort of completion on that day that makes them steady enough on their feet
to appear graceful even if they are not.

They command the center of the sidewalk whistle softly in unlit doors. [pp. 49–50; emphasis added]

Just as the reader gets used to the oral quality of the narrative, it shifts gears and becomes visual:

The woman who churned a man's blood as she leaned all alone on a fence by a country road might not expect even to catch his eye in the City. But if she is clipping quickly down the big-city street in heels, swinging her purse, or sitting on a stoop with a cool beer in her hand, dangling her shoe from the toes of her foot, the man, reacting to her posture, to soft skin on stone, the weight of the building stressing the delicate, dangling shoe, is captured. And he'd think it was the woman he wanted and not some combination of curved stone, and a swinging, highheeled shoe moving in and out of sunlight. He would know right away the deception, the trick of shapes and light and movement, but it wouldn't matter at all because the deception was part of it too. [p. 34]

Opening with another reference to *Cane*, here, the text takes on the quality of what Deborah McDowell calls photocollage, incorporating "descriptions of many of [James Van der Zee's] photographs."[14]

In becoming both oral and photographic, the text does not choose between ancestor and stranger for its form. It embodies both the ancestor's orality and the modernity of photography. In this way it is like the migrant, a new subject, and like jazz. In fact, in its entirety, the text is like an arrangement for a jazz orchestra.

The gift of the ancestor that this text gives us is not the ancestor of the South, but an ancestor who is herself a migrant. Like Malcolm X for the hip-hop generation this text offers us an alternative figure, one who carries the wisdom of those first migrants, their music, their history, their vision, and even the literature that defined their moment. It also carries a warning against doing what the narrator admits to:

It was loving the City that distracted me and gave me ideas. Made me think I could speak its loud voice and make that sound human. . . . I missed the people altogether. I was watching the streets, thrilled by the buildings pressing and pressed by

stone; so glad to be looking out and in on things I dismissed what went on in heart-pockets closed to me. [pp. 220–21]

Loving the City, loving the desire it creates, "distracts" from the humans who inhabit it. Seeing images, illusions, plays of light, and shadow "distract" from seeing women, full-bodied flesh and heart. Under these conditions, black women may die at the hands of their lovers without a cry of remorse from the "community" they inhabit. There is no anger, indignation, and horror following Dorcas's murder. Her aunt does not call the police because she knows they do not value black lives. Her lover is never punished, he simply wallows in self-pity. And his crazy wife tries to deface her corpse. Throughout she is painted as a character who does not deserve our sympathy, as a selfish, uncaring young woman. The lack of public outcry following Dorcas's death is evidence the lack of value placed on black women's lives by her very own communities. As readers we must ask Morrison, "Is this the price of black modernity?"

Morrison's narrative not only seeks to redefine notions of the Jazz Age and the Harlem Renaissance, but also comments on the negative and positive consequences of migration. These consequences are evident in the crisis and the creativity that emerge from contemporary black urban communities. *Jazz* is a portrait of a people in the midst of self-creation, a document of what they created and what they lost along the way.

Notes

1. Susan Willis uses this term to describe the major characters of *Tar Baby*. See her *Specifying: Black Women Writing the American Experience* (Madison: University of Wisconsin Press, 1987).

2. The use of Old Testament names like Palestine and Rome signal a connection between black migration and the Jewish exodus. Both peoples migrate to escape persecution. Deborah McDowell makes this point in her dazzling review of the novel: "In naming these fictive cities of the pre-Migration past, Morrison forges her connection to that link the slaves made between themselves and the Israelites under Egyptian bondage, suggesting that even in Jazz Age Harlem the footprints of slavery have not been lost to time." "Harlem Nocturne," *Women's Review of Books* 9 (June 1992): 3.

3. Toni Morrison, *Jazz* (1992; repr., New York: Plume, 1993), 98; page numbers cited in the text refer to this edition.

4. Jean Toomer's poem "Reapers," which appears in the Southern section of *Cane*, is especially fitting in this description of the cane cutters' fear of killing Wild:

> Black reapers with the sound of steel on stones
> Are sharpening scythes. I see them place the hones
> In their hip pockets as a thing that's done,
> And start their silent swinging, one by one.
> Black horses drive a mower through the weeds,
> And there, a field rat, startled, squealing bleeds,
> His belly close to ground. I see the blade,

Blood-stained, continue cutting weeds and shade. *Cane* (New York: Liveright, 1975), 5. The reapers' tools are masculine, penetrating the earth and the creatures that inhabit it, including a field mouse, and, in *Jazz*, Wild.

5. Again, references to Cane are apparent: In her inability to mother her child, Wild is like Karintha. Other references to Cane abound throughout Morrison's novel. Wild is a naturewoman, who turns Toomer's nature-defined women into surreal and absurd figures.

6. In numerous interviews and essays, Morrison has stressed the significance of the neighborhood and the specificity of place in her fiction. See especially Robert Stepto, "'Intimate Things in Place': A Conversation with Toni Morrison," *Massachusetts Review* 18 (Autumn 1977); Thomas Leclair, "'The Language Must Not Sweat': A Conversation with Toni Morrison," *New Republic* 184 (Autumn 1977); Toni Morrison, "City Limits. Village Values: Concepts of the Neighborhood in Black Fiction," in *Literature and the Urban Experience*, ed. Jaye Michael and Ann Chalmers Watts (New Brunswick, NJ: Rutgers University Press, 1981).

7. In her strength, sensuality, and determination, here Violet resembles Jean Toomer's "Carma, in overalls, and strong as any man, stand[ing] behind the old brown mule, driving the wagon home" (*Cane*, 12).

8. In *The Jazz Revolution: Twenties America and the Meaning of Jazz* (New York: Oxford University Press, 1989), Kathy Ogren documents the media-pulpit debate about jazz music.

9. F. Scott Fitzgerald, "Echoes of the Jazz Age," in *The Crack-Up*, ed. Edmund Wilson (1941; repr., New York: New Directions Press, 1945), 15.

10. Ogren, *Jazz Revolution*, 149–50.

11. Toni Morrison, *Playing in the Dark: Whiteness and the Literary Imagination* (Cambridge, MA: Harvard University Press, 1992), vii.

12. Ibid., 6–7.

13. Henry Louis Gates, Jr., Review of *Jazz*, in *Toni Morrison: Critical Perspectives Past and Present*, ed. Henry Louis Gates, Jr., and K. A. Appiah (New York: Amistad, 1993).

14. McDowell, "Harlem Nocturne," 4.

James Baldwin, 1955. Photograph
by Carl Van Vechten

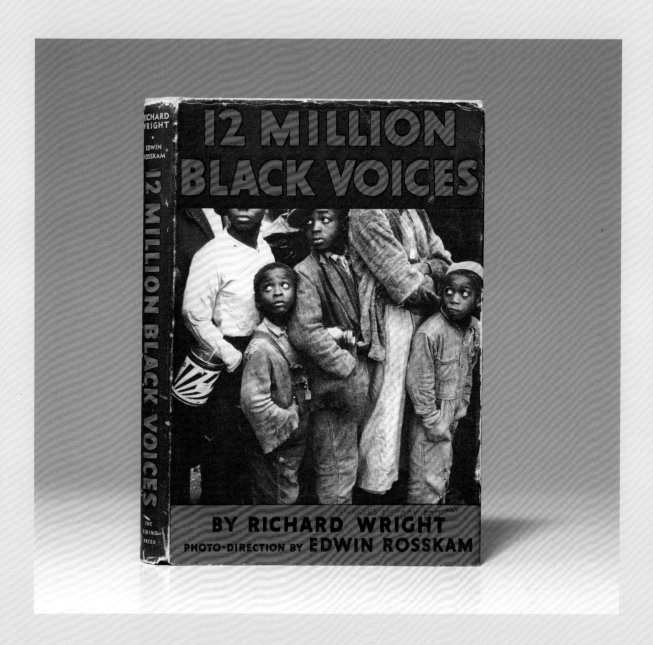

Cover of *12 Million Black Voices* by Richard
Wright, featuring a 1937 image by Walker
Evans, 1941

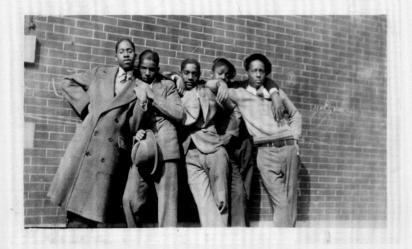

Cornelius Page and Maitlon Russell with
friends on 15th and Catherine Streets,
Philadelphia, 1929. Photographer unknown

Top: Students at Morgan State University,
Baltimore, 1963. Photographer unknown

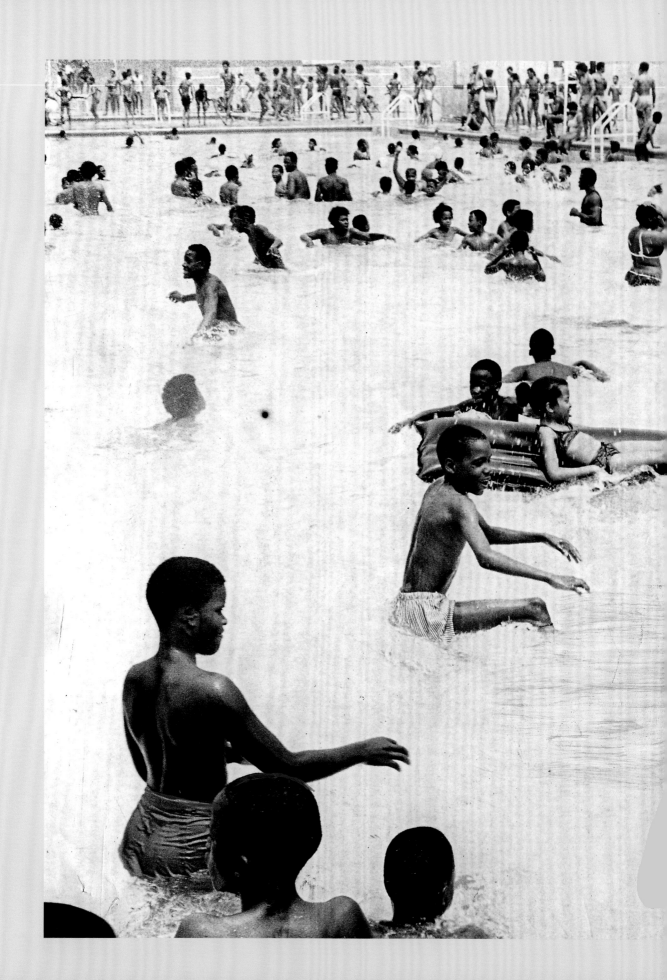

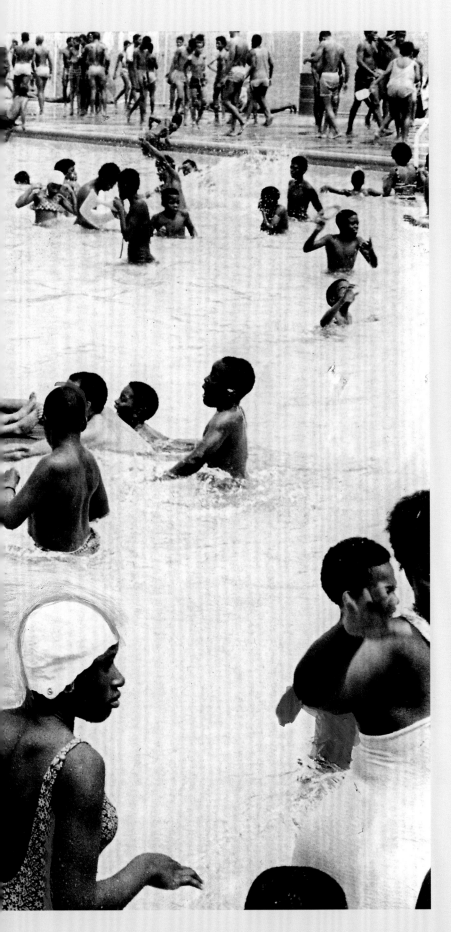

Children at the segregated Druid Hill
Park swimming pool, Baltimore, 1955.
Photographer unknown

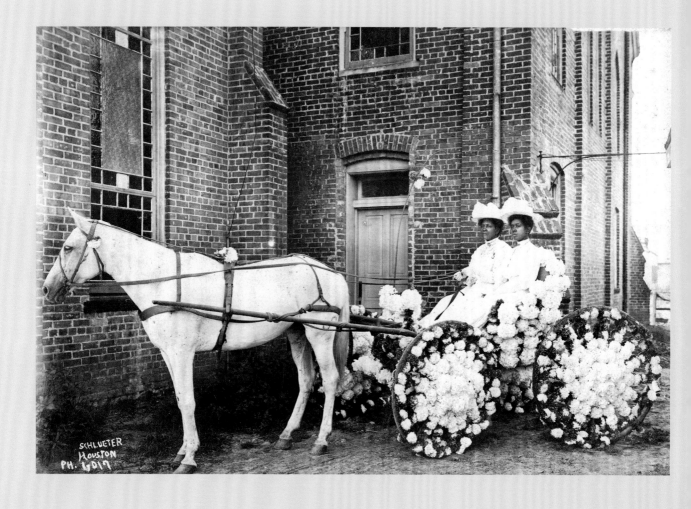

Martha Yates Jones (left) and Pinkie
Yates (right) parked in front of Antioch
Baptist Church at the annual Juneteenth
Celebration, Fourth Ward, Houston, 1908.
Photographer unknown

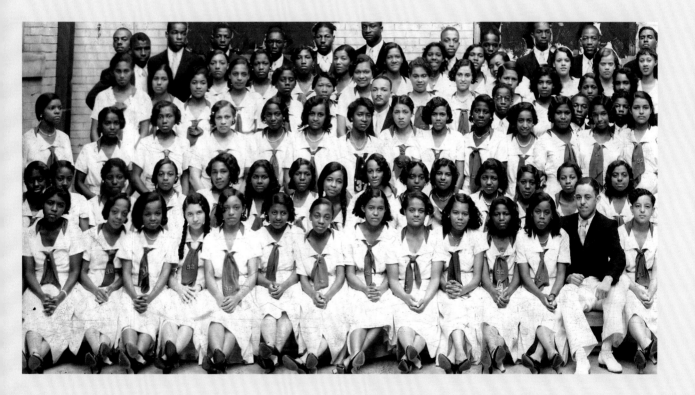

Students at the segregated
Frederick Douglass High
School, Baltimore, 1932.
Photographer unknown

"A Transplant that Did Not Take: August Wilson's Views on the Great Migration"

Sandra G. Shannon

"Contemporary Theatre," special issue, *African American Review* 31, no. 4 (Winter 1997): 1–9

On two occasions, I have witnessed playwright August Wilson stir his audience into an emotional frenzy by stating his views on the Great Migration. In September 1995, as a guest at a day-long series of forums at Howard University, and in April 1996, as the recipient of the 15th Annual William Inge Distinguished Playwright Award in Independence, Kansas, he articulated what has become for his plays a profound artistic influence and for his politics a well-rehearsed platform. Since neither of the two heated discussions afforded me the opportunity to record Wilson's comments, I was happy to find that he has aired the same controversial view on the Great Migration expressed in both Washington, D.C., and in Independence, Kansas, in several published interviews. In one such interview, he asserts,

> We were land-based agrarian people from Africa. We were uprooted from Africa, and we spent 200 years developing our culture as black Americans. And then we left the South. We uprooted ourselves and attempted to transplant this culture to the pavements of the industrialized North. And it was a transplant that did not take. I think if we had stayed in the South, we would have been a stronger people. And because the connection between the South of the '20s, '30s and '40s has been broken, it's very difficult to understand who we are. (Rothstein 8)

In another, he notes,

> We came to the North, and we're still victims of discrimination and oppression in the North. The real reason that the people left was a search for jobs, because the agriculture, cotton agriculture in particular, could no longer support us. But the move to the cities has not been a good move. Today . . . we still don't have jobs. The last time blacks in America were working was during the Second World War, when there was a need for labor, and it did not matter what color you were. (Moyers 167)

Blacks in both audiences cringed in disbelief, arguing passionately that the South held very few opportunities for their grandmothers and grandfathers, many of whom—given the prevalence of Ku Klux Klansmen

violence, voter disenfranchisement, and the eternal financial rut of tenant farming—saw moving north as their only logical option. Whites, likewise, in both audiences, stood their ground, baffled that Wilson could not concede that the relative progress blacks have made in Northern cities was proof that the move even exceeded original expectations.

When pressed to respond to both groups, Wilson, without hesitation, easily shifted the direction of both debates from his *implied* call for contemporary descendants of the Great Migration to embark upon an *actual* physical relocation back down south to a sobering account of the extent of their rejection up north. In highly charged and eloquent, yet stinging, indictments of the North, Wilson takes as his text the "mistake" made by blacks in leaving the South yet focuses his verbal agility upon revealing the double jeopardy of their settling in the North. In both scenarios, Wilson's rhetorical maneuvers, his articulate and engaging delivery, and the sheer passion of his argument ultimately silenced dissenters. By the end of both sessions, neither audience seemed particularly aware of or bothered by his red herring tactic, nor did they appear conscious of the original premises of their respective arguments against him. What occurred in both instances, I contend, was the playwright's very calculated and choreographed invitation to both audiences to share and experience that same blues landscape that informs his plays. It is a landscape much like that designed by Jean Toomer, author of the soulful *Cane,* wherein the blues-ridden author "weary of homeless waters . . . turns back to the ancestral soil, opens himself to its folk art and its folk ways, tries to find his roots, his origins . . . a step toward the definition of himself." (Munson 173)

Even away from such public forums, in his private role as writer, Wilson continues to show the apocalyptic and tragic results of what he deems the original sin of African Americans; that is, the mistake they made in transplanting an agrarian-based culture to a concrete-based environment. Thus, his characters are often portrayed as wide-eyed optimists who, despite their earnest attempts to determine their destinies, either perish in the city or become part of its human refuse. Utilizing both subtle and glaringly obvious dramatic techniques, the playwright reinforces his position about the "transplant that did not take" or the "mistake" of the black migration North. His characters who hail from Southern states such as Alabama, Mississippi, and Georgia and have made their homes in Pittsburgh or Chicago—or those who even *aspire* to relocate to such places—seem doomed to failure, turmoil, restlessness, alienation, or possibly death. While I am sure Wilson concedes to the impracticality of arguing for a sweeping reversal of the massive exodus of blacks at the turn of the century, he demonstrates in two of the seven plays he has

published to date—*Seven Guitars* and *Ma Rainey's Black Bottom*—that a mistake has been made, that some form of cosmic retribution is certain, and that atonement for this so-called original sin sometimes comes at a high price. Like Toomer, Wilson achieves his objective correlative by capturing the blues impulse in his writing which enables his audience to "finger the jagged grain" (Ellison 90) of life up north for the Southern-born and bred Negro.

To some extent, August Wilson visits the theme of the Great Migration as an enormous mistake in each of his seven published plays: *Jitney, Joe Turner's Come And Gone, Ma Rainey's Black Bottom, The Piano Lesson, Fences, Two Trains Running,* and *Seven Guitars.* Set in either Pittsburgh or Chicago, each captures the blues impulse of the Southern Negro's initiation into the Northern way of life. Blasphemy, self-mutilation, convulsions, arrested speech, unexplained scars, incarceration, domestic turmoil, splintering of the nuclear family structure, and mental trauma that manifests itself in either neurosis, schizophrenia, or dementia are but a few of the evils that plague Wilson's Northern-bound characters.

In Wilson's two works which deal with the blues music recording industry and the related lure of Chicago, this mistake is elevated to tragedy. *Seven Guitars* and *Ma Rainey's Black Bottom* convey Wilson's subtle curse upon the black Southern migrant, which he visits upon the aspiring blues artist. While the other five plays end with characters "pointing in the right direction" (to use Wilson's phrase), these two plays end with the rather gloomy spectre of death for the bluesman—figurative and literal. *Seven Guitars'* Floyd "Schoolboy" Barton and *Ma Rainey's* Levee fail in their attempts to leave their mark on the blues recording industry at the expense of denouncing both Africa and the South. Kim Pereira, author of *August Wilson and the African American Odyssey,* explains the reason that the blues musician's often tragic love affair with Chicago is one of Wilson's favorite metaphors for emphasizing the extreme difficulties Southern migrants experienced once up north:

> *Migration and the motives that prompted it are typified in the peripatetic lifestyle of blues singers. . . . Having been tied down for so long by slavery and sharecropping, blacks were anxious to be on the move, unable to put down roots just yet, desperate to fill a spiritual void created by three hundred years of captivity. Blues lyrics spoke of this desire to get away and reflected the separation behind the migration: men and women looking for each other or leaving their homes and their loved ones. (61–62)*

As Pereira suggests, Wilson calls upon his dramatic efforts to compress the stories of hundreds of black Southern migrants into the individual sufferings of blues musicians. In the Preface to *Ma Rainey's Black Bottom,* Wilson explains,

> *It is with these Negroes that our concern lies most heavily: their values, their attitudes, and particularly their music the Alabama or Mississippi roots have been strangled by the northern manners and customs of free men of definite and sincere worth, men for whom this music often lies at the forefront of their conscience and concerns. Thus they are laid open to be consumed by it . . . (xv–xvi)*

Seven Guitars, August Wilson's seventh and most recent installment in his project to write ten plays of the black experience since 1900—affirms in numerous ways that the transplant of the migration did not take. Set in Pittsburgh in 1948, the play has as its central focus Floyd "Schoolboy" Barton, a blues musician whose dream of a Chicago recording deal is lost to desperate circumstances. Despite having his sights set on marrying his true love, moving to Chicago, and signing with a big record company, Floyd Barton's seemingly inevitable compunction for trying to move even further north, from Pittsburgh to Chicago, dictates that he will be arrested for vagrancy in Pittsburgh and sentenced to ninety days in jail, that he will be denied the money he earns in jail from a work detail due to a technicality, that he must pawn his all-important guitar, and that he will desperately resort to armed robbery to obtain the price of a grave marker for his mother and a ticket to Chicago. His ultimate curse is that, before reaching Chicago, he will die in a scuffle over the same stolen money.

Other characters who frequent the backyard setting in Pittsburgh have their share of trouble as well: the erratic and obsessive Hedley, who dreams that someday he will own a plantation and be a "big man"; the lone and cynical landlord Louise, who frequently laments yet endures the single life; the "fast" and pregnant new arrival Ruby, who flees man trouble down south, seeking temporary refuge up north in her Aunt's home; the brooding Canewell, whose blues is captured by his melodious and talented harmonica playing; and the hopeless flirt Red Carter, who brags of his wife's fertility, yet makes no pretense about being monogamous. Having common fates as Southern migrants in a Northern town, these characters regularly gather in a backyard setting to commiserate about the rejection they face daily and about the frightening contrasts between the rituals of Southern and Northern living. In one such moment, Red Carter recalls,

> *Once upon a time in America it use to be all right to have a rooster in your yard. Now that done changed. It use to be you could leave your door open. Now you got to bar the roof. . . . You need a license for everything. You need a license to sing on the*

street. You need a license to sell peanuts. Soon, you mark my words, soon you need a license to walk down the street. (82–83)

Although Pittsburgh is sufficiently "Northern" for many of the characters, such as Louise and Ruby, they share Floyd's belief that "It ain't as good as Chicago" (68). For others, such as Red Carter, Vera, and Floyd, Chicago is the proverbial Promised Land—where a black man can conceivably become rich and where "more people mean more opportunity and more things to do." (62).

The *Chicago Defender* newspaper took the lead in promoting this image of Chicago as a Northern utopia for the Southern migrant. According to a recent study on the Great Black Migration,

> *Despite numerous attempts to halt its distribution, the Defender was circulated. Stated federal investigator T. J. Woofter, the Chicago paper "makes its lurid appeal to the lowly class of Negroes. In some sections it has probably been more effective in carrying off Negroes than all the labor agents put together."... The Defender was said to have sold more than 150,000 copies an issue. Frederick Detweiler, who has studied the black press extensively, concludes that a more realistic estimate of readership is 1,000 readers to every 100 copies sold. A correspondent of the Defender wrote: "White people are paying more attention to the race in order to keep them in the South, but the Chicago Defender has emblazoned upon their minds 'Bound for the Promised Land.'" (Marks 28)*

Despite the *Chicago Defender's* obviously successful media blitz that emphasized in the most convincing ways the great advantages which were awaiting those who would go north, Wilson challenges its propagandistic premise on an artistic level, countering its very basic appeals to the Negro that the North can offer all that the South does not.

This artistic war that Wilson wages against the myth promoted by the *Defender* and against the so-called "transplant that did not take" continues to find expression in several less obvious features of *Seven Guitars*. For example, Miss Tillery's rooster becomes the source of much discontent for Floyd and Louise, especially, who reject it as a residual of their now geographically and culturally distant Southern heritage. Louise, who lives next door, grumbles, "She don't need that rooster. All she got to do is go down to Woolworth's and get her an alarm clock. It don't cost but a dollar and forty-nine cents." Like Louise, Floyd frequently registers his disgust for the barnyard bird: "If I had me a BB gun I'd shoot that rooster," and "Stop all that noise!" followed by a carefully aimed stone hurled across the fence (59). The bird's instinctual crowing in this Northern urban setting is regarded by several of the characters not only as unwelcomed noise but also as an absurdist ritual or, to use one of Wilson's familiar phrases, a "leftover from history." That is, unlike this group of migrants or descendants of migrants, the rooster unashamedly holds onto his tradition, ignoring the related stigma that it is an obsolete presence in a debatably more progressive Northern environment. Despite having been transplanted out of its familiar surroundings, it continues to affirm its uncompromised identity though its periodic crowing.

As a familiar image of the local color of the Southern landscape, the rooster is especially familiar in Southern folklore as well as in voodoo ritual. Canewell provides a sampling of its narrative possibilities: "That's one of them Alabama roosters. See, he fall in love with the way he sound and want to crow about every thing. Every time the notion strike him. That don't do nothing but get people confused. That kind of rooster ain't no good for nobody. Best thing you can do is try and make a stew out of him." He continues, "The rooster didn't crow during slavery. He say, 'Naw. I ain't gonna be part of nothing like that. I ain't gonna wake nobody up.' He didn't start crowing again till after the Emancipation Proclamation. The people got to whooping and hollering so, he say, 'Naw, you all ain't gonna leave me out.'" (60)

While Miss Tillery's rooster inspires such amusing anecdotes, it also assumes a darker role in *Seven Guitars* as it becomes, at the hands of Hedley, a sacrificial object. Taking his cue from Louise and Floyd's constant complaints against the bird, Hedley excuses himself from the group, force fully abducts it from its owners' premises, and returns later to cut its throat before a disbelieving crowd. Inasmuch as this scene recalls similar bloodletting rituals performed by the resident conjure man in *Joe Turner's Come And Gone*, it also warrants being viewed in terms of Wilson's efforts to infuse his plays with recognizable images of Africa. Mindful of the meaning afforded by this African context, it is feasible, therefore, to view Hedley's slashing of the rooster's throat—in clear view of those who deplore it—as a paradoxical "wake-up call," a ringing alarm to those who have been lulled into a similar rejection of their immediate Southern past and familiar rituals of a not-so-distant Africa. In Hedley's role as the play's slightly deranged and misunderstood conscience, he explains the rooster's historical importance to the black man in affirming the continuity of life from slavery to the present, ultimately equating the fate of the bird with that of the transplanted Negro:

> *God ain't making no more roosters. It is a thing of the past. Soon you mark my words when God ain't making no more niggers You hear this rooster you know you alive. You be glad to see the sun cause there come a time sure enough when you see your last day and this rooster you don't hear no more. (64)*

This unspoken, though strongly suggested, "transplant that did not take" finds yet another signification in the goldenseal plant which Canewell presents to Vera once he learns that she is contemplating a move further north to Chicago with Floyd. It is a medicinal plant whose healing tea, made from either its leaves or its roots, according to Canewell, promises to "be all the doctor you need." His warning to her to "plant it now. Don't let the roots dry out" (27) creates a basis for regarding the plant as another one of Wilson's metaphors for the misplaced black Southern migrant. Like the rooster, it has been removed from its familiar home and compelled to exist in alien soil. Its fragile roots—too long exposed to the hostile winds of the North—promise imminent doom.

Despite Hedley's care in planting Vera's floral gift, Floyd unearths its roots when he stashes stolen money nearby. Again, the image of the unsuccessful transplant looms large and gains even more relevance as it envelops Floyd. Wilson's mixing of images in this scene of the goldenseal's exposed roots and that of a potential blues legend turned armed robber speaks volumes. Like the plant, Floyd has lost hold of his anchor, his support base which slips even further from his grasp as he looks toward a new life in Chicago. His subsequent demise is certain.

Ma Rainey's Black Bottom puts another tragic spin on Wilson's pronouncement against Southern black involvement in the Great Migration. He conveys this negative judgment most noticeably through Ma Rainey's trumpet player, Levee, who has left behind him an emotionally painful South and who now aspires to make a name for himself in Chicago by recording his own lyrics. Yet, like Floyd, Levee is destined to self destruct. He is a product of the Deep South who, like other talented musicians in Ma Rainey's band, has made his way from the cotton fields and mule teams of Dixie to the big city recording studio of Chicago.

Convening in a cold, dingy studio in Chicago to record their music for a Paramount label, Ma's backup musicians must accept $25 and a pat on the back for their efforts. Their unenviable circumstances provide an ironic scenario of what Floyd Barton might have fallen prey to had he not perished in Pittsburgh. Although *Ma Rainey's Black Bottom* is about the plight of bluesmen, the Southern blues diva Ma Rainey commands an appreciable amount of the play's attention. After prolonging her arrival, she finally comes to a recording session flanked by an entourage of hangers-on, further irritating the white producers with demands for a Coca-Cola, more heat in the studio, and a microphone for her stuttering nephew, who, she insists, will announce her on the album before she sings.

While Ma tries the patience of her two promoters, her crew of black male musicians waiting in the basement band room argue and amuse each other with bouts of the dozens and pseudo-philosophical wisdom. Their conversations, which slip from an argument over the correct spelling of the word *music* to an existentialist discussion of black history, gradually intensify and unexpectedly erupt when a commonplace incident leads to murder. The self-made philosopher and pianist Toledo inadvertently steps on the new Florsheim shoes of the sulking trumpet player Levee. Apparently still angered by the recent refusal of one of Ma Rainey's promoters to help launch his musical career, Levee becomes enraged and stabs Toledo in the back.

Perhaps more than any of Wilson's other converts of the North, Levee is "laid open to be consumed by it" (xvi). Abrasive, conniving, insecure, bitter, blatantly anti-Christian, and ultimately homicidal, Levee epitomizes the transplant that did not take. He does so in several ways, none more obvious and reverberating than the murder of a fellow member of Ma's band. Prior to Toledo's seemingly inconsequential act of stepping on Levee's new pair of Florsheims, Levee sulks over a business deal gone bad with one of Ma's white promoters and broods over the beating he suffered at the hands of Toledo for cursing his God. In an interview with Kim Powers, Wilson describes the violence against Toledo as "a transference of aggression from Sturdyvant to Toledo, who throughout the play has been set up as a substitute for the white man" (54). Although Wilson's psychoanalytic explanation of Levee's fit of insanity may shed some light on the trumpeter's twisted logic, an equally useful view of the black-on-black crime is that Toledo's murder is but the final phase of Levee's unsuccessful attempts to make it in Chicago. As Wilson does in *Seven Guitars,* he here teases us with images of a possible good life looming within reach of these sons of the South, yet, as if awakening from a pleasant dream to a nightmarish reality of the North, only death, doom, and self-destruction greet him.

Levee's potential to self-destruct because of his severed ties with the South is also evident in his futile attempts to replace Ma Rainey's "old jug band music" with his jazzed-up arrangements. He scowls at his colleagues, and repeatedly taunts them with insults stemming from his deepseated loathing of anything related to life in the South. His aversion to the South surfaces in his instructions to fellow band members on how to adopt his style of music: "Now we gonna dance it . . . but we ain't gonna countrify it. This ain't no barn dance" *(Ma Rainey* 38). It also appears in an early verbal jab at Toledo: "Nigger got them clod hoppers! Old brogans! He ain't nothing but a sharecropper. . . . Got nerve to put on a suit and tie with them farming boots" (40). And later, he teases Slow Drag: "That's why you so backwards. You just an old country boy talking about Fat Back, Arkansas, and New Orleans in the same breath" (54).

Levee's bitter rejections by both Ma Rainey, who eventually fires him, and Sturdyvant, who misleads him, suggest that the gods whom he denounces viciously throughout the play have conspired against him. After he witnesses the rape of his mother and the murder of his father on their own land down south, his reasons for leaving this place may appear understandable, yet his fate is nonetheless directly related to his decisions to flee north rather than stay south, avenge his father's murder, and retrieve his family's land. According to Wilson's design, there are no exceptions. Thus, Levee's irreverence, his violence, and ultimately the certain fate that awaits him may all be interpreted as the wages of his sins against his past. After he breaks free of the South as well as Ma's band, self-destruction soon follows.

As Wilson does in *Seven Guitars,* he uses certain seemingly minor animate and/ or inanimate props as symbolic media for his meta-discourse on the pervasive theme of the troubled transplant. Levee's Florsheim shoes, for example, represent much more than fancy footwear. Coded in his actions and reactions toward this item of apparel is what psychoanalysts refer to as displacement; that is, the unconscious attempt to "present concealed wishes through symbols, softening our desires" (Bressler 91). Also, the shoes become the thrust of a subtext subtly analogous to the play's larger thematic emphasis upon the transplant that did not take. Levee projects onto these shoes certain aspects of his own subconscious struggle to succeed in the North and to create as much geographic and cultural distance as he can between himself and the South. The exquisite shoes regularly worn by the fashion-minded Northerner of impeccable taste are the antithesis of the brogans so typical of an agricultural environment. Investing $4 of the money he won shooting craps and $7 of his own personal money, Levee acquires his coveted Florsheims and expects immediate results: women, good music, and good times. Like the lime-green suit Lymon buys from Wining Boy in Wilson's *The Piano Lesson,* the Florsheim shoes are believed to possess magical powers.

Despite the absurdity of wearing Florsheims in a dingy recording studio, Levee is proud of his purchase. Yet somehow this pride turns to obsession when Toledo inadvertently steps on his $11 investment and pays dearly for having done so. Displacement, absurdity, and obsession are conditions associated with Levee's shoes as well as conditions brought on by the realization that the move north was somehow against the principles of nature.

Perhaps as a result of August Wilson's parallel and ongoing interest in poetry—his first love as a young artist—his plays are grounded in figurative language and illusion. Perhaps also due to his demonstrated skill at extemporaneous debate, coupled, incidentally, with his acknowledged love of the sport of boxing, his plays combine aspects of artful dodging and crafty maneuvers.

Wilson, in honor of his African ancestors, preserves the folklore and the wisdom he learned while sitting at the feet of his elders. Whether he vents his controversial philosophy of the Great Migration on stage through a succession of troubled characters and highly suggestive props or whether he raises this same issue before a confrontational audience, his evasive posture foregrounds his guiding dramatic principle that the transplant simply did not take.

Works Cited

Bressler, Charles. *Literary Criticism: An Introduction to Theory and Practice.* Englewood Cliffs: Prentice, 1994.

Ellison, Ralph. "Richard Wright's Blues." 1945. *Shadow and Act.* New York: NAL, 1964. 89–104.

Marks, Carole. *Farewell-We're Good and Gone: The Great Black Migration.* Bloomington: Indiana UP, 1989.

Moyers, Bill. "August Wilson." *A World of Ideas: Conversations with Thoughtful Men and Women.* Ed. Moyers. New York: Doubleday, 1989. 167–80.

Munson, Gorham B. "Toomer as Artist." 1925. *Cane: A Norton Critical Edition.* Ed. Darwin T. Turner. New York: Norton, 1988. 171–74.

Pereira, Kim. *August Wilson and the African-American Odyssey.* Urbana: Illinois UP, 1995.

Powers, Kim. "An Interview with August Wilson." *Theater* 16 (Fall/ Winter 1984): 50–55.

Rothstein, Mervyn. "Round Five for the Theatrical Heavyweight." *New York Times* 15 Apr. 1990: 1+.

Wilson, August. *Ma Rainey's Black Bottom.* New York: Plume, 1985. *Seven Guitars.* New York: Penguin, 1996.

EXCERPT

Troubling Vision: Performance, Visuality, and Blackness

Nicole R. Fleetwood

Chapter 1: "Charles Harris and Photographic Non-Iconicity," 42–49. Chicago: University of Chicago Press, 2010

While [Charles] Harris's practice deviated from the tradition of social documentary photography in many respects, his work must be understood within that genre's history and its roots in "the social conscience of liberal sensibility," with its concern for "moralism" over "revolutionary politics," as articulated by Martha Rosler.[1] The Farm Security Administration (FSA) Photographic Project (1935–42), made popular by Depression-era works by Walker Evans, Dorothea Lange, Gordon Parks, and Russell Lee, produced many of the symbols of photographic iconicity for forthcoming photographic documentary studies in the United States.[2] While the photographers associated with FSA had their own distinct style and practice, the school in the broadest sense has been characterized as promoting a noble or transcendental notion of humanity embodied in the poorest and most disenfranchised members of society.[3] The FSA School, as well as the earlier documentary photographic projects of Jacob Riis and Lewis Hine, focused on the struggle of the working class and poor and the social forces that contributed to the plight of individuals. These photographic studies are foundational in creating a visual lexicon in the US public discourse, visual culture, and scholarship.[4] As photographic scholars have long established, these documentary works were intended to be part of social reform efforts and the photograph was seen as an index of social ills. In her study of social documentary photography, Maren Stange argues:

> In order to assert more or less explicitly that their images presented viewers with the truth, reformers relied on the photograph's status as index—that is, as a symbol fulfilling its representative function "by virtue of a character which it could not have if its object did not exist" [citing Charles Sanders Peirce] in a standard semiotic definition. But they also realized that codes of photographic realism could be used to associate reform with individuals' humanitarian impulses as well as with the social engineering institutionalized by reform movements.[5]

Stange uses Peirce's definition of index to emphasize how practitioners of canonical documentary photography relied on the power of the photographic image as evidentiary tool of reality. Stange points to the tension in many documentary projects between the claim of empirical truth as recorded through optical technologies and the agenda or strategic uses of the image by the photographer or others who control the distribution of the work.

Black photographers—Roy DeCarava, Gordon Parks, Richard Saunders, Roland Freeman, and Moneta Sleet Jr., to name a few—often have used the aesthetics of social documentary to produce visual records of the daily practices of blacks in the United States and more precisely to document the conditions of black life under racial segregation and systemic inequalities. David A. Bailey and Stuart Hall write that for black photographers, using documentary aesthetics is potentially an "attempt to reposition the guaranteed centres of knowledge of realism and the classic realist text, and the struggle to contest negative images with positive ones."[6] Of note, Roy DeCarava and Gordon Parks worked at the time when Harris was a photojournalist in the late 1940s and 1950s; also, like Harris, Parks's and DeCarava's careers spanned over five decades.[7] DeCarava's street scenes of Harlem, perhaps the most iconic and photographed black neighborhood of the century, provide important visual signs that shape our understanding of the social conditions of early and mid-twentieth-century urban black life. He is known also for his photographic series on jazz musicians.[8] Gordon Parks, whose long and varied career path is legendary, was the first black photographer hired by *Life* magazine. According to Deborah Willis, Parks decided that he wanted to be a photographer after seeing the work of the FSA in 1937.[9] Early in his time with FSA, Parks photographed Ella Watson, janitorial staff for governmental buildings in Washington, DC. The photograph, entitled *American Gothic* (1942), is one of the most reproduced photographs of the twentieth century. In the image Watson stands in front of the American flag with broom and mop in hand.[10] The image is an obvious riff on Grant Wood's famous painting *American Gothic* (1930). Later in his life, Parks describes what led to the photograph:

> That was my first day in Washington, D.C., in 1942. I had experienced a kind of bigotry and discrimination here that I never expected to experience. And I photographed her after everyone had left the building. At first, I asked her about her life, what it was like, and so disastrous that I felt that I must photograph this woman in a way that would make me feel or make the public teel about what Washington, D.C. was in 1942. So I put her before the American flag with a broom in one hand and a mop in another. And I said, "American Gothic" —that's how I felt at the moment. I didn't care about what anybody else felt. That's what I felt about America and Ella Watson's position inside America.[11]

Parks enunciates the juxtaposition of signs that produce meaning in this iconic photograph: the broom and mop against the American flag; the black maid, the descendant of slaves, who cleans the federal buildings.

Parks, like DeCarava and others, offered a potent critique of US racial and class stratification often through the juxtaposition clearly articulated in *American Gothic*. DeCarava's *Man Coming Up Subway Stairs* (1952) is striking given that the image captures a seemingly ordinary moment of a middle-aged black man walking up subway stairs. However, the expression on the man's face and the contrast and tone of the image convey a stillness and solitude. The man is not just walking upstairs; he is struggling with systemic inequality as the visual signs suggest. His lips are pinched tightly; his clothes are soiled; the brim of his hat askew. Both Parks and DeCarava focused on documenting blacks in familiar urban communities in carefully studied and highly stylized portraits, and both went on to capture some of the most iconic images in US photographic history. I mention the works of these two great photographers in some detail in part because of the stillness and "timelessness" conveyed in some of their more notable works. Also I want to highlight how they are known for individual pieces that embody universalizing notions of humanity, freedom, and struggle.

The legacy of representing blacks in social documentary photography evidences the multitiered ways in which the photograph gets employed to make sense of history: (1) the photograph is the historical document; (2) it stands in for the historical moment; (3) it provides evidence of an historical event; and (4) it frames the possibility of understanding a specific historical time period. Roland Barthes theorizes that "the photograph possesses an evidential force, and that its testimony bears not on the object but on time. From a phenomenological viewpoint, in the Photograph, the power of authentication exceeds the power of representation."[12] Again as Peirce suggests, the photograph is the index and the icon. A series of iconic images from the mid-century has become one of the most foundational ways in which the public understands and indexes black twentieth-century struggles for equality and freedom.

Leigh Raiford and Martin Berger have written about the strategic uses of photography by civil rights activists to garner public support for organizations and the broader cause during the movement. Berger argues that images of the 1960s civil rights struggles were chosen and cropped in such a way as to "routinely cast African Americans as the passive and hapless victims of active and violent whites" to garner white sympathies and support.[13] He argues that images portraying blacks as active agents often appeared in the black press but were excluded from magazines like Life. Examining the

Student Nonviolent Coordinating Committee's (SNCC) use of photography in the 1960s, Raiford argues:

> These images have shaped and informed the ways scholars, politicians, artists, and everyday people recount, remember, and memorialize the 1960s freedom struggle specifically and movement histories generally. The use and repetition of movement photographs in contexts as varied as electoral campaigns, art exhibits, commercials, and of course academic texts, have crystallized many of these photographs into icons, images that come to distill and symbolize a range of complex events, ideas, and ideologies.[14]

For the broader public, these images are not only evidence of the struggle but also provide its narrative. They are believed to tell the story of black freedom struggles. Raiford and Renee C. Romano discuss the ways in which a particular narrative of the civil rights era has been institutionalized and memorialized by mainstream discourse, which they label "a consensus memory, a dominant narrative of the movement's goals, practices, victories, and, of course, its most lasting legacies."[15] Raiford and Romano ask what is left out of this consensus memory and whose purpose does this omission serve. Looking at how the state and public officials employ the legacy, they write:

> Especially in the case of the civil rights movement, which can be held up as a shining example of the success of American democracy, the state has a strong interest in using the memory of the movement as a tool of nationbuilding and of fostering and fomenting hegemony through consensus. The movement in this way can become proof of the vitality of America's legal and political institutions, and evidence of the nation's ongoing quest to live up to its founding ideals of egalitarianism and justice.[16]

The workings of this narrative became all the more prescient during the 2008 presidential campaign and election in which the news media, for months before the election, anticipated being able to mark the historical significance of Barack Obama as the first "African American" president.[17] In the national imaginary and public discourse, the civil rights legacy becomes incorporated into a grander narrative of the United States as the model of progressive democracy in which citizens can actualize change and pursue liberties.[18]

The icon is a fixed image so immersed in rehearsed narratives that it replaces the need for narrative unfolding. In its singularity—as exceptional moment, individual, event—it calls on universality, notably here the progress of democracy. While the icon evokes universality, it also plays with specificity as it encompasses a host of possibilities and contradictions for understanding what it means

to be a black in the United States. Moreover, civil rights "consensus memory" relies on a nationalist framework of understanding black Americans as disenfranchised but *deserving* citizens of US democracy. The icon of this photographic genre is more often than not patriotic in its emotional appeal—to call out American hypocrisy while simultaneously upholding the belief in the superiority of the United States as a nation-state. The photographic icon of black freedom struggles is a noble image, a moral image, one that pleads for equality and upholds the ideology of democratic and capitalistic progress.[19]

Known for his many public and personal portraits of Martin Luther King Jr. and family, Moneta Sleet Jr. photographed some of the most recognized images of the civil rights era. Like many black photojournalists of the period, he began his career working for the black press. Sleet described his style as one of honing an "eye" to capture "special moments."[20] He focused his camera on black political leaders, celebrities, and cultural figures, stating, "When you are dealing with people who really are renowned and are top stars or super stars, they have a certain quality about them that makes you feel ease."[21] In 1956, early in his career, Sleet developed a close relationship with the King family while on assignment. He authored many of the most well-known photographs of King as civil rights leader, including the March to Selma and the March on Washington, and he accompanied King to Norway when he was honored with the Nobel Peace Prize in 1964. In addition to documenting King as the highly visible leader of the movement, Sleet also took many pictures of the King family in domestic settings. He is best known for his 1969 Pulitzer Prize-winning photograph *Mrs. Coretta Scott King and her daughter Bernice at the funeral of Dr. King*, making him the first black American to receive the prize for photojournalism. The image is a medium close-up shot of a veiled Coretta Scott King in black reclining in a church pew as she holds a mournful Bernice, the Kings' young daughter, in her arms. The photograph became a symbol of the waning civil rights era and marked the movement's successes and failures as King's assassination stood for the relentless power of white racism while his death became a potent symbol of the struggle for American democracy.

My critique of black civil rights iconicity is not meant to do away with the image database or its circulation but to contextualize its significance within dominant notions of understanding blackness, inequality, and lived experience. The reliance on images of iconic blackness and spectacular blackness is wedded to binary modes of rendering black subjects through narratives of exceptionalism or deviance. This binary continues to pin visible blackness to the hypervisible and the invisible. In this context Harris's photography troubles the dominant visual modes of representing black lived experience by offering a huge, yet incomplete, archive

of seeing what Deborah Willis has described of his work as "the normalcy of black life."[22] According to Charles A. Harris, Teenie Harris's eldest son who collaborates with Carnegie Museum of Art to exhibit and archive his father's work, the photographer aimed for a representational practice that normalized black lived subjects, as a counterpoint to narratives of invisibility or deviant hypervisibility that circulated in mainstream media:

> One of the things that really bothered him was the uneven hand in the way that the mainstream newspapers handled the community, the Hill District community as a whole. They never had anything positive in the mainstream press, but if it was something negative, then you might see that in the newspapers. His problem was that people in the community had nothing to look at that was from a positive standpoint, to show them just how that community was. And that community was just like any other community in a sense. I would say that it had everything in the community that was in downtown Pittsburgh and this is because of the race situation at the time. There was still quite a bit of segregation, so that the Hill District was forced to be self-sufficient. So when they got the newspaper on Saturday, as I said before, they saw pictures of kids' birthday parties, and they saw all kinds of activities, different social activities, as well as sports activities, which normalized them, just as the mainstream press would normalize the average everyday life.[23]

While the notion of "positive" and the aim to "normalize" lend Harris's work to critique of how such images reproduce dominant codes of gender, family, and progress, I read the idea of normalcy in his work in interventionist terms of producing visual subjects who have been excluded from dominant society and public memory, especially during segregation. Judith Butler's writing on norm, normalization, and normativity helps to explicate how some subjects are afforded a "livable existence" and how others are excluded through "socially instituted relations." Butler looks at the dual meaning of normativity as "the aims and aspirations that guide us, the precepts by which we are compelled to act or speak to one another, the commonly held presuppositions by which we are oriented, and which give direction to our actions." The second meaning is more binding and exclusionary as "the process of normalization, the way that certain norms, ideas and ideals hold sway over embodied life, provide coercive criteria for normal 'men' and 'women,'" Butler does not call for a doing away with norms but that we "extend the norms that support viable life."[24] Such a revision would expand our understanding of intelligible life. In this sense, Harris's

practice renders black living beings as intelligible and subjects of value.

Notes

1. Martha Rosler, "In, Around, and Afterthoughts On Documentary Photography," in *The Photography Reader*, ed. Liz Wells (New York: Routledge, 2003), 262.

2. The FSA Photographic Project, under the direction of Roy Stryker, created thousands of images, including Dust Bowl refugees, migrant laborers, rural poverty, and Japanese American internment, which were meant to serve the New Deal legislation and garner public support for Franklin Delano Roosevelt's policies to recover from the Great Depression. See William Stott, *Documentary Expression and Thirties America* (Chicago: University of Chicago Press, 1986): James Curtis, *Mind's Eye, Mind's Truth: FSA Photography Reconsidered* (Philadelphia: Temple University Press, 1992); Alan Trachtenberg, *Reading American Photographs: Images as History, Matthew Brady to Walker Evans* (New York: Hill and Wang, 1990); James Curtis, "Making Sense of Documentary Photography," from the Making Sense of Evidence series on *History Matters: The U.S. Survey on the Web*, located at http://historymatters.gmu.edu: 4 (accessed July 5, 2008).

3. See Martha Rosler's analysis of one of the most reproduced images in the world, Dorothea Lange's *Migrant Mother*, which was photographed in 1936 as part of the FSA project. Rosler asks what happens to the historic subjects of many of these iconic images. She looks at the news coverage of Florence Thompson, the mother photographed in *Migrant Mother*, who continued a lifetime of poverty. Rosler considers the incongruity between the life of the historic subject photographed and its reception and continued circulation. She quotes Thompson as saying that she has not benefited materially from the image and has tried unsuccessfully to stop its circulation. Rosler quotes Roy Stryker, the director of the FSA Photographic Project, as stating about the photograph, "To me, it was the picture of Farm Security.... She has all of the suffering of mankind in her but all of the perseverance too.... You can see anything you want to in her. She is immortal" ("In, Around, and Afterthoughts," 267).

4. While the rationale behind the FSA Photographic Project was abundantly clear to photographers and for the most part to audiences, the depiction of race within the FSA School was filled with ambiguity. As has been well documented, FSA photographers were encouraged to focus more attention on the plights of rural whites given the administration's belief that these images would generate more sympathy from the national public than images of blacks. Whites were considered more deserving of government aid. See Nicholas Natanson, *The Black Image in the New Deal: The Politics of FSA Photographs* (Knoxville: University of Tennessee Press, 1992). In many instances where FSA photographers worked to document black subjects, dominant racial discourse dictated their crafting. James Curtis examines how Arthur Rothstein's images of blacks at Gee's Bend, Alabama, were orchestrated in such a way to support racial assumptions of the time, even if it meant denying or reimagining the personal narratives and biographical details of the photographic subjects. See Curtis, "Making Sense of Documentary Photography," 8–9.

5. Maren Stange, *Symbols of Ideal Life: Social Documentary Photography in America 1890–1950* (Cambridge: Cambridge University Press, 1989), xii.

6. David A. Bailey and Stuart Hall, "The Vertigo of Displacement," in *The Photography Reader*, ed. Wells, 381.

7. While Parks and DeCarava's careers overlapped with Harris, they are about fifteen years younger than Harris.

8. See DeCarava's collaboration with Langston Hughes, *The Sweet Flypaper of Life* (New York: Simon and Schuster, 1955), which focuses on working-class families and urban life in Harlem.

9. Deborah Willis, *Reflections in Black: A History of Black Photographers 1840 to the Present* (New York and London: W. W. Norton & Company, 2000), 89.

10. In her study, *The Art of History: African American Women Artists Engage the Past*, Lisa Gail Collins describes how Parks spent a month with Watson documenting her everyday life. As part of this time with her, another iconic image emerged titled *Children with Doll* (1942). The image depicts Watson's young granddaughter and grandson crouched in a barren corner holding a white doll. Collins writes that Gordon "staged a picture of her grandchildren with their white doll in order to expose the critical lack of economic resources in the grandmother–led household, despite her hard work.... Through this work, Parks tried to increase viewers' awareness of poverty and racial discrimination and to foster their indignation that children were in physical danger due to these social conditions" (106).

11. Gordon Parks, "Half Past Autumn," interview by Phil Ponce, January 6, 1998, NewsHour, http://www.pbs.org/newshour/bb/entertainment/jan–june98/gordon_1-6.html.

12. Roland Barthes, *Camera Lucida*, trans Richard Howard (New York: Hill and Wang, 1981), 88–89.

13. Martin Berger, "Civil Rights Photography and the Politics of Race in the 1960s America," unpublished draft of "The Formulas of Documentary Photography," in *In Black and White: Civil Rights Photography and 1960s America* (Berkeley: University of California Press, 2011).

14. Leigh Raiford, ""Come Let Us Build a New World Together": SNCC and Photography of the Civil Rights Movement," *American Quarterly* 59, no. 4 (December 2007): 1129–57.

15. Renee C. Romano and Leigh Raiford, "Introduction: The Struggle over Memory," in *The Civil Rights Movement in American Memory*, ed. Romano and Raiford (Athens, GA: University of Georgia Press, 2006), xiv.

16. Ibid., xvii.

17. I place "African American" in quotation marks because of the controversy that ensued during the election about whether Obama is African American, given that he is not a descendant of American slavery (although his white ancestors have a legacy in slave-owning). See Tavia Nyong'o's *The Amalgamation Waltz: Race, Performance, and the Ruses of Memory* (Minneapolis: University of Minnesota Press, 2009) for an astute analysis. Regarding the anticipation of declaring this historical marker, see *New York Times* headline "Obama Elected President as Racial Barrier Falls,"

November 5, 2008. Also several sources announced that CNN topped all networks for viewership on November 4, 2008, the night of the 2008 presidential elections. Immediately afterward, CNN ran several commercials touting its rating. See "Election Night Ratings Blowout: 71.5 Million Watch Obama Win," *The Hollywood Reporter*, http://www.thrfeed.com/2008/11/election -rating.html.

18. It is the movement toward "a more perfect union," as Obama phrased it in his 2008 Philadelphia address while campaigning to be the Democratic contender for United States president. Barack Obama, "A More Perfect Union" speech, Philadelphia, March 18, 2008, http://www.barackobama.com/2008/03/18/remarks_of _senator_barack_obam_53.php.

19. The Contemporary play *The Good Negro* engages with the use of visuality to forward notions of blacks as deserving of full citizenship status during the era.

20. *Moneta Sleet, Jr.: Pulitzer Prize Photojournalist*, Schomburg Center for Research in Black Culture's Traveling Exhibition Program, curated by Julia Van Haaften and Deborah Willis, New York City, November 8, 2007–December 31, 2007. Sleet worked for *The Amsterdam News* and *Our World* before joining the staff of *Ebony* magazine, for which he documented the civil rights struggles in the United States as well as the rise in independent African nations.

21. Doris E. Saunders, ed., *Special Moments in African-American History: 1955–1996. The Photographs of Moneta Sleet Jr., Ebony Magazine's Pulitzer Prize Winner* (Chicago: Johnson Publishing, 1998), 140.

22. Deborah Willis, interview, in *One Shot Harris: The Photographs of Charles "Teenie" Harris* (New York: Abrams, 2002). Transcribed by the author.

23. Charles A. Harris, telephone interview with author, November 12, 2009.

24. Judith Butler, *Undoing Gender* (New York: Routledge), 206, 225.

EXCERPTS

Blues People: The Negro Experience in White America and the Music that Developed from It

LeRoi Jones

Chapter 4: "Afro-Christian Music and Religion," 31–49. New York: Morrow, 1963

When the first slaves were brought to this country, there was no idea at all of converting them. Africans were thought of as beasts, and there was certainly no idea held among the whites that, somehow, these beasts would benefit by exposure to the Christian God. As late as the twentieth century there have been books "proving" the Negro's close relationship to lower animals that have been immensely popular in the South. The idea that perhaps slavery could be condoned as a method for converting heathens to the Christian God did not become popular until the latter part of the eighteenth century, and then only among a few "radical" Northern missionaries. There could be no soul-saving activities, N. N. Puckett points out in his book *Folk Beliefs of the Southern Negro*, where there was no soul.[1]

But still Christianity was adopted by Negroes before the great attempts by missionaries and evangelists in the early part of the nineteenth century to convert them. The reasons for this grasping of the white man's religion by the North American Negro are fairly simple. First, his own religion was prohibited in this country. In some parts of the South, "conjuring" or use of "hoodoo" or "devil talk" was punishable by death or, at the very least, whipping. Also, the African has always had a traditional respect for his conqueror's gods. Not that they are always worshiped, but they are at least recognized as powerful and placed in the hierarchy of the conquered tribe's gods.

The growing "social awareness" of the slave can be mentioned as another reason for the African's swift embrace of the white man's God: social awareness in the sense that the African, or at least his progeny, soon realized that he was living in a white man's world. Not only was it an ancient African belief that the stronger tribe's gods were to be revered, but the African was also forced to realize that all the things he thought important were thought by the white man to be primitive nonsense. The constant contact between black and white in the United States must have produced in the black man a profound anxiety regarding the reasons for his status and the reasons for the white man's dominance. The African's belief in "stronger gods" assuaged or explained slavery for the African slave and was, perhaps, a partial

explanation for his rapid adoption of pre-missionary Christianity. But for the American slave, Christianity was attractive simply because it was something the white man did that the black man could do also, and in the time of the missionaries, was encouraged to do. The house Negroes, who spent their lives finding new facets of the white culture that they could imitate, were the first to adopt Christianity. And they and their descendants, even today, practice the most European or American forms of Christianity. The various black Episcopal and Presbyterian churches of the North were invariably started by the black freedmen, who were usually the sons and daughters of "house niggers." The strange "melting pot" of the United States, where after a few decades the new African slaves were ridiculed by their "American" brothers because they were African! And this was for purely "social" reasons. That is, the slaves who had come to America only a few years earlier began to apply what they thought were the white man's standards to their own behavior as well as to that of their newly arrived brothers.

> *Sinner, what you gonna do*
> *When de World's on fi-er?*
> *Sinner, what you gonna do*
> *When de world's on fi-er?*
> *Sinner, what you gonna do*
> *When de world's on fi-er?*
> *O my Lawd.*[2]

Because the African came from an intensely religious culture, a society where religion was a daily, minute-to-minute concern, and not something relegated to a specious once-a-week reaffirmation, he had to find other methods of worshiping gods when his white captors declared that he could no longer worship in the old ways. (The first slaves thought of the white men as captors; it was later, after they had become Americans, that they began to think of these captors as masters and themselves as slaves, rather than captives.) The immediate reaction of course, was to try to worship in secret. The more impressive rites had to be discarded unless they could be performed clandestinely; the daily rituals, however, continued. The common day-to-day stance of the African toward his gods could not be erased overnight. In fact, many of the "superstitions" of the Negroes that the whites thought "charming" were holdovers from African religions. Even today in many Southern rural areas, strange mixtures of voodoo, or other primarily African fetish religions, and Christianity exist. Among less educated, or less sophisticated, Negroes the particular significance of dreams, luck and lucky charms, roots and herbs, is directly attributable to African religious beliefs. Also, many aphorisms used by Negroes in strictly social situations spring from African religion.

For example, there was recently a rhythm & blues song that talked of "Spreading goober dust all around

your bed/When you wake up you find your own self dead." To most whites (and indeed to most modern sophisticated city Negroes) the song was probably catchy but essentially unintelligible. But now in 1963, one hundred years after the Emancipation of slaves, there exists a song integrated somewhat into the mainstream of American society that refers directly to an African religious belief. (A goober is what a peanut is called by many Southern Negroes. The word itself comes from the African word gooba, which is a kind of African nut. In Africa the ground-up gooba was used to conjure with, and was thought to give one person power over another if the ground gooba ("goober dust") was spread around the victim's hut. In the South, peanut shells spread in front of someone's door supposedly cause something terrible to happen to him.)

"Never go to bed on an empty stomach," my grandmother has told me all my life. Perhaps the origins of this seemingly health-conscious aphorism have been forgotten even by her. But the Africans believed that evil spirits could steal your soul while you slept if your body was empty. "If the sun is shining and it is raining at the same time, the devil's beating his wife." "Sweeping out the house after dark is disrespectful." Both these aphorisms I heard when I was younger, and they are both essentially African. The latter refers to the African's practice of praying each night for the gods to protect him while he slept from evil spirits; it was thought that the benevolent gods would actually descend and sit in one's house. Sweeping at night, one might sweep the guardian out since he was invisible. The "gods" of the African eventually became "The Holy Ghos'" of the American Negro.

And so to "outlaw" the African slave's religion completely was impossible, although the circumstance of slavery did relegate religious practice to a much smaller area of his life. But the African could not function as a human being without religion; he daily invoked the "conjure men," herb doctors and root healers, cult priests and sorcerers—the mystical forces he thought controlled the world. The sorcerer was consulted each day to find out the disposition of the gods toward a man and his activities, just as we dial our phones for the weather report.

The first attempts by Negroes to openly embrace the white Christ were rebuffed, sometimes cruelly, because of the Christian theologians' belief that Africans were beasts, literally, lower animals. "You would not give oxen the holy scripture." Also, on a slightly more humane level, it was thought by white Christians that if the Africans were given Christianity, there could be no real justification for enslaving them, since they would no longer be heathens or savages. In spite of this, the slaves did go off into the woods to hold some semblance of a Christian rite when they could. By the beginning

Souvenir folder from The Blue Note,
Philadelphia, date unknown

of the nineteenth century, however, against the wishes of most of the planters and slave owners, attempts were made to convert the slaves because of the protests of the Quakers and other religious groups.

Fannie Kemble, in her journal of 1838 and 1839, reported: "*You have heard, of course, many* and contradictory statements as to the degree of religious instruction afforded to the Negroes of the South, and their opportunities of worship, etc. Until the late abolition movement, the spiritual interests of the slaves were about as little regarded as their physical necessities. The outcry which has been raised with threefold force within the last few years against the whole system has induced its upholders and defenders to adopt, as measures of personal extenuation, some appearance of religious instruction (such as it is), and some pretense at physical indulgences (such as they are), bestowed apparently voluntarily upon their dependents. At Darien a church is appropriated to the especial use of the slaves, who are almost all of them Baptists here; and a gentleman officiates it (of course, white) who, I understand, is very zealous in the cause of the spiritual well-being. He, like most Southern men, clergy or others, jump the present life in their charities to the slaves, and go on to furnish them with all requisite conveniences for the next."[3]

She added: "Some of the planters are entirely inimical to any such proceedings and neither allow their Negroes to attend worship, or to congregate together for religious purposes. . . . On other plantations, again, the same rigid discipline is not observed; and some planters and overseers go even farther than toleration, and encourage these devotional exercises and professions of religion, having actually discovered that a man may become more faithful and trustworthy, even as a slave, who acknowledges the higher influences of Christianity. . . ."[4]

The ambivalent attitude of the slave-holders toward the conversion of the slaves to Christianity is further illustrated by another of Miss Kemble's observations: ". . . this man is known to be a hard master; his Negro houses are sheds not fit to stable beasts in; his slaves are ragged, half-naked, and miserable; yet he is urgent for their religious comforts, and writes to Mr. Butler about 'their souls—their precious souls.'"[5]

The Quakers and other religious groups began to realize that the only justification for slavery was that the slaves could be converted to Christianity, and the great missionary and evangelistic movements of the nineteenth century began. Some of the churches, such as the Methodist and Baptist began to send ministers among the slaves to convert them. Soon the grossest disparagement the "religious" Negro could make of another was that he or she was "a heathen." (When I spilled food on the table or otherwise acted with boyish slovenliness, my grandmother would always think to dress me down by calling me "a heathen.")

The emotionalism and evangelism of the Methodists and Baptists appealed much more to the slaves than any of the other denominations. Also the Baptists, especially, allowed the Negroes to participate in the services a great deal and began early to "appoint" black ministers or deacons to conduct the services while the missionaries themselves went on to other plantations. And on the poorer plantation the lower-class white was more apt to be Baptist or Methodist than Episcopal or Presbyterian. Another, possibly more important reason why the Negroes were drawn to the Baptist Church was the method of conversion. Total immersion in water, which is the way Baptists symbolize their conversion to the "true church" and the teachings of Christ, in imitation of Christ's immersion by Saint John "The Baptist" was perhaps particularly attractive to the early slaves because in most of the religions of West Africa the river spirits were thought to be among the most powerful of the deities, and the priests of the river cults were among the most powerful and influential men in African society.

The Christian slave became more of an American slave, or at least a more "Westernized" slave, than the one who tried to keep his older African traditions. The slave masters also learned early that the Africans who had begun to accept the Christian ethic or even some crude part of its dogma were less likely to run away or start rebellions or uprisings. Christianity, as it was first given to the slaves (as Miss Kemble pointed out), was to be used strictly as a code of conduct which would enable its devotees to participate in an afterlife; it was from its very inception among the black slaves, a slave ethic. It acted as a great pacifier and palliative, although it also produced a great inner strength among the devout and an almost inhuman indifference to pain. Christianity was to prepare the black man for his Maker, and the anthropomorphic "heben" where all his "sins and suffering would be washed away." One of the very reasons Christianity proved so popular was that it was the religion, according to older Biblical tradition, of an oppressed people. The struggles of the Jews and their long-sought "Promised Land" proved a strong analogy for the black slaves.

> *Mary, don't you weep an' Marthie don't you moan,*
> *Mary, don't you weep an' Marthie don't you moan;*
> *Pharaoh's army got drown-ded,*
> *Oh Mary don't you weep.*
>
> *I thinks every day an' I wish I could*
> *Stan' on de rock whar Mose stood*
> *Oh, Pharaoh's army got drown-ded,*
> *Oh Mary don't you weep.*

The Christianity of the slave represented a movement away from Africa. It was the beginning of Africa as "a foreign place." In the early days of slavery, Christianity's sole purpose was to propose a metaphysical resolution

for the slave's natural yearnings for freedom, and as such it literally made life easier for him. The secret African chants and songs were about Africa, and expressed the African slave's desire to return to the land of his birth. The Christian Negro's music became an expression of his desire to "cross Jordan" and "see his Lord." He no longer wished to return to Africa. (And one can see, perhaps, how "perfect" Christianity was in that sense. It took the slave's mind off Africa, or material freedom, and proposed that if the black man wished to escape the filthy paternalism and cruelty of slavery, he wait, at least, until he died, when he could be transported peacefully and majestically to the Promised Land.)

> *Gonna shout trouble over*
> *When I get home,*
> *Gonna shout trouble over*
> *When I get home.*
>
> *No mo' prayin', no mo' dyin'*
> *When I get home.*
> *No mo' prayin' an' no mo' dyin'*
> *When I get home.*
>
> *Meet my father*
> *When I get home,*
> *Meet my father*
> *When I get home.*

The religious imagery of the Negro's Christianity is full of references to the suffering and hopes of the oppressed Jews of Biblical times. Many of the Negro spirituals reflect this identification: *Go Down, Moses, I'm Marching to Zion, Walk Into Jerusalem Just Like John*, etc. "Crossing the river Jordan" meant not only death but also the entrance into the very real heaven and a release from an earthly bondage; it came to represent all the slave's yearnings to be freed from the inhuman yoke of slavery. But at the time, at least for the early black Christian, this freedom was one that could only be reached through death. The later secular music protested conditions here, in America. No longer was the great majority of slaves concerned with leaving this country (except, perhaps, the old folks who sat around and, I suppose, remembered). This was their country, and they became interested in merely living in it a little better and a little longer.

The early black Christian churches or the pre-church "praise houses" became the social focal points of Negro life. The relative autonomy of the developing Negro Christian religious gathering made it one of the only areas in the slave's life where he was relatively free of the white man's domination. (Aside from the more formally religious activities of the fledgling Negro churches, they served as the only centers where the slave community could hold strictly social functions.) The "praise nights," or "prayer meetings," were also the only times when the Negro felt he could express himself as freely and

emotionally as possible. It is here that music becomes indispensable to any discussion of Afro-Christian religion.

"The spirit will not descend without song."

This is an old African dictum that very necessarily was incorporated into Afro-Christian worship. The Negro church, whether Christian or "heathen," has always been a "church of emotion." In Africa, ritual dances and songs were integral parts of African religious observances, and the emotional frenzies that were usually concomitant with an African religious practice have been pretty well documented, though I would suppose, rarely understood. This heritage of emotional religion was one of the strongest contributions that the African culture made to the Afro-American. And, of course, the tedious, repressive yoke of slavery must well have served to give the black slave a huge reservoir of emotional energy which could be used up in his religion.

"Spirit possession," as it is called in the African religions, was also intrinsic to Afro-Christianity. "Gettin' the spirit," "gettin' religion" or "gettin' happy" were indispensable features of the early American Negro church and, even today, of the non-middle-class and rural Negro churches. And always music was an important part of the total emotional Configuration of the Negro church, acting in most cases as the catalyst for those worshipers who would suddenly "feel the spirit." "The spirit will not descend without song."

The first Afro-Christian music differed from the earlier work songs and essentially nonreligious shouts first of all in its subject matter and content. Secondly, the religious music became much more melodic and musical than the field hollers because it was sung rather than grunted or "hollered." (Though no aspect of Negro song is completely without the shout, if later, only as an element of style.) Also, this religious music was drawn from many sources, and represented, in its most mature stage, an amalgam of forms, styles, and influences.

Christianity was a Western form but the actual practice of it by the American Negro was totally strange to the West. The American Negro's religious music developed quite similarly, taking its superficial forms (and instrumentation, in many cases) from European or American models, but there the imitation ended. The lyrics, rhythms, and even the harmonies were essentially of African derivation, subjected, of course, to the transformations that American life had brought into existence. The Negro's religious music was his original creation, and the spirituals themselves were probably the first completely *native American* music the slaves made. When I refer to the Negro's religious music, however, I mean not only the spiritual, which is used, I am aware, as a general catchall for all the nonsecular music made by the American black man, but I am referring as well to the church marches, ring and shuffle shouts, "sankeys,"

chants, camp or meetin' songs and hymns or "ballits," that the Afro-Christian church produced.

But even as the masses of Negroes began to enter the Christian Church and get rid of their "heathenisms," Africa and its religious and secular traditions could not be completely shaken off. In fact, as Borneman points out: "The Methodist revival movement began to address itself directly to the slaves, but ended up not by converting the Africans to a Christian ritual, but by converting itself to an African ritual."

The more conscientious Christian ministers among the slaves sought to get rid of "all dem hedun ways," but it was difficult. For instance, the Christian Church saw dancing an evil worldly excess, but dancing as an integral part of the African's life could not be displaced by the still white notes of the *Wesleyan Hymnal*. The "ring shouts" or "shuffle shouts" of the early Negro churches were attempts by the black Christians to have their cake and eat it: to maintain African tradition, however veiled or unconscious the attempt might be, yet embrace the new religion. Since dancing was irreligious and sinful, the Negro said that only "crossing the feet" constituted actual dancing. So the ring shout developed, where the worshipers link arms and shuffle, at first slowly but then with increasing emotional display, around in a circle, singing hymns or chanting as they move. This shuffle, besides getting around the dogma of the stricter "white folks" Christianity also seems derived from African religious dances of exactly the same nature. "Rocking Daniel" dances and the "Flower Dance" were among the dances that the black Christians allowed themselves to retain. The so-called "sanctified" Protestant churches still retain some of these "steps" and "moo-mens" today. And indeed, the "sanctified" churches always remained closer to the African traditions than any of the other Afro-Christian sects. They have always included drums and sometimes tambourines in their ceremonies, something none of the other sects ever dared do.

A description of a typical Afro-Christian church service is found in H. E. Krehbiel's book. Krehbiel had excerpted it from the May 30, 1867, issue of *The Nation*:

> . . . the benches are pushed back to the wall when the formal meeting is over, and old and young, men and women, sprucely dressed young men, grotesquely half-clad field hands—the women generally with gay handkerchiefs twisted about their heads and with short skirts—boys with tattered shirts and men's trousers, young girls bare-footed, all stand up in the middle of the floor, and when the 'sperichil' is struck up begin, first walking and by and by shuffling around, one after the other, in a ring. The foot is hardly taken from the floor, and the progression is mainly due to a jerking, hitching motion which agitates the entire shouter, and soon

> brings out streams of perspiration. Sometimes they dance silently, sometimes as they shuffle they sing the chorus of the spiritual, and sometimes the song itself is also sung by the dancers. But more frequently a band, composed of some of the best singers and of tired shouters, stand at the side of the room to 'base' the others, singing the body of the song and clapping their hands together or on the knees. Song and dance are alike extreme energetic, and often, when the shout lasts into the middle of the night, the monotonous thud, thud of feet prevents sleep within half a mile of the praise house.[7]

The music that was produced by Negro Christianity was the result of diverse influences. First of all there was that music which issued from pure African ritual sources and which was changed to fit the new religion—just as the ring shouts were transformed from pure African religious dances to pseudo-Christian religious observance, or the Dahomey river cult ceremonies were incorporated into the baptism ceremony. Early observers also pointed out that a great many of the first Negro Christian religious songs had been taken almost untouched from the great body of African religious music. This was especially true of the melodies of certain black Christian spirituals that could also be heard in some parts of Africa.

Maude Cuney-Hare, in her early book *Negro Musicians and Their Music*, cites the experience of a Bishop Fisher of Calcutta who traveled to Central Africa: ". . . in Rhodesia he had heard natives sing a melody so closely resembling *Swing Low, Sweet Chariot* that he felt that he had found it in its original form: moreover, the region near the great Victoria Falls have a custom from which the song arose. When one of their chiefs, in the old days, was about to die, he was placed in a great canoe together with trappings that marked his rank, and food for his journey. The canoe was set afloat in midstream headed toward the great Falls and the vast column of mist that rises from them. Meanwhile the tribe on the shore would sing its chant of farewell. The legend is that on one occasion the king was seen to rise in his canoe at the very brink of the Falls and enter a chariot that, descending from the mists, bore him aloft. This incident gave rise to the words 'Swing Low, Sweet Chariot,' and the song, brought to America by African slaves long ago, became anglicized and modified by their Christian faith."[8]

It would be quite simple for an African melody that was known traditionally to most of the slaves to be used as a Christian song. All that would have to be done was change the words (which is also the only basic difference between a great many of the "devil music" songs and the most devout of the Christian religious songs. Just as many high school students put their own words to the tune *Yankee Doodle Dandy*, for whatever purpose, the converted slave had only to alter his lyrics to make

the song "Christian"). Of course, the point here is that the slave had to be able to change the words, that is, he had to know enough of the language in which the new religion was spoken so that he could make up lyrics in that language. Christian songs in African tongues are extremely rare, for obvious reasons. (What is the word for God in any of the African dialects? The answer would be: Which god?)

Almost all parts of the early Negro Christian church service had to do in some way with music, which was also true of the African religions. And not only were African songs transformed into a kind of completely personal Christian liturgical music but African prayers and chants as well. The black minister of an early Christian church (as well as the Negro ministers of today's less sophisticated black churches) himself contributed the most musical and most emotional parts of the church service. The long, long, fantastically rhythmical sermons of the early Negro Baptist and Methodist preachers are well known. These men were singers, and they sang the word of this new God with such passion and belief, as well as skill, that the congregation had to be moved. The traditional African call-and-response song shaped the form this kind of worship took on. The minister would begin slowly and softly, then build his sermon to an unbelievable frenzy with the staccato punctuation of his congregation's answers. "Have you got good religion?/Certainly, Lord," is the way one spiritual goes, modeled on the call-and-response, preacher-to-congregation type of song. When the preacher and the congregation reach their peaks, their music rivals any of the more formal Afro-American musics in intensity and beauty.

Oh, my Lawd, God, what happened when Adam took de apple? (Amen, Amen). Yas, didn't de Lawd tell dat po' foolish sinner not to listen to that spiteful wo-man? (Amen, Amen). Yas, Lawd, Did he tell him or no? (Amen, Amen, Yas he told him, brother). And what did Adam do, huh? Yas, Lawd, after you told him not to, what did he do? (Amen, Amen, brother, preach, preach).

Another kind of song that the Negro church produced in America was one based on European or American religious (and sometimes secular) songs. In these songs the words often remained the same (with, of course, the natural variances of Negro speech). For instance, Puckett seemed puzzled by the use of the word *fellom-city* in Negro spirituals. The word, most old Negroes say, means some kind of peace, so I would think the word to be felicity. The melodies of many of the white Christian and European religious songs which the Negros incorporated into their worship remained the same, but the Negroes changed the rhythms and harmonies of these songs to suit themselves. The very fact that the Negroes sang these songs in their peculiar way, with not only the idiosyncratic American idiom of early Negro speech but the inflection, rhythm and stress of that speech, also served to shape the borrowed songs to a strictly Negro idiom. And usually, no matter how closely a Negro spiritual might resemble superficially one of the white hymns taken from sources like the *Bay Psalm Book*, the *Wesleyan Hymnal*, the *Anglican Hymnal*, or the *Moody Hymnal*, when the song was actually sung, there could be no mistake that it had been made over into an original Negro song. A very popular white Christian hymn like *Climb Jacob's Ladder* is completely changed when sung in the Negro church as *Climin' Jacob's Ladda. Jesus, Lover of my Soul*, a song out of the *Sankey Hymnal*, is changed by the Shouting Baptists of Trinidad into an unmistakably African song. And, as Herskovits noted, in a great many parts of the West Indies, all the Protestant pseudo-Christian religious songs are called "sankeys."

Rhythmic syncopation, polyphony, and shifted accents, as well as the altered timbral qualities and diverse vibrato effects of African music were all used

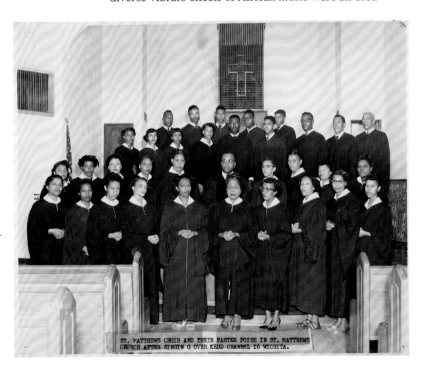

St. Matthew's Church choir and pastor after singing on KEDD Channel 16 Wichita, Kansas, date unknown. Photograph by Leon K. Hughes

by the Negro to transform most of the "white hymns" into Negro spirituals. The pentatonic scale of the white hymn underwent the same "aberrations" by which the early musicologists characterized African music. The same chords and notes in the scale would be flattened or diminished. And the meeting of the two different musics, the white Christian hymn and the Negro spiritual using that hymn as its point of departure, also produced certain elements that were later used in completely secular music. The first instrumental voicings of New Orleans jazz seem to have come from the arrangement of the singing voices in the early Negro churches, as well as the models for the "riffs" and "breaks" of later jazz music. The Negro's religious music contained the same "rags," "blue notes" and "stop times" as were emphasized later and to a much greater extent in jazz.

The purely social function of the early Negro Christian churches is of extreme importance if one is trying to analyze any area of American Negro culture. First of all, as I have said, because the church for a long time was the only place the slave had for any kind of vaguely human activity. The black churches, as they grew more and more autonomous and freer of the white man's supervision, began to take on social characteristics that, while imitative of their white counterparts in many instances, developed equally, if not more rigid social mores of their own. Not only did the churches sponsor the various social affairs, such as the barbecues, picnics, concerts, etc., but they became the sole arbiters of what kind of affair would be sponsored.

During the time of slavery, the black churches had almost no competition for the Negro's time. After he had worked in the fields, there was no place to go for any semblance of social intercourse but the praise houses. It was not until well after the Emancipation that the Negro had much secular life at all. It is no wonder then that early books about Negro music talked about "the paucity of Negro secular music." The churches called sinful all the "fiddle sings," "devil songs," and "jig tunes"— even the "corn songs" were outlawed by some church elders. Also, certain musical instruments, such as the violin and banjo, were said to be the devil's own. The Negro church, as it was begun, was the only place where the Negro could release the emotions that slavery would naturally tend to curtail. The Negro went to church, literally, to be free, and to prepare himself for his freedom in the Promised Land. But as the church grew more established and began to shape itself more and more in its image of the white man's church, the things it desired to achieve for Negroes began to change. The church began to produce social stations as well. The ministers, deacons, elders, trustees even the ushers, of the Baptist and Methodist churches formed a definite social hierarchy, and that hierarchy dominated the whole of the Negro society. The "backslider" (the sinning churchgoer) and

the "heathen" became in the new theocracy the lowest rungs of the social ladder. And during slavery, the churches controlled by the house Negroes or the "freedmen" imposed even stricter social categories than did the other Negro churches. The churches after a time, of course, became as concerned with social matters as with religion, although all such concerns were still couched in religious terms. And what came to be known as "progress," or "advance," to the growing numbers of willing congregations came to mean merely the imitation of the white man—in practice, if not in theory.

As some indication of this practice, in W. F. Allen's book, published in 1867, when mentioning the "paucity of secular songs" among the Negroes, Allen goes on to say: "We have succeeded in obtaining only a very few songs of this character. Our intercourse with the colored people has been chiefly through the work of the Freedmen's Commission, which deals with the serious and earnest side of the negro character. . . . It is very likely that if we had found it possible to get at more of their secular music we should have come to another conclusion as to the proportion of the barbaric element."[9]

But the end of slavery had, in many ways, a disintegrating effect on the kind of slave culture the church had made possible. With the legal end of slavery, there was now proposed for the Negro masses a much fuller life outside the church. There came to be more and more backsliders, and more and more of the devil music was heard.

Notes

The citations below reflect the information available in the original publication.

1. *Folk Beliefs of the Southern Negro* (Chapel Hill, NC: University of North Carolina Press, 1926).
2. From Howard W. Odum and Guy B. Johnson, *Negro Workaday Songs* (Chapel Hill, NC: University of North Carolina Press, 1926), 195.
3. *Op. cit.*, pp. 92–93.
4. *Ibid.*, p. 106.
5. *Ibid.*
6. *Loc. cit.*, 21.
7. *Op. cit.*, 33.
8. *Op. cit.*, 69.
9. *Slave Songs of the United States* (New York, 1867).

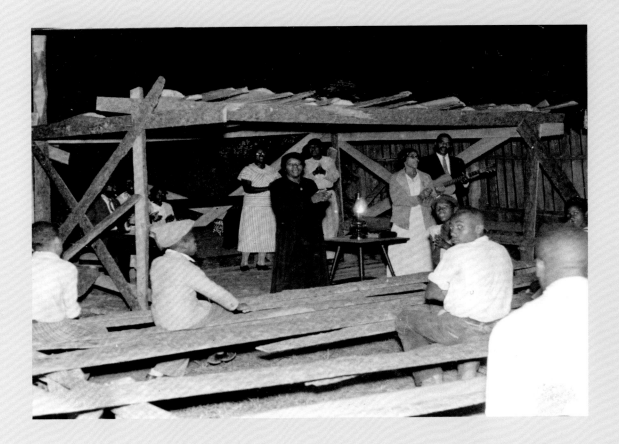

Women leading a worship service,
Mississippi, c. 1920–40, from sociologist
Newbell Niles Puckett's research
documentation of the church life of
African Americans in the Southern
United States

Marian Anderson, Atlantic City,
1941. Photographer unknown

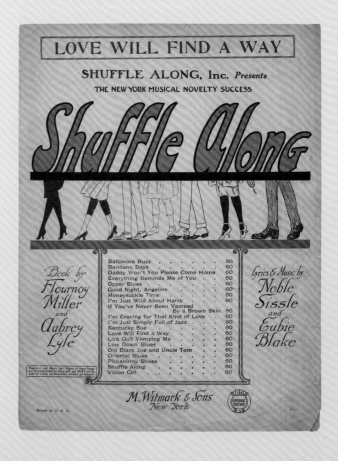

Clockwise from left:

Louis Armstrong and Billie Holiday,
1947. Photographer unknown

Cab Calloway, 1930. Photograph by
James Kriegsmann

Sheet music for "Love Will Find a Way"
by Noble Sissle and Eubie Blake, 1921

Eubie Blake and Noble Sissle,
1935. Photographer unknown

"It's NOT A Man's World"

Bernice White

The Afro-American (Baltimore), October 24, 1970

The National Council of Negro Women Inc. has initiated a Roll Call for a Black Women's Unity Drive. This drive is being sponsored to help mobilize the power of four million black women.

Miss Dorothy Height, national president of NCNW, Inc., has issued an impressive open letter to black women. Following is the text of that appeal.

"We are women, determined to reap the fruits of our labor which is rightfully ours. The history of black people in the United States portrays clearly the prominent role that the black woman has played in the struggle against racism and exploitation.

"As mother, wife, and worker, she had witnessed the frustration and anguish of the men, women and children living in her community.

"The black woman has been a witness to chronic malnutrition, bad housing, inferior education and many other problems that do violence in the lives of people. It is the violence of social, intellectual and economic slavery.

"We in the NCNW are committed to a continuous crusade against this violence. In the rural South where hunger and malnutrition destroy life, we have initiated self-help food production programs.

"We have established day care centers where black children, who are victims of poverty and persecution, can begin to reclaim their lives.

"NCNW has pioneered in initiating Turnkey III—a home ownership program for low-income families.

"A scholarship project has been begun to enable black youth to attend the educational institutions of their choice.

"These are but a few of the ongoing programs launched to combat the problems that do violence in the lives of black people.

"Today black woman united are a powerful force to continue the struggle yet to be won.

"Unity is the only answer to repression. Just as Sojourner Truth, Hariet Tubman, Mary McLeod Bethune, and others stood up to be counted for justice and equality, so now more than ever, you are called to be involved in a meaningful way."

This writer recently heard a male speaker tell a Men's Day audience that black males need a new look,

Members of the class of 1965 at Eastern High School pose for a group portrait during Senior Day, Baltimore, 1964. Photographer unknown

a new psychology, and that they need "no longer look at women to solve problems."

He stated that the black man should seek a renewal of commitment through the religious, educational, and economic institutions of our society, and rise up and take a place in the sun.

All of this is quite good. But wouldn't it be so much better if black men and black women could and would work together in a renewal of this commitment instead of gettign all hung up over the so-called matriarchal society and the repression of the male ego by the female.

The problems facig us are tremendous and it will take the call for unity for black men and women—together—to put this old world right side up again.

All of us should [*illegible*] rather as brothers and sisters, all of us human, all of us understanding, compassionate and realizing we are our brother's keeper.

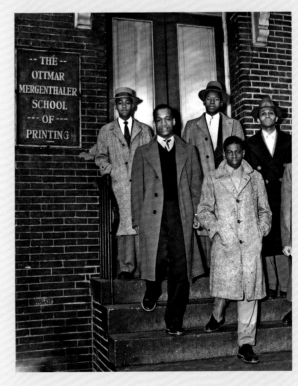

Graduation day at Howard University,
Washington, D.C., 1919. Photographer
unknown

Right: Young students outside the
Ottmar Mergenthaler School of Printing,
Baltimore, 1960. Photographer unknown

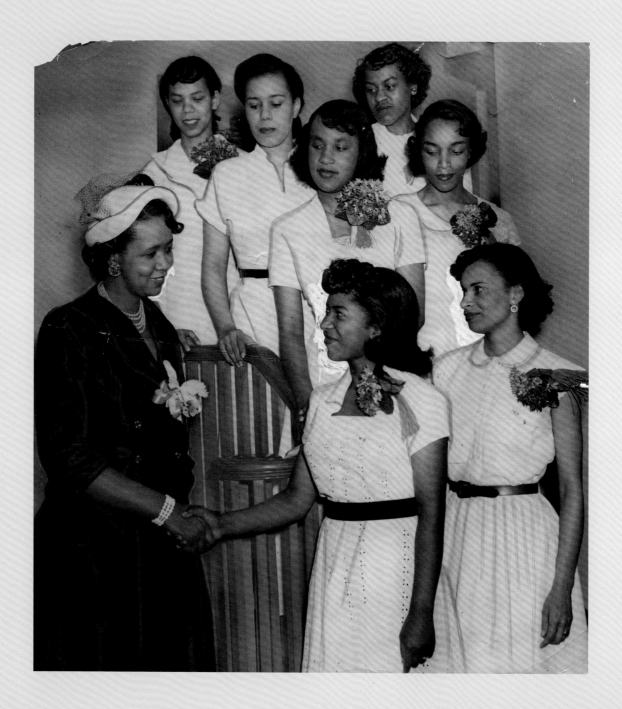

Dorothy I. Height, 10th National President
(1947–56) of Delta Sigma Theta Sorority,
congratulates Anne Talmadge on entering
the sorority, 1950. Photographer unknown

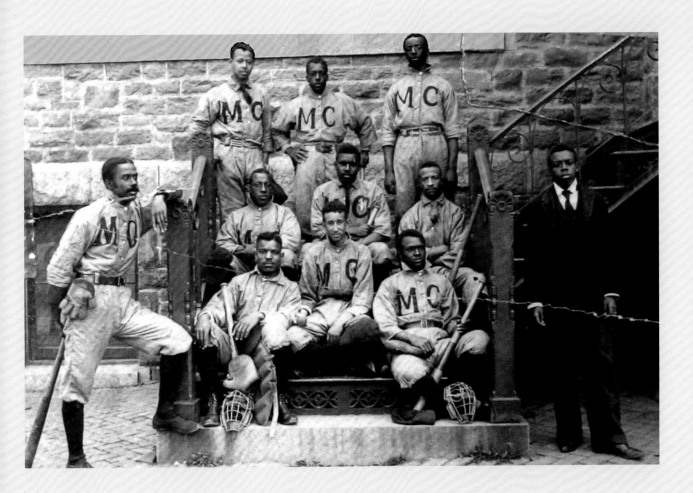

Baseball team of Morgan State College,
Baltimore, 1928. Photographer unknown

Irving Henry Phillips Sr. in the darkroom of
his photography studio, Baltimore, c. 1950s

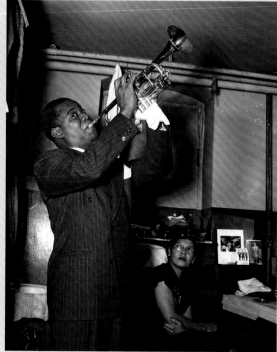

Louis Armstrong performing backstage
at the Royal Theatre, Baltimore, c. 1950s.
Photograph by I. Henry Phillips Sr.

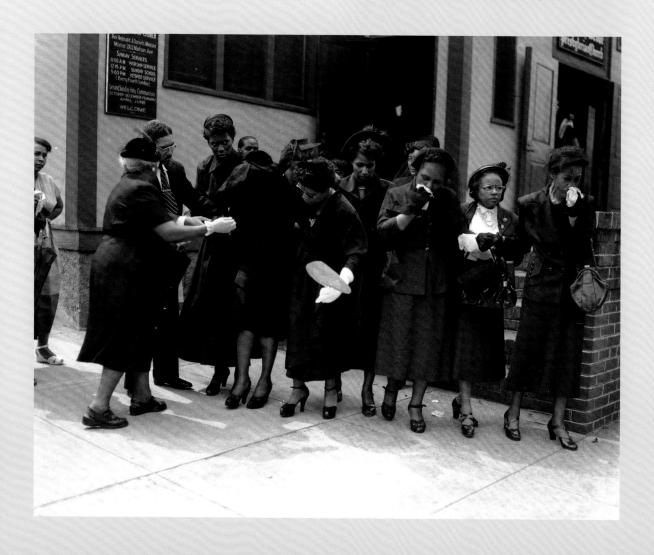

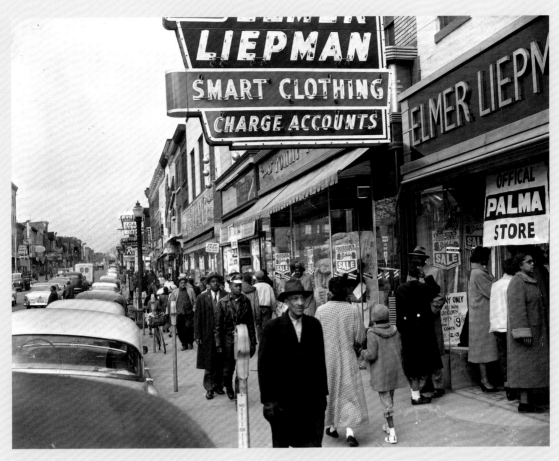

Shoppers along Pennsylvania Avenue, the beating heart of Black business in Baltimore, c. 1950s. Photograph by I. Henry Phillips Sr.

Opposite: Parishioners mourning outside Madison Avenue Presbyterian Church, Baltimore, c. 1950s. Photograph by I. Henry Phillips Sr.

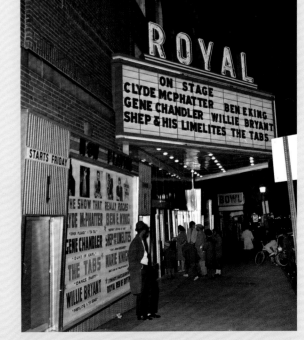

Marquee of the Royal Theatre (est. 1922), an important Black-owned and operated performance venue located on the historic Pennsylvania Avenue corridor, Baltimore, c. 1960s. Photograph by I. Henry Phillips Sr.

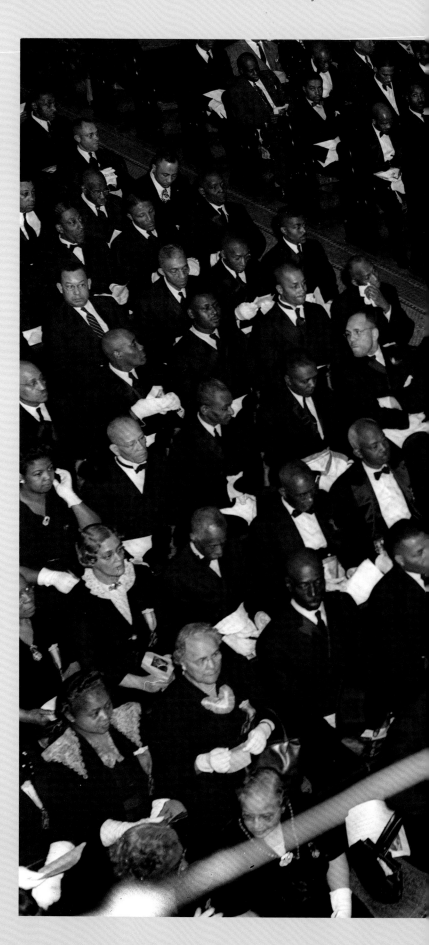

Gathering of a Black fraternal society,
date unknown. Photograph by I. Henry
Phillips Sr.

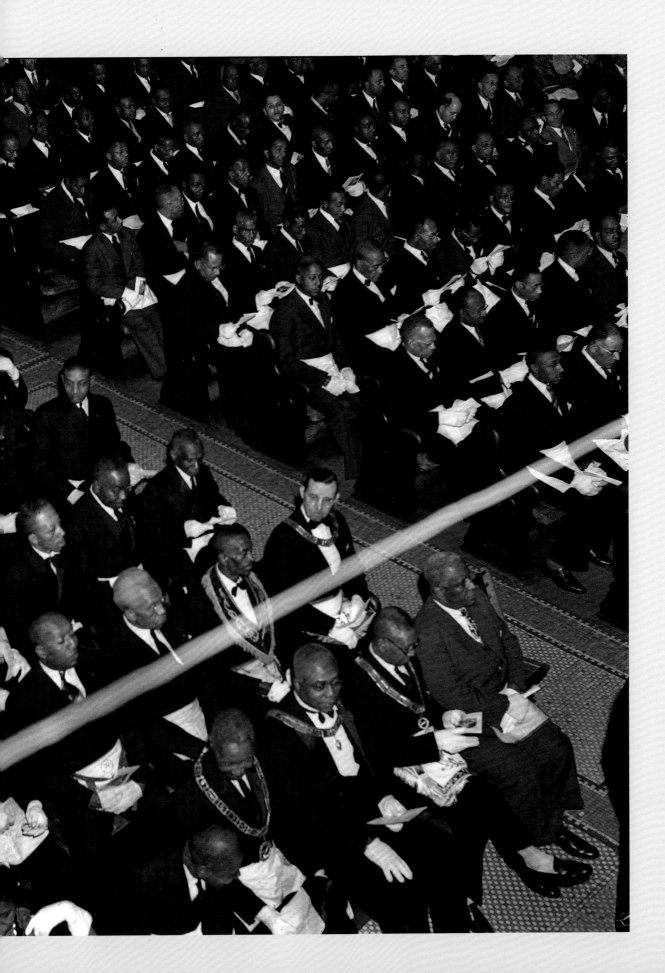

Image and Text Credits: Section III

The permission of rights holders has been obtained whenever necessary and possible. Applicable copyright holders, photographers, and sources beyond those named in the text headers and image captions are as follows.

p. 201: Carl Van Vechten Photograph Collection, Prints and Photographs Division, Library of Congress, LC-DIG-van-5a52142. pp. 202–3, 209, 289: Newbell Niles Puckett Memorial Gift, Cleveland Public Library, Special Collections. pp. 204–17: From *New World A-Coming: Black Religion and Racial Identity During the Great Migration* by Judith Weisenfeld. © 2016 New York University. Used by permission of the publisher. p. 205: Photo by George Rinhart/Corbis via Getty Images. pp. 206, 231, 232 (left and right), 234, 248 (left), 248–49, 251 (top): Photographs and Prints Division, Schomburg Center for Research in Black Culture, The New York Public Library. p. 215: AP Wire/Philadelphia Record photograph morgue [collection V07], Historical Society of Pennsylvania. p. 216: National Archives and Records Administration, National Personnel Records Center, Saint Louis, Missouri. pp. 218–19, 244, 245 (top and bottom), 246, 247, 267 (bottom), 283, 290–91, 292 (left), 295 (top): Robert Langmuir African American Photograph Collection, Stuart A. Rose Manuscript, Archive, and Rare Book Library, Emory University. p. 222 (photo): Jean Toomer Papers, Yale Collection of American Literature, Beinecke Rare Book and Manuscript Library. p. 222 (text): Reprinted with permission of W.W. Norton & Company, Inc. © 2011. pp. 223, 226, 228, 235 (left), 237, 238 (left and right), 239 (left and right), 252: © 2021 The Jacob and Gwendolyn Knight Lawrence Foundation, Seattle / Artists Rights Society (ARS), New York. p. 223: Digital Image © The Museum of Modern Art/Licensed by SCALA / Art Resource, NY. pp. 224, 225: *The Crisis*. The Crisis Publishing Company https://archive.org/details/sim_crisis_1924-11_29_1. p. 224: https://www.jstor.org/stable/i20575388. p. 227: *The Crisis*. The Crisis Publishing Company https://archive.org/details/sim_crisis_1925-01_29_3. p. 228: Photo by Lee Stalsworth. Hirshhorn Museum and Sculpture Garden. p. 229, 240, 292 (top right): Bettmann/Getty Images. p. 232 (left and right): Photo by Andrew Herman, Art Services Project, WPA. p. 234: Photograph © Morgan and Marvin Smith. p. 235 (bottom right): Image © The Metropolitan Museum of Art. Image source: Art Resource, NY. p. 236: © Estate of Norman Lewis; Courtesy of Michael Rosenfeld Gallery LLC, New York, NY. p. 237: Digital image © The Museum of Modern Art/Licensed by SCALA / Art Resource, NY. p. 238 (right): Photo: The Jacob and Gwendolyn Lawrence Foundation / Art Resource, NY. pp. 242–43: Jean Blackwell Hutson Research and Reference Division, Schomburg Center for Research in Black Culture, The New York Public Library. pp. 248–49: Photograph by Austin Hansen, used by permission of the Estate of Austin Hansen. pp. 250–51: Billy Rose Theatre Division, The New York Public Library. pp. 252–56: Reprinted with permission of the author and Studio Museum in Harlem. p. 253 (left): © 2021 Catlett Mora Family Trust / Licensed by VAGA at Artists Rights Society (ARS), NY. p. 254 (left): Image: Courtesy of Michael Rosenfeld Gallery LLC, New York, NY. p. 254 (bottom): © Estate of James Van Der Zee, courtesy Donna Mussenden Van Der Zee. p. 255: Courtesy of the Hayden Family Revocable Art Trust. pp. 256–64: © 1995 by Farah Jasmine Griffin, Oxford University Press, reproduced with permission of the Licensor through PLSclear. p. 265: Carl Van Vechten Photograph Collection, Prints and Photographs Division, Library of Congress, LC-DIG-van-5a51683. p. 266: Photo courtesy Bauman Rare Books. pp. 267 (top), 268–69, 271, 294 (image), 295 (bottom), 296, 297: Photo by Afro American Newspapers/Gado/Getty Images. p. 270: MSS 0281-PH037, Reverend Jack Yates Family and Antioch Baptist Church Collection 1872–1986, The African American Library at The Gregory School, Houston Public Library. pp. 272–76: Reprinted by

Roundtable:
A Movement in Every Direction

On March 16 and 19, 2021, the artists, writers, and curators behind *A Movement in Every Direction* and its accompanying publications convened online to discuss both personal and collective legacies of the Great Migration. This is an edited transcript of the recorded conversations.

Ryan N. Dennis: Thank you for carving out time to talk with us and each other about the Great Migration project. I'd like to do a brief welcome and then we'll open up into some dialogue. I'm Ryan Dennis, Chief Curator and Artistic Director of CAPE (Center for Art and Public Exchange) at the Mississippi Museum of Art (MMA). Now I'll turn it over to my co-curator, Jessica Bell Brown.

Jessica Bell Brown: Hi, everybody, I'm Jessica Bell Brown, Associate Curator of Contemporary Art at the Baltimore Museum of Art (BMA). It's such a delight to bring us all together today. Our goal is to resituate the Great Migration as something that is unfinished, and to center the personal and family narratives of our connections to the South and hold space for Great Migration narratives that fall within that wider familial narrative.

RND: Yes, we are so thankful for an opportunity to put together the con-stellations that are being made within this exhibition, but we also really want to center you all, and just take a moment for y'all to hold space with each other. We want to make sure that collaboration flows throughout the project, and that care and sensitivity is brought around that. So with that, can each of you share who you are, where you're based, and where your people are from?

Jamea Richmond-Edwards: My name is Jamea Richmond-Edwards. Born and raised in Detroit. I'm currently based in Maryland, outside DC— also known as the DMV—and my people are from Georgia, Mississippi, Alabama, South Carolina, and Virginia. I'm a drawer, and I'll be moving to Mississippi later this year.

Torkwase Dyson: My name is Torkwase Dyson. I am based in New York and Newburgh, New York. And my people are from Pensacola, Florida; New Orleans; Maryland; and Montgomery, Alabama.

Larry W. Cook: I'm Larry Cook. I'm based right outside of Washington, DC. My family's from Georgia, North Carolina, and South Carolina.

Theaster Gates: My name is Theaster Gates. I live in Chicago. And my dad is from Silver City, Mississippi. My mom is from Belzoni, Mississippi—Humphreys County is the area. So we're Mississippi people.

Jessica Lynne: Hi, everyone. I'm Jessica Lynne. I live in the Hampton Roads area of Virginia along the Chesapeake Bay. My family is from here, South Carolina, Middle Georgia, and Alabama.

Allison Janae Hamilton: I'm Al Hamilton. I live in New York City, but one year ago today I came back to my hometown in Northern Florida, just across the Georgia border, because New York was quickly becoming the next COVID-19 hotspot. I thought I'd be here for maybe four weeks, six weeks, and I'm still here 365 days later. My mom's side of the family is from Tennessee. That's where our farm is. So I grew up in Florida and spent time in Tennessee for major planting and harvesting seasons. I was born in Kentucky. My dad's side is from the Carolinas. Larry, we might be cousins.

Leslie Hewitt: My name is Leslie Hewitt. I'm from New York—Queens, specifically Saint Albans, by way of Harlem. And I am currently based in Harlem. I'm always very much interested in the return, in being in locations that somehow have marked my existence even before I even was born. My work engages with this type of memory, memory loss, and memory reclamation. My family is definitely marked in the most beautiful way by the Great Migration. On my father's side it's New Bern, North Carolina, and Macon, Georgia. On my mother's side it's New York City.

The maternal side of my family can trace back in New York to 1824. And the paternal side of my mom's family is from Carlisle, Pennsylvania. And in both instances a great deal of my historical narrative comes from pictures and stories, never from my own corporeal memory. My parents were both born in New York and did not engage in making that land-body connection. So this project is really perfect, and comes at the perfect time to make this connection for myself and also for the work.

Zoë Charlton: Hi, y'all. I'm currently living in Baltimore, and I work in DC at American University, where I've been for eighteen years. My people are from the Florida panhandle, and I'm making work and really thinking about the Great Migration through their lens. I am a drawer that makes collages and installations, and sculptures, and animations. I'm really excited about what I'll be doing for the Great Migration project. I love it when I get into things where I don't know what to do, which is going to be kind of fun.

Robert Pruitt: I'm Robert Pruitt. I'm from Houston, Texas. Right now I'm living in New York. My people are from Houston and the country outside of Houston. I make large drawings, and I'm excited to be in the company of all of y'all.

Willie J. Wright: Will Wright, from Houston, Texas. My father's from Franklin, Louisiana, which is thirty minutes south of Lafayette. My mom's people are from Cold Springs, Texas, which is north of Houston. I teach at Rutgers in the departments of geography and Africana studies, but I'm currently in Houston with family.

Sharifa Rhodes-Pitts: Hi, everyone. I'm Sharifa Rhodes-Pitts. I'm a writer. I'm living in the Hudson Valley right now, and have been for a while. And I am from Houston. My family, on my mother's side, is from Texas, from the country outside of Austin. And my dad is from Chicago, of Alabama

origins. His parents are both Migration children. I think a lot about the side that stayed and the side that moved, and how I'm a product of both of those intentions.

"I think a lot about the side that stayed and the side that moved, and how I'm a product of both of those intentions."

Steffani Jemison: Hey everyone. My name is Steffani Jemison. I also teach at Rutgers. I'm an artist. I work with video and other media. I grew up in Cincinnati, Ohio, which is on the border of the North and the South. My mother's family is from Pittsburgh, and my mother's parents are both from a small town on the border of North and South Carolina. My father grew up in Chicago, and his mother's from Mississippi, his father's from Alabama. Happy to be here.

Mark Bradford: My name is Mark Bradford, and I live in Los Angeles. I don't know that much about my people, actually, on both sides. My mother's people are from Coatesville, Pennsylvania, and they're still there. But because their mother died when they were very young, the chain kind of broke. I don't know anything about my father's side. I grew up in Los Angeles. So this will be kind of interesting, actually, for me.

Akea Brionne: Hey y'all. I'm Akea Brionne. I'm originally from New Orleans, Louisiana. My family is from Columbus, Mississippi, and pretty much all around New Orleans, Lafayette, Fazendeville. I am looking a lot at my family's migration from Mississippi to the Southwest, actually to New Mexico, where my mother was born and raised. I'm currently based and live in Baltimore. A lot of my work is centered around photography, lens-based image making in relation to a deep historical research practice. I'm excited to be in conversation with y'all.

Kiese Laymon: My name is Kiese Laymon. I was born and raised in Jackson, Mississippi. I'm a writer and a teacher; I teach at the University of Mississippi right now. I'm very thankful to be here.

Carrie Mae Weems: I'm Carrie Mae Weems. It's wonderful to meet you. I'm looking forward to working on this project. And I'm from Portland, Oregon, born and raised. My family is from Clarksdale, Mississippi, on my mother's side. And on my father's side, from Arkansas.

JBB: In thinking about this project we keep returning to this notion of how we can reckon with history through a contemporary lens. The Great Migration was one of the driving forces of the twentieth century and touched so many Black Americans throughout the country, and really reshaped our nation as such. And while we can narrate through historical context, we felt one of the things that hasn't really been done before is to offer up this space of rumination to you all, to think it through alongside us. We want to sit with how you understand the legacies of the Great Migration and hopefully build a shared vocabulary throughout this process.

RND: We've been in so many conversations with you all to date. And one of the things that continued to be highlighted throughout this exploration is storytelling, the narrative around the Great Migration, the narrative around leaving—or staying in—the South. This is an opportunity to expand the conversation around the Great Migration as a historical phenomenon, and also look at the migratory path from the South to the West, or other movements that have taken place. Jessica and I are also really thinking about how we can be a liaison, if you will, to you all, to the public, and to others around

opening up the conversation, so that it doesn't end so narrowly around trauma. So for those who feel comfortable, we hope you'll share how the Great Migration story ends up being part of your family's history.

LH: Whenever I think about the Great Migration I feel like it is an artistic story. I feel like a lot of the culture shifted when Black people left the South and moved to some of these urban centers—Detroit, Chicago, New York. And with that they brought their stories in the nomadic form, where it's embodied knowledge. So I just wanted to start there and think about the Great Migration as a nomadic story. We're not the first group that had to move from place A to place B, bringing with us the most essential things that were embodied and shared. And I think in our case, if I could generalize, these ended up being very expressive forms that came out of many of these cities. It's really amazing that we're now thinking about this in terms of visual art, because I think one could go to the sonic register quite immediately.

> "So I just wanted to start there and think about the Great Migration as a nomadic story. We're not the first group that had to move from place A to place B, bringing with us the most essential things that were embodied and shared."

JRE: For me it's very dichotomous. My family who stays South, they thrive. They still live on their ancestral lands. My paternal side is in Covington, Virginia, and my family essentially owns the majority of Covington. But for my family who went to Detroit from Georgia, from Mississippi, what I perceive as I'm looking at this data and my understanding of history is that it was a trap. My family got caught in the heroin, crack, and AIDS epidemics, and my brother died. My mother and father were on drugs, and me and my sister, it's our responsibility to provide this upward mobility. Essentially for me I'm going back South because up here I was not really feeling at home. I'm currently building a home right outside of Jackson, Mississippi, trying to reclaim some of this, what I felt was lost. You have the trauma but that's part of the human experience, specifically the Black, Indigenous experience. I don't necessarily look at it as this tragedy, but I'm approaching this as the prodigal son, returning home and trying to understand what this thing was.

AJH: I'm also taking a different approach. On both sides of my family I'm from the branch of the family who stayed in the South, so I don't have a direct Great Migration story at all. As I said before, my mom's side is from rural Tennessee, and I grew up partly there, back and forth between there and Florida. My grandma is one of ten. Half of her siblings moved to Flint in the 1950s during the automotive boom, but she stayed—she's still on the farm today, at almost ninety-one. And on my dad's side, he's from the Carolinas, and some of his mother's people went to Philly, but our side stayed in the south.

I had never lived above the Mason-Dixon line until I moved to New York after college. For me the South is not a historical thing, the South is today. So I guess I'm approaching the South through a contemporary lens, thinking about micro-migrations around the region. There's a history of Black farmers being cheated out of or displaced from their land due to a number of circumstances. That history is in my family. So I'm thinking through the emotional resonance of all these micro-migrations. I've made work about my great aunt—my grandmother's older sister—killing all the family's peach trees when they were forced off of their first farm. My dad's mom, when she was little, was originally from Georgia, but they had to flee from Georgia

to North Carolina in the middle of the night because of a significant threat of racial violence. I didn't even know until I was an adult that, well, before Carolina we had been a Georgia family on that side.

And then of course coming from a hurricane state I'm always interested in climate and environmental justice and how climate change is not this universal thing on the horizon that's coming for everybody equally. It's already here now, impacting and affecting rural Black folks. All my elder Black aunts and cousins could tell you everything about the climate crisis, and yet voices like theirs are not equitably represented in conversations on the environment. Knowing about the land and climate and agriculture from them in a now-space is how I'm approaching this.

> **"My family's relationship to place is informed by certain types of hauntings."**

JL: I really appreciate that note about the contemporary, Al. I've been thinking a lot about that and how often if you are a part of a family who doesn't necessarily have direct routes to the Great Migration, the South is historicized as only being a thing that has already happened and not a thing that is actively contemporary. One of the things that I've been thinking about since coming back home to the Chesapeake Bay is how a lot of my family's relationship to place is informed by certain types of hauntings. There are several different gaps in the oral histories of both sides of my family. So I've been thinking a lot about what it means to be haunted by that which is presumably familiar, and how to negotiate those types of terrain. Especially in the specific case of my family, it occurs across multiple states, both violence at the hands of the state but also interpersonal, intrafamilial negotiations as well.

LWC: For me, in doing my research I discovered roots in Georgia, but growing up it was just the Carolinas. And on both my mother's side and my father's side, everyone migrated to Washington, DC. I've always equated the Carolinas with our roots, with history, where all the elders were. But then there was also this negative connotation as well. I think part of that was due to media portrayal and how history characterizes the South—as though the North is in the modern world and the South is very slow. Because of that I felt like for the later generations there was much more of a disconnect between the South and where we are. I have been looking at the South more from a very romanticized perspective. I think this project is a great opportunity for me to really immerse myself within my cultural history, the past, and to be able to share that with my wife and children, and try to bring that full circle.

KL: I just want to say, I have a wonder. It's much more complicated than what I'm about to say, but I wonder about this idea about how the Great Migration hurt Mississippi art, or deeply Southern art. I'm not sure I buy it. I actually think I buy the notion that the Great Migration helped Mississippi art and artists, and deep Southern artists. I have no way to substantiate that claim, but I'm interested in hearing other people talk through it so I can understand that a little bit more.

I think of Mississippi in particular as the center of most popular Black and popular art forms. And from doing ethnographic research with my family who are musicians and artists, I think a lot of that art that was created in Mississippi—so much incredible blues—was a reaction to a lot of their cousins, and mothers, and fathers, and other people moving up. So I just want to push back against the notion that the Great Migration actually left Mississippi artfully bereft, because I actually don't think it did.

CMW: Because we know that it didn't. And we might just find out that we're brothers and sisters and cousins.

RND: For real.

CMW: I think that there are a number of people from the Mississippi Delta area. I bet you if we really sat down and talked, we would find many cross-references to family and friends. Which I think is sort of fascinating in its own right.

The center of my work is really my grandfather, who grew up on the Sunshine Plantation, and who became a laborer and union organizer for the Sunshine Plantation. And the last known photograph that we have of him is in his lawyer's office in Chicago, preparing to file suit against the state of Mississippi. So that's where all of my energy is really focused around this project—unpacking the disappearance of my grandfather.

ZC: I wrote down this question: "What is greatness, and who benefited from that? Who culturally benefited from this mass exodus?" I wasn't raised in the South, but I returned after my parents retired. A lot of people from their generation were trying to leave the panhandle, they were trying to leave racism, and lynching. I think it's a real curious thing when I meet other Black folks from the area. They're like, we never want to go back to the South. But I have a real desire to return to it because it's home. It's really special.

I've been thinking a lot about what constitutes a migration. I had one aunt and her husband move to Harrisburg, Pennsylvania, which follows along the trajectory of the Great Migration. And why? Because of industry. But there were a lot of men in my family, including my dad, that went into the military to escape poverty. So the military was another space of the Great Migration. I think about what it is about me that wants to return, and knowing that my life has benefited from my dad's decision to leave the South because I grew up in the service.

> "So I just want to push back against the notion that the Great Migration actually left Mississippi artfully bereft, because I actually don't think it did."

JBB: Zoë, one of the things that I was reflecting on as you were speaking is that one of our hopes for this show is to really rethink how we cast the Great Migration as the story of those who stayed, or those who were left behind, and those who left. Moving away from the dichotomy of stasis or flux, or breaking out of a place, and toward what I think Leslie Hewitt described as a kind of reckoning with a corporeal memory of a place, or a lack thereof. The ways in which there's continuity between the South and other regions vis-à-vis things that have yet to be described, or named, or framed. I wonder if folks might have ways to describe how to name the thing that one is after in their work on this project.

SRP: I'll speak to that a bit, because it's still a very new area of research for me. After not being sure what I wanted to write about, I started thinking about the Camp Logan uprising in Houston, just around the time that the Great Migration was getting going. The reason it has struck me and troubled me is because it's not organized in a way where you can say this was a successful attack on the power structure, or that this was a planned attack on the power structure, or got them what they wanted. I'm not sure that any of that is true, and that's what interests me about it. It got me thinking about a kind of physics of this dispersed energy that can't land in the promised land, and can't stay in the bosom of origin stories. It's something

much more anarchic than that. And most of those soldiers, they weren't Southerners, and part of what they were chafing against, was the way they were being treated in Houston by Texans.

I'm also beginning this research thinking about what's not documented, what's not possible to document. People stayed for a reason. Some stayed because they had land, or I've come across in research really determined organizations in Georgia that were founded by Black people to combat the departure. I'm really interested in those concerted actions.

AB: I've been thinking a lot about how I navigate through spaces, keeping my family with me. Especially being in Baltimore and in Maryland in general, which is technically the northernmost Southern state, and the southernmost Northern state. Depending on where you are in the state, it feels very removed from the South. I think about it a lot, especially with most of my family being from New Orleans, and being Creole, and having to navigate a lot of things just being mulatto, and my great-great-grandparents speaking patois, and actually having to navigate different levels of Southernness and Blackness simultaneously. I have been noticing that I've often identified myself through my Southern heritage, and less through my Blackness, which has been something that I've felt a bit isolated in, especially living in Baltimore.

> "Moving away from the dichotomy of stasis or flux, or breaking out of a place, and toward what I think Leslie Hewitt described as a kind of reckoning with a corporeal memory of a place, or a lack thereof."

The music my family has consumed, and the food that is such a critical part of our gathering—it's very interesting to think about how other people are removed from that. Most of my direct family stayed in Mississippi. But my great-grandmother, all her brothers ended up going north. It's very, very interesting seeing what moving north did. Not just for our family, but the separation of the family. And realizing how many different branches of people, honestly, are so out of touch with not just where they come from, but also where they've been, where they've been going.

RND: Thank you so much. Food for thought.

JRE: My family migrated to Detroit, built it up. My grandfather had a diamond business, a bread business, bustling entrepreneurship. They cut the interstates in our community, and from there, the family went into the projects. And from the projects came the heroin, the crack. It really just ripped through my family. When I started doing my genealogical research, I discovered that my family who stayed south still had their land, the majority were college educated, and those from my line that came up north, everything that could go bad went bad. So I'm looking at that dichotomy like wait, why did y'all leave? And you already had land south?

> "I've been thinking a lot about how I navigate through spaces, keeping my family with me."

I'm trying to resolve that and connect with my Southern family. I'm interested in the nuances around why we left, and in what were hoping to gain up north. When the interstates cut through these communities, this was happening nationally. So to me, this seems like it was a plan.

SRP: It was definitely in the plan. I shared this with the curators when we first started communicating—there are letters from the migrants that were published in the *Journal of Negro History* as it was happening. What I find so amazing is that they understood that something really major was going on. We have these primary sources,

so some of the questions and yearnings that have been voiced, we can talk directly to them because we have these letters where people are writing back and forth asking what is it like, or asking should I come, or this is what I found. It's just a really beautiful resource.

SJ: During the last fifteen years I've spent more time in the Southern US than ever before. My partner's family lives in rural Alabama—coincidentally very close to where my father's father was born—as well as in suburban Atlanta. For me, this exhibition has been an opportunity to do some travel, some writing, some genealogical research, and a lot of hanging out with people, just talking with them and learning from them. One thing that has really struck me is the anarchy of dispersion, as Sharifa mentioned. Instability, volatility, mutability. Fluidity. I've been thinking about the way this plays out in the contemporary moment, how technology creates new forms of intimacy, new pathways of desire, new experiences of compression and expansion of space and time. What kind of movement is possible these days—not just physical, but also virtual? I've been focusing less on the past and more on the present of "migration," thinking about shapeshifting and identity play as forms of movement.

RP: I'll say, for me, I tend to think about Black utopias. The last few years, I've shifted some of that thinking toward revisiting the world that I came from, which is Houston: Black Houston, the Black church I grew up in, my father's Black business. I'm interested in trying to concretize some of those ephemeral things that I saw, or felt, or heard. I'm looking for materials that maybe speak to this history that I'm thinking about. My father was a funeral director for fifty years in the same two neighborhoods. I have this one memory of him taking me to a . . . what do you call the Black club organizations that would do these sort of community service things, but they were also very private? Anyway, I remember seeing all these portraits of the line of people. And I remember thinking about the sort of secret history within that space.

> "One thing that has really struck me is the anarchy of dispersion. . . . Instability, volatility, mutability. Fluidity. I've been thinking about the way this plays out in the contemporary moment, how technology creates new forms of intimacy, new pathways of desire."

There are multiple versions of those moments that I kind of carry with me, but they were sort of quick, instantaneous moments that happen. I'm interested in digging up some of these histories. I'm also interested in the idea of creating situations where you were protected from that terror, especially as a young person growing up years after some of that happened. You have no real connection to it, other than stories and things. It felt like we had a cosmos within these communities. That's kind of how I always felt about long-time Black neighborhoods. I'm interested in what created that, partially because so much of it is disappearing.

I mean, obviously gentrification has been going on and changing the landscapes of these places. it is happening to me. I left Houston. Never thought I would not live in Houston. And now I get these alerts from friends: that closed, that closed, that closed, that building has been torn down.

JRE: "Gentrification" is a soft word for what happened with the interstates. It's so important that you document that information, because it's painful. It's happening everywhere, and we're not addressing it. It's terror.

KL: I agree. I just want to say it seems like when people usually talk about it, they only talk about the Robert Moses expressway in New York, which is another, I think, form of not valuing of what is happening to other parts of the country and the world—in particular, in Southern folkways and shit.

RP: Mm-hmm (affirmative). It feels so traumatic that these things are missing. When I go back, the landscape will be so totally different. I don't know what it's going to feel like. I haven't been home in a few years, so I'm interested in trying to build up some sort of . . . I don't want to say archive, because I feel like that's a different thing than what I'm thinking about. Obviously, I'm an artist. I want to make art about this thing that does something different than an archive does. Something that provides the emotional meaning and spirit of those histories.

> "I am also interested in the idea of creating situations where you were protected from that terror, especially as a young person growing up years after some of that happened."

CMW: Well, this is so fascinating to hear you talking about this. I've been thinking about similar groups in these times of the Elks, the Masons. I keep coming back to the notion of the North Star, which somehow feels to be grounding me, not only in this project, but in this life. And then I realized the North Star, of course, is the papers of [Frederick] Douglass himself, and all of the work that he published was called *The North Star*. The building where he worked and where he published his first journal is actually only an hour away from my home in central New York, in western New York. So I'm right on the Underground Railroad. All around me are these monument sites that are dedicated to this notion of those people who were fleeing.

And again, there's this idea of understanding something about the sky, about mythology. Understanding something about astronomy, ultimately. Understanding something about nature that could actually lead you out of that place. That, to me, is really fascinating. So, wonderful material, Robert, to be digging into for sure.

AB: I'm very interested in that conversation as well. My great-grandfather was the Grand Exalted Ruler of the Elks for the New Orleans chapter. It's probably the most regal image I have of a family member. And on that side of my family, there's a very deep involvement in honoring the Earth, honoring this ancestral Indigenous wisdom that I feel like we've become very separated from. Which I think is another layered conversation about what was really lost in this migration as well—the deep wisdom that I think we all have embedded in us. Really recognizing how deeply a landscape also informs or sort of disinforms you from deeper levels of engagement. I think about that a lot while navigating through Baltimore. The way people connect with the city is not the same way people connect with New Orleans. It's not the same way people connect in Columbus down in Mississippi.

> "And on that side of my family, there's a very deep involvement in honoring the Earth, honoring this ancestral Indigenous wisdom that I feel like we've become very separated from."

RP: When I was young, it felt like everybody I knew had cousins in New Orleans. I have no family there, no relationship to New Orleans, and it always felt like this magical place, because everybody had this connection to it. New Orleans and Houston have a real link. It wasn't until I got older that I started to feel more of those threads coming into my life. But definitely it feels, in some ways, mythological to me still, even today.

AB: Yeah, I think there's a very, very deep connection between the two cities. I don't think that conversation has been opened up enough, really, especially in the way they're laid out. There's also not many cities that really are designated in wards. I think food is the biggest signifier of those connections. I'm very interested in, as I had mentioned earlier, how much history is embedded in the foods. It's also why I love being from New Orleans. I feel like it's a place unlike any other, in terms of how deeply your ancestors are communicating to you through your food.

WJW: Akea, you made me think about a cousin of mine who is a chef who makes gumbo, etouffee, jambalaya. Initially I wanted to write about Black folk moving back to the South, this kind of reverse migration. But lately, in the winter time, I traveled to Franklin, [Mississippi]. My aunt had passed over the summertime unexpectedly, and she was the knowledge keeper. I did this pilgrimage to her home, and it got me thinking about intra-South migration. Oftentimes, we think about Black folk who went north, went west. But before we went to those places, Black folk went to Birmingham, or they went to New Orleans. They went to these metropolitan places in the South. My pops was one of those Black folk. He loved Franklin. He grew up working on a sugarcane farm, or plantation, really, as did his siblings and his father. And he eventually left because of something that happened with a white man and came to Houston. I'm wanting to kind of track this intra-South migration, centering, to some extent, my pops. That's what I'll be writing about.

TD: I want to go back to what Leslie was talking about for a second, this idea of mobility and modularity. And for me, the way I zoom into this question of the Great Migration is to say that people are still weaponizing migration and weaponizing movement. People of the Global South, Black folks in particular, Indigenous folks, folks who have been migrating around the Americas, still see movement themed as crime. I'm working back from that idea. Growing up in Chicago, spending so much time in the South, there's a network between us all that's both quotidian and phenomenological. Thinking about what Leslie was saying, there's a sonic condition that came out of the South. And there's a sonic condition that came out of Chicago. And there's a sonic condition that came out of the West Coast where all of the liminal spaces between are migratory patterns.

Where I'm struggling, actually, is where do I begin to think about this without getting trapped in the idea of universality, especially when it comes to, let's just say, the catastrophe of the Middle Passage, and then the crisis of the climate change? I know whose belly I was in, but whose belly was she in, and where was that person? Because my father, I thought he was born in Chicago, but no, the woman with a big belly went down Montgomery and had him in Montgomery. Since women populate the planet I figured I'd just follow the women and then figure out the rest.

JBB: I think a theme that's emerging so far is positioning oneself in one's work to lay claim to that notion of migration anew. Whether that be mapping Black diasporic and Indigenous narratives onto each other, or laying claim as a Southerner who was rooted to migration as experienced from afar or on a county-by-county basis, and not necessarily a more romanticized version of migration as fleeing the North or fleeing west. It's so beautiful to think about all of these new possibilities or potentialities that are just waiting to be visualized through your work.

"Since women populate the planet I figured I'd just follow the women and then figure out the rest."

TG: Yeah. It's been a rare occasion to think with colleagues about the importance of where we're from, where our parents are from, where our grandparents are from. For me, Mississippi is very much the place that made me. Sister Hamilton was saying that it's a place where your people stayed. It's definitely a place that my dad left, my mom left. Whatever Mississippi was for my mom and dad had already changed for me to something that was nostalgic, so it's a place of dream conjuring and romanticism.

Mississippi is a thing that I carry with me into new constructs. And I keep wanting to speak a native language of labor even though I no longer have the burden of calling "Master Johnny, Master Johnny." I ain't got to call them master and I ain't got to say nothing to them motherfuckers. I ain't got to say nothing to nobody. I'm really interested in that—like my dad's distrust of my Polish contractors because they look white. And I'm like, "Dad, they're not white like American Southerners, they're Polish." And he's like, "I don't know what that means, them motherfuckers look white to me." So there's this truth of race that won't let my dad go, but it holds me differently. The ghosts of the South, they all start there. This point that Torkwase made about just following the bellies—I think that has something to do with not only where the women take you but what my mama taught me.

JRE: You said something interesting that reminds me of something I've been exploring, especially when we talk about land and how tending to the land is a burden. When I look at documentaries, when they describe it they say, "Oh you have the poor South and people had to work these horrible lands." But then they start talking about the white musicians who were in the South and it was "they had this amazing relationship with the land." Many of my lines were never enslaved. And so they had this history of owning land, working the land, and me being a Northerner visiting I'm like, "You all doing all that work on that farm, that's slave work." And it's like, "No, that's actually ancestral work that's been part of this greater history of tending the land."

I've counted about a thousand acres of land that my family owned. There was this bamboozling, as Al said, out of our land, and so I'm trying to understand it: farm work, burdensome; slavery; the land being stolen. But if land is stolen, who owned it to begin with, you know what I mean? We had to understand this land to be able to grow crops on it. Some really interesting themes emerge from just land alone. I've now purchased land in Mississippi, and I feel really motivated to work it a little bit at least.

> "That's actually ancestral work that's been part of this greater history of tending the land."

And you said Mississippian, Theaster. When we talk about Mississippian we don't talk about the Indigenous Mississippian culture. We have all these ancient mounds throughout the South, and I'm trying to understand my family's relationship to these structures that exist really everywhere.

LWC: I wanted to piggyback on what you were saying Jamea, and also Theaster, when you say "a ghost." There is a way the South is viewed as this backdrop of fear and racism. Then you also have this other element where there's fear within family dynamics, a lot of secrets. So on one hand you think, well, people are fleeing the South in part because of racism, but there's other elements, whether domestic abuse or something else. When I was doing my research I found myself to be a little bit more privileged in being able to trace back certain generations, where not everyone has that luxury. A lot of their history is lost, so they just disconnect themselves

from that. I wonder in terms of this exhibition what our responsibility is to reshape that narrative to allow people or to encourage people to seek or explore their genealogy or reconnect with their Southern roots.

RND: Jessica and I talk a lot about where family archives show up or what archives are built in the country, and trying to find a way to maybe demystify white folks' attachments to—or rather disassociation from—the archive. We would love for visitors and folks to get a sense of self while they're walking through the exhibition and really leave with the understanding that now is as good as any moment to start collecting, keeping things, asking their great aunts if they're alive, or their aunts, to share family histories. I've been going through our family history with my mom and my aunts in Louisiana, in ways that it just hasn't been present before. I definitely think the exhibition will allow for—I don't know if it's about reclaiming, but just recognizing what's there in your family and how that's shared out.

> "So what does it mean to continue the triumph of the Migration? What things were learned in, I'll call it a Black condition of distance?"

AJH: Jumping off of Larry's comment and I think a little bit off Theaster and maybe even Torkwase, thinking about the female lineage of a family, on my mom's side, I literally have the slave schedules that have my great-great-great-grandma's name and age. On both sides of my family, for whatever reason, both my grandmas are part of a sibling set of ten, and they're both the second youngest. And so I only have three generations to jump from me at thirty-six years old to slavery. And so I'm also thinking about what gets passed down, and then passed down, and then passed down. There's a lot of unlearning and releasing these emotional, affective ghosts. My two closest friends in New York are also from back home in the South, and we talk about, all the time, how our parents are from the civil rights generation, and just the emotional resonance of that. There's this emotional baggage that we have to navigate—what are we letting go? What are we holding onto? What is still important to retain? What do we feel like we want to keep? And what emotional, affective ghosts do we want to let go of? I think a lot of that has to do with place and land and even gender.

On my mom's side, I come from a line of tough women—farmers and hunters. My great grandmother, who I was named after, famously could shoot a match out with a rifle from the top of a hill on our farm. So I also have these gender norms that've been suspended and subverted if I look toward the women in my family who worked and lived with the land. I'm curious about these different things, even with the assumed prescriptions of femininity—what's getting passed down, how are we taught to comfort ourselves either explicitly or not. What have I been taught implicitly that comes from slavery? How much of that am I unlearning? So for me part of it is: which ghosts are emotional?

JBB: I think also, Al, what ghosts have we not exhumed yet? Leslie was talking about corporeal memory. We share a connection to Macon, Georgia, where I grew up. I have a corporeal memory of it, and Leslie does not. However, I imagine there are ways of being and modes of existing that are equally tangible and have continuity but have yet to be named or have yet to be framed. I'm really curious about how that could also sit within how we're understanding the ghosts of our family history vis-à-vis these historical phenomena that we are experiencing as a collective body.

TD: I want to ask about the idea that maybe the Migration is unfinished. Maybe I still want to go by choice. So what does it mean to continue the triumph of the Migration? What things were learned in, I'll call it a Black condition of distance? What has distance done to or how has it showed up on the Black body in a way that we can talk about it as a triumph? I think about my parents. Their parents put them in a global conversation of Blackness. So there was a triumph in relationship to migration and I'm not sure where to enter it yet. I want to think about migration as an unfinished project. It's not just movement that was forced by climate, or by racial capitalism and new conditions of petro-colonization in the South. It's movement that is produced and enforced by collective powers and the nomancy built in nomadicity.

TG: Yeah. Torkwase, for me, I think about how if I have children they'll look at me and they'll imagine their father. But as I age I look like my mom. When I was young, I saw myself. As I age I see my head is elongated like my father's and my lips are darkening. My eyes are yellowing like my mom's. I have her face. So in a way, my body is also tracing time. My daughter will know my mom, her grandmother, because she sees my face. There's land and the body, which is my mom showing up in me. I don't know what I'm saying except that what you call the condition of distance, the idea of reverse migration, in a way it's all happening in us, on us, at the same time. It loses space. I'm not in Chicago, I live in Mississippi existence wherever I am.

JRE: Because time and space is an illusion. And that's the thing: you are your mom, I am my mom, I am my great-great-great-great-great. I think even the timing of this exhibition, post-COVID, is very serendipitous—we are finding our roots but we're also discovering parts of ourselves that were fragmented, and so that sense of space, that's really an illusion. It's interesting how art, from just the shared trauma, the shared triumphs, really talks about the gift of being Black. From having this melanated skin we're dealing with this trauma. But the beauty is, yeah, we'll reclaim those stories. I began on my genealogical journey four years ago, and I know I feel empowered even by saying their names, even by putting my bare feet on that land in Georgia, in Mississippi. I encourage you guys, if you haven't, once you step foot on that land, take your shoes off to let that land greet you and feed you.

> **"I feel empowered even by saying their names, even by putting my bare feet on that land in Georgia, in Mississippi. I encourage you guys, if you haven't, once you step foot on that land, take your shoes off to let that land greet you and feed you."**

JBB: I want to express our gratitude to all of you for you holding space with us.

RND: Thank you so much. Maybe we'll reconvene in the next few months, and just check in when folks are in deep writing, and in deep moments of making, and just keep it going. Really appreciate y'all.

Contributors

Jessica Bell Brown is the Associate Curator for Contemporary Art at the Baltimore Museum of Art (BMA). Her recent projects there include *How Do We Know the World?* (2021), *Stephanie Syjuco: Vanishing Point (Overlay)* (2021), and *Thaddeus Mosley: Forest* (2021). Prior to joining the BMA, Brown helmed roles at Gracie Mansion Conservancy, Creative Time, and the Brooklyn Academy of Music. She was the 2016–17 Museum Research Consortium Fellow at the Museum of Modern Art, New York, where she worked on *Robert Rauschenberg: Among Friends* (2017). A Ph.D. candidate in modern and contemporary art at Princeton University, her writing has appeared in various publications including *Flash Art*, *Artforum*, *Art Papers*, and *The Brooklyn Rail*.

Ryan N. Dennis is Chief Curator and Artistic Director of the Center for Art & Public Exchange (CAPE) at the Mississippi Museum of Art (MMA). Her recent projects include *Leonardo Drew: City in the Grass* (2020), *Betye Saar: Call and Response* (2021), *Piercing the Inner Wall: The Art of Dusti Bongé* (2021), and *Collective Care for Black Mothers and Caretakers*, a CAPE residency project by Shani Peters organized with the community. She has published widely, and been a visiting lecturer and critic at a number of art schools and institutions. She was co-curator of the 2021 Texas Biennial and recently served as guest art editor for *Gulf Coast: A Journal of Literature and Fine Arts*.

Exhibition Artists

Mark Bradford (b. 1961, Los Angeles) has a wide-ranging conceptual practice and is best known for his multimedia abstract paintings and collages with scavenged materials and weathered and incised surfaces that often reveal the atrocities and struggles of race and poverty. His work has been widely exhibited internationally and in 2017 he represented the US at the 57th Venice Biennale. Bradford received his BFA and MFA from the California Institute of the Arts and lives and works in Los Angeles.

Akea Brionne (b. 1996, New Orleans) is a photographer, writer, curator, and researcher who investigates the implications of historical racial and social structures in relation to the development of contemporary Black life and identity within America. Her work is featured in the Smithsonian's Ralph Rinzler Folklife Archives and Collections and Duke University's Rubenstein Library. In 2019, Brown co-founded Shades Collective. She received her BFA from the Maryland Institute College of Art and currently lives in Baltimore.

Zoë Charlton (b. 1973, Eglin AFB, FL) creates figure drawings, collages, and installations that depict her subjects' relationships to culturally loaded objects and landscapes. She co-founded 'sindikit, an artist project space in Baltimore, and holds a seat on the Maryland State Arts Council. Charlton received her BFA from Florida State University and her MFA from University of Texas at Austin. She is an associate professor of art at American University and resides in Baltimore.

Larry W. Cook (b. 1986, Silver Spring, MD) is a conceptual artist working across photography, video, and installation. Cook has exhibited his work nationally at MoMA PS1 (2020), UTA Artist Space (2020), and the National Portrait Gallery (2019), and internationally at Weiss Berlin in Germany (2020). He received his MFA from George Washington University and his BA in photography from SUNY Plattsburgh. He is currently based in Washington, DC, where he is an assistant professor of photography at Howard University.

Torkwase Dyson (b. 1973, Chicago) works in multiple mediums. Describing herself as a painter whose forms address the continuity of ecology, infrastructure, and architecture, she investigates our connections to imagination, materiality, geography, and belonging. In 2016 Dyson was elected to the board of the Architectural League of New York as Vice President

of Visual Arts. She received a BFA from Virginia Commonwealth University and an MFA from Yale School of Art in painting and printmaking. Dyson is now based in New York.

Theaster Gates (b. 1973, Chicago) creates works that engage with space theory and land development, sculpture, and performance. He has exhibited and performed internationally at major museums, including, most recently, Tate Liverpool, UK (2020), and Haus der Kunst, Munich (2020). He lives in Chicago and is a professor in the University of Chicago's Department of Visual Arts and Harris School of Public Policy as well as a Distinguished Visiting Artist and Director of Artist Initiatives at the Lunder Institute for American Art at Colby College.

Allison Janae Hamilton (b. 1984 Lexington, KY) is a multidisciplinary artist working in sculpture, installation, photography, and video who fuses land-centered folklore and her own family narratives into mythologies that address the social and political concerns of today's changing Southern terrain. Her work has been exhibited nationally and internationally, including in surveys at MASS MoCA (2018) and Atlanta Contemporary (2018). She holds a PhD in American Studies from New York University and an MFA in Visual Arts from Columbia University.

Leslie Hewitt (b. 1977, St. Albans, NY) uses a hybrid approach to photography and sculpture to revisit the still-life genre from a post-minimalist perspective. Interested in the mechanisms behind the construction of meaning and memory, she challenges both by evoking connections and meaning in her juxtapositions. Hewitt earned a BFA from the Cooper Union for the Advancement of Science and Art, New York and an MFA in sculpture from Yale University.

Steffani Jemison (b. 1981, Berkeley, CA) is an interdisciplinary artist based in Brooklyn. Her work has been the subject of solo exhibitions and special projects at LAXART, Los Angeles (2013); the Museum of Modern Art, New York (2015); Mass MoCA (2016); Jeu de Paume, Paris (2017); Nottingham Contemporary (2018); the Stedelijk Museum, Amsterdam (2019); and the Contemporary Art Center Cincinnati (2021), among others. Since 2016, Jemison has been a part of the musical collaborative Mikrokosmos with Justin Hicks.

Robert Pruitt (b. 1975, Houston) is known for his drawings, videos, and installations examining the historical and contemporary experiences of African Americans and the Black body and identity. He was a participating artist in the 2006 Whitney Biennial and has had solo exhibitions at the Contemporary Arts Museum in Houston (2006), The Studio Museum in Harlem (2013), and the California African American Museum (2019). Pruitt received his BA from Texas Southern University and his MFA from the University of Texas at Austin. He lives and works in New York.

Jamea Richmond-Edwards (b. 1982, Detroit) is an interdisciplinary artist who creates monumental assemblages and immersive installations. She draws inspiration from her experiences growing up in Detroit during the crack and AIDs epidemics that created devastating and lasting effects in Black and Indigenous communities across the US. Her works are in the collections of the United States Embassy, the Rubell Museum, and the Studio Museum in Harlem. Richmond-Edwards received her BA from Jackson State University and her MFA in painting from Howard University.

Carrie Mae Weems (b. 1953, Portland, OR) examines issues of race, class, and gender identity, working primarily in photography and video but also exploring everything from verse to performance. Her central focus is looking at history as a way to better understand the present. She was named a MacArthur Foundation Fellow in 2013. Weems received her BFA from the California Institute of the Arts and her MFA from the University of California, San Diego. She currently lives and works in Syracuse, New York, and is Artist in Residence at Syracuse University.

Contributing Writers

Kiese Laymon is a Black southern writer from Jackson, Mississippi. He is the author of the novel *Long Division*, the essay collection *How to Slowly Kill Yourself and Others in America*, and the award-winning *Heavy: An American Memoir*, which was named one of the 50 Best Memoirs of the Past 50 Years by the *New York Times*.

Jessica Lynne is a writer and art critic. Her writing has been featured in publications such as *Artforum*, *Art in America*, *The Believer*, and *Frieze*. She is a founding editor of ARTS. BLACK, an online journal of art criticism from Black perspectives.

Sharifa Rhodes-Pitts is the author of *Harlem Is Nowhere: A Journey to the Mecca of Black America*. She is working on a trilogy on African Americans and utopia that explores Harlem, Haiti, and the Black Belt of the American South.

Willie J. Wright is a 2021 Andy Warhol Foundation Arts Writers Grant finalist and co-curator of Project Row Houses' Round 52 installation *Gulf Coast Anthropocene*. His forthcoming book, *Social Practice in the City: Black Artist Collectives in Houston's Third Ward*, positions Black residents' spatial performances as central to the community's culture of arts.

This book is published in conjunction with the exhibition *A Movement in Every Direction: Legacies of the Great Migration*, presented at the Mississippi Museum of Art, April 9–September 11, 2022, and at the Baltimore Museum of Art, October 30, 2022–January 29, 2023.

This project is supported by a grant from the Ford Foundation.

 FORDFOUNDATION

Generous support is provided by the Henry Luce Foundation, The Andy Warhol Foundation for the Visual Arts, the National Endowment for the Humanities, and the National Endowment for the Arts.

Any views, findings, conclusions, or recommendations expressed in this project do not necessarily represent those of the National Endowment for the Humanities.

The presentation at the Mississippi Museum of Art is supported by the W. K. Kellogg Foundation and The Robert M. Hearin Support Foundation.

The presentation at the Baltimore Museum of Art is supported in part by John Meyerhoff and Lenel Srochi-Meyerhoff.

Library of Congress Control Number: 2021948055
ISBN 978-0-300-26446-3

Published by the Baltimore Museum of Art and the Mississippi Museum of Art in association with Yale University Press

Baltimore Museum of Art
10 Art Museum Drive
Baltimore, MD 21218
artbma.org

Mississippi Museum of Art
380 South Lamar Street
Jackson, MS 39201
msmuseumart.org

Yale University Press
302 Temple Street
P.O. Box 209040
New Haven, CT 06520-9040
yalebooks.com/art

Produced by Lucia|Marquand, Seattle
luciamarquand.com

Publication management by Jessica Novak
Edited by Amanda Glesmann
Designed by Polymode, Los Angeles/Raleigh: Brian Johnson, Silas Munro, and Randa Hadi
Image and text acquisition and permissions by Meghan Gross
Curatorial research assistants: Amarie Gipson, Cynthia Hodge-Thorne, Lydia Jasper, and Christina McField
Typeset in Dapifer by Brynn Warriner
Proofread by Ted Gilley
Color management by I/O Color, Seattle
Printed and bound in China by C&C Offset Printing Co., Ltd.

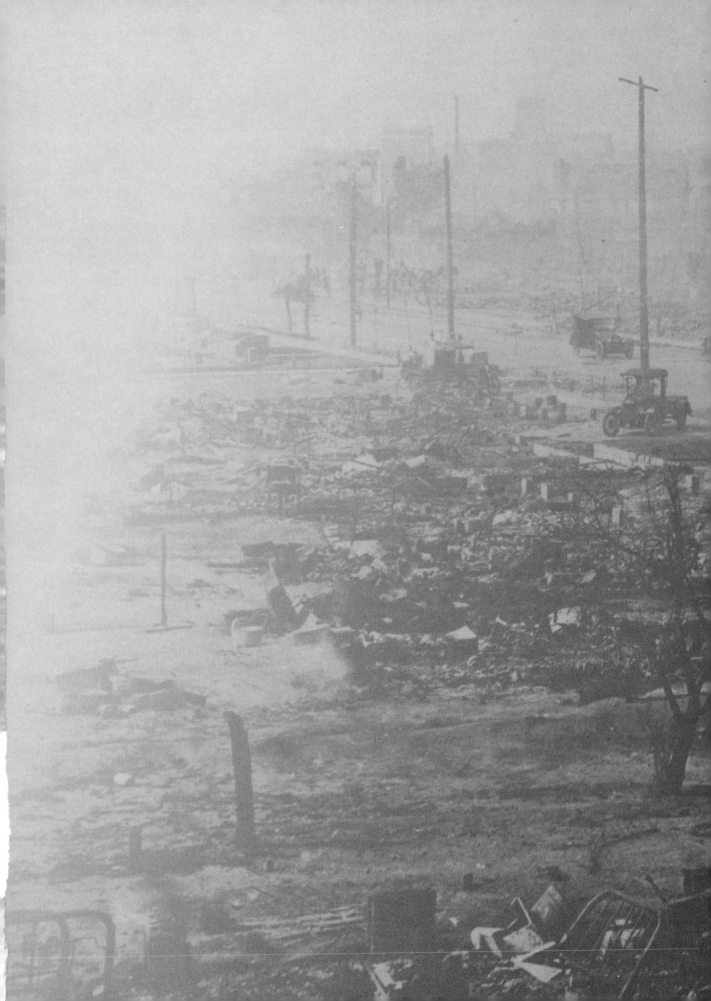

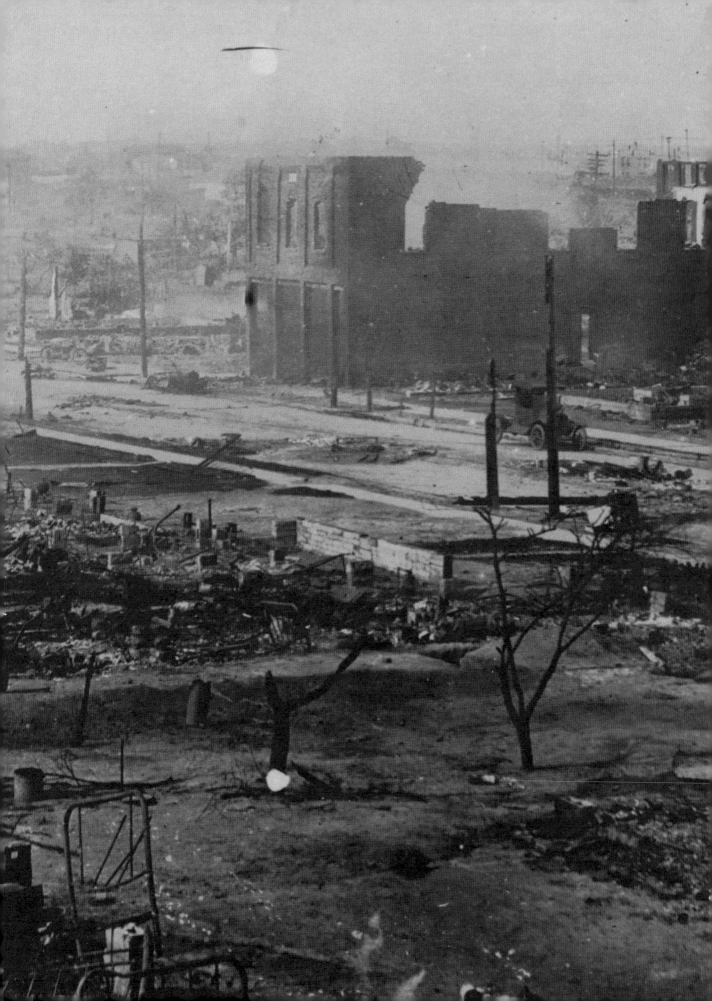